SURREALISM

desire unbound

SURREALISM

desire unbound

EDITED BY
Jennifer Mundy

CONSULTANT EDITOR
Dawn Ades

SPECIAL ADVISER
Vincent Gille

PRINCETON UNIVERSITY PRESS

Published by order of the Tate Trustees
on the occasion of the exhibition at Tate Modern, London
20 September 2001 – 1 January 2002
and touring to The Metropolitan Museum of Art, New York
6 February – 12 May 2002

Published in 2001 by Tate Publishing Ltd, a division of Tate Enterprises Ltd,
Millbank, London SW1P 4RG

Published in North America by
Princeton University Press
41 William Street, Princeton, New Jersey 08540
www.pup.princeton.edu

Project editor: Judith Severne
Print production: Tim Holton
Book design: Eileen Boxer, Brooklyn, New York
Design layout: Abbie Coppard

Printed and bound in Great Britain by Balding + Mansell, Norwich

Library of Congress Cataloging-in-Publication Data

Surrealism : desire unbound / Jennifer Mundy, general editor ; Dawn Ades, consultant editor ;
Vincent Gille, special adviser.
 p. cm.
Catalog of an exhibition held at Tate Modern, London, Sept. 20, 2001–Jan. 1, 2002, and the
Metropolitan Museum of Art, New York, Feb. 6–May 12, 2002.
Includes bibliographical references and index.
ISBN 0-691-09064-5 (cloth : alk. paper)
1. Surrealism—Exhibitions. 2. Desire in art—Exhibitions. I. Mundy, Jennifer. II. Gille, Vincent.
III. Ades, Dawn. IV. Tate Modern (Gallery). V. Metropolitan Museum of Art (New York, N.Y.)
NX456.5.S8 S872 2001
709′.04′06307442164—dc21 2001032101

Cover: Man Ray, *Untitled (from Facile)* 1935
Page 54: Andre Masson, *Gradiva* 1939 (detail, fig.46)
Page 276: René Magritte, *A Courtesan's Palace* 1928 (detail, fig.268)
Page 298: Toyen, *Screen* 1966 (detail, fig.287)

The display letters that open each chapter are from
Jindřich Heisler, *Alphabet*, 1952, courtesy private collection, Paris

Authorship of short texts is indicated by initials:

DA	Dawn Ades	JM	Jennifer Mundy
DH	David Hopkins	J-MG	Jean-Michel Goutier
DL	David Lomas	NC	Neil Cox
JK	Julia Kelly		

For Christopher, Amelia and Thomas

FOREWORD

Surrealism was one of the most extraordinary artistic and intellectual movements of the twentieth century. It was a movement that was distinguished by enormous breadth and richness, and it embraced not only art and literature but also psychoanalysis, philosophy and politics. The surrealists aimed to liberate the human imagination, and their vision, expressed in the works of some of the great artists and writers of the twentieth century, has had a major influence on modern life. Aspects of surrealism's critique of conventional values and ways of thinking still have resonance today.

Surrealism: Desire Unbound explores one of the central themes of the movement: the idea that man is a creature who is driven by desire. For the surrealists desire was the authentic voice of the inner self and at the same time a path to self-discovery. It was also an expression of the sexual instinct and, in sublimated form, the impulse behind love. The many different aspects of surrealism – its art, its literature, its politics – were inspired by this vision of man as desirous of love, poetry and liberty.

This exhibition brings together many of the most important surrealist paintings, sculptures and drawings, as well as a range of lesser-known works. It also includes many documents of a private nature, some of which have never been exhibited before. None of this would have been possible, of course, without the great generosity of the owners concerned. We are deeply grateful to the public collections and many private collectors who have supported the project, and enabled us to realise this ambitious exhibition.

The exhibition has been conceived and selected by Tate curator Jennifer Mundy. She has shaped the argument and has persuaded owners to lend to an exhibition which will explore new ground, much previously hidden. I should like to thank her for her insights and commitment to the project. I would also like to thank Professor Dawn Ades, a foremost authority on surrealism, for her advice and support, and for her work as consultant editor of the catalogue. I would also like to express my gratitude to Vincent Gille of the Pavillon des Arts, Paris, for his invaluable contribution to the sections that deal with the surrealists' love poetry and interest in eroticism, aspects of the movement that have rarely been given their due in previous exhibitions. All three have written essays for this volume, as have a number of distinguished writers from France, America and Britain. I should like to take this opportunity to thank all of them for their contributions.

An exhibition of this size and complexity poses a significant challenge to all involved in the planning and organisation, and I should like to thank in particular Helen Sainsbury and her team at Tate Modern for their dedication and commitment. I would also like to thank Judith Severne of Tate Publishing for her skilled work in editing this catalogue.

We are delighted that this exhibition will be seen at The Metropolitan Museum of Art, New York, and we would like to thank Philippe de Montebello, William S. Lieberman and Anne L. Strauss for their enthusiasm for the project.

The realisation of this exhibition has depended upon the generous sponsorship we have received from Morgan Stanley, a company that has proved one of the most imaginative supporters of the arts in this country. We are very grateful to them for their support.

Sir Nicholas Serota
Director

ACKNOWLEDGEMENTS

I have met with extraordinary kindness and generosity in my research for this exhibition. I have been shown great treasures, some of which have been lent to this exhibition, others of which could not be lent, but all of which have deepened my understanding of the movement, and given me a vision of the movement's richness that is not to be gained from art history books alone. To all those lenders who spent time with me, and shared something of their knowledge of surrealism with me, I am profoundly grateful. I hope something of the passion and integrity I have encountered in my dealings with those who collect surrealism has informed, in some measure, the vision behind this exhibition.

Independently and together, Vincent Gille and I have incurred a number of profound debts to people who have given both their time and encouragement to this exhibition. Some would not wish to be named, but of those that we may acknowledge we should like to thank, in particular, Mr Victor Arwas, Mr Timothy Baum, M. Serge Benhamou, M. Jean Benoît, M. Pierre Bergé, M. Claude Bernard, M. Claude Berri, M. Jean Boghici, Ms Louise Bourgeois, Mr Adam Boxer, Mme Micheline Catti, Mr John Cavaliero, Mr Pieter Coray, Mr Ronald Cordover, Mme Marie-Claire Dumas, M. Pierre Dourthe, M. Jean-Pierre Dutel, Mme Aube Elléouët-Breton, M. Gilles Erhmann, M. Jean-Pierre Faur, M. David Fleiss, M. Marcel Fleiss, M. Bernard Galateau, Mr Jerry Gorovoy, M. Jean-Michel Goutier, M. Didier Grandsart, Mme Thessa Hérold, M. Charles Herscovici, Mme Myrtle Hugnet, M. Radovan Ivsic, M. Marcel Lannoy, Mme Annie Le Brun, Mr Robert Lehrman, M. Pierre Leroy, Mr Herbert Lust II, Ms Darlene Lutz, Mme Isabelle Maeght, Mme Sandrine Marchand, Sr Giorgio Marconi, Mrs Anna Maria Martin Turner, Mme Claudine Martin, Mme Guite Masson, Mme Jacqueline Matisse Monnier, Ms Mary-Ann Martin, Mr James Mayor, Mr Andrew Murray, Mme Tissato Nakahara, M. and Mme Ostier-Barbier, M. Claude Oterelo, Mr Richard Overstreet, Mr Antony and Mrs Roz Penrose, Ms Meg Perlman, M. Sébastien Petitbon, M. Jean-Jacques Plaisance, M. and Mme Perahim, Mme Manou Pouderoux, Dr Jean-François Rabain, Mr Birger Raben-Skov, M. Dominique Rabourdin, M. Jean Ristat, Ms Dorothea Tanning, Mme C. Thieck, M. Jacques Tillieu, M. Lucien Treillard, M. Arnaud de Vitry, Ms Jennifer Vorbach, Ms Rebecca Windschitl, Ms Virginia Zabriskie, Mr Richard Zeisler. To all those who have so generously parted with their works in order to allow this show to be made, I can only express my deep gratitude. A list of lenders to the exhibition is provided at the end of the catalogue.

Among colleagues in institutions and museums around the world, we should particularly like to thank Sra Montse Agúe, Mme Anne Baldessari, M. Jean-Michel Bouhours, Mr Richard Calvocoressi, Dr Rumjana Dačeva, Ms Susan Davidson, M. Charles Van Deun, Ms Louise Downie, Mme Sylvie Gonzalez, Ms Linda Hartigan, Dr William Jeffett, Ms Pam Johnson, Mr Piet de Jong, Herr Christian Klemm, M. Xavier Le Bertre, Mme Nathalie Leleu, Mr William S. Lieberman, Mme Danièle Maïsetti, Mme Jacqueline Munck, Mme Gisèle Ollinger-Zinque, M. Alfred Pacquement, Mme Suzanne Pagé, Mme Béatrice Riottot El-Habib, Ms Cora Rosavear, Mr T. Marshall Rousseau, Mr Philip Rylands, M. Alain Sayag, M. Didier Schulmann, Ms Anne L. Strauss, Mr Michael Taylor, Ms Ann Temkin, and Mr Kirk Varnedoe. Finally, there are many experts in the field who have helped our research. They include Ms Fiona Bradley, Ms Giorgiana Colvile, Ms Elizabeth Cowling, Prof. Christopher Green, Ms Pam Johnson, Sr Arturo Schwarz, Ms Sarah Whitfield, Dr Sarah Wilson and Ms Judith Young-Mallin. Mr David Nash has provided invaluable assistance to the organisation of the exhibition in New York.

The exhibition has been designed by Sir Richard McCormack, working with Gerald Fox and Jocasta Innes, and to them we should like to extend our thanks for their creative vision and enthusiasm for the project. At Tate Modern the exhibition has been organised with skill and enormous dedication by Helen Sainsbury, to whom a great debt is owed, together with her team of Giorgia Bottinelli, Sophie Clark, Claire Fitzsimmons and Adrian George. My thanks to them all. A project of this size requires the participation of a great many people from many departments, too many to name individually. However, I should like to thank in particular for their sterling work Stephen Dunn, Derek Pullen, Calvin Winner and, especially for his work in bringing to fruition the displays of documentary items, Brian McKenzie. Clare Storey and Krzysztof Cieszkowski of the Tate Library have been wonderfully helpful in locating research materials, and I am extremely grateful to them. Within my own department I should like to give special thanks to Jeremy Lewison, who has given unstinting support for my work on this exhibition. I should also like to thank for their help Rosie Bass and Sophie Howarth, along with those who have assisted in the research for this exhibition, notably Dr Julia Kelly, and Caroline Hancock, Imogen Cornwall-Jones, Katherine Green, Dan Porter and Katarina Wadstein. Eileen Boxer has provided an inspired catalogue design, which offers a vision of the material that is both contemporary in feel and strongly rooted in surrealist aesthetics. Within Tate Publishing I should like to thank Tim Holton and Odile Matteoda-Witte. Above all, I should like to thank Judith Severne, who has edited the catalogue with flair and great dedication. It has been a pleasure to work with her.

Professor Dawn Ades has generously provided support and encouragement for this project from its inception, and I am deeply grateful to her for her invaluable insights and kindness. Finally, I should like to express my gratitude to my colleague in Paris, M. Vincent Gille. He had played a critical role in shaping the two sections of the exhibition dominated by documentary items, and has done so with great professionalism. His vision of the importance of love in the lives and in the works of the surrealists, expressed in the conception of the exhibition and in his two essays in this catalogue, has been a constant source of inspiration and delight.

Jennifer Mundy

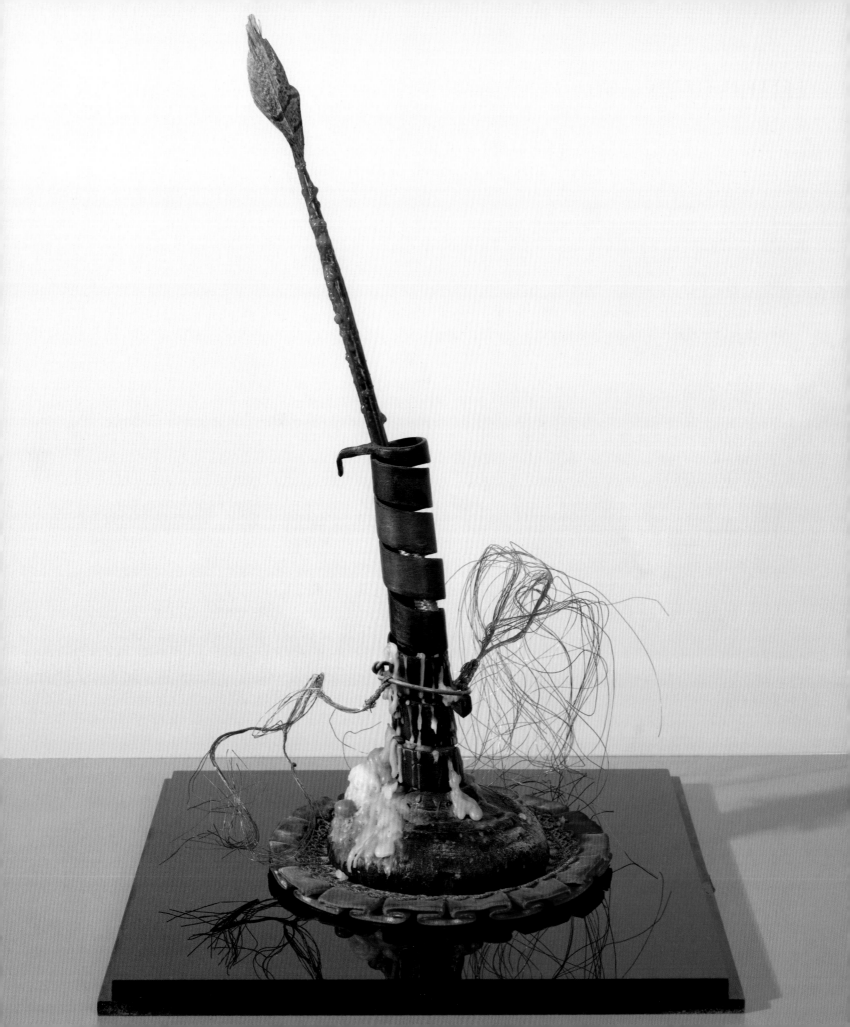

chapter one
LETTERS OF *DESIRE*

Jennifer Mundy

we must not let the paths of desire become overgrown

André Breton, 1937

The word desire runs like a silver thread through the poetry and writings of the surrealist group in all its phases. In the surrealists' meditations on poetry, freedom and love – the three watchwords of this international movement that aimed to 'change life' – desire was seen as the authentic voice of the inner self. It was an expression of the sexual instinct, and, in sublimated form, the impulse behind love. It was also a path to self-knowledge. André Breton, the leader of the Paris-based surrealist group, described it in his homage to love *L'Amour fou* (1937), as 'the sole motivating principle of the world, the only master that humans must recognise'.[2]

In French as in English, 'desire' has a range of meanings, encompassing both a simple want and, in its strongest sense, a powerful yearning. For Breton, desire was integral to life itself. 'Desire is the great force': these words – a verse of 1913 by the influential avant-garde poet Guillaume Apollinaire – were quoted by Breton in 1917 in an article in which he celebrated Apollinaire's ability to find inspiration in the everyday, and to retain an optimistic vision of life despite his experiences as a soldier in the trenches.[3] The connection between desire and the will to live was echoed by Breton a few years later in an article in which he considered the legitimacy of suicide and noted that desire for life would always prevail with him.[4] Breton was to retain this broad, and deliberately non-specific, vision of desire throughout his life. In the catalogue of the *Exposition internationale du surréalisme* (or *EROS* exhibition), held in Paris in 1959–60, Breton and others published a *Lexique succincte de l'érotisme*. Here desire was defined loosely as a 'profound, invincible and generally spontaneous tendency that drives all beings to "appropriate" for themselves in some way or other an element of the exterior world, indeed another being'. This 'tendency', it was said, culminated in sexuality but its manifestations were also 'innumerable and enigmatic'; and Apollinaire's verse, 'Desire is the great force', was cited again.[5]

In the early years of the surrealist movement desire was not a dominant theme. For much of the 1920s the group focused on the dream, revolution, poetry, and, above all, love, and although desire was implicit in all of these, it was not identified as a major aspect of surrealism. In the late 1920s and early 1930s, however, desire – specifically, though not exclusively, erotic desire – came much more to the fore in surrealist art and writings. There was a new willingness to confront the darker aspects of sexuality, and a new urgency in the surrealists' explorations of the deeper workings of the mind. (In these years Louis Aragon, for example, published the erotic novel *Le Con d'Irène*, Breton and Paul Eluard collaborated in the writing of a poeticised version of the Kama Sutra in the chapter on love in *L'Immaculée Conception*, and Salvador Dalí initially tested the limits of even the surrealists' broadmindedness with his scenes of perversion and vice.)

The new focus on desire – a word that was used more frequently in the surrealists' writings and in the titles of their artworks – reflected, in part, a much greater familiarity with the writings of Sigmund Freud. Freud was the immensely influential founder of psychoanalysis and theorist who from the early 1900s had identified the sexual instincts, and their sublimation, as factors of central importance to the development of the individual and of civilisation as a whole. Although Freud's

fig.1
ENRICO DONATI
La Plume de ma tante 1947
Mixed media
45.7 x 25.4 x 25.4 cm
Enrico Donati, courtesy Zabriskie Gallery, New York

ideas had been known in general terms for some time, many of his seminal books were translated from German into French only over the course of the 1920s. *The Interpretation of Dreams*, for example, first published in 1900, was translated only in 1926, while *Three Essays on Sexuality* of 1905 was available in French only in 1923. The surrealists took from Freud confirmation of the existence of a deep reservoir of unknown and scarcely tapped energies within the psyche. Their use of techniques to reduce the element of conscious control in their drawings and writings, and their patient recording of dream imagery were more and more seen by the theorists of the movement as attempts to express the inner world of undirected and uncensored thought that Freud had described. Freud's decoding of psychosexual instincts and complexes in everyday thoughts and actions also encouraged the surrealists to study themselves, the events in their lives and the world around them as if looking for hidden meanings, or clues to the secrets of existence.

fig.2
SALVADOR DALI
The Accommodations of Desires 1929
Oil and collage on board
22.2 x 35 cm
The Metropolitan Museum of Art, New York.
Jacques and Natasha Gelman Collection, 1998

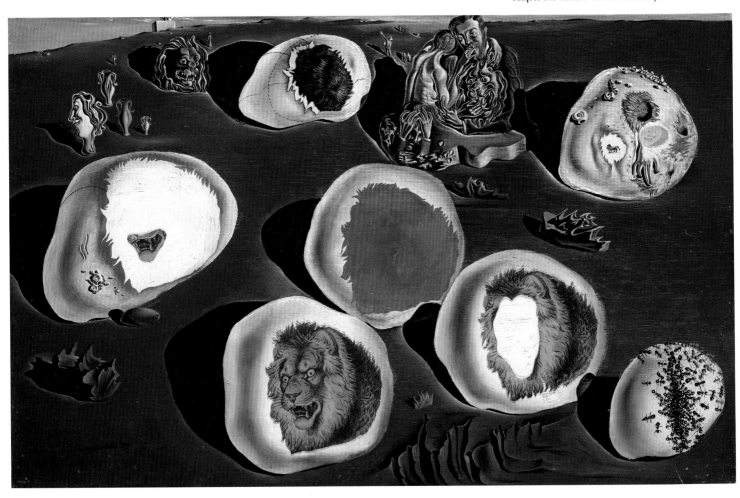

In this second phase of surrealism human beings were seen as agents for desires that were perennially in search of an 'object'. The 'object' of desire might be the body of a loved one (it is striking how much of the art and the poetry of the group was inspired by real love affairs; and how amid the serial affairs that marked the amorous life of some members of the group, the search for love resulted in passionate and long-lasting relationships). Or the 'object' might be any number of goals that were not, at least manifestly, sexual in character. Small wonder that the surrealists began in the early 1930s to make objects that, melding desires with reality, seemed taken straight from dreams. Surrealist artists and writers also sought to represent the arousal and renewal of desire. Their paintings and poems were characterised by images of searching and finding, of veiling and revealing, of presence and absence, of thresholds and passages, in a surrealised universe in which there were no clear boundaries or fixed identities.

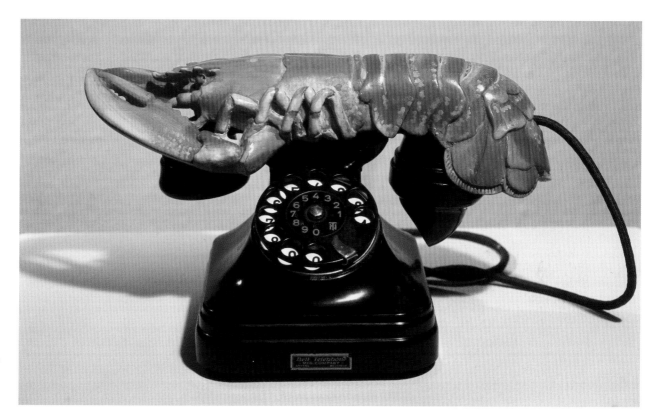

fig.3
SALVADOR DALI
Lobster Telephone 1936
Mixed media
17.8 x 33 x 17.8 cm
Tate. Purchased 1981

In the early 1930s the Yugoslav surrealist group – surrealism was very much an international movement in this period, with centres in many countries in Europe and beyond – attempted to elucidate some of the complexities of desire through a survey. (Surveys were a popular tool of the surrealist movement, in part because they stimulated debate and in part because the responses illuminated the question of the extent to which a person's opinions were individual or shaped by the views of the collective.) This survey, which included the responses of a handful of surrealists in Paris, was published in the periodical *Nadrealisam danas i ovde* (Surrealism Here and Now) in January 1932. It began, 'What importance do you give man's desires and his most immediate needs?' Another question asked: 'Do you have secret desires, that could be thought of as sinful, immoral, base, or that you personally find squalid, vile, filthy? If so, what do you do? Do you struggle against them, or do you satisfy them in your imagination? Or in real life? In that case what role do you see your will having? Or your conscience?' The issue of the potential vagueness of the term was also raised: 'Do you find the word "desire" is justified in all the cases where it is commonly used? Do you think that it would be better to distinguish between the various needs that are normally called desire? Do you think, for example, that there is an essential difference between sensory and material needs (hunger, libido)

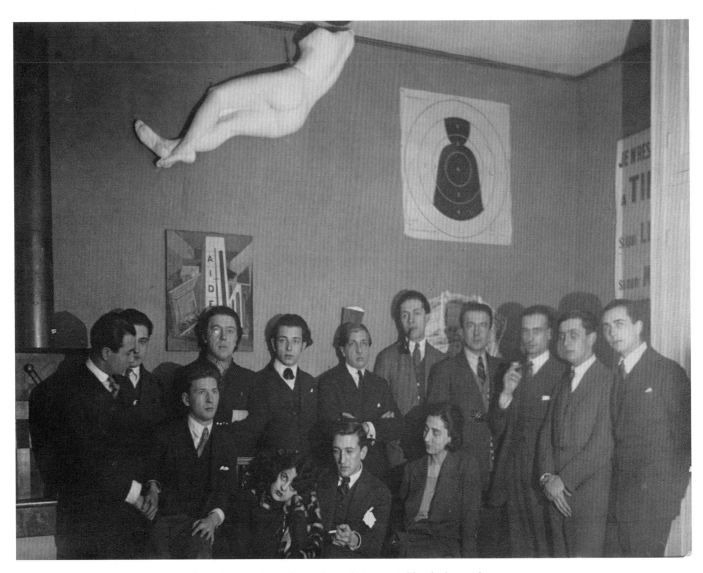

fig.4
MAN RAY
*Inside the Central Office of Surrealist
Research* 1924
Private collection

From October 1924 to April 1925 the surrealists ran the Bureau central de recherches surréalistes, rue de Grenelle, in Paris, where people could come and find out about surrealism, give their views and answer questions.

Back row, left to right: Jacques Baron, Raymond Queneau, André Breton, Jacques-André Boiffard, Giorgio de Chirico, Roger Vitrac, Paul Eluard, Philippe Soupault, Robert Desnos, Louis Aragon. Front row: Pierre Naville, Simone Breton, Max Morise, Marie-Louise Soupault

fig.5
MAN RAY
Surrealists in front of Tristan Tzara's Studio, Paris 1930
Musée d'art et d'histoire, Saint-Denis

Back row, left to right: Man Ray, Jean Arp, Tanguy, André Breton.
Front row: Tristan Tzara, Salvador Dalí, Paul Eluard, Max Ernst, René Crevel

fig.7
ANONYMOUS
Members of the Surrealist Group at Pierre Matisse's Home, New York 1945
Marcel Duchamp Archives, Villiers sous Grez

Front row, left to right: André Breton, Suzanne Césaire, Jacqueline Matisse, Elisa Breton, Mme Calas,
M. Calas, Patricia Matta, Roberto Matta, Alexina Matisse, Aimé Césaire. Back row: Esteban Francès, Denis de
Rougemont, Sonia Sekula, Yves Tanguy, Marcel Duchamp

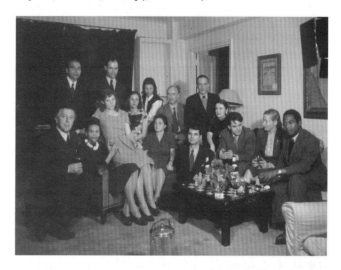

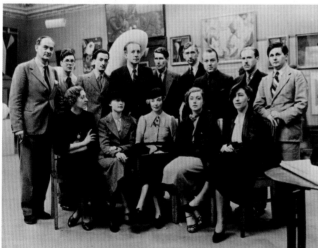

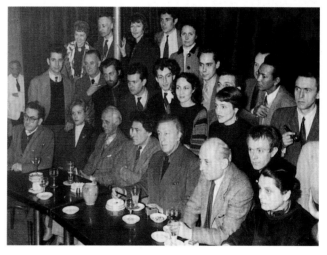

fig.6
ANONYMOUS
The Surrealist Group in London 1936
Tate Archive

Back row, left to right: Rupert Lee, unidentified, Salvador Dalí, Paul Eluard, Roland Penrose,
Herbert Read, E.L.T. Mesens, unidentified, unidentified.
Front row: Diana Brinton Lee, Nusch Eluard, Eileen Agar, Sheila Legge, unidentified

fig.8
JACQUES CORDONNIER
The Surrealist Group at the Café de la Place Blanche, Paris 1953
Private collection

Jacques Cordonnier was the husband of Suzanne Muzard, present in this photograph, who
had been the 'X' in Breton's novel *Nadja*.
Front row, left to right: Man Ray, Maryse Zimbacca, Max Ernst, Alberto Giacometti, André Breton, Benjamin
Péret, Toyen. Middle row: Michel Zimbacca, Clovis Trouille, Andralis, Jean-Louis Bédouin, Jean-Pierre Duprey,
Jacqueline Duprey, Nora Mirtani, Simon Hantaï. Back row: Suzanne Cordonnier, Julien Gracq, Elisa Breton,
José Pierre, Sarah X, Adonis Kyrou, Gérard Legrand (half-masked by Nora Mitrani), Wolfgang Paalen (half-
masked by Wilfredo Lam), Bernard Roger

and immaterial, spiritual needs (need to listen to music)? … On the other hand, do you think that some distinctions are not well drawn, that it would be best to get rid of them and give the notion of desire a broader and at the same time more precise definition?'[6]

Breton's replies to this survey, which were not published in French until 1967, have remained relatively little discussed. They throw interesting light, however, on the ways in which in these years desire was seen as bound up with issues of central importance to surrealism – individual freedom, the imagination and its relationship to reality, sexuality and the controls placed upon it by restrictive social structures, and man's relationship to nature.

'Human desires', Breton began, 'seem to me the medium through which nature generally makes itself known to man, *affecting* him in relation to what is (and at the same time, to what is not), and through which it expresses itself spontaneously to him as a fully formed imperative, encompassing all beings, real or potential, at the same time.' He did not pick up on the issue of the

The noblest desire is that of combating all obstacles placed by bourgeois society in the path of the realisation of the vital desires of man, as much those of his body as those of his imagination, these two categories being nearly always closely linked and mutually determining.

Paul Eluard's response to the survey on desire in Yugoslav surrealist periodical *Nadrealisam danas i ovde* (Surrealism Here and Now) 1932

I feel absolutely no embarrassment in making public desires generally considered as the most shameful, which means that I have never done so to the limit despite my very strong tendency towards exhibitionism. I have secret desires that even I do not know about as I am constantly discovering new ones. I think that secret desires represent the true future and, what is more, that the true spiritual culture can only be a culture of desires. No desire is blameworthy; the only fault lies in repressing them.

The term desire is justified in all cases where it is a question of eroticism, in other words, in all ordinary cases. There is no fundamental difference (see 'sublimation').

Salvador Dali's response to the survey on desire in *Nadrealisam danas i ovde*, 1932

term's definition (in contrast to his close friend Paul Eluard, for example, who wrote that for him desire was made up of so many desires that he found it difficult to have a clear idea of it). Instead, Breton avowed himself incapable of establishing any hierarchy of 'base' or 'noble' desires (what would be the criterion?), or of distinguishing between the needs of the body and those of the spirit (there was no difference between the two). He said he strove to give free rein to his own desires insofar as this did not incur penalties disproportionate to the importance he attached to satisfying those desires, and added that he felt 'sympathy, esteem and admiration' for those with the most 'original' desires. 'For it seems to me that the exercise of the greatest personal freedom in this sphere must give rise to extremely salutary doubts about the principle of "rational" liberty as it is understood in a society based on inequality, because it is something that, to my mind, could bring about the dissolution of this society.' He acknowledged the apparent opposition of desire and duty, in particular the conflict between his vocation as a poet and his political commitment (the question of whether it was possible to abide by the communist party's directives and belong to the surrealist movement was threatening then to tear the movement apart). However, it was this conflict, Breton said, that gave him a '*concrete* sense of his own being'. He would continue to 'reconcile the two through living, through not giving up, in order to live, on being *myself*'.[7]

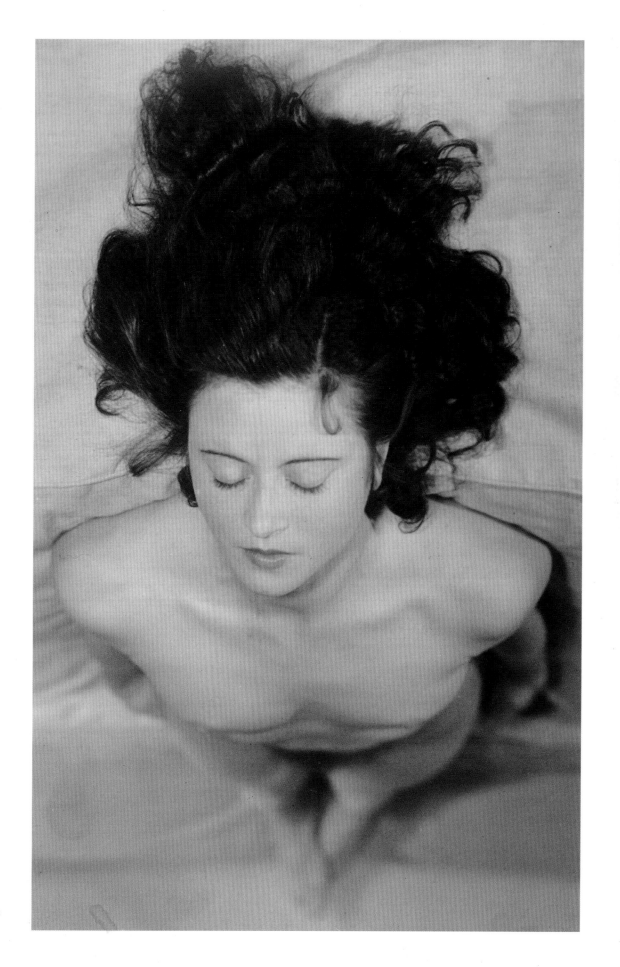

fig.9
JACQUES-ANDRE BOIFFARD
Renée Jacobi 1930
Gelatin silver print
23.8 x 18.8 cm
Centre Georges Pompidou, Paris. Musée
national d'art moderne

(AB) Love always has plenty of time. Love has before it the brow, from which thought seems to emanate; the eyes which will soon have to be distracted from their own glance; the throat where sounds will curdle; it has the breasts and the depths of the mouth. It has before it the inguinal folds, the legs that ran and the steam coming down their veils; it has the plea-sure of the snow falling outside the window. (PE) The tongue outlines the lips, brings the eyes together, raises the breasts, deepens the armpits, opens the window; the mouth attracts the flesh with all its might, it founders in a wandering kiss, it takes the place of the mouth it has carried away, it is the mixing of night and day. The man's arms and thighs are tied to the woman's arms and thighs, wind is mixing with smoke, hands take the imprint of desires.

André Breton and Paul Eluard, from chapter on
Love in *L'Immaculée Conception*, 1930

(AB) The secret of love is found in these words. It must always be the first time. The first time I see you, the first time I leave, the first time you answer me, the first time you are naked, the first time you leave, the first time I cry, the first time you return, the first time that everything is as if you were dead.

The wonderful reverse of this beautiful secret is contained in these words: it must always be the last time. (PE) I discover you and will continue to discover you because I am always losing you. As soon as you appear you disappear, as soon as you are dressed you are naked. My eyes do not even keep your shadow, my hands no longer seek you. You have never been, your absence is to be no more.

André Breton and Paul Eluard, abandoned draft of
beginning of chapter on Love in *L'Immaculée Conception*,
1930

Little further effort by the group was expended thereafter in attempting to define desire per se: the term was missing, for example, from *Le Dictionnaire abrégé du surréalisme* published in 1938. An amalgam of the conscious and the unconscious, of will and feeling, desire was perhaps felt to be too individual, mutable and mysterious a phenomenon to be usefully cate-gorised. Revealing the operation of desire, however, remained central to the surrealists' goal, first announced in the *Manifeste du surréalisme* (1924), of coming close to the 'real functioning of thought'. A spontaneous phenomenon, desire was also impli-cated in the ethical imperatives that led the surrealists in the early years to celebrate the irrational and imaginative aspects of the human spirit. Given that man was born with desires, it was in his nature, according to the surrealists, to explore them in defi-ance of those forces that threatened to repress individuality and control sexuality, and this remained a guiding principle of the movement in all its phases.

Thus, the great poets of the movement – Louis Aragon, René Char, Robert Desnos, Paul Eluard, Benjamin Péret and Breton himself, to name but a few of the earliest surrealists – recorded the soaring emotions and and bodily sensations con-nected with love, ranging from a lyrical union with the loved one, and through the loved one, with the physical world, to unfulfilled yearning and despair. Their use of language was shaped by the concept of desire: liberated from reason, words, they felt, should be free to 'make love', linking themselves spontaneously to new partners and creating new images. (Or, as Breton wrote in the opening lines of 'The Road to San Romano' (1948), 'Poetry is made in a bed like love / Its rumpled sheets are the dawn of things'.) In parallel, the artists of the movement explored ways of representing the multiplicities of desire, often refashioning the 'object' body in order to evoke the 'subject's' touch, gaze and erotic obsession. New techniques were developed to recreate the sensations and mechanisms of desire, ranging from Max Ernst's use of 'frottage' (literally 'rubbing') in order to discover new and unpredicted images of his desires to Man Ray's solarisation of photographs that played with bodily contours.

The surrealists' concern with desire was mirrored in the life and activities of the group itself. Eluard's volume of poetry *Au Défaut du silence* (1925), for example, was a homage to his wife Gala and a commentary on the passion and pain of their *ménage à trois* with Max Ernst, who illustrated the volume with portrait

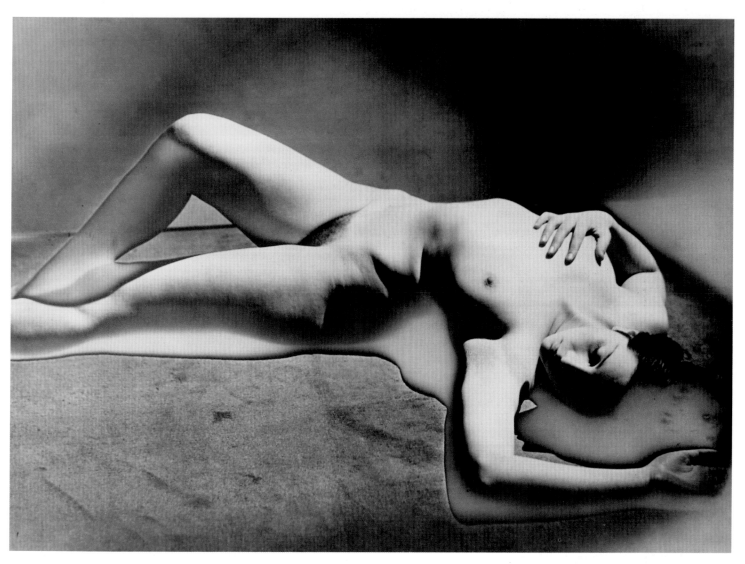

fig.10
MAN RAY
Primacy of Matter over Thought 1929
Gelatin silver print
20.8 x 29.1 cm
Manfred Heiting, Amsterdam

drawings of the woman who inspired both men. Although the identity of the loved one was often not made public at the time, many of the most important surrealist love poems and writings on love and desire were directly inspired by particular relationships. More generally, the group's surveys on love (1929), on the encounter (1933), and in later years on striptease (1958) and erotic representations (1964), were designed to elicit direct and personal responses, as a corrective to the movement's more theoretical or artistic statements, and to focus attention on desire as a live issue. (The last mentioned survey, for example, asked, 'How would you describe what you imagine during the act of love? Is it possible to apply value judgements to such images?'[8]) The concept of the meeting of two entities, of which the lovers' encounter was a model, underpinned a number of the games played by the group. In 'dialogues', for example, one party wrote a question beginning 'What is …' on a piece of paper, folded it, and passed it to the second party who wrote an answer, in ignorance of the question, beginning 'It is …'. It was a formula for provoking the creation of verbal

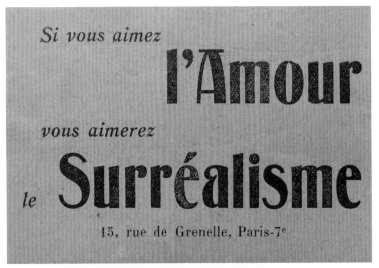

fig.11
If You Love Love, You'll Love Surrealism 1924
Printed paper
6.8 x 10.8 cm
Galerie 1900–2000, Marcel and David Fleiss,
Paris

One of sixteen surrealist 'papillons' or fliers published by the surrealist group and posted around Paris in late 1924, advertising the existence of surrealism and the opening of the movement's headquarters, the Bureau central de recherches surréalistes at 15 rue de Grenelle.

images, all the more poetic for being unexpected. More literal encounters – on the streets and in the cafés of Paris – were central to the group's amorous life. The surrealists sought clues to the mysteries of existence in the circumstances of their falling in love, or in their chance meetings with strangers. For them, the city – an amalgam of reality, symbols and site of unpredictable events – was a territory of desire.

The surrealists explored desire with a humour that was alternately black and ribald, and, above all, with passion. The intensity of the surrealists' commitment to a broad, uncensored vision of human nature helped sustain and define the movement from its birth in the 1920s to its demise in the late 1960s. It also lends immediacy to their works. However, the surrealists' attitudes towards desire cannot be understood without reference to a complex range of factors, some of which are remote from modern experience. Factors such as the stiflingly conservative social ethos in France through much of the period in question, strict censorship laws, the pervasive influence of the Catholic Church, the stark legal and social inequalities between men and women, the political and ethical dilemmas posed by the rise of fascism and communism, and the experience of the two world wars. If the surrealists celebrated poetry, freedom and love above all else, it was because these embodied values that they felt were threatened most by the society in which they lived.

THE 1934 DIALOGUE

Marcelle Ferry and André Breton

B. *What is beauty?*
M. *It is an ethereal cry.*

M. *What is mystery?*
B. *It is the proud wind through a suburb.*

M. *What is solitude?*
B. *It is the queen sitting at the base of the throne.*

M. *What is an encounter?*
B. *It is a savage.*

M. *What is [chance]?*
B. *It is a Gothic novel.*

M. *What is saying farewell never to meet again?*
B. *It is a slave market stretching as far as the eye can see.*

B. *What is everything that is not?*
M. *It is a liking for the worst.*

M. *What is jealousy?*
B. *It is a bugle on a laid table.*

B. *What is the number 7?*
M. *It is a fourposter bed with a hanged man.*

M. *What is fire that smoulders?*
B. *It is a screech-owl followed by a horse.*

M. *What is debauchery?*
B. *It is the place in a meadow where the grass suddenly becomes thicker. It can be seen from a long way off.*

B. *What is the future?*
M. *It is something we don't think about enough.*

M. *What is a path through the imagination?*
B. *It is a light green wheel-driven pump that has never been of service.*

M. *What is surrealism?*
B. *It is old tin cutlery before the invention of the fork.*

M. *What is not knowing?*
B. *It is a blind eagle guided by its prey.*

M. *What is black magic?*
B. *It is a litter of small cats spotted with butterflies.*

B. *What is womankind?*
M. *It is a star in water.*

fig.12
VALENTINE HUGO, PAUL ELUARD,
ANDRE BRETON AND NUSCH ELUARD
Exquisite Corpse 1934
Crayon on paper
31 x 24 cm
Musée d'art et d'histoire, Saint-Denis

The ingenuity expended in enumerating the positions of partners' bodies during the act of love contrasts sharply with the silence over the position of their minds, and over the imaginary representations which they attach to the objective world. Would we believe the words of love if they did not carry hope of that union of the real and the imaginary of which the lovers' encounter forms the allegory?

An Inquiry into Erotic Images, *La Brèche*, 1965

WHO AM I?

In 1922 – that is, two years before the official launch of the movement with the publication of the first *Manifeste du surréalisme* – Breton published anonymously a short text entitled 'L'Esprit nouveau'. If the phrase had been coined by Apollinaire in a lecture in which he called for poetry to be allied to the discoveries of science, and later became associated with the Purist artists Ozenfant and Le Corbusier and their celebratory vision of modernity, Breton's article suggested a very different vision of what was of interest in contemporary life. In the text Breton described a seemingly insignificant but troubling coincidence. While making their separate ways to the same café, he, the poet Louis Aragon and the artist André Derain each happened to see a striking-looking young woman behaving oddly. She was wandering along seemingly aimlessly, looking behind her often; from time to time she became involved in conversations with men, and suddenly went off on a bus with one of them. Was she on drugs? Had she experienced some catastrophe in her life? Aragon was struck by her attractiveness, Breton by her air of being lost; but both, the text reported, were at a loss to understand fully why they had been so affected by this episode.[9]

I think of nothing but love. The continual amusement I derive from intellectual pursuits, for which I am always being reproached as if it were a crime, finds its very justification in this singular and unceasing taste for love. For me there is no idea that is not eclipsed by love. If it were up to me, everything opposed to love would be abolished. That is roughly what I mean when I claim to be an anarchist.

Louis Aragon, 1924

The themes of this modest text – sexuality, chance, and enigma – were to be developed in Breton's novel *Nadja* (1928). The book is named after a woman with whom he had a brief love affair, but the novel's famous opening lines make clear that its true subject was Breton himself; or, rather, a self that Breton compared to a ghost-like presence within his mind. 'Who am I? If this once I were to rely on a proverb, then perhaps everything would amount to knowing whom I "haunt".'[10] With this evocative image, Breton aligned himself and surrealism with trends in modern philosophy and psychology showing that the self was not to be regarded as a single, stable and knowable entity. Studies of the insane, of mediums, and of the phenomena of multiple personalities, automatism and hysteria, had revealed something of the capacities of the mind to escape the control of the consciousness. Breton, who as a young medical student had had direct experience of studying mental trauma through his work with shell-shocked soldiers during the First World War, used *Nadja* to promulgate a vision of his self as the object, not the subject, of enquiry.

The narrative of the affair with Nadja – the details of their meetings, the comments that Nadja made, Breton's own fluctuating responses to her, his doubts and his ruminations on his responsibility towards this young woman who was so ill-equipped to fend for herself – make compelling reading. As in the 1922 episode described in 'L'Esprit nouveau', the story of Nadja begins with an encounter on the streets of Paris. On one 'idle, gloomy' afternoon in October, Breton was aimlessly walking, observing the crowds of workers returning home. He had just bought the latest volume of Leon Trotsky's writings, and was musing dispiritedly on the fact that the people he saw around him were unlikely to create a revolution soon, when he spotted a young, poorly dressed woman walking towards him. She had already noticed him. 'She carried her head high, unlike everyone else on the sidewalk. And she looked so delicate that she scarcely seemed to touch the ground as she walked … I had never seen such eyes. Without a moment's hesitation, I spoke to this unknown woman'.[11] So began their affair.

fig.13
ANDRE BRETON
First page of *Nadja* manuscript 1927
32 x 23 cm
Yves Saint Laurent – Pierre Bergé

NADJA

A Monsieur H. L. Mermod
très sincère hommage
/ André / Breton

Qui suis-je? Si par exception je m'en rapportais à un adage : en effet pourquoi tout ne reviendrait-il pas à savoir qui je « hante »? Je dois avouer que ce dernier mot m'égare, tendant à établir entre certains êtres et moi des rapports plus singuliers, moins évitables, plus troublants que je ne pensais. Il dit beaucoup plus qu'il ne veut dire, il me fait jouer de mon vivant le rôle d'un fantôme, évidemment il fait allusion à ce qu'il a fallu que je cessasse d'être, pour être qui je suis. Pris d'une manière à peine abusive dans cette acception, il me donne à entendre que ce que je tiens pour les manifestations objectives de mon existence, manifestations plus ou moins délibérées, n'est que ce qui passe, dans les limites de cette vie, d'une activité dont le champ véritable m'est tout à fait inconnu. La représentation que j'ai du « fantôme », avec ce qu'il offre de conventionnel aussi bien dans son aspect que dans son aveugle soumission à certaines contingences d'heure et de lieu, vaut avant tout pour moi comme image finie d'un tourment qui peut être éternel. Il se peut que ma vie ne soit qu'une image de ce genre, et que je sois condamné à revenir sur mes pas tout en croyant que j'explore, à essayer de connaître ce que je devrais fort bien reconnaître, à apprendre une faible partie de ce que j'ai oublié. Cette vue sur moi-même ne me paraît fausse qu'autant qu'elle me présuppose à moi-même, qu'elle situe arbitrairement sur un plan d'antériorité une figure achevée de ma pensée qui n'a aucune raison de composer avec le temps, qu'elle implique dans ce même temps une idée de perte irréparable, de pénitence ou de chute dont le manque de fondement moral ne saurait, à mon sens, souffrir aucune discussion. L'important est que les aptitudes particulières que je me découvre lentement ici-bas ne me distraient en rien de la recherche d'une aptitude générale, qui me serait propre et ne m'est pas donnée. Par delà toutes sortes de goûts que je me connais, d'affinités que je me sens, d'attirances que je subis, d'événements qui m'arrivent et n'arrivent qu'à moi, par delà quantité de mouvements que je me vois faire, d'émotions que je suis seul à éprouver, je m'efforce, par rapport aux autres hommes, de savoir en quoi consiste, sinon à quoi tient, ma différenciation. N'est-ce pas dans la mesure exacte où je prendrai conscience de cette différenciation que je me révélerai à moi-même ce qu'entre tous les autres je suis venu faire en ce monde et de quel message unique je suis porteur pour ne pouvoir répondre de son sort que sur ma tête?

C'est à partir de telles réflexions que je trouve souhaitable que la critique, renonçant, il est vrai, à ses plus chères prérogatives mais se proposant, à tout prendre, un but moins vain que celui de la mise au point automatique des idées, se borne à de savantes incursions dans le domaine qu'elle se croit le plus interdit et qui est, en dehors de l'œuvre, celui où la personne de l'auteur, en proie aux menus faits de la vie courante, s'exprime en toute indépendance, d'une manière souvent si distinctive. Le souvenir de cette anecdote : Hugo, vers la fin de sa vie, refaisant avec Juliette Drouet pour la millième fois la même promenade et n'interrompant sa méditation silencieuse qu'au passage de leur voiture devant une propriété à laquelle il y avait deux portes, une grande, une petite, pour désigner à Juliette la grande : « Porte cavalière, Madame » et l'entendre, elle, montrant la petite, répondre : « Porte piétonne, Monsieur » puis, un peu plus loin, devant deux arbres entrelaçant leurs branches, reprendre : « Philémon et Baucis », sachant qu'à cela Juliette ne répondrait pas, et l'assurance qu'on vous donne que cette poignante cérémonie s'est répétée quotidiennement pendant des années, comment la meilleure étude de l'œuvre de Hugo nous donnerait-elle à ce

Almost from the outset, even as we read of their first kiss and of their trip one night to a hotel outside Paris,[12] we realise that Breton was not so much in love with her as bewitched, and challenged, by her poetic pronouncements and strange, detached vision of reality. The book's focus shifts to an examination of the meaning of the affair. What had caused him to notice her in the first place? Was their meeting predestined, or was it a reflection of an unconscious hope for change in his life, expressed earlier in his gloomy thoughts about the lack of hope for revolution? Was his extreme admiration for her some form of compensation for his inability to reciprocate her love? Why did he not see from the beginning that she was mentally unstable? After having been so close to her, how was he able to cut her out of his life, to the extent of not visiting her in the asylum to which she was taken a few short months after their affair ended?

This word, love, upon which buffoons have strained their coarse wits to inflict every possible generalisation and corruption (filial love, divine love, love of the fatherland), we are here, needless to say, restoring to its strict and threatening sense of total attachment to another being, based on the imperative recognition of truth, of our truth 'in body and soul', the body and soul of this human being.

Survey on love, *La Révolution surréaliste*, 1929

At this point Breton was unable to answer such questions about this 'decisive episode'. He could only note that he had not been in love with her. But questions about love were to go on haunting him. In 1929, in the last issue of the surrealist periodical *La Révolution surréaliste*, the group conducted a survey on love asking, for example, 'What sort of hope do you place in love?', and 'Do you believe in the victory of admirable love over sordid life, or of sordid life over admirable life?' (The questions were framed by Breton as he struggled to work out his own attitudes towards love during his turbulent relationship with Suzanne Muzard, the woman who entered his life immediately following the ending of his affair with Nadja.)[13] In 1933 another survey, composed by Breton and his close friend the poet Paul Eluard, asked, 'What do you consider the most important encounter in your life? To what extent did this encounter seem to you, and does it seem it you now, to be fortuitous, or preordained?'

This latter survey, as Breton reflected a few years later in *L'Amour fou*, was something of a failure. The majority of the correspondents had not understood the issue that he felt lay behind the

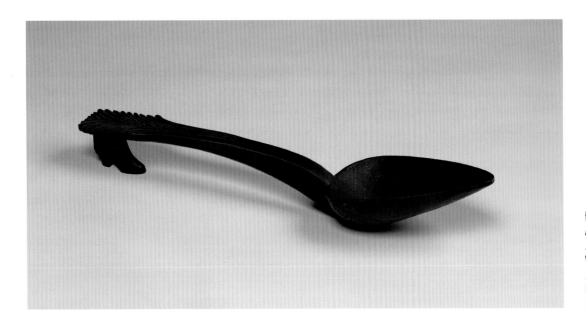

fig.14
ANONYMOUS
Spoon-Shoe n.d.
Wood
5.5 x 37 x 8.5 cm
Former collection André Breton
Private collection

deceptively simply questions. And yet he later described it as of all the surveys conducted by the surrealist group the one closest to his heart.[14] In *L'Amour fou* he spelled out what he thought the issue was – the coming together in certain chance 'encounters' of the events and forces of the material world ('natural or logical necessity', to use Breton's philosophical term) with the intentions and perceptions of human minds ('human necessity'), and the rare resulting sense of something both magical and disturbing occurring in this coincidence.

At the heart of a book was an extended analysis of the symbolism and hidden meaning of the purchase he and the sculptor Alberto Giacometti made in a flea market one day, of two strange objects – an iron mask and a strange wooden spoon-shoe (fig.14). Exploring in the manner of a psychoanalyst the host of interrelated associations and events that surrounded these objects in the lives of the two men (and concluding that the spoon-shoe symbolised his own longing for a new woman to enter his life), Breton wove a complex tapestry of deduction and inference around the operations of desire in this period of his life. 'I think I have succeeded', he concluded, 'in establishing that [the most apparently trivial and the most meaningful facts of my life] share a common denominator situated in the human mind, and which is none other than *desire*. What I have wanted to do above all is to show the precautions and the ruses which desire, in search of its object, employs as it manoeuvres in preconscious waters, and, once this object is discovered, the means (so far stupefying) it uses to reveal it through consciousness.'[15]

Reciprocal love, such as I envisage it, is a system of mirrors which reflects for me, under the thousand angles that the unknown can take for me, the faithful image of the one I love, always more surprising in her divining of my own desire and more gilded with life.
André Breton, 1937

L'Amour fou culminates in the story of Breton's meeting and falling in love with his second wife, the artist Jacqueline Lamba. From the idea of love he passed to the state of being in love. And the rightness of this love could be detected in his own fitting together of what, from his perspective, seemed like pieces of the jigsaw of his life. A poem he had written in 1923 now seemed to him to foretell the circumstances of his meeting with Lamba. And this led him to urge that everyone should look at the 'screen' of strange patterns of facts that make up their lives and read into them their own future. 'Everything humans might want to know is written upon this screen in phosphorescent letters, in letters of *desire*.'[16]

Breton's at times agonised attempts to analyse desire, penetrate its mysteries, and seek answers to the question 'Who am I?', were not shared by all the surrealists. His outlook was both more intensely philosophical than that of some others in the movement, and bound by his belief in the principles of reciprocity and equality in amorous relationships. Nonetheless, his influence was enormous and many of the themes on which he focused in his attempts to understand the operations of desire – coincidence, chance encounters, the object, erotic adventure and, above all, love – inspired the artists and other writers of the group. Autobiography and self analysis were the dominant themes of the texts produced by both the poets and artists; while much of the art created by those involved with the movement (whether artists, writers or their loved ones) embodied intuitive research into the workings of the psyche. But how, exactly, did the surrealists and their contemporaries envisage the drives and compulsions associated with desire?

ROUND TRIP

There was – and is – no consensus among philosophers, writers or psychoanalysts about how desire can be conceptualised and how the processes by which individuals become aware of their desires should be described. In the eighteenth century a vision of the universe as a mass of infinite elements in perpetual motion led some thinkers to adopt a mechanistic philosophy in which desire was uncoupled from the constraints of social convention and morality. The French physician Julien La Mettrie (1709–1751), for example, argued that, like the universe itself, human beings were but complicated machines, and he concluded from this that there was no purpose in life beyond the pleasures of the senses. The idea of nature as a seething mass of elements in motion also underpinned the vision of sexual desire as an imperious bodily function in the novels of the Marquis de Sade (1740–1814). Morality, utilitarian logic and the concept of society itself were depicted in Sade's writings as shams and deceits, while embodied desire – 'some swollen little vessels' – was presented as the ultimate and sole arbiter of truth. 'You seek to analyse the laws of nature,' he has one of his characters say, 'and yet your own heart, in which those laws are graven, remains an enigma which you cannot possibly resolve! … you cannot possibly explain to me how it is that some swollen little vessels can instantly send someone out of his wits, and in the space of a single day transform the worthiest of men into a wicked scoundrel.'[17] In neither of these Enlightenment writers nor in the later exponents of Romanticism, for whom the themes of love and desire were a constant source of artistic inspiration and self-analysis, was the category of desire subjected to any fundamental analysis or dissection. Even with the burgeoning of the medical sciences in the nineteenth century, and the extensive studies and categorisations of sexual behaviour, desire itself remained unexplored.

It was Sigmund Freud, the father of psychoanalysis, who provided a theoretical model for understanding desire as a psychophysical phenomenon. In *Beyond the Pleasure Principle* (1920; translated into French in 1927), he underscored the difficulty of defining the impulses at the core of our being. 'We would readily express our gratitude', he wrote, 'to any philosophical or psychological theory which was able to inform us of the meaning of the feelings of pleasure and unpleasure which act so imperatively upon us. But on this point we are, alas, offered nothing to our purpose.' He continued, 'This is the most obscure and inaccessible region of the mind, and, since we cannot avoid contact with it, the least rigid hypothesis, it seems to me, will do the best.'[18] Taking up terms first used in a text of 1895 but not significantly developed in the intervening years, Freud wrote in *Beyond the Pleasure Principle* of an 'unbound' form of energy (or 'quantity of excitation') in the mind, which it was a major function of the 'mental apparatus' to 'bind' as a preliminary to its 'final elimination in the pleasure of discharge'.[19] Within the unconscious, however, 'unbound' psychical energy flowed freely. Linking ideas and associations via the mechanisms Freud termed 'condensation' and 'displacement', this energy fuelled the production of unconscious desires and fantasies that infused certain elements of the conscious life with a strange, often disturbing power.

If Freud used the rather abstract concept of 'unbound' energy to describe the origins of desire, he used a familiar mechanistic metaphor to describe the satisfaction of the sexual instincts (in its beginnings psychoanalysis was very much rooted in the materialist and evolutionist concepts of nineteenth-century biology). Stimulation of the erotogenic zones, Freud wrote in 1905, 'leads to an increase in tension which in its turn is responsible for producing the necessary motor

energy for the conclusion of the sexual act'.[20] In *On the Universal Tendency Towards Debasement in the Sphere of Love*, of 1912, Freud examined the question of why, unlike many other desires, sexual desire was rarely sated. Unlike all other instincts, he wrote, it was possible that 'something in the sexual instinct is unfavourable to the realisation of complete satisfaction'. He hypothesised that infantile attachments to part-objects such as breasts and excrement meant that the partner in the sexual act was not the original object of desire but only a surrogate for it, while the restrictions on sexual activity, notably the barrier against incest, imposed by civilisation on the individual, also contributed to a dissatisfaction in love:

> Psychoanalysis has shown us that when the original object of a wishful impulse has been lost as a result of repression, it is frequently represented by an endless series of substitute objects none of which, however, brings full satisfaction. This may explain the inconstancy in object-choice, the 'craving for stimulation' which is so often a feature of the love of adults.[21]

This suggestion of an originary 'lack' at the heart of desire, seen by Freud as an element in the 'compulsion to repeat' within the psyche and a source of fetishistic attachments to a range of 'substitutes' for a sexual partner, offered a compelling conceptual model for the operation of desire. The model was to be variously developed by followers of Freud, including the French psychoanalyst Jacques Lacan. For Lacan, who was close to surrealist circles from the 1930s onwards and who shared their interest in the philosophy of Hegel, desire was also something that could never be fulfilled or sated. Originating in the period when an infant became aware of its separateness from its mother but remained dependent upon her for the satisfaction of its needs, desire, in Lacan's terms, was always the desire of, and for, the other (initially, the mother).[22] It involved desire for recognition by the other; it required desire to be directed to something new (it is impossible to desire what one already has); and, logically, it demanded that the subject desired only what was already designated as desirable by the other. For Lacan desire was an inescapable element of the maturation of an infant and of its entry into the world of language.

The surrealists' exploration of desire was influenced by psychoanalysis but not subservient to it. Freud was regarded, with but a few reservations, as a pioneering figure of incalculable importance, but the surrealists rejected the notion of 'cure' and the standards of 'normalcy' implicit in psychoanalysis. They also ultimately – and in their poetic texts quite insistently – preferred a vision of desire as an active, ever-creative force, to a concept of desire founded on the notion of lack.[23] Nonetheless, the two principal images used within Freudian psychoanalysis to conjure desire and its effects – 'unbound' energy within the unconscious, on the one hand, and a compulsive, fetishistic process, on the other – find strong echoes in the surrealists' explorations of desire. Through the techniques of automatic writing and automatic drawing, for example, the surrealists tapped into, or came close to, the energies and half-formed thoughts and impulses of the lower levels of the consciousness. Breton once described automatism as leading to the psychophysical region characterised by the 'absence of contradiction' and 'the relaxation of emotional tension', that, he said, alluding openly to Freud, was ruled by the pleasure principle alone.[24] The fetishistic model of desire corresponded to the surrealists' trompe l'oeil visual images remembered from

dreams and fantasies, and to their specially constructed 'objects with a symbolic function'. In these works the image or object stood in the place of veiled or sublimated impulses and desires, as a recompense for, or an intervention in, what the surrealists saw as the inadequacies of reality.

However, the very first works of art on the theme of desire by an artist associated with the surrealist movement predated the impact of psychoanalysis on French thought. Through his long career Marcel Duchamp made eroticism – a universal and, as he said, a universally understood, '-ism' – the central theme of his art. His fascination with the erotic impulse was announced in the early 1920s in the punning name of the feminine alter ego he created, Rrose Sélavy (a homophone for 'éros, c'est la vie', or 'eros, that's life'). Duchamp first reflected on how to express intangible desire in art as early as 1912–13. Notes made in preparation for his *oeuvre à clef The Bride Stripped Bare by her Bachelors, Even*, known as *The Large Glass* (1915–23; fig.15), show that for this project he conceived of desire in terms of pushes and pulls, akin to the action of physical forces in the material world. One note mentioned the problem of 'free will' and 'Buridan's ass', in reference to the sophism about an ass that, though standing within reach of hay and water, died because he was unable to decide whether to eat or drink first (fig.16). Another note described desire as a cycle of attraction followed by disappointment. Musing on the metaphysical implications of reflections seen in shop windows, Duchamp described the 'demands' of these windows as a seductive invitation to penetrate the enclosed space visually and imaginatively. 'One's choice is "round trip" … No obstinacy, ad absurdam, of hiding coition with one or many objects of the shop window through a glass pane. The penalty consists in cutting the pane and in feeling regret as soon as possession is consummated.'[25]

The vision of desire encapsulated in *The Large Glass,* for which the shop window was perhaps the antecedent, might be seen as equally pessimistic. With its separate domains of the 'bachelors' below and the 'bride' above, *The Large Glass* represents a desired and imagined sexual fulfilment that nonetheless stops short of union. The mechanical 'bachelors' in the lower half of the work are condemned to a grinding cycle of unremitting desire, while the 'bride', who controls the process through her 'timid power' and 'love gasoline', merely imagines her orgasmic 'blossoming'. Drawing on familiar notions of man as machine, updated to take into account the invention of the internal combustion engine, Duchamp describes both the 'bride' and the bachelors' in his notes as 'desire motors', complete with 'gears', 'air coolers' and 'cylinders'.

Duchamp's was an ironical vision of sex, in which there was no place for the idea of spiritual union, and in which sexual pleasures were solitary and repetitive. To this extent, it was distinct from mainstream discussions of sexual desire within surrealism. And yet Breton, who emphatically did not divorce sex from love, celebrated Duchamp's vision of eros following the publication by the latter in 1934 of the majority of the notes for *The Large Glass*. Recognising that *The Large Glass* stood at the crossroads of many streams of thought – scientific, philosophical, literary, linguistic – within western culture, Breton had no difficulty in hailing the importance of Duchamp's work and vision of eroticism. This may have been in large measure because he found in the notes' extensive discussion of the bride evidence of a commitment to the concept of woman as a superior and inspiring being – a defining feature of surrealism. Calling his text on Duchamp 'Phare de *La Mariée*' (Lighthouse of *The Bride*), Breton combined sexual innuendo with the poetic image of woman as a source of illumination.[26]

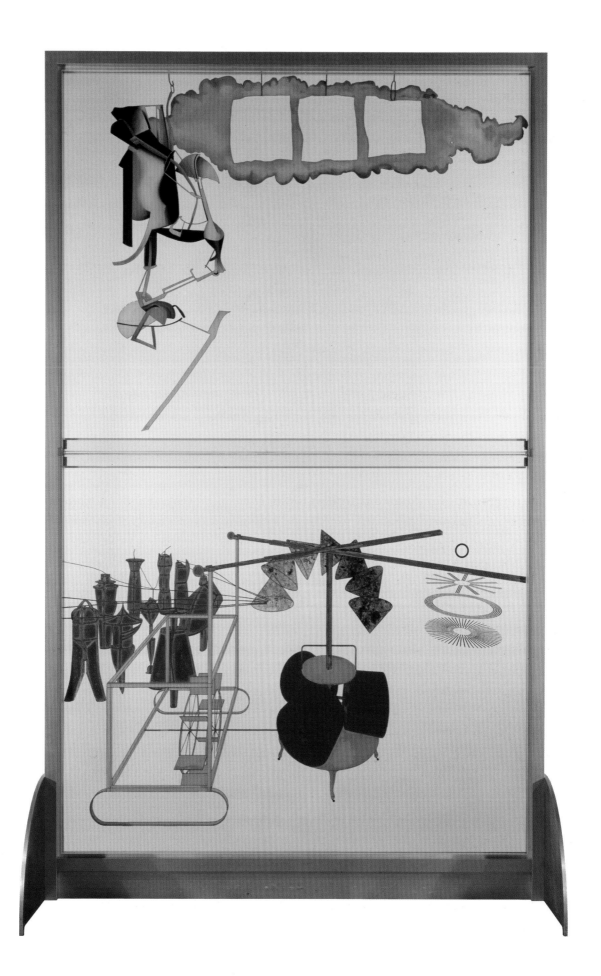

fig.15
MARCEL DUCHAMP AND
RICHARD HAMILTON
*The Bride Stripped Bare by her
Bachelors, Even (The Large
Glass)* 1915–23, replica
1965–6
Mixed media on glass
277.5 x 175.9 cm
Tate. Presented by William N.
Copley through the American
Federation of Arts 1975

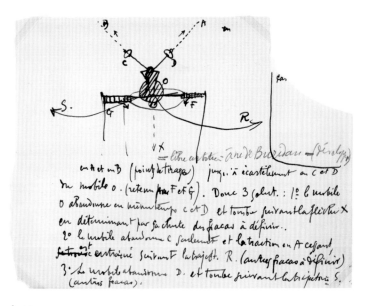

fig.16
MARCEL DUCHAMP
Free Will 1913
Ink and pencil on torn paper
15.3 x 20.2 cm
Centre Georges Pompidou, Paris. Musée national d'art moderne

The first line of the inscription on this note reads: 'free will – Ass of Buridan (develop)'. The inscription then details three quasi-engineering solutions for overcoming the Bachelor's indecision about meeting the Bride, involving 'mobile weights' and gravity: '3 solutions: 1. the mobile / O releases C and D at the same time and falls following the arrow X / determining by its fall crashes yet to define. / 2. the mobile releases only C and the tension ceasing in A, / it gets drawn along following traject.[ory] R (other crashes to define). / 3. The mobile releases D, and falls according to the trajectory S. / (other crashes).' This note suggests that emotions, actions and even states of indecision are, or can be described as subject in some way to the laws of physics.

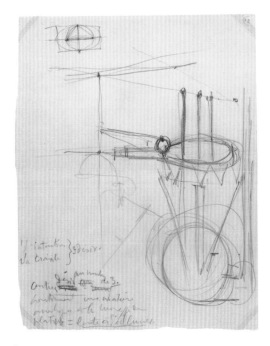

fig.17
MARCEL DUCHAMP
Intention, Fear and Desire 1915
Crayon on paper
20 x 15.8 cm
Centre Georges Pompidou, Paris. Musée national d'art moderne

The title of this note, based on Duchamp's inscription, '1 intention / 2 fear / 3 desire', suggests that the Bachelor's intention to meet the Bride is countered by his fear of the consequences, and that these two emotions fuel his desire.

However, Breton had a very different concept of the operations of desire. If Duchamp had written in his notes of a window pane separating the desiring subject from the desired object, and of the 'penalty' of pain and regret involved in breaking through the glass, Breton was led to use the metaphor of the window-as-barrier in another way. In the first *Manifeste du surréalisme* (1924) he described how once, as he was falling asleep, he became aware of a curious phrase that came totally unbidden to his mind but that struck him, in its strangeness, as having a personal and poetic resonance. (The phrase was 'There is a man cut in two by a window'.) Other sentences quickly followed: in Breton's words, they 'knocked at the window' of his consciousness.[27] Here Breton pictured the barrier separating the conscious and the unconscious as a sheet of transparent glass: it was necessary only to get close to the glass and be receptive in order to hear the messages from the 'the limitless expanses' of the mind wherein, he wrote, 'desires are made manifest'.[28]

Surrealism aimed at surmounting the antinomies that govern so much of our mental life. In 1930 Breton announced:

Everything tends to make us believe that there exists a certain point of the mind at which life and death, the real and the imagined, past and future, the communicable and

the incommunicable, high and low, cease to be perceived as contradictions. Search as one may one will never find any other motivating force in the activities of the surrealists than the hope of finding and fixing this point.[29]

However, if the goal was fusion, the process of reaching that goal necessarily implied a consciousness of the barrier between the self and the other, the inner and outer worlds. The barrier might be very fine, even, at the limit, permeable. Breton spoke of a 'capillary tissue' separating the two realms. Duchamp towards the end of his life envisaged an 'ultra thin' liminality marking the separation of two elements, or their passage from one state to another, as in the almost imperceptible melding of the smell of tobacco smoke and the smell of the mouth that exhales it. Much of surrealist activity can be seen in terms of an attempt to bring the desiring self close to the object of its desire, to remove the obstacles, intellectual as much as social, in the path of the wished-for union. The barrier between the self and the other, however visualised, helped define the identity of the desiring subject and remained an element in desire itself, but was not, within Breton's vision of surrealism, an inhibiting factor or a source of anxiety or regret. The pursuit of the objects of desire was a pleasure to be savoured *ad libertam*.

(Desire pleasure): Love — Chastity: ... O irreconcilables, let someone else decide between you. I'd like to grant you equal power in my country, establish you as twin sovereigns of this kingdom: my life and its reactions. But constitutional princes — absolutely not. Charming tyrants — or else abdicate! In each I like what distinguishes it from its brother. In both I prefer excess, approaching the absolute.
 Claude Cahun, 1930

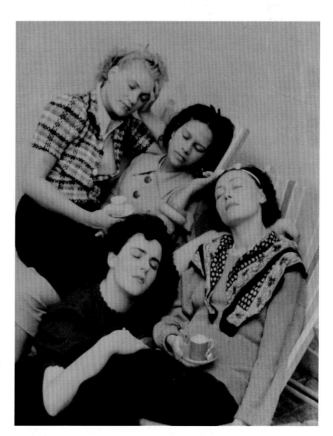

fig.18
ROLAND PENROSE
Leonora Carrington, Nusch Eluard, Ady Fidelin, Lee Miller in Cornwall 1937
Modern photograph
40.6 x 30.5 cm
Lee Miller Archives

ON THE IRRATIONAL KNOWLEDGE OF THE OBJECT – A PIECE OF PINK VELVET

Le Surréalisme au service de la révolution, 1933

1. *Does it come out by day or by night?*
 André Breton: *By night.*

2. *Is it conducive to love?*
 Extremely conducive.

3. *Is it capable of performing metamorphoses?*
 It is capable of performing those natural metamorphoses known today.

4. *What is its spatial position with regard to the individual?*
 Around the face.

5. *To what period does it correspond?*
 1880.

6. *To what element does it correspond?*
 Fire.

7. *With what historical figure can it be identified?*
 Isabeau of Bavaria. *

8. *How does it die?*
 During the night, by throwing itself in a pool.

9. *What should it meet on a dissecting table to make it beautiful?*
 The Sphinx.

10. *Where would you place it on the naked body of a sleeping woman?*
 On her throat.

11. *And if the woman is dead?*
 On the lower part of the face, concealing the mouth.

12. *What illness does it bring to mind?*
 Hysteria.

13. *What district of Paris does it inhabit?*
 The Etoile district.

14. *What might be its profession?*
 Sneak thief.

15. *In what material do you see it wrapped?*
 In a bottle butterfly.

16. *Is it happy or unhappy?*
 Profoundly unhappy.

17. *What language does it speak?*
 Irish.

18. *Who is its favourite poet?*
 Henry Bataille. **

19. *What place does it occupy in the family?*
 Brother and sister.

20. *How would you kill it?*
 By trampling on it.

21. *How does it move?*
 By flying clumsily like night birds.

22. *To what sexual perversion does it correspond?*
 Fetishism.

23. *What perfume best suits it?*
 Honeysuckle.

24. *To what painter does it correspond?*
 Manet.

* Isabeau of Bavaria (1371–1435). She was declared regent of France when her husband Charles VI became mad, and in favouring her husband's brother, provoked war between the Amagnacs and the Bourguignons.

** Henry Bataille (1872–1922). Poet, playwright and painter in a style that evoked late Symbolist decadence.

BLACK SUN

With hindsight, the surrealists were remarkable perhaps not so much for their openness in sexual matters, as for their refusal to allow love to be divorced from sexuality. In an interview given in 1956, Breton talked about the closeness of much surrealist love poetry to the traditions of courtly love found in medieval Provençal poetry. At the same time, he said, the surrealists had studied the 'nadir' of love; and it was this dialectical process, he said, that had made the genius of the Marquis de Sade shine for them like a black sun. Were the surrealists' interest in love to be restricted to the elevated spheres of poetry by Eluard or Benjamin Péret, he wrote, love, at its most incandescent, would become rarefied. 'Such a flame's admirable, blinding light must not be allowed to conceal what it feeds on, the deep mine shafts criss-crossed by hellish currents, which nonetheless permit us to extract its substance – a substance that must continue to fuel this flame if we don't want it to go out.'[30] Love was made all the more sublime and more authentic by its open avowal of physical pleasure; eroticism was dignified by its recognition of its centrality within the human psyche; and both love and eroticism, in the extremes of sensation they engendered, opened ways of seeing the world anew, transformed by desire.

My love because you understood my desires
Set your lips like a star in the sky of your words
Your kisses in the living night
And the wake of your arms around me
Like a flame in token of conquest
My dreams are in the world
Clear and perpetual

And when you are not here
I dream that I sleep I dream that I dream
Paul Eluard, 1929

Thus, the movement embraced, without the slightest sense of contradiction, both the most lyrical expressions of love and taboo-breaking, even scabrous, evocations of sexual feelings. Eluard's volume of poetry *Facile* (1935) comprised lyrical evocations of the loved one, interlaced with ethereal photographic images, taken by Man Ray, of the lithe naked body of Nusch, Eluard's companion (figs.99, 135). The tone throughout is romantic and sensual. At the same time, many in the surrealist group produced or illustrated erotic texts, albeit generally in secret because of the real risks of censorship and prosecution. *1929*, for example, contains poems by Aragon and Péret, written in the language of the street, and close-up photographs, again by Man Ray, of different forms of sexual congress. Robert Desnos in his extended poem *The Night of Loveless Nights* of 1930 wrote of love as an 'eternal flame' but at the same time stressed its carnal dimension and insisted that love, like a diamond in mud, remained undefiled or unaltered by physical infidelity ('The most sincere lover capable of the greatest love / Is not chaste, nor ascetic or a puritan. / And if he tries the bodies of the most beautiful / It is because he knows full well that the most beautiful is the loved one's.')[31] In the poem *L'Amour et la mémoire* (1930), Salvador Dalí outrageously sexualised the similes conventionally used in love poetry to evoke the loved one's charms when he wrote of his Gala, shortly after she had left Eluard for him, 'her eye resembling her anus / her anus resembling her knees / her knees resembling her ears / her ears resembling her breasts / her breasts resembling the large lips of her sex', etc. But in the same poem he wrote of Gala as integral to his very being; her suffering was his suffering, her death would be his; and so intense and eternal was his love that she stood, he wrote, outside of the operations of time and memory.[32]

Similarly, surrealist art pushed at the barriers of conventional notions of decency and morality in the name of this unified conception of love and sexuality. Miró's canvases from the mid-1920s breathe a guiltless eroticism, with scenes of coupling and frank depictions of sexual

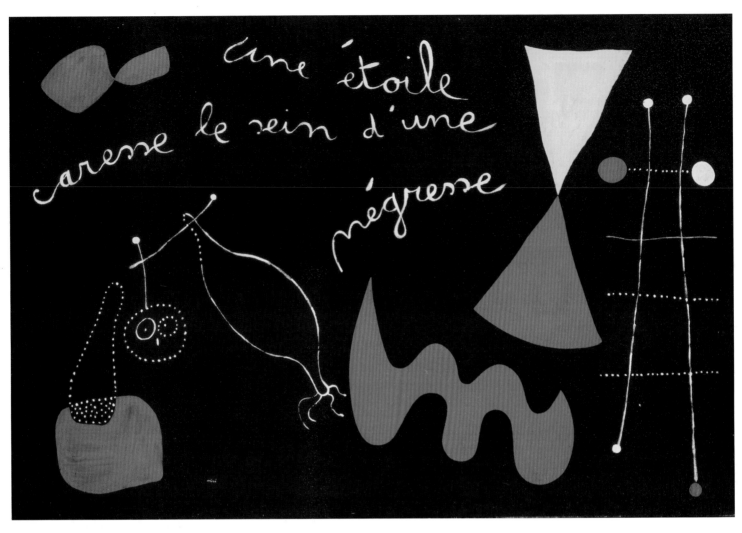

fig.19
JOAN MIRO
A Star Caresses the Breast of a Negress (Painting-Poem) 1938
Oil on canvas
129.5 x 194.3 cm
Tate. Purchased 1983

organs. Inspired by his poet friends, Miró combined visual and verbal imagery, using snatches of his own poetic texts (for example, 'a star caresses the breast of a negress'[33]) or the simple declaration 'love', to express the idea of the union of mental and physical sensations in sexual love (figs.19, 20). Dalí explored normally repressed feelings of sexual guilt and shame in works that were often homages to Gala. Masturbation, fellatio and sodomy were among the 'vices' paraded in the paintings and objects of the Spanish artist who declared that perversion and vice were

Love has not changed for me. I have been able to lose myself in the deserts of vulgarity and stupidity. I have been able to visit regularly the worst representatives of false love. Passion has kept from me its flavour of crime and powder … I don't know how far love will take my desires. They will be licit because passionate.

Robert Desnos, 1926

'the most revolutionary forms of thought and activity'.[34] His 'scatological object', which comprised a shoe once worn by Gala, a cup of milk into which a sugar lump could be dipped, a wooden spoon, soft paste the colour of excrement, pubic hair and a photograph of a naked couple, aimed to encourage recognition by viewers of their own repressed sexual impulses (fig.21). Picasso was another artist who, under the influence of surrealism in the 1930s, produced works that both idealise and abase the image of the loved one in phallic and excremental shapes (fig.24). At the same time, surrealist photographers such as Man Ray, Ubac, Brassaï and Dora Maar used the devices of close-ups, angled shots, cropping, cutting and montage, to create images of the female nude that evoked the transfixed and transforming gaze of a lover.

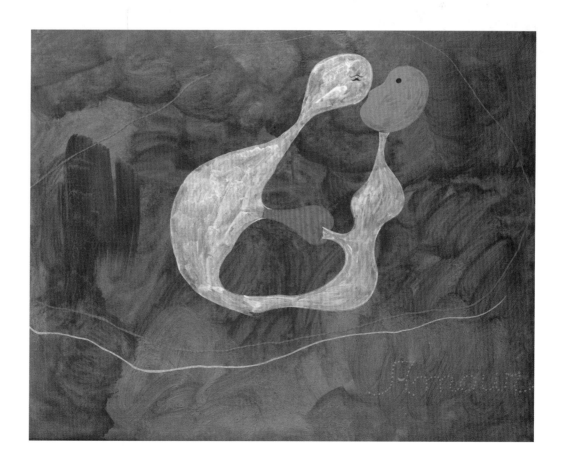

fig.20
JOAN MIRO
Love 1925
Oil on canvas
74.3 x 92 cm
Mr and Mrs Ahmet Ertegun

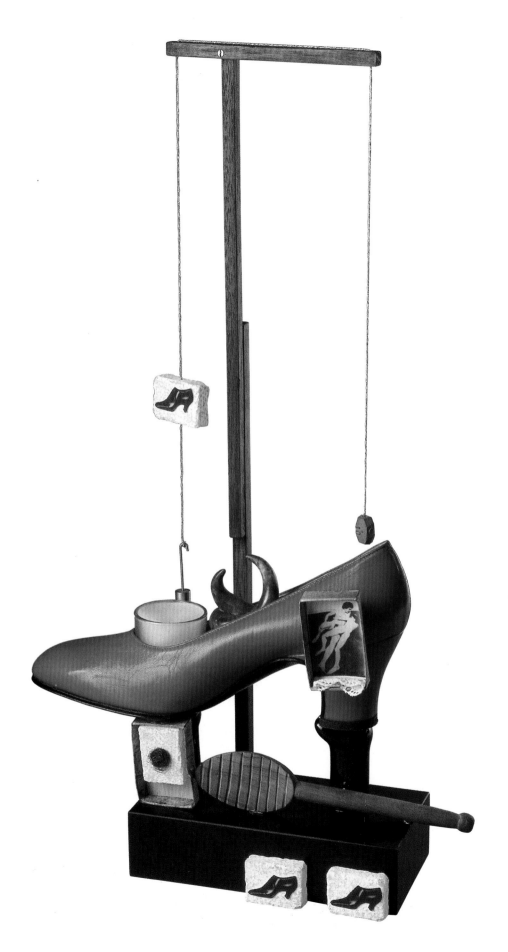

fig.21
SALVADOR DALI
Scatological Object Functioning Symbolically 1930, replica 1973
Assemblage
48 x 24 x 14 cm
Museum Boijmans Van Beuningen, Rotterdam

The culture of the mind will become identified with the culture of desire.
Salvador Dalí, 1931

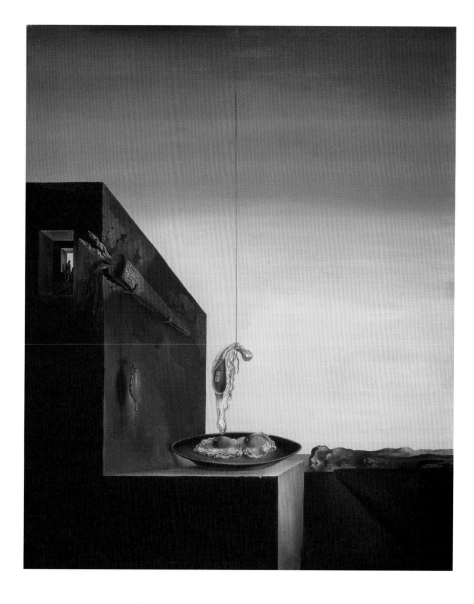

fig.22
SALVADOR DALI
Fried Eggs on the Plate Without the Plate 1932
Oil on canvas
60.3 x 41.9 cm
Salvador Dalí Museum, St Petersburg, Florida

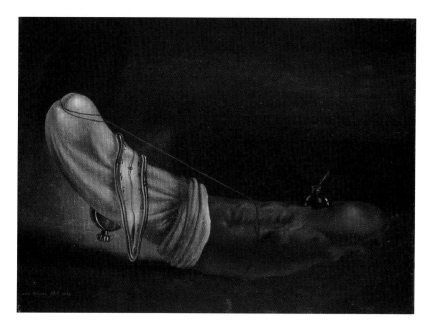

fig.23
SALVADOR DALI
Anthropomorphic Bread – Catalonian Bread 1932
Oil on canvas
24 x 32 cm
Salvador Dalí Museum, St Petersburg, Florida

fig.24
PABLO PICASSO
Head: Study for Monument 1929
Oil on canvas
73 x 60 cm
Baltimore Museum of Art: The Dexter M. Ferry, Jr.
Trustee Corporation Fund

This mingling, or interpenetration, of love and a demanding, sometimes aggressive sexuality, was perhaps nowhere better, or more disturbingly, shown than in the work of Hans Bellmer. In the early 1930s, in protest against the values of his father and more generally of the Nazi regime, Bellmer chose to explore the sensual pleasures and psychic anxieties of what he called the 'enchanted garden of childhood'. Using wood and papier mâché, he constructed in all two large dolls, made to resemble the developed body of a teenager. He photographed the doll, in parts or whole, naked or semi-clothed, often adding subtle highlights of gouache or aniline colours to accentuate the sensory impact of his prints. However mutilated or monstrous the doll's forms (Bellmer provided the second doll with two sets of hips and legs, doubling its implicit sexual possibilities), it is difficult to distinguish completely between the sadistic and loving impulses in his work: they constitute a web of circulating emotions and anxieties. In his drawings Bellmer turned increasingly to exploring the apparently infinite mutability of the female figure. In these, the figure is emptied of individual significance, and becomes a mirror for an

*desire shapes
the image of
the desired one.*
Hans Bellmer, 1947

fig.25
HANS BELLMER
Untitled c.1936
Gouache on paper
24.8 x 32.4 cm
Ubu Gallery, New York, and Galerie Berinson, Berlin

fig.26
HANS BELLMER
The Doll c.1934
Gelatin silver print
29.7 x 19.5 cm
The Metropolitan Museum of Art, New York. Ford Motor Company Collection, Gift of Ford Motor Company and John C. Waddell, 1987

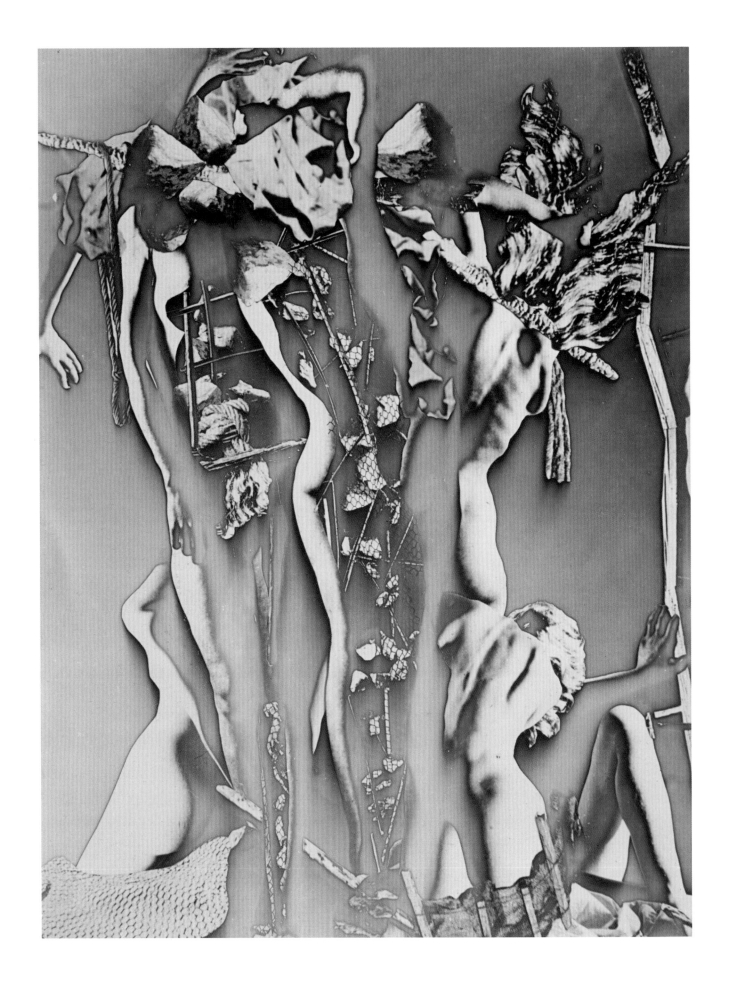

fig.28
RAOUL UBAC
Untitled 1938
Gelatin silver print
22.5 x 16.5 cm
Former collection Jacques Hérold
Private collection

fig.27
RAOUL UBAC
Group 1 1939
Gelatin silver print
38.7 x 29.3 cm
Claude Berri

essentially narcissistic desire, a vehicle for what the artist once described as a 'series of projections of the phallus'.[35] Expressing a fantasy of incarnating the loved one, and of subverting sexual difference, Bellmer wrote:

As for me, I wonder if I will wear the tight seamless trousers made of your legs, ornamented all along the inside with faux-excrements? And do you think I will, without swooning prematurely, button over my chest the heavy and trembling waistcoat of your breasts? As soon as I am immobilised beneath the pleated skirt of all your fingers … you will breathe in me your perfume and your fever, so that, in full light, from the interior of your sex, mine will emerge.[36]

This extraordinary imagery reflected surrealism's broader engagement with the idea of the other as a projection, or objectification, of the self. Dalí, for example, was intrigued by the concept of the object as being, at its most elemental level, a second self, and in the early 1930s claimed that surrealism was dominated by the quest to understand the 'terrifying body of the "objective self"'.[37] The questions posed by the relationship of the self and objects were similar to those posed by the relationship of the lover and the loved one. In the surrealists' concept of love there were no clear or fixed boundaries between the lover and the loved one: they shared a physical and mental unity, in which each was subject and each was object. In this union lay the basis of the surrealists' code of ethics, and lay the ideal that inspired so much of the poetry and art associated with the movement. Péret, for example, expressed this idea of the interpenetration of the self and the other when he wrote of 'Rosa' in his collection of poems *Je Sublime* (1936): 'today I look out through your hair / Rosa of morning opal / and I wake through your sight / Rosa of armour / I think through your exploding breasts.'[38]

The capacity of sexual desire not only to overcome inhibition and taboo but also to transform perceptions and memories, as it were, to eroticise the world, led the surrealists to study what was commonly defined as pornography and to produce texts which were graphic in their descriptions of sexual acts. Responding to the dark, subterranean nature of eroticism, as much as the legal restrictions on the publication and distribution of such material, the authors were content to produce their works in very small editions (the name of the Czech series Edice 69, which produced volumes in editions of literally sixty-nine copies, needs no further comment). Surrealist erotic books circulated privately among the group or, occasionally, were produced with a view to raising money to support other activities of the movement. Among the many remarkable books produced by the group was Jindřich Štyrský's *Emilie Comes to Me in a Dream* (1933). Illustrated with collages that used images taken from pornographic magazines, the text was a hymn to Štyrský's palimpsestic memories of women – Emilie, Clara, Martha, prostitutes, his sister, and their touch, scents, sexual parts and smiles. Interlaced with these memories were fantastical descriptions and reflections on putrefaction and mortality:

Then I put an aquarium on my window sill. I had a golden-haired vulva in it and a magnificent specimen of a penis with a blue eye and delicate veins on its temples. As time went on, I threw everything I had ever loved into it: broken cups, hairpins,

Barbara's slippers, burnt-out light bulbs, shadows, cigarette butts, sardine tines, all my letters and used condoms. Many strange creatures were born in that world. I felt myself to be a Creator and I had every right to think so. When I had the aquarium sealed up, I gazed contentedly at my mouldering dreams until there was no seeing through the mildew on the glass. Yet I was sure that everything I loved in the world was there inside.[39]

Štyrský's book contained a postface about the nature of pornography, written by the psychoanalyst Bohuslav Brouk. In this Brouk, who was closely involved in the Czech surrealist group, analysed what he termed the puritanism of the ruling élites that led them to shun reminders of their animal sexuality and mortality, and so condemn pornography. If ordinary pornography had a sadistic and misogynistic quality, artistic pornography, he asserted, expressed a poetic hedonism. 'The artist frees our bodily acts from their biological purpose', he wrote, 'and lets us enjoy fully what has been granted to us by nature, while having carefully alleviated our animality from the depressing vision.'[40] But could frank depictions of human sexuality be divorced from a 'depressing vision' of animality? This was a question that the surrealists, in fact, found difficult to answer, but one which they were obliged to return to time and time again because of the criticisms they faced from Georges Bataille, a friend of a number of surrealists and intellectual rival to Breton.

Bataille argued that the surrealists, far from seeing the world as it really was, were allowing themselves to view it through the filter of romantic idealism. Their blinkered focus on the redemptive aspects of love, he said, blinded them to the stark realities of eros. An early statement of these realities was found in Bataille's article 'Le Language des fleurs' (1929), in which he pointed out that, although generally ignored, at the very centre of a flower, traditionally seen as a symbol of beauty, lay the plant's relatively unattractive, even sordid, sexual organs; and he noted that it was these sexual parts that survived when petals withered and dropped.[41] For Bataille, sexuality, death and decay were the bedrock of life.

Bataille developed these themes in his book *L'Erotisme* (1957), in which he defined eroticism as a 'psychological quest' that opened the way to death. 'We are discontinuous beings,' he wrote, 'individuals who perish in isolation in the midst of an incomprehensible adventure, but we yearn for our lost continuity.' Eroticism, in its essence, implied violence and violation, an end to the 'self-contained' character of the lives of the participants. Bataille, now on amicable terms with Breton, acknowledged the power of love in this book: 'For the lover, the beloved makes the world transparent'. But he emphasised the precariousness of love: 'only the beloved can in this world bring about what our human limitations deny, a total blending of two beings, a continuity between two discontinuous creatures. Hence love spells suffering for us insofar as it is a quest for the impossible, and at a lower level, a quest for union at the mercy of circumstances.'[42]

In the catalogue of the 1959 surrealist exhibition on the theme of eros Breton generously acknowledged the strengths of Bataille's interpretation of eroticism, citing in his own essay Bataille's description of eroticism as 'that within man which calls his inner being in question'. However, he felt that not all was as black as the latter had painted: eroticism was very personal, and not everyone would experience it in such dark terms.[43] In fact, Breton never abandoned his faith in the sensations of joy and contentment love brought nor his belief that his vision of love-amid-sex and sex-amid-love entailed, ultimately, a fuller conception of man than Bataille's concept of the human condition as abject and gripped by the ineluctable embrace of death and fear of death.

THE GOLDEN AGE

'My general idea in writing with Buñuel the scenario of *L'Age d'or*', wrote Dalí in 1931 for the programme notes for the film, 'was to present the straight and pure line of "conduct" of a person who pursues love, meeting and cutting across vile humanitarian and patriotic ideals and other shabby mechanisms of reality.'[44] These words summarise the plot but do not do justice to the visual impact of this sexually provocative and deliberately blasphemous film. As the hero reclaims his rights to act as he chooses, or as his impulses dictate, in the name of a mad, and maddening, love, his unrequited, scabrous desire is symbolised by heaving pools of volcanic lava. In what may have been the first simulation of fellatio outside pornographic films, the heroine in her frustration sucks the toe of a statue. Gratuitous acts of incivility and violence abound: an old woman is slapped around, a dog is run over, and a child is killed by his father. And reflecting the surrealists' fierce hatred of Catholicism, not only is an bishop thrown from a window but the figure shown heading a group of libertines leaving the famous castle in Sade's novel of debauchery *The 120 Days of Sodom* in the film's final scene is none other than Jesus Christ.

For once, the provocation of the surrealists engendered a provocative, violent response. Shortly after the opening of the film in Paris, members of the right-wing Ligue des patriots and Ligue anti-juive staged a riot in the cinema, hurling ink at the screen and slashing surrealist paintings in the cinema vestibule. This incident was followed by rumours of papal excommunication for the film's financier and his actual expulsion from the prestigious Jockey Club, denouncements of the surrealists in the press, and heated debates in the town hall, culminating in a ban on the commercial showing of the film in its entirety which was to remain in place for decades. If proof were necessary, the incident demonstrated the gulf between surrealism at its most radical and what the surrealists regarded as the highly repressive institutions of bourgeois society.

In sexual matters the surrealists had long distanced themselves from the conduct advocated by Church and State. In the eyes of the Catholic Church, the only permissible goal of sex was procreation and all other forms of sexual behaviour, and any pursuit of bodily pleasure, sinful. The artist Max Ernst used humour to savage the Church's convoluted sexual codes in an article called 'Danger de pollution' (1930). If 'pollution' was a common euphemism for masturbation, Ernst turned the tables, using quotations from an ecclesiastical guide to sexual sins for the use of confessors, by suggesting that if anyone had perverted and 'polluting' attitudes towards sex, it was the Church. Love, he wrote, had to be freed from the concepts of sin and duty:

fig.29
Jindřich Štyrský
French Cardinal 1941
Collage
23.5 x 15 cm
Private collection, Paris

The sad conjugal duty, invented to set the multiplying machine going, to give the Church souls that may be brutalised and to fatherlands, individuals fit for the demands of production and for military service, the sad conjugal act that doctors of divinity authorise those who want to unite in love, is only a photograph resembling the act of love. Lovers are *robbed by the Church*. Rimbaud said: *Love must be reinvented.* [45]

In France in the interwar years the Church was particularly active in encouraging women to stay home and raise families. Successive governments, anxious to boost the population in order to counter the economic and military threat posed by Germany, reinforced this message, creating an informal alliance between Church and State in this area of sexual politics that was to remain in place until the late 1950s (it was only then, for example, that the 1920 law banning the sale of contraceptives and the provision of information about contraception was challenged by the establishment of family planning clinics; the law itself was to be repealed only in 1967). These ideological fetters on sexual behaviour were sufficient to provoke in the surrealists hostility towards motherhood and the raising of children.

Inspired by the Russian Revolution's ideals of free love and its attacks on the institutions of marriage and the family, as well as by older Romantic and socialist traditions, the surrealists led lives of remarkable sexual freedom. In many cases they had open marriages. Eluard, for example, never ceased regarding Gala, his first wife, as the true love of his life, but as his passionate letters to her in the 1920s show, he freely discussed with her his desire to have affairs and accepted her affairs as well. Their casual sexual encounters were 'pure dilettantism'; what mattered was the unequivocal love they shared, a love which, Eluard insisted, knew no past or future but was always 'present' and undiminished by the fact that their lives had already taken separate courses:

My being, I can talk seriously only to you, because I love you, because I love only you … I wanted to give you that freedom that no one would have given you. I offer you all possible pleasure, all enjoyment of yourself, but I am so afraid that you will let me slip from your mind, even if only for an instant. You should be very proud that I am above being troubled by others, despite all my wanting to be so. In you alone my desires engender delirium, in you alone my love bathes in love. But my love must filter through your absolute love. If not, I shall kill myself.[46]

Breton equally kept his first wife Simone fully informed about his relationships, platonic and sexual, and would have accepted her affair with a member of the surrealist group, had she not kept it a secret from him and so in his eyes betrayed the ideal of complete trust in each other.

As part of this ethic of total openness, the surrealists embarked in 1928 on a remarkable series of group discussions about individual sexual experiences. (For whatever reason, women participated only in the later sessions.) The discussions, recorded verbatim, attempted to ascertain basic facts about sexual practices and attitudes towards them, as a basis for trying to understand the correlation between ideology and reality in this most personal area of life. Beyond the predictable claims of wide and varied sexual experiences, the sessions revealed marked differences of opinion within the group, notably on the issues of the acceptability of homosexuality and prostitution, and on the need for reciprocity, and equal rights, in love. Breton insisted on the link between sex and love, and drew a distinction between his own serial searches for love and what he saw as the love-denying libertinage of other members of the group. He later expressed his firm belief that most of the disputes in the history of the movement, which had generally been ascribed to political differences, had been caused in fact by fundamental disagreements between him and others about this question of the ethics of love and sex.

In 1982 Oppenheim wrote that this object 'evokes for me the association of thighs squeezed together in pleasure. In fact, almost a 'proposition'. When I was a little girl, four or five, we (my little sister and I) had a young nursemaid. She was dressed in white (Sunday best?). Maybe she was in love, maybe that's why she exuded a sensual atmosphere of which I was unconsciously aware'. Max Ernst, with whom Oppenheim had had a passionate affair for nearly a year in 1934, provided her with the white shoes used in the original version of this object. The shoes had been discarded by his wife Marie-Berthe, who, in a fit of anger and jealousy untypical of the open attitudes towards sexual relationships within the group, attacked and destroyed the work when she saw it displayed at the surrealist exhibition of objects held at the Galerie Charles Ratton, Paris, in 1936. JM

fig.30
MERET OPPENHEIM
My Nurse 1936
Metal, shoes, string and paper
14 x 21 x 33 cm
Moderna Museet, Stockholm

RESEARCHES INTO SEXUALITY

MARCEL DUHAMEL *Does Aragon attach more importance to the man's orgasm than the woman's?*

LOUIS ARAGON *It depends on the occasion.*

Before leaving, I must declare that what disturbs me about most of answers given here is the notion I believe I detect of the inequality of the man and the woman. For myself, nothing can be said about physical love if one doesn't start from the fact that men and women have equal rights in it.

ANDRE BRETON *Who has claimed the contrary?*

LOUIS ARAGON *Let me explain. The validity of all that has been said so far seems to me to have been undermined in part by the inevitable predominance of the male point of view.*

January 1928

MAX ERNST *Are you monogamous? That's to say, do you believe there is a woman who is your destiny, to the exclusion of all others?*

ANDRE BRETON *Naturally.*

MAX ERNST, GEORGES SADOUL, MARCEL NOLL *Yes, without any doubt.*

PIERRE UNIK *Yes (Doubtful)*

RAYMOND QUENEAU *No, never. (Becomes heated.) No woman could satisfy me or make me monogamous. And I don't give a shit!*

ANDRE BRETON *I protest at that last word.*

MAX ERNST *And so do I.*

February 1928

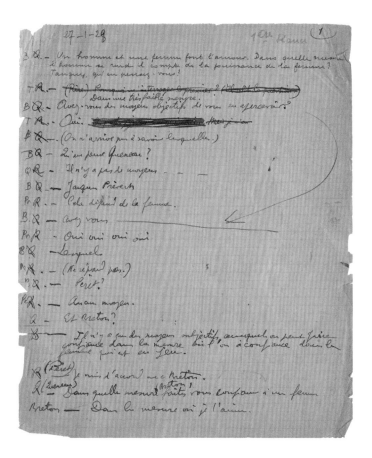

fig.31
Minutes of the first session of the *Recherches sur la sexualité*, 27 January 1928
Manuscript
31 x 20 cm
Private collection

The surrealists came together to discuss sexual questions frankly on twelve occasions between January 1928 and August 1932. At each meeting one person in the group took verbatim notes of what was said. The texts of the first two sessions were published in *La Révolution surréaliste* in March 1928. The others remained unpublished until recently.

ANTONIN ARTAUD *Faced with a sexual desire and a significant desire of another nature, which would you choose, assuming of course that both occurred at the same time?*

BENJAMIN PERET *A sexual desire holds no interest for me unless it is accompanied by love, and for love I would leave everything.*

ANTONIN ARTAUD *You're jumping into a different realm.*

BENJAMIN PERET *The two are intimately linked.*

ANTONIN ARTAUD *If one can bring love into an investigation of sexuality, the investigation is pointless.*

ANDRE BRETON *Why do you wish to separate them?*

ANTONIN ARTAUD *Because otherwise you confuse everything. My question concerned sexuality alone. I'll rephrase it: 'In a case where there is no question of love and where you are faced with a sexual desire and another kind of desire, which of the two would Breton choose?'*

ANDRE BRETON *The second, naturally. But I still believe we must begin by linking the question of sexuality to that of love. The whole point of this investigation is, in love, to establish what part belongs to sexuality.*

March 1928

PAUL ELUARD *Desire gives me as much mental satisfaction as the satisfaction of that desire.*

ANDRE BRETON *Well then! Why satisfy that desire?*

PAUL ELUARD *To renew it.*

ANDRE BRETON *With one person after another?*

PAUL ELUARD *Or with the same person, it doesn't make any difference …*

ANDRE BRETON *That idea tends to elevate the idea of love over the being whom one loves or wants to love, that is to say, to turn them into a means. I love women too much, and I believe I am too susceptible to loving a woman, not to object to such an attitude.*

November 1930

That the surrealist group engaged with the subject of sex at all brought it into conflict with the one political grouping that the movement wanted to support, the French Communist Party. Many of the group were members of the party, and all believed in the idea of class struggle leading to revolution and the creation of an egalitarian society, in which human relationships were no longer distorted by disparities in wealth and class structures. However, the Soviet Union itself had turned conservative in sexual matters, and had repealed most of its earlier reforms in the area of women's rights. Increasingly anxious about the size of its population in the late 1920s and early 1930s, it banned abortion, penalised divorce, and promoted motherhood. Following suit, the French Communist Party had no truck with what it regarded as the pornographic, and hence counter-revolutionary, elements in surrealist art and literature. On one occasion a number of surrealists, including Aragon, were hauled before a communist committee and were persuaded, much to Breton's fury, to denounce the publication of an erotic text by Dalí in the surrealist periodical *Le Surréalisme au service de la révolution*. It was the first of many such spats, which were to lead to the defection of several surrealists from the group, including Aragon in 1932 and in the late 1930s Eluard, both of whom became hard-line supporters of the Communist Party.

Although by the mid-1930s Breton had ceased trying to reach an understanding with the Communist Party, he maintained his faith in the idea of revolution. The manifesto written by Breton and Trotsky, during the former's visit to Mexico in 1938, declared, 'True art, which is not content to play variations on ready-made models but rather insists on expressing the inner needs of man and of mankind in its time – true art is unable *not* to be revolutionary, *not* to aspire to a complete and radical reconstruction of society'.[47] The Second World War put such hopes on hold. But with the liberation of Paris in August 1944, Breton, then in exile in the United States, turned his thoughts once more to the ideal of a better society.

In *Arcane 17*, written from August to October 1944, and in his eulogy of a neglected nineteenth-century utopian thinker *Ode à Charles Fourier*, written in 1945, Breton wrote of a vision of a non-repressive social order where desires were given free rein. It was based on a positive vision of the harmony between man and nature, which reflected feminine rather than masculine values ('the time has come to value the ideas of women at the expense of those of men, whose bankruptcy is coming to pass fairly tumultuously today'[48]).

The two main themes of the catalogue for the 1947 surrealist exhibition that, as it were, announced the return of surrealism to Paris were liberty and love. Against the backdrop of the horrors of the war and its aftermath, and reacting against the despairing element in existentialist philosophy, contributors to the catalogue reiterated Breton's optimistic vision of changing society through poetry and love. One of the many new authors attracted to the group, Sarane Alexandrian, then only twenty years old, wrote, 'It is time for us to remember that we are made of material that can be illuminated only by love and all the desires it provokes in us ... [man] must free himself from all the social or religious ethics that do not fit well with his physical body, and in his need of an ethical ideal, he should entrust himself to poetry, which confirms, each day more strongly, his right to indolence and love.'[49]

Love and the emotion sometimes awakened by the seductions of the world, made us dream of a reality without hardness, without a constraining objectivity and without a rational structure, of a reality where all paths would be open to men's desires ...

Fernand Aliqué, 1947

Fourier, Sade and Freud – the 'three great emancipators of desire', according to Breton[50] – remained the touchstones of surrealist attitudes towards sex and love through the late 1940s and 1950s. The same authors, and Breton himself, also influenced intellectuals outside the movement. Lacan's revisioning of Freud in the post-war years, the political ideas expressed by Herbert Marcuse in *Eros and Civilisation* (1955), and the 'anti-Oedipal' concept of desire proposed later by the philosophers Gilles Deleuze and Felix Guattari, for example, all shared a lineage with, or were a response to, surrealism in the postwar years; and the same was true of the new departures in French art represented by the Lettriste international and the Situationist movements, as well as the 'Happenings' staged in the early 1960s by the artist Jean-Jacques Lebel. By the time of the student riots of May 1968 Breton had been dead for two years, and the remaining surrealist group was soon to declare surrealism officially ended. But the link between surrealism and liberation was far from forgotten. Among the slogans borrowed by the students from surrealism was the title of an early poem by Breton, 'Plutôt la vie' or 'Rather Life'.[51] On the question of sexual liberation, however, Breton had already distanced himself from those who advocated (mere) openness in this area among the young. In a text titled 'This Is the Price' he wrote in 1964: 'The irresistible pressure of Freud's ideas has led to an increasing measure of agreement today that sexuality drives the world

… Systematic sexual education can only be meaningful if it leaves intact the incentive towards 'sublimation' and finds the means of transcending the lure of 'forbidden fruit'. The only possible approach is that of initiation, with the whole aura of sacredness – outside of all religions, of course – that the word implies, an initiation providing the impulse for that spirit of quest which the ideal constitution of each human couple demands. *This is the price of love.*[52]

FREE AND ADORED

The 1947 exhibition catalogue contained a quotation from the eighteenth-century French revolutionary Saint-Just: 'Among truly free peoples, women are free and adored.' Placed perhaps provocatively at the foot of an essay by Bellmer, filled with his intense meditations on sexual desire, these words of Saint-Just went some way to encapsulating the surrealists' complex attitudes towards women and towards the symbolic figure of woman. The surrealists aimed to free women just as much as men. This liberation, they believed, would entail a freer romantic and sexual life for all, and at the same time enshrine rather than diminish the special status of woman.

The surrealists' elevated concept of woman was criticised by Simone de Beauvoir in her ground-breaking study of the position of women in society *The Second Sex* (1949). In this she accused the surrealists of falling into the trap of always seeing woman as a salvation for mankind, but never enquiring what practical, as opposed to inspiring, role she might play in bringing about this salvation. 'Truth, Beauty, Poetry – she is All: once more all under the form of the Other. All except herself'.

> If the question of her own private destiny were raised, the reply would be involved with the ideal of reciprocal love: woman has no vocation other than love; this does not make her inferior, since man's vocation is also love. But one would like to know if for her also love is key to the world and revelation of beauty. Will she find that beauty in her lover, or in her own image? Will she be capable of that poetic action which raises poetry through a sentient being, or will she limit herself to approving the work of her male?[53]

In relation to the lives of the women involved in the surrealist movement, the questions posed by Beauvoir did not fully recognise the extent to which the women who belonged to the movement had already broken out of the 'doll's house', had already rebelled against convention, and were valued within the movement as individual creative artists and writers. Nor did the questions reflect the conviction among the surrealists, and many other intellectuals of the interwar generation, that the overriding priority was the revolution of the working classes, from which all other desired changes in social and intellectual life, it was predicted, would follow. 'It is only when the proletariat has become conscious of the myths on which capitalist culture rests, when it has become conscious of what these myths, this culture, represent for it, and when it has destroyed them, that it will be able to move on to the developments that are natural to it'. These words by the writer-artist Claude Cahun were cited by Breton in 1934, who added, 'Surrealism asks for nothing more than this'.[54] Later, in the early 1940s the group showed an increased awareness of the interest of a specifically feminine point of view; and Breton wrote sympathetically of the need for women to achieve greater autonomy, 'without man's more than problematical help'.[55] But the concept of evaluating the goals

and theories of the movement from the perspective of one sex only remained anathema to the group. The works of men and women in the group may have suggested gender differences in their experiences of desire and love, but the surrealists believed that the imagination itself has no gender.

The tropes of woman used by the surrealists inevitably reflected both their goals and the culture of the times. From the earliest days of the movement male surrealists drew inspiration from women on the fringes of society – Nadja figures, the infamous Papin sisters who committed a savage double murder, hysterics in asylums, music hall singers and glamorous actresses – women, in other words, who had a potentially disruptive relationship to existing social structures, a relationship that derived in some measure from their sexuality. From age-old literary and mythical traditions, both men and women surrealists borrowed the image of woman as sphinx or sorceress, in touch with the mysteries and the untamed energies of nature. Inspired in part by Gothic novels, Dorothea Tanning painted in the 1940s scenes in which young girls were agents of unleashed preternatural energies. In the same period Breton wrote in *Arcane 17* about the figure of a magical 'child-woman' who 'sends fissures through the best organised systems because nothing has been able to subdue or encompass her'.[56] At the same time surrealists – who had in their midst women who incarnated the principles of liberty in the creative sphere and in their personal lives – celebrated distinctly contemporary images of women as taboo-breaking and thoroughly liberated. Whether mythical or contemporary, such images of women resonated within the life of the group because they were felt to be among the most disruptive and liberating tropes available, in contrast to other, socially sanctioned images of woman as dutiful daughter, respectable wife, good mother, or productive factory worker.

The varied images of woman within surrealism and the equally varied experiences of women as individuals within the group intersect in the self-portraits produced by a number of surrealist women artists. Some artists were attracted by the empowering aspects of the surrealist cult of magical, sorceress-like figures. Leonora Carrington, Leonora Fini and Remedios Varo used images of disguised magical beings to express an alternately troubling and wonderful distinction between appearance and essence. For others, surrealism's engagement with the imaginary and the dream-like provided a path beyond the

fig.32
MAX ERNST
Alice in 1941 1941
Oil on paper mounted on canvas
40 x 32.3 cm
The Museum of Modern Art, New York. James Thrall Soby Bequest

Woman? All they knew for sure was that they desired her. Desire, a gigantic five-letter word. The millions of words they lavished on here were not diagrams for her degradation. They were disguised hymns to her invincibility.

Dorothea Tanning, 1986

fig.33
DOROTHEA TANNING
Eine Kleine Nachtmusik
1943
Oil on canvas
40.7 x 61 cm
Tate. Purchased with
assistance from the
National Art Collections
Fund and the American
Fund for the Tate
Gallery 1997

fig.34
DOROTHEA TANNING
The Mirror 1950
Oil on canvas
30.5 x 46.4 cm
Arno Schefler

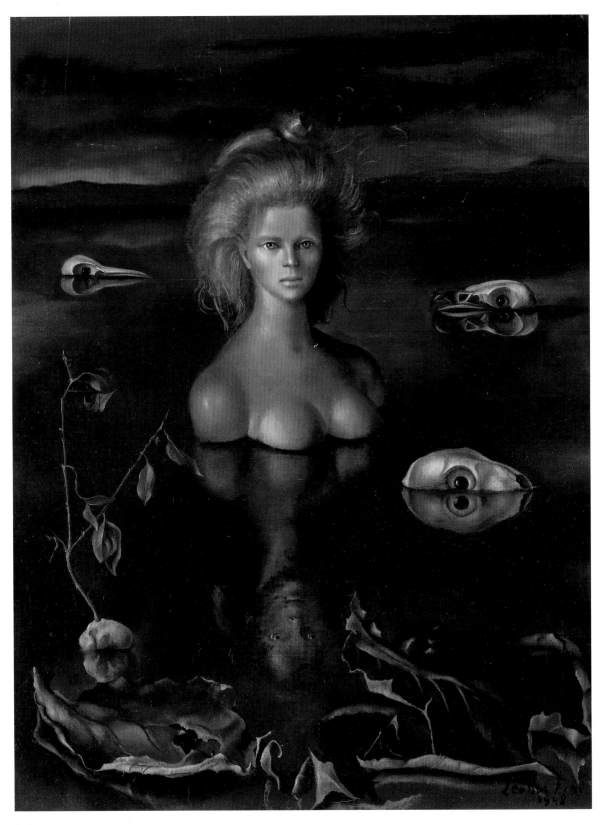

fig.35
LEONOR FINI
The Ends of the Earth 1949
Oil on canvas
35 x 28 cm
Private collection

potentially confining aspects of conventional desire and identity. The trappings of femininity might be present but the apparent 'subjects' of the works are not always, or unambiguously, gendered. Erasure of identity was the theme of the opening poem of Alice Paalen's volume of poems *A même la terre* (1936): 'A woman who was beautiful / one day / removed her face / her head became smooth / blind and deaf / safe from the snares of mirrors / and from looks of love'. In turning away from the world, the faceless woman gained a new purpose. The poem ends: 'secrets much more beautiful / for not having been said / words not written / steps erased / nameless ashes flown away / without marble plaque / desecrating memory / so many wings to break / before nightfall'.[57] Whatever the precise nature of these wings, the suggestion was that the subject of the poem – perhaps the poet herself, or woman in general – would achieve fulfilment through the process of breaking and changing.

The surrealists sought change in all aspects of life, personal as well as political. To realise this, they championed the cause of an unfettered imagination, and attacked the restraints – intellectual and social – that served to censor the human spirit. That their pursuit of freedom might entail a risk of generating new forms of repression was something they did not countenance. Their battle lay with reclaiming freedom from the controlling mechanisms of the psyche and of society, and it was on this that their energies focused. Exploitation was alien to the surrealists' impassioned and elevated vision of love and eros, and they steered clear of all those who saw in eroticism only sexual pleasure. Even if, as Breton noted, some in the group transgressed in their private conduct, on a daily basis, the ideals to which they publicly subscribed, the ideals nonetheless united the group. The ideal of reciprocity in relationships, and the celebration of the spiritual as well as the physical, served, he hoped, as bulwarks against misinterpretation of the movement's goals and ethics.

Breton once said that in love it was not happiness he sought, but love itself.[58] It was a statement that expressed the combination of hope and despair that fuelled the movement's unwavering engagement with the theme of love. It can also be seen as a key to understanding the complex ethical issues surrounding surrealism's investigations of sexuality and desire. Neither love nor desire, as the surrealists fully recognised and demonstrated in their explorations of the 'real functioning of thought', could be understood outside of the subjectivity of individual experience or separated from the contingent nature of social conditions. Following Breton's death in 1966, Duchamp underscored the fundamental importance of understanding the movement's ethics in the context of what Breton and the group as a whole had seen as the corruption of human relationships by the institutions and values of modern society. 'I have never known a man', Duchamp said of his friend, 'with a greater capacity for love, or a greater power of loving life's greatness. It's impossible to understand his hatreds if you don't see that, for him, it was a question of protecting the quality of that love … Breton loved as a heart beats. He was in love with love in a world that believes in prostitution.'[59] This paradox lay at the heart of the surrealists' attempts to see love, sexuality and desire as uncensored or unbound.

fig.36
ANDRE BRETON
Heart in the Arrow 1958
Cork
29.5 x 9.8 cm
Private collection

Breton made this object especially for the *EROS* exhibition of 1959–60

chapter two

THE OMNIPOTENCE OF DESIRE:
SURREALISM, PSYCHOANALYSIS AND HYSTERIA

David Lomas

> *Here we find ourselves confronted by a new affirmation, accompanied by formal proofs, of the omnipotence of desire, which has remained, since its beginnings, surrealism's sole act of faith.*
>
> André Breton, 1934[1]

he concluding line of *Nadja*, André Breton's narrative testament to the omnipotence of desire, alludes unmistakably to the famed convulsive hysterics of the Salpêtrière Hospital. 'Beauty will be CONVULSIVE or will not be', Breton declares.[2] Hysteria is pivotal to a surrealist poetics and aesthetics of desire. The Bretonian conception of poetry hinges crucially on a dynamic interrelationship between repression and the return of the repressed which the figure of hysteria vividly dramatises. It is, moreover, from such a 'poetics' of hysteria that one can extrapolate a politics and ethics of surrealist revolt, their belief in erotic desire as the agent of a critical transformation in human consciousness. Desire, unquenchable and indomitable, is a *convulsive* force to be pitted against the despised status quo of bourgeois, patriarchal society and religion.

As a powerfully influential discourse of human desire, psychoanalysis was no less dependent upon the example of the hysteric. Aside from the talking cure itself, suggested to Sigmund Freud and his colleague Josef Breuer by one of their female hysterical patients, the key psychoanalytic concepts of repression, fantasy, and the unconscious all emerged from the studies of hysteria. Examining the role of hysteria within surrealist texts and visual iconography brings into focus the closely intertwined historical and cultural trajectories of surrealism and psychoanalysis in France. It reveals what the surrealists regarded as most valuable in Freud's discoveries, and how they endeavoured to realise its radical artistic and cultural implications.

FREUD AND FRANCE

> *Around 1880, amidst those surprising, convulsive women, the service of Professor Charcot at the Salpêtrière will observe the energies [of the marvellous] harnessed to an extraordinary enterprise, the materialisation of a miracle. The new century will dawn over Sigmund Freud who focuses the scandalous eyes of sexuality on the incomprehensible.*
>
> Louis Aragon, 1930[3]

In 1933 Breton located Jean Martin Charcot 'at the origin of the magnificent debate on hysteria' and so traced back to him responsibility for a project of research which engaged Breton's attentions as well as those of a good number of his fellow surrealists.[4] The legacy of Charcotian hysteria was one that surrealism and psychoanalysis both shared.

It was Freud's sojourn in Paris between October 1885 and February 1886, during which time he worked under Charcot at the Salpêtrière, that brought about a decisive reorientation in his professional interests. His attention shifted from neurology to the neuroses, particularly hysteria, the study of which helped to shape his views about the ubiquitous role of sexual

55

fig.37
GIORGIO DE CHIRICO
The Child's Brain 1914
Oil on canvas
80 x 65 cm
Moderna Museet, Stockholm

Giorgio de Chirico was regarded by the surrealists as one of their crucial precursors. His interest in dream as the site of 'the sensations of revelation' and his groupings of disparate objects were seen as pre-empting surrealist concerns. In 1916 Breton saw *The Child's Brain* in the window of Paul Guillaume's Paris gallery from a moving bus and was so struck by this enigmatic image that he got off the bus to go back and look at the painting. He was able to acquire the work in 1919 and it hung over his bed in his apartment at the Fontaine for nearly all his life. Breton also owned *The Enigma of a Day* from 1924 to 1935.

The Child's Brain, a rare example of a 'portrait' in de Chirico's early work, is widely read as an evocation of the artist's father. The father as an ambivalent figure of threatening and seductive power was an important surrealist theme, relating in particular to Freud's theories of Oedipal trauma and the castration complex. While de Chirico is not known to have taken a direct interest in Freud's work, the sexuality of the paternal figure in *The Child's Brain* is ambiguous: his striking moustache is combined with long feminine eyelashes. His pose, eyes closed and his right arm obscured behind a half-drawn curtain, may be seen as suggesting masturbation, symbolised by the thin red bookmark in the pages of a yellow book in front of him.

The looming towers and dark hollows of city arcades in both *The Child's Brain* and *The Enigma of a Day* are often interpreted as male and female symbols. In 1933 in *Le Surréalisme au service de la révolution* Breton published the results of a survey conducted among fellow surrealists, which asked them a series of questions about *The Enigma of a Day*, including 'Where would you make love?', 'Where would you masturbate?' and 'Where would you defecate?' Their answers, which in Breton's words aimed to 'reanimate this sleeping dream', showed the continuing significance for the surrealists of de Chirico's work of the 1910s, even after the artist himself had definitively fallen from their favour in 1928. The survey also brought out the erotic potential of the strange details in the painting, such as the statue's outstretched hand, the abandoned railway carriage, the isolated stone to the bottom left, and the steam engine glimpsed through a narrow arch to the far right. JK

fig.38
GIORGIO DE CHIRICO
The Enigma of a Day 1914
Oil on canvas
185.5 x 139.7 cm
The Museum of Modern Art, New York.
James Thrall Soby Bequest, 1979

SOME FRENCH PUBLICATIONS OF WORKS BY FREUD

The emergence of surrealism coincided with an upsurge in interest in France in Freud's writings, which were not translated in any number until the 1920s. The choice of Freud's texts for translation into French was somewhat haphazard (it was not until 1988 that the first volumes of a French edition of Freud's complete works appeared). This resulted in some serious gaps in terms of what was readily available to the surrealists. Freud's essay on fetishism, for instance, was not translated until 1969. Significantly, French has but a single word, *désir*, to cover the meanings of the several German words used by Freud: *Begierde*, *Lust*, and *Wunsch*. The foregrounding of the thematics of desire within the Freudian corpus in France can be seen in part as a byproduct of its French translation.

The following list provides some of the main publications that appeared in France. It excludes some of the shorter translations that appeared in the scholarly journal *La Revue française de psychanalyse* from 1927 onwards. Works are listed chronologically with the date of French publication followed by the date of the original German text.

1896 /
'L'Hérédité et l'étiologie des névroses' (Heredity and the Aetiology of the Neuroses), *Revue neurologique*, vol.4, no.6, 30 March 1896.

This article, first published in French, also contains the first published appearance of the word 'psycho-analyse'.

1922 / 1916–17
Introduction à la psychanalyse (Introductory Lectures on Psychoanalysis). Paris, Payot.

André Masson recalled that this book was displayed at the Bureau central de recherches surréalistes in the 1920s, along with Lautreamont's *Les Chants de Maldoror* and the popular series of novels by Marcel Allain and Pierre Sylvestre about *Fantômas*, as objects of veneration.

1922 / 1901
La Psychopathologie de la vie quotidienne (The Psychopathology of Everyday Life). Paris, Payot.

1923 / 1905
Trois essais sur la théorie de la sexualité (Three Essays on the Theory of Sexuality). Paris, Ed. Nouvelle revue française.

1923 / 1910
Cinq leçons sur la psychanalyse (Five Lectures on Psycho-Analysis), Paris, Payot.

1924 / 1913
Totem et Tabou (Totem and Taboo). Paris, Payot.

1926 / 1900
La Science des rêves (The Interpretation of Dreams). Paris, Alcan.

This edition also included two texts by Dr Otto Rank, an early follower of Freud who extended psychoanalysis to the study of culture and literature, in 'Rêve et poésie' and 'Rêve et mythe'.

1927 / 1920
'Au-delà du principe du plaisir' (Beyond the Pleasure Principle), in *Essais de psychanalyse*. Paris, Payot.

1927 / 1923
'Le Moi et le soi' (The Ego and the Id), in *Essais de psychanalyse*. Paris, Payot.

Breton drew on this book for his discussion of the sexual instinct and the death instinct in the manifesto programme for *L'Age d'or* (1930) and again in *L'Amour fou* (1937). He also paraphrased another section of 'The Ego and the Id' in a lecture in 1935, 'Position politique de l'art d'aujourd'hui'.

1927 / 1910
Un souvenir d'enfance de Léonard de Vinci (Leonardo da Vinci and a Memory of his Childhood). Paris, Gallimard.

1928 / 1926
'Psychanalyse et médecine' (The Question of Lay Analysis), in *Ma vie et la psychanalyse*. Paris, Gallimard.

An extract of this text, which dealt with the question of who was entitled to use psychanalysis, was published in 'La Question de l'anaylse par les non-médecins' in *La Révolution surréaliste*, nos.9–10, 1 Oct. 1927.

1929 / 1928
'L'Humour' (Humour), *Variétés* (Brussels), June 1929. Special issue: 'Le Surréalisme en 1929'.

This essay informed Breton's *Anthologie de l'humour noir* (1940; enlarged editions in 1950 and 1966).

1930 / 1905
Les Mots d'esprit et ses rapports avec l'inconscient (Jokes and their Relation to the Unconscious). Paris, Gallimard.

1931 / 1907
Délire et rêves dans un ouvrage littéraire, la 'Gradiva' de Jensen (Delusions and Dreams in Jensen's 'Gradiva'). Paris, Gallimard.

Accompanying the 1931 edition was a translation of the novel by Wilhelm Jensen, *Gradiva: Fantaisie pompéienne*. In this period Paul Eluard wrote to Gala, 'I hope you have received Gradiva', suggesting that Dalí, for whom Freud's study of the *Gradiva* novel was all-important, probably acquired the book through Eluard.

1932 / 1911
'Remarques psychanalytiques sur l'autobiographie d'un cas de paranoïa (Le Président Schreber)' (Psycho-Analytic Notes on an Autobiographical Account of a Case of Paranoia (Dementia Paranoïdes)), *Revue française de psychanalyse*, vol.5, no.1, 1932, reprinted in *Cinq psychanalyses*. Paris, Denoël et Steele, 1935.

1933 / 1919
'L'inquiétante étrangeté' [The 'Uncanny'], in *Essais de psychanalyse appliquée*. Paris, Gallimard.

Although the uncanny has been much discussed in recent scholarship on surrealism, the surrealists themselves kept silent on the subject.

1933
'Letters to André Breton' in *Le Surréalisme au service de la révolution*, nos.5–6, 15 May 1933.

1934 / 1930
Malaise dans la civilisation (Civilisation and its Discontents). Paris, Denoël et Steele.

1969 / 1927
'Le Fétishisme' (Fetishism) in *La Vie sexuelle*, Paris, PUF, pp.133–8. DL

drives in mental life. It was this aspect of Freudian theory that caused greatest controversy and was a main sticking-point in the reception of psychoanalysis in France. The role of traumatic memories in the causation of hysteria had already been recognised by Charcot: Freud's innovation was to assert that these traumas were of a sexual nature, a hypothesis outlined in an article first published in the *Revue neurologique* in 1896 (and containing, incidentally, the earliest published reference to 'a new method of psycho-analysis'): 'each of the major neuroses which I have enumerated has as its immediate cause one particular disturbance of the economics of the nervous system, and … these functional pathological modifications *have as their common source the subject's sexual life, whether they lie in a disorder of his contemporary sexual life or in important events in his past life*.'[5]

Freud claimed that in cases of hysteria the invariable causative factor was a passive sexual experience occurring before puberty. What was so peculiar about memories of a sexual nature that they are able to produce anxiety and consequently neurosis after an interval of years has elapsed from the alleged traumatic incident? Freud conjectured that this was due to the long delay in human sexual maturation which allows an event that was not in itself traumatic to become so after puberty when it is belatedly invested with erotic significance. The second factor contributing to the frequency of sexual traumas in the causation of neuroses was the system of morality and social taboos pertaining to sexuality that made such thoughts more often unacceptable to consciousness. Thus they were liable to persist unchanged as a nidus of ideas dissociated from conscious recollection which may become traumatic when, rekindled, they attempt to force their way into consciousness.

Pierre Janet, a figure often cited as an antecedent for the surrealist doctrine of automatism, set the tone of the hostile reaction that greeted Freud's theories in France. Like Freud, Janet had a professional stake in the hysteria diagnosis. However, his understanding of the condition diverged from Freud's in key respects. Janet was prepared to concede only a minor part to sexual disturbance, and then as a secondary phenomenon rather than a cause of the neurosis. A preoccupation with eroticism is certainly found in the hysterical delirium but only as one among many possible *idées fixes* and no more commonly than among normal subjects of similar age, Janet believed. He reported an incidence of four out of 120 of his own cases where it played the predominant role. In keeping with his view of hysteria as a 'faiblesse mental', a weakening of the mental capacities, he asserted that frigidity was the main such

fig.39
HENRY MOORE
Figure 1933–4
Corsehill stone
74 x 40 x 43 cm
Private collection,
courtesy Pieter Coray

fig.40
GIORGIO DE CHIRICO
Spring 1914
Oil on canvas
35.1 x 27 cm
Private collection

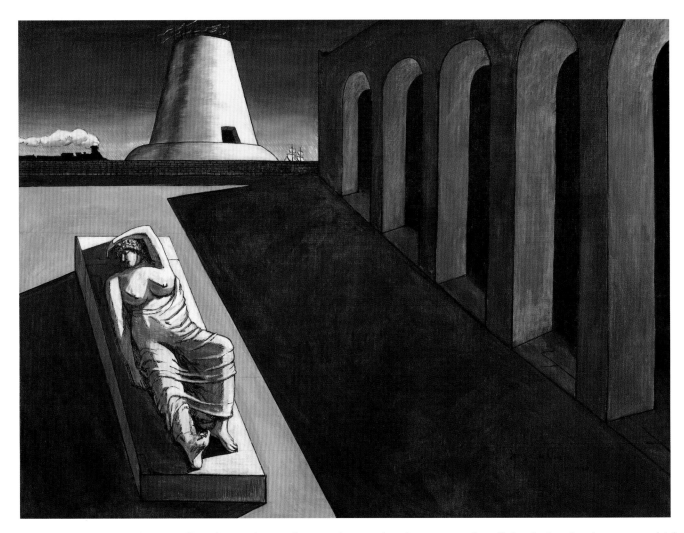

fig.41
GIORGIO DE CHIRICO
Ariadne 1913
Oil and pencil on canvas
135.6 x 180 cm
The Metropolitan Museum of Art,
New York. Bequest of Florence M.
Schoenborn, 1995

disturbance.[6] Janet chose an international congress of medicine in London in 1913 at which to publicly air his grievances about psychoanalysis, many of which centred on the 'indefinite extension' of the meaning of sexuality. Of the concept of libido (or pansexualism as it was known at this time), Janet wrote that Freud 'stretches the signification of this term in such a way that he is able to apply it to everything'.[7] Janet differentiated Freud's doctrine, this psychology of the Oedipus complex, from his own as a 'difference between unlimited generalisation and precise verification'. Amid the climate of xenophobia and heightened suspicion of anything foreign that prevailed in France during and after the First World War, Janet's strident objections to 'the dogma of pansexuality' found a receptive audience among those critics who judged it alien to the Cartesian French spirit, as did his contradictory assertion that Freud (an Austrian) had in large part pilfered ideas from his own psychological analysis.[8]

Responding to the distortions and misrepresentations of psychoanalysis issuing from France, in an essay from 1925 ('An Autobiographical Study'), Freud angrily refuted the suggestion that he made use of his time in Paris to pillage the ideas of his rival: 'I should therefore like to say explicitly that during the whole of my visit to the Salpêtrière Janet's name was never so much as mentioned.'[9] With respect to Charcot, however, he was disposed to be more generous. Indeed, Freud implied that Charcot would not have been averse to his sexual theory of the neuroses, reporting a conversation overheard between Charcot and another physician

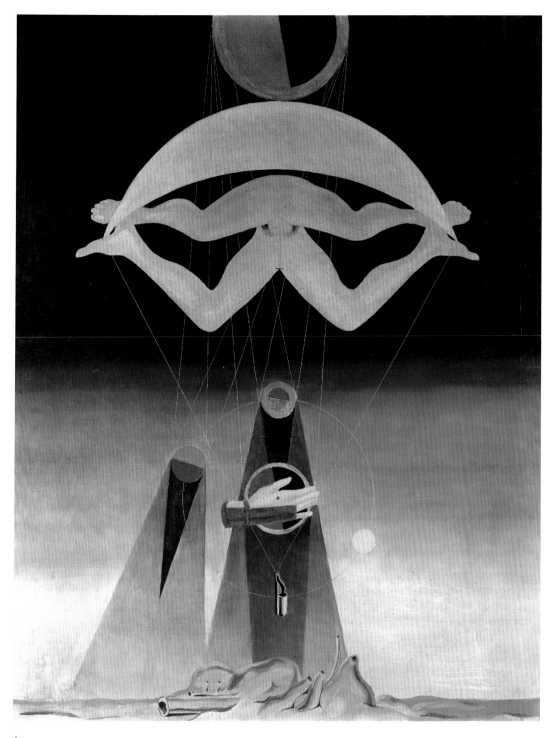

fig.42
MAX ERNST
Men Shall Know Nothing of This 1923
Oil on canvas
80.3 x 63.8 cm
Tate. Purchased 1960

Bearing a title which openly declares its occult agenda, Max Ernst's *Men Shall Know Nothing of This* was owned by André Breton and has a poem on its reverse dedicated to him.

Ernst had been familiar with Freudian psychoanalysis since his student days at Bonn University. A likely source for the picture's imagery is Freud's analysis of Daniel Paul Schreber's *Memoirs of my Nervous Illness* (1911). As a paranoid schizophrenic, Schreber had been plagued by fantasies that his body was attacked by 'rays' to God, to the sun and to other planetary bodies. Imagining himself 'floating in voluptuousness', he asserted, 'I have to imagine myself as man and woman in one person having intercourse with myself'.

However much the painting seems to project the dynamics of the Freudian unconscious, it also has a universalising, mystical dimension. The image of a copulating couple (often a king and queen) floating in mid-air was common in the convoluted allegories of medieval alchemy. The image symbolised the 'conjunctio', the union of opposites. Other elements of Ernst's picture might also have alchemical connections, the (reversed) crescent moon for instance, or the visceral forms sprouting from the earth that look like the necks of alchemists' flasks.

The psychoanalytic, alchemical and erotic dimensions of this painting can be brought together in that in alchemical allegory the male sex was often equated with the solar principle and the female with the lunar principle: the crescent moon is clearly visible here, and a half-eclipsed sun appears at the very top of the picture. Part of the poem on the back of the picture reads 'The crescent moon (yellow and parachute-like) prevents the little whistle falling to the ground / Because someone is paying attention to it the whistle thinks it is rising to the sun'. These words could be read in Oedipal terms. The whistle (an overtly phallic symbol) is kept upright by unconscious desire for the mother, while simultaneously it aspires to the potency of the sun. (In the Schreber analysis, Freud had correlated the sun with the father-principle.) This suggests that the picture depicts a kind of cosmic apparatus crazily designed to both generate and suppress Oedipal instincts. It is as though the modern 'science' of psychoanalysis has been submitted to the pseudo-scientific logic of an alchemistic worldview.

It is not surprising, then, that the picture has the atmosphere of an inexplicable ritual. The dominant image of copulation in the painting might most simply be squared with Freud's discussions of the child's traumatising experiences of the 'primal scene' (parental intercourse). In that sense, one effect of the picture might be to jettison us back into the mind-set of a child, awe-struck at the enigma of the sex act. DH

OMNIPOTENCE OF DESIRE 61

who were discussing the case of a young woman with hysterical symptoms in which the master, in a state of great animation, declared: "You know, in such cases it's always a genital thing, always … always … always'.[10] Independently of any such specific derivation, Freud – no less than the surrealists perhaps – draws upon a more diffuse *fin de siècle* construct linking hysteria and a frustrated, because insatiable, female sexuality. This equation of *hystérie*, *érotomanie* and *amour fou* is apotheosised in the description of Salome as represented by Gustave Moreau (a favourite of the surrealists) in J.-K. Huysmans's symbolist cult novel, *A rebours* (1884): 'She had become, as it were, the symbolic incarnation of undying Lust, the Goddess of immortal Hysteria, the accursed Beauty exalted above all other beauties by the catalepsy that hardens the flesh and steels her muscles.'[11]

Important to Freud was Charcot's defence of the reality of hysteria against the accusation that it was merely a sham display: 'She was no longer necessarily a malingerer, for Charcot had thrown the whole weight of his authority on the side of the genuineness and objectivity of hysterical phenomena.'[12] Even during its heyday, at the height of the hysteria epidemic that gripped Paris in the 1870s and 1880s, there were some who argued that its fits and starts and other bizarre symptoms were merely a product of coaching and suggestion, a viewpoint associated mainly with Charcot's rival, Dr Hippolyte Bernheim. Bernheim's theory of suggestion eventually prevailed, and by the time of the surrealists hysteria was widely regarded within the medical mainstream as a simulated illness. Charcot's reputation was damaged, as shown by assessments of his legacy on the occasion of his centenary in 1925, and it provided ammunition for opponents of psychoanalysis to portray it as a remedy for a non-existent disease. Freud, who had translated Bernheim's *De la suggestion* into German, was initially favourable to the theory of suggestion because it offered a purely psychological account of hysteria, but increasingly he expressed dissatisfaction with it. In psychoanalysis the patient's suggestibility is explained by 'the transference', which refers to the tendency of a subject to repeat within the analytic situation its relations with love objects from the past, notably parental figures. It was in the experience of the transference that Freud claimed victory over critics of his libidinal theory of the neuroses: 'It may be said that our conviction of the significance of symptoms as substitutive satisfactions of the libido only received its final confirmation after the enlistment of the transference.'[13]

fig.43
MAX ERNST
Aquis Submersus 1919
Oil on canvas
54 x 43.8 cm
Städtische Galerie im Städelschen Kunstinstitut,
Frankfurt am Main

fig.44
MAX ERNST
Mobile Object Recommended to Families 1936
Wood and hemp
98.5 x 57.5 x 46 cm
Stiftung Wilhelm Lehmbruck Museum, Duisburg

The transference thus offers proof of the omnipotence of desire. In 'The Fiftieth Anniversary of Hysteria', a text that extolled hysteria as 'the greatest poetic discovery of the later nineteenth century', Louis Aragon and Breton inferred that the transference love between hysterics and their attending physicians did not always go unrequited: 'Does Freud, who owes so much to Charcot, remember the time when, according to survivors, the interns at the Salpêtrière mixed up their professional duties with their amorous tastes, and when at dusk the patients either met the doctors outside the hospital or admitted them to their own beds?' And clearly a sophisticated understanding of the ongoing debates about hysteria lay behind their statement that 'this mental condition is based on the need of a reciprocal seduction, which explains the hastily accepted miracles of medical suggestion (or counter suggestion)'.[14]

A 'POETICS' OF HYSTERIA

2nd P.S. (1936). 'Of Eros and the struggle against Eros!' In its enigmatic form, this exclamation by Freud happens to obsess me on certain days as only some poetry can.
André Breton, 1937[15]

There is possibly a willful anachronism to be discerned in the surrealists' decision to resurrect the Salpêtrière studies of hysteria at a time when, in France, the diagnosis had fallen into disrepute and Charcot himself was widely regarded as having been the dupe of his 'hysterical' subjects.[16] It may be, in fact, that the all but complete disappearance of hysteria from psychiatry was a necessary prelude to its appropriation by the surrealists.[17] As early as 1920, an entry in Breton's private diary refers to hysteria as 'one of the most beautiful poetic discoveries of our epoch'.[18] As forms of expression, hysteria and poetry – and the dream likewise – are linked in the sense that they articulate a dialectic of desire and repression that lies at the crux of the whole surrealist enterprise.

Elaborated by Freud and Josef Breuer in the context of the *Studies on Hysteria* (1895), repression (*Verdrängung*) is a psychical process that acts on particular ideas and memories that it seeks to prevent from reaching consciousness. A line of demarcation known as 'the censorship' enforces the separation of the two systems, conscious and unconscious. The wider resonances of such a term were not lost on the surrealists, and indeed more than once Freud explicitly compared the psychical operation with political and press censorship. Within this dynamic model of conflictual forces, hysterical symptoms are understood as a compromise between the forces of repression and the forbidden wish: 'The psychoanalysis of hysterics showed that they fell ill as a result of the conflict between their libido and their sexual repression and that their symptoms were in the nature of compromises between the two mental currents.'[19] Dreams, likewise, are a resultant of these two opposed currents. The displacements and condensations of the dream-work that are responsible for the poetic character of dreams bear the marks of the censorship just as surely as the wish that is striving for expression. Breton located the source of poetry at just this point – in the ruses of desire as it endeavours to outwit the censoring agency. He wrote in *L'Amour fou* that, 'What I have wanted to do above all is to show the precautions and the ruses which desire, in search of its object, employs as it manoeuvres in preconscious waters, and, once this object is discovered, the means (so far stupefying) it uses to reveal it through consciousness.'[20]

fig.45
SALVADOR DALI
Gradiva Rediscovers the Anthropomorphic Ruins –
Retrospective Fantasy 1931–2
Oil on canvas
65 x 54 cm
Museo Thyssen-Bornemisza, Madrid

In the late 1930s the fictional character Gradiva became firmly established within surrealism as a *femme fatale* and muse-like figure. In Wilhelm Jensen's novella *Gradiva: A Pompeian Fantasy* (1903), which was analysed by Freud in 1907, an archaeologist fell in love with a girl represented in a plaster cast relief, and pursued what he believed to be her ghost, before discovering her to be an old childhood friend for whom his unconscious desire had long gone unrecognised. The obsessive traction felt towards the woman called Gradiva in this tale, with her strange walk, one foot held almost perpendicular to the ground, proved an inspiration to many surrealist artists and writers.

Masson's masterpiece *Gradiva* (1939) can be read on one level as an illustration of Jensen's story. The figure's erect foot, the volcano in the background representing the eruption of Vesuvius in which Gradiva supposedly perished and the gap in the wall through which her spirit passed, are all details taken from this source. Yet the artist also transforms this scene into an evocation of unbridled libidinal forces. The Pygmalion-like motif of stone becoming flesh is here metaphorically extended so that Gradiva's torso becomes a raw steak, while her vagina turns into a gaping shell. A swarm of bees suggests an ambiguous honey sweetness seeping from this half-rotten body. If for other surrealists Gradiva symbolised male longing and displaced desire, Masson's figure is opened up, her sexuality explicit. Her right foot casts a dagger-like shadow near her open sex, and the shooting volcano leaves no doubt as to the potential outcome of this encounter.

Gradiva's position on a stone tablet and the bloody colouring of this scene also suggest the theme of sacrifice. Ten years earlier in the periodical *Documents*, the art historian Carl Einstein had analysed the breakdown of the human body in Masson's work as a process of self-sacrifice, leading to a state of ecstasy. During the First World War the artist had seen the head of a nearby soldier split open like a 'ripe pomegranate' and was himself badly wounded. The striking metamorphosis of Masson's female figure, her body cleaved and disintegrating into a jumble of fleshy parts, strikingly evokes a combination of the extremes of pain and pleasure at a moment of sexual release. JK

fig.46
ANDRE MASSON
Gradiva 1939
Oil on canvas
97 x 130 cm
Private collection

Both of these paintings belongs to a myth chosen or created by Dalí, through which he explores desire and guilt, fear and aggression. *William Tell* depicts a confrontation between a youth and an old man, one of several paintings in which Dalí adapted the legend of William Tell as castrative and vengeful father in his own version of Freud's Oedipal scenario. In the Greek myth the jealous father rejects his son, Oedipus, who later unwittingly kills his father and marries his mother, blinding himself when he learns the truth. The story had an immediate relevance for Dalí, as his father had just turned him out of the family home, partly as a consequence of his affair with Gala, a married woman. Shortly after, mimicking the Tell legend in which the fourteenth-century Swiss patriot is forced by the occupying Austrian forces to shoot an apple placed on the head of his son, Dalí had himself photographed with a sea urchin balanced on his shaved head. The poem 'L'amour et la mémoire' (1931) celebrates his love for Gala but also describes a nightmare vision of William Tell, 'rage in his heart' and with 'furious and bloodshot eyes', climbing a tree with a baguette which he places in a nest. The painting pulsates with aggression and anxiety, its castration symbolism fully apparent. The father is horrific, both powerful and repugnant. The rotting donkey and grand piano issuing from his shoulder, reprise a scene in the film *Un chien andalou*, marking him as a despised symbol of the decaying and cloying sentimentality of bourgeois culture. The collaged nest of eggs in the foreground might symbolise birth and Dalí's new love for Gala. The cypresses in the background recall a painting by the nineteenth-century Swiss artist Arnold Böcklin, *Isle of the Dead*, which for Dalí united eroticism and death.

Whilst *William Tell* has a convulsive energy, *Meditation on the Harp* is a mournful picture, its uncanny doubling underlined by the contrast between the ghostly glow of the couple and the earth-dark, bony son. It is one of many paintings related to Dalí's extended study of Jean François Millet's hugely popular devotional painting *The Angelus* (1852). Begun early in the 1930s, his book *Le Mythe Tragique de l'Angélus de Millet* interpreted the image of the peasant couple pausing to pray as 'the maternal variant of the grandiose, atrocious myth of Saturn, of Abraham, of the Eternal Father with Jesus Christ, and of William Tell himself – all devouring their own sons'. For Dalí *The Angelus* was 'rich in unconscious thoughts'; a series of spontaneous associations arising from his obsession with it were subjected to rigorous analysis along the lines of Freud's *The Interpretation of Dreams*, and of his case histories. In the sexual encounter Dalí claimed to uncover, the identities of the couple mutate between husband/wife and mother/son; the man's hat covered an erection and the woman's pose was linked to various forms of female aggression, including the praying mantis which was popularly supposed to devour her mate after coupling. Dalí also claimed that the scene might have represented a burial, an idea apparently confirmed by the fact that x-rays reveal a coffin-like shape in the foreground that Millet had painted out. In *Meditation on the Harp* the dead son returns to confront his parents. The woman, now a naked object of desire, raises her heel in the Gradiva posture, thus drawing in another of Dalí's favourite Freudian myths (see p.64). DA

fig.47
SALVADOR DALI
Meditation on the Harp 1932–4
Oil on canvas
67 x 47 cm
Salvador Dalí Museum,
St Petersburg, Florida

fig.48
SALVADOR DALI
William Tell 1930
Oil and collage on canvas
113 x 87 cm
Private collection

Repression, and the return of the repressed, lie at the heart of the Gradiva case.[21] Freud's study was based on Wilhelm Jensen's short story *Gradiva: A Pompeiian Fantasy*. This tells of a young archaeologist, Norbert Hanold, who succumbs to a delusional fantasy about a girl represented on a Roman relief, whom he names Gradiva. After dreaming that she was buried in the eruption of Vesuvius he sets off to Pompeii to see if he can find any traces of her. While wandering the streets of Pompeii he encounters by chance a childhood sweetheart called Zoë Bertgang, and at first he is convinced that she is Gradiva or her reincarnation. It transpires that the source of his delusion is actually the repressed memory of Zoë. When eventually he falls in love with Zoë for herself, his obsession with Gradiva is cured: meeting Zoë has released his repressed desire. What this tale reveals is the artfulness of desire in its efforts to overcome obstacles: 'in and behind the repressing force, what was repressed proves itself victor in the end'. In order to illustrate this point, Freud cited an etching by Félicien Rops that depicts the temptation of a monk by a voluptuous naked woman in a crucifixion pose. By placing Sin in the place of the Saviour on the cross, the artist confirms what psychoanalysis has more painstakingly revealed, namely that: 'when what has been repressed returns, it emerges from the repressing force itself'. Something equivalent to Rops is portrayed by Salvador Dalí in his etched frontispiece for Eluard and Breton's *L'Immaculée Conception* (1930). A young man buries his head in his hands, but towering over his guilt and shame is the object of his desire triumphant, a licentious woman with a cross shape cut out of her skin-tight dress exposing the crotch and nipples.

It is in the most revolting perversions that the forces of repression – disgust, shame and morality – are definitively triumphed over. Ironically, notes Freud (although the line could have been penned by Dalí), 'The omnipotence of love is perhaps never more strongly proved than in such of its aberrations as these.'[22] Harbouring few inhibitions about displaying in public the dirty linen of the analytic session, at the time he joined the surrealists Dalí willingly professed to proclivities that even his liberated acquaintances found distasteful. 'L'Amour', a poem dedicated to his new wife Gala, announces with alarming candour: 'I wish it to be known that in love I attach a high price to everything that is commonly named perversion and vice.'[23] It is hard to imagine Breton sympathising altogether with this viewpoint. Breton's poetic was modelled on the neuroses in which, by contrast with the perversions, desire maintains a certain discretion and finds expression in roundabout ways. Even more disconcerting must have been Dalí's claim that the 'treasure land' (*terre de trésors*) the surrealists hankered after lay concealed behind objects of the most extreme revulsion: blood, shit and putrefaction. Not for the last time, Dalí found himself at the centre of a debate about censorship. His reception piece among the surrealists, *The Lugubrious Game* (1929), was the subject of a detailed psychoanalytic reading by Georges Bataille which draws attention to the very aspects of the picture that Breton in his eagerness to get Dalí on board the surrealist group had conveniently overlooked, themes of anal eroticism and so forth. In an earlier version of the article, titled 'Dalí Screams with Sade', Bataille outlined his objections to art that plays a polite game of symbolic transpositions (Breton's poetic) on the grounds that it is tantamount to siding with the censor: 'The elements of a dream or a hallucination are transpositions; the poetic utilisation of the dream comes down to a consecration of the unconscious censorship, that is to say to a secret shame and cowardice.'[24] In opposition to an art modelled on psychoneurosis, that is to say on the indirect expression of unconscious fantasies, Bataille posits an art of conscious lucidity – of

perversion, in other words. A consistent aesthetic stance is evolved by writers of the *Documents* group that rejects the play of metaphor and substitution in favour of an ever more abrupt encounter with the unadorned truth of desire. The divergences on this issue throw into heightened relief the polarised aesthetic stances of Breton and Bataille, and also show the extent to which Dalí was a crucial defining influence for both of them.[25]

SEDUCTION/SUBVERSION

Hysteria is a more or less irreducible mental condition, marked by the subversion, quite apart from any delirium–system, of the relations established between the subject and the moral world under whose authority he believes himself, practically, to be. This mental condition is based on the need of a reciprocal seduction.

Louis Aragon and André Breton, 1928[26]

Seduction is one of the so-called primal scenes (*Ur-szenes*) described by Freud. Inclined at first to accept as factual truth the stories of childhood seduction recounted by female hysterical patients in analysis, Freud later came to doubt the veracity of these memories, concluding instead that they were the reversal of a primary wishful fantasy to seduce the father. Abandoning belief in the reality of the event led him to the threshold of that other scene (*ein anderer Schauplatz*) that psychoanalysis designates as psychical reality, and to a recognition that perceptions and affects arising from fantasies can have an equivalent pathogenic force to those derived from events in the external world: 'If hysterical subjects trace back their symptoms to traumas that are fictitious, then the new factor that emerges is that they create such scenes in *phantasy*, and this psychical reality requires to be taken into account alongside practical reality.'[27] Fantasies, the stuff of psychoanalysis as much as of surrealism, are narrative scenarios which have as their purpose a *mise en scène* or staging of desire.

The surrealist redefinition of hysteria asserts a connection between seduction and subversion, as demonstrated by Max Ernst's collage novel *Rêve d'une petite fille qui voulut entrer au Carmel* (1930).[28] With the adoption of the collage novel format, Ernst found a means of overcoming one of the principal drawbacks of the image from a surrealist point of view, namely its intrinsically static character. The format thus provided an ideal vehicle for the narration of desire. Allusions to hysteria abound in Ernst's collage novels but nowhere more so than in this exposé of the repressed wishes of a saintly young girl called Marceline-Marie. If the dream and hysteria are interwoven in Ernst's dream-book, it is because Freud does likewise in his. The frequent asides on hysteria within the main argument of *The Interpretation of Dreams* are intended to assert a strict parallelism between dreams and symptoms of hysteria, in both of which Freud discerns the fulfillment of an infantile wishful impulse. A temporal structure of delay governs both, with archaic material being recapitulated in dreams and neuroses alike. Already, by 1897, Freud had been convinced that in hysteria 'everything goes back to the reproduction of scenes' and it is in this context that he first introduced the notion of a primal scene, speculating that 'the psychical structures which, in hysteria, are affected by repression are … *impulses* which arise from the primal

scenes'.[29] By the same token, in *The Interpretation of Dreams* one learns that a 'dream [too] might be described as *a substitute for an infantile scene modified by being transferred onto a recent experience*'.[30]

Ernst's *Rêve* opens with the reproduction of an infantile scene. The first plate is based on a source illustration of an embracing couple probably snipped from a pulp novel, to which Ernst has appended a caption that radically transforms its meaning (fig.49). This reads 'The Father: "Your kiss seems adult, my child. Coming from God, it will go far. Go, my daughter, go ahead and ..."' Once it is recognised, the seduction motif can be seen played out in relation to a succession of male figures who embody patriarchal authority.

A vertical axis of paternal authority that the son sets out to topple is a staple in Ernst's work of the early 1920s. In this task the hysteric is his ally. By the end of the decade, the father series (father-priest-God) very clearly symbolises the moral order that Aragon and Breton claimed is subverted by hysteria. 'Love is the great enemy of Christian morality', Ernst wrote in 'Danger de pollution', a text that gave full vent to his virulent anti-Catholicism and thus can usefully be read in conjunction with *Rêve*.[31] Ernst's collage-novel has been convincingly shown to be an elaborate spoof of *Histoire d'une âme*, the autobiography of Saint Theresa of Lisieux first published in 1898.[32] Ernst alludes to many of the episodes recounted in this book, including the spiritual training of Saint Theresa for her entry into the ascetic Carmelite order. Saint Theresa's intense piety and the mawkish sentimentality of *Histoire d'une âme* made her into a figure of immense popular veneration among the French middle classes after she was canonised in 1925, and also a ready butt for Ernst's anti-Catholicism. From within a surrealist milieu, Pierre Mabille wrote of Saint Theresa's passionate love of Christ as a bourgeois family romance writ large. After losing her mother at the age of four, Theresa was brought up by her father towards whom she developed a strong attachment. Mabille argued that the psychological motivation for seeking out the cloistered existence of the convent was in order to preserve this

Le Père : « Votre baiser me semble adulte, mon enfant. Venu de Dieu, il ira loin. Allez, ma fille, allez en avant et ..

fig.49
MAX ERNST
First illustration in *Rêve d'une petite fille qui voulet entrer au Carmel*
Paris 1930

primordial complex: 'the family is transported to the Carmelites and the real father substituted by an ideal, eternal father who, moreover, assumes the role of spouse.'[33] Mabille follows with the observation that the institution of the Church depends for its existence on exploiting this sublimated infantile complex and that were the patriarchal family to be dismantled, 'the whole edifice of catholicism would crumble immediately'.

Enlisting the hysteric, as Ernst does, in order to blaspheme the Church and impugn its authority brings to mind a current of anti-clericalism in Charcot's work that has been discussed by Jan Goldstein and which Ernst might have intuited of his own accord.[34] Charcot delineated a phase of the hysterical attack in which poses evoking religious piety or ecstasy, mingled often with a blatant eroticism, would be assumed by the subject. In a parodic version of the *Imitatio Christi* of early Christian saints and martyrs, the hysteric would sometimes take up a crucifixion pose during the attack. One can imagine Ernst's glee at such a find, having previously identified himself with Christ in his painting *Pietà or Revolution by Night* (fig.52), and mustering all his ingenuity to work it into the narrative of his collage novel *Une semaine de bonté* (1934). Charcot sifted through religious art, claiming to discover in the poses and gestures innocently recorded by artists of the past independent validation for his clinical observations. The retrospective diagnosis of hysteria was one means whereby Charcot sought to defend the veracity of the condition against charges that it was merely a piece of theatre, of dissimulation, with no substance to it. The first such study by Charcot and Paul Richer, his assistant, was published in 1887 as *Les Démoniaques dans l'art*. Goldstein believes that a republican, anti-clerical agenda also lay behind Charcot's triumphal claim to recognise in the visionary saints, witches and possessed of the past what in a secular age can finally be given its proper name – hysteria, 'the great convulsives of today'.

Nearer in time to the surrealists, Janet, in *De l'angoisse à l'extase* (1926), reported on a patient called Madeleine, a deeply devout woman whose case he followed for more than twenty years.[35] Among the many extraordinary features of the case, the woman exhibited physical lesions on her hands and feet like the stigmata of Christ. In states of ecstasy, she would maintain a statuesque immobility for hours, sometimes even for one or two days, kneeling down in prayer or with her arms spread-eagled in a crucifixion pose. What first brought her to Janet's attention in the

fig.50
MAX ERNST
Two Children Are Threatened by a Nightingale 1924
Oil on wood with wood construction
69.8 x 57.1 x 11.4 cm
The Museum of Modern Art, New York. Purchase 1937

wards of the Salpêtrière was a peculiar hysterical gait that she ascribed to a force raising her above the earth and causing her to walk on tiptoes. Defiance of the laws of gravity is a conspicuous element in Ernst's portrayal of hysteria which serves to reinforce the link with himself in the guise of his alter ego, the bird Loplop.

Ernst attributed to the actively seductive hysteric the capacity to destabilise or subvert patriarchal power and authority. Since the early 1980s heated controversy surrounding recovered memories of childhood abuse has refocused attention on Freud's seduction theory and the issue of the real or fantasised origin of these accounts.[36] It is a highly charged issue, with Freud accused in some quarters of evading the actual reality of abuse within the patriarchal family. It is instructive to examine the conduct of the surrealists with the benefit of this hindsight. The trial in 1933 of Violette Nozières, an eighteen-year-old girl who had poisoned her stepfather and then claimed in defence that he had been raping her repeatedly over a number of years, was a sensation in the national press. Public opinion was polarised on the truth or falsehood of her dreadful accusations against the dead man. The surrealist artists and poets rallied to her cause, publishing a collection of poems and illustrations praising her as the slayer of a monstrous patriarch: 'le papa le petit papa qui violait' (Papa, the little papa, who raped) intones a poem by Benjamin Péret.[37] On this occasion, their expected commitment to the primacy of fantasy did not prevent them from accepting the girl's claims and exploiting the occasion for an outpouring of anti-patriarchal sentiment. More questionable, however, is their conduct in relation to Augustine, whose photographs they reproduced in *La Révolution surréaliste* in 1928 (fig.51).[38] X… L…, known as Augustine, entered the Salpêtrière on 21 October 1875, aged just fifteen and a half. The detailed case notes in the *Iconographie photographique de la Salpêtrière* relate that the girl's hysterical attacks began shortly after she was raped by Monsieur C…, in whose safekeeping she had been placed by her mother.[39] Soon after she entered the household, it appears that C… began making unwelcome advances that rapidly escalated in violence. After she rejected him several times,

fig.51
This photograph of 'Augustine' was one of six reproduced in the article on hysteria in *La Révolution surréaliste* with the heading 'Les Attitudes passionelles en 1878' (Postures of Passion in 1878). It was later reproduced in Robert Benayoun's *Erotique du surréalisme* (1965), one of the last books about surrealism to be read in draft and approved by André Breton before his death.

he menaced her with a razor, forced her to drink alcohol, and then raped her. The child learned afterwards that her mother, a maidservant, was also the mistress of C…, which may explain why no charges were brought against the perpetrator. The hysterical attacks, which began in the days immediately following the assault, compulsively reenact the terrifying event that lies at their origin, as the lengthy descriptions that accompany the photographs made clear. The bald presentation of the images in the surrealist journal devoid of any reference to these circumstances induces the viewer to regard them as just another instance of *l'amour fou*, or as Breton later stated, 'veritable *tableaux vivants* of a woman in love'.

PSYCHOANALYTIC INTERPRETATIONS

When the work of interpretation has been completed, we perceive that a dream is the fulfilment of a wish.
Sigmund Freud, *The Interpretation of Dreams*, 1900[40]

Declining Breton's request for a contribution to an anthology of dreams in 1937, Freud cited as his main reason the fact that the manifest content of the dream – that which excited Breton on account of its poetic nature – was of little interest to him.[41] For psychoanalysis the manifest dream is but grist to the mill of interpretation which aims at tracking down the latent dream content, exposing the unconscious wish of which the dream is but a disguised expression. Interpretation seeks to overcome repression (the resistance) and bring to light concealed drives and impulses. Described in this way, psychoanalytic interpretation ostensibly functions in the service of unconscious desire. However, analysis or interpretation can also be viewed more negatively as a rational appropriation of desire, disarming it and submitting it to the control of (psycho)analytic reason. Small wonder, then, that Breton prevaricated interminably on the question of the merit, or otherwise, of interpreting surrealist texts.

What about the psychoanalytic interpretation of surrealist images? Louis Aragon, in 'Max Ernst, peintre des illusions' (an essay contemporaneous with the collage paintings of 1921–3 but not published until later) holds out for the mystified viewer of Ernst's work a tantalising escape hatch from the enigmas they pose. 'Treat these drawings like dreams,' Aragon wrote, 'and analyse them in the manner of Freud. You will find there a very simple phallic meaning.'[42] Art historical scholarship on Ernst has made good on this promise, but in recent times the validity of an approach modelled on dream interpretation has been disputed. Uwe Schneede, in the catalogue of an Ernst retrospective at the Tate Gallery in 1981, objected to all this 'compulsively psychoanalytic' interpretation of the artist's work.[43] In a similar vein, Werner Spies proposes that in looking at Ernst's work one should eschew interpretation altogether. *Men Shall Know Nothing of This*, the title of a painting of 1923 (fig.42), conveys, according to Spies, the kernel of enigma that is vital to all Ernst's imagery. For all that they look dream-like, the secrets of collage, and of paintings inspired by collage, are not meant to be unlocked by any key to dreams; they are there simply to be marvelled at. Spies argues that 'Max Ernst's work diverged from the beginning from the rebus or puzzle subject to logical solution … [Ernst] was interested foremost in the superadded value of the dream, the inexplicability produced by dream distortion and dream compression, and not

fig.52
MAX ERNST
Pietà or Revolution by Night 1923
Oil on canvas
116.2 x 88.9 cm
Tate. Purchased 1981

This painting, which was owned by the poet Paul Eluard and reproduced as a reflection of surrealist concerns in the periodical *La Révolution surréaliste* in 1925, demonstrates on several Ernst's commitment to psychoanalytical theory.

The internal 'logic' of the picture follows the model of Freudian 'dream work'. Taking a cluster of autobiographical and artistic starting points, Ernst submits them to the processes of 'displacement' and 'condensation' by which, according to a dream's mechanisms, the repressed desires and anxieties of the dreamer are encoded in the dream itself. The picture's title encourages us to interpret the image as a kind of reverse-Pietà. Rather than the Virgin Mother-of-Christ with her dead son in her arms, the painting presents the image of a kneeling bowler-hatted man who holds a statuesque figure (a form of 'displacement').

From various visual clues, notably the moustache, this figure can be identified as Ernst's father, Phillipe. Given the reverse-Pietà logic, he must also represent God-the-Father, and bearing in mind that on one occasion in Ernst's childhood, his pious father, who was a 'Sunday painter', had painted Ernst as the infant Jesus, it becomes apparent that Philippe is offering us a petrifed Ernst-as-Christ. The implication is that the father has sacrificed his son, and this in turn suggests that an Oedipal fantasy of paternal revenge underlies the picture. As with a dream, a number of associative strands have been shunted together or 'condensed' into a single image. Beyond this straightforwardly Oedipal reading, a further level of Freudianism possibly underpins the image: this time the specific details of Freud's so-called 'Wolf Man' case history of 1918. This case had involved a patient fantasising that, as Christ, he would give birth to God's child.

Freud had used this fantasy of male filiation to corroborate his notion of a proto-homosexual 'inverted Oedipus complex' in which the son unconsciously harbours a feminine relation to the father. If the *Pietà* therefore expresses an ambivalent relation to the father — as desired object as much as destroyer — it is interesting that in *The Meeting of Friends*, an important group portrait of the Paris dadaists of late 1922 that immediately preceded the *Pietà*, Ernst had depicted himself perched, rather coquettiishly, on the knee of a patriarchal-looking Dostoevsky. Given that Ernst's pose is similar in both paintings, it seems that Ernst may have been flirting with an essentially homo-erotic fantasy. DH

in analysis or explication'.[44] In support of this aesthetic of bafflement, as it might be described, Spies calls upon Theodor Adorno, who had argued that in trying to explain the strangeness of surrealism in terms of familiar themes like the Oedipus complex one winds up 'explaining away that which only needed to be explained'.[45] Psychoanalysis stands accused of cramming the 'luxuriant multiplicity' of surrealism into a procrustean bed of limited, reductive categories. The shock value of surrealist imagery, a function of surprise and *in*explicability, is dissipated if we know all the answers in advance.

The idea of an encrypted secret meaning, buried or repressed, of which men shall know nothing, far from being foreign to the conceptual baggage of psychoanalysis, is in fact one of its most fundamental themes. Freud argued that 'we obtain our concept of the unconscious from the theory of repression. The repressed is the prototype of the unconscious for us.'[46] It is even possible to suggest that Ernst figures the structure of a repressed complex pictorially in *Oedipus Rex* (1923), a picture that, more than any other, appears at first sight to hold out the promise of a simple phallic sense. The nutshell at the centre of the image, which the hand holding it seems to be trying unsuccessfully to prise open, is the visual analogue of an unsolvable enigma. Does Ernst hand us the meaning or withhold it? The complex interplay of concealment and exposure implies that the image contains *both* the structure of a concealed secret *and* the bringing of it to light.

Rêve d'une petite fille qui voulut entrer au Carmel is patently not a very hopeful test case for Werner Spies's assertion that the dream-collage comparison is misleading and misdirected. The format of the collage novel provided Ernst with an ideal vehicle for emulating the temporality of unconscious desire in dreams and fantasies, and his earlier collage paintings mime the condensations and displacements of the dream-work. Although plainly much happens in the course of *Rêve* that defies ordinary criteria of intelligiblity this does not mean that the only response to surrealist images should be one of bemused enjoyment and that there is no place for judicious interpretation. For one thing, such a claim overlooks the fact that *Rêve* is itself a parodic interpretation of another text, *Histoire de l'âme*, the recognition of which is indispensable to its function as a critique. The seduction fantasy around which Ernst structured this collage novel is a prime example of a repressed kernel of meaning – one men would prefer to know nothing of, as the present-day debate over sexual abuse within the family shows. The subversion of dominant values that Ernst pursues in concert with the unruly, disruptive hysteric is dependent on a return of the repressed, that is to say on a crucial shifting of the balance from repression to recognition, and interpretation does play a necessary role in this.

In a letter to André Breton in 1932, Freud confessed in a tone of exasperation: 'Although I have received many testimonies of the interest that you and your friends show for my research, I am not able to clarify for myself what surrealism is and what it wants. Perhaps I am not destined to understand it, I who am so distant from art.'[47] Despite Freud's professed incomprehension, an examination of the theme of hysteria reveals the extent to which surrealism and psychoanalysis are linked, their convergence apparent at the most general level of a description of the human subject. As Jacques Lacan, whose 'return' to Freud owes much to his former surrealist affiliation, put it: 'The subject in question is not that of reflexive consciousness, but that of desire.'[48] If the exchanges between Breton and Freud sometimes appear to show mutual incomprehension, the

reasons are to be found not in any fundamental misunderstanding of psychoanalysis by the surrealists but in their imperative to change the world. For them it was a matter of knowing not only how our dreams are shaped by the remote past, but also how they might be realised concretely in the future. In its refusal to compromise on that secular act of faith, whatever its other limitations, surrealism retains a seductive appeal. '*Desire*, yes, *always*.'[49]

fig.53
MAX ERNST
The Robing of the Bride 1940
Oil on canvas
129.6 x 96.3 cm
Peggy Guggenheim Collection, Venice.
Solomon R. Guggenheim Foundation, New York

The Robing of the Bride is an immensely rich, multi-layered production. As with the illustrations to Ernst's early 1930s collage-novels a cluster of apparently disparate elements have been fused into a seamless narrative. This 'collaging' is not just visual but extends to a range of symbolic and literary sources.

This painting was completed during a period when Max Ernst, separated from his lover Leonora Carrington, was interned as an 'enemy alien' in France. Given this, the whole scene suddenly becomes redolent of one of the 'witch trials' of the Middle Ages, with the greenish heron/stork at the left playing the part of one of the inquisitors whose job it was to strip suspected witches and probe their bodies for 'witch marks'.

Many aspects of the image conform to the iconography of withcraft. The right-hand figure, whose body and hair/headdress seems to be tugged at by invisible forces, is probably a reworking of one of the 'weather witches' of German legend. (The witchcraft scenes of the German Renaissance master Hans Baldung Grien are a demonstrable source for the picture, to say nothing of allusions to the body-types found in Cranach's paintings.) If the general scenario reads as one of exorcism the puffed-up throat of the right-hand figure becomes understandable: grotesque swellings were alleged to occur in witches' bodies prior to the expulsion of demons.

The expelled 'demonic' presences — the disconsolate homunculus in the bottom right corner and the shrunken gold head above the breast of the central bird/woman — could also be read as mutant alchemical products. In alchemy the 'Bride' was a term given to the perfected 'stone' after its 'stripping' and 'robing' (colour changes) in the furnace. This product was also synonymous with the Philosopher's Stone and the alchemical androgyne. In one of the more baroque hermetic parables, *The Chymical Wedding of Christian Rosenkreutz*, the stone is equated with a fabulous bird, nourished on royal blood. But if alchemy, in idealist terms, saw the androgyne as representing an analogue for the perfection of the Philosopher's Stone, the homunculus with its overly sexualised body speaks of an alchemy-gone-awry.

The 'possessed' sorceress at the right of the image finally expresses something of the surrealists' attitude towards female sexuality. The surrealists approvingly reinterpreted 'possession' as analogous to hysteria. This 'feminine' disorder, manifested in symptoms for which there was no physical cause and said by Freud to arise from the inability to release sexual excitement, had been a late nineteenth-century 'discovery' which the surrealists revalorised, publishing old photographs of patients in '*attitudes passionelles*'. DH

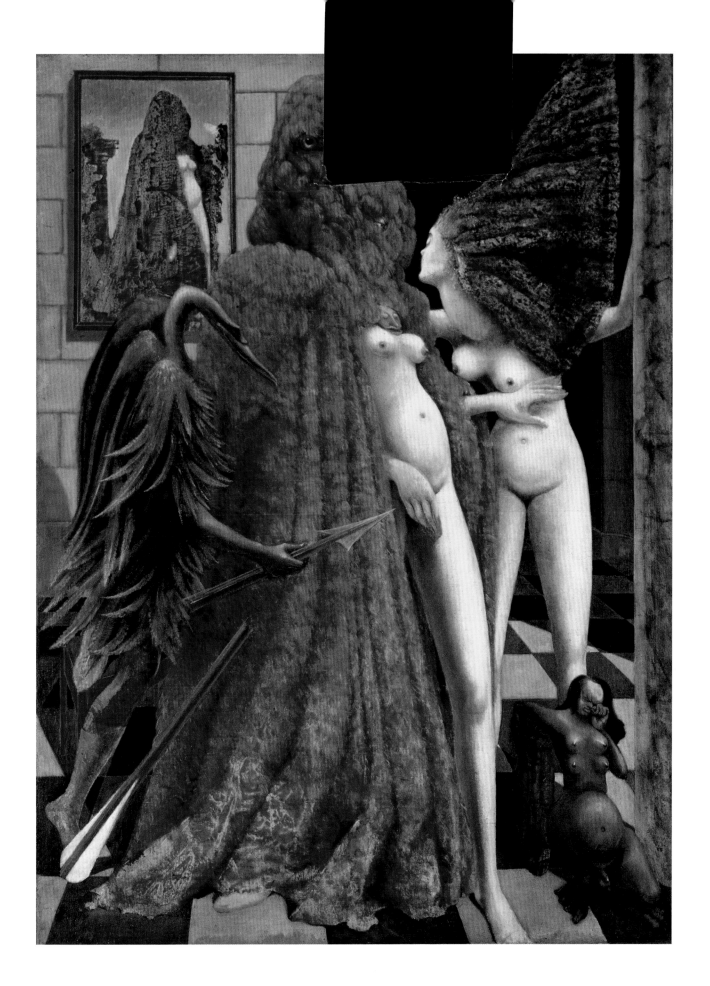

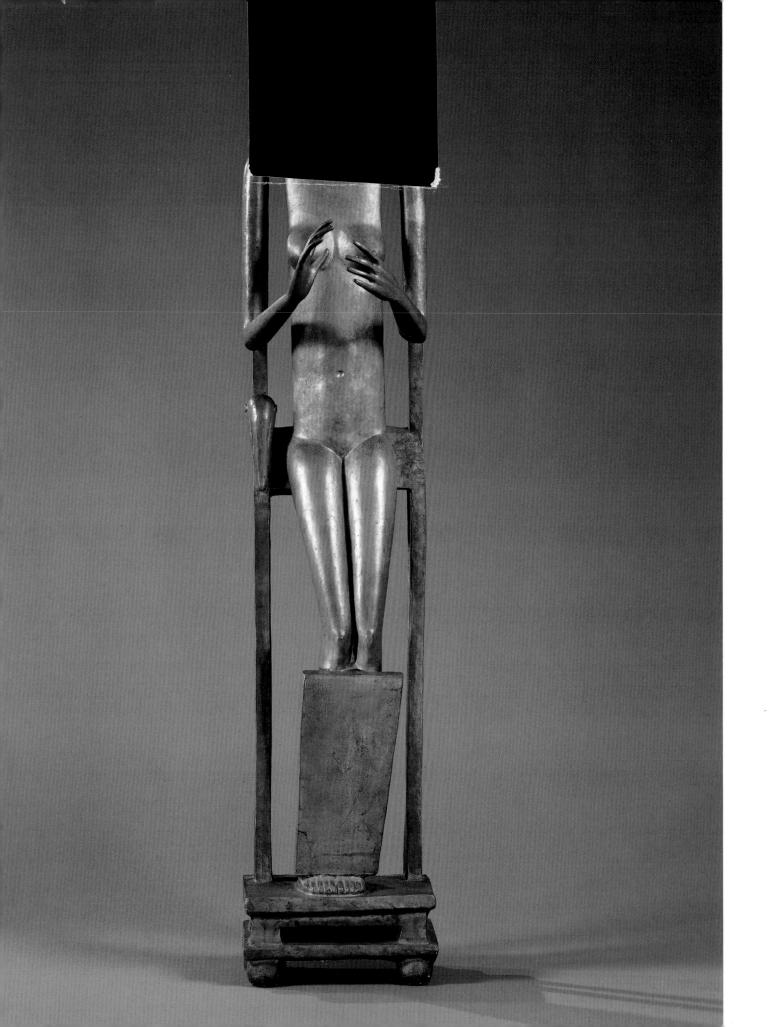

tantalising and fleeting, comes across strongly in this sculpture and its web of associations, where the crucial meeting is significant as much for the ongoing search it provokes as for its moments of fixed experience. In *L'Amour fou* Breton describes how now he is 'only counting on what comes of my own openness (*disponibilité*), my eagerness to wander *in search* of everything'.[4] The suggestive imagery of hands and eyes, surface textures and sensual tactility, evoked in Breton's account of Giacometti's sculpture, is appropriate to these ambivalent meetings.

The French term *frôler* ('to brush against') seems particularly appropriate for the sort of touches evoked in surrealist objects and paintings: the glancing touch which provokes and excites, the feel of fur, feathers, fabric. If, for example, Breton used the term *frotter* to describe the impact between different realities whose rubbing together produces the spark or fire of surrealist revelation, the more delicate *frôler* suggests a constant state of arousal without real fulfilment. This kind of touch promises much but does not deliver. *Frôleuses* can also be teasing prostitutes, whose métier is seduction without an eventual

A few years ago one constantly saw at the Bal Bullier, in Paris, a tall girl whose face was lean and bony, but whose black hair was of truly remarkable length. She wore it flowing down her shoulders and loins. Men often followed her in the street to touch or kiss the hair. Others would accompany her home and pay her for the mere pleasure of touching and kissing the long black tresses. One, in consideration of a relatively considerable sum, desired to pollute the silky hair. She was obliged to be always on her guard, and to take all sorts of precautions to prevent any one cutting off this ornament, which constituted her only beauty as well as her livelihood.

E. Laurent, *L'Amour morbide*, 1891

amorous outcome. In this way the encounter, as a cornerstone of surrealist erotic experience, is mediated through ambiguity and distance, its tensions and frustrations heightening its sensual and libidinal appeal.

Breton evoked in *Les Vases communicants* (1932) the effect of bringing together two very different objects, and the energy that their meeting could produce: 'two different bodies, rubbed one against the other, attain, by their spark, their supreme unity in fire.'[5] The potential of such random combinations was famously inspired by a passage in Lautréamont's *Maldoror* (1868–70), which describes a charged urban encounter between the protagonist and a handsome young English boy, Mervyn. Here the scene is set in the twilit rue Vivienne in Paris, among its dazzling shop windows. Mervyn's great beauty is compared to, among other things, the beauty of 'the chance encounter of a sewing machine and an umbrella on a dissecting table'.[6] The setting for this meeting, the deserted street with its seductive shop displays, later inspired André Masson in the creation of his *Rue Vivienne* streetwalker mannequin for the 1938 *Exposition internationale du surréalisme*. Breton picked up on the sexual implications of this pairing of the sewing machine and umbrella, identifying them as female and male, and imagining them as engaged in mechanical intercourse.[7]

Objects in surrealism suggest some of these dynamics of meeting and coupling. Meret Oppenheim's *Object (Le Déjeuner en fourrure)* appears as the unlikely offspring of the physical union of crockery set (the hollow forms of female sex organs) and wild beast, a hybrid creation of illicit intercourse, like the monstrous Minotaur. Past encounters and physical contact, real or imagined, are recorded in the form of mementoes, such as the bronze glove included by Breton in his novel *Nadja* (1928), a cast of a potential love token and a challenge (a dropped gauntlet) to the pursuant, like Cinderella's dropped slipper. The glove also has chivalric echoes, like those worn in

chapter three
'PRIÈRE DE FRÔLER': THE TOUCH IN SURREALISM

Julia Kelly

A girlish figure with half-open lips stands as if waiting for something to happen. Her large round eyes express wonder or awe, a state of innocence and expectancy. She is naked, her knees bent and pressed together, her arms and shoulders awkwardly hunched. Her hands reach before her, their fragile fingers stretching out to feel an empty space. This sculpture in smooth white plaster stands in Alberto Giacometti's Paris studio. André Breton sees her, and is captivated.

The meeting between Breton and Giacometti's *Invisible Object* is described first in a text entitled 'Equation de l'objet trouvé', published in 1934, and then in *L'Amour fou* (1937), Breton's famous exploration of the special nature of surrealist love and the means of attaining it.[1] Here, the *Invisible Object*, created in 1934, encapsulates the mysterious dynamics of the surrealist encounter, potential prelude to amorous and erotic experiences. In Breton's account of his and Giacometti's wanderings and discoveries at Paris's Saint-Ouen flea market, the *Invisible Object* comes to stand at the centre of a series of realised and unrealised desires and meetings. For Breton, this sculpture represents the libidinal forces that motivate the ongoing surrealist quest, and is 'the very emanation of the *desire to love and be loved* in search of its real human object, in its painful ignorance'.[2]

In his evocation of this work, Breton weaves together details of its creation and composition with his own desires. The figure's empty hands, gesturing forward and partly obscuring a view of her breasts, tantalise him. The process of her creation becomes intimately associated with two strange objects found at the flea market. A metal half-mask noticed by Giacometti is seen to resonate with the mysterious expression on the figure's face and provide a catalyst for its completion. A wooden spoon with a slipper-shaped handle purchased by Breton evokes for him Cinderella's lost slipper, and uncovers a chain of hidden erotic associations (fig.14). Breton recalls having some months earlier asked Giacometti to create for him a shoe-shaped ashtray or 'cinder holder' (*cendrier*), which he now identifies as an unrealised and wished for fetish-link to an imaginary Cinderella figure, *Cendrillon* of Charles Perrault's fairy tale. Playing on a famous ambivalence in Perrault's text in the description of the heroine's lost slipper, Breton envisages this non-existent object as made of either glass or fur, according to the confusion of the homonyms *verre* (glass) and *vair* (squirrel fur).[3] Its sleek and smooth imagined form, like the streamlined shape of the wooden flea-market spoon which substitutes for it, recalls for Breton his own penis.

The constellation of associations evoked by this sculpture in Breton's account bring out its functions as a paradigmatic figure of surrealist encounter. Her hands suggest a desire to make contact but also form a distancing screen against the onlooker's touch. Her eyes are speculatively mediated through the mask, a means of partly obscuring her gaze, which could only filter through its fine slits. While the feet of Giacometti's finished sculpture are immobilised, Breton's meditation on the slipper-spoon suggests the wandering feet of Cinderella, straying illicitly at night in order to meet her erotic destiny. The feel of glass and fur in contact with the foot heightens the sensual potential of this narrative of meetings.

The idea of an encounter which is near but also always at some distance, intimate but also

fig.54
ALBERTO GIACOMETTI
The Invisible Object
(Hands Holding the Void) 1934, cast 1935
Bronze
153 x 32.6 x 29.8 cm
National Gallery of Art, Washington, DC.
Ailsa Mellon Bruce Fund

Few works of art in recent years have so cap-
tured the popular imagination as has Meret
Oppenheim's surrealist object, the 'fur-lined
cup, plate and spoon'. Like Lautrémont's
renowned image, like Dalí's limp watches, the
'fur-lined tea set' makes concretely real the
most extreme, the most bizarre improbability.
The tension and excitement caused by this
object in the minds of tens of thousands of
Americans have been expressed in rage,
laughter, disgust or delight.

Alfred H. Barr Jr, Museum of Modern Art, 1937

fig.55
MERET OPPENHEIM
Object (Le Déjeuner en fourrure) 1936
Fur-covered cup, saucer and spoon
7.3 cm high
The Museum of Modern Art,
New York. Purchase 1946

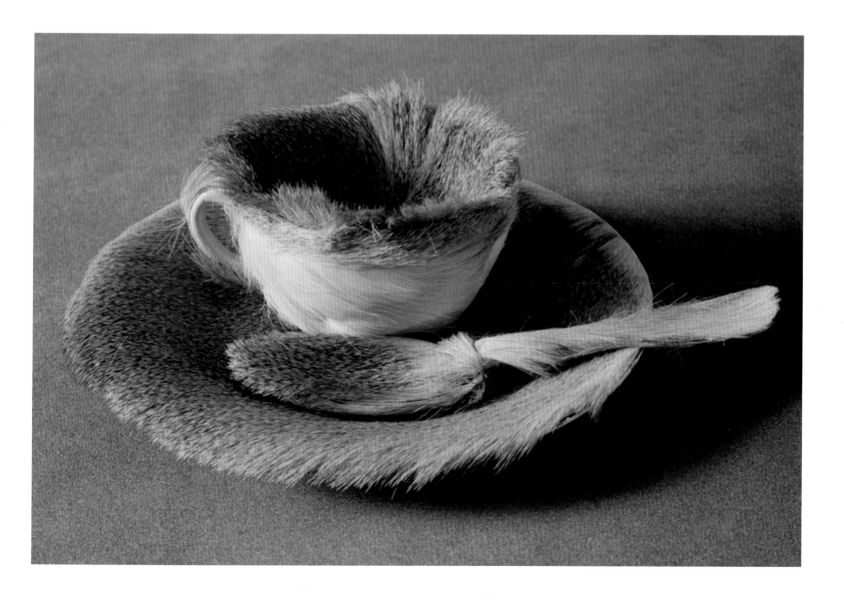

fig.56
JOSEPH CORNELL
Taglioni's Jewel Casket 1940
Wooden box containing glass ice cubes, jewellery, etc
12 x 30.2 x 21 cm
The Museum of Modern Art, New York.
Gift of James Thrall Soby, 1953

L'Egypte de Mlle Cléo de Mérode is one of Joseph Cornell's earliest homages to the ethereal but secular goddesses of stage and screen, remote objects of intense devotion. His boxes, encasing objects, fragments and photographs which have real or imagined associations with the object of desire, distil a longing for the unattainable mediated through the compensatory power of memories.

Cléo de Mérode was a famous beauty of fin-de-siècle Paris; dancer and lover of Léopold II of Belgium, she was one of the models for the actress Rachel in Proust's *A la recherche du temps perdu*. For Cornell she was a legendary figure from an age that fascinated him as much as the earlier stars of the romantic ballet, such as Marie Taglioni whose encounter with a Russian highwayman on the icy steppes inspired *Taglioni's Jewel Casket*. At the time that the box was made Cornell was probably unaware that Cléo was still alive and surrounded by admirers.

The dark-stained oak box is itself redolent of nineteenth-century luxury and travel; its compartments and bottles, readymade miracles of efficient storage, here recall a scientific specimen case rather than a jewel casket. Working on the nominal link with Cleopatra and Egypt, Cornell plays on the idea of the Egyptian queen as the sign of timeless glamour, and on archaeology as a metaphor for the buried and partially retrievable past.

A print of the goddess Hathor, the Egyptian Aphrodite whose sway extended to the afterlife, is pasted into the lid. This image together with the delicately marbled paper lining the box suggests the painted interior of an Egyptian tomb, the contents sealed for posterity but already labelled for the archaeologist of the future. Made, like so many of his boxes, to be handled, the contents are only fully visible when the bottles are lifted out. Beneath the sheet of glass that seals the lower horizontal compartment of the box he spread red sand to evoke the desert, scattered with the arm of a porcelain doll, wooden ball, a German coin and fragments of glass and mirror.

In the upper level of the box the shallow glass section to the right contains plastic rose petals and the legend 'Rosée à feuilles de rose' (Rose-leaf dew). The twelve cork-stoppered glass bottles contain heterogeneous objects. One bottle contains a cut-out photograph, probably of Cléo, set in yellow sand (the photograph resembles one reproduced by Georges Bataille in his essay on 'The Human Face' in *Documents*, September 1929), labelled 'CLEO DE MERODE / Sphinx'. A bottle with tulle, rhinestones, sequins, pearls, metal and glass fragments is labelled 'Les Mille et Une Nuits' (The Thousand and One Nights). Some refer to the 'Natural History' of the title: a bottle with red paint and shell or bone fragments is labelled 'Temps fabuleux/fossiles végétaux' (Fabled era/plant fossils). This recalls Cornell's first major installation in a surrealist exhibition (Alfred Barr's 1936 *Fantastic Art, Dada, Surrealism* at the Museum of Modern Art, New York) 'The Elements of Natural Philosophy', in which he used a similar case of specimen bottles. In Cornell's world of complex associations, temporal, historical, geographical and affective, 'natural history' leads both to the ancient eras of the geological universe and the display cases of New York's Natural History Museum.

Although Cornell never travelled abroad, he fuelled his imaginary journeys with materials garnered from antiquarian stores and junk shops in New York, flotsam and jetsam from the beach, trinkets from dime stores and mementoes of many kinds. He kept files of material relating to people or experiences of special importance, and the boxes themselves are often the distillation from these archives. His box-constructions are a highly diverse genre; some are ready found, others made to his specifications. The associations are always multiple and convey longing in its many guises: shop windows, display cases, cages, the lost world of children's toys. The explicit erotic symbolism of the surrealist object as Salvador Dalí envisaged it was alien to Cornell's delicately allusive work, which explores desire and its complex layers through association, concealment, displacement and memory.

A special entry was devoted to Cléo de Mérode in the *Lexique succinct de l'érotisme*, published in the 1959 *EROS* catalogue. It was said of her that 'the purity of her face framed by flat bandeaux made it the most complete image of the "femme fleur" (woman-flower) that dominated around 1900'. DA

fig.57
JOSEPH CORNELL
*L'Egypte de Mlle Cléo de Mérode: cours
élementaire d'histoire naturelle* 1940
Mixed-media construction
12.1 x 27.3 x 18.4 cm
Robert Lehrman, Washington, DC

fig.58
PAUL DELVAUX
Street of Trams 1938–9
Oil on canvas
90.3 x 130.5 cm
Scottish National Gallery of Modern
Art, Edinburgh. Bequeathed by
Gabrielle Keiller 1995

fig.59
PAUL DELVAUX
Dawn over the City 1940
Oil on canvas
174 x 200 cm
Artesia Bank, Belgium

fig.60
RENE MAGRITTE
The Elusive Woman 1928
Oil on canvas
81 x 116 cm
Private collection

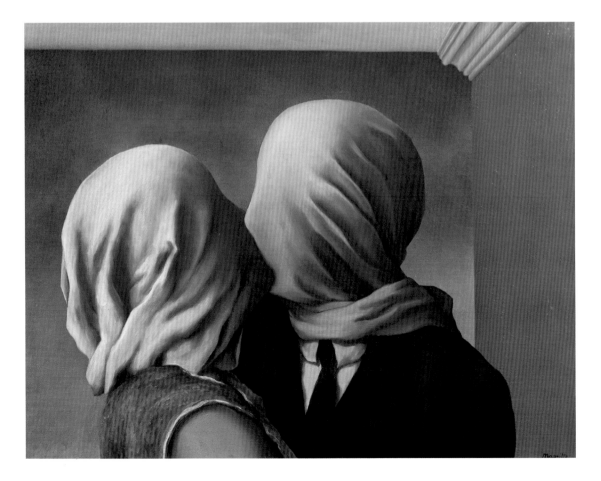

fig.61
RENE MAGRITTE
The Lovers 1928
Oil on canvas
54 x 73.4 cm
The Museum of Modern Art, New York.
Fractional and promised gift of
Richard S. Zeisler, 1998

fig.62
JOSEPH CORNELL
Untitled (Mona Lisa) c.1940–2
Lidded and papered cylindrical cardboard box sealed with painted clear glass, containing photographic reproductions, sequins, hairpin, glass beads and black paper fragment
3.5 x 7.6 cm (diameter)
Marguerite and Robert Hoffman

knights' helmets, and defended to the death. Joseph Cornell's glass ice cubes in *Taglioni's Jewel Casket* of 1940 similarly stand as the souvenir of an erotically charged encounter between the ballerina and a highway robber, the pure distillation in this case of a moment of danger full of repressed sexual thrill, while the jewel-case itself symbolises the female genitalia.[8] This work shares the quality of fragility and preciousness of the fairytale glass slipper. These objects are all of a hand-held scale, and by their functions involve the touch and grasp of fingers.

In the paintings of René Magritte and Paul Delvaux, touch and sight are combined strikingly in evocations of encounters with strange women. In Magritte's *The Elusive Woman* (fig.60), four reaching hands are trapped in their stony surround, never to touch the naked woman between them. Her awkward gesture (both shielding and caressing) only serves to draw attention to her hairless and unprotected pubis, while her impassive face makes no eye contact with the onlooker. Her stance suggests ambiguity, a potential openness to sensual and sexual advances, and Magritte's treatment of his subject heightens this: her smooth flesh contrasts with the textured rock in its sensual properties, but its hard grey shadows also evoke an equivalent hardness and inviolability. Paul Delvaux's *Street of Trams* (fig.58) depicts a series of women in a modern urban setting, awaiting a tram in a deserted street. To the left two women are interrupted in the process of an intimate act: one of them treads a discarded piece of white clothing underfoot, while the identity of the other is partly obscured by a curtain. These two figures are framed by their architectural setting, the focus of their composition lying precisely at the titillating point where one woman's hand appears to brush against the other's buttocks. The sensual impact of the painting, latent in its theme of waiting prostitutes, is encapsulated in this one small tactile detail.[9]

Cornell's *Untitled (Mona Lisa)* consists of two round cases. In one, the artist isolates the suggestive detail of the Mona Lisa's crossed hands, one appearing to caress the other with its gently parted index and middle fingers. The other case focuses on her face, the pasted reproduction of which is enclosed behind glass, on top of which a few small jewelled trinkets lay. The three-dimensional immediacy of these tiny toy-like objects, with their invitation to the curiosity of hand and eye, points up the distance of the woman whose gaze meets ours, mediated through layers of art historical past, paper reproduction and glass

fig.63
JOSEPH CORNELL
Untitled (Greta Garbo) c.1939
Mixed-media construction
33.7 x 24.1 x 7.6 cm
Richard L. Feigen

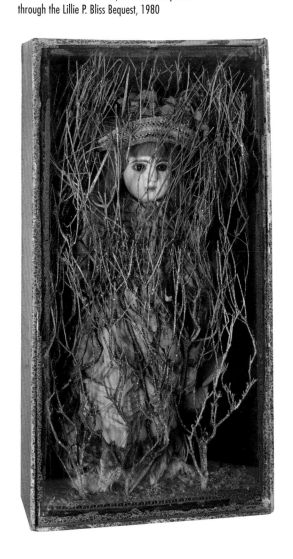

fig.65
JOSEPH CORNELL
Untitled (Pinturicchio Boy) 1942–52
Mixed-media construction
35.2 x 28.3 x 9.8 cm
The Joseph and Robert Cornell Memorial
Foundation, courtesy C&M Arts, New York

fig.64
JOSEPH CORNELL
Untitled (Bébé Marie) early 1940s
Papered and painted wooden box with painted
corrugated cardboard floor, containing doll in cloth
dress and straw hat with cloth flowers, etc.
59.7 x 31.5 x 13.3 cm
The Museum of Modern Art, New York. Acquired
through the Lillie P. Bliss Bequest, 1980

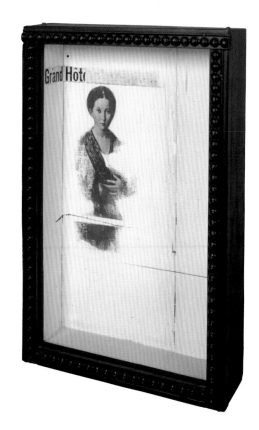

fig.66
JOSEPH CORNELL
Untitled (Grand Hôtel) c.1950
Mixed-media construction
48.3 x 32.4 x 10.2 cm
The Joseph and Robert Cornell
Memorial Foundation,
courtesy C&M Arts, New York

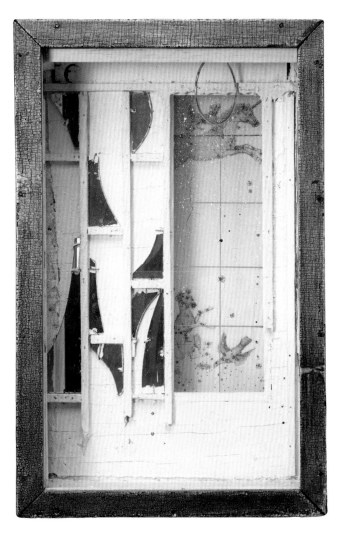

fig.67
JOSEPH CORNELL
Observatory Colomba Carrousel c.1953
Mixed-media construction
46 x 29.2 x 14.6 cm
Robert Lehrman, Washington, DC

fig.68
JOSEPH CORNELL
An Image for 2 Emilies c.1954
Mixed-media construction
34.9 x 26.7 x 7 cm
Robert Lehrman, Washington, DC

covering. This layering effect is a striking feature of Cornell's homage to Greta Garbo, *Untitled (Greta Garbo)* (fig.63), in which the star is presented in a scaled-up daguerreotype format, her photograph sealed behind several sheets of plain, blue-tinted and mirrored glass. The dark blue soft velvet lining of the sides of the box creates an effect of tactility, and Garbo's glittering necklace is doubled, brought into tantalising relief, by the addition of a few rhinestones and a string of pearls. The overall blue colouring of this piece suggests a frozen coldness to Garbo's smooth skin, the inaccessibility of the cinema star, while the mirrored glass throws the gaze of the viewer back out of this precious realm onto their own desiring self. Shards of mirror create a similar effect in *Observatory Colomba Carrousel* (fig.67), underlining the onlooker's distance from the evocative domain of the word-fragment 'hotel'. The urban contexts of much of Cornell's work, and its sources in the movie theatre, the museum, the shop window and the junk store, suggest a kind of desire-led wandering, whose moments of epiphany are captured in boxes full of sensual promise, seductive mementoes of the ultimately unattainable.[10]

The location par excellence of the erotic encounter within surrealism is the city. The motif of 'wishful wandering', strolling through the streets of Paris hoping for the sexual frisson of a meeting with an unknown woman is crucial to surrealism's early years, and explored above all in Aragon's *Le Paysan de Paris* of 1926 and Breton's *Nadja* of 1928. Breton made explicit the most important aspect of the marvellous in the city in an interview of the 1950s: 'the unforeseen encounter which always tends, explicitly or not, to take on a woman's features,

It has become very difficult to differentiate at first sight an honest woman or a pure young girl from a whore … All women, from the adolescent to the grandmother are moulded according to the same model: they wear lipstick and powder their faces, have pearly eyelids, long black lashes, painted nails, platinum or red hair … they all smoke, drink cocktails, loiter at dance halls, drive cars … Given the promiscuity of these bodies that are not always comparable to Venus, how can we place them? Which is the marquise, the wife of the wealthy industrialist? Or simply the woman of easy virtue? What an embarrassing question and what a difficult problem to solve!'

Léon Bizard, *La Vie des filles*, 1934

marks the culmination of that quest.'[11] The surrealists' conception of sensual city experience drew its inspiration most strikingly from Charles Baudelaire's *flâneur* in 'The Painter of Modern Life' (1863), the man moving 'into the crowd as though into an immense reservoir of electricity', and highly sensitive to every detail of soft furs, shiny gauzes, glittering jewels and dramatic make-up in the ranks of women that he brushes against.[12] A poem-object by Breton of 1937 combines the evocation of a walk in a specific Parisian location, the avenue des Acacias near to the Arc de Triomphe, with a miniature decorative ermine in white fur (fig.74).

Breton's novel *Nadja* evokes the narrator's meeting with a mysterious woman he notices one day in a Paris street, catching his attention with her dark eye make-up, her strange smile and her floating walk.[13] A series of successive encounters ensue, both planned and sometimes unplanned, Nadja appearing by chance in the same street as Breton. Their relationship is finally overshadowed by another meeting with the unnamed 'X' (Suzanne Muzard) who represents the real object of Breton's quest for 'ideal love', at least as he presents it. Breton ceases to contact Nadja, who is finally confined to a mental hospital. It is significant, however, that although the encounter with 'X' has a transcendental status within the novel, this meeting is not described in detail, and the main interest of the narrative as a whole is Nadja and her precarious existence.

The images through which Nadja's presence is evoked stand as telling examples of a glancing

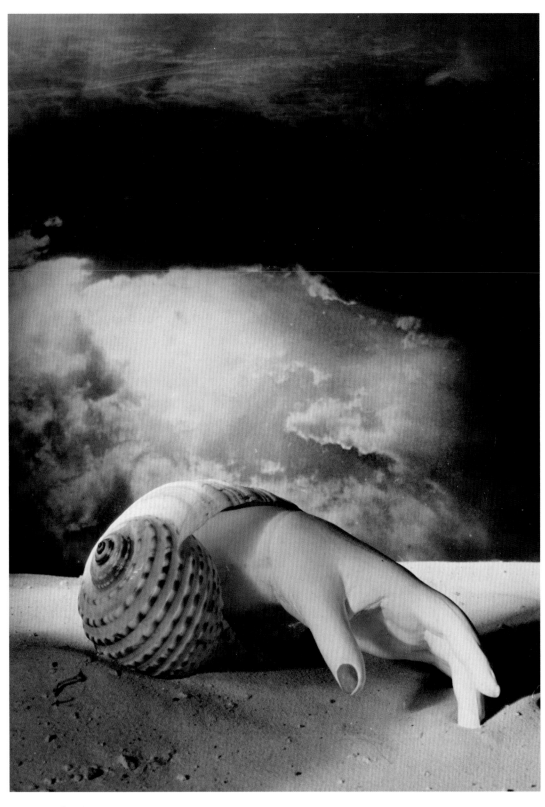

fig.69
DORA MAAR
Untitled 1933–4
Gelatin silver print glued on cardboard,
photomontage 37.5 x 27 cm
Centre Georges Pompidou, Paris. Musée
national d'art moderne

fig.70
MAN RAY
The Enigma of Isidore Ducasse 1920, replica 1970
Sewing machine, wood, fabric, card
38 x 55 x 24 cm
Lucien Treillard

fig.71
MAN RAY
Optical Hopes and Illusions 1944
Wood, string, glass
53.3 x 17.7 x 11.5 cm
Private collection

Of all surrealism's experimental activities, the surrealist object is one of the most far-reaching in its significance and its legacies. Launched by Salvador Dalí in the surrealist review *Le Surréalisme au service de la révolution* in 1931, as part of a programme to ginger up a movement in crisis, its origins in fact go back to the foundation of surrealism and beyond.

André Breton first spoke of the fabrication of a special kind of object in his 'Introduction to the Discourse on the Paucity of Reality', published in the same year as the first *Manifeste du surréalisme*, 1924. Preoccupied with the problem of the real, and questioning the narrow pragmatism that governed what was commonly accepted as such, Breton speculated on the nature of the 'poetic testimony' brought back from their 'expeditions', voyages into the unknown of the human psyche. Human fetishism, unconcerned with the substitutive character of its desired objects or their worldly value, needs their material verification: 'must try on the white helmet, or caress the fur bonnet'. Breton proposed that objects which appear in dreams could, like fetishes, be given tangible form. Having while asleep come across 'a curious book in an open-air market, whose back was formed by a wooden statue with a white beard, its pages of heavy black cloth', he regretted its absence when he awoke, and had the idea of putting into circulation such 'problematical and intriguing' objects. Not only would they make concrete something produced by the unconscious working of the imagination, but they would also interfere in the world of things and trouble the value normally placed on utilitarian objects.

Justified neither as utility nor art, such objects and those produced copiously by the surrealists through 1930s, also looked back to Marcel Duchamp's readymades, and especially his 'assisted readymades'. The readymades, such as the *Bottlerack* of 1914, anonymous mass-produced objects chosen by Duchamp and infiltrated into the world of art, raise questions about the nature of artistic activity and the idea of choice as a creative process. Assisted readymades, such as *Why Not Sneeze, Rose Sélavy?* (1921), for which Duchamp, as a visual pun, altered a birdcage and filled it with white marble sawn to resemble sugar cubes, intrigued the surrealists. The juxtaposition of odd materials and objects, though often born of a conceptual or speculative idea, affiliated them to the poetic and erotic objects they envisaged.

Dalí's 'Objets surréalistes' was one of several texts in the third issue of *Le Surréalisme au service de la révolution* concerning the 'object'. These included Alberto Giacometti's 'Objets mobiles et muets' (seven drawings of actual or proposed objects accompanied by a short text), Breton's 'Objet fantôme', on dream objects and their interpretation, and Yves Tanguy's 'Poids et couleurs', with drawings and descriptions of objects in various materials and colours. Dalí lists six categories of surrealist object, the first of which is 'Objects functioning symbolically'. Such objects were fabricated entirely from readymade or found objects. In their real or suggested movement they corresponded to unconscious acts, and incarnated erotic desires and fantasies. Four objects were illustrated, by Dalí, Gala Eluard, Breton, and Valentine Hugo. The pairing of two men and two women was deliberate, and moreover underlined the idea that anyone, artist or poet (or simply muse) could participate. Each of the four objects was accompanied with an elaborate description of its composition and potential symbolic action. Dalí's object involved plunging a sugar lump into a glass of warm milk secreted inside a shoe, itself a clear reference to the idea of the fetish; Breton's included among other things a bicycle saddle, an alabaster book, a photograph of the Leaning Tower of Pisa, a green sugared almond, and foliage.

In 'L'Objet fantôme' Breton, whilst recognising their extraordinary 'explosive value', expresses some reservations about the highly personal and over-specific character of these objects 'functioning symbolically'; in his opinion the incorporation of the latent into the manifest content, in Freud's terminology, weakened their suggestive power. This did not discourage the making of surrealist objects, but they tended to become somewhat simpler in conception.

In 1936 the surrealist exhibition of objects held at the Charles Ratton Gallery in Paris gathered together an astonishing range of things: the catalogue lists 'natural objects' (animal, vegetable and mineral), 'interpreted natural objects', 'incorporated natural objects', 'perturbed objects' (such as a bottle found after a volcanic eruption), 'found objects', 'interpreted found objects', 'American objects' (Eskimo masks, Hopi dolls, Peruvian pots), 'Oceanic objects', 'mathematical objects', a 'readymade' (Duchamp's *Bottlerack*) and 'assisted readymade' (*Why Not Sneeze, Rose Sélavy?*) and finally 'surrealist objects'. This diversity underlines the role that the object, in its widest sense, took in erasing aesthetic hierarchies and encouraging a radical mixture of western and non-western cultures. Distinctions between utilitarian and ritual, found and made, collective and individual are blurred. Like dada, surrealism embraced the anti-art aspect of the object, but went on to uncover its potential both to crystallise and to perturb 'the real'. DA

face to face with one's own dark psyche was echoed in Aragon's erotic novel *Le Con d'Irène*: 'The erotic idea is the worst mirror. What you learn there of yourself makes you shudder.'[29]

Giacometti was very interested in Aragon's *Le Paysan de Paris* when it first appeared in 1926. Prostitution was a concern in his writings, sculpture and paintings, and he had an obsessive interest in the Sphinx brothel in Montparnasse, a few minutes walk from his studio.[30] This brothel was known for its gleaming functional decor and Egyptian-style salon, among the tables of which naked girls would wander.[31] The intimation of deathliness in the venal encounter suggested in Aragon's writings also finds an echo in Giacometti's work. *The Invisible Object* can be seen as an ambiguous combination: a Cinderella-figure of a magical meeting as well as an evocation of mortality. Breton pointed to the presence of Thanatos (the Greek spirit who personified death) hidden in the object found by Giacometti at the flea market, the metal mask which turned out to be a wartime visor.[32] While this figure's arms gesture forward, her feet are strikingly fixed in place, trapped beneath a rectangular plaque like a fragment of tomb lid. Her rigid pose and stylised features suggest an Egyptian mummy, preserved in time, from the culture that so fascinated Giacometti. This moment of stasis is highly ambivalent: it may precede reanimation, or it may mark the onset of future immobility. One of the common uses of the verb *frôler* in French is in the phrase *frôler la mort*, 'to brush with death'. It is appropriate that Giacometti's sculpture, subtitled *Hands Holding the Void*, should have as its focus a pair of skeletal hands held suggestively apart, their fragile fingers frozen in a permanent seductive caress.

captivating associations: 'This unfurled hair had the electric pallor of storms, the cloudiness of breath upon metal.' The experience of having one's own hair cut is also marked out as an occasion for physical contact of an erotic nature, and Aragon calls for the education of all hairdressers in the 'geography of pleasure' with its own series of atlases: 'From these maps the youths will learn to let their fingers stray across skulls: they will learn to make them linger at the level of the lambda where pleasure reaches its peak.'[25]

The Passage de l'Opéra (whose existence was threatened by one of Haussmann's building projects still not yet completed) was for Aragon the crucial site of erotic moments. One of the last to leave the Passage one evening, the narrator is struck by a strange green light and humming noise coming from the window of a cane shop, where, coming closer, he sees a small woman floating in the window display, naked to the waist and with a mermaid's tail. He suddenly recognises her as a prostitute he had known in Germany where he served during the war. First encountered on the banks of the Saar, Lisel is surely a variant on the fatal and mythic German Romantic Liselotte. When he tries to talk to this vision its begins to escape him: 'The siren turned a scared face towards me and stretched out her arms in my direction. Immediately the window display was seized by a general convulsion.'[26] This meeting with a figure

An important date in the history of Montparnasse was the opening of the Sphinx on the Boulevard Edgar–Quinet. Hundreds of artists had been invited, and the champagne flowed like water. The main salon was like a café, but in the background, under a waterfall, was a glittering statue of a golden sphinx– the only luxury in the bordello. For this house broke with the usual tradition: heavy curtains, red velvet sofas, walls covered with fabrics … At the Sphinx, everything was enamelled, waxed, white, clean, functional, hygienic. It was like an operating room. There was another innovation: the men could bring their wives and children. Going to the Sphinx was like a family outing. The little boys would stare wide-eyed at the sylphs offering their charms, weaving stark naked in and out among the tables.'

Brassaï, 1976

from his earlier life is trapped in an unattainable past, held back behind the glass frontage, tantalising but unreachable. The whole arcade, for Aragon, partakes of this essential distance, as a symbolic location of erotic memory foretelling its own destruction and death: 'What I forgot to say is that the Passage de l'Opéra is a big glass coffin … In the changing light of the arcades, a light ranging from the brightness of the tomb to the shadow of sensual pleasure, delicious girls can be seen serving both cults with provocative movements of the hips and the sharp upward curl of a smile.'[27]

The erotic meeting place of the brothel, as the implicit equivalent of the enclosed and tomb-like arcade, also functioned for Aragon as a deathly place of refuge and of authentic self-knowledge. In a remarkable passage of self-justification, he proclaimed: 'People are rather apt to accuse me of extolling prostitution, and even … of aiding and abetting its procedures. And the same people go on to raise dark doubts about the concept I may have, *deep down*, of love. But is it not evident that my taste and my respect for this passion is so enormous … that the sense of repugnance is powerless to bar me from its humblest, least worthy altars. Is it not to misunderstand the nature of love to believe it incompatible with this degradation, this absolute negation of adventure which is nevertheless still a venture by my own self, the man jumping into the sea, the renunciation of all masquerade: a process that is overwhelmingly attractive for the true lover?'[28] The underwater imagery in these lines recalls the floating German siren figure, as well as Aragon's eulogy of the public baths. The suggestion here of a kind of amorous encounter that functions as a means of coming

contact, keeping Breton's interaction with her at a distance. Her fragile build and pale complexion, reminders of past illnesses, complement her own descriptions of herself as phantom-like, a 'genie' and a 'wandering soul'. Of Nadja's own appearance, the reader sees only her delicate 'fern-like' eyes, repeated four times in a photo-collage as if to signal her obsessive gaze (fig.109). One of the self-portraits she gives to him as a love-token (described by Breton but not reproduced in the book) shows her as a Mazda light-bulb with butterfly's wings, the ethereal bringer of illumination.[14] Breton also transcribes among her expressions of love for him her claim, 'I am but a tiny atom breathing at the corner of your lips or expiring' (see p.138).[15] This image of her contact with him through the tiniest particle of breath, a kind of dematerialised kiss, expresses strikingly the principle of *frôlement*. The motif of the hand too, so central to this novel, is the agent of the enticing caress, like the red 'hand of fire' that Nadja is desperate to touch and which for her represents Breton.[16]

In *Nadja* the ambiguity of the glancing encounter also becomes pressing. Breton's exemplary muse figure herself has a troubled status. In her past, Nadja implies, she has had to resort to prostitution in dire financial circumstances, and she suggests to him that she will do so again in her current situation, prompting a gift of money from Breton. In his writings Breton often professed his repugnance for prostitution and prostitutes. However, it is clear that the figure of the prostitute also intrigued him.[17] In *Les Vases communicants* he recalls a formative memory of a streetwalker whose most striking feature continues to haunt him: 'Many times, and still very recently, I had confessed to some friend the extraordinary nostalgia caused in me, since the age of thirteen or fourteen, by the kind of violet eyes that had fascinated me in a woman who must have worked the pavement at the corner of the rue Réamur and the rue Palaestro.'[18] He also describes his process of approaching women in the street, sometimes bearing a single red rose, to elicit a flirtatious glance or a smile.[19] Breton is aware of the problems of these urban muses, for example, the young dancer he comes across who innocently agrees to accompany him and whose lack of prudence makes him ponder: 'I couldn't help vaguely wondering what exactly she was doing there at that time and forming some doubt, vigorously resisted afterwards, as to her morality.'[20] In this text Breton compares the process of wandering in the city to the dream, where moral barriers are broken down by the force of 'desire searching for the object of its realisation', and he uses the erotic image of the bed sheet to represent the city, cut into by the force of desire, and sewn up again at the moment of encounter.[21]

In *Le Paysan de Paris*, on the other hand, Aragon celebrated prostitution as an essential component of his mythology of the surrealist city.[22] The roving narrator of the novel sought out a range of ways in which random meetings could excite and inspire, whose scope was much broader than Breton's insistence on 'ideal love'. In the section 'Le Passage de l'Opéra', Aragon traced the spread of all kinds of erotic activity within city locations. New realms for casual encounters suggested themselves to his imagination, such as massage parlours, but also the public baths, whose piquancy was enhanced by their accessibility and 'the sense of intimacy in the very centre of a public place'.[23] The crush of the Métro yielded opportunities for frustrated married women to experience fleeting physical contact.[24] And, most poetic of all in Aragon's account, the hairdresser is revealed as the site of unacknowledged sensual pleasures. The narrator is lost in the contemplation of a head of blond hair, 'the pure, lazy coils of a python of blondness' whose shining mass provokes a stream of

fig.72
SALVADOR DALI
Venus with Drawers 1936
Plaster, metal and fur
98 x 32.5 x 34 cm
Private collection

fig.73
EILEEN AGAR
Angel of Anarchy 1936–40
Textiles over plaster and mixed media
52 x 31.7 x 33.6 cm
Tate. Presented by the Friends of the Tate
Gallery 1983

In the Luxembourg Gardens the sun was shining, when I addressed the three friends. Breton was a somewhat pale and thin young man, who in spite of his bad financial situation maintained a certain elegance ... You must know that I'm no dadaist, I said to him straight off — Me neither, he replied, with that smile that he kept his whole life when he was distancing himself from his own doctrinaire principles. Also this type has always impressed me. You remember, I found that he came across as a 'proper man'. I felt myself extraordinarily drawn to him and was very curious ... But I was also afraid. I had to put my knitting down, when he eventually came that day, my hands were shaking so.

Letter from Simone Kahn (soon to be Breton), to Denise Lévy, July 1920

fig.74
ANDRE BRETON
Poem-Object 1937
Mixed media
28.3 x 19.8 cm
Timothy Baum, New York

Text reads:
'Madame
You appeared for the first time
What a storm that night
We wandered both of us down the Avenue de Acacias
I like your lowered eyes'

In early 1937, when Breton created *Song-Object* for Dora Maar, he was keenly interested in Wilhelm Jensen's heroine, Gradiva, whose name he used for the surrealist gallery he had just taken over. In the introductory pamphlet for his new exhibition space, Breton embellished each of the letters of the word GRADIVA with a woman's name, choosing Dora for the middle D.

Decorated with floral motifs and bordered with lacy paper, the lid of the box that contains Breton's poem-object bears the label: 'Les Parures de Mariées G.D.L. Nouveautés de Paris' (Finery for Brides G.D.L. New Fashions from Paris) as if, it would seem, to strip Marcel Duchamp's *Bride* bare. The inscription on the stopper of the bottle, 'During the night', leads into the nocturnal arena of dreams, that 'desire fulfilled', as Freud wrote in *Delusion and Dream in Wilhelm Jensen's 'Gradiva'* (1907).

The ceramic tile could easily bring to mind Gradiva's house in Pompeii that was destroyed when Vesuvius erupted. The rectangular plaque, in a blue that only plastic could recreate, symbolises the watery deep where the sea horse swims, an allusion to Rimbaud's famous poem *Le Bâteau Ivre* (The Drunken Boat, 1883): 'A crazy plank with black sea horses for escort'. The four pipe cleaners describe the smoke of some steamer against the blue. The poem in blue ink by Breton updates the song of the sirens: 'On a cork seat / In the midst of the Mediterranean / While they laughed / Twisting the sheets over their piano / To make waves / O ancient register of love'. The object above the label, which displays the title of the work and Breton's signature, is like the inking-pad of some oceanic deity, his abstracted smile reversing the poetic steam.

Did Breton dedicate this *Chanson-Objet* to Dora Maar to celebrate the publication of *L'Amour fou* (the printing was completed on 2 February) which, among other photographs, included the one she took of Giacometti's *Invisible Object*? Whatever the reason for the creation of this poem-object, the 'objectification of the act of dreaming', according to its author, it remains a fine homage to a young woman whom Paul Eluard introduced to Pablo Picasso in 1935 and whom the latter immortalised in the series of paintings called *The Weeping Woman*, painted in 1937. J-MG

fig.75
ANDRE BRETON
Song-Object 1937
Mixed media
22.5 x 30 x 6 cm
Private collection, Paris

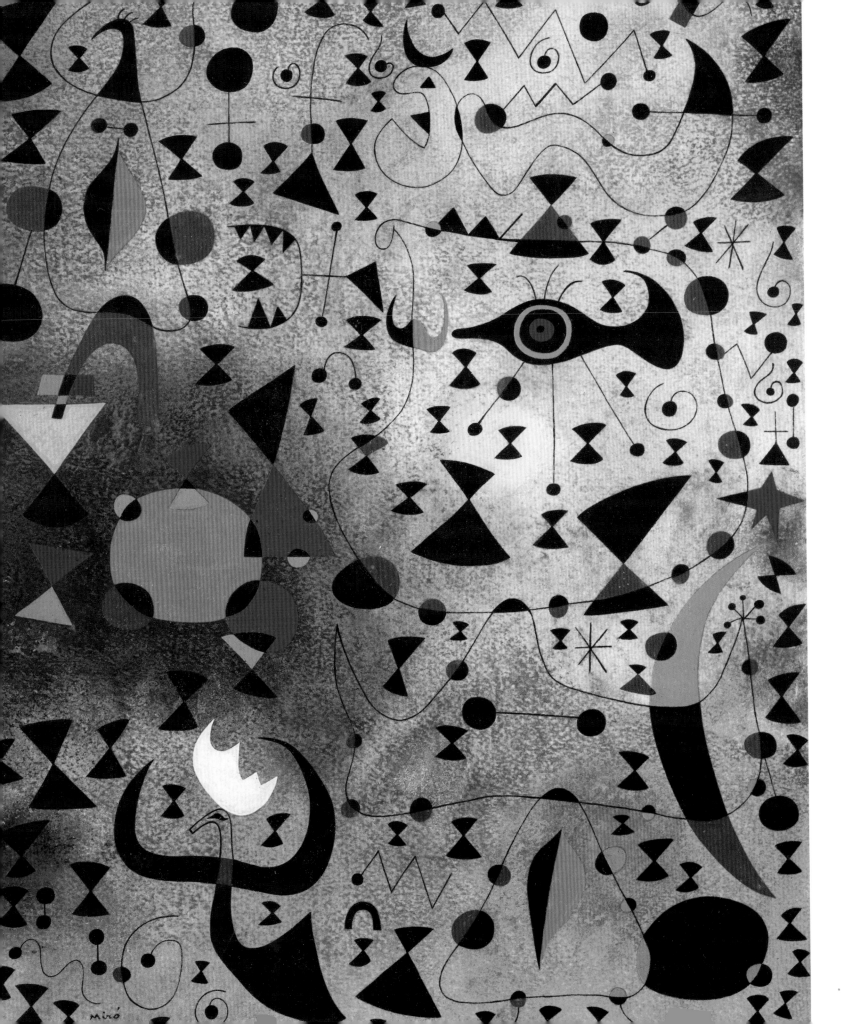

ANAMORPHIC LOVE: THE SURREALIST POETRY OF DESIRE

Katharine Conley

he concept of anamorphosis – literally from the Greek words for form (*morphe*), seen backwards or understood retrospectively (*ana*) – could be understood as emblematic of the surrealist worldview. This is because of the way in which, in an anamorphic work such as Hans Holbein's *The Ambassadors* (1533), two different images co-exist but cannot be properly perceived simultaneously. This trick of perspective may be understood to function metaphorically in surrealism because of the way in which surrealist works attempt to convey the co-existence of two apparently mutually exclusive worlds – that of conscious reality together with that of unconscious dream reality. The point where the two realities converge into what André Breton called 'surreality' may be seen as equivalent to the instant when the viewer of *The Ambassadors* suddenly sees and understands how the two very different perspectives in the painting work together,[1] in a retrospective glance akin to a flash of insight.

The Ambassadors – the most famous anamorphic painting – portrays two magnificently robed ambassadors surrounded by symbols of knowledge and wealth. Off-centre, in the lower portion of the otherwise realistic painting, lies a distorted anamorphic skull, reminding the viewer of human mortality.[2] The writer Jurgis Baltrusaitis explains how *The Ambassadors* was intended to be hung near a door, with another door facing it. These two doors would have allowed the viewer to see the painting from two distinct perspectives. In what Baltrusaitis calls the 'first act' the viewer entered the room by the door facing the painting and saw the realistic ambassadors. Only upon leaving the room by the door next to the painting could the viewer appreciate the 'second act' of the painting's spectacle, because the skull at the base of the painting is only clearly visible from this lateral perspective: 'the visual contraction makes the main scene disappear completely and the hidden figure appears. The characters and all of their scientific equipment fade away and in their place emerges the sign of the End. The spectacle is over.'[3] The painting is a *vanitas*, embodying the view that art and science are mere illusions when faced with the true word of God.

The surrealists did not believe in God, of course, for they were atheists. Yet, as is implicit in Holbein's painting, they believed that a powerful alternative exists to rational reality, that what lies buried in the unconscious mind – desires, emotions, intuitions, and impulses – provides a corrective to a rational Cartesian worldview. They advocated the incorporation of an awareness of the unconscious into accepted notions of reality, just as Holbein's anamorphic skull has its strange place in an otherwise realistic painting and must be viewed twice to be understood.

ANAMORPHOSIS AND THE SURREALIST 'IN-BETWEEN'

By seeking to navigate the unconscious mind via the automatic experience – giving free reign to unconscious images – the surrealist, like the viewer of the anamorphic skull in *The Ambassadors* first encountered a dream reality, which initially seemed impenetrable. Viewing that dream reality 'laterally', however, opening up to it and resisting the temptation to condemn it for appearing irrational, can make it intelligible. In principle, having had such an automatic experience, the surrealist would

fig.76
JOAN MIRO
Women at the Border of a Lake Irradiated by the Passage of a Swan 1941
Gouache and oil wash on paper
46 x 38.1 cm
Private collection

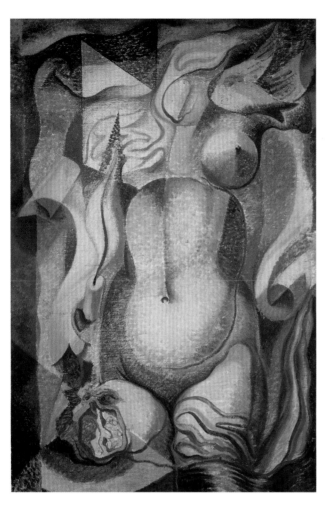

fig.77
ANDRE MASSON
The Armour 1925
Oil on canvas
80.6 x 54 cm
Former collection Georges Bataille
Peggy Guggenheim Collection, Venice.
Solomon R. Guggenheim Foundation,
New York

become capable of walking around during the day fully enlightened by insights usually possible only in dreams, of seeing 'normal' reality with double vision and perceiving the dream or unconscious reality usually hidden within it. Conversely, the surrealist could dream awake and circulate consciously in dreams.[4]

This dual state of consciousness, which exists only as a desirable yet improbable state, is emblematised by a line in Paul Eluard's poem 'Life': 'When she goes out she sleeps' (*Quand elle sort elle dort*).[5] This line evokes the fully integrated worlds of conscious and unconscious reality as imagined by the surrealists. The poem reflects the optimistic assertion that the world of dreams may be tapped and explored at will, in defiance of potential psychic risks.[6] The intense beauty of the automatic experience, during which the poet's body is the alert yet passive receptacle for the fluid passage of the automatic word through him, is expressed by Eluard in 'The Word'.[7] In this poem the automatic freedom of the 'word' in dream-time – where one word-image slips effortlessly into another, as smoothly as 'silk' – occurs with the arrival of the most creative time of the day, the 'in-between' moment of sunset. This image of the setting sun in the poem doubles as an image of an eye closing and looking inward at the instant when the conscious mind is released into sleep.

At the exact moment when the sun sinks below the horizon it should be possible to see day and night simultaneously, to capture in one glance the visual clarity of daylight and the visionary quality of night. It seems almost possible, and yet it is not quite. Such a moment in time represents Breton's idea of surreality as a desired instant of convergence even as it is simultaneously an

fig.78
ANDRE MASSON
Children of the Islands 1926–7
Oil on canvas
92 x 60 cm
Former collection Jacques Lacan
Private collection, Paris

emblem of separation. This frontier-space between day and night, described by Eluard as a suspended instant in time, works as a beat, the instant of double-take, like the beat separating the moment between seeing one image and then another in an anamorphosis. It is what I call the surrealist 'in-between,' described by Breton in the first *Manifeste du surréalisme* when he explains the creative significance of the moment of falling asleep.

Breton heard his first 'automatic' sentence as he was about to fall asleep one night. The sentence – 'There is a man cut in two by the window' – was 'automatic' because it seemed to come from nowhere, like a 'knock on the windowpane of consciousness'. Breton explained that as he 'heard' the sentence, he had a faint vision of a man with a window around his middle section. This strange image visualises the division between inner and outer consciousness – the precise division that Breton and the surrealists were eager to navigate and, literally, to see through. Not surprisingly, Breton's first automatic text, *Les Champs magnétiques* (1919), co-authored with Philippe Soupault, opened with a section entitled 'The Unsilvered Mirror', which suggests the possibility of looking through, instead of into, the reflective surface of a mirror, as though staring through glass from one state of consciousness into another.

fig.79
ANDRE MASSON
Vegetable Delirium 1925
Ink on paper
42.5 x 30.5 cm
Private collection, Paris

fig.80
ANDRE MASSON
Birth of Birds 1925
Pen and ink on paper
41.9 x 31.4 cm
The Museum of Modern Art, New York. Purchase

fig.81
ANDRE MASSON
Ariadne's Thread 1938
Oil and sand on board
22 x 27 cm
Former collection
Georges Bataille
Private collection, Paris

Looking back on the free-flowing images that he produced in the mid-1920s, André Masson affirmed their close relationship with sexual themes: 'the automatic drawing ... almost always had a kind of erotic foundation. An eroticism that could have been that of the Cosmos, but whose element was Eros.' He also noted their difference from other erotic drawings in his repertoire: 'they are worrying, they make you uneasy.'

In the first issue of *La Révolution surréaliste* in December 1924, Max Morise had stressed the importance of 'the succession of images, the flight of ideas' to any visual surrealist art, the exact form of which, he maintained, was still at that point open to question. Masson was one of the most widely represented artists in the journal, particularly through drawings such as *The Birth of Birds*, reproduced in *La Révolution surréaliste* in October 1925, its linear qualities making it a particularly appropriate counterpart to 'automatic' writing. In this drawing, the forms of a seated female nude emerge from a series of fluid lines evoking hands, plants and fruit-like shapes. Two nipples appear as a star and a comet respectively, suggesting an elision between cosmic forces and physical sensuality. From a tangle of lines in her lap, at the level of her sex, two birds soar upwards towards the right of the composition.

In *The Birth of Birds*, the delicate qualities of the pen and ink drawing enhance the airy connotations of its theme, whilst in *Ariadne's Thread* sand is used to create an earthy effect. Both works reprise a sexual motif taken from the writings of the Comte de Lautréamont (1846–1870), that of unnatural couplings between humans and beasts. *Ariadne's Thread* shows Ariadne not as a salvatory force guiding Theseus back from the deadly maze, but as engaged in a passionate embrace, which is delineated by a convulsive calligraphic line of black paint. The bull's head suggests the origins of the monstrous Minotaur himself, born of Pasiphaë's transgressive love for a bull. The work's red colouring evokes the visceral interior of the body as well as the blood of the slaughtered Minotaur. The labyrinth motif within surrealism was used as a metaphor for the subconscious mind, with its hidden urges of sex and violence. In this painting, bought in 1939 by Jacques Lacan, who had a relationship with the sister of the artist's wife, Masson suggests the overwhelming power of the unconscious as the site of irrational erotic energy. JK

Robert Desnos visualised this 'in-between' as a human bottle. In the love poem from 1926 'If You Only Knew', Desnos imagines himself as a 'nocturnal bottle' through which he is able to 'see' wondrous shooting stars and entire constellations bursting against the inner walls: 'Far from me, a shooting star falls into the poet's nocturnal bottle. He quickly corks it and from then on he watches the star enclosed in the glass, he watches the constellations exploding on its inside walls, far from me, you are far from me.'[8] Inner space within automatic experimentation is as vast and strange as outer space. The walls of the bottle are akin to the surface of the poet's skin that, in the automatic experience, with eyes turned inward, may be seen through. In Desnos's poem the glass 'window' visualised by Breton has become moulded to the contours of a three-dimensional human being rendered translucent by automatism.

MIRO'S SURREALIST DOUBLE-TAKE

Few surrealist painters were able to reproduce in art the spontaneous automatic strategies of the surrealist poets because usually more preparation is required in planning a painting than in putting pen to paper. André Masson, with glue, paint, and sand, created automatic works of visual poetry that retained a graphic quality. Around 1925, within a year of the publication of Breton's first *Manifeste du surréalisme*, Masson's next-door neighbour Joan Miró was also exploring the space between verbal and visual representations.

Miró's *Stars in the Sexes of Snails* (fig.82) is an 'in-between' work, a hybrid between a painting and a poem, a poem-painting. The visual elements in the painting – the bright red circle, the black star and its trails of black light, the thin ink-like black line overwriting the circle and adding weight to the bottom two-thirds of the canvas, the blue-grey mist swirls in the top left-hand corner, the washed background overlaid with faded black splotches in random organic shapes – include words. The calligraphic words read downwards at a diagonal from the upper left-hand corner: 'stars in the sexes of snails,' or perhaps more accurately, 'stars in the shape of the sexes of snails'. The words are so visually striking as to function almost as an anamorphosis. After an instant, their visual impact fades and they become readable, transforming Miró's washed canvas background into the equivalent of the surrealist poet's paper, almost rendering it invisible before the dominance of the poetic line itself.

The work crackles with a mix of visual and verbal significance creating what Rosalind Krauss has called a 'magnetic field', in reference to Breton and Soupault's *Les Champs magnétiques*.[9] Krauss sees both Breton and Soupault's text and Miró's paintings from 1925 as sharing 'the problem of inventing a language which would simultaneously describe the world of objects and the opacity of the medium that renders them – whether that medium be line or words'.[10] Miró's painting is one (verbal) form *and* another (visual) form combined. While married felicitously in one space, they remain distinct.[11] Like any optical illusion, the exciting effect of

fig.82
JOAN MIRO
Stars in the Sexes of Snails 1925
Oil on canvas
129.5 x 97 cm
Kunstsammlung Nordrhein-Westfalen,
Düsseldorf

fig.83
JOAN MIRO
Lady Strolling on the Rambla in Barcelona 1925
Oil on canvas
132 x 97 cm
New Orleans Museum of Art.
Bequest of Victor K. Kiam

fig.84
JOAN MIRO
The Red Spot 1925
Oil on canvas
116 x 114 cm
Museo Nacional Centro de
Arte Reina Sofía, Madrid

simultaneity in Miró's new formal language only *appears* to make it possible to see both completely at the same time. In fact, as with an anamorphic painting, *Stars in the Sexes of Snails* must be seen twice – from the front as a visual work and 'laterally' as a verbal one – to be fully appreciated as 'in-between' painting and poem. Miró's signs communicate at the frontier of the generic distinctions between art and writing.

This combination of verbal and visual elements in Miró's painting is reminiscent of Desnos's use of verbal signs as visual elements in his *Rrose Sélavy* (1922–3), inspired by Marcel Duchamp.[12] Desnos was the most gifted of all the surrealists at automatic poetic production – he spoke poetry and wrote and drew easily while in hypnotic trances. These one-line poems, many of which were initially composed orally by Desnos during the surrealist 'period of sleeps' – the five months when the group around Breton experimented with collective automatism – turn on the aural and visual resemblances between words and syllables. Poems such as 'Le Temps est un aigle agile dans un temple' (Time Is an Agile Eagle in a Temple), for example, play on the tongue-twisting and visual similarities between syllables and letters. Breton saw in these resemblances veritable attractions and stated that these poems expressed desire within language itself: with Desnos's Rrose Sélavy poems, Breton claimed, 'Words make love'.[13] For although this particular short poem could be seen as merely a game for the eye and the ear, a product of pure automatism, in fact the 'attractions' between the words produce coherent statements. Time *is* quick like an

At the same time … Pierre Reverdy wrote: The image is a pure creation of the mind. It cannot be born from a comparison but rather from the juxtaposition of two more or less distant realities. The more the relationship between these two juxtaposed realities is distant and true, the more powerful the image will be — it will have greater emotional power and poetic reality … etc. These words, although sibylline for the uninitiated, were very revealing and I meditated upon them for a long time.

André Breton, 1924

fig.85
JEAN ARP
Head: Scottish Lips 1927
Painted card with cut-out
areas
51 x 39 cm
Géraldine Galateau

eagle in the twentieth century, and is revered as never before in history, as in a temple. In this poem and even more so in another example, 'Les Lois du désir sont des dés sans loisir' (The Laws of Desire Are Restless Dice), the verb 'to be' acts as the fulcrum of a rhetorical chiasmus with either side, 'agile time' and 'eagle temple,' 'laws of desire' and 'restless dice,' leaning into the other in a mirroring play of resemblances.

Thirty years later, the surrealist couple Hans Bellmer and Unica Zürn pursued the semantic games initiated by Desnos in his *Rrose Sélavy* poems in both visual and verbal terms. Zürn wrote anagrams compulsively, describing in her memoir *L'Homme jasmin* the 'inexhaustible pleasure' she felt 'finding sentences within one another'.[14] She also experienced her own body as an anagrammatically expressive medium for her fantasy lover-nemesis, the Jasmine Man, who, she believed, communicated with her telepathically.[15] This parallel between the articulations of words and bodies in Zürn's imagination found its corollary in her companion Bellmer's dolls, which he constructed, photographed, and commented upon throughout his career, starting in 1934. To his biographer Peter Webb he wrote in the 1950s: 'I was aware of what I called the physical unconscious, the body's underlying awareness of itself … The body is like a sentence that invites us to rearrange it, so that its real meaning becomes clear through a series of endless anagrams.'[16]

Like his friend Desnos, Miró plays visually with verbal elements in *Stars in the Sexes of Snails*, as Margit Rowell has shown, especially with the calligraphic curves of the repeated letters. Not only may Miró's poetic line, be read in reverse, 'snails' genitals in the form of stars,' in the manner of Desnos's *Rrose Sélavy* poems (i.e. 'restless dice' are the 'laws of desire' in the poem 'The Laws of Desire Are Restless Dice'), specific letter combinations in the poem may also be reversed, as in

fig.86
JEAN ARP
Garland of Buds I 1936
Limestone
49.1 x 37.5 cm (base height 15.4 cm)
Peggy Guggenheim Collection, Venice.
Solomon R. Guggenheim Foundation,
New York

an anagram, namely *es* (*se*) and *to* (*ot*), particularly when *étoiles* is understood in Miró's native tongue as *estel*.[17] Like Desnos's *Rrose Sélavy* poems, Miró's painting-poem dramatises Breton's idea that through automatism language is freed to follow its own attractions, to express its own desires. Both verbal and visual reversals in Miró's poetic line also reflect surrealist ideology about sexual union – the result of sexual (and surrealist) desire – which is that both partners should be free and equal in their fulfilment of their desires. Reversal implies non-hierarchical equality (as does the prominence of the verb 'to be' in Desnos's *Rrose Sélavy* poems).

Stars in the Sexes of Snails also reads somewhat like a calligram – a poem in which the words are arranged to look like the objects they describe, as in Guillaume Apollinaire's calligram 'My heart like an upside-down flame'. Like a calligram, *Stars in the Sexes of Snails* 'says the same thing twice.'[18] The eye sees the visual shooting star painted over faded amorphous black shapes that, while of indeterminate shape, suddenly resemble snail tracks on the canvas. Then the almost unconscious awareness of such a possible resemblance partly fades as the lines of handwriting become legible as the verbal signs of *écriture* because as one sign system comes to the fore the other one seems to disappear, as with anamorphosis.[19] Nevertheless, once the painting becomes legible as a verbal statement, traces of its visual impact linger still and produce an aftereffect. As the viewer reads the painting's *écriture* the memory lingers of the texture of a snail's viscous glide across the canvas's surface.

Since most snails are hermaphroditic, capable of switching from one sex to another, sex between them would necessarily be equal. Ideologically, sex, and love (an essential equation in Bretonian surrealism), should be reciprocal always. The surrealist ideal of equal partnership in love, however, was not always completely realised. The ways in which the reality fell short of the desired dream may be seen in the poetry from the first period of surrealism, the 1920s, by some of the poets who defined surrealism: Breton, Eluard, and Desnos. Each of these poets expresses desire with exquisite sincerity, even with reverence. Each of their poems reads like an invitation to their beloved objects of desire to respond in kind. Yet their language, in which the beloved is often beautifully inspiring but silent, perhaps points to why women's names were absent from the

rosters of official surrealism in the 1920s. Beginning in the 1930s, however, many young women were drawn to surrealism, doubtless having heard the implicit invitation in the poems of the surrealist men.[20]

ANAMORPHIC POETRY, ANAMORPHIC LOVE

All poetry is anamorphic, Michael Riffaterre has argued, because a poem can only be understood retrospectively due to the ways in which poetic language distorts regular forms of expression. 'During his initial reading of a poem', writes Riffaterre, 'the reader experiences it as a distortion of language … A new ad hoc semantic system is discovered when the text is perceived as a whole retroactively.'[21] This is particularly true of surrealist poetry that seeks to express the experiences of dreams, automatic experimentation, and unconscious drives. Poets from Louise Labé and Pierre de Ronsard in the sixteenth century to Charles Baudelaire in the nineteenth century have focused their desire on the inspirational quality of the lover's physical attributes, on her or his curly hair and shining eyes, from which more spiritual characteristics might be intuited. Unlike these predecessors, surrealist poets of desire tend to focus initially on the dream-like vision of the beloved, from which the lover's physical presence must be imagined. Over time, however, from the 1920s to the 1950s, when Joyce Mansour joined the movement, these surrealist dream-lovers become increasingly fully realised and come closer to fusing dream-presence with corporeal immediacy.

Breton, Desnos, Eluard and Mansour all seek to incarnate the beloved in their poems. In Breton's 'Sunflower', for instance, the incarnation of his dream-wraith beloved is prospective: his automatic poem anticipates their encounter. In Desnos's 'I Have Dreamed So Much of You,' it is the excess of feeling expressed by the emphatic repetition of the adverb 'so' that transforms his beloved from dream-spirit to full-bodied woman. The desire evident in Eluard's 'The Kiss' renders his beloved more fully figured than the women in the poems of Breton and Desnos, while Mansour's male beloved remains caught in between fragmented essence and corporeal presence in *Cris*. In these poems it is the three-dimensional waking presence of the beloved that is difficult to discern initially and which may only be glimpsed 'laterally', in a human and beautified version of Holbein's distorted skull.

What could be called the most prophetic surrealist love poem, 'Sunflower', illustrates Riffaterre's argument about the anamorphic properties of poetry as well as more specifically surrealist anamorphic qualities.[22] Breton wrote it automatically in 1923 and only understood it eleven years later when 'the night of the sunflower' actually came to pass. One night in 1934, Breton and the artist Jacqueline Lamba took a magical nocturnal walk through Paris.[23] Leaving the Chien Qui Fume bistro, they passed along the edge of Les Halles, across the Seine by way of the Pont-au-Change with a stop at the flower market on the Ile de la Cité, ending up at rue Gît-le-Coeur on the Left Bank.

Days later, as Breton explains in *L'Amour fou*, a phrase from his own poem came into his head as he was getting dressed. He looked it up, reread it, and understood it for the first time as having described in anticipation the night he would meet the woman who became his second wife. Breton's process of rereading his own poem perfectly illustrates Riffaterre's description of how verbal anamorphosis works: 'The internal coherence and logic of the poem are understood all at once, and with a backwards glance … The reading finished, the improprieties, the anomalies, are not erased, but … illuminated by the memory of everything that has been read (in a retroactive

'My heart like an upside-down flame'
Guillaume Apollinaire [published posthumously, 1925]

reading), the various linguistic anomalies acquire a significant continuity'.[24] What Riffaterre calls the 'linguistic anomalies' characteristic of all poetry – language which by its syntax and layout rarely conforms to regular everyday speech – are exacerbated in automatic poetry. With automatism words and their sequences come unbidden to the poet who transforms the self into a 'modest recording instrument' and jots down what murmurs have been overheard by the unconscious 'voice' – the scenario enacted in Eluard's 'The Word'. In the case of 'Sunflower', the poet could not get that clarifying backwards look at his own poem until the walk through Paris predicted by the poem came to pass.

In 'Sunflower' the phrases that portray Jacqueline Lamba focus on her ephemerality: 'The female traveller who crossed Les Halles at the end of summer / Was walking on tiptoe'; 'The young woman could only be seen by them poorly and laterally / Was I dealing with the ambassadress of saltpetre / Or the white curve on a black background that we call thought'; 'The shadowless lady kneeled down on the Pont-au-Change'; 'the ghosts / some of whom, like this woman, seem to swim / And into love some of their substance slips / She interiorises them'. She is like 'thought' and is as 'shadowless' as a spectre. How can the reader imagine what she looks like? This absent presence is more of a dream-woman than she is a real woman. Breton reminds the reader *first* of her existence as an ideal dream creature, because that is the only way she existed eleven years before the walk through Paris took place. This is the reader's 'frontal' view of the anamorphic beloved, while he himself is represented as the three-dimensional observer-dreamer ('André Breton, said he, pass by'). The 'lateral' view, the hidden figure in Breton's poem, is the living, desirable woman herself.

The woman in Breton's poem comes through as a spirit from the poet's imagination; it is as a mortal walking woman that she figures as the poem's unconscious. In non-surrealist poetry such as Ronsard' sonnets, for example, it is usually the other way around: it is the beloved's dream life that must be imagined, based on her visible and desirable physical assets – her smooth cheeks, her flashing eyes. Furthermore, since the surrealist poet often invokes the beloved while himself in the immobilised dream-state of automatism, she has more potential for union with him as a dream-wraith than as a flesh-and-blood person. As long as he lingers in the 'in-between' state of automatism, their desired union is possible, just as it seems intermittently possible to see fully both Miró's legible poem and visual colour composition truly simultaneously in a single encompassing glance. Yet such a union will not necessarily survive the dream. The two can only safely co-exist within the unifying rhetorical frame of the poem itself, as in an anamorphic painting where two distinct realities co-exist.

Desnos presents the paradoxes of dream-union with his beloved in his best-known poem from 1926, 'I Have Dreamed So Much of You':

I have dreamed so much of you that you are losing your reality.
Is there still time to reach this living body and to kiss on this mouth
 the birth of the voice that is so dear to me?
I have dreamed so much of you that my arms, used to embracing your shadow, and
 finding my own chest, would not be able to bend
 around the contours of your body, perhaps.
And that, despite the real appearance of the one who has haunted and
 governed me for days and years, I would no doubt become a shadow,
Oh sentimental scales.
I have dreamed so much of you that there is no doubt no time left for me
 to awaken. I sleep standing up, my body exposed to all the
 appearances of life and of love and you, the only one who counts
 for me today, I could less touch your forehead and your lips than
 the first lips and the first forehead to present themselves to me.
I have dreamed so much of you, walked so much, talked, slept with your phantom, that
all that is yet left to me perhaps, is to be a phantom amongst phantoms and a hundred
times more of a shadow than the shadow which walks and will continue to walk gaily
on the sundial of your life.[25]

This dream woman is utterly elusive; the poet's love unrequited. She is a shadow woman whom he can only embrace in his dreams. Consequently he dreams so much in order to try to capture her there in his dream world but in doing so he runs two risks, as presented in the first and second half of the poem. The first risk is that her dream self has become more real than her real self so that if his dream were to come true, he might find himself unable to respond to the actual singer who inspired his love. After the pivotal point at the poem's heart – the 'sentimental scales' – comes the second risk, that he himself will disappear into dreams and lose his material substance. At the poem's conclusion his best hope is that, despite his disappearance, his trace will remain as a phantom-memory in her mind as she – restored to her body – walks 'gaily' through life.

 Only in retrospect does the reader understand how the poet has shifted from body to phantom while his beloved has slowly acquired greater substance. The image of the scales at the poem's suspended centre is the only place where the poet comes close to union with his beloved. The anamorphic distortion begins as the 'reality' in the poem switches from dream reality to waking reality. As the scales tip from the emotion of yearning to the retrospective emotion of acceptance, both realities, the dream reality and the waking reality, coexist in a delicate balance. Their shadows cross paths but their bodies cannot meet in this automatic dream poem. For an immobilised instant alone, the beat of the 'in-between', does the possibility exist that contact could be made between the two beings and their distinct worlds.

 Eluard's love poetry comes closer to presenting a complete union between the poet and his beloved than that of Breton or Desnos. In 'The Kiss',[26] written at the close of the Second World War, the beloved acquires greater substantiality:

fig.87
ALBERTO GIACOMETTI
Reclining Woman who Dreams 1929,
cast 1959 or 1960
Painted bronze
23.5 x 42.8 x 14.6 cm
Hirshhorn Museum and Sculpture Garden,
Smithsonian Institution.
Gift of Joseph H. Hirshhorn, 1966

fig.88
ALBERTO GIACOMETTI
Woman 1929
Bronze
48 x 39 x 8.5 cm
Alberto Giacometti-Stiftung,
Dauerleihgabe Kunsthaus Zürich

fig.90
GILLES ERHMANN
Joyce Mansour c.1958
Photograph
13 x 18 cm
Private collection, Paris

THE BELOVED SPEAKS

The concept of 'automatic writing' in surrealism was illustrated by a staged photograph of a woman dressed as a schoolgirl sitting at a desk with a pen in her hand, which appeared on the cover of the surrealist journal *La Révolution surréaliste* in March 1927. Her face is turned away from her hand as she looks expectantly into space. A woman's body, artificially dressed with childlike innocence, illustrates the idea that automatic writing travels from the unconscious mind to the page through the receptive body. Perhaps not coincidentally several surrealist women, including Joyce Mansour, reflect more awareness of the role of their bodies in the automatic process.

Mansour's first book of poetry, *Cris*, erupted on the post Second World War surrealist scene in 1953, immediately drawing the attention and admiration of Breton. *Cris* is made up of a sequence of short poems without titles which may be read as isolated moments of a single long poem, expressing unabashed anger, pain, and sexual desire in almost equal proportions.[29] For Mansour, desire is a matter of life or death, as 'I Will Fish Out Your Empty Soul' indicates:

> I will fish out your empty soul
> In the coffin where your mouldy body lies
> I will hold your empty soul.
> I will tear off its beating wings
> Its coagulated dreams
> And I will swallow it.

The poet's anger that death has emptied her lover's soul and caused him to abandon her is countered by her faith that death has not destroyed his dreams, which she might yet rescue and digest, thus recuperating something of his wasted life.

fig.91
NUSCH ELUARD
Wood of the Islands c.1936
Collage on postcard
13.7 x 8.6 cm
Timothy Baum, New York

The suggestion that she is reconciled with her lost beloved in her dreams is countered elsewhere in *Cris* with references to lovemaking between living beings:

> Between your fingers
> My mouth
> Between your teeth
> My eyes
> In my belly
> Your fierce rhythm
> Peels my body
> Of raw sensations.

The dreams and desires expressed in Mansour's poems are fully embodied; her unconscious fantasies are three-dimensional. However, although sensually vivid, these poems render no more precise a physical portrait of the beloved than the poems by the men. The lover can once again only be glimpsed 'laterally', as a disturbing yet compelling figure. His ghost-like presence is like a mere partial impression of Holbein's skull. Mansour's 'cries' play a levelling function within a historical understanding of surrealism since they play back for male readers an earthy version of the experience for women readers of reading the love poetry of the male surrealists.

The poet's voice changes sex from Breton's 'Sunflower' to Mansour's 'Between Your Fingers' the way snails and stars do. Surrealist desire is the stuff of dreams, whether penned by a man or a woman. The beloved in the poems is alternately characterised as abstract ('that white light against a black background which we call thought'), elusive ('you are losing your reality'), corporeal ('odorous and tasty'), and frankly sexual ('In my belly / Your fierce rhythm'). The absent lover's traces in these surrealist poems, retrieved from the poet's unconscious, are evoked with increasing physicality, when they are read in chronological order from 1922 to 1953. As surrealist poetry becomes more tangible in its representations of desire, it becomes less anamorphic because it becomes increasingly possible for the reader to visualise a union that, in the work of Mansour, takes place in the present tense, within the scenario of the poem. At the same time the moment of retrospective understanding of each poem as an expression of desire remains consistently true. Surrealist love is anamorphic in the way that it seeks to marry two experiences of reality – dream and waking, unconscious and conscious – into one whole. It is within the theatre of the reader's mind, and in retrospect, that the two perspectives fuse, creating a fuller reality than the one perceived in everyday life, a surreality, wherein apparent contradictions might be resolved..

In the late 1920s Giacometti's sculptural handling of the human figure, and the female form in particular, became increasingly sensual and eroticised. *Woman* (1929) derives from a series of 'plaques': flattened front-facing planes on small pedestals, evoking heads. In this work, vestiges of facial features – an eye, a cheek and a pair of lips – double as body parts. The spherical hollow suggests a receptacle-like rounded abdomen, while two parallel strips suggest the female sex or a pair of legs. Delicate incisions indicate arms and wisps of hair.

In notes accompanying a rough sketch of *Woman* and another male figure, Giacometti described a mother with 'long black hair ... tender blue eyes, immense domed forehead and parted lips'. The metaphorical transformation of the attributes of the female body was a striking aspect of surrealist visual and verbal practice. Here, the woman's fertile belly is the focus of male desire. The sculpture's flattened form, like an inscribed tablet, invites not only the eyes but also the hand to read its dips and markings.

In *Reclining Woman who Dreams*, the woman's body becomes grid-like and transparent, and is broken up into a series of interconnecting 'bony' parts. Two undulating planes indicate the curves of her lying figure, whilst a head and arm are evoked by a spoon-like form resting against them. Three parallel spikes suggest a ribcage. The weightless appearance of this sculpture is reflected in its poetic title, referring to the important surrealist theme of the dream. Its schematic forms also recall a clock face, with a pointer and numerals, an iconography of time appropriate to the depiction of sleep. Giacometti painted this bronze white, probably in imitation of the original plaster version, enhancing the work's ethereal quality. This whiteness also highlights its skeletal character. This deathly connotation marks a point of transition in the sculptor's work, as sexual lyricism takes on a more ambiguous air.

Photographs of groups of works in Giacometti's studio, including *Reclining Woman who Dreams*, were reproduced for the first time in the periodical *Documents* in 1929. In an accompanying article, Michel Leiris wrote of 'disturbing grills interposed between the interior and the exterior' and of the moments of 'crisis' that Giacometti's sculptures encapsulated. The close and traumatic relationship between eroticism and death, which this work begins to suggest, would become a central concern in his 1930s sculpture, and within a darker current of surrealist thought. JK

fig.89
ALBERTO GIACOMETTI
Standing Woman 1928
Bronze
39.5 x 16.5 x 8 cm
Alberto Giacometti-Stiftung,
Dauerleihgabe Kunsthaus Zürich

Warm still from the abandoned sheets
You close your eyes and you move
The way a song moves at its birth
Vaguely but coming from everywhere

Odorous and tasty
You overtake, without losing yourself,
The borders of your body

You have overstepped time
Here you are a new woman
Revealed to infinity.

The woman who inspires the kiss oversteps the divide separating her from the poet when she overcomes time: by 'overtaking' the borders of her body she becomes 'revealed to infinity'. The first five lines praise her sensuality: her inviting smell and her languorous dance-like movements. She is truly an 'in-between' woman since she steps out of time and space into surreality – wherein lover and poet can completely co-exist – and yet she does not lose herself or her earthy sensuality. She is at once in and out of this world; she may be appreciated both 'frontally' and 'laterally'.

Through her and owing to her inspiration, the poet can momentarily hope to achieve the 'sublime point' where dream and reality, body and mind, man and woman, cease to be separate entities and coalesce into one. The dominant image of the title's imagined kiss recalls the myth of the lost Androgyne, admired by the surrealists, according to which humans were once spherical male-and-female beings who were separated by the gods and condemned to search the earth in search of their lost other half.[27] In an in-between state, together with a lover, longing sparked by separation could be obliterated by reunion. Yet according to the reality of the poem, it is the actual kiss of the title that acts as the anamorphic distortion of the poem. It represents the moment of physical union hovering over/under the observations in the poem that cannot be seen 'frontally' in the poem itself.

Surrealist anamorphosis, while functioning like Holbein's distorted skull in *The Ambassadors*, projects the opposite message to that given out by the skull. Baltrusaitis explains how the skull, a *vanitas*, conveys the theistic message of the influential sixteenth-century philosopher Cornelius Agrippa: 'Everything is dust and illusion. There is only divine power which knows and dominates everything.'[28] Consciousness in these poems is in reverse: what is depicted is the dream-reality of automatism harvested from the unconscious. The unconscious in these love poems, often distorted and at times hard to read, is the everyday corporeal reality linked to waking consciousness. So whereas Agrippa's message was that all the knowledge and riches of the handsomely attired ambassadors was nothing in the face of God's power, the message of the surrealists is that dream reality is at least as real as what we may observe during our waking hours. Our identities are shaped not by God but by our unconscious minds and only by casting light upon the drives that lie buried therein will we come close to realising our potential as human beings. Allowing our waking lives to be enriched by our dream-lives, taking time for a retrospective double-take on how dreams inform everyday reality, will render us wiser. The surrealist who perhaps best conveys the sense of being alive in the world and in her body while washed in automatic insight is Joyce Mansour.

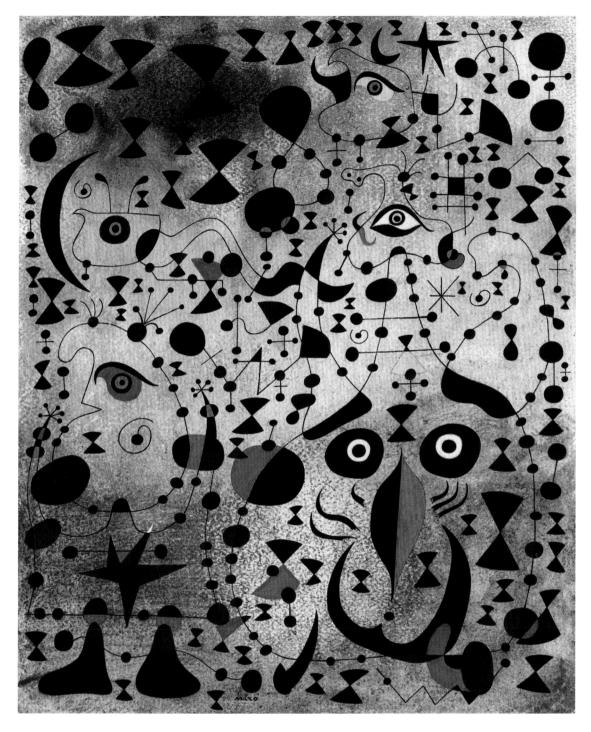

fig.92
JOAN MIRO
*The Beautiful Bird Revealing the Unknown
to a Pair of Lovers* 1941
Gouache and oil wash on paper
45.7 x 38 cm
The Museum of Modern Art, New York.
Acquired through the Lillie P. Bliss Bequest

In notes of 1940–1, while the *Constellation* series was in progress, Miró wrote of his earlier paintings, 'the sexual symbolism of those canvases is a little gratuitous'. *The Beautiful Bird Revealing the Unknown to a Pair of Lovers* is certainly more subtle and poetic, and the *Constellations* as a whole are seen as among the artist's most accomplished and lyrical works, the culmination of his macrocosmic vision during a time of distress and upheaval. In these works, human and animal figures are held in place by a dense and intricate pattern of lines and dots, as well as triangular, crescent and star-shaped forms. Their ethereal bodies merge into the celestial realm, against a dusky background of softly glowing light.

Alongside this unearthly effect, Miró's complex forms also evoke a powerful libidinal energy. Unfolding cones and exploding stars are infused with a sense of bursting desire, while tiny spermatozoa turn spiralling loops. In *The Beautiful Bird* a grotesque face with two staring eyes and a lopsided smile to the bottom right is transformed, on closer inspection, into a female torso, with breasts and genitals. A large red and black nose becomes a vulva, fringed with flame-like pubic hair. Just below it, a bulbous sweep of black paint delineates the contours of two buttocks, while an isolated point doubles as an anus.

The complexity of Miró's conception of sexuality, in particular the troubling dark side to its life-giving potential, is apparent in some of his earliest writings. In a 1924 letter to the poet Michel Leiris he described the effect of his works as equivalent to both 'the cry of a child in its cradle' and to 'the shrieks of a whore in love'. For many surrealists, procreation was the antithesis of erotic love. Miró's explorations of scatological functions and 'base' bodily details have been aligned with the concerns of Georges Bataille and the 'dissident surrealists. Here, however, these are combined with a poetic and affirmative sexual vision.

In this gouache, the busy mesh of starry markings slowly reveals its erotic undercurrents. Miró described how he created this work by first brushing in the backgrounds with a mixture of oil paint and turpentine 'with no preconceived ideas' and then began the details in gouache. The shimmering surface of the oily ground contrasts with the flat matt finish of the forms painted upon it. The sharply-bounded areas of impenetrable black form a series of holes onto the beyond, and suggest glimpses of a subconscious unknown. JK

My love whose hair is woodfire
Her thoughts heat lightning
Her waist an hourglass
My love an otter in the tiger's jaws
Her mouth a rosette bouquet of stars of the highest
 magnitude
Her teeth the footprints of white mice on the white earth
Her tongue as smooth as amber and glass
My love her tongue a sacred host stabbed through
Her tongue a doll whose eyes close and open
Her tongue a fantastic stone
A child's hand traced each eyelash
Her eyebrows the edge of a swallow's nest
My love her temples slates on a greenhouse roof
And their misted panes
My love whose shoulders are champagne
And the dolphin heads of a fountain under ice
My love her wrists as thin as matchsticks
Whose fingers are chance and the ace of hearts
Whose fingers are mowed hay
Marten fur and beechnuts under her arms
Midsummer night
Of privet and the nests of angel fish
Whose arms are seafoam and river locks
And of the mingling of wheat and mill
Whose legs are fireworks
Moving like clockwork and despair
Marrow of eldertree
Whose feet are serifs
Key rings and sparrows drinking
My love her neck pearled with barley
My love with the throat of a golden valley
Rendez-vous in the torrent's very bed
Her breasts of night
Her breasts molehills under the sea
Crucibles of rubies
Spectre of the dewsparkled rose
Whose belly unfurls the fan of every day
Its giant claws
Whose back is a bird's vertical flight
Whose back is quicksilver
Whose back is light
The nape of her neck is crushed stone and damp chalk
And the fall of a glass where we just drank

My love whose hips are skiffs on high
Whose hips are chandeliers and feathers
And the stems of white peacock plumes
Imperceptible in their sway
My love whose buttocks are of sandstone
Of swan's back and amianthus
And of springtime
My love whose sex is swordlily
Is placer and platypus
Algae and sweets of yore
Is mirror
Eyes full of tears
Of violet panoply and magnetic needle
My love of savannah eyes
Of eyes of water to drink in prison
Eyes of wood always to be chopped
Eyes of water level earth and air and fire

André Breton, 1931

THEY TELL ME THAT OVER THERE

They tell me that over there the beaches are black
From the lava running to the sea
Stretched out at the foot of a great peak smoking with snow
Under a second sun of wild canaries
So what is this far off land
Seeming to take its light from your life
It trembles very real at the tip of your lashes
Sweet to your carnation like intangible linen
Freshly pulled from the half-open trunk of the ages
Behind you
Casting its last sombre fires between your legs
The earth of the lost paradise
Glass of shadows mirror of love
And lower towards your arms opening
Proof by springtime
OF AFTERWARDS
Of the non-existence of evil
All the flowering appletree of the sea

André Breton, 1934

SUNFLOWER

The female traveller who crossed Les Halles at the end
* of summer*
Was walking on tiptoe
Despair rolled around the sky its large and lovely arum
* lilies*
And in her handbag was my dream, this bottle of salts
Sniffed only by the godmother of God
Torpors unfold like mist
At the Chien Qui Fume bar
Where pro and con has just entered
The young woman could only be seen by them poorly and
* laterally*
Was I dealing with the ambassadress of saltpetre
Or the white curve on a black background that we call
* thought*
The ball of innocents was in full swing
The Chinese lanterns were slowly beginning to glow in
* the chestnut trees*
The shadowless lady kneeled down on the Pont-au-Change
In rue Gît-le-coeur the stamps were no longer the same
The promises of the night finally held
The voyager pigeons the kisses of help
Joined with the breasts of the beautiful unknown woman
Shot beneath the crepe of perfect meanings
A farm prospered in the heart of Paris
And its windows opened onto the Milky Way
But no one lived there yet because of the surprise guests
Surprise guests known to be more devoted than the ghosts
Some of whom, like this woman, seem to swim
And into love some of their substance slips
She interiorises them
I am the plaything of no sensory power
Yet the cricket who was singing in the ash hair
One evening near the statue of Etienne Marcel
Threw me a knowledgeable glance
André Breton, said he, pass by.

André Breton, 1923

I'VE TOLD YOU

I've told you for the clouds
Told you for the ocean's tree
For each wave for birds in the leaves
For the small stones of sound
For the familiar hands
For the eye changing to face or landscape
And sleep restores colour to the sky
For all the night drunk deep
For the grillwork of the roads
For the window opened for a forehead laid bare
I've told you for your thoughts your words
Every caress every confidence survives.

Paul Eluard, 1929

WINK

Parakeets fly through my head when I see you in profile
and the greasy sky streaks with blue flashes
tracing your name in all directions
Rosa coiffed with a black tribe standing in rows on the
* stairs*
the women's pointed breasts looking out through men's
* eyes*
Today I look out through your hair
Rosa of morning opal
and I wake through your sight
Rosa of armour
I think through your exploding breasts
Rosa of a pool the frogs turn green
and I sleep in your navel of Caspian sea
Rosa of honeysuckle in the general strike
and I'm lost in your Milky Way shoulders the comets
* made fecund*
Rosa of jasmine in the night of washing
Rosa of haunted house
Rosa of black forest filled with in blue and green stamps
Rosa of kite over a vacant lot where children are fighting
Rosa of cigar smoke
Rosa of seafoam made crystal
Rosa

Benjamin Péret, 1936

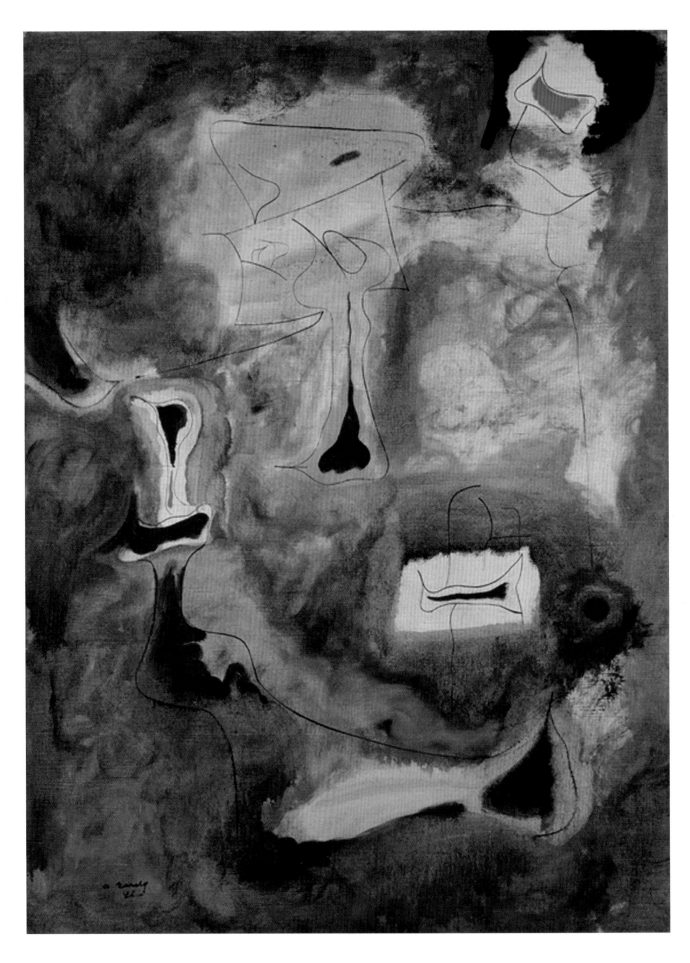

fig.93
ARSHILE GORKY
Charred Beloved II
1946
Oil on canvas
137 x 101.6 cm
National Gallery of
Canada, Ottawa.
Purchased 1971

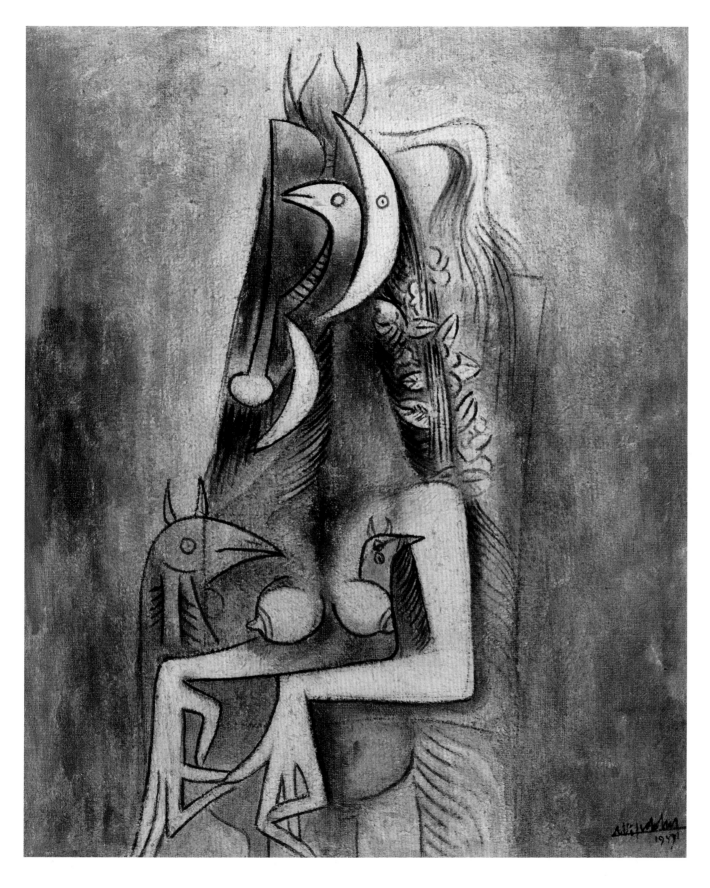

fig.94
WILFREDO LAM
*The Casting of the
Spell (Personnage)*
1947
Oil on burlap
109.5 x 91.5 cm
Santa Barbara
Museum of Art,
Gift of Wright S.
Ludington

chapter five
LOVE OF BOOKS, LOVE BOOKS

Vincent Gille

The dream, then, has been of a paradise of books – a select few – in which the beams supporting the volumes should truly be sunbeams. A special condition attaching to these books is that they should all be worth reading, that they and they alone should form the phosphorescent substance of what we are expected to know and love, of what enables us to look forward, not backward, and act accordingly.

André Breton, 1937[1]

n 1923 André Breton, speaking also on behalf of Paul Eluard and Robert Desnos, announced their intention of never writing anything again. Breton explained:

I consider the situation of the things I defend to be desperate. I even believe that the game is irretrievably lost. But nothing must be done to heal the wound represented by the work of Cocteau, Rivière and Morand, by Paul Valéry's recent books, by *Les Nouvelles Littéraires*, etc. You may be sure that I shall never be short of insults where these people are concerned … From now on I want to be left in the dark about everything: books, periodicals, newspapers, and so on. I will not engage in literary activity at all.[2]

This angry rejection of 'literary activity' lies at the heart of the surrealists' attitude towards books. Their distaste did not extend to the book as such,[3] but was directed towards commonly held concepts of literature and of the writer's 'profession'. The book itself was, and always would be, important to them because of what it could harbour in the way of the unforeseen, the stunning, the infinitely rare – in a word, the poetic. The surrealists set out to demolish a way of conceiving and practising art that, being divorced from the life of feelings, served only to justify and maintain the order of the real world. Arch-realism, blinkered logic, concern for one's own career above all else, as well as the snare and delusion of style for the sake of style and of word for sake of word – these were the surrealists' targets.[4]

Breton, Eluard, Desnos and all the other surrealists were to go on writing and publishing, but as they did so they radically changed the relationship between literature and life. They adopted an approach to the world based on feelings, so that the mind might 'occupy itself with its own life, wherein the attained and the desired no longer exclude one another'.[5] Like the poet Guillaume Apollinaire they affirmed the primacy of desire in life ('Desire is the great force', Apollinaire had written in 1913). Breaking the censorship of reason, the surrealists' experiments with automatic writing enabled them to come close to the 'real functioning of thought', and so

fig.95
ANDRE BRETON AND PAUL ELUARD
L'Immaculée Conception
25.5 x 19.5 cm
Paris, Editions Surréalistes chez José Corti 1930
Binding by Paul Bonet 1941–2
Copy owned by Paul Eluard
Pierre Leroy, Paris

give birth to a majestic flowering of metaphors based not on logical but illogical relationships. This language, Breton wrote, was the only one that could 'illuminate a life of fertile relationships'.[6] Breton and others continued to write but 'outside every aesthetic or moral preoccupation'.[7] And in doing so, they contributed to the destruction of the systems of reference on which until then all literary *fiction* had rested.

'One must not work. I believe that work brutalises people', Breton declared in 1923. 'Obviously, [the mind] cannot function without some nourishment. It will get it from love, and from the most disorderly [*déréglé*] love in particular.'[8] Breton's appeal here to love is significant. For the surrealists the impassioned exaltation of love was a supreme example of the 'disordering' of life and of language itself. 'Words … have stopped playing. Words are making love', Breton wrote in 1922.[9] The surrealists believed in a close kinship between the poetic image – born of the spontaneous shock produced by the coming together of two elements, alien to each other yet bound together by desire – and the amorous encounter. From the outset surrealism established an intimate, pressing and luminous bond between poetry and love. 'We will reduce art to its simplest expression, love', Breton had predicted in *Poisson soluble* in 1924;[10] and in a poem in 1949 he wrote 'Poetry is made in bed like love '.[11] It is hardly surprising therefore that love books outnumbered all other surrealist writings.

The salient characteristic of these books is that they responded to a need. For the surrealists writing and publishing could neither be gratuitous, nor, at the other extreme, driven by commercial considerations.[12] Texts having no connection with a lived experience – be it only a dream experience – are few and far between. The writing of *Nadja*, for example, was begun in August 1927, a few months after Breton's liaison with the young woman called Nadja (the relationship lasted from October 1926 to February 1927). The text was only completed in December 1928, by which point Breton had met and fallen in love with Suzanne Muzard, an event related at the end of the book. Similarly, *L'Amour fou* (1937) followed the encounter with Jacqueline Lamba, and *Arcane 17* (1944) that with Elisa. All Eluard's poetry is a hymn to Gala, his first wife, or to Nusch, whom he married in 1934. It is known that the female figures in Louis Aragon's texts and poems correspond in large measure to real women he loved,[13] In the case of Robert Desnos, the 'Poèmes à la mystérieuse' (1926) and his book *La Liberté, ou l'amour!* (1927) are dedicated to Yvonne Georges, the poet's great love of the 1920s.

Never, though, was the purpose of these texts to offer a trivial account of an affair, or a transposition of the story of the relationship into fiction. In *L'Amour fou* Breton wrote: 'What I have wanted to do above all is to show the precautions and the ruses which desire, in search of its object, employs as it manoeuvres in pre-conscious waters, and, once this object is discovered, the means (so far stupefying) it uses to reveal it through consciousness.'[14] At stake here is the unfolding of desire in the whole of life, the ways it inscribes itself into the density of dreams, springs suddenly from banal reality, shines forth, irradiates the body as well as the mind, and expresses ecstasy in poetry through lyricism.

No distinction can be drawn between the 'love poems' and 'erotic' texts of the surrealists, who celebrated carnal love to an extent that was unprecedented in the history of literary movements: 'Love, the only love there is, carnal love, I have never ceased to worship your baneful shade, your

mortal shadow', Breton wrote. 'A day will come when man can acknowledge you as his sole master and honour you, even in the mysterious perversions with which you surround him.'[15] This way of looking at things imposed on the surrealist author the obligation to speak frankly and in the first person. Inner experience was gradually developed (in the photographic sense of the word), and the prime concern was veracity. In surrealist writings love cast aside its literary, psychological, religious and moral masks so as to be reinstated in its social context and restored to full possession of its spiritual *and* carnal, conscious *and* unconscious components.[16]

In contrast to earlier literature, surrealist texts can be seen as *documents* (they could almost be called 'reports'). They are indissociable from the experiences that gave rise to them, and reconstitute the substance and almost palpable aura of those experiences.[17] The value of surrealist writings as a form of testimony is apparent to anyone leafing through certain special copies, as a general rule intended by the author to be seen or owned by close friends, and in which various rare documents (manuscripts, letters, photographs, drawings) with a direct or indirect relationship with the book, are included. Such books are called in French '*truffés*' or 'truffled'. Eluard bound into his copy of *Au défaut du silence* (1925), for example, the manuscript of a poetic fragment, the manuscript of a prose poem dedicated to Gala, several drawings of Gala by Max Ernst, a sheet of paper on which he and Gala exchanged messages during their stay at the Clavadel sanatorium, two portraits of Gala by Giorgio de Chirico, and an autograph manuscript by his friend, the surrealist writer René Crevel (see p.136). Breton bound with his manuscript of *Nadja* a handwritten text and two drawings by Nadja, two postcards she had sent him, the programme of the film *L'Etreinte de la pieuvre*, and several photographs not reproduced in the published version (see pp.138–40). In the manuscript volume of *Arcane 17* that Breton prepared especially for his third wife Elisa, he stuck leaves, newspaper cuttings, photographs, train tickets, cards and adverts, elements that formed part of his surroundings while he was composing the book, and formed part of his mental universe (see fig.97 and p.168). It could be said that Breton first made this practice 'official' in *Nadja* and in *L'Amour fou* by including in the published volumes photographs of drawings by Nadja and portraits of himself, Eluard and Desnos, as well as photographs by Brassaï of the places mentioned and so on. These 'truffles' – whatever their nature – are signs of the reality at the core of which the story of the love affair is inscribed. They function

fig.96
Cover of manuscript of André Breton's *Arcane 17* 1944
Binding by Lucienne Talheimer
Private collection

as mementoes, connecting the love affair with earlier events that had a determining influence upon it, or signalling the different levels of feeling involved in the affair. In every case, these 'truffles' – concrete and affective – serve as a counterpoint to the text. As if, indeed, life was no longer kept at the margins of poetry but was slipping into it, like two bodies under the same sheet.

The model of the amorous encounter also governed the collaboration on a book between two authors or between a writer and an illustrator. Max Ernst wrote that 'the systematic fusion of the thoughts of two or more authors in the same work ... can also be considered as similar to a collage'.[18] Such collaborations were occasionally the work of a couple in real life (Max Ernst and Leonora Carrington, Valentine Hugo and Paul Eluard, and so on). Often, however, they brought together two men, for male friendship in the surrealist group had a decidedly passionate aspect.[19] The resulting books were not products of mere circumstances, but sprang from a decision made by men who had chosen to live an artistic adventure in common. Hardly had they met (in October 1921) than Max Ernst and Paul Eluard decided to produce a book together. Entitled *Répétitions*, it appeared in March 1922. Other books were to follow, including *Au défaut du silence*, published anonymously in 1925, which was a public declaration of the love both men felt for Gala. Many examples of similar collaborations could be cited: Desnos and Masson, Desnos and Malkine, Aragon and Masson, Leiris and Masson, Bataille and Masson, Péret and Tanguy, Aragon and Tanguy, Nezval and Štyrský, Eluard and Dalí, Mesens and Magritte, Breton and Matta, Breton and Miró, Lely and Ernst, Eluard and Man Ray, Hugnet and Bellmer, and so on. This practice was related to the analogous phenomenon of surrealist books written by several authors. The finest examples include *Les Champs magnétiques* (1919) by Breton and Soupault, and, above all, *L'Immaculée Conception* (1930) by Breton and Eluard, where in a note the two writers stressed the significance of their collaboration:

Being two to destroy, to construct, to live, is already to be all, to be the other to infinity and no longer oneself. Each flicker of sunlight bears a snowflake, each extended hand holds a look that is familiar. An in-depth examination of the possibilities of thought shared by all makes vain any hierarchy between men. Between man and woman, it would be the very negation of their respective roles.[20]

It is not hard to see that what is at stake here is something going well beyond the usually artificial association between a writer and an illustrator common in modern publishing. What lay at the heart of the surrealist experience was something more than the simple coming together of poets and writers. The aim was to arrive at a genuine pooling of thought. This experience, which had no equivalent in any other artistic movement, is most clearly sensed in the books produced by the movement.

The relationship between text and image in surrealist books has often been studied.[21] The more or less exclusively formal approach usually adopted in these studies, however, overlooks the fact that at the source of this all-encompassing relationship lay first and foremost a sensitive, loving interaction which found expression in ways unique to itself.[22] The images did not fulfil the traditional role of illustrations but engaged freely with the text. As Eluard wrote,

The painter looking at a poem is like the poet standing in front of a picture. He dreams, he imagines, he creates. And all of a sudden, lo and behold, the real object gives birth to the virtual object, which becomes real in its turn, and from one reality to another an image is constituted, just as one word leads to all the others. There is no mistaking the object any longer since everything is connected, in harmony, interchangeable and shown to best advantage.[23]

Thus, the relationship created between Eluard's poems and Ernst's portraits of Gala in *Au défaut du silence*, or between Man Ray's photographs of Nusch and Eluard's words in *Facile*, is not that of classic book illustrations: the play between text and image involved here is metaphorical, or rather, analogical in nature, and it is from such encounters that meaning sprang (the lyrical transmutation of the love of Ernst and Eluard for Gala, or of Eluard and Man Ray for Nusch). In the manner of a surrealist collage, the conjunction of these two realities gave birth to the book in the form in which it had been desired and conceived. There were, however, a few exceptions to this practice – Georges Malkine's illustrations for *The Night of Loveless Nights* by Desnos, for example, and André Masson's creations for the erotic books of Aragon and Bataille. 'When I illustrated erotic books', said Masson, 'I did so literally. In total submission to the author. They are the most realistic drawings I have ever done. I consider such to be the rules of the game. The long and short of it is that in the erotic book the painter has to be the author's photographer.'[24]

Seeking ways of transcending literature, the surrealists often chose to undermine it from within, by subverting existing genres and literary forms. If formal experimentation, in typography and layout, both in books and periodicals, allied to radical upheaval in language and poetic expression, seemed to have been taken to extremes by earlier dada publications, the surrealists, with a few exceptions, were relatively restrained, even classical. Having decided that a root-and-branch reform literature was unfeasible, the surrealists developed a different strategy: the recycling of familiar literary forms.

The surrealists drew on various genres, with the exception of the 'royal' genre of the French literary tradition, the novel. Benjamin Péret and Eluard had fun in bringing 152 proverbs 'into line with current taste'. Marcel Duchamp used and abused spoonerisms, and Desnos joined him in the same exercise, going so far as to take over Duchamp's pseudonym, Rrose Sélavy while doing so. Desnos modelled stories on adventure novels such as *Fantômas* and *Nick Carter*, and borrowed from the cinema its narrative methods and cutting procedures. For his 'collage-novels' Ernst was inspired by – and took the bulk of his visual material from – serials published in nineteenth-century newspapers. Eluard and Man Ray turned the sentimental 'photo novel' into the 'photo poems' of *Facile*. In *L'Immaculée Conception* (1930) Breton and Eluard gave a new twist to the religious doctrine of the same name, reinventing the Kama Sutra in the chapter called 'Love'. Even the very genre of 'eroticism' itself, in its crudest manifestation – that is, the sort generally published clandestinely – was subverted for example, in *1929* by Aragon, Péret and Man Ray,[25] or Péret's *Rouilles encagées* (a spoonerism for 'couilles enragées', 'feverish balls'). Eric Losfield, the publisher of the latter volume, declared in the preface:

It is a well-known fact that modern works coming under the heading 'eroticism' are few and far between and that the vast majority of them lack all originality, being much more concerned with exploiting a genre than engaging in an act of authentic artistic creation ... The work you are about to read completely eschews such banality: rather, the reproach which the author risks having levelled at him is that of having yielded to an unbridled fancy with too much obvious satisfaction.[26]

Deliberately taking over conventional or popular literary forms, the surrealists gave them their own particular twist, expanding them by breaking each genre's technical and moral rules.

To subversion of form was added the subversion of language and style. Breton reminds us that in *Nadja,* 'the tone adopted for the narrative is closely modelled on that of medical observation, particularly neuropsychiatric observation, which tends to record everything revealed by examination or interrogation without paying the slightest attention to stylistic frills'.[27] A second disjuncture was created through the use of language, whether neutral in tone and avoiding all 'stylistic effect', or wildly impassioned as in the narratives of Péret and Desnos.

The novel combination of familiar literary forms and a new way of writing fulfilled two aims: to put poetry and love – that is to say, the *magical* – back into everyday life, and to disseminate as widely as possible a lyrical idea of love, understood, above all, in its most carnal aspects. In this way poetic form – whether a single poem or a collection of poems – was also eroticised by the surrealists. The two books by Salvador Dalí, *L'Amour et la mémoire* and *La Femme visible*, and the various texts he contributed to the review *Le Surréalisme au service de la révolution* expressed an eroticism that was unprecedented in its frankness.

Both of Dalí's books were published by Editions Surréalistes, doubtless the only imprint under which they could have appeared. The problem of distributing such books arose more or less immediately; and the great variety – and often sheer muddle – of the distribution methods employed by the surrealists needs to be stressed. Quite often, a text would be

published first in a partial version in a periodical, then in full in book form, and sometimes for a third time in an edition augmented with illustrations.[28]

The surrealists' paramount concern seems to have been to disseminate their writings as widely as possible. Thus, periodicals were particularly important, not only those directly managed by the group (*Littérature*, *La Révolution surréaliste*, *Le Surréalisme au service de la révolution*, then after the Second World War *Médium*, *Le Surréalisme, même*, *La Brèche*, *L'Archibras* and so on), but also 'friendly' reviews (like *Les Cahiers du sud*, or *La Revue européenne*) that welcomed them, or which (like *Minotaure*) the surrealists gradually took over.

Although the circulation of these journals never exceeded a few thousand copies,[29] periodicals had the great advantage of being flexible and allowing a proactive form of editorial control. Texts could be presented in a carefully chosen, sympathetic context, which gave each issue a sense of cohesion. 'Poetic' texts were combined with political texts and moral, social and critical commentaries. On the other hand (with the exception of *Minotaure* and *Le Surréalisme, même*), this form of presentation generally precluded the isolation of a text or a special layout linking it, for example, to the work of a particular illustrator. In order to restore the text to its original state, complete and unabridged, or to guarantee its publication in a format that satisfied the author, it was often found necessary to issue it in volume form.

Breton, Aragon and Eluard were taken on by Gallimard, a literary publisher, in the early 1920s.[30] But other firms were also called upon, notably Editions Au Sans Pareil (founded by René Hilsum, a former classmate of Breton's), Editions du Sagittaire Chez Simon Kra (the Sagittaire imprint was taken over after the war by Jean-Jacques Pauvert), Guy Levis Mano (G.L.M.) from the 1930s onwards, and Eric Losfeld from the 1950s. Some books, too, were published by art galleries (Galerie Simon, Jeanne Bucher, and so on), by booksellers (Tschann, Libraire du Luxembourg, among others) and by such periodicals as *Les Cahiers Libres* and *Fontaine*.

The reasons behind the choice of a particular publisher should be studied on a case by case basis. Sometimes the

fig.100
ANONYMOUS [GEORGES HUGNET]
Le Feu au cul
Illustrated by Oscar Dominguez
10.3 x 15.3 cm
Without place [Paris] or publisher's name [R.J. Godet],
undated [1943]
Copy on best quality cotton paper from the Marais paper mill no.33/40
Mony Vibescu

fig.101
ROBERT DESNOS
La Liberté, ou l'amour!
Censored example showing one of
several pages in this edition left blank
16.5 x 12 cm
Paris, Aux Editions du Sagittaire 1927
Copy on Rives wove paper, no.655/965
Claude Oterelo

choice was simply the consequence of another publisher turning a proposal down. From the early 1930s onwards Gallimard, for example, decided not to publish certain books because of the moral objections or political problems to which they might give rise: there were after all limits to what a mainstream publisher could tolerate.[31] Aragon wrote in 1931:

> In 1930 André Breton became the target in his private life of all the persecutions which the machinery of the law is able to devise. Eluard had his right to leave France withdrawn by the police. As is well known, Buñuel and Dalí's admirable creation, *L'Age d'or*, was the subject of banning orders and other dirty tricks. In the seventeenth century writers were arrested, books were seized by the censors, and people had to get their work printed in Holland. We surrealists face a similar situation, only they use new methods on us. So Crevel and I just cannot get printed any more, for example. It is the content of what we write that puts publishers off.[32]

Thus, early in 1931 Gallimard stopped making the monthly payments that Aragon had been promised until the end of the year, and turned down his manuscripts. This kind of pre-publication censorship concerned texts of a political as well as those of an erotic nature. It was to evade this censorship that the surrealists turned to other publishers, set up their own imprints in France or beyond French jurisdiction, or chose to have their books printed abroad. In the latter case, however, this did not prevent the French customs from intercepting book shipments at the border. When E.L.T. Mesens undertook to get the pamphlet *Violette Nozières* printed in Brussels, Eluard wrote to him:

Something ghastly has happened. Before delivering *Violette Nozières* to Corti the customs took it upon themselves to send a copy to the Ministry of the Interior. I've no idea what the outcome of that is likely to be. At all events, just as a precaution against the possibility of the book being banned (here in a country where censorship does not exist officially) would you please *immediately* despatch by post the following consignments (five copies to each parcel). They will get through.[33]

1929 was also intercepted by the French customs at the Belgian border, but a number of copies nonetheless slipped through the net.

Erotic texts were published under pseudonyms, with the identity of the author and publisher disguised, until the early 1950s. In France, Aragon's *Le Con d'Irène* and Bataille's *Histoire de l'œil* were published by René Bonnel, Bataille's *Madame Edwarda* by René Chatté, and André Thirion's *Le Grand Ordinaire* by R.J. Godet.[34] *L'Anglais décrit dans un château fermé*, by André Pieyre de Mandiargues, was the last text to be published clandestinely by Jean-Jacques Pauvert in 1953. Similarly, the works of the Marquis de Sade were either made available in limited editions on a subscription basis to a handful of connoisseurs, or were published secretly.[35] These books were systematically proscribed and seized and the publisher prosecuted until 1953, when proceedings against Pauvert, who had embarked on the open publication of a new edition in 1947,

fig.102
VALENTINE PENROSE
Herbe à la lune 1935
Preface by Paul Eluard
Unique binding by Georges Hugnet
19.5 x 15 cm
Paris, G.L.M. 1935
A. & R. Penrose

were dropped.[36] The situation was similar in a number of other countries. In the early 1930s the Czech surrealist Jindřich Štyrský launched the *Erotická revue* and the Edice 69, which consisted of erotic texts and was sold solely by subscription. The journal *Alge*, the brainchild of a group of young Romanian surrealists, was seized in May 1933 and its editors jailed for several days for publishing pornography.

When there was no other solution, the surrealists had to fall back on publication at the author's own expense, usually under the general imprint of the Editions Surréalistes.[37] Launched in 1926, the Editions Surréalistes were to publish some sixty titles by 1968. Volumes of poetry rubbed shoulders with political manifestoes, editions of objects, occasional pamphlets, richly illustrated works, and brochures consisting of a couple of pages simply stapled together. It was this imprint that published, for example, Aragon's *Persécuté persécuteur* that Gallimard turned down in 1931, René Char's *Artine* and *L'Action de la justice est éteinte*, *L'Immaculée Conception* by Eluard and Breton, Salvador Dalí's *La Femme visible* and *L'Amour et la mémoire*, Benjamin Péret's *Je sublime* and Gilbert Lely's *Je ne veux pas qu'on tue cette femme*. An independent publisher if ever there was one, the Editions Surréalistes were not subject to any kind of censorship, and seemed to follow no strategy other than that of facilitating the group's free poetic *and* political expression. Its method of self-financing did impose, however, some constraints, but such restrictions were common to publications operating on a subscription basis, where, thanks to the sale of copies of a limited first impression, printed on fine paper and embellished with drawings, manuscripts, original engravings, and so on, it was often possible to cover the book's production costs. For example, to finance the printing of the 2,000 copies of *L'Immaculée Conception*, priced at 25 francs each, 116 so-called 'lead copies' were produced on different papers and embellished with a frontispiece consisting of an engraving by Dalí (2,000 or 3,000 francs for the single rice-paper copy, 1,000 francs for the ten copies on white japonacré vellum, and 150 francs for the 100 copies on Hollande Van Gelder).[38] In addition, the manuscript was sold to the Vicomte de Noailles, and the artist Valentine Hugo bought the original drafts. This manner of financing the operation thus demanded a book that involved original illustrations produced by a painter or a photographer, as well as a special layout, typography and choice of paper. GLM Editions also favoured 'lead' impressions for all its books.[39]

The creation of rare books, with luxurious 'lead copies', or even unique specimens with original bindings by Georges Hugnet or with additional documents (manuscripts, personal statements and so on) was in keeping with the idea that the book, *qua* object, should also be an object of *passion*. This calls to mind the books printed in a few copies which Aragon and Gilbert Lely created, the 'book-objects' made by Gherasim Luca, and the poem-objects of Breton and Heisler.[40] From the writing of the book to its production, from its publication to its purchase, all was a question of rarity, of choice – that is to say, of love. As Breton wrote to Frederick Kiesler, who set the type of his *Ode à Charles Fourier*:

> As I go on thinking that the poem is likely to cause a big stir, and that the typesetting you have been responsible for will make it a bibliographical curiosity as well, I fervently hope that it will be possible to include in all twenty-five of the Holland paper copies an inset which will make them passionately sought after.[41]

It is perhaps no longer necessary to underscore Breton's use here of the words 'fervently' and 'passionately'. Love books and love of books are two aspects of the same desire. The aim at every stage of the conception, production and distribution of the object was not to create a 'product', as people today like to call it,[42] but rather (to adopt one of Benjamin Péret's expressions), to create something that would 'strut about': 'There is nothing any longer', he said, 'to stop the book spreading out its tail feathers like a peacock and sweeping along in its wake the thousand gulls of desire approaching its chosen island'.[43]

Translated by John Fletcher

chapter six
LIVES AND LOVES

Vincent Gille

GALA, PAUL ELUARD, MAX ERNST

From an early age recurrent tuberculosis forced Paul Eluard (1895–1952) to make frequent stays at sanatoriums. It was at the Clavadel sanatorium in Switzerland that, in 1912, he met Helena Dimitrovnie Diakonova (1894–1982), who had come from Russia on a cure: he was seventeen and she was eighteen. Eluard soon nicknamed her Gala. They were married in Paris in February 1917, and their daughter Cécile was born in May 1918.

Although much is usually made of the all-consuming intensity of Eluard's feelings for Gala, there is a tendency to forget that the young woman was just as passionately in love with Eluard. In 1916 she wrote: 'I remember something poignant – at Clavadel, when you were "getting on well" with Mlle …, I prayed to God, perhaps for the first time, to return my beloved boy to me. And now you are mine (and I am yours forever, with all my mind, body and soul); I know that I depend on you completely, I cannot live without you. And you feel the same.'

Their relationship was intensely sensual and this soon spilled over into Eluard's poetry although, because of their youth, their feelings were also tinged with a sense of mystery and unease: 'If I do everything with you – "strange things" – it is because I'm sure that with you, because I love you, everything is pure, everything is beautiful, everything is right,' Gala wrote to Eluard in 1916.

Eluard's poetry abounds with nostalgic, even sorrowful evocations of the early years he spent with Gala. This can be seen, for example, in the question asked in *Nuits partagées* (1935): 'Can I not once more as in my youth declare myself your disciple?' seems to echo the phrase 'I am your disciple', which appeared on a sheet of messages between Gala and Eluard, written at Clavadel.

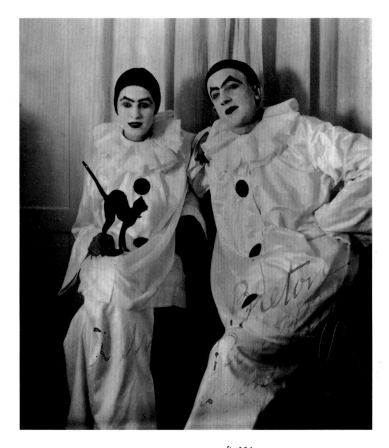

fig.104
ANONYMOUS
Paul Eluard and Gala in fancy dress in the sanatorium at Clavadel 1912–13
Musée d'art et d'histoire, Saint-Denis

fig.103
Handwritten notes exchanged by Gala and Eluard at the Clavadel sanatorium. Sheet bound by Eluard into his copy of *Au défaut du silence*.
Pierre Leroy, Paris

Text reads:
[Gala] I want to draw you
[Gala] Triangalism
 Portrait of a young man
[Gala] Of a seventeen-year-old poet
[Paul] Of which young man
 Tell me quickly
[Paul] And I (do not) want to look
[Paul] What
 With you
[Gala] This evening you will eat with me
[Gala] Every evening
[Paul] I am your disciple

Probably more than any of the other surrealists, Eluard personalised the books in his library, whether they were by him or his friends. His copy of *Au défaut du silence* was bound with portraits of Gala by Max Ernst and Giorgio de Chirico, handwritten originals of poems, photographs, and the manuscript of an article by René Crevel entitled 'Au Carrefour de l'Amour, la Poésie, la Science et la Révolution'. Also included was the sheet reproduced here, of notes exchanged by the two young patients at the sanatorium: talking was against the rules at certain times of the day and so this was the only way they could hold a conversation. On the right-hand side of the paper is a geometrised portrait of Eluard by Gala. This document is the earliest surviving record of Eluard and Gala's relationship.

fig.110
Handwritten poem by Nadja 1926
Pierre Leroy, Paris

Breton began to meet Nadja less and less frequently, and in February 1927 he finally broke off the relationship, sensing that the young woman felt a passion for him that he did not share and fearing that her state of mind was worsening daily. This estrangement plunged Nadja into complete despair, as can be seen by this poem, dating from December 1926, which reads:

> My lover
> A huge burden weighs on my breast
> and my heart grows heavy with refuted fears
> [My beloved, your absence]
> Unbearable absence [oh sweet] of my moral backbone, pleasure of my eyes
> object of my love

Nadja, who suffered from increasingly severe emotional problems, was committed in March 1927. She remained in a psychiatric hospital until her death on 15 January 1941.

fig.106
Pages from *Au défaut du silence*, 1925
Pierre Leroy, Paris
Eluard's verse reads: 'Love, Oh my love,
I have taken a vow to lose you.'

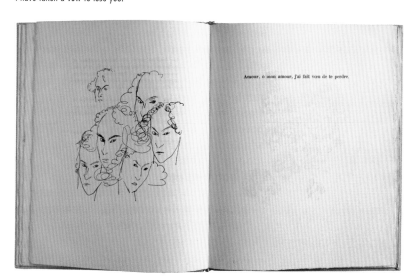

It is unforgivable for me to go on seeing her if I do not love her. Don't I love her? … In her position, she is bound to need me suddenly, in one way or another. Whatever she asks me, it would be hateful to refuse her as she is so pure, so free of any earthly tie, and she cares so little, yet so marvellously, for life. She was shivering yesterday, perhaps from the cold. So scantily dressed. It would also be unforgivable for me not to reassure her about the kind of interest I feel for her, for me not to convince her that she would never be an object of curiosity or, how could she believe it, a mere whim. What should I do? … What can I do, except go to the bar where we have met before, around six o'clock? There is no chance of finding her there, of course, unless … But isn't 'unless' where the great possibility of Nadja's intervention resides, quite beyond any question of luck?

André Breton, note written on 7 October 1926,

In 1925 *Au défaut du silence* was published without the names of either the author or illustrator. The book is a collection of poems by Eluard, illustrated with drawings by Ernst that featured numerous images of Gala's face. This book is the only direct tangible evidence of the love that united the three of them for several years.

Eluard's poems, about which Philippe Soupault wrote in the *Revue européenne*, 'Here are some poems which I believe are the most beautiful to have been written since Baudelaire', are suffused with sorrow and uncertainty.

The vivacious, sensitive faces drawn by Ernst are haunting because they are repeated so often and seem to foreshadow two of Eluard's lines in *L'Amour la poésie*, published in 1929, and dedicated to Gala:

> Every single name in the world
> Was bound to have one face

Nadja has invented a wonderful flower for me: 'The Lovers' Flower' ... This essentially represents the dominant theme of the time we spent together and it remains the graphic symbol which has given Nadja the key to all the rest.

André Breton, *Nadja*, 1928

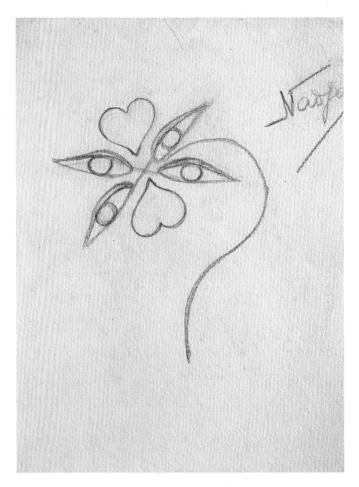

fig.111
NADJA
The Lovers' Flower 1926
Drawing bound with the manuscript of *Nadja*
Yves Saint Laurent – Pierre Bergé

fig.112
NADJA
The Lovers' Flower 1926
Pierre Leroy, Paris

There are several examples of this motif, including the one bound by Breton into the manuscript with a note recalling the circumstances surrounding its creation: 'This is Nadja's first drawing, on the paper tablecloth from the restaurant.'

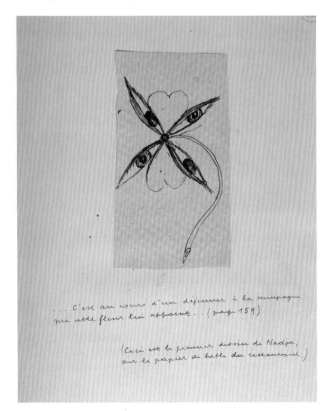

... C'est au cours d'un déjeuner à la campagne que cette fleur lui apparut ... (page 159)

(Ceci est le premier dessin de Nadja, sur le papier de table du restaurant.)

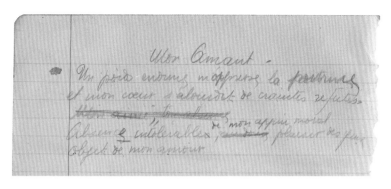

fig.110
Handwritten poem by Nadja 1926
Pierre Leroy, Paris

Breton began to meet Nadja less and less frequently, and in February 1927 he finally broke off the relationship, sensing that the young woman felt a passion for him that he did not share and fearing that her state of mind was worsening daily. This estrangement plunged Nadja into complete despair, as can be seen by this poem, dating from December 1926, which reads:

> My lover
> A huge burden weighs on my breast
> and my heart grows heavy with refuted fears
> [My beloved, your absence]
> Unbearable absence [oh sweet] of my moral backbone, pleasure of my eyes
> object of my love

Nadja, who suffered from increasingly severe emotional problems, was committed in March 1927. She remained in a psychiatric hospital until her death on 15 January 1941.

It is unforgivable for me to go on seeing her if I do not love her. Don't I love her? ... In her position, she is bound to need me suddenly, in one way or another. Whatever she asks me, it would be hateful to refuse her as she is so pure, so free of any earthly tie, and she cares so little, yet so marvellously, for life. She was shivering yesterday, perhaps from the cold. So scantily dressed. It would also be unforgivable for me not to reassure her about the kind of interest I feel for her, for me not to convince her that she would never be an object of curiosity or, how could she believe it, a mere whim. What should I do? ... What can I do, except go to the bar where we have met before, around six o'clock? There is no chance of finding her there, of course, unless ... But isn't 'unless' where the great possibility of Nadja's intervention resides, quite beyond any question of luck?

André Breton, note written on 7 October 1926,
Nadja, 1928

Breton and Nadja had a sexual relationship. However, in 1964, when Breton revised the text of *Nadja* for a new edition, it was noticed that his corrections included a change to his account of their journey to Saint-Germain-en-Laye: Breton removed the reference to the hotel where he spent the night with Nadja. 'In this way', stressed André Pieyre de Mandiargues, 'readers will have the impression that nothing of a sexual nature took place between Breton and Nadja. Nadja's character, in the altered version, appears more ghostlike when she is no longer seen as a sexual entity.'

Nadja has invented a wonderful flower for me: 'The Lovers' Flower' ... This essentially represents the dominant theme of the time we spent together and it remains the graphic symbol which has given Nadja the key to all the rest.

André Breton, *Nadja*, 1928

fig.112
NADJA
The Lovers' Flower 1926
Pierre Leroy, Paris

There are several examples of this motif, including the one bound by Breton into the manuscript with a note recalling the circumstances surrounding its creation: 'This is Nadja's first drawing, on the paper tablecloth from the restaurant.'

fig.111
NADJA
The Lovers' Flower 1926
Drawing bound with the manuscript of *Nadja*
Yves Saint Laurent – Pierre Bergé

I also remember the playful suggestion made one day in my presence to a woman, proposing that she give the 'Centrale surréaliste' one of the amazing sky-blue gloves she was wearing …, and my panic when I saw she was about to consent, how I begged her not to do any such thing. I don't know what could have been so terribly, marvellously decisive about the thought of that glove leaving that hand forever. Yet this did not assume its greatest, its true proportions … until the moment when this woman proposed to come back and lay on the table, on the very spot where I had so fervently hoped she would not leave the blue glove, a bronze glove that she possessed and which since then I have seen at her home.

André Breton, *Nadja*, 1928

The 'Lady with the Glove' was Lise Deharme (1907–1980), whom Breton loved unremittingly from 1925 and who was 'a continual, gruelling torment' for him (letter from Simone Breton to her cousin Denise). It may well be that when Breton decided to live at the Manoir d'Ango, in Normandy, in August 1927, to write the first part of Nadja, it was because Lise Deharme was staying near. 'I think those days were among the most melancholy of [my] life', said Breton, writing about that summer.

The book was tinged with despair – but this was the case with many of Breton's 'love stories'. His relationships both with Nadja, who loved him, and with Lise Deharme, whom Breton loved, ended in 'disaster', placing a question mark over his life and his way of loving. Speaking of Nadja, Breton wrote to his wife Simone in November 1926: 'What can I do? Since I don't love this woman and since, in all likelihood, I will never love her, she can only, and you know how, challenge everything I love and my way of loving. She is no less dangerous for that.'

In a text written in 1930 about Nadja, Breton wrote: '[I] cannot conceive of disappointment in love but [I] regard and have never ceased to regard life – in its continuity – as the scene of every disappointment.'

fig.114
ANONYMOUS
Eyre de Lanux c.1926
Private collection

Everything written by Louis Aragon (1897–1982) contains veiled autobiographical references concealed behind a bewilderingly lyrical facade. Thus it is possible to detect a dual presence behind the female figure who appears in the second part of the *Le Paysan de Paris*: that of Eyre de Lanux, the former mistress of Pierre Drieu La Rochelle (1894–1945), a close friend of Aragon's until 1925, and Denise, whom Aragon loved secretly – and unrequitedly. Denise was Simone Breton's cousin, born in 1896 and married in 1921 to M. Lévy.

There were numerous love affairs within the close-knit fellowship formed by the surrealist group and these were complicated by the fact that several friends were liable to fall in love with the same woman. Eluard and Aragon had strong feelings for Denise Lévy, but Breton and Péret also dedicated poems to her. Recently published letters have revealed the intensity of Aragon's love for her and how concerned he was when he found out that she was in love with another member of the surrealist group, Pierre Naville (1903–1993), then editor of *La Révolution surréaliste*:

> You see, I am raving mad and convinced that I never admitted anything to you, that I could keep this secret with all my heart. Ridiculous child, ah, don't make fun of me. This morning, for example, would you believe that I went into Naville's bedroom and that there were two photos of you, in his room, in Naville's room, two photos in which you looked so tender, so noble, photos by Man Ray, and it's absurd, and I should never tell you and I am ashamed: but I have been so jealous that I could scream, jealous, that's right. Sad, also, so sad I could die … Sometimes, if I close my eyes, I remember yours, I remember two or three faces I have seen you wear; and I ask myself if I dreamt it all and yet I feel that there is something in you that belongs to me and no one else, and then life seems even more unfair, crazy, crazy. Yes, truly you belong to me, like my light, oh my shining light.'
>
> Louis Aragon, letter to Denise Lévy, late 1924

fig.115
ANONYMOUS
Simone Breton and Denise Lévy c.1925
Private collection

Let us spit if you want
On what we have loved together
Let us spit on love
On our unmade beds
On our silence and on the stammered words
On the stars even if they were
Your eyes
On the sun even if it were
Your teeth
On eternity even if it were
Your mouth
And on our love
Even if it were
YOUR love

Let us spit if you want

Extract from Aragon's 'Poem to Shout among the Ruins', 1929

fig.116
MAN RAY
Nancy Cunard c.1928
Private collection

Aragon met Nancy Cunard (1896–1965), granddaughter of the founder of the Cunard Line transatlantic liner company, in 1925 or 1926 and parted with great sadness, in Venice, in 1928. Their love was as intense as it was stormy. Aragon's jealousy was put to the test by Nancy Cunard's independent lifestyle. He was also not as wealthy as her: 'This woman whom I loved had a very different lifestyle to mine, and I could not continue this double life. It was difficult for me, in material terms, to put myself on an equal footing with her and how could I allow her to do the same for me?' The tragic 'Poem to Shout Among the Ruins', which concludes the collection *La Grande Gaieté*, bears witness to the end of their love affair.

And yet woman you take the place of every form … Charming substitute, you are the epitome of a marvellous world, of the natural world, and it is you who are reborn when I close my eyes. You are the wall and its breach. You are the horizon and the presence. The ladder and the iron bars. The total eclipse. The light. The miracle: and how can you think of anything that is not the miracle, when the miracle stands before you in its nocturnal gown?

Louis Aragon, 1926

fig. 117
LOUIS ARAGON
*Poem Written in the Toilets
with a Knife on the Wall* 1930
Private collection

POEM WRITTEN IN THE TOILETS WITH A KNIFE ON THE WALL

Unlight the star
At the edge of the bed
Milky white
Horizontal

Lovely bitterness
Are you sleeping
Mouth of autumn
Your breasts burned

The night is nude
Where there murmurs
An unknown tongue
In my ear

My orange oh
Foreign woman
You my madness
And my woods

I am the wolf
Devouring you
The dogs who
Lick your feet

Listen from the
Bottom of me
My tempest
Rising towards you

I have the name of you
Anger of you
The immense jolt
Of loving

Here is the moment
Of fear
And the marvel
To shout about

To shout to shout
To shout to shout
 Shout
 Shout

I am I am
 I am
 DYING
I die

It was a heartbroken, listless Aragon whom Elsa Triolet (1896–1970) met in the autumn of 1928, barely a few weeks after his break with Nancy Cunard. On 8 April 1929 Elsa Triolet wrote in her diary: 'We are living together. This is an incredible event in my life … And whatever his love for me, however great it is, it is still not enough for me and that will never suit me.' In 1974 Aragon said about 'Poem Written in the Toilets': 'I had written several poems, strictly speaking *De amore Elsa*, all unpublished, between the end of 1928 and the summer of 1930. One of these poems, which I had given to Elsa and which she knew at the time I was not going to publish, has by chance recently come to hand. Probably kept by Elsa, because it was the only one of those poems which did not feature her name.'

Elsa Triolet and Aragon made a legendary couple. Triolet was praised and extolled by Aragon in many poetry collections (*Elsa's Eyes*, 1942, *Elsa*, 1959, *Elsa's Madman*, 1963). However, some of the novels (*Aurélien*, 1944, *Blanche or Forgetfulness*, 1967) were also haunted by the veiled memory of Denise Lévy.

fig.118
ANONYMOUS
Louis Aragon, Elsa Triolet, André Breton,
Paul Eluard and Nusch 1930
Private collection

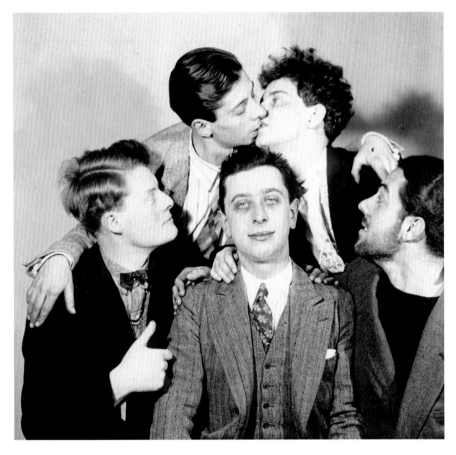

*My laughter and my joy crystallise
around you. It's your makeup, it's your
powder, it's your rouge, it's your snake-
skin bag, it's your silk stockings … and
it's also that little fold between your ear
and your nape, at the base of your neck,
it's your silk trousers and your delicate
blouse and your fur coat, your rounded
stomach, it's my laughter and my joy,
your feet and all your jewels.*

*To tell the truth, you are well-dressed
and richly adorned.*

**Extract from Robert Desnos,
'O Sorrows of Love!' in 'Poems to the
Mysterious Woman', 1926**

Robert Desnos (1900–1945) met the singer Yvonne Georges in
early 1925. That April she gave several recitals at the Olympia, one
of the largest music-hall venues in Paris, and Desnos wrote an
impassioned article about her: 'This woman appeared to speak to
us in the name of love and desire. Our dormant passion awakes
and reminds us that the time is near when we must obey the law of
dramatic encounters'. According to Théodore Fraenkel, what
Desnos felt for Yvonne Georges was 'a violent, painful, tirelessly
attentive love. But it was never reciprocated'. A faithful admirer
who even went so far as to help her obtain drugs, Desnos could
only stand by and watch the slow, painful demise of Yvonne
Georges, who died in April 1930. She was the mysterious woman
in 'Poèmes à la mystérieuse' (1926) and the dedicatee of *La Liberté
ou l'amour!* (1927).

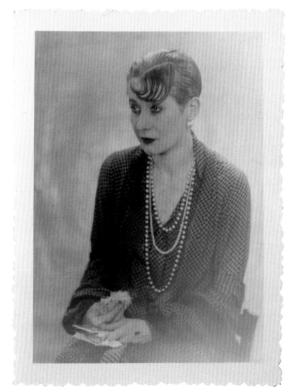

fig.120
ANONYMOUS
Yvonne Georges c.1926
Private collection

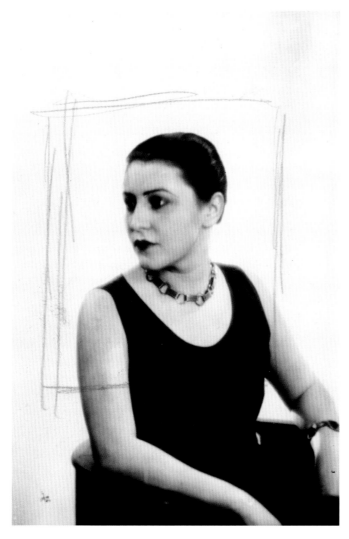

fig.121
MAN RAY
Youki Desnos Foujita 1929
Centre Georges Pompidou, Paris. Musée
national d'art moderne

fig.122
ANONYMOUS
Siren n.d.
Former collection Robert Desnos
Centre d'étude et de documentation Jacovsky-Frère, Commune de Blainville-Crevon

It was Yvonne Georges who gave Desnos a small figurine of a siren.
However, discovering a strange connection that led from one woman
to the other, it was Youki (Lucie Badoul, known as Youki, born in
1903, a famous Montparnasse model who was the wife of the painter
Foujita) whom Desnos nicknamed 'the siren'. Desnos became
friendly with Youki in 1928 and he lived with her from 1932 onwards.

The two women became juxtaposed in the poet's mind,
corroborating Théodore Fraenkel's recollection: 'Desnos, who had
spent his entire life in pursuit of love, had an incredibly small
number of affairs with women: he only really ever loved two women –
Yvonne Georges and Youki … For Desnos, passion never found its
fullest expression in tranquil satisfaction but, on the contrary, in the
unrelenting threat of loss.'

This siren you have given me, it is she.
Do you know what fearsome chain of symbols has led me to you
[which star governed the woman who is the siren?]
O parallel sisters of the sky and the Ocean!
But you,
I met you the other night,
A splendid night of storms, of tears, of tenderness and anger.
Yes, I met you it was really you.
But when I drew near and I called you and I spoke to you,
It was another woman who answered me:
'How do you know my name?'

Robert Desnos, from 'Siramour', 1931

GALA, SALVADOR DALI, PAUL ELUARD

During the summer of 1929, Eluard, Gala and their daughter Cécile stayed with Salvador Dalí (1904–1989) in Cadaquès, in Spain. Eluard and Gala's relationship was going through a rocky patch and both of them had, for several years, been having affairs. It was love at first sight for Gala and Dalí, and Eluard returned to Paris alone. For several weeks he believed that Gala would come back to him, but when she returned to Paris with Dalí, they moved into Eluard's apartment, forcing him to move out.

fig.123
SALVADOR DALI
Photomontage reproduced as the frontispiece to
L'Amour et la mémoire 1931
Mony Vibescu, Paris

In Cadaquès, [Gala] had gathered together some disorganised and unintelligible texts to which she had succeeded in giving a communicable 'form'. These notes had already been fairly well developed, so I revised them and recast them as a theoretical, poetic work that was published under the title The Visible Woman. *Gala, obviously, was the 'visible woman' of my first book.*

Salvador Dali, *The Secret Life of Salvador Dali*, 1942

La Femme visible was followed by another book, *L'Amour et la mémoire*, very much coloured by his love for Gala. Just like the 'double images' produced by Dalí in the early 1930s, Dalí and Gala soon became inseparable, and Dalí signed several of his paintings 'Gala Dalí'.

Eluard did nothing to prevent the couple from being together, indeed, during the early years, he sold artworks and books to help them financially. Nevertheless, he suffered terribly at his separation from Gala:

> My Gala, because I could not live if you were not mine. You don't know, you can scarcely imagine the atmosphere in this apartment which I really wanted for you and where you lived for so little time and in the winter. And the area around here, the corner of the street where we strolled together, everything I dreamed of: where I would take you, your dresses, your pleasure, your sleep, your dreams, everything I did that was clumsy, everything I wanted to put right … I have loved you for seventeen years and I'm still seventeen. The idea of unhappiness was born today with my love for you, without any hope of salvation.
> Eluard, letter to Gala, April 1930

The collection *Nuits partagées*, an edition of which was produced in 1935 illustrated by Dalí, reveals Eluard's grief: 'At the end of a long voyage, I still see this corridor, this mole, this hot shadow for which the sea spray prescribes pure currents of air like very small children, I still see the room where I have just broken the bread of our desires with you, I still see your unclothed paleness which, in the morning, becomes one with the dying stars.'

Gala understood me. She adopted me. I became her newborn, her child, her son, her lover — the man to be loved — she gave me the skies and both of us sat on the clouds, far from the world. She assumed the power of being my protectress, my divine mother, my queen. I gave her the strength to create the mirage of her own myth in front of her eyes and before the world. Both our lives were henceforth to be justified. 'My darling, we will never be parted again.' Those words uttered by Gala sealed the pact of the Dalínian miracle.

Salvador Dalí, *The Secret Life of Salvador Dalí*, 1942

fig.125
ANDRE BRETON AND PAUL ELUARD
Prière d'insérer for *La Femme visible* 1930
21 x 15.1 cm
Musée d'art et d'histoire, Saint Denis

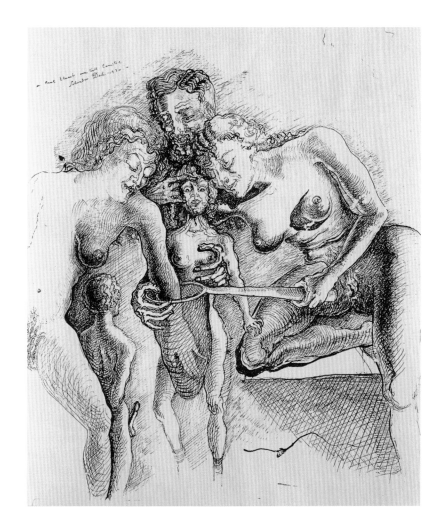

fig.124
SALVADOR DALI
Study for *Butterfly Hunting*
in René Char's copy of *La Femme visible*
Pierre Leroy, Paris

fig.126
MAN RAY
Hands of Gala and Dalí 1936
Lucien Treillard

The book open on Artine's knees was only legible on gloomy days. At irregular intervals, the heroes came to learn of the misfortunes that were once again about to sweep down on them, the countless, terrifying paths which their irreproachable destiny was once again about to take. Only concerned with Fate, most of them were physically attractive. They moved slowly, proved not to be very talka-tive. They expressed their desires with the help of expansive unpredictable movements of the head. They appeared moreover to ignore each other completely.

The poet has killed his model.

From René Char, *Artine*, 1930

Artine is one of the most mysterious female figures in surrealist literature. In 1983 René Char clarified certain aspects of her genesis:

Originally, there was this young brunette who came during one of my mother's absences to offer her services as a maidservant and who died, leaving behind only Lola Abba, a name that I read by night, with the help of a match, on a cross in the cemetery of L'Isle [sur-la-Sorgue], in the paupers' section … Artine was fashioned from two characters: the young woman who drowned, Lola Abba, and the young girl I met, three or four years earlier, on the lawn of a race-course … I can still see myself, leaning against the fence surrounding the weighing-in enclosure, when a very blond young girl, the type we call charming, came to stand next to me, her elbows touching mine. She smiled at me. We leaned towards each other and kissed. But her father called her, aggressively … Since then, this Artine has stayed with me on and off. She appeared to me in different guises on the fringes of the invisible, the woman passing by on the horizon, her neck bare.

When *Artine* was published, René Char put an advert in a newspaper: 'Poet seeks model for poems. Sittings exclusively during mutual sleep. René Char, 8b, *Rue des Saules*, Paris. No point coming before it is completely dark. Light is fatal for me.' Two young women arrived, several days later, at the Hôtel des Trois Moulins, rue des Saules, in Paris, and asked to meet Monsieur René Char. 'Who has seen,' asked André Breton and Paul Eluard, in the advertising flier for this book, 'our friend René Char since he has found a woman as a model for poems, a woman about whom he dreamed, a beautiful woman to prevent him from waking? The woman was as dangerous for the poet as the poet was for the woman. We left them on the edge of a precipice. No one. Who can say where this vanished perfume will lead us?'

fig.127
RENE CHAR
Artine
With frontispiece by
Salvador Dalí
Paris, Editions
Surréalistes 1930
Pierre Leroy, Paris

LOVE
To be
The first to come.
René Char, 1930

fig.128
ANDRÉ BRETON AND
PAUL ELUARD
Prière d'insérer for
Artine 1930
Claude Oterlo

During the summer of 1930 André Breton and Paul Eluard were both on their own. They were living in the same building on rue Fontaine, two floors apart, and together they wrote *L'Immaculée Conception* in a fortnight. On 27 August Eluard wrote to Gala: 'I'm writing a long text with Breton on mankind in five parts: conception, intrauterine life, birth, life, death. Not bad. But such hard work!' Several days later he wrote to Nusch: 'Today, we could not do anything. Very tired. This evening we are trying to write down all the ways of making love for the book. Very difficult.' The chapter on 'Love' took the form of a poetic Kama Sutra, glorifying and celebrating sexual love – at a time, however, when both men were going through a very difficult emotional period in their life, which can be sensed in the rough notes and abandoned drafts for this work. The manuscript also provides an insight into the writing process for the book, showing how closely both poets' contributions overlapped.

Only a few books within the surrealist camp were the product of a collaboration between several writers. *L'Immaculée Conception* is probably one of the most successful after *Les Champs magnétiques* (1919), written by Breton and Philippe Soupault. These collaborations not only required a considerable intellectual affinity between authors, but also an intimate emotional bond.

In a note written later Breton and Eluard stated: 'The fact that we both knew each other inside out made this task easier. But, above all, it encouraged us to organise the text in such a way that it emanated a poetical philosophy which, without ever subjecting language to the dictates of reason, may one day lead to the development of a true philosophy of poetry.'

L'Immaculée Conception is probably one of the most important texts of the surrealist movement. The idea behind it and its ambitious nature make it one of the most daring surrealist initiatives, although it has never truly been acknowledged as such: the true extent of the mysterious influence exerted by this rich and informative book has yet to be assessed.

fig.129
ANDRE BRETON AND PAUL ELUARD
First page of the chapter 'Love' in the manuscript of
L'Immaculée Conception
Musée Picasso, Paris

1. *When the woman is on her back and the man is lying on top of her, this is the* cedilla.
2. *When the man is on his back and his mistress is lying on top of him, this is the* c.
3. *When the man and his mistress are lying on one side facing each other, this is the* windscreen.
4. *When the man and the woman are lying on their side and only the woman's back can be seen, this is the* Devil's Pond.
5. *When the man and his mistress are lying on their side, face to face, and she twines her legs around the man's legs, with the window wide open, this is the* oasis.

fig.130
ANDRE BRETON
Self-Portrait
Collage
Pierre Leroy, Paris

fig.131
ANDRE BRETON
Paul Eluard
Collage
Pierre Leroy, Paris

As was his wont, Eluard inserted many documents in his copy of *L'Immaculée Conception*, including two portrait collages by Breton, probably based on photographs by Man Ray. These collages were later reproduced in the *Dictionnaire abrégé du surréalisme* compiled by Breton and Eluard in 1938. The book also contains studies by Dalí for the print used for the frontispiece and for the hand that illustrated the book's cover – a motif used by the binder Paul Bonnet as a decorative element (fig.95). Eluard probably grangerised his copy in the late 1930s, that is, when he had permanently distanced himself from surrealism and Breton.

ANDRE BRETON, SUZANNE MUZARD, VALENTINE HUGO, MARCELLE FERRY

One day in November 1927, Emmanuel Berl (a writer and essayist who had very little to do with surrealism) met André Breton at a café to discuss a publishing project. Berl brought a girlfriend, Suzanne Muzard, with him and Breton spent the entire discussion gazing at her. Several weeks later Breton and Suzanne Muzard were together in the south of France. For several months the young woman divided her time between Breton and Berl. At Suzanne's request, Breton began divorce proceedings, but it was Berl she married in December 1928 – although this did not prevent her from continuing to spend time with Breton until March 1930.

Not only was Breton's reply to the 1929 survey on love composed by Suzanne Muzard, they also wrote many surrealist 'dialogues' together, including the one quoted here. This gives a fairly accurate idea of the extremely stormy nature of the passion they shared:

André Breton: – What hovers above S. and me?
Suzanne Muzard: – Large black, threatening clouds.

Suzanne Muzard was the 'X' in Breton's *Nadja* and in his *Les Vases communicants*, a book that revolves around the end of their love affair.

fig.132
ANONYMOUS
Suzanne Muzard and André Breton
*c.*1929–30
Private collection

In 1931 Valentine Hugo (1887–1968) found her love for Breton reciprocated in some measure. Breton ended the affair after a year, but they continued to be friends. As an artist Valentine Hugo made several objects and paintings that revealed her love for Breton, and in 1933 she illustrated a volume of stories, *Contes Bizarres*, by Achim von Arnim for which Breton wrote the preface.

After Valentine Hugo, Breton had a short liaison with Marcelle Ferry (1904–1985), nicknamed 'Lila' by Georges Hugnet (1906–1974), with whom she subsequently had a relationship. The surrealist painter Oscar Dominguez (1906–1957) was also her lover.

fig.134
ANDRE BRETON
Collage dated 1 January 1934
and dedicated to Marcelle Ferry,
in a copy of *Violette Nozières*
Dominique Rabourdin

For Marcelle
the black elder
the fiery dogwood
the wood of Saint Lucy
and all the other flowers that have
a hermetic language
from the hedge of my love
André

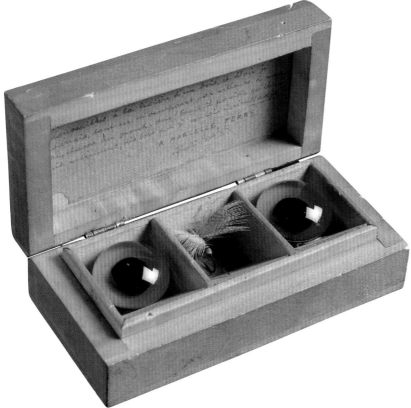

fig.133
ANDRE BRETON
Page-Object 1934
With inscription by Breton taken from *Nadja*,
and dedicated to Marcelle Ferry
Galleria Nazionale d'Arte Moderna, Rome

PAUL ELUARD, NUSCH

Strolling along boulevard Haussmann one day in May 1930, Paul Eluard and René Char met a young woman. They took her to a café where she ravenously devoured the croissants they bought for her. This was how Paul Eluard first met Maria Benz (1906–1946), known as Nusch, a young, impoverished performer working at the time at the Grand Guignol circus.

Eluard was still grief-stricken by his separation from Gala, whom he continued to love deeply. He wrote to Gala in January 1931: 'I saw Nusch at Mulhouse, very nice. I don't think I will ever find a better companion. You know, I'm so afraid of being alone. I'm so weary, so wretched.' Eluard continued to want Gala, whom he also continued to see regularly throughout the 1930s. On 28 February 1931, for example, he wrote to Gala: 'I think only of you, I adore your sex, your eyes, your breasts, your hands, your feet, your mouth, and your thoughts, all of my Gala.' The same day, he wrote to Nusch: 'My little darling, … I am on my way back, and I will have you again, fragile and pure, in my arms, by Tuesday week at the latest. I hope you are well, … that you are certain that I love you, my beloved little child, my beautiful Nusch.' Nusch seems to have accepted the enduring presence of Gala – and other women – on the fringes of her relationship with Eluard, whom she married in August 1934.

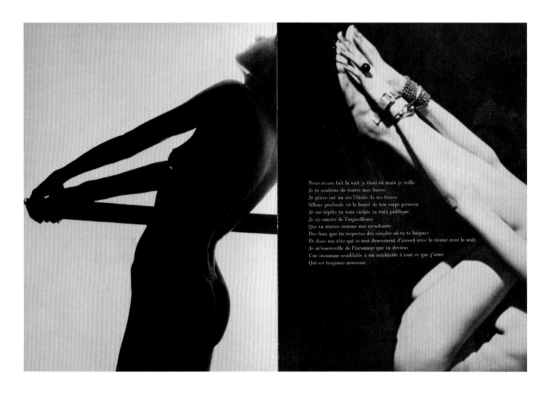

fig.135
PAUL ELUARD AND MAN RAY
Facile
Editions GLM, Paris 1935
Private collection, Paris

A true hymn to Nusch's charms, *Facile*, with poems by Eluard and photographs by Man Ray, seems to have been produced at the latter's behest. The purity of Eluard's lines, the veiled presence of Nusch's body, the layout with its interplay of light, shadow and curves, endows the book with a rare sense of unity.

We have made it through the night I hold your hand I keep watch
I hold you up with all my strength
I engrave on a rock the star of your strength
Deep furrows where the goodness of your body will sprout
I repeat to myself your secret voice your public voice
I laugh again at the proud woman
How you treat me like a beggar woman
The madmen whom you respect the simpletons where you bathe
And in my mind which softly agrees with you with the night
I wonder at the unknown woman you become
An unknown woman similar to you similar to everything I love
Who is always new

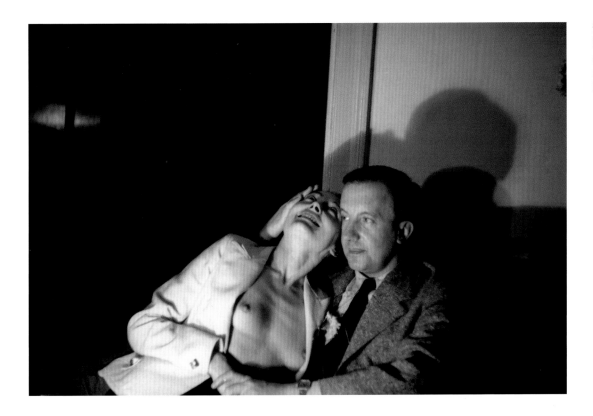

Uncomplicated, cheerful and generous, Nusch was immediately accepted by all Eluard's friends. In the 1930s Picasso painted several portraits of her and she also posed for Man Ray and Dora Maar. When she died suddenly of a brain haemorrhage, in November 1946, Eluard was plunged into a deep despair, as can be seen in *Le Temps déborde* (1947). This was published under the pseudonym of Didier Desroches and illustrated with photographs by Man Ray and Dora Maar.

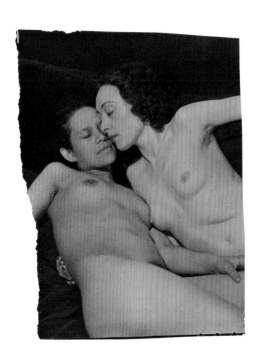

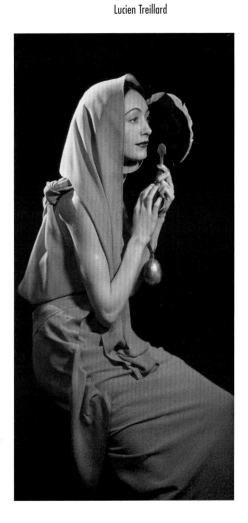

ANDRE BRETON, JACQUELINE LAMBA

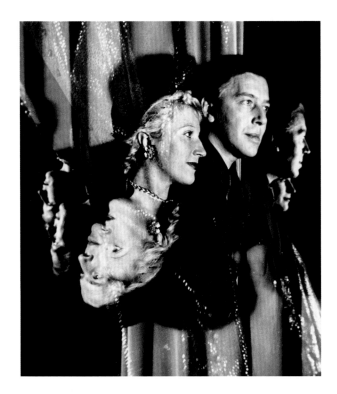

Soon it will be June, and the heliotrope will be bending its thousands of crests over to look in the round black mirrors of the wet earth ... All the flowers, even the least exhuberant in this climate, delight in mingling their strength as if to restore to me the youth of feeling. A clear fountain where my desire to take a new being along with me is reflected and comes to slake its thirst, the desire for that which has not yet been possible — to go together down the path lost with the loss of childhood, winding along, perfuming the woman still unmet, the woman to come amid the prairies. Are you, at last, this woman? is it only today you were to come?

...

The following 14 August, I married the all-powerful commander of the night of the sunflower.

 Andre Breton, 1937

André Breton married Jacqueline Lamba in August 1934. In December 1935 their daughter Aube was born, and Breton took his responsibilities as a father very seriously. *L'Amour fou* concludes with a letter addressed to Aube then an infant, for when she turned sixteen:

> I've never stopped seeing the flesh of the person I love and the snow on the mountaintops at sunrise as one. In love I wanted only to experience the hours of triumph and I am fastening the necklace of them about your neck. Even the black pearl, the last one, I am sure you will understand the weakness that binds me to it, the supreme hope of conjuration I placed in it. I do not deny that love is at odds with life. I say that it must conquer and for that it must be raised to such a poetic awareness of itself that everything inevitably hostile it meets melts in the hearth of its own glory.

fig.141
Illustration from *L'Amour fou* (photograph by Rogi André)
Dominique Rabourdin

L'Amour fou is, among other things, a lengthy attempt
to clarify the mystery surrounding Breton's meeting
with a young woman, Jacqueline Lamba (1910–1993),
on the evening of 29 May 1934, at the Café des Oiseaux
in Paris. In one of the chapters of the book, Breton
deciphers each of the portents of this meeting that had
appeared in a poem written nearly eleven years
earlier and entitled 'Sunflower' (see p.121). 'Some like
this woman seem to be swimming', says one line of the
poem, for example. After trying to interpret this image
by referring to a line of poetry by Charles Baudelaire,
an explanation which did not satisfy him, Breton
recognised the *prophetic* nature of the poem: 'I don't
know what could have kept the true content, the
particularly plain meaning of those words, hidden
from me for so long': Jacqueline was earning a living
through performances as a nude swimmer in a music
hall.

During their exile in New York, in the early years of the war,
André Breton and Jacqueline Lamba gradually grew further and
further apart. Eventually Jacqueline Lamba married the painter
and sculptor David Hare (born in 1917), who was also editor of
the journal *VVV*, while Breton married Elisa, whom he met in
1943. Nevertheless, they remained friends. When the new edition
of *L'Amour fou* was published in 1965, André Breton sent a copy
to Jacqueline Lamba with this dedication: 'The explorer who
crossed Les Halles at the close of summer … in glorious mem-
ory, André, 23 April 1965.' He also attached a photograph of
himself holding a sunflower, probably taken by Elisa, in front of
the door of the house that he owned at Saint-Cirq-La-Popie in
the south of France.

Jacqueline Lamba took part in many surrealist activities
while pursuing her career as a painter. Among other things, she
collaborated on a number of *cadavre exquis* drawings, and her
paintings appeared in all the group exhibitions from 1934 to
1948 (in 1934 at Santa Cruz de Tenerife, in the Azores, in 1936 in
Paris, in 1938 in London, in 1942 in New York and in 1947 in
Paris). For her first solo exhibition, held in New York in 1944, she
wrote, 'Art, poetry, is the precipitate of beauty in emotion. Man
has only two motor-emotions: Love and Liberty. Any expression
in art not stemming from liberty and love is false.' Later, she was
to write in a biographical note that her painting ceased to be
surrealist after 1948.

fig. 142
ANDRE BRETON, JACQUELINE LAMBA,
YVES TANGUY
Untitled (Exquisite Corpse) 1938
The Mayor Gallery, London

MAN RAY, KIKI, LEE MILLER

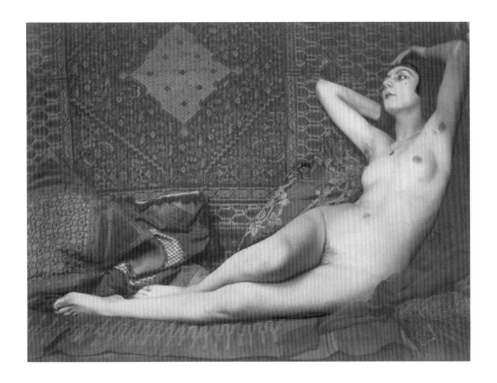

fig.143
MAN RAY
Kiki de Montparnasse as Odalisque c.1925
Lucien Treillard

'I've met an American who takes lovely photos. I'm going to pose for him. He has an accent that I like and there is something mysterious about him. He says to me: "Kiki, don't look at me like that! You're making me uncomfortable…!"' related Kiki in her memoirs. A famous Montparnasse model, Kiki (Alice Ernestine Prin, 1901–1953) shared Man Ray's life between 1921 and 1928.

In 1929 Man Ray took on a new assistant, a twenty-two year old American woman, Lee Miller, who had worked as a model and a mannequin in New York. Not only did Lee Miller work as his assistant – as the story goes, she invented solarisation by accident while printing photographs for Man Ray – she was also his model and his lover. She opened her own studio in Paris in 1930, but returned to New York in 1932. From 1934 to 1936 she lived in Egypt with her husband, Aziz Eloui Bey, returning to Paris in 1937.

Just like Kiki, Lee Miller was used to a great deal of freedom. Man Ray's feelings, and his jealousy, were therefore put to the test several times, as can be seen by a letter he wrote to her:

> I wish you too would tell me without reserve every-
> thing you do, down to the slightest detail,
> especially what you think would hurt. I never
> forget the things you say however casual and
> thoughtless, just as before your departure you
> hinted that you have hidden some things from
> me. And in spite of it all, I love you beyond all
> words and can only think of rejoining you, and
> everything else forgotten and healed … I have nothing to complain of in
> you, on the contrary (so often repeated) I acknowledge you have always
> given me more than you promised. And that in circumstances where you were
> terribly tried, I know.
>
> My darling Lee, I shall try to be everything you want me to be toward you, because I
> realise it is the only way to keep you. You are so young and beautiful and free and I hate
> myself for trying to cramp that in you which I admire most, and find so rare in women, or
> non-existent?
>
> I'll write you the day before my departure, but already feel you in my arms, darling …
> Yours
> Man

fig.144
MAN RAY
The Lovers (My Dream)
1933, remade 1973
Lucien Treillard

fig.145
MAN RAY
Elizabeth Lee 1932
A. & R. Penrose

fig.146
MAN RAY
Miss You
Postcard addressed to Juliet Man Ray *c*.1952
Lucien Treillard

fig.147
MAN RAY
Lee's Eye
Photograph, with inscription on reverse
A. & R. Penrose

Man Ray returned to the United States in 1940, and that summer met Juliet Browner in Hollywood. They married in 1946, after which she was the only model he ever used. The couple moved to Paris in 1951 and lived there until Man Ray's death in 1976.

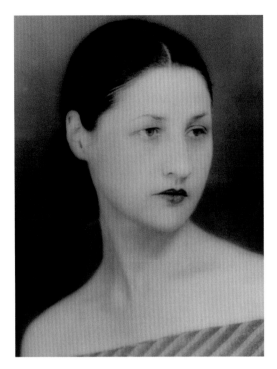

fig.148
MAN RAY
Valentine Penrose c.1932
A.& R. Penrose

fig.149
ROLAND PENROSE
Winged Domino: Portrait of Valentine 1938
Private collection

The painter Roland Penrose (1900–1981) saw a lot of the surrealists from the mid-1920s. 'Penrose is surrealist by friendship', Breton once said about him. It was Roland Penrose, among others, who organised the International Surrealism Exhibition in London in 1936. In 1923 he married a French poet, Valentine Boué (1903–1979). Eluard wrote the preface for Valentine Penrose's first collection of poems, *Herbe à la lune* (1935). The following year Valentine left Roland and went to India. There she was joined by Alice Paalen (who had just had a brief liaison with Picasso) and for several months the two women had an affair. This is evidenced in their respective poetry collections, *Sorts de Lune* by Valentine Penrose (1937) and *Sablier Couché* by Alice Paalen (1938). Love affairs between women were not all that rare within the various surrealist groups. From 1945 until her death, Valentine Penrose spent six months of every year living with Roland Penrose and Lee Miller.

fig.150
EILEEN AGAR
Roland Penrose and Lee Miller on the Beach at Juan-Les-Pins 1937
Tate Archive Photographic
Collection

Roland Penrose met Lee Miller for the first time at a masked ball in the summer of 1937:

> The young women had exercised considerable ingenuity in highlighting their natural charms; one of them was wearing nothing but a few sprigs of ivy. Despite such blatant provocation, I was, to my great surprise, attracted to a young woman dressed very conventionally in an evening dress. Friendly, blonde with blue eyes, she seemed to enjoy the abyssal contrast between her elegance and my appalling coarseness. And, for the second time, this was love at first sight.
>
> Roland Penrose, *Scrap Book, 1900–1981*, 1981

fig.151
ROLAND PENROSE
Picnic at Mougins 1937
Lee Miller Archives

From left to right:
Paul Eluard, Lee Miller, Nusch
Eluard, Man Ray, Ady Fidelin

Eluard and Nusch, Man Ray and Ady Fidelin (who was his model and companion in the late 1930s), Lee Miller and Roland Penrose certainly had a hedonist notion of love. At the time of the 1930 survey on sexuality Eluard stated that he had already had 'between 500 and 1,000' women. Like Louis Aragon, Gilbert Lély and Georges Bataille, Eluard visited brothels – the Czech painter Toyen sometimes went with him, waited, and then continued their walk together.

Eluard, Man Ray, Max Ernst, Lély, Gala, Lee Miller, Nusch and Meret Oppenheim, to name but a few, had a large number of affairs and liaisons throughout their lives and agreed, despite feelings of jealousy, that their partners should do the same. This somewhat libertine notion of romantic relationships was at times in complete opposition to the views held by Breton. Breton went so far as to declare, in 1947, that disagreements concerning this issue had, in fact, been more important in terms of the history of the movement than quarrels over other matters, including politics.

fig.152
Postcard sent to Man Ray late 1930s
Lucien Treillard

Signed by Roland Penrose, Lee Miller,
Léonor Fini, Max Ernst, Leonora
Carrington and others

fig.153
ROLAND PENROSE
The Road Is Wider than Long 1938
Manuscript book
A. & R. Penrose

'...count on me!' Marceline-Marie: 'My costume seems indecent,
Papa, in the presence of Father Dulac. It's a delicate situation for
a child of Mary ...' The R.F.: 'Joy will be yours, my child!'
The father: 'Let me weep and ...

fig. 154
MAX ERNST
Illustration in *Rêve d'une petite fille qui voulut entrer au Carmel*
Editions du Carrefour, Paris 1930

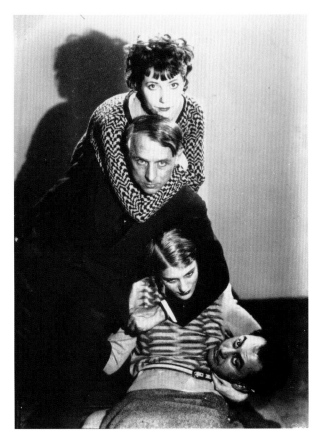

fig.155
MAN RAY
*Marie-Berthe Aurenche, Max Ernst,
Lee Miller, Man Ray* c.1930
Lucien Treillard

It is thought that the young girl in this story is based on a com-
bination of Max Ernst's own sister, Louise, who had just entered
a convent, and Marie-Berthe Aurenche, the young daughter of a
good family who had recently left the convent of the Fidèles
Compagnes de Jésus, in Jersey, where she had been brought up.

Marie-Berthe Aurenche was eighteen when the thirty-five-
year-old Max Ernst met her in 1926. He immediately whisked
her away to Bordeaux, kindling the wrath of Monsieur Aurenche
and earning the accusation of 'corrupting a minor'. Nevertheless,
they married the following year, after Max Ernst had divorced
his first wife, Louise Strauss-Ernst. Notwithstanding the fits of
jealousy thrown understandably by Marie-Berthe Aurenche
(whom he divorced in 1936), Max Ernst, an extremely charis-
matic man, enjoyed a complicated love life. This was reflected
perhaps in the increasing number of his works with a strong
romantic and erotic bias produced from the mid-1920s
onwards.

fig.156
LEE MILLER
Leonora Carrington 1939
Lee Miller Archives

Whether fair wind or foul, this is the Bride of the Wind. Who is the Bride of the Wind? Can she read? Can she write faultless French? What wood does she burn to keep herself warm? She keeps herself warm with her intense life, her mystery, her poetry. She has read nothing, but she has absorbed everything. She cannot read. Yet the nightingale has seen her, sitting on the stone of spring, reading. And, although she read in silence, the animals and the horses listened in admiration.

**Max Ernst, extract from 'Loplop Presents the Bride of the Wind',
preface to Leonora Carrington, *La Maison de la peur*, 1938**

Max Ernst met Leonora Carrington at Roland Penrose's house in London, in 1936. Born in 1917, she was the daughter of the President of Imperial Chemical Industries and was at that time studying at Amédée Ozenfant's Academy of Art. The following year they made their home in an old house in Saint-Martin d'Ardèche, in the south of France.

When war broke out, Max Ernst, being German, was interned in the camp at Les Milles, where Hans Bellmer was as well. Carrington, in despair, fled to Spain, where she suffered a serious nervous breakdown, which she described later in *Down Under*. Ernst and Carrington met again in Lisbon in 1941. Peggy Guggenheim, who had been involved with Max Ernst for several months, related that 'For several weeks it was absolute hell. Max continually waited for a call from Leonora. She often spent the day with him and I felt so neglected at those times that, for days, I didn't say a word to Max.'

Carrington, who now lives in Mexico, exhibited in a number of surrealist exhibitions and wrote many collections of short stories – including *La Maison de la peur* (1938) and *La Dame ovale* (1939), both illustrated by Ernst.

I like Dorothea Tanning's work because the realm of the fantastic is her country of birth; because, in the daring undertaking that involves painting the intimate biography of the universe, the emotions of the child's soul, the mysteries of love and that entire monstrousness that is swallowing up the age of reason, she has found a method of figurative representation which is both new, spontaneous and convincing … Precision is her mystery. This precision has allowed her to attain the power to guide us with the confidence of a sleepwalker through the real world as well as through that of the imagination.

**Extract from Max Ernst,
Dorothea Tanning, 1944**

fig.157
LEE MILLER
Max Ernst and Dorothea Tanning in Sedona 1946
Lee Miller Archives

Ernst met Dorothea Tanning in New York in 1942 where Tanning, born in 1912, was painting and earning a living as an illustrator. The following year, they were in Arizona. Breton wrote to Tanning during his New York exile: 'The end of the war is beginning to come into sight, but our view is so blurred that it confuses what is with what will come after. There are so few clearings in this darkness that I can no longer write. Of those clearings, one of the few that are comforting is that you are with Max and that you are happy as *you should be*. Every day, I think of you both, you who possess such a large part of a world which I have regarded as the only truth. You will bring some paintings here which will enable us to find all our eyes again. Max will have succeeded in salvaging a great deal from this wreckage.' Ernst and Tanning married in 1946 and lived in Sedona, in Arizona, until the late 1940s. From 1955 Tanning lived with Ernst in France until his death in 1976, and now lives in New York.

HANS BELLMER, NORA MITRANI, UNICA ZURN

Reversibility, numbers, permutations, algebra, unconfessed emotional constants. But the body undressed in the sights of love, but the woman without her image ignore them. Should Bellmer encounter them in his games and anatomical constructions, he simultaneously contradicts:

— Nature: not the supple and hot child of desire, but the blind, utilitarian brute; he reinvents it back to front, according to the laws of a constructed and calculated marvellous

— Geometry: not its rigour, but the rational and commercial uses of this rigour; he condemns it to renounce the uncertainties of love

— And love itself: not the pathetic aspect of hopeless love, but its defence mechanisms, the continual temptations of escape; he compels it ... to recompose itself, from the provocative sham of 'being the target' to the real, tangible anatomical image of tenderness, burning with impossibility.

Nora Mitrani, 'Rose with the Violet Heart', 1947

fig.158
HANS BELLMER
Nora Mitrani late 1940s
Private collection

Hans Bellmer (1902–1975) had been living in France since 1938. His book *Die Puppe* had been enthusiastically received there, particularly by Eluard. In April 1946, he met Nora Mitrani (1921–1961), a young poetess of Bulgarian origin. They lived together until 1948 and she featured in many of his works. Together they wrote the anagrammatic poem, *Rose au coeur violet* (Rose with the Violet Heart), which contains a pun on 'violet' and 'violé' (violated), and was a line by Nerval that Nora Mitrani wanted to use as the title of the book she wrote in 1947 about Bellmer. This poem and the book on which Bellmer was working during those years, *La Petite Anatomie de l'image*, are closely linked.

From the early 1950s Nora Mitrani devoted her life to her work as a sociologist. But she also published several texts in surrealist journals. 'The idea I have of nobility was often influenced by the inflections of her language and her thoughts', André Breton once said about her.

Unica Zürn (1916–1971) and Hans Bellmer met in 1953. They had a difficult, intense and violent life together, peppered with separations and disrupted by Zürn's nervous breakdowns, Bellmer's ill health from the late 1950s and, last but not least, by the isolation experienced by the couple, who lived in poverty and seclusion. Bellmer seems to have fed on Zürn's illness: 'One can see me as the type of man with antennae that can pick up a potential *woman-victim* … It remains to be seen if I immediately, from the first time we met, "sensed" that Unica was a victim. If Unica seriously asked herself this question, which she may have done, she would, I think, reply YES!', wrote Bellmer to Dr Ferdière, a psychiatrist, in 1964. Zürn, despite her work as a painter and writer, which was supported and encouraged by Bellmer, never found lasting respite. She committed suicide in 1970. Several months before her suicide she wrote:

The scenes of madness, of torture, of ecstasy were drawn by Bellmer with the sensitivity of a musician, the precision of an engineer, the brusqueness of a surgeon. If we watch Bellmer at work, his hand seems weightless. Despite everything, his body and soul are filled with tenderness. So much talent inspires distrust. One wants to know if his hand is tense against the paper, if this pleasing line is not a piece of sorcery from the Void. The obscene drawings that he has been producing over and over for years (perhaps he is an erotomaniac) are executed cautiously and with precision, a blend of incredible, pitiless coldness and burning excitement.

Whoever, man or woman, is sketched by him or photographed with his pencil shares with him the abhorrence of self. It is impossible for me to give Him any greater praise.

Unica Zürn, 'Remarks of an Observer' [about Hans Bellmer], in the issue of the journal *Obliques* devoted to 'The Surrealist Woman', 1977

fig.160
ANONYMOUS
Hans Bellmer and Unica Zürn n.d.

To obtain objective evidence [of the reality of the imagination], we will have recourse therefore to the criminal artisan through the most humanly tangible and most beautiful passion, that of removing the wall separating the woman from her image. From the accurate memory we have of a certain photographic document, a man, to transform his victim, had tightly bound her thighs, shoulders and breasts with a criss-cross of tight wire as a precaution, causing her flesh to swell, irregular spherical triangles, lengthening the folds, unsavoury lips, causing an increasing number of breasts never seen before in undisclosable places.'

Hans Bellmer, *Petite anatomie de l'inconscient physique ou l'anatomie de l'image*, 1957

fig.159
HANS BELLMER
Store in a Cool Place 1958
Collage with gouache
Ubu Gallery, New York, and Galerie Berinson, Berlin

Zürn posed for a series of photographs in which her body was bound with string. This collage was used for the cover of an issue of *Le Surréalisme, même* in 1958.

ANDRE BRETON, ELISA

Chilean-born Elisa Claro (1906– 2000) lived in New York. When André Breton met her, in December 1943, her sixteen-year-old daughter had just tragically died. They travelled together to Quebec, a journey during which Breton wrote *Arcane 17*, published in New York in 1944 with illustrations by Matta. The couple were married in July 1945. Later, for Elisa, he copied extracts from *Arcane 17* into a notebook, and added items recalling their trip (figs.96, 97).

It was in later 'additions' to *Arcane 17* that Breton clarified, in 1947, his position with regard to love: 'Nevertheless, like many others, it is a completely intuitive impulse that has led me to choose the passionate, exclusive form of love, tending to preclude anything that in comparison could be viewed as compromise, whim and distraction. I know that this view may have seemed perhaps narrow and arbitrarily restrictive and I have long had some difficulty to find a good argument to defend it when it happened to come up against the view held by sceptics or even more or less enlightened libertines.'

fig.162
ANONYMOUS
Elisa Breton c.1943
Private collection

fig.161
ROBERTO MATTA
The Lover
Illustration for *Arcane 17* by André Breton
New York, Brentano's 1944
Mony Vibescu

In the icy street I see you once more modelled on a shiver, only your eyes exposed. Your collar turned up high, the scarf clasped tightly by your hand at your mouth, you were the very image of secrecy, of one of nature's great secrets at the point when it is revealed and in your end-of-storm eyes one could see a very pale rainbow take shape ... This mysterious sign, which I have never seen except in you, presides over a sort of quivering question which at the same time provides its answer and still carries me to the very source of spiritual life.'

André Breton, *Arcane 17*

Elisa Breton participated in surrealist activities, wrote in journals and presented works at exhibitions. She made a number of objects, particularly during the 1970s. She remained with Breton until his death in 1966.

fig.164
ELISA BRETON
Hold On 1972
Private collection

fig.163
?ELISA BRETON
André Breton at Saint-Cirq-La-Popie c.1960
Dominique Rabourdin

TRANSLATED BY SUE ROSE FOR
BYWORD, LONDON

A woman's hand, your hand in its starry paleness refracts its rays in mine only to help you descend. Its slightest contact arborises within me and describes for a second above us those airy vaults where the overturned sky mingles its blue leaves in the haze of the aspen or the willow ... Before I knew you I had encountered misfortune, despair. Before I knew you — come now, those words have lost their meaning. You know very well that when I saw you for the first time I recognised you without the slightest hesitation. And from which borders, the most ferociously guarded of all, did you come, which initiation, whose entry was barred to everyone or almost everyone, consecrated you as what you are?

André Breton, *Arcane 17*, 1944

chapter seven
SURREALISM, MALE-FEMALE
Dawn Ades

The case against surrealism and its attitude to women has had powerful advocates in the last few decades. Surrealism has been criticised for idealising woman while marginalising real women, for its indifference to female artists and writers, for the celebration of heterosexual love at the expense of other sexualities, and for a pervasive misogyny, especially in the apparent violence done to the female body in representation.[1] In the process there has been a tendency to reduce surrealism to a single voice and forget its complex and extra-artistic character as what the Czech artist Toyen called a 'community of ethical views'.[2] Argued from different positions, however, this case has had the positive consequence of bringing back to light the works of many women artists and writers closely associated with the movement but side-lined by it or forgotten by its historians.[3] It is less often acknowledged, however, that questions of female creativity and the representation of woman in surrealism are inseparable from its wider concerns about gender, and that male anxieties as well as same-sex desire are integral to them.

The very transparency surrealism attempted to establish in this area of sexual desire and identity produced contradictions in its own discourse about love and the idealisation of woman, and raised questions about masculinity and femininity, sexual preference, deviance and normality that simultaneously began to dismantle surrealism's own myths. Through debates on sexuality, through the privileging of the erotic and the condition of madness, through ambiguities raised by the question of 'woman as nature' seen in surrealist terms, through an insistent troubling of gender identity, through the attempts to make representations of the body speak as revolutionary signs, and through the apparent clash between the celebration of the lover in surrealist poetry and the violence done (largely to 'her') in its visual arts, the possibility of a different view of human relations and the potential of radically new forms of expression were opened up.

As the dust clears from the debates it is becoming evident that some women artists and writers have spoken with great force from positions within a surrealism that opened up new ways of writing, experimented with verbal and visual language and invested problematic modes like parody with new significance. The interrogations of culture and sexual identity by Claude Cahun in her book illustrated with her own collages *Aveux non avenus* (1930), the experiences of madness written by Leonora Carrington (*Down Below,* 1944) and Unica Zürn (*L'Homme-jasmin,* 1971), for instance, rank with the better-known texts by André Breton such as *Nadja* (1928) or *L'Amour fou* (1937) and Louis Aragon's *Le Paysan de Paris* (1926). Many women surrealists resisted the invitation to abandon their special place as female icons: in 1957 Nora Mitrani argued against the tenets of Simone de Beauvoir's *The Second Sex* (1949) in an article in the surrealist periodical *Le Surréalisme, même*.[4] Others, however, refused to allow gender to force a wedge between male and female creators, disavowing difference. Meret Oppenheim criticised the ghettoising of women artists, and Dorothea Tanning mocked what she perceived as irrelevant biological determinism: 'A medical examination should be a condition for inclusion – above all today when imposture is so rife that a woman exhibitor could be only a man.'[5] Like the poet Joyce Mansour, Carrington questioned the

fig.165
JOSEPH CORNELL
Untitled (photomontage for '"Enchanted Wanderer": Excerpt from a Journey Album for Hedy Lamarr') c.1941
Gelatin silver print
22 x 17.7 cm
Joseph Cornell Study Center, Smithsonian American Art Museum, Gift of Mr and Mrs John A. Benton

sexual polarities that seemed to order the universe of passion: 'In *l'amour-passion*, it is the loved one, the other who gives the key. Now the question is: Who can the loved one be? It can be a man or a horse or another woman.'[6] A recent commentator, Marie-Claire Barnet, has proposed a wider exploration of the 'theories of love called surrealist', insisting on the diversity of their expression. 'It is necessary to insist on their changing character, despite critical analyses which have tended to fix the surrealist movement, or, in the wake of [the feminist writer] Xavière Gauthier, reduce them to a limited list of positions on sexuality. How can one define love through sexuality?'[7]

The 'problem of woman' increasingly became the focus of surrealist energies. Woman is placed in a position of spectacular prominence: 'The problem of woman is all that is marvellous and troubling in the world. And that is to the degree that it is restored to us by the faith that an uncorrupted man must be capable of placing not just in the Revolution but in love', Breton wrote in 1929.[8] But even if the surrealists agreed with marxism that female emancipation was a bourgeois issue, and that the exploitation of woman had primarily economic causes, the importance they accorded to love and to sexuality remained irreconcilable with the aims of the Communist Party in the interwar years. For the Communist Party, not only was the emancipation and full equality of women necessarily dependent upon the social equality of all, but sexual problems were regarded as a distraction and deviation, and love a luxury. Lenin said: 'The Revolution demands the concentration, the tension of forces … It does not tolerate orgiastic states.'[9]

It is possible that the 'Recherches sur la sexualité', conversations of startling frankness on sexual practices and preferences, recorded verbatim, were undertaken not just in a sociological spirit but also as a materialist investigation, in keeping with the spirit in which several of the group (Aragon, Breton, Paul Eluard, Benjamin Péret, Pierre Unik) had joined the Party in 1927. The 'Recherches' would thus constitute an attempt to adapt to the Party's demands that the surrealists recognise the revolution as 'of the world of facts 'and not just linked to 'the purgation of the inner life', without giving up their identity as surrealists.[10] Two of the conversations were published in *La Révolution surréaliste* in 1928. In the following year the final issue of the review published, rather than the promised sequel to the 'Recherches', a questionnaire on love and the *Second Manifeste du surréalisme* which made the surrealists' difficulties with the Party public.

To attempt to judge women by the defective character that they display in Civilisation is like trying to judge the nature of man by the character of the Russian peasant who has no conception whatsoever of honour or of liberty. It is like judging beavers by the sluggishness that they show in captivity whereas in a state of liberty and co-ordinated labour they become the most intelligent of all the quadrupeds. The same contrast will reign between the enslaved women of Civilisation and the free women of the Combined Order. They will surpass men in dedication to their work, in loyalty and in nobility; but outside the free and combined state woman becomes … a creature so inferior to its destiny and its powers that it is easy to scorn it when one judges it superficially and on the basis of appearances.

Charles Fourier

Nonetheless, Breton still struggled to reconcile his faith in love with dialectical materialism: reciprocal love, the only sort he believed in, could only be realised, he said, through radical social change 'whose effect would be to suppress, along with capitalist production, the conditions governing ownership which belong to it'.[11] The revolution might produce the conditions necessary for reciprocal love, but the surrealists had no intention of abandoning their interest in love, sexuality and the myth of woman as the ideal mediator and muse.

The gap is striking between the surrealist rhetoric about woman and the discourse on gender equality and sexual difference within the French socialist tradition established by Charles Fourier (1772–1837). This tradition, embracing the Saint-Simonians, Flora Tristan and the anarchists of

the Paris Commune, placed a high priority on the issue of sexual difference in the construction of the new society.[12] The surrealists' disillusionment with the Communist Party was followed by a surge of interest in Fourier, but Breton's 'Ode à Charles Fourier' (1945) celebrates above all the utopian socialist thinker's extraordinary capacity to imagine in complete and vivid detail a new society rather than his insistence on female equality. Simone Debout, in the catalogue of the *EROS* exhibition of 1959–60, suggested that for Fourier women played the role that the proletariat did for Marx. She explores the consequences of this idea at some length: 'If women are to be the lever for total effective liberation, they would not be able, like the proletariat, to assure its triumph by violence: internal maturity alone can give it birth: conditioned by economic transformations, it relies on the progressive dismantling of prejudices. Fourier leads us to an unheard of place where no human being is treated as a means, but only ever as an end.'[13] Women would be in charge of their own destiny and the unnatural monogamy of marriage would be replaced by free amorous relations. However, Fourier, in his objective interest in manias and perversions, in the variety of sexual proclivities and in the notion that masculine and feminine qualities were independent of gender, could be seen as the precursor of Freud rather than Marx.

The feminist author Simone de Beauvoir placed Breton's elevation of the feminine within the Fourier tradition, and highlighted the problem of the woman who is always spoken for but has no voice herself. In *The Second Sex* (1949) she examined the myth of woman in the work of five authors, one of whom was Breton. It is not just as the incarnation of nature that Breton sees woman, but as the channel capable of releasing its magic. For him she is the 'indispensable mediatress', according to de Beauvoir, who can recreate and recolour the world through love and poetry: 'Woman has no vocation other than love; this does not make her inferior, since man's vocation is also love. But one would like to know if for her also love is key to the world and revelation of beauty … She is poetry in essence, directly – that is to say, for man; we are not told whether she is poetry for herself also. Breton does not speak of woman as subject.'[14] Although reciprocity in love is always the ideal, the absence of the female voice means that she can neither confirm nor deny her position.

The Fourierist evaluation of a feminine world view served to reinforce a romantic surrealist myth of the child-woman/fairy Mélusine. In *Arcane 17* (1945) Breton wrote:

> I can see only one solution: it is high time for woman's ideas to prevail over man's, whose bankruptcy is clear enough in the tumult of today. It is up to the artist, in particular, to privilege as much as possible the feminine system in opposition to the masculine system, to draw exclusively on woman's faculties, better, to exalt, to appropriate so far as to make them jealously his own, everything that distinguishes her from man in terms of modes of appreciation and will.[15]

Breton's appeal could be said to demasculinise as much as to feminise social values. It is neither produced by nor responsive to woman's role in society, and her right to full political and economic equality. Significantly, though, Breton is not speaking of woman as irrepressible natural creature: it is in terms of culture, not nature, that he seeks to privilege the 'feminine system', whose intellectual properties, 'modes of appreciation and will', would oppose the masculine values of 'père, patron, patrie', family, work and state.

However, the idea of the child-woman, fey object of desire, tends to dominate, and renders his argument ambiguous. In the aftermath of the Second World War a group of revolutionary surrealists sought to expose the surrealist myth of woman as complicit with patriarchal control. René Passeron's 'Introduction à une érotique révolutionnaire' which appeared in the one and only issue of *Le Surréalisme révolutionnaire*, was also a critique of *Arcane 17*. Both Eve and the Virgin Mary, he wrote, are myths

> from which we must free our mentality. The child-woman, in her reign here below on earth – what is she? A sentimental sublimation which, substituting a pedestal for an altar, maintains woman in her Marian position. Without doubt, woman's sensibility, 'once her infinite servitude is finally broken', will confound the old masculine fatuity. But it is not in sublimating a being that one liberates them. Sublimation has always had its inverse, oppression … It is not by celebrating Mélusine that we shall advance a step towards the reign of desire, but by subjecting to materialist method the myths by which woman is lulled the better to be exploited.[16]

If woman is a mediator for the experiences and experiments of the surrealists with language both verbal and visual, is she able ever to become herself a speaking subject? And if she does, on what terms?

Rather than addressing this as a separate issue, I propose to frame it in a discussion of the complex and diverse ways in which sexual difference is mobilised, challenged or ignored in surrealist works, and to consider the extent to which a crisis in masculine identity is interlinked with the problematic of feminist identity and the female artist. Acceptance, assertion and denials of difference and of a 'normative' sexuality will be set within a context of surrealist opposition to bourgeois values.

Two images which appear to reinforce gender stereotypes and 'the myth of woman' in fact problematise them in different ways, raising questions about displays of sexual difference in terms of male–female divisions. Both works introduce ambiguities about the nature of these divisions. Visually utterly dissimilar, Marcel Duchamp's *The Bride Stripped Bare by her Bachelors, Even (The Large Glass)* (1915–23; fig.15) and René Magritte's *I Do Not See the* [Woman] *Hidden in the Forest* (1929) apparently present similar scenes incarnating a myth of woman: a lone female vis-à-vis a group of males. 'Vis-à-vis' is a convenient term to cover the different and ambivalent relations between these emphatically gendered parties, for they are embedded in the respective visual schema without a clear relationship necessarily being conveyed. In *The Large Glass* the bride is skied above her bachelors, harking back to a sacred iconography of visions of the Assumption of the Virgin Mary, depicted in a heavenward ascent above clouds and male worshippers. The masculine domain in *The Large Glass* also contains a group of 'oculist witnesses', symbolised by Duchamp in the form of ellipses scratched in silvered glass, as a species of 'peeping toms' observing but not participating in the elaborate erotic encounter between the bride and her bachelors. Magritte's collage of photographs of the male surrealists arranged in a tight rectangle around his painting *I Do Not See the Woman* [Hidden] *in the Forest*, by contrast, encloses and contains the female as a popular pin-up, a secular icon. The nude seen here, erect rather than reclining,

parodies the tradition of the nude in painting with its subli-
mated values of beauty, from Titian to Renoir, its masculine
audience made visible, an embarrassingly public self-reflexive
daydream.

Both images appear to present isolation and non-commu-
nication between the sexes, but also homosocial solidarity. In the
case of the Magritte, it has been argued that surrealism is here
revealed as a 'men's club': 'The surrealists lived in their own mas-
culine world, with their eyes closed, the better to construct their
male phantasms of the feminine … These masculine dreams
play an active part in patriarchy's misogynist positioning of
women.'[17] But the confrontation between the single female and a
group of consenting males is quite ambiguous. To begin with,
making the (male) viewers of the female nude visible is unusual
– apart from scenes based on the biblical story of Susannah and
the Elders, there is little iconographical precedent. To represent
both object and subject of desire introduces an unaccustomed
mode of reflection on the dynamic of the male gaze, here veiled
and turned inwards. The woman enfolds herself narcissistically,
while the group of males is far from the representing a confident
and exclusively masculine club. There is no celebration here of
virility: if not quite 'malic moulds', as Duchamp described his
bachelors, the insistence on the ties worn by Magritte's male sur-
realists, which recalls the 'male mannequin' in the Paris dada
exhibition of 1921, suspended from a balcony along with a fringe
of carefully knotted ties, hints at a kind of male masquerade, a
symbolic show. There may be an element of intense male friend-
ship presented here, in which it is tempting to see a satirical cast,
given Magritte's position as something of an outsider in the
group. But consciously or unconsciously Magritte's image
addresses a crisis in masculinity rather than the misogynist
comfort of a male club.

Magritte's most immediate points of reference are internal
to surrealism. *I Do Not See …* is a part of his response to the
questionnaire on love published in the final issue of *La
Révolution surréaliste* in 1929. He makes it a pendant to the
photo-collage in the journal's first issue, in 1924, in which the
surrealists and a group of chosen 'fellow travellers', including
Picasso and Freud, are loosely arranged around a mug-shot of
the anarchist Germaine Berton, with an epigraph taken by
Eluard from the nineteenth-century poet Charles Baudelaire:
'woman is the being who casts the greatest shadow or the

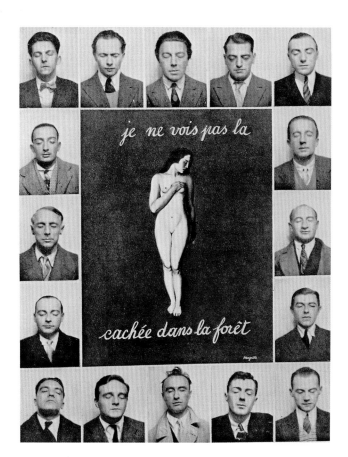

fig.166
RENE MAGRITTE
I Do Not See the [Woman] *Hidden in
the Forest*
Collage reproduced in *La Révolution
surréaliste*, no.12, 1929
Collection Galerie 1900–2000,
Marcel et David Fleiss, Paris

greatest light into our dreams'. Magritte's image may also refer to Breton's equivocal desire 'to meet, at night and in a wood, a beautiful naked woman or rather, since such a wish once expressed means nothing, I regret, beyond belief, not having met her'.[18]

Magritte's montage can be seen in terms of a negative encounter, like the paradox of the title. If the woman is passive and self-absorbed, so are the males. Perhaps, by contrast with Magritte's response to the questionnaire, in which he answers to the question 'What kind of hope do you place in love?' that it is only a woman who can give love reality, *I Do Not See …* reflects upon the gap between desire and reality. Breton did not share Magritte's certainty. In *Les Vases communicants* (1931) he recognises, in the misery of a failed love, that 'I did not know how to make, of the immediacy of a being whom I thought I knew by heart, a real being'.[19] For Breton this posed in the acutest form the 'problem of problems', that of objective chance, which was the philosophical problem of the relationship between need and freedom, between natural necessity and human necessity.[20] In its concrete form it governed the encounter, the magical spark of a chance attraction, the unpredictable resolution of an unconscious need. But the difficulty was reconciling the real woman with the ideal type – in Breton's case above all, the Delilah of the late nineteenth-century symbolist painter Gustave Moreau:

> My discovery, at the age of sixteen, of the Musée Gustave Moreau influenced for ever my idea of love. Beauty and love were first revealed to me there through the medium of a few faces, the poses of a few women. The particular 'type' of these women plunged me into a state of complete enchantment and probably prevented me from recognising any other type. A great part must have played, too, by the myths which in these pictures were endowed with miraculous new power.[21]

This is what lies behind his question in *Nadja*, 'whom do I haunt?' Who is it that will recognise him as their inner necessity? And if it is not reciprocal?

A similar story to that told from Breton's perspective in *Nadja*, the meeting with a woman whom in the end he did not love, and whose mysterious attraction had its dark roots in a mental instability that in the end overtakes her, is told from the woman's perspective in Unica Zürn's *L'Homme-jasmin*. This is an example of the creative voice of a woman not echoing but speaking out, and speaking to the complex discourse in surrealism on love and madness, on, in fact, *l'amour fou*. By contrast with the simulations of madness in Breton and Eluard's book *L'Immaculée conception* (1930), Zürn gives a detailed account of the progress of her breakdown, with its delusions, hallucinations and lacunae. The encounter with the Man of Jasmine was Zürn's first secret, a childhood vision of love: 'The Man of Jasmine! Boundless consolation! Sighing with relief, she sits down opposite him and studies him. He is paralysed! What good fortune. He will never leave his seat in the garden where the jasmine even blossoms in winter … this man becomes her image of love.'[22] Much later, as a grown woman,

> in a room in Paris she finds herself standing before the Man of Jasmine. The shock of this encounter is so great that she is unable to get over it. From this day on she begins, very very slowly, to lose her reason. The image of her childhood vision is identical with

this man's appearance. With the sole difference that he is not paralysed and that here there is no garden with jasmine blossoms surrounding him.[23]

The encounter between the compulsion of the inner vision and its object has no purchase in the real world; the person whom she haunts fails to reciprocate, as does Breton with Nadja, whose phrases of love as fleetingly reported by Breton curiously resemble those of Zürn.

The closer one looks, indeed, at the ways in which the idea and the experiences of love, *l'amour fou* and sexuality work through surrealist texts, the greater is the divide between the stereotypes built up by later criticism and their real complexity. Duchamp's *The Large Glass* destabilises the gender stereotypes that it purports to set up, through a process of invention based on a system of oppositions in which gender difference plays its part. It is worth recalling the degree to which every aspect of life, activity and occupation was gendered still in the early decades of the century: at school, for instance, boys learnt a different method of drawing from that taught to girls.[24] Thus resistance and challenges to the stultifying and rigid educational and social as well as artistic codes reverberated across each other. The extent, in particular, to which avant-garde art was allied in the popular mind to a transgressive sexuality is striking. Breton and the dadaists were denounced as pederasts, their anti-art stance being aligned with and virtually indistinguishable from a perceived collapse in values and human sexual and social decency.

Dry (male) mechanical drawing was introduced by Duchamp as a corrective to personal expression and the over-valuation of the purely 'retinal'. This in turn was to generate an iconography with the machine as metaphor for human sexual relations, which produced comic, sadistic and satirical scenarios. In Francis Picabia's hands, these often reinforce a 'laddish' masculinity. Man Ray's pair of photographs of 'readymades' (figs.167, 168), relate to Picabia's machine portraits (a drawing of a sparking plug, for example, symbolised a young American girl in a state of nudity). But the aggressive male potency of Man Ray's 'egg-beater' is undermined by the banal domesticity of the object.

A fantasy of male procreation, the bearing as well as engendering of children, was one of the odder consequences of the social pressures of the calls for female emancipation and greater sexual equality as well as more broadly an expression of a crisis in industrial society. A text by Paul Haviland in the American dada review *291* in 1915, prominently adorned with symbolic machine portraits by Picabia, was crammed with references to male procreativity: 'We are living in the age of the machine. Man made the machine in his own image … The machine is his 'daughter born without a mother'. That is why he loves her. He has made the machine superior to himself. Photography is one of the fine fruits of this union. The photographic print is one element of this new trinity: Man the creator, with thought and will: the mother machine-action: and their product, the work accomplished.'[25] As a response to a sense of impotence, of the passing of power and control to the machine, this idea of a 'girl born without a mother' can be seen as a kind of return of repressed virility. The shadow of misogyny here would be a response to and defence against emasculation as well as a reaction against feminism.

This fantasy had antecedents in the utopian visions of the Saint-Simonians of a new social order both begotten and borne in labour by its male progenitors, in a metaphor specifically aimed at restoring a central role to men. On the other hand, women in the group had attacked the

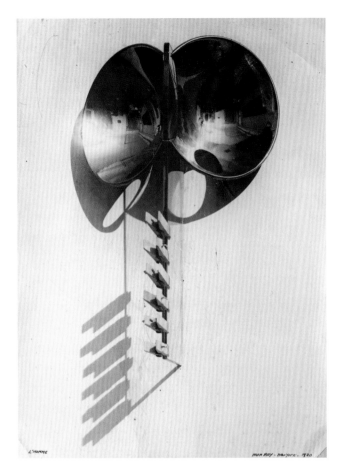

167
MAN RAY
Man 1920
Gelatin silver print
39 x 29 cm
Marguerite Arp Foundation, Locarno

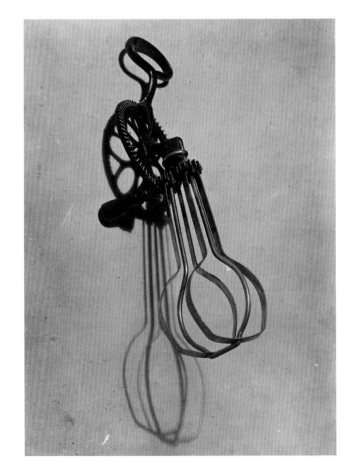

fig.168
MAN RAY
Man 1918
Gelatin silver print
48.3 x 36.8 cm
Jederman Collection, N.A.

Napoleonic Code that treated women as minors and gave men the right to appropriate children at birth, claiming that children should bear the mother's name. Woman's 'natural' function as wife and mother was increasingly challenged at the same time that a 'natural' right to sexual freedom was proclaimed. Eleanor Marx and Edward Aveling argued in their 1886 essay 'The Woman Question' that, 'There is no more a "natural calling" of woman than there is a "natural" law of capitalistic production.'[26]

Conservative anxiety about the threat to the family posed by such ideas and by the emergence of a 'new woman' who emphasised her freedom by adopting masculine attitudes, was satirised by Guillaume Apollinaire in his 'drame surréaliste', *Les Mamelles de Tirésias* (1917). The plot is succinctly summarised by David Hopkins:

> Thérèse, the main character, announces her conversion to feminism, declaring, 'I want to make war … not children.' As a result she changes into Tirésias, during which her bosom (two balloons) falls off and she grows a moustache and beard. She moves house, taking with her a chamber pot, a basin, and a urinal, leaving her husband tied up, wearing her skirt. With women off-stage shouting 'No more children, no more children', the husband decides he will personally have to set about repopulating Zanzibar (the setting for the play). He consequently produces 40,049 offspring. Tirésias eventually returns and is welcomed back by her husband with a gift of balloons and rubber balls with which to rebuild her figure.[27]

fig.170
FRANCIS PICABIA
The Fiancé c.1915–17
Gouache and metallic paint on canvas
26.5 x 33.5 cm
Musée d'art moderne, Saint-Etienne

fig.169
FRANCIS PICABIA
Paroxysm of Suffering 1915
Oil and metallic paint on cardboard
80 x 80 cm
National Gallery of Canada, Ottawa

fig.171
MARCEL DUCHAMP
Sad Young Man on a Train 1911–12
Oil on cardboard
100 x 73 cm
Peggy Guggenheim Collection, Venice.
Solomon R. Guggenheim Foundation, New York

Apollinaire said the idea went back to the early years of the century, and it is possible that he had in mind, as well as national alarm about the falling birth rate, the feminist demonstrations in 1904, following the failure of a suffrage bill, when balloons were released during the anniversary celebrations of the Napoleonic Code.[28]

Apollinaire shared with Duchamp and Picabia a fascination with gender reversals, male procreation and both male and female separatism. In Duchamp's case the ancient metaphor of the male artist 'bearing' the fruits of his genius takes an original twist as he devised new methods of invention, which included linguistic puns and an oppositional logic the results of which were as bizarre as its operations were mechanical. The bachelors, for example, in *The Large Glass*, were the result of designing 'a direct opposition to the theme of the Bride'.[29] Duchamp's system produces not a husband, which would simply make a binary pair, but a plurality of unmarried males – the bachelors. Bride and bachelors are then theoretically (or poetically) inscribed in a complex narrative of sexual interaction, powered by every imaginable form of energy, but remaining forever separate in their irreconcilable spheres (air and earth, ideal and material, natural and mechanical), visibly gendered by different means of representation – the bachelors and their machines drawn according to strict laws of perspective, the bride anamorphic and abstract.

The bride, subject of the 1912 painting whose central form was transferred to the upper half of *The Large Glass*, had her roots in Symbolist types of femininity: carnal bride, spiritual bride and *femme fatale*. But Duchamp represents her as a pulsing mass of internal organs with hints of mechanical parts, an image which harks back to Leonardo da Vinci's drawings of copulation and the female womb, in a partly humorous reflection on male fascination with female mystery masking a desire to appropriate its procreativity. Curiosity disguises envy rather than lasciviousness. In *The Large Glass* this takes on another dimension, as the Bride's identity merges with that of the Virgin Mary, who gave birth to Christ parthenogenetically: the Son born without a father. His miraculous conception could thus offer, in a spirit of humorous blasphemy, a potentially reversible prototype for the masculine fantasy. Moreover, Duchamp remarked that 'Christ' was also linked to the idea of 'stripping', for He, too, was stripped, thus conflating iconoclastically male and female eroticism.[30]

Paradoxically, then, the logic of oppositions can produce a

172
MARCEL DUCHAMP
Bride 1912
Oil on canvas
90.2 x 53.3 cm
Philadelphia Museum of Art,
Louise and Walter Arensberg Collection

fig.173
MAN RAY
Rrose Sélavy 1921
Gelatin silver print
17.5 x 12.5 cm
Jacqueline Matisse Monnier

fig.175
MAN RAY
Rrose Sélavy c.1924
Gelatin silver print on paper
21.7 x 17.9 cm
Private collection

fig.174
MAN RAY
Rrose Sélavy 1921
Sepia-toned print on paper
14.9 x 11 cm
Private collection

176
MAN RAY
Rrose Sélavy c.1924
Gelatin silver print
13.5 x 10.7 cm
Private collection

destabilisation of gender, as meanings and identities multiply and oscillate. But more radical interrogations and even denials of sexual difference were to follow: the reversible masquerades of Rrose Sélavy; the ambiguities in Man Ray's photographic portraits; the complexities of same-sex desire in the poetry of Valentine Penrose or the work of Claude Cahun; confusion of conventional attributes and values as in Joyce Mansour's 'virile woman or veiled man'. To loosen the principle of identity 'like a bad tooth' was their aim.[31]

Both Man Ray and Duchamp experimented with cross-dressing before the camera, but Duchamp did so in the context of a carefully worked out female persona, Rrose Sélavy ('Eros, c'est la vie', or 'Eros, that's life'). The first group of photographs by Man Ray of Rrose Sélavy of 1921 are somewhat grotesque, but Duchamp nonetheless used one for his 'assisted readymade' *Beautiful Breath, Beautiful Water*, so that it becomes a hallmark of female luxury. The second series of photographs of *c.*1924 are far more successful in conveying an aura of femininity: hat, fur, make-up and hands (belonging to Picabia's companion Germaine Everling) combine to produce a seductive portrait resembling those of film-stars and actresses, mementoes for an admirer.[32] With Rrose Sélavy Duchamp activates a dialogue with the ever-renewed 'New Woman' of the time. In Victor Margueritte's best-selling novel *La Garçonne* (1922) Monique flees her bourgeois home and looming marriage; she cuts her hair and opens a successful interior design shop, becoming part of an avant-garde of actors, artists and dancers. Although not an '*homme-femme*', she does temporarily defeminise herself in order to move freely. She crosses the gender boundaries that structure her background, and meets Fourierist academics such as Dr Vignabos, who argues that, 'If the natural desires of women had not been suppressed for centuries, there would be more sexual balance in the world'.[33] The imbalance exacerbated the effects of

fig.177
MARCEL DUCHAMP
Beautiful Breath, Beautiful Water 1921
Perfume bottle with label created by Duchamp and Man Ray in an cardboard box
16.3 x 11.2 cm
Yves Saint Laurent – Pierre Bergé

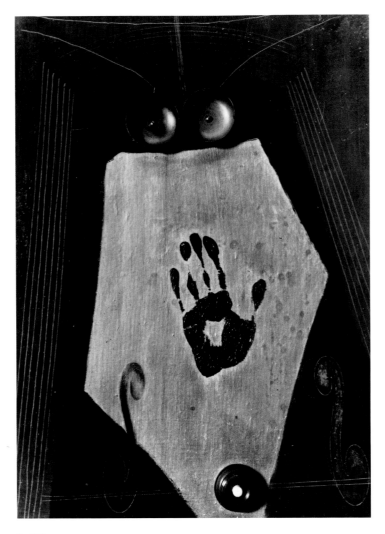

fig.178
MAN RAY
Self-Portrait 1916
Gelatin silver print
28 x 20.5 cm
Private collection

fig.179
MAN RAY
Photograph reproduced in
Photographs by Man Ray
1920–Paris 1934 1934

fig.180
MAN RAY
Barbette Dressing 1920s
Gelatin silver print
10.5 x 7.5 cm
The Metropolitan Museum of Art,
New York. Ford Motor Company
Collection, Gift of Ford Motor
Company and John C. Waddell,
1987

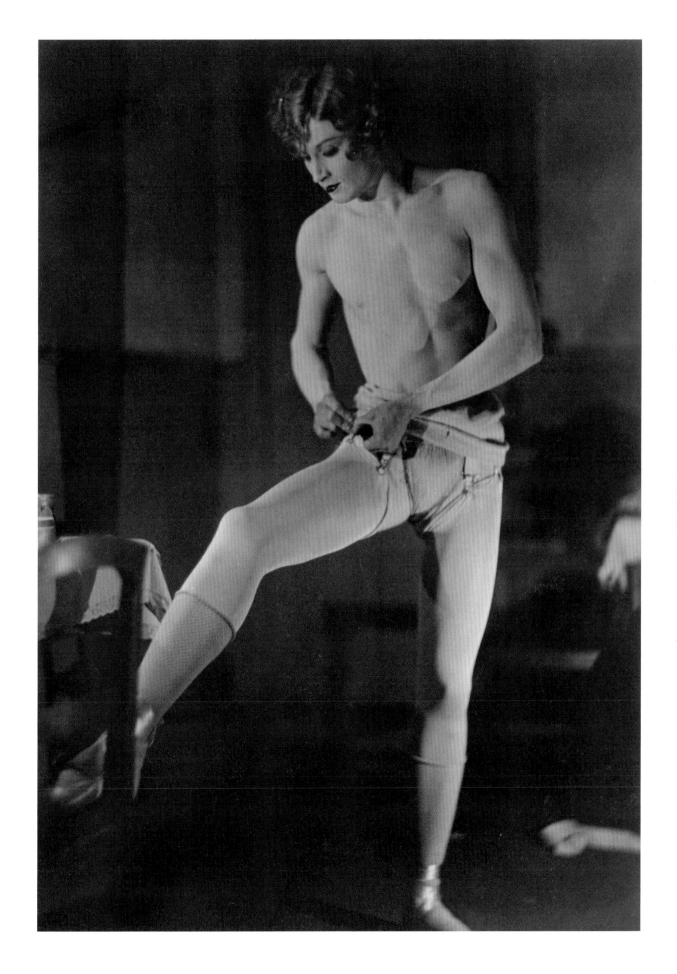

sexual difference: 'In our time it is this discordance between feminine idealism and male brutality which has engendered the sexual anarchy which prevails.'[34] Rrose Sélavy takes the female masquerade to its furthest point; while the New Woman or Bachelor Girl would take their sexual life into their own hands in a form of empowerment, Rrose Sélavy seems in this set of photographs to invite the male gaze, and see what it is like to be an object of desire – coolly observing from the observed position.

In *Photographs by Man Ray 1920–Paris 1934* Man Ray further inverts and plays with gender categories. Dividing two of the carefully organised sequences of photographs is a strange text 'Men before the Mirror', accredited to, and possibly appropriated by, Rrose Sélavy.[35] Preceding it are close-ups of carefully accoutred women, some sexually ambivalent, culminating with that doyenne of the *femme-homme*, the writer Gertrude Stein. Facing her to start the second section is Man Ray himself with his camera, and the subsequent series of male portraits ends with the female impersonator Barbette. 'Men Before the Mirror' exposes male vanity and insecurity as 'they stare at the landscape which is themselves, the mountains of their noses', as 'the mirror looks at them'. 'What is most poignant in the text', writes David Hopkins, 'is the way that the conventionalised image of the strong, outward looking male is deconstructed in favour of an evocation of male self-reflexiveness and insufficiency. This in turn is predicated on an unusual view of men as peculiarly prone to self-objectification; to a paralysing internalised rift between self-image and body image.'[36] As in Magritte's montage *I Do Not See …*, the active, purposive male is substituted by a passive, uncertain dreamer.

Photography was one of the most fruitful allies in surrealism's exploration of desire. The human body and human face, massively enlarged through close-ups, dislocated from one another and left separate or recombined across a single surface become the intimate coinage of surrealist photography's examination of inter-subjective spaces and sexual ambiguities. The camera lens in the service of surrealism is a mobile agent which alters and displaces its objects, blurs clear-cut identities and contracts and expands space. Its natural affiliation with the mirror opened up new forms of dialogue with self-images.

Claude Cahun challenged 'the verities of sexual difference' in her photographs and photomontages, in her book *Aveux non avenus*, and in her objects.[37] Her relationship with surrealism, however, has come under scrutiny in the context of her lesbianism and the perceived insistence by surrealism on heterosexuality. This reopens the wider issue of surrealism's attitude to homosexuality, and the assumption that surrealism spoke and was perceived as speaking with one voice about it. Breton's notorious dismissal of the subject in the 'Recherches' of 1928 is always cited, but the full transcript shows a strong case put by Aragon for the discussion of 'all sexual inclinations', and attitudes ranging from enthusiasm through indifference to violent objection.[38] The range of surrealism's investigations of sexual identity and the operations of desire, in poetry and photography especially, must raise doubts about the assertion that 'the surrealists opposed heterosexual freedom to bourgeois repression' and that their 'antibourgeois sentiments – at least in the realm of gender and sexuality – sustained the dichotomies between heterosexuality and homosexuality, pure and impure, and fantasy and reality they sought in theory to challenge.'[39] Breton may indeed have subscribed to the view, traceable back to Fourier, that bourgeois moral values produced vice (adultery, prostitution, betrayal and double standards) but like Fourier surrealism did not oppose

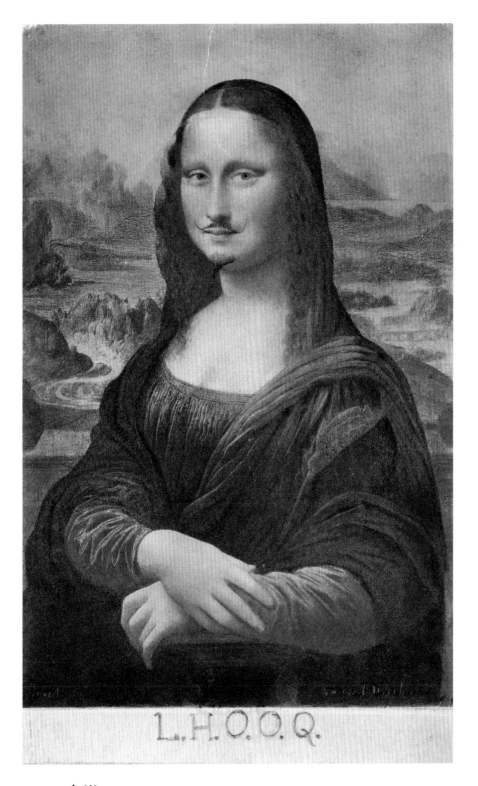

fig.181
MARCEL DUCHAMP
L.H.O.O.Q 1919
Pencil on photographic reproduction
19.6 x 12.3 cm
Private collection

this to a 'pure' heterosexual love, but rather opened up radical questions about the 'normal' and fixed poles of sexual identity. To distance on these grounds Cahun's work from surrealism when it so evidently inscribes itself within it at many levels is to resort to an essentialising view of surrealism which its experimental practice denies.

In the photomontage heading the second section of *Aveux non avenus* (1930): 'Myself. The Siren Succumbs to her own Voice', there is a mirror reflecting a half-veiled face; the mirror/window becomes the trope through which she explores and criticises the myth of Narcissus:

> Sash window.
> Glass sheet. Where shall I put the silvering? On this side or the other; in front of or behind the pane?
> In front. I imprison myself. I blind myself. What does it matter to me, Passer-by, to offer you a mirror in which you recognise yourself, even if it's a deforming mirror and signed by me …
> Behind. I am equally shut in. I shall know nothing of the outside. At least I shall know my own face and perhaps it will be tolerable enough to please me.
> Leave the glass clear, and according to chance and the hours see, confused and partially, sometimes fugitives and sometimes my own look.
> Then, break the glass panes … with the fragments, compose a stained glass. Byzantine work!
> Transparency, opacity. What a vow of artifice![40]

There is a difference between Narcissus and her own self-love: 'The death of Narcissus always seemed to me the most incomprehensible. There is only one explanation: Narcissus did not love himself. He allowed himself to be deceived by an image.'[41] He fails to recognise himself beyond the mirage in the water/mirror, which could just as well have been a nymph. The image of the 'other' forecloses the convulsive and simultaneous recognition and loss of identity: on the one hand, 'Self-love. A hand clenched on the mirror – a mouth, palpitating nostrils – between swooning eyelids, the mad gaze of enlarged irises';[42] and on the other, a dispersal of the self in all of nature. The photomontage seethes with sexualised visual metaphors: eye,

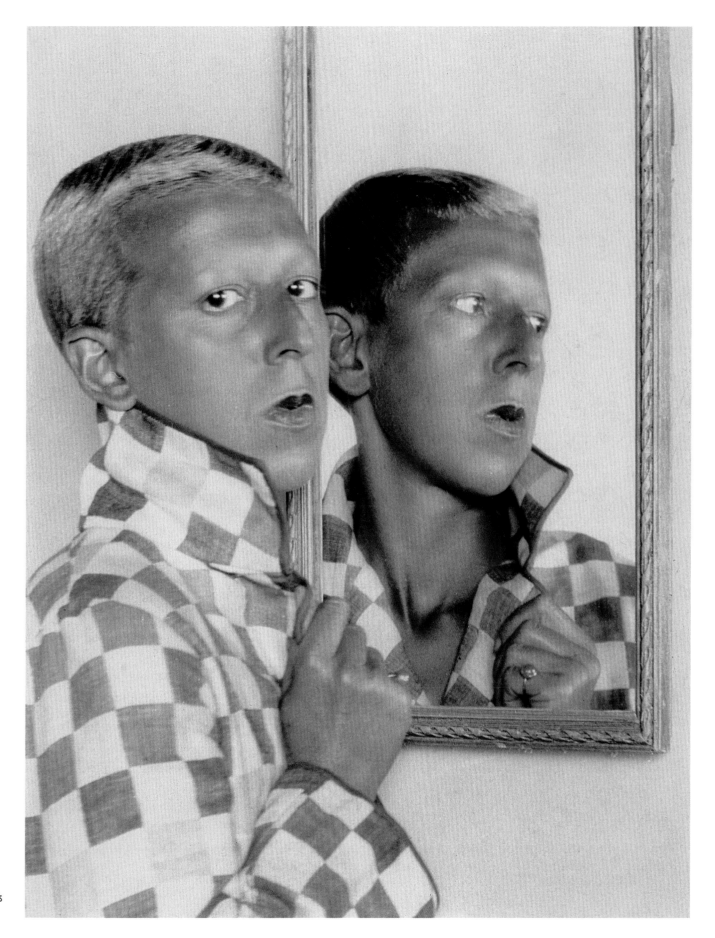

fig.182
CLAUDE CAHUN
Self-Portrait 1928
Gelatin silver print
30 x 23.5 cm
Musée des Beaux-Arts
de Nantes

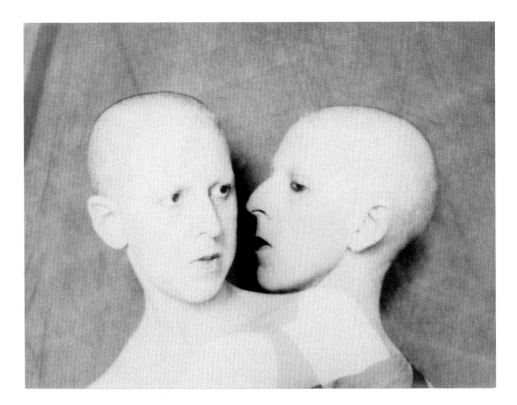

fig.183
CLAUDE CAHUN
What Do You Want From Me? 1928
Gelatin silver print
23 x 18 cm
Private collection

fig.184
CLAUDE CAHUN
Self-Portrait 1929
Vintage photograph
14 x 9 cm
Private collection

fig.186
CLAUDE CAHUN
Self-Portrait c.1927
Vintage photograph
14 x 9 cm
Private collection

fig.185
CLAUDE CAHUN
Self-Portrait c.1927
Vintage photograph
23.5 x 17.5 cm
Private collection

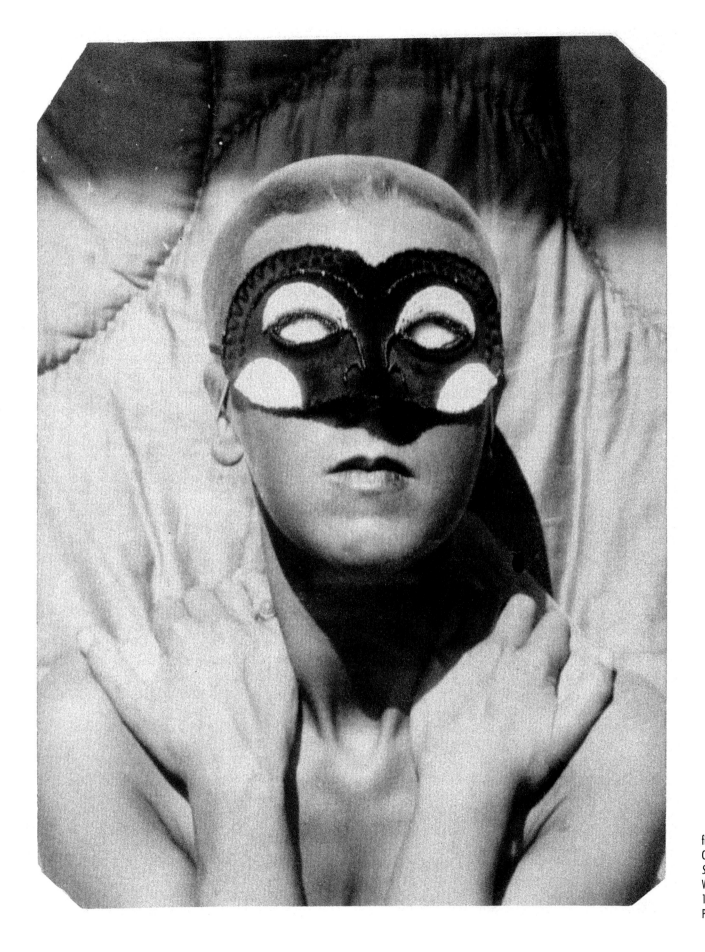

fig.187
CLAUDE CAHUN
Self-Portrait 1928
Vintage photograph
17.4 x 13 cm
Private collection

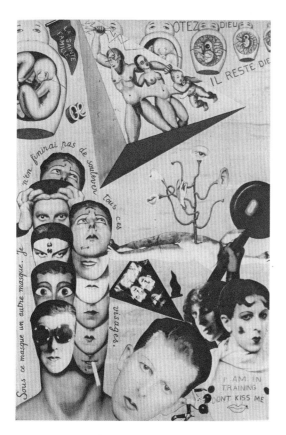

fig.188
CLAUDE CAHUN AND MARCEL MOORE
Illustration in *Aveux non avenus*
1929–30
Private collection

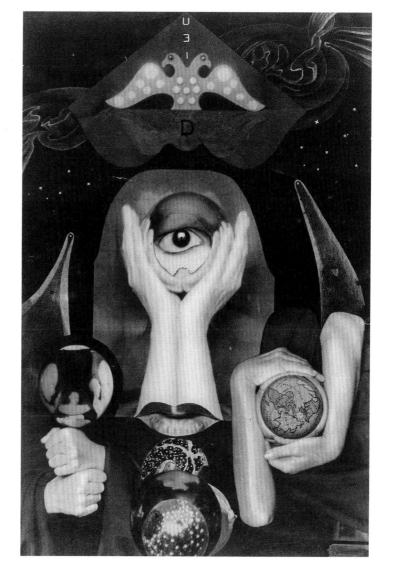

fig.189
CLAUDE CAHUN
Untitled (for 'Aveux non avenus')
1929–30
Vintage photograph
51.9 x 35.1
Private collection

parted legs, and an arm doubled up and squeezed together are all inscribed with the form of the female sex.

Cahun's photomontages are frequently elaborations on her own photographic self-portraits. In one photomontage from *Aveux non avenus,* Cahun includes among the self-portraits a column of overlapping heads showing only eyes or mouths, with the inscription: 'Under this mask another mask. I shall never finish stripping away all these faces' (fig.188). Unlike Rrose Sélavy's reversible masquerade, Cahun dissolves herself into a never-ending series of masks that have no 'real' underneath. These are not so much disguises as adoptions of the socially imposed shells of feminine or masculine identities (like the doll-woman) which need first to be displayed in order then to be stripped.

Cahun's attacks on the 'myth of the family', motherhood and the church, for example, as in the photomontage introducing the ninth and final section of *Aveux non avenus* entitled 'I.O.U. One Has the God one Deserves, Too Bad', are obviously identical with surrealist concerns. The question as to whether it is a specifically lesbian desire that is articulated by Cahun has been raised.[43] If the dialogue with Narcissus – who following Freud's analysis, was widely accepted as the signifier of homosexual identity – would indicate the wish to differentiate between male and female same-sex desire, Cahun also stages Oedipal conflict in her work (Oedipus was another of the myths she taunts and tests in *Aveux non avenus*). Whereas reversibility, as in Man Ray's photographs, maintains difference in play, Cahun 'disturbs the normal terms of sexual difference, both recalling and refusing castration'.[44] Here the idea of any stable identity is resisted, and the uncanny doubles that figure in several of her manipulated photographs, as in the photomontages from *Aveux non avenus,* have been described as a way of producing herself as a fetish. She does this in a conscious spirit of parody. 'Through the trope of the body double, Cahun uses substitution not simply to trouble or transgress binary distinctions between genders, but to deprive those distinctions (and hence the relationship between gender and sexuality) of a referent even as she (again parodi-cally) leaves them intact … The parody permits her to remain happily and benignly castrated, to "be" the phallus in order to escape the economy of meaning organised round the phallus.'[45]

Parody is an important mode within surrealism; as an always debased aesthetic, it serves to bring down the myths of,

fig.190
SALVADOR DALI
Couple with their Heads Full of Clouds 1936
Oil on panel
Two panels: 92.5 x 69.6, 82.5 x 62.5 cm
Museum Boijmans Van Beuningen, Rotterdam

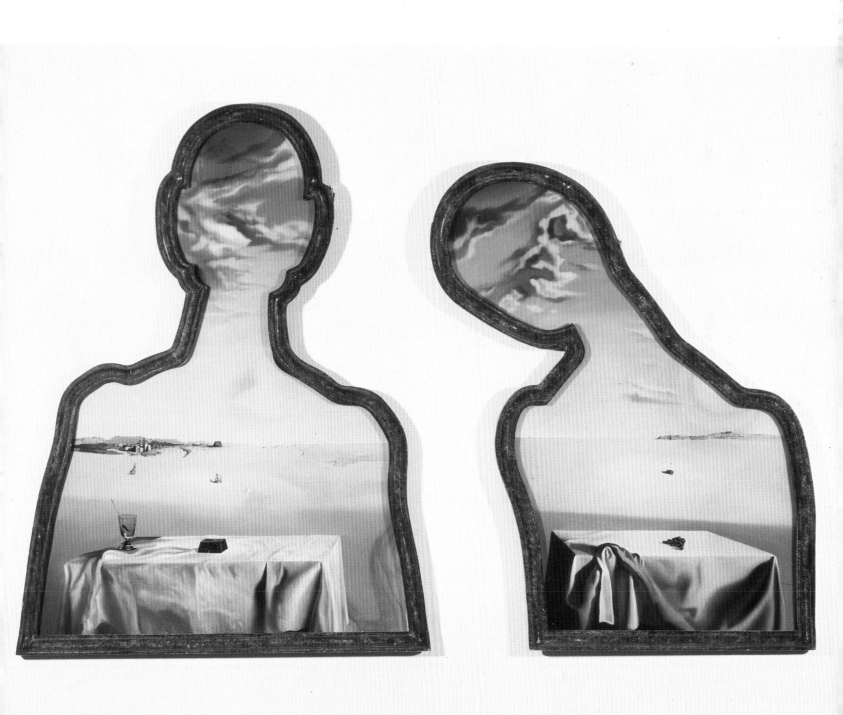

and the myths created by, a transcendental notion of art and culture. Because it occludes a 'true' authorial voice without substituting even a fictional alternative, it is peculiarly apt for the refusal of fixed meanings, and the production of uncertain laughter. 'It seems likely that the surrealism of creative women, if it thinks itself subversive, passes via a revision of the new clichés of subversion, by a subversion of the 'masculine' surrealist subversion,'[46] Marie-Clare Barnet has written. Cahun subverts the notion of castration anxiety, revealing it as a cultural myth. The poet Joyce Mansour parodies the celebration by the male surrealists of the hysteric's 'passion', itself subversive of the supposed clinical detachment of doctor and patient.[47]

Parody is a form of subversion, but only one of the modes through which men and women artists responded to the sexual anarchy produced in part by the rift between socially acceptable forms of sexuality and the dramatic revelations of psychoanalysis regarding such issues as child sexuality. If psychoanalysis itself led to renewed exclusions of women from the symbolic order of patriarchy, surrealism and its artistic legacies have helped to keep the routes open to the expression, if not the solution, of the riddle of gender, sexuality and love.

This self-portrait, painted on the occasion of her thirtieth birthday, was on her easel when Max Ernst visited Dorothea Tanning for the first time, in the course of a tour of New York studios to select an exhibition of work by women painters. Discovering not only a gifted artist with an intelligence, pride and curiosity to match his own, already working in a surrealist manner, but also a chess player, he soon came to stay. To a collector visiting the couple shortly after, Ernst announced that the painting was not for sale. 'I want to spend the rest of my life with Dorothea. This picture is part of that life.' Tanning tells this anecdote in her memoirs, also entitled *Birthday*, the name Ernst had given the self-portrait.

In her memoirs she tells of the painting's origin in her fascination with the array of doors in the six almost empty rooms of her apartment, their imminent opening and shutting and potentially endless extension. Like the surrealists' favourite image of the labyrinth, the doors and hidden rooms symbolise an inner as much as an outer unknown, the chambers of the unconscious mind. Her gaze and her posture, holding a door knob with one hand and looping up the folds of a skirt with the other in a gesture that recalls the female figure in Jan van Eyck's painting commonly known as *The Arnolfini Marriage* (1493), express both anticipation of an unknown future and fear of the void. The bare geometrical setting is the perfect foil for her elaborate self-image, with its odd conjunction of protective layers and erotic exposure, wholly modern face and hair and antique or fairytale garb. A theatrical, possibly male, royal purple and gold jacket with lace cuffs reveals her breasts, while tangled roots and twigs resembling mistletoe, but containing writhing couples, partially encase her, like the brambles round the Sleeping Beauty or the bush into which the nymph Daphne was transformed. It is as though she is trying out myths of nature and of culture and none is quite cut to her figure. At her feet is a composite creature, a lemur with wings. The lemur is a nocturnal animal found only in Madagascar, where it has long been associated with night and spirits of the dead.

In *Birthday* Tanning represents herself poised, and as if in a dream, on the eve of a discovery, perhaps about to take flight on this night creature. One should not overlook the unusual adoption, in the context of a budding surrealist who was to go on to great pictorial audacity, of a transparent naturalism: there is nothing, formally speaking, to disturb the scene. Figures and objects are to scale; there is neither distortion nor disruption of space, nor the free gestures of automatism. The realism is neither photographic, nor rudimentary, nor naive, nor exaggerated to mimic nineteenth-century academic painting. This makes its evocation of a world beyond the immediate senses all the more mysterious and effective. DA

fig.191
DOROTHEA TANNING
Birthday 1942
Oil on canvas
102.2 x 64.8 cm
Philadelphia Museum of Art. Purchased with funds
contributed by Charles K. Williams II, 1999

Mira que si te quise, fué por el pelo,
Ahora que estás pelona, ya no te quiero.

Frida Kahlo was her own favourite subject. Over and above the self-portraits, she used her own image in imaginary or symbolic scenarios to represent the experiences, desires and sorrows of her tumultuous life. *Self-Portrait with Monkey* and *Self-Portrait with Cropped Hair* were painted during the year of her divorce from Diego Rivera (they remarried at the end of the same year, 1940). The mood of *Self-Portrait with Cropped Hair* is both angry and forlorn; in retaliation against Rivera she has cut off the long hair he loved, stripped herself of all feminine adornments save earrings and shoes, and donned an outsize masculine suit. The shorn hair horrifically multiplies as though uncannily alive across the barren landscape.

The step from the reality of her body to a world of the imagination, of signs and symbols was easy for Kahlo. Unfettered by either the didactic realism of the Mexican muralists or the formal concerns of modernism, she forged a unique style out of her various sources: the stiff but charming regional academic painting of nineteenth-century Mexico, and popular art, especially retablos. These small, naive, usually anonymous paintings depicted scenes of miraculous recovery from sickness or danger, with a written dedication to the saint in whose shrine it would be hung. *Self-Portrait with Cropped Hair* uses this device but transposes the dedication into a mock popular song, recording loss rather than salvation.

Although conceived in ignorance of their ideas, Kahlo's work appealed instantly to the surrealists. For her 1938 exhibition at the Julien Levy Gallery in New York, Breton wrote a preface romantically linking Kahlo with Mexico's prodigal natural beauty: 'adorned like a fairy-tale princess, with magic spells at her finger tips, an apparition in the flash of light of the quetzal bird which scatters opals among the rocks as it flies away.' Her paintings combine child-like directness with a sophisticated exploration of 'the eye's capacity to pass from visual power to visionary power'.

Kahlo's self-portraits are as highly composed as her own elaborately adorned image. However, rather than depicting herself as artist-subject in the act of painting, her trope is the mirror; the painting itself becomes the mirror device, and sometimes she added a brightly coloured border like those of Mexican tin mirrors. In *Self-Portrait with Monkey* she wears a blood-red ribbon that winds through her hair and round her neck. Hayden Herrera in *Frida: A Biography of Frida Kahlo* (1983) suggests that the ribbon links her 'as a metaphoric blood-line' to a pet spider monkey whose paws embrace her: pets increasingly took the place of the children she could not have. She scrutinises the two faces, one almost human, her own slightly masculine, with heavy black brows meeting like a bird's wings, and faint moustache. Her own calm proud stare and the monkey's dignity mask a sense of danger and wilderness.

The ribbon also echoes Breton's comment in 1938: 'There is no art more exclusively feminine, in the sense that, in order to be a seductive as possible, it is only too willing to play alternately at being absolutely pure and absolutely pernicious. The art of Frida Kahlo is a ribbon around a bomb.' DA

fig.194
LEONORA CARRINGTON
Cat Woman 1951
Painted wood
201.9 cm high
Private collection

fig.195
LEONORA CARRINGTON
The Pleasures of Dagobert 1945
Egg tempera on masonite
74.9 x 86.7 cm
Private collection

In 1942 Leonora Carrington settled in Mexico where she joined Remedios Varo and the poet Benjamin Péret. Within the small surrealist group a close, collaborative friendship grew between the two women, who shared an interest in alchemy, magic and the strange potions on sale at the witches' market in Mexico City.

In Carrington's *The Pleasures of Dagobert* distinct episodes, each with their own landscape, co-exist in a beautifully orchestrated cellular composition. As in Hieronymus Bosch's *The Temptations of St Anthony* (c.1500), separate incidents and actions occur simultaneously. Whereas some surrealists, such as Roberto Matta, had evoked the mysterious recesses of the unconscious in more abstract, automatist paintings,

Carrington portrays here, with the luminous clarity of her egg tempera technique, complete imaginary worlds. Dagobert was a Merovingian king who ruled Gaul in the early seventh century. Popularly remembered as a king whose taste for sexual excess was matched by a love of luxury, his reign constituted a high point in Merovingian culture.

The different landscapes correspond to the four elements of alchemy and medieval natural history: earth, air, fire and water. There is a definite rhythm to their placings: the dry, ghostly extinct volcanoes of the Valley of Mexico are juxtaposed on one side with a lake of fire engulfing an inverted idol, and on the other with a watery world where a hairy giant with a double animal head holds out a human-faced puffer fish. Trans-

formations, of the elements, of human, animal, plant, of animate and inanimate, occur at every point. The dark interior of the flying boat becomes a black figure, shadow and alter ego of the pale goddess within it, her hair spreading upwards to become the meshes of an aerial fishing net. At the centre the old bearded king is led by a child, horse and carriage miraculously elided. Female figures alone, white as the moon, traverse the different regions. Towards the centre of the painting a floating figure supports on her head a star-eyed fish with deer's horns, a memory of the Sacred Deer still worshipped in parts of Mexico. These visions are not only inspired by legend and myth, but also perhaps by Carrington's own experiences of a supernatural acuity during her breakdown,

described in *Down Below*, first published in 1944: 'I was an androgyne, the Moon, the Holy Ghost, a gypsy, an acrobat, Leonora Carrington and a woman.'

Cat Woman stands with her elegant hands poised, in a delicate parody of Alberto Giacometti's *Invisible Object*, at her groin (see fig.54). She is painted with scenes of human-animal encounters, shamanic identifications recalling the man-jaguar transformation of Pre-Columbian America. On her legs two figures wrapped in cocoons echo in their positions the forms of the cat woman's thighs, whilst the position of their feet, pointing towards her sex, evoke a link between their potential metamorphosis and her sexuality. DA

GH

... ON AND VEILING IN SURREALIST PHOTOGRAPHY: WOMAN AS FETISH, AS SHATTERED OBJECT, AS PHALLUS

Hal Foster

veryone knows that the surrealists preached the liberation of desire. But most surrealists were men, and men came first in this liberation. They included women, to be sure; indeed, this liberation focused on women, but as *sites* of desire more than as *subjects* of desire; woman were asked to represent it more than to inhabit it. This becomes clear enough when we turn to surrealist photography, which is dominated by portraits and nudes of women. Many of these images present versions of femininity that, whatever the rhetoric then, can only be seen as restrictive now, such as woman as erotic object (these are legion in surrealist painting, poetry, and prose as well) or, conversely, woman as Medusan threat (a 1930 close-up by Jacques-André Boiffard of a wild-eyed woman caged by her own snaky hair sticks in my mind). Manipulated in various ways, such photographs may appear strange formally, but often they are familiar psychically, for most of these images position women as 'objects of the male gaze' (the feminist formula holds true here). Yet sometimes too these photographs display an ambiguity, or otherwise disclose an ambivalence, that cannot be so neatly understood, as when this gaze is returned by the woman, as if it were refused. (In the Boiffard portrait, for example, 'the male gaze' is suffered, but it is also thrown back, and her subjection turns into our challenge.)

This doubling of the gaze may only increase the anxiety that many of the images appear to treat. Freud tells us that this anxiety derives from a threat that is specifically associated with woman, with the 'castration' that her body is said to signify to the boy/man. To this hypothetical male the woman lacks a penis, and he imagines that this lack may be visited upon him as well, perhaps somehow at her hand.[1] Sometimes, according to Freud, this fear about loss is registered as an anxiety about blindness, and numerous portraits of woman with distorted eyes (enlarged, split, and so on) suggests that some surrealists made this association as well. Man Ray perfected this fantasy image of woman as castrative Medusa in his 1930 portrait of the Marquise Cassati, a surrealist patron whose eyes, through double exposure, are made to appear both severed and severing.

There is, then, a castrative aspect in many surrealist *portraits*. The relevant photographs provide evidence enough, but this hypothesis is further supported by a complementary tendency that is more pronounced: the fetishistic aspect of many surrealist *nudes*. Often these nudes are cropped or otherwise manipulated in a way that turns the female body into a semi-penile form, a near fetish-image, as in the well-known nude by Brassaï of 1933, in which the head and legs of the woman are lost from view, the buttocks and back turned, and the truncated body illuminated, so that it seems to float in space as this apparition. There are many examples of such photographic transformation in the work of Man Ray, André Kertész, and others; and women like Lee Miller played with this fetishistic form as well, just as they did with the semi-sexist types of woman mentioned above – an indication that these types insisted across gender lines.[2]

According to Freud, the fetish is one response to the traumatic sighting of castration in which the boy/man turns to an often penile object in order to disavow the lack of the penis in the female body, as if to say

fig.196
GEORGES HUGNET
Untitled 1961
Collage
23.8 x 19 cm
D. Grandsart –
Galerie Obsis, Paris

fig.197
LEE MILLER
Nude Bent Forward c.1931
Gelatin silver print
20 x 17.5 cm
The Art Institute of Chicago, Julian Levy Collection,
Gift of Jean Levy and the Estate of Julian Levy

fig.198
BRASSAI
Nude 1931–2
Gelatin silver print
28.3 x 41.1 cm
Courtesy Edwynn Houk Gallery

'*it* is not really gone as long as I have *this*'. The great trick of some surrealist photographs that evoke this traumatic sighting is that they reshape the very body that is said to signal the threat of castration into a fetishistic form that may defend against this same threat. But the transformation is rarely complete. In the manner of some fetishes described by Freud, many images seem to acknowledge castration even as they appear to disavow it, and sometimes they do so in the same act, as when the cropping that reshapes the body into fetish-form simultaneously marks it with a castrative cut (this occurs in the 1933 nude by Brassaï, for example). In such cases, as Freud comments, the fetish as 'protection' against castration is also the fetish as 'memorial' to it. It is this ambiguity of form that seems to disclose an ambivalence of intent in the artist, as well to produce an ambivalence of affect in the viewer. Or at least in some viewers: wittingly or not, surrealist photography underscores sexual difference in spectatorship (which is not the same thing as sexual identity).

At this point a troublesome question arises concerning surrealist awareness of Freudian psychoanalysis, and it cannot be answered definitively.[3] Often surrealism appears illustrative of Freudian notions, it is true, but it can also run parallel to them, anticipate them, or even contradict them. Few surrealists read German, and French translations of Freud often came late (see p.58). Although Freud mentions fetishism early on, in *Three Essays on the Theory of Sexuality* (1905), his short text devoted to the subject dates to 1927, and it likely did not influence these surrealist photographs directly. My own view is that the most effective of these images are not illustrative of psychoanalytic notions, and the same answer holds for the photographic devices that they develop. The most effective of these devices – close cropping, extreme angles, raked lighting, mirror distortions, double exposures, montage and solarisation – are not contrived to stage psychoanalytic notions given beforehand. Sometimes these devices appeared almost by accident, as if they were found, indeed, as if they were instances of 'objective chance' (to use the surrealist term). Yet, paradoxically, this 'marvellous' accident made these devices all the more pointed and personal as expressive mediums of psychic conflict.

Again, the tension between surrealist woman-as-castrative and woman-as-fetish can be finessed, as when the castrative body is reshaped into a fetishistic form, but it cannot be resolved absolutely, for these types remain contradictory at bottom. And so we often see in such surrealist photography an oscillation between images in which, on the one hand, the anxiety provoked by woman is somehow expressed or flaunted, and, on the other hand, somehow deflected or contained. This oscillation between castrative and fetishistic visions of women is most intense in the doll photographs of Hans Bellmer, and when he attempts to arrest it through a near-impossible conflation of the two types it becomes all the more volatile.

Made of wood, metal, plaster pieces, and ball joints, the two principal sets of *poupées* were often manipulated in drastic ways and photographed in extreme positions. Ten images of the first doll were published in *Die Puppe* (1934), and a suite of eighteen photographs followed in *Minotaure* (no.6, Winter 1934–5) under the title 'Variations sur le montage d'une mineure articulée'. For Bellmer these 'variations' of the first *poupée* produced a volatile mixture of 'joy, exaltation, and fear', an ambivalence that sounds fetishistic in nature.[4] Bellmer did not discourage this reading: in 'Memories of the Doll Theme,' the introductory text of *Die Puppe*, he describes the first doll as a talisman with which he hoped to recover 'the enchanted garden' of childhood, a familiar trope for a

pre-Oedipal moment before any impression of castration or other loss. Apparently, however, his ambivalence of 'joy, exaltation, and fear' was too intense to be contained by this trope, too intense *not* to be acted out on the doll, for the *poupée* hardly exists in 'the enchanted garden' of childhood, unless we rethink this childhood as riven by an outrageous sexuality.

The second *poupée*, even less anatomical than the first, makes this fetishistic manipulation even more manifest, for this doll consists of tumescent body-parts that are perversely repeated, aggressively conjoined, and obsessively transformed. What Freud writes of 'Medusa's Head' in his short essay of 1922 seems true of the second *poupée* as well: in its various decapitations a castration anxiety appears to be in play, while at the same time a fetishistic 'multiplication of penis symbols' – in the snaky hair of the Medusa, in the tumescent body-parts of the doll – works to counter this anxiety. And yet, as Freud also suggests, this fetishistic multiplication may only stress the very castration that it is intended to deny.[5] In 'Corpus Delicti,' her seminal text on surrealist photography, Rosalind Krauss makes this same allusion to Freud, and her paradoxical description of the construction of the doll as a *dis*memberment captures its contradictory embodiment of the castrative (in the disconnection of its parts) and the fetishistic (in the often penile appearance of these parts).[6] That this formal conjunction does not suffice as a psychic resolution may be inferred from the fact that Bellmer was often led to pose the second *poupée* in sadistic tableaux – in scenes that sometimes evoke the aftermath of child abuse, rape, or murder.

Bellmer often investigates the first doll with apparent cruelty too. In 'Variations sur le montage d'une mineure articulée,' there is no clear narrative of construction, let alone resolution of desire; rather, we witness the poupée in various states not only of *déshabillé* but of disassembly. Indeed, like the little Hans analysed by Freud in 'Analysis of a Phobia in a Five-Year-Old Boy' (1909), this old Hans seems to violate the doll so as to expose the signs of gender and/or the mechanics of birth.[7] Here, rather than denied fetishistically, it is as though castration were openly staged, even aggressively prosecuted, with the *poupée* also punished for the damaged condition that she is made to represent. (In one photograph in 'Variations sur le montage' the doll appears punished to the point of a disarticulation that is documented almost forensically.) As with the fetishist according to Freud, so with Bellmer here: erotic delight seems mixed with 'horror at the mutilated creature or triumphant contempt for her.'[8]

Yet we should not be too quick to pathologise Bellmer. First, these scenes are representations, not realities – a fact that some viewers still seem to overlook. Second, one finds similar scenes in the work of other surrealists, female as well as male. And, third, the subject implicated in these scenes, as elsewhere in surrealism, is not necessarily identical with the artist, and in any case the fantasies staged therein are driven by intentions that are difficult to determine. Yet, clearly, a sadism is inscribed in the dolls as much as a fetishism, and it is hardly hidden. Apart from these photographic records of imaginary misdeeds, Bellmer writes openly of a drive to master 'victims', and to this end he poses all his poupées very voyeuristically. With the first doll he goes so far as to design an internal mechanism filled with miniature panoramas as a means to 'pluck away the secret thoughts of the little girls'.[9] Obviously, then, a patriarchal fantasy of visual control is in play – visual control not only over creation but over desire as such. Although Bellmer may claim that other desires are figured here ('the secret thoughts of the little girls'), it is clear who the masterful is, and what the mastered object.

fig.199
HANS BELLMER
The Doll 1934
Gelatin silver print on original mount
30.3 x 19.3 cm
Ubu Gallery, New York, and Galerie Berinson, Berlin

Or is it? What is this desire exactly, and if it is so masterful, why does it require such a show of mastering? This show is so extreme as to be almost parodic, or at least pathetic, which suggests that Bellmer may not be totally in control after all. If the dolls were only about fetishism, one would expect a fixing of desire in particular details, but this is not strictly the case in the *poupées*: they enact a shifting of desire too, one that points to possible reversals of positions and vicissitudes of drives. In his essay on 'Instincts and their Vicissitudes' (1915), Freud argues that the voyeur may be an exhibitionist in disguise, and that the sadist may conceal a masochist within. Might this be true of Bellmer – or of the subject that he projects here? The scenarios of the dolls do stage a sadistic attack that seems to go beyond the female object to redound on the male subject. Might this shared shattering be the 'erotic liberation' that he seeks, and the 'final triumph' of the *poupées* that he claims?[10] Paradoxically, in 'Memories of the Doll Theme' Bellmer locates this triumph at the very moment that the dolls are 'captured' by his gaze. How are we to understand this excessive entanglement?

One way to begin is to posit a masochistic subtext in the sadistic staging of the *poupées*. 'I wanted to help people,' Bellmer remarked in retrospect, 'come to terms with their instincts.'[11] Here we should take him at his word, I think, for the dolls do stage some struggle between instinctual fusion and defusion – in his own words, between 'the innumerable integrating and disintegrating possibilities according to which desire fashions the image of the desired.'[12] According to the later Freud, there is, within each of us, a nonsexual drive to master the object that, when turned inward, is made sexual; when turned outward again, this drive becomes sadistic. Yet there remains, within each of us, an element of aggressivity that Freud calls an 'original erotogenic masochism.'[13] It is this difficult relay between sadism and masochism, erotogenic and the destructive, that the poupées evoke for me. For in his sadistic scenes Bellmer leaves behind masochistic traces; in his erotic manipulation of the dolls he explores a destructive impulse that is also self-destructive. In this way the dolls may go inside sadistic mastery to the point where the subject confronts its greatest fear: its own fragmentation and disintegration. And yet this may also be its greatest desire: 'All dreams return again to the only remaining instinct,' Bellmer writes, 'to escape from the outline of the self.'[14] Is this why he seems not only to desire the dolls but also, in some sense,

to *identify* with them, not only to (dis)articulate them sadistically but also, in some sense, to *become* them masochistically? In one photograph in 'Variations sur le montage d'une mineure articulée', Bellmer appears opposite the first doll less as its separate creator than as its spectral double. And the very notion of a 'montage' intimates a kind of splicing of subject and object, here a kind of suturing of Bellmer into the scenes of his *poupées*. Moreover, in his subsequent drawings of such 'minors', he often commingles his image with theirs. 'Should not this be the solution?'[15]

Again, the dominant model of the surrealist photograph is the fetish, as is most manifest in the aforementioned nudes where a phantom of the penis returns uncannily on the female body (even *as* the female body) that was imagined to lack it. Yet, as we have seen, this formal manoeuvre

fig.200
HANS BELLMER
The Doll c.1934
Gelatin silver print
25.3 x 32.7 cm
The Metropolitan Museum of Art,
New York. Ford Motor Company
Collection, Gift of Ford Motor
Company and John C. Waddell,
1987

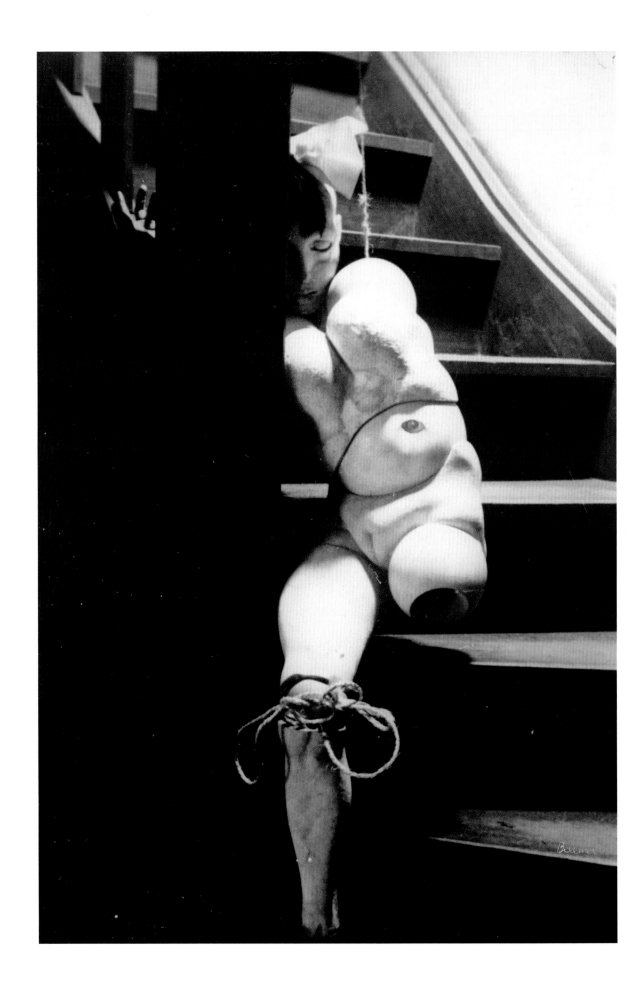

fig.201
HANS BELLMER
The Doll 1936
Hand-coloured gelatin silver print
73.7 x 50.8 cm
Herbert Lust Gallery

fig.202
HANS BELLMER
The Doll 1932–45
Painted wood, hair, shoes, socks
61 x 170 x 51 cm
Centre Georges Pompidou, Paris.
Musée national d'art moderne

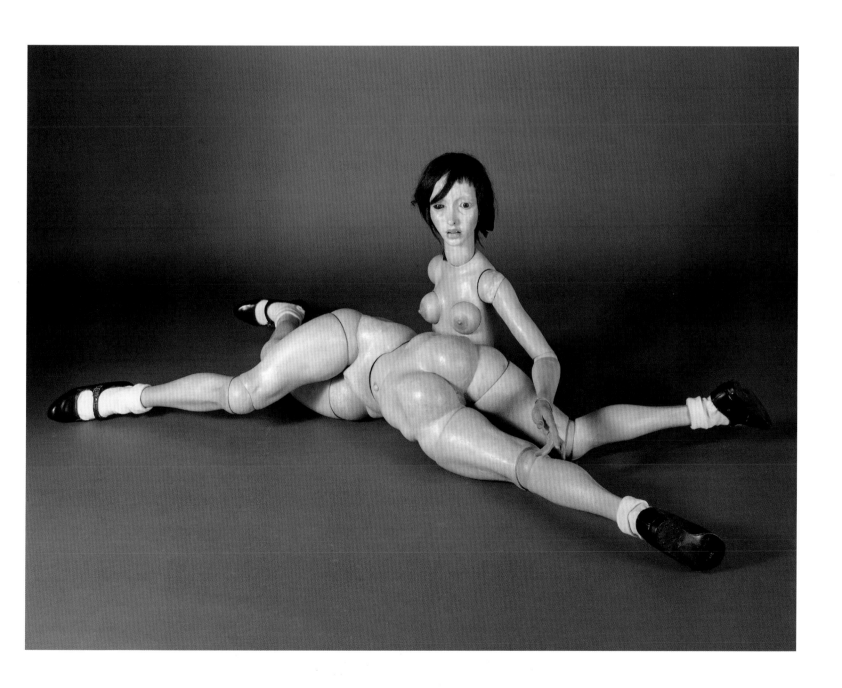

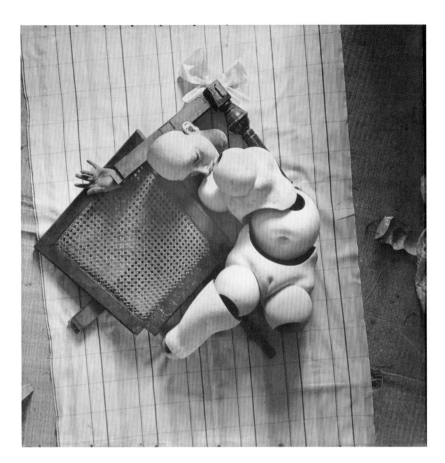

fig.203
HANS BELLMER
The Doll 1935
Hand-coloured gelatin silver print
66 x 66 cm
Claude Berri

fig.204
HANS BELLMER
The Doll 1935
Hand-coloured gelatin silver print
on original stretcher
66 x 66 cm
Ubu Gallery, New York, and
Galerie Berinson, Berlin

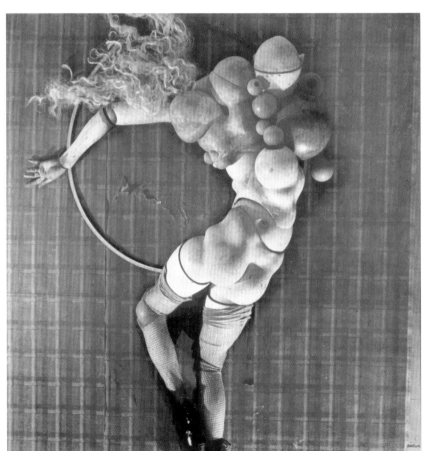

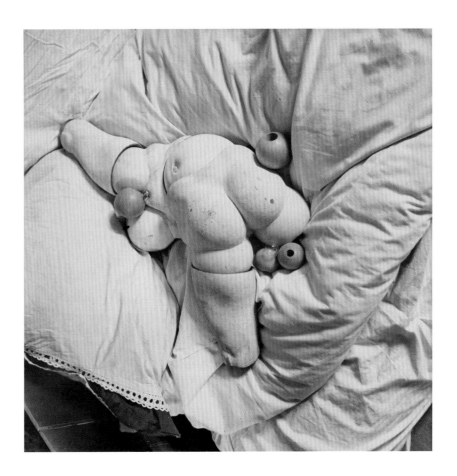

fig.205
HANS BELLMER
The Doll 1938
Gelatin silver print
66.4 x 65.1 cm
Claude Berri

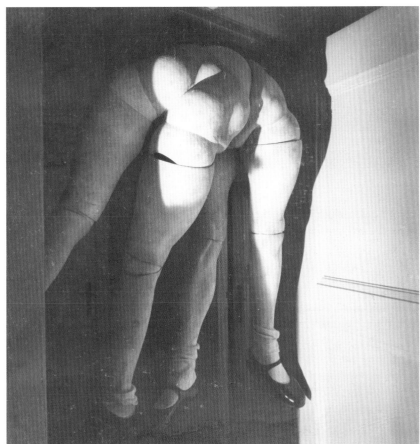

fig.206
HANS BELLMER
The Doll 1938
Hand-coloured gelatin silver print
66 x 66 cm
Ubu Gallery, New York, and
Galerie Berinson, Berlin

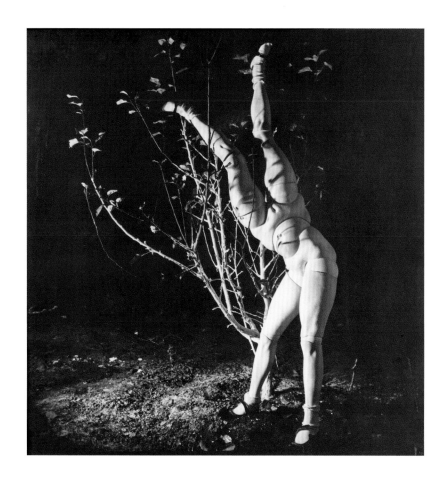

fig.207
HANS BELLMER
The Doll 1935
Gelatin silver print on stretcher
66 x 66 cm
Ubu Gallery, New York, and
Galerie Berinson, Berlin

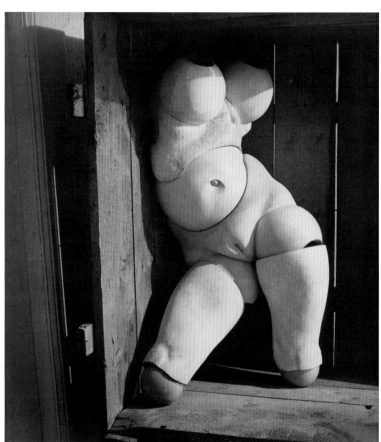

fig.208
HANS BELLMER
The Doll 1935
Gelatin silver print
67.3 x 63.2 cm
Claude Berri

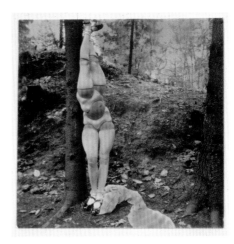

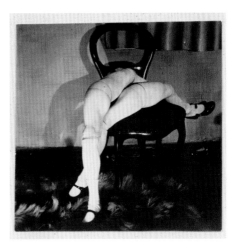

fig.209
HANS BELLMER
The Doll (Maquette for 'Les Jeux de la Poupée') c.1938
Hand-coloured gelatin silver contact print on original mount
5.4 x 5.5 cm
Ubu Gallery, New York, and Galerie Berinson, Berlin

fig.210
HANS BELLMER
The Doll (Maquette for 'Les Jeux de la Poupée') c.1938
Hand-coloured gelatin silver contact print on original mount
5.4 x 5.4 cm
Ubu Gallery, New York, and Galerie Berinson, Berlin

fig.211
HANS BELLMER
The Doll (Maquette for 'Les Jeux de la Poupée') c.1938
Hand-coloured gelatin silver contact print on original mount
5.5 x 5.3 cm
Ubu Gallery, New York, and Galerie Berinson, Berlin

is not a psychic resolution, and sometimes the fetishistic defence breaks down, an event that can release an aggressivity of the sort performed in the Bellmer dolls. In effect, these *poupées* elaborate the logic of the fetish to the point of collapse – to the point where this logic is both exposed and undone – and in this collapse of the fetish another logic of the object begins to emerge.

In the final analysis fetishism is a disavowal of sexual difference, a faltering at the threshold of the genital order in which such difference is established. Psychically, if it is not arrested with a fetish, this faltering may precipitate a fall from the genital order, in particular a regression to an anal order. Psychoanalysis has long understood this world as one not only of sexual indifference but of strange substitutions and odd equivalences in which the body never appears whole. According to Freud, the things (or tokens) that are 'ill-distinguished' in this world include faeces, babies, and penises.[16] With the second doll it is almost as if Bellmer wanted to add buttocks, breasts, and heads to this list. In *Compulsive Beauty* (1993) I argued that Bellmer performed this regression as an act of defiance against his Nazi father, as a gesture of assault on all phallic author-ity – paternal and political. Here, as the psychoanalyst Janine Chasseguet-Smirgel has remarked, the perversion of the dolls is precisely a *père-version*, a turning away from the father, a disavowal of his genital monopoly and a challenge to his pre-emptive law through 'an erosion of the double dif-ference between the sexes and the generations'.[17] This erosion is so scandalous because it exposes an archaic order of the drives, 'the undifferentiated anal-sadistic dimension'.[18] And it is this order of the drives, with its logic of part-objects, that Bellmer reveals, as it were, underneath the broken surface of the surrealist fetish.[19] In this way, if the first doll suggests a breakdown of the fetish with its fixed desire, the second doll suggests a release of the part-object with its wild associations – again, legs which are breasts, which are buttocks, which are heads…

In a later text titled *Petite anatomie de l'inconscient physique, ou L'Anatomie de l'image* (1957), Bellmer refers to the dolls as a 'dictionary of analogues-antagonisms'.[20] This trope also intimates less a fixing of desire in a fetish than a roaming of drives across part-objects. It is likely that he came to this notion of a bodily dictionary through the writing of Georges Bataille, in particular his *Histoire de l'oeil* (1928), which Bellmer illustrated in 1947. In a sense *Histoire de l'oeil* is what its title announces: the story of an object (an eye) that calls up first a set of similar objects (balls, breasts, eggs...) and then a set of liquid correlatives (piss, milk, yokes...). According to Roland Barthes, the transgression that we associate with Bataille is effected in the story when these two metaphoric lines cross metonymically, that is, when new encounters between part-objects and drives replace old associations, as in 'an eye sucked like breast.' 'The result is a kind of general contagion of qualities and actions', Barthes writes. 'The world becomes *blurred*'.[21] This blurring is fundamental to Bataillean eroticism: it is a somatic transgression, a crossing of the limits of the subject, doubled by a semantic transgression, a crossing of the lines of sense. And it is this Bataillean eroticism that Bellmer explores, not the fetishistic beauty touted by André Breton and others: out of his difficult dictionary of analogues-antagonisms he devises a transgressive anatomy of desires-drives. In this way Bellmer illuminates the tension between 'integrating and disintegrating possibilities' more starkly than any other surrealist; he illuminates it more because he sublimates it less. The result is that the sadomasochistic nature of sexuality is revealed as a difficult crux not only of the *poupées* but of all surrealism, Bataillean and Bretonian alike.

Bellmer came to surrealism fairly late, however, and his vision of surrealism was rather extreme: most surrealists never approached it, or they shied away from it if they did. As we have seen, the common response to the contradiction between the castrative and the fetishistic was not to compound it, as Bellmer did, but to resolve it or to suspend it somehow. There are also some images in the surrealist repertoire that attempt to go further – to block out this tension entirely, and so to remain fully committed to the phallic order, however disguised it might then be. Such is the operation of a most beautiful set of surrealist nudes, whose very beauty might depend on this same blockage. Many of these images are by Man Ray (who used his fellow photographer and one-time lover Lee Miller as a model), but he is not alone: Brassaï, Miller, and others worked in this undeclared genre as well. As usual these nudes reshape the female body in fetishistic form, but here there is little reminder of castration (or its analogues) in the transformation. The subject is clearly a woman, but she is more phallic than fetishistic; in some sense she is woman *as* phallus.

There are two basic versions of these nudes. In the first version the nude is cropped of legs and head (which suggests that the woman is cropped of subjectivity), and the torso is reshaped as a phallus. In a 1931 nude by Brassaï a headless body, lighted from above and shot from the side, seems to float, foreshortened, as such a white phallus, while in a 1934 nude by Miller another headless body, seen from behind and below, rises up as an anamorphic apparition of a similar sort. The second example reverses the strategy of the first, but to the same end: here the body is nothing but head and neck, which are elongated by pose and angle in order to form another kind of phallic figure. The best example is the 1929 *Anatomies* of Man Ray, who photographs his model with her neck stretched out and head pulled back. (The model may be Miller; in any case a 1930

portrait of Miller attenuates her neck through a related stretching). Soon enough these headless bodies and bodyless heads were subsumed under the rubric of the Minotaur, the bull-man of Greek mythology whom the surrealists adapted as a totemic figure of the surrealist subject lost in the labyrinth of his own desire (the journal *Minotaure* appeared from 1933 to 1939). But often this man-as-animal is evoked through the woman-as-phallus; in the most famous incarnation of the surrealist Minotaur, a 1933 photograph by Man Ray, the head of the bull is figured by the torso of a woman (fig.214).

Perhaps the most extraordinary instance of the surrealist woman-as-phallus is the earliest, the wryly titled *Return to Reason* of 1923 by Man Ray. This nude is cropped at neck and navel and posed in the near dark by a curtained window; she is also turned in such a way that a veil of refracted light and shadow striates her body almost to the point of its dissolution into the liquescent space of the room (or is it the print? this slide between spaces is one surreal effect of surrealist photography). The image must have fascinated Man Ray, even arrested him, for he returned to it often enough. In a related photomontage of 1924 two pairs of breasts, more frontal now, are stacked one above the other to form a phallic figure. To transgender this female body-part in this way is a bold move, but the cut of the montage makes the image appear less perfectly phallic than the others in question. Five years later, in a suite of photographs of Miller, Man Ray returns to the type. Again posed by the window, the nude is more explicitly veiled here – in the first image by a lace curtain, in the others by various patterns of refracted light and shadow (as in *Return to Reason*). Significantly, in this suite Miller is not headless: she retains this sign of subjectivity, and her various expressions and postures seem to convey different moods – mysterious, contemplative,

fig.212
MAN RAY
Anatomies 1929
Gelatin silver print
22.6 x 17.2 cm
Museum of Modern Art, New York.
Gift of James Thrall Soby

fig.213
MAN RAY
Lee Miller (Neck) c.1930
Gelatin silver print
22.5 x 18 cm
A. & R. Penrose

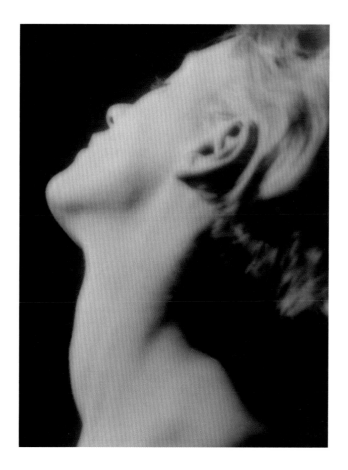

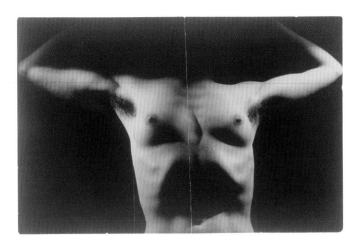

fig.214
MAN RAY
Minotaur 1934
Gelatin silver print
15 x 23.3 cm
Michael Senft, New York

intense. Closely related to these images is another photograph of Miller. Headless once again, with her body more frontal and her breasts and arms less obscured, she is reconfigured vertically, phallicly, by a similar arabesque of refracted light and shadow. Krauss has described these veiled nudes as an 'inscription of the body by space … in which boundaries are indeed broken and distinctions truly blurred'; that is, she has referred them to the 'formless' and 'psychasthenic' states discussed by Bataille and the surrealist writer Roger Caillois respectively.[22] But I think we can also see them in the terms offered here: not quite the logic of the fetish, certainly not that of the part-object, but that of the 'beautiful' phallus, in which distinctions – between male and female above all – are indeed blurred.

To elaborate these terms we need to turn to Jacques Lacan, who was a young associate of the surrealists in the early 1930s. In his celebrated revision of psychoanalysis elaborated in the 1950s and 1960s, Lacan reread Freud through the structural linguistics of Ferdinand de Saussure, a contemporary of Freud whose work Freud did not know, but whose *episteme* he shared in part. It is through this association of Freud and Saussure that Lacan arrives at such formulas as the famous one presented in 'The Meaning of the Phallus': that the unconscious is structured like a language; in particular, that the psychic mechanisms of condensation and displacement at work in dreams can be understood in terms of the linguistic operations of metaphorical substitution and metonymic connection. Perhaps in a similar way we can now reread Lacan through certain notions of the surrealists. Certainly surrealism resurfaces in his work with deferred effectivity in the late 1950s and early 1960s, as is especially evident in his seminars on trauma, repetition, and the gaze held in 1964 (seminars known to us as *The Four Fundamental Concepts of Psychoanalysis*).

At first glance, however, this hypothesis seems contradicted by a text like 'The Meaning of the Phallus,' which dates to 1958. Here Lacan revisits psychoanalytic debates of the 1920s and 1930s involving Karl Abraham, Ernest Jones, and Melanie Klein, debates regarding the phallus that indirectly implicate surrealism as well. Against the positions articulated by these early analysts, Lacan argues that the phallus is neither a fetish-fantasy nor a part-object, models that (as we have seen) are also at work in surrealism. 'It is even less the organ', Lacan states. 'For the phallus is a signifier.'[23] Of course, it is not just any signifier for Lacan;

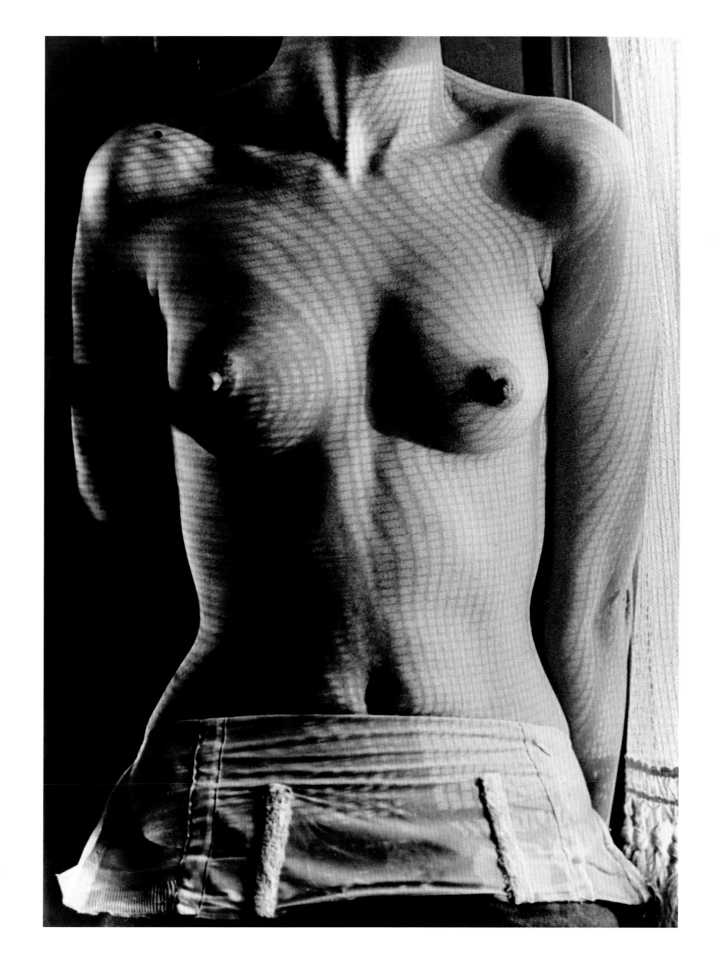

fig.215
MAN RAY
Lee Miller (Torso) c.1930
Gelatin silver print
29.6 x 22.5 cm
A. & R. Penrose

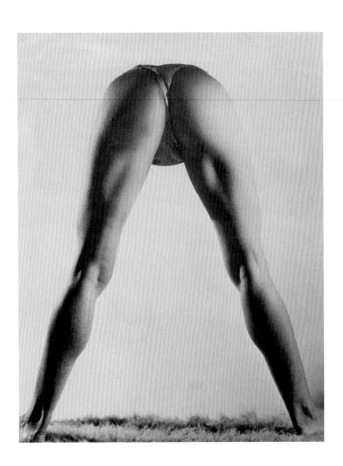
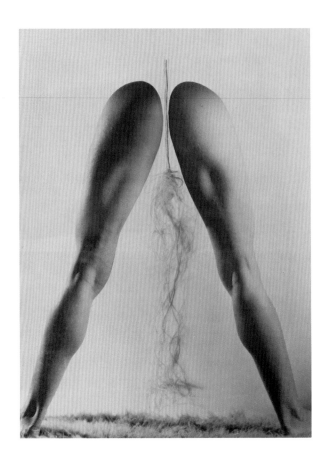

it is *the* signifier, the primary signifier of all desire. It has this status because it is the desire of the other, in the first instance the desire of the mother, a desire that is born of lack ('castration'). In this account the phallus is also the primary signifier of lack, the lack of the phallus that the child soon detects in the mother. It is this lack, moreover, that initiates the child into the play of difference that is language, into the symbolic order supervised by the father. 'The phallus is our term for the signifier of his alienation in signification,' Lacan writes a year later in 1959.[24]

No one can possess this signifier, of course. Nevertheless, Lacan claims, 'the relations between the sexes' turn on the fantasy that men have the phallus and that women embody it, with 'the effect that the ideal or typical manifestations of behaviour in both sexes, up to and including the act of copulation, are entirely propelled into comedy.'[25] These manifestations are comic because men pretend to possess the phallus in order 'to protect it,' and women to be it in order 'to mask its lack.' To these ends men are led to a 'virile display' of masculinity (with the added irony that any such display is culturally coded as feminine), and women to a 'masquerade' of femininity (for 'it is for what she is not that she expects to be desired as well as loved').[26]

Not a fetish, not a part-object, 'even less the organ': this conception of the phallus as signifier depends on its distinction from the penis. This difference is very significant, theoretically and politically, for in principle it renders us all, men and women alike, equal before lack and desire. But, as feminists like Kaja Silverman and Jane Gallop have charged, the separation is not nearly complete in Lacan; in some sense the phallus remains propped on the penis in his work.[27] This propping is most evident in 'The Meaning of the Phallus' when Lacan alludes to 'the famous painting in the Villa of Pompeii' of the Dionysiac rites of betrothal and marriage. One scene in this

fig.216
DORA MAAR
Legs I, Legs II 1935
Two silver gelatin prints
framed together
28.5 x 22.5 cm
Roger Thérond Collection

Great Frieze of the Villa of Mysteries shows a phallic object covered by a purple veil attended by a kneeling woman who appears about to unveil it. Of this scene Lacan remarks that 'the phallus can only play its role as veiled'.[28] Contrary to the account that he then develops, this statement implies that the phallus can maintain its dominant position in our symbolic order only if it remains a signifier – that is, only if it remains not only veiled and hidden as a thing but inflated and elevated as a signifier. Only then can the phallus retain its status as the symbol of sovereign potency: if it were not sublated to this transcendental level, it might be unveiled as a mere penis in disguise.

Now a visual evocation of this veiled sublation occurs, I think, in the surrealist nudes in question here. Not only is the castrated/castrative woman transformed fetishistically into a penile form, but this form is also disguised, raised to the power of a signifier. And the result is that the male subject may not only contemplate this body-turned-signifier with peace of mind, all castration anxiety allayed, but may also admire this phallus *as if it were the beauty of woman to which he pays homage and not the inflated prowess of his little thing*. Of course this peace of mind, this 'return to reason', comes at the cost of a total confusion of female and male, a complete collapse of difference, which surrealists of both Bretonian and Bataillean stripes were more than willing to indulge.[29] My reading of this kind of nude as a specular idealisation of the feminine-as-phallic is tendentious, I admit, but we should remember that several years before the Paris art world was witness to a public controversy involving a related confusion of the feminine and the phallic.[30] In 1920 Constantin Brancusi exhibited his *Princess X* (1916) at the Salon des Indépendants. He designated this oblong curve of polished marble (another was executed in bronze) 'the Eternal Feminine' after Goethe, but everyone else – from Picasso to the police who came to remove the sculpture – saw it for what it was: a phallus. Neither party was wrong, or rather, both were right: it is a woman, but it is also a phallus; it is woman-as-phallus, and it was this identification that was so scandalous. In the surrealist nudes this identification is precisely veiled, which is to say that these photographs allow a perfect misrecognition of feminine beauty as phallic plenitude.[31]

More is at stake in my cross-referencing of surrealism and Lacan than the veiled nudes of surrealist photography, and I want to conclude with a stab at what this might be. The central concept of Bretonian surrealism is 'convulsive beauty,' which Breton introduces in his novel *Nadja* (1928) and elaborates in *L'Amour fou* (1937). There this beauty is evoked through three kinds of uncanny experience that he never quite defines: 'fixed-explosive', 'veiled-erotic', and 'magical-circumstantial'. In 'Photography in the Service of Surrealism', Krauss relates these three categories of beauty to three operations of photography – to its stopping, framing, and spacing of the world, in short, to its rendering of the world as a sign. In this way surrealist photography discovers convulsive beauty in 'the experience of reality transformed into representation … [of] nature convulsed into a kind of writing.'[32] Krauss describes this photographic transformation as a 'fetishisation of reality,' but 'phallicisation' is more exact. Again, Lacan writes, 'the phallus can only play its role as veiled'; but then he adds: 'that is, as in itself the sign of the latency with which everything signifiable is struck as soon as it is raised (*aufgehoben*) to the function of signifier.' Lacan intends *aufgehoben* here as Hegel used the term, to mean 'dialectically sublated' – cancelled on one, referential level (the level of the penis), only to be preserved, indeed elevated, on another, semiotic level (the level of the phallus).[33] This formulation is difficult, to be sure, but one might understand 'the latency with which everything signifiable is struck' as precisely the surrealist experience of a

reality pregnant with uncanny meaning, of a reality that awaits revelation as representation by the inspired surrealist detective-lover-reader. What else is surreality but this 'striking' of semiotic potential, a striking that is explosive but fixed, erotic but veiled, magical but circumstantial? And what else is this potential but a potency culturally coded as phallic? (Incidentally, Brassaï is the great photographer of this surreality. Think of *The Statue of Marshal Ney in the Fog* of 1933, with the uncanny sign of 'Hôtel' in the distance that glows dimly through the fog-shrouded Paris night, guarded – or threatened? – by the sabre-drawn ghost of Marshall Ney in the foreground. Think of all his other phallic guardians of Paris, the Gothic gargoyles and Métro ornaments.)

In *L'Amour fou* Breton defined this surreality as a 'screen' on which 'everything humans might want to know is written … in phosphorescent letters, in letters of *desire*', a proposal seconded by Max Ernst in *Beyond Painting*.[34] I understand this 'screen' as the phallic prism of lack through which the world is 'struck' with the 'latency' of the 'signifiable', with letters that appear as ciphers of desire to the subject presumed to be male. Both time and place of these ciphers are obscure: in Breton as in Ernst, the surrealist subject regards them as omens of the future, even though they 'retrace' the past; and he reads them passively, as if it were they that discover him when it is he who projects them. This willful confusion is at the heart of the surrealist aesthetic (Ernst presents it most suggestively in *Beyond Painting*): these signs of past trauma are taken as portents of future desire; and they appear as if by chance even though they are always already there, as it were, readymade in the unconscious – for why else would they be experienced as uncanny?

After Ernst, Dalí transformed this confusion into a programme, 'the paranoid-critical method', while Breton understood it as 'interpretive delirium'. 'Interpretive delirium', he writes in *L'Amour fou*, 'begins only when man, ill-prepared, is taken by a sudden fear in the *forest of symbols*'.[35] Why is this experience felt as 'fear'? Perhaps because this ill-prepared man has forgotten (or repressed) the fact that he is the one who prepared this forest of symbols in the first place; perhaps, too, because the surrealist 'phallicisation' of the world as so many letters of desire depends on a prior recognition of castration that cannot be occluded outright. In any case this uncanny fear is a small price to pay for the command of a reality in which the 'marvellous precipitates of desire' are to be found everywhere for the surrealist subject. And in the end, as Freud suggests, this fearful uncanniness is just another way of being-at-home. Or as Breton says, 'You only have to know how to get along in the labyrinth.'[36] This is easy enough for the surrealist subject who is not only the Minotaur of his maze but its Daedalus as well.

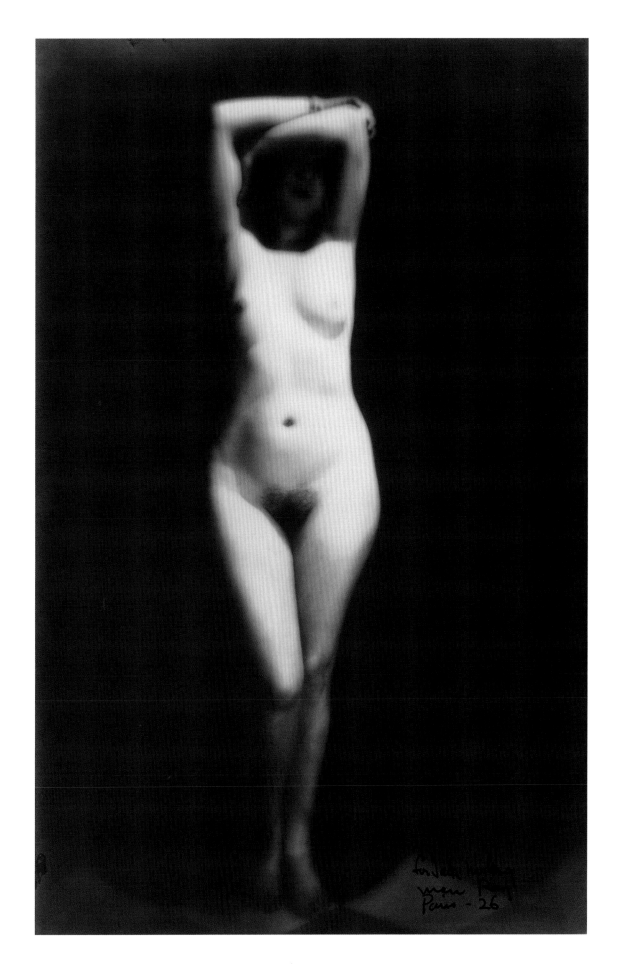

fig.217
MAN RAY
Untitled 1926
Gelatin silver print
28.2 x 18.1 cm
Roger Thérond Collection

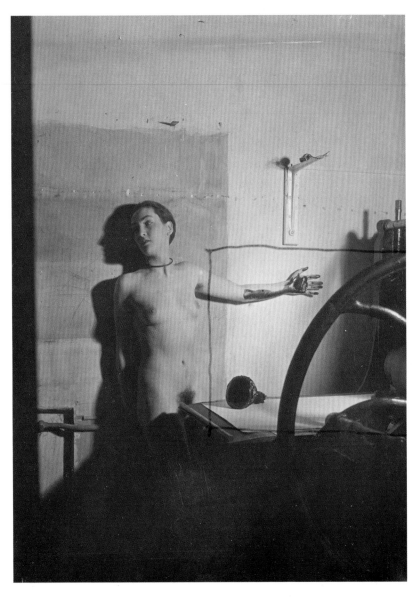

fig.218
MAN RAY
Untitled (from the 'Veiled Erotic' series)
1933
Vintage photograph
11.5 x 8.5 cm
Lucien Treillard

This less well-known image, taken during the same photographic session, emphasises Oppenheim's youthfulness and potential vulnerability: she was then only nineteen. Man Ray drew a rectangle onto this photograph to identify the section he wanted to print as a close-up.

Man Ray's photographs of Meret Oppenheim pictured naked beside an etching press in the studio of painter Louis Marcoussis bespeak the double bind of women artists within surrealism. Swiss-born Oppenheim came to Paris in 1932, when she was only eighteen, and was introduced to the surrealists by her compatriot Alberto Giacometti. At the time these photographs of her were taken she was having a brief affair with Man Ray, who later described her in his memoirs as one of the most uninhibited people he had ever met. The celebrated photograph of her by a printing press wheel appears to cast her in the guise of simply model or muse, erotic inspiration for a presumptively male artist. But such a judgement may be too precipitous. It underestimates the degree to which Oppenheim, and likewise Marcoussis who donned a false beard and bowler hat for the photographic session, were play-acting and hence might be thought of as Man Ray's artistic collaborators. Maybe their purpose was to use photography in order to send up an outmoded allegory that demeans women and excludes them from the male province of artistic creation? A closer look at this version of *Veiled Erotic* reveals the extent to which it taps into controversies about female gender roles and definitions in the period.

Photography was well placed to capture the ways in which gender relations were being transformed. Less hidebound than painting, it was nearer to fashion and mass culture where the blurring of gender boundaries attained heightened visibility in the androgynous icon of the New Woman. Black and white photography is, moreover, intrinsically connected with the idea of reversibility. Man Ray manipulates the photographic medium so as to emphasise this formal property that resonates in his oeuvre with the theme of gender reversal. In *Veiled Erotic* the cast iron printing press (a mechanical apparatus analogous to photography as a means for reproducing images) acts as a pivot or hinge between formal concerns and gender ones. The handle, in particular, arms the female body with a detachable phallus, a pointer to the ways in which the privileged signifier of sexual difference was now 'up for grabs'. Less overtly, the wheel partially covers her breasts, hinting at the erasure of distinctions between the sexes, while the hips angled slightly away from the camera appear rather masculine. Oppenheim also sports a fashionably close-cropped hairstyle.

The photograph was reproduced by André Breton in a squarer format with the lower third omitted as an illustration to an article on 'convulsive beauty' in the surrealist journal *Minotaure* in 1934. It is tempting to compare the cropping of the photograph, which effectively removes the phallic signifier from the unwelcome spotlight of contested gender relations, to a deliberate act of censorship. Attention now concentrates on the abstracted female figure's inked hand, raised as if to imprint directly on the photographic plate. Elsewhere, Breton said, 'Woman always keep starlight in her window and in her hand the life-line of her lover.' The Eternal Woman in Breton's poetic canon is invariably veiled in mystery, a perpetual incitement and reflective support to his desire. By contrast, Oppenheim was to argue in later life that each human being had both both male and female elements, and often chose to be photographed in ways that underlined her belief that gender was a potentially fluid, unstable category. DL

fig.219
MAN RAY
Veiled Erotic 1933
Vintage photograph
11.5 x 8.5 cm
Lucien Treillard

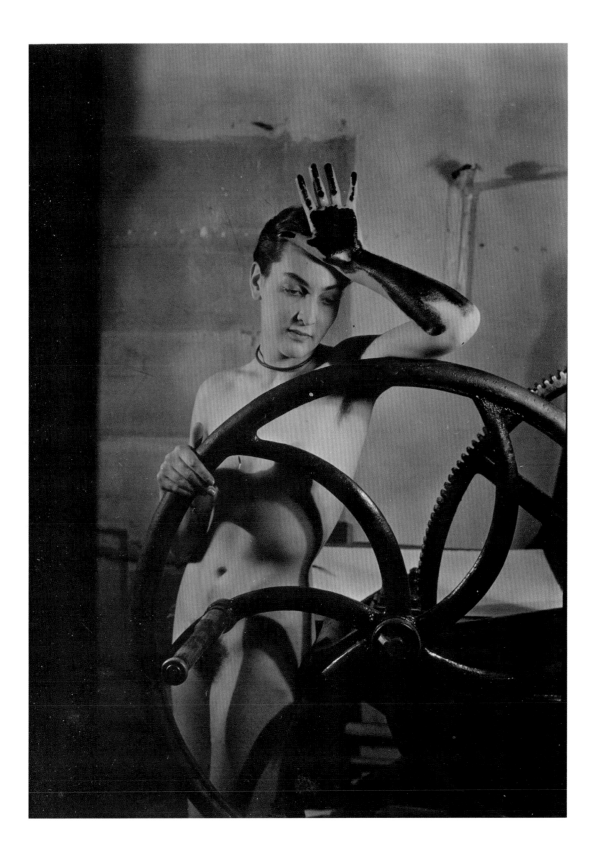

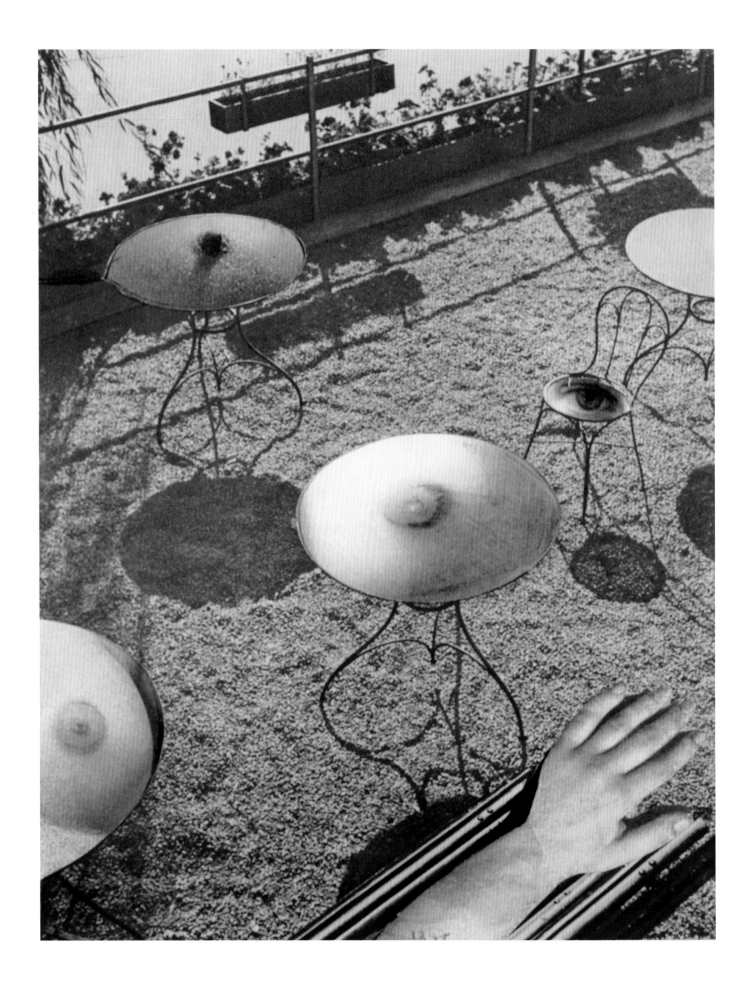

chapter nine

HISTORY, PORNOGRAPHY AND THE SOCIAL BODY

Carolyn J. Dean

istories of pornography have always seemed ill at ease with their object of inquiry – and not because of any moral queasiness. They seem rather to be haunted by a dim recognition that pornography eludes efforts to position it in a coherent historical narrative: that it escapes any clear definition, that it is fundamentally elastic, adaptable, and refers to an astonishingly wide variety of objects and texts, from cheap magazines to great literature and, since the Second World War, even to images of genocide. In the 1950s and 1960s when many histories of pornography were first published, they tended to be stories about great writers from Gustave Flaubert to James Joyce, who had been ignobly persecuted by uncomprehending judges, juries, and moralists. In other words, they tended not to be about pornography, but about works that had been *mistaken for* pornography. In a more recent effort to account for the seeming versatility of the concept, one historian claimed that pornography is virtually anything elites believe threatens their power at a given time and place.[1] Others have spoken not of pornography but of a 'pornographic imagination' that expresses the self-shattering experience associated with works that seem pornographic but on closer examination are sophisticated pieces of literature – the French writer Georges Bataille's work in particular, but surrealist eroticism as well.[2] Most of these accounts, all struggling to validate and preserve in different ways the formidable, perhaps subversive and often discomfiting feats of imagination that emerge in unexpected places, indicate that we cannot ever assume that we know what pornography is. And yet they also insist that pornography is distinct from great literature and from the psychic soaring, expansion, and longing we attribute to the imagination. Although undoubtedly we can draw formal distinctions between what we think pornography is and other work – indeed, film and literary theorists have done just that – we cannot explain the radically contingent, oddly empty and thus slippery signification of the term. One way of addressing this problem might be to try and account for when and how pornography began to signify a conceptually indeterminate category and was first attributed with its current plasticity. And indeed, during the interwar period – a crucial turning point in the history of pornography – the term ceased to refer only to a specific body of sexually exciting or morally questionable material and enlarged its frame of reference to describe the violation of the dignified human body in a variety of contexts, including both aesthetic and political ones.

In what follows, I outline how certain writers attributed new meanings to pornography after 1918, especially in France, in order to understand changing significations of the erotic and, in particular, pornography's increasingly forceful association with the metaphorical shattering of the dignified, constrained, and yet willful self that underpins democratic citizenship. During this period critics first equated pornography with the destruction of the body politic. Without this frame of reference it is difficult to understand fully the impact of surrealist eroticism, or why Georges Bataille, for example, believed that many surrealist works betrayed eroticism's challenge to the high modernist emphasis on aesthetic transfiguration. At stake in these various positions is the cultural signification of eroticism and its pornographic forms as they were imagined after the First World War.

fig.220
KAREL TEIGE
Untitled 1947
Collage
49.8 x 36 cm
Museum of Czech Literature, Prague

In mid-nineteenth century western Europe the Church began to lose its moral authority, and nation states began to regulate moral order in the interest of assuring healthy, 'normal' populations fit for combat, reproduction, and productive labour. In France, England, and Germany, as well as the United States, the modern concept of the 'pornographic' was invented by the 1880s, as bourgeois elites acted to control the publication and distribution of literature that provoked anti-social sexual sensations and deeds in those they deemed morally weak or unformed: women, children, and working-class men. Doctors and legislators alike believed that pornography overstimulated the nervous system and wore down the body's resistance to sexual and other temptations. Pornography was thus a pervasive metaphor for moral decline and national emasculation, and its emergence was concurrent with the threat posed to bourgeois men by workers militating for rights and women demanding the vote in a period of increasing wealth, consumption, and literacy. In Great Britain Lord Campbell engineered the passage of the Obscene Publications Act in 1857, and Lord Chief Justice Alexander Cockburn defined more specifically the test of obscenity in 1868 as 'whether the tendency of the matter charged as obscenity is to deprave and corrupt those whose minds are open to such immoral influences, and into whose hands a publication of this sort may fall'.[3] The Comstock Law, passed in the United States in 1873, forbade the mailing of obscene art and literature and all material about controlling procreation, using a similar rationale. The newly unified German Reich incorporated a Prussian anti-obscenity statute banning all writings that 'violated the reader's sense of shame and morality' into the Reich Criminal Code in 1871. French legislators, prodded by critics certain that France was in the midst of a moral crisis after the French defeat in the Franco-Prussian War, passed successive laws aimed at prohibiting an increasingly wide variety of so-called pornographic material in 1881, 1882, 1892, and 1908, all in the name of a '*défense de la famille*'. There too, 'pornography' included birth control information, pacifist literature and sexually explicit images that circulated in cheap magazines purchased primarily by working-class men. Critics decried the new visibility of so-called pornographic material in railway stations, bookstores, music halls, and popular magazines as cheap print runs and high profits encouraged widespread distribution of illicit literature. In 1912 the French government subjected all new purchases in municipal libraries to police surveillance, in particular to target so-called subversive, or communist and anarchist publications.

After the First World War such perceptions of moral and social crisis intensified as millions of men perished and promises that the war would restore virility proved to be utterly illusory. Discussions in the interwar period make very clear that talk about pornography was really about the social body's metaphorical masculinity and how to protect it from symbolic sexual violation – from shame, desecration, and subjugation. As the influential British sexologist Havelock Ellis had already argued in 1914, all young people should be taught a proper 'reverence for the body' in order to guarantee its solidity in the face of adulterous, homosexual, and other longings.[4] The unprecedented mobilisation of the First World War – highly technological weaponry, anonymous modes of combat, and largely anonymous annihilation – had compromised that solidity, transforming men into 'lowly cog[s]' in a 'gigantic machine', in which a man was 'less and less free to do what he will with his activity and his body.'[5] Thousands of soldiers, according to angry veterans and other commentators, had become the disposable material parts of a war machine whose rationale was proven false, and had been seduced by a 'grand illusion' that blinded them to their real spiritual

CENSORSHIP c.1860–1960

1857
The Obscene Publications Act is passed in Great Britain. Its passage was engineered by Lord John Campbell, who sought to permit search warrants on the grounds of obscenity. The Act targeted literature that would 'corrupt the morals of youth' and shock 'feelings of decency in any well-regulated mind'. Campbell this way sought to ensure that great literature would not be condemned or seized under the Act.

1870
Germany is unified under Chancellor Bismarck. The Reich Criminal Code adopts the language originally in the Prussian Criminal Code that bans obscene literature. The Reich Criminal Code defines 'unzuechtige Schriften' as writings that 'injure the reader's sense of shame and morality'.

1870–1
Founding of the Third Republic in France.

1873
In the United States President Grant signs 'An Act for the Suppression of Trade in, and Circulation of, Obscene Literature and Articles of Immoral Use'. It becomes dubbed the Comstock Law after Anthony Comstock, a private citizen who eventually becomes a special agent entrusted with its enforcement in the United States Postal Service.

1881
French legislators declare freedom of the press a basic foundation of the new Third Republic. In article 28 of the same bill they repress the 'distribution, sale, and display' of a wide variety of material deemed pornographic. The legislature passes successive laws in 1882, 1898, and 1908 extending the provisions of this law. These laws become the basis for all obscenity prosecutions in France for the next half-century.

1909
Four executions by guillotine are filmed in Béthune, France, leading to the implementation of film censorship. In a circular distributed by the Minister of the Interior 'cinematographic spectacles of this kind', capable of provoking social disturbances, are forbidden. Censorship is left to local authorities.

1914–18
First World War.

1919
The French government issues a decree establishing a national film censorship board comprised of thirty politicians and educators to control the distribution of all films. Later, in 1928, the state includes representatives of the film industry on the board.

1920
In a law harsher than its predecessors, the French legislature makes advocacy of, and distribution of written information about birth control and abortion a crime and increases penalties for doctors who perform, and women discovered to have had, abortions. The law's penalties are the most draconian in western Europe.

1925
A military tribunal condemns communist activists for distributing literature hostile to the French occupation of the Ruhr. The government, via military tribunal, actively seeks to suppress so-called subversive literature throughout the 1920s.

1928
Radclyffe Hall's *The Well of Loneliness* in banned in Britain under the Obscene Publications Act because it depicts lesbianism.

1933
In the United States Judge John M. Woolsey declares that James Joyce's *Ulysses* is not pornographic. He argues that it is of sufficiently literary merit and does not give rise to 'impure thoughts'. The decision lays the groundwork for arguments in the United States that art mitigates the potentially obscene effects of a literary work.

1939
French legislators pass a new and more extensive anti-pornography law that targets 'engravings, photographic paintings, snapshots, reproductions, emblems, and all objects contrary to good morals'. Significantly, its rationale is the 'protection of the race'.

1939–45
Second World War.

1956
In France Jean-Jacques Pauvert and Jean Paulhan are put on trial for obscenity after being accused, respectively, of publishing and distributing the works of the Marquis de Sade, whose writing had been circulating clandestinely since the late nineteenth century. The defence lawyer, Maurice Garçon, insists that Sade was a great writer and that his work is 'hardly dangerous'. The defence is successful.

1957
Roth v. The United States upholds the conviction of publisher Samuel Roth on obscenity grounds but in delivering their opinion the majority of judges refuse to conflate sex and obscenity. Instead, they provide new grounds for obscenity convictions, insisting that the material in question must not simply address sexuality but must also appeal to 'prurient interest'.

1958
The French government modernises articles 283 and 285 of the Penal Code pertaining to obscene material ('les outrages aux bonnes moeurs') to ensure the laws were applied not only to 'books, posters, paintings, objects, and images', but to 'photographs, films, and photographic reproductions'.

1959
The Obscene Publications Act is revised in Great Britain to permit publication of works deemed to have literary merit. The Act retains the older test by which literature that depraves and corrupts is obscene, but throws out the notion that a text could be inherently obscene. Obscenity now has to be determined in relation to the work's literary or artistic merits and in relation to the reader.

1960
D.H. Lawrence's novel *Lady Chatterley's Lover* is put on trial for obscenity in *Regina v. Penguin Books Ltd*, the first major test case in Britain of the revised Obscene Publications Act. Under the revised Act, the defence has to prove that, however obscene isolated sections of the text appear to be, the work has literary merit and is thus a contribution to the public good. The defence proves its case and the publishers are acquitted. The trial is seen as a landmark case in the liberalisation of British censorship laws and British attitudes toward sexuality.
CD

degradation. An entire generation of young men returned home depleted of will and addicted to pleasure wrought from suffering and horror, psychologically incapable of serious commitments to nation and family. German writer Paul Englisch wrote that, 'Long years in the trenches stirred men's sadistic instincts and their taste for horror,' and noted that in Germany pornographers now focused primarily on depicting sexual perversion. The French critic Edmond Haracourt insisted that the war had transformed sexual desire into a longing 'for death' and that pornography was a continuation of the war by other means.[6]

A vast array of commentators on both the left and the right throughout western Europe claimed that 'loose' women, sexually liberated youth, increasingly visible homosexual expression, and even jazz music were all symbolic extensions of the war's violence, whose industrial character paradoxically expressed itself in so-called excessive, primarily sexual, and sado-masochistic pleasure that sapped the body politic of its energy and rendered it metaphorically feminine, porous, and permeable. The prolific interwar French writer Georges Anquetil denounced French culture itself as 'pornographic', using the term no longer to refer only to specific texts, but also to the postwar problem of too much pleasure – not to denote sexually explicit or politically dissident works usually covered under the rubric of obscenity, but to describe the general problem of postwar cultural degradation symbolically as the new permeability of the social body. Thus the French novel *La Garçonne*, a bestseller published in 1922, was deemed pornographic by some because its heroine defies sexual conventions. According to its author Victor Margueritte, critics also dubbed the book pornographic because its heroine's sexual escapades were metaphors for the unrestrained eroticism of postwar culture. In other words, pornography remained a specific (and yet still imprecise) body of material but it now also described the triumph of a 'death' culture (as Edmond Haracourt put it) in which noble feelings about country, family, and fellow had shaded over into the aimless and compulsive pursuit of self-gratifying pleasure and the depletion of will, discipline, and therefore, of dignity.

The adjective 'pornographic' described a widespread cultural phenomenon: it figured the war's sapping of character primarily as excessive, degraded, omnipresent, sadomasochistic and homosexual eroticism rather than as a threat represented by sensations to which only the particularly weak and intellectually unformed were susceptible. Accordingly, doctors deemed sexual education and 'sexual hygiene' – as reformers euphemistically referred to the effects of proper and moderate sex – necessary to the health of the collective body damaged by the sadomasochistic sexual excesses associated with war. In a remarkable reversal, some critics held nineteenth-century anti-pornography and obscenity laws responsible for moral degeneration, now conceived as the bankruptcy of a political system and as the hypocrisy and tyranny of the established elites who had pursued the war. The French journalist Lionel d'Autrec declared that the very politicians who glorified war and permitted the most explicit descriptions of violence also suppressed 'the most normal and the most beautiful of all human acts'. The same men who denounced moral laxity – all the 'democracy's elite'– saw prostitutes, engaged in sadomasochistic practices, and smoked opium. The same men who had passed anti-pornography legislation were the same men who violated those laws.[7] Thus duplicitous elites touted moral purity while destroying it, and the sadomasochism unleashed by the war exemplified the effects of their hypocritical repression of men's sexuality.

Numerous treatises on sex and histories of erotica published in those years thus aimed to titillate readers in the name of wresting sex and eroticism out of the grip of dark, repressive forces

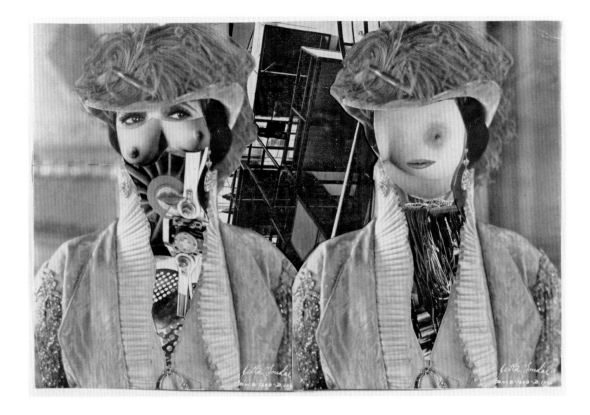

obstructing the development of natural, healthy sexuality, putatively uncontaminated by sado-masochistic and homosexual desires. Havelock Ellis, who had declared that the task of social hygiene was to teach men how to respect rather than despise their bodies, now also insisted that only frank sex education would dim the lustre of forbidden pleasures and keep the body metaphorically impermeable and whole. He insisted that 'secrecy and repression are against nature'.[8] The pioneering American child psychologist G. Stanley Hall expressed the same sentiments in similar terms.[9] The great British author D.H. Lawrence insisted that unhealthy sexuality would disappear if only men would 'face up to their sexuality'.[10] And the new French Ligue contre le puritanisme fought sexual repression on the grounds that it stifled the sophisticated and harmless pleasures associated with Latin 'genius' while encouraging the degraded sadomasochistic and homosexual pleasures associated with postwar culture. So widespread was this concept of 'healthy' sex that even anarchists and self-identified homosexuals paid it lip service. The first gay magazine in France, provocatively entitled *Inversions* and censored under the 1882 anti-pornography law in 1925, published commentary by Havelock Ellis, who counted (male) homosexuals among the ranks of the potentially healthy, though his was a distinctly marginal opinion. It used sex 'surveys' and included among its editorialists the writer-artist Claude Cahun. The well-known surrealist 'investigations into sexuality' – really a discussion among various surrealists about their own sexual tastes and published in *La Révolution surréaliste* – was part of this more general revaluation and discussion of sexuality during the interwar period.

Over and over, a vast array of critics, writers, youth leaders, sexologists, and others throughout Western Europe and the United States no longer associated the open expression of sexuality with the destruction of the body politic but with its renewal, so that critics now conceived material once

HISTOIRE DE L'OEIL

Histoire de l'oeil was Georges Bataille's first novella, written in 1927 and published under the pseudonym of Lord Auch in a tiny edition of 134 in 1928, illustrated with eight original lithographs by André Masson. A 'new version' with numerous textual changes was published in 1947, with a false date of 1940 on its title page, accompanied by six engravings by Hans Bellmer. It was not until 1967 that the novella appeared in Bataille's name and in a large print run.

The tale itself is told in thirteen short chapters, comprising Part One. The teenage narrator relays the history of his obsessive relationship with a girl named Simone, founded on their shared and profound anxiety over sexual matters. Their odyssey is inaugurated by an act of looking: on a hot afternoon when the two are alone in her family villa, Simone teases the narrator by sitting in a saucer of cat's milk: lying at her feet he catches his first glimpse of her '"pink and black" flesh'. This arrested moment stands at the threshold of a chain of perverse acts, delivered in a strange combination of elegant French literary style and pornographic nouns and verbs. These dirty words, Susan Rubin Suleiman has commented, 'crash through the structure of the syntax as Simone's transgressive behaviour crashes through the stillness of a summer afternoon'. The first chapter, 'The Cat's Eye', contains two further incidents. The first is a car accident in which a young woman cyclist is run over by Simone and the narrator. They are transfixed by the corpse, which has been more or less decapitated: 'The horror and despair at so much bloody flesh, nauseating in part, and in part very beautiful, was fairly equivalent to our usual impression upon seeing one another'. After this the two engage in a masturbatory orgy on the beach during which Simone introduces the idea of urination. The orgy is interrupted by another important character, a young girl named Marcelle, whose innocence and shame provokes the pair to rape her during a thunderstorm, an act of despoliation so ripe that Simone expresses her ecstasy by covering herself in mud and filth. The density of this chapter indicates the bizarre nature of the story, driven as it is by that first act of looking as the focus of sexual anxiety, migrating to the sight of a headless corpse,

and then to the obscene connection of urine and genital sex. In the second chapter a further strange element is introduced in the form of sex acts using eggs. These games are elaborated later on in the context of the rediscovery of 'childhood lewdness', and in a passage at the limit of surrealist poetics, recalling Raymond Roussel's plays or Duchamp's puns and anticipating the opening scene of the film *Un chien andalou*, the narrator tries to follow Simone's logic:

> Upon my asking what the word *urinate* reminded her of, she replied *terminate*, the eyes, with a razor, something red, the sun. And *egg*? A calf's eye, because of the colour of the head (the calf's head) and also because the white of the egg was the white of the eye, and the yolk the eyeball. The eye, she said, was egg-shaped … She played gaily with the words, speaking of *broken eggs*, and then *broken eyes*.

Simone's obsession with eyes and eggs, and urine with semen, leads her to urinate into the eyes of Marcelle when the latter is found hanged. Simone and the narrator flee France to Spain, where Marcelle's role as third party is taken over by 'an Englishman' named Sir Edmund. Attending a bullfight, Simone is presented with the uncooked testicles of the slaughtered bull – 'of a pearly whiteness, faintly bloodshot, like the globe of an eye' – one of which she devours and the other she inserts in her vagina. Her resulting orgasm coincides with the death of a toreador, speared through the eye by a bull's horn.

The finale of the novel is the rape and murder of a priest in the Church of Don Juan, Madrid. Simone strangles him in order to make him ejaculate in her, and then commissions Sir Edmund to pluck out the eye from the corpse. Inserting the eye in her vagina, Simone closes the circle of obsession with which the narrator began:

> Now I stood up, and while Simone lay on her side, I drew her thighs apart, and found myself facing something I imagine I had been waiting for in the same way that a guillotine waits for a neck to slice. I even felt as if my eyes were bulging

from my head, erectile with horror; in Simone's hairy vagina, I saw the wan blue eye of Marcelle, gazing at me through tears of urine.

Histoire de l'oeil is both pornographic in terms of its content and in its disturbingly potent incarnation of the deranged consciousness of the erotically obsessed. The narrative persistently connects sexuality and a sacred or intensely alluring and terrifying experience of mortality. This connection is forged again, but in a philosophical mode, in Bataille's late essays on eroticism. If, for Bataille writing in 1957, eroticism was 'assenting to life up to the point of death' and the entry into a realm of dissolution and discontinuity, so in *Histoire de l'oeil* the flux of metaphor embodies the violent transaction of vitality and death in the erotic. Roland Barthes brilliantly captured its strangely formal construction – its development of two series of substitutions around eye and egg (white and globular objects) on the one hand and liquids on the other. But a number of critics have disputed what they see as Barthes' attempt to inscribe the eroticism of the text as an exclusively rhetorical phenomenon. One of the profound puzzles presented to the interpreter of the narrative is the status of Part Two of the novel, a brief essay entitled 'Coincidences'. Here the author outlines the autobiographical sources of the story's elements, in particular emphasising the traumatic memories he has of his syphilitic father, urinating on a commode and rolling his blind eyes up into his cranium. Fixation on the father, and a loathing for the mother, are bound up in other incidents. Many of the 'facts' given in 'Coincidences' bear some relation to Bataille's childhood, a relation passionately disputed during his lifetime by his brother Martial, but it is all to easy to forget that the author of *Histoire de l'oeil* – both tale and autobiographical explanation – is not Georges Bataille but 'Lord Auch', a pseudonym alluding to the crude expression 'Dieu aux Chiottes' (God in the Shithouse). Bataille apparently wrote the book at the suggestion of his psychoanalyst, Dr Adrien Borel, and unravelling its order means fathoming Bataille's dizzying and defamatory metaphor of a naked God 'manuring with the majesty of a tempest'. NC

fig.222
ANDRE MASSON
Drawing for Histoire de l'oeil 1928
Pencil on tracing paper
25 x 20 cm
Mony Vibescu

fig.224
ANDRE MASSON
Drawing for Histoire de l'oeil 1928
Pencil on tracing paper
25 x 20 cm
Mony Vibescu

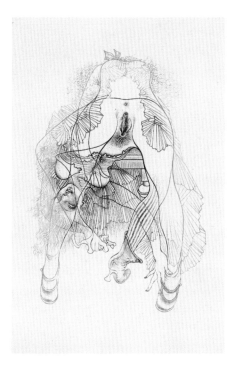

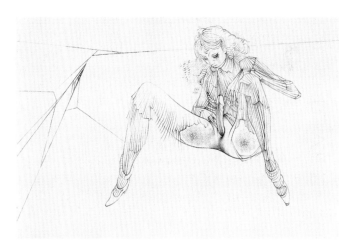

fig.225
HANS BELLMER
Histoire de l'oeil by Lord Auch
[Georges Bataille], pl.4 1944
Two-colour etching
12.7 x 20.3 cm
Herbert Lust Gallery

fig.223
HANS BELLMER
Histoire de l'oeil by Lord Auch
[Georges Bataille], pl.1 1944
Two-colour etching
20.3 x 12.7 cm
Herbert Lust Gallery

deemed pornographic as signs of a healthy, vital, renewed, and integral masculine social body. Writers who protested against trials for books deemed obscene in France and England and who reassessed works that had been declared pornographic (by such authors as Emile Zola, Gabriele d'Annunzio, Stéphane Mallarmé, and the Marquis de Sade), expanded the realm of the non-obscene in the name of restoring social health. One French commentator insisted that such literature was not itself pornographic but contributed to the struggle against those 'perversions' that are 'killing our race'; and another asserted that perversion was born of the repression of 'natural' instincts by our puritanical culture.[11] In other words, such literature did not encourage perversion, of which homosexuality was one privileged symbol, but promised to contain it by exposing its so-called harm. Critics now praised novelists such as Zola for the same reason they had once been condemned: for shedding light on moral decay by describing it explicitly and frankly. And though most of them never employed this language of moral decay, this discourse traversed avant-garde circles and the surrealists in particular, who claimed the Marquis de Sade was no pornographer but the avatar of a glorious future, an emblem of spiritual freedom in a world encumbered by moral convention. As the surrealist writer Robert Desnos put it, in Sade's 'extreme fantasy … sadists, masochists, masturbators, sodomites, and flagellants are revealed without baseness or filth'.[12] The surrealist poet Paul Eluard claimed that Sade was 'more lucid and pure than any other man of his time'.[13] In Germany, progressive and even some conservative elites no longer deemed the *Nacktkultur* (the nudist movement) obscene, but believed that it encouraged the development of an ideally fit, healthy, and sexually normal human body. There was fear in some circles that nudism covertly encouraged homosexuality, but its proponents insisted that to the contrary, nudism eliminated perversion.

Some writers thus believed pornography was so omnipresent that they sought not to contain but to appropriate its energies in the interest of purifying the social body. Yet no matter how purified pornography was, it could never be sufficiently cleansed, and no matter how colonised by the expansion of the non-obscene, it could never be sufficiently conquered. For as pornography became or was perceived to be increasingly pervasive, it also became increasingly intangible, protean, and promiscuous and traversed the boundary between private and public often undetected. According to different writers, commentators, and even religious figures, pornography was present in the magazine that made its way into the sanctity of the domestic sphere and surprised the innocent family, and it was 'trash' that masqueraded as decent and even advertised itself as a moral guide. Most often, as one French lawyer put it, pornography enters homes under a 'benign appearance', and he noted that in contrast to the last century, now 'pornography is everywhere and no place, however sacred it is, remains completely closed, because [pornography] is a supple, rich, intelligent enemy who hesitates at nothing'.[14]

No longer hidden, pornography nevertheless eluded identification, infiltrated even dignified settings and, ever cunning, presented itself in the guise of culture itself. In France in particular, pornography's seeming ability to mutate into a wide variety of forms encouraged police to cast their nets ever wider and far less tidily. They included in their pursuits not only those texts deemed pornographic in the nineteenth century, but also, by 1939, even books – once thought to be solely the domain of an elite immune from pornography's lure – classified ads, as well as a far more extensive array of magazines and journals. The new sexual openness was thus also characterised paradoxically by more widespread repression of homosexuality and other 'pornographic'

fig.226
WILHELM FREDDIE
Sex-paralysappeal 1936
Painted plaster, glass, rope, wood, suede
64.5 cm high
Nordjyllands Kunstmuseum, Aalborg

Sex-paralysappeal was one of three works by Wilhelm Freddie seized by the police from his exhibition *Pull the Fork out of the Eye of the Butterfly: Sex-surreal*, held in Copenhagen in 1937. Freddie was prosecuted for pornographic activity and imprisoned for ten days, and the object was kept in the Danish Museum of Crime until 1963, when Freddie was retried and acquitted.

Freddie had been aware of surrealism since the early 1930s, but he first saw paintings by Salvador Dalí and others only in 1935. This contact was sufficient to unleash in him a life-long determination to make sexual pleasure and eroticism the main subjects of his work. He later met Breton and the surrealist group in Paris when he was invited to participate in the international exhibition held there in 1947. JM

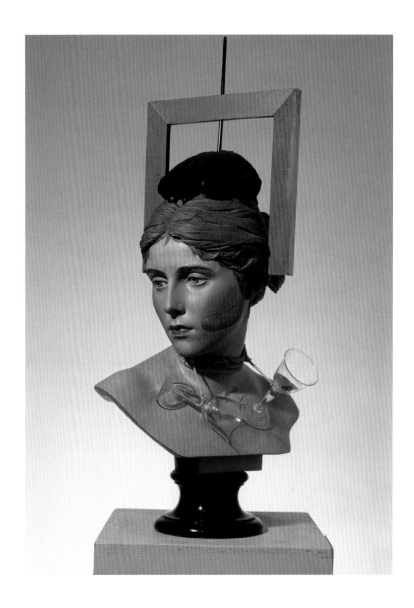

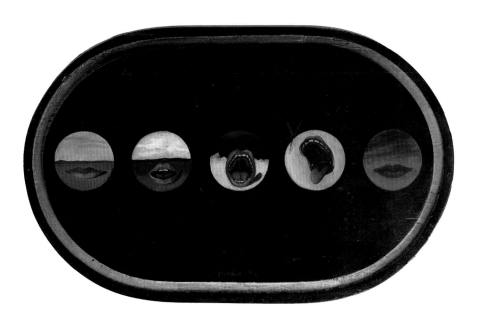

fig.227
WILHELM FREDDIE
The Definite Rejection of a Request for a Kiss 1940
Oil on wood
21 x 33.5 cm
Birger Raben-Skov, Copenhagen

perversions in which the war's violence had been symbolically located. Of course, there were conservative thinkers, particularly Catholics, who had no truck with the liberal criticism of sexual repression and sought increasingly interventionist measures to fight this elusive and yet omnipotent enemy. But it is more apt to say that legislators did not intensify repression as much as they generated new laws in accord with recent ideas about the pervasive and yet surreptitious nature of pornography, laws which addressed the diffusion of authorship into vast networks of distributors, publishers, importers, and illustrators, all of whom were agents of contamination and thus symptoms of an epidemic rather than its cause, as if pornography had taken on a life of its own.

Laws from the interwar period to the present extended the late nineteenth-century laws in new ways to combat this perceived epidemic, whose symptoms were the same as they had been at the end of the century, only now seen to be more dangerous and widespread – perverse sexuality, especially homosexuality, and female sexual autonomy.[15] Hence the French government in 1920 enacted the most draconian anti-abortion law in Western Europe, prohibiting the mere advocacy of birth control or abortion and increasing the penalties for abortion. In 1923 several nations, including France, signed an accord against trafficking that repressed the import, export, or transport of obscene books to combat an enemy that knew no national boundaries. The gay magazine *Inversions* – which contained no sexually explicit material – was condemned by a judge who reinterpreted the 1882 pornography law to target any book that was 'flagrantly immoral': he wrote that 'the law of 1882, once sufficient to repress these kinds of abuses in its own time, now leaves decency and public morality defenceless against new forms [of indecency] that pornography, so good at insinuating itself in all the legal cracks, has been able to imagine.'[16] After 1919, all films were subjected to censorship by a board comprised of thirty educators, politicians, and eventually, representatives of the film industry.[17] In the 1920s, various courts issued different decisions meant to provide updated guidelines for determining obscenity, and in 1930 the Court de Paris insisted that pornography was that which falls outside 'the accepted morals of a century' as well as 'habits and social conventions making life bearable for good citizens in a civilised society'. By July 1939 the government issued a decree banning all forms of

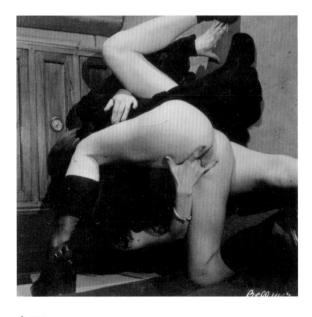

fig.228
HANS BELLMER
The Oral Cross 1935
Hand-coloured silver gelatin print
11.8 x 12 cm
Ubu Gallery, New York, and Galerie Berinson, Berlin

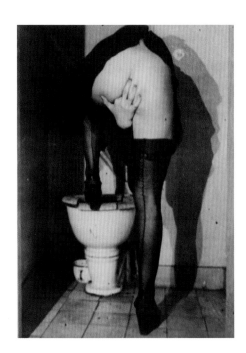

fig.229
HANS BELLMER
Untitled (Study for *Histoire de l'oeil* by Lord Auch [Georges Bataille]) 1946
Silver gelatin print
18.3 x 12 cm
Ubu Gallery, New York, and Galerie Berinson, Berlin

obscenity, including books, in the name of protecting not just the family but the 'race', permitting more vociferous prosecution of homosexually oriented material. In January 1940, six months before the French defeat by Hitler's forces, the government established a seven-member special commission charged with evaluating which books were obscene and (in a tip of the hat to sexual progressives) with distinguishing between erotic literature and '*pornographie grossière*', in which they included 'perversion' and homosexuality. By December 1958, more than a decade after General Charles de Gaulle restored parliamentary democracy, the government modernised older obscenity clauses, extending them to apply not just to 'books, posters, paintings, objects, and images', but also to 'photographs, films, and photographic reproductions'.[18] The disappearance of the author was now complete.

Antipornography laws thus became increasingly expansive at a historical moment when pornography was becoming more difficult to define with any precision. While nineteenth-century prosecution proceeded with confidence in the solidity of the pornography concept, twentieth-century legislators, scholars, critics, and others instead presumed its conceptual indeterminacy even as they seem to know what they were pursuing. This dogged pursuit of something that no one can quite define suggests that pornography is not intrinsically empty, as so many of its proponents insisted, but rather allegorised the pervasive, body-shattering, sadomasochistic and homosexual eroticism that appeared in so many guises that its meaning was hard to pin down and necessarily exceeded all efforts to contain or eliminate it. In other words, pornography expressed and still expresses violent eroticism as a potentially permanent dimension of the social body, so palpably and yet so intangibly (and imprecisely) that the United States Supreme Court Judge Stewart Potter was forced to conclude in 1964 that he knew pornography when he saw it, implying that he could otherwise provide no substantive definition of its meaning.

By focusing on changing images of the social body as a way of exploring the changing meanings of pornography, we may see how historically and culturally specific images of the body catalyse and shape debates about what constitutes pornography. In so doing, we can move beyond trans-historical arguments of French advocates of the liberated imagination, American free speech advocates, moralists, and even some feminists who seek to draw distinctions between art and pornography in legal or moral terms when they are instead often talking about a healthy social body – that is to say, an ideal, normative vision of social order.

Discussions about pornography were and are still shaped by and embedded in fantasies about the destruction of the social body, a concept that identified a generalised threat to the fantasmic integral male body after which social order was fashioned. This recent meaning of the pornographic explains why, for example, surrealism and other modernist and postmodernist art forms have a pornographic dimension – are believed, metaphorically, to violate the dignified and impermeable, ideally masculine social body – since they not only depict eroticism in an often explicit fashion, but also enact, mobilise (and often deflect) that body-violating desire in their formal innovations. Surrealism arguably internalised the dramatic cultural paradox of the interwar period: it renewed, purified, and reinvigorated the body by giving free rein to eroticism, and yet in so doing manifested the social body's potential permeability – that which can never be entirely cleansed or eliminated. For cultural and aesthetic conservatives, surrealism represented a destructive, dignity-sapping link between sexuality and violence no matter what its explicit content. For other commentators, such as Georges Bataille, many surrealists, and André Breton in particular, never forged that link as dramatically or subversively as was necessary to seriously challenge liberal democratic notions of integral selfhood. According to Bataille, Breton inadvertently bracketed pornography, rendered it an alien and degraded category of meaning by celebrating Sade and repressing the famous writer's depictions of human violence.[19] Pornography, in this view, would now be a symptom of repressed anxiety about our capacity for violence that we are still working through.

fig.230
TOYEN
Hermaphrodite with Shell 1930–31
Ink on paper
27 x 21 cm
Mony Vibescu

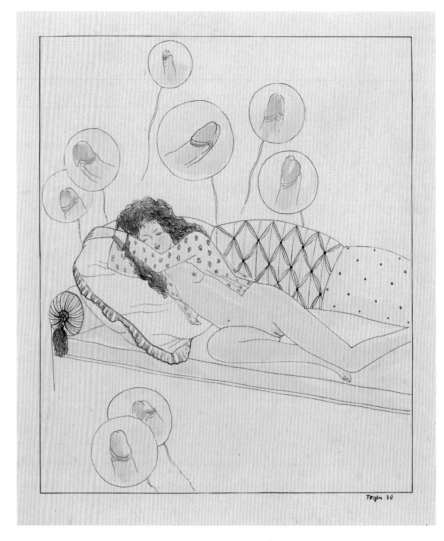

fig.232
TOYEN
Young Girl who Dreams 1930
Ink and watercolour on paper
20 x 17 cm
Mony Vibescu

Erotická revue

ročník druhý

redigoval J. Štyrský

Praha

květen 1932

V. H. Brauner

fig.231
Erotická revue, vol.2 1932
20.8 x 13.5 cm
Mony Vibescu

SURREALISM IN PRAGUE

Prague was second only to Paris as a centre for surrealism in the early and mid-1930s. The creation of an independent Czechoslovakia in 1918 had led to the development of a flourishing literary and artistic avant-garde, open to influences from Germany, Russia and France. In the early 1920s the leading poet Vítìzslav Nezval helped found the Devetsil movement that attracted the poets Jaroslav Seifert and Konstantin Biebl, the essayist and theoretician Karel Teige, as well as such artists as Jindřich Štyrský and Toyen. The movement was in contact with the Paris surrealist group and in the early 1930s recognised that its goals converged with those of surrealism. The leading figures in Devetsil officially founded a surrealist group in Prague in 1934, and the first exhibition of Czech surrealist art was held in 1935. In the same year André Breton, accompanied by his wife Jacqueline, as well as by Paul Eluard and Nusch, came to Prague to deliver a series of lectures on surrealism, and was overwhelmed by the respect with which he was received and by the interest shown in his ideas.

A striking feature of Czech surrealism was its focus on eroticism. The artist Štyrský published the *Erotická revue* from 1930 to 1933. This publication – which under Czech obscenity laws could not be sold publicly, lent or distributed – comprised selections of writings on erotic themes, reflections on the theories of Freud, as well as translations of texts by the Parisian surrealists including extracts of Aragon's *Le Con d'Irène*, of *L'Immaculée Conception* by Breton and Eluard, and of the group's *Recherches sur la sexualité*. The *Erotická revue* was illustrated with a variety of erotic drawings, including some by the nineteenth-century masters Aubrey Beardsley and Felicién Rops, as well as by modern Czech artists. Štyrský's partner Toyen contributed some of the most explicit works. Her drawings – hand-coloured in the *éditions de luxe* – did not hide her femininity but revealed something of the male or asexual alter ego she cultivated in this period.

In 1931 Štyrský launched a series of books known as the Edice 69, each volume of which was issued in an edition of only sixty-nine copies. The first was *Sexuální nocturno* by Nezval. This 'story of an illusion unmasked' used taboo words and addressed the theme of child sexuality, and as such had no precedents in published Czech literature. The collages Štyrský made for this book were his first works in this medium, and his first

works with erotic themes. A second volume was a translation of *Justine* by the Marquis de Sade, illustrated by Toyen. In the sixth and final volume in the series, *Emilie Comes to Me in a Dream* (1933) Štyrský published an erotic text and ten collages which combined everyday objects and scenes with images taken primarily from German and English pornographic magazines.

From 1935 Karel Teige also turned to collage or, more exactly, photomontage. He saw it as an inherently democratic medium, open to all, and believed that the use of magazine images or advertisements signalled an engagement with modern life. Often alluding to other surrealist images, his erotic collages embraced a dreamy lyricism and an alternately satirical and disturbing reworking of the female form.

Marxism, with its call for the abolition of marriage and cult of free love, had prepared these artists and writers to adopt a radical stance in sexual matters. Freud's writings had also been received with enthusiasm in Czechoslovakia, unlike in France, and the group was well versed in psychoanalytic theory. But there was a further factor in the readiness with which these Czech artists and writers celebrated eroticism in the early 1930s. From the beginning the Devetsil group had identified poetry as a lyrical and creative force in life, a force it recognised as linked to the sexual instinct. The group's theory of 'poetism' involved not only changing society but also changing man through teaching him to be happy. 'The great discovery of poetism is *happiness*', wrote Teige in a manifesto of 1928, adding 'happiness lies in creation'. Without this predisposition among the Czech avant-garde to celebrate the 'pleasure principle', surrealism would not have found its second home in Prague, nor would the Czech surrealists have focused so intently on eroticism.

The Czech surrealists were to enjoy only a few years of relative freedom. News of the Stalinist purges and show trials in Russia from 1936 caused bitter quarrels among the group. Nezval, loyal to Stalinist communism, officially disbanded the surrealist group, though it continued to function under the leadership of Teige through the war and beyond. In the early and mid-1930s, however, the Czech group, like its Parisian counterparts, saw eroticism as part of the cure for the problems of society rather than a refuge from them. JM

fig.233
ANONYMOUS
Jindřich Štyrský, Paul Eluard,
Toyen and Nusch Eluard, Prague 1935
Vintage photograph
6.5 x 6.5 cm
Collection Galerie 1900–2000,
Marcel et David Fleiss, Paris

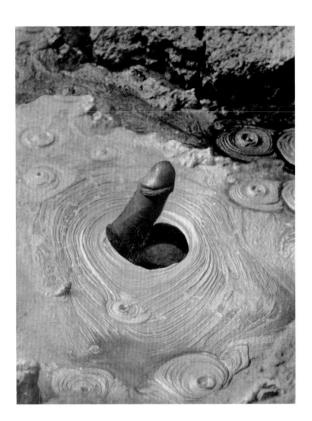

234
JINDŘICH ŠTYRSKÝ
Untitled (Emilie Comes to Me in a Dream, No.1) 1933
Collage
24.3 x 18.5 cm
Ubu Gallery, New York

fig.236
JINDŘICH ŠTYRSKÝ
Untitled (Emilie Comes to Me in a Dream, No.5) 1933
Collage
20.9 x 17.7 cm
Ordóñez Falcón Collection of
Photography

fig.235
JINDŘICH ŠTYRSKÝ
Untitled (Emilie Comes to Me in a Dream, No.6) 1933
Collage
30 x 22.8 cm
Thomas Walther

fig.237
JINDŘICH ŠTYRSKÝ
Sexual Nocturne 1931
Collage and ink on paper
18.5 x 14 cm
Mony Vibescu

fig.238
JINDŘICH ŠTYRSKÝ
Sexual Nocturne 1931
Collage and ink on paper
23.3 x 17.7 cm
Mony Vibecsco

For the surrealists the cinema was an enchanted place, a threshold between reality and fiction, waking life and a dream. Passing through the muffled doors into swift blackness is like going 'through a critical point as captivating and imperceptible as that uniting waking and sleeping.'[1] Darkness and the insulation from the outside world enhanced the analogy with the unconscious and dreams. The surrealists would drop into a cinema regardless of the programme, and leave before the end, content with a collage of impressions, 'for it is there that the only absolutely modern mystery is celebrated'.[2]

The 1920s was an era of massive popularity for films, which were silent until 1929. The surrealists favoured American comic movies (Mack Sennett, Charlie Chaplin, Buster Keaton, Harry Langdon), but also the unintentional comedy of execrable productions (especially, Breton noted, French screenplays like *Diana la charmeuse*), two-reelers, mystery dramas and serial screen thrillers such as *Les Vampires*. The poet Robert Desnos, who regularly wrote screen criticism, singled out cinematic eroticism as the supreme consolation for the disappointments of everyday life.[3]

Film was cited, together with photography, during early arguments over the role of the visual arts in surrealism, as the true replacement of painting. Man Ray made some forays into film during the 1920s[4] and Antonin Artaud wrote a scenario, *La Coquille et le Clergyman*, in which he sought to realise his belief in the affinity of the cinematic image with the mechanisms of the human unconscious. He chose Germaine Dulac to make the film, but the result dissatisfied him, and the premiere in February 1928 was disrupted by the surrealists. Dulac's interest in nature was bound to a symbolist aesthetic, and conflicted with Artaud's and the surrealists' desire to go beyond representation, to reach a psychic directness that related to experience rather than the expression of feelings. It was not until the collaboration between Luis Buñuel and Salvador Dalí in 1929 that a film fully realised its potential within a surrealist context, taking advantage of 'the spontaneous and almost despotic qualities of the visual image which made its access to the circulation of desire more immediate.'[5] This film, *Un chien andalou*, neither belonged to experimental avant-garde films nor Hollywood melodrama and comedy, though it borrowed from both. The fledgling film-maker and the painter had already written about film, distinguishing between 'art-film and anti-artistic film', rubbishing the former in

favour of 'anti-artistic' Hollywood movies.[6] Later, Buñuel also acknowledged his admiration for Eisenstein, especially for his film *The Battleship Potemkin* (1925).

Un chien andalou (1929) and *L'Age d'or* (1930) remain among the surrealist movement's greatest achievements. *Un chien Andalou* was planned over the winter of 1928–9, before either Dalí or Buñuel became official members. But as Buñuel noted when the scenario was published in the final issue of *La Révolution surréaliste* in 1929, '*Un chien andalou* would not exist if surrealism did not exist'. The collaboration on the scenario was intense, swift and harmonious: 'in less than a week we had a script; our only rule was very simple: no idea or image that lent itself to a rational explanation of any kind would be accepted.'[7]

Un chien andalou does not recount a dream, but 'profits by a mechanism analogous to that of dreams'.[8] Dalí described it as a film of 'adolescence and death'.[9] The images and the acts of the protagonists follow not a causal but an emotional logic, working directly on the spectator to provoke alternately attraction and repulsion, hilarity and horror, enhanced by a soundtrack that intersperses tango music with the 'Liebestod' from Wagner's opera *Tristan and Isolde*. The action of the film encompasses love, desire, inhibition, violence and death.

The structure of sequences is poetic rather than narrative, often working through a specifically filmic use of metaphor (montage, dissolve, double exposure). In the opening sequence an innocent romantic metaphor comparing eye and moon moves inexorably to a violent and antithetical conclusion, as the bisection of the moon by a razor-thin cloud is followed by the slitting and spilling of the eye. The operation posits in a horribly physical manner the surrealist motif of the pierced eye symbolising inner vision, the imaginary world.

Un chien andalou eschews both the purely formal experiments of avant-garde films and theatrical naturalism. As inventive in its use of gags as Keaton or Langdon (for example, the cocktail shaker stand-in for the ringing of a doorbell), the film's extraordinary power simultaneously to disorient and to hypnotise also profits from Buñuel's inspired use and abuse of ideas floating around at the time in avant-garde cinema. Close-ups of objects, for instance, which Dalí had celebrated in his 1927 text 'Photography, Pure Creation of the Mind',[10] uncover not just the poetry of everyday things, passive and enigmatic from a

rational point of view, but their unconscious meanings. For Buñuel and Dalí, guided by their reading of Freud, objects function symbolically, like the surrealist objects Dalí was to invent in 1931, and thus enter the psychological drama in a new way. Film's natural propensity to collapse time and space – as experienced in popular scientific documentaries of the period which might allow the viewer to see 'oaks spring up and antelopes floating through the air'[11] – is subverted; dislocation and contradiction serve the purposes of disorientation.

Unlike *Un chien andalou*, which played to packed houses at Studio 28 in Paris for months, *L'Age d'or* provoked a major scandal. Following a violent rightwing demonstration, it was banned shortly after its first performance in November 1930, and was not shown again in public for nearly fifty years. Commissioned by the Vicomte de Noailles as a short, like *Un chien andalou*, the original scenario by Buñuel and Dalí grew to feature length, and was one of the first sound films to be made in France. 'My general idea', Dalí wrote for the booklet that accompanied its launch, 'in writing the scenario for *L'Age d'or* with Buñuel has been to present the straight and pure course of "conduct" of a human being pursuing love contrary to the ignoble ideals of humanity, patriotism, and all the miserable mechanisms of reality.'[12]

The collaboration was less harmonious than before; Dalí subsequently denounced Buñuel's crude anti-clericalism, whilst the extent of Dalí's involvement was minimised by Buñuel. It seems likely that the '"social" jokes are Buñuel's, and the "sexual" ones are Dalí's'.[13] The film's heterogeneous collage of 'found' and created fragments is fully surrealist, and the tension between political satire and sexual desire corresponds to the splintering aims within the surrealist movement at the time, as they struggled to reconcile alliance with the Communist Party with their original aim of exploring unconscious drives. The film is both a sustained attack on religion, family, police and nation, and a perverse account of the single-minded pursuit of love, forever interrupted by social convention. In fact it is the frustration, deferral and betrayal of love, rather than the ideal union of *l'amour fou*, that governs the action. The central scenes around an aristocratic party – during which a tumbril with drunken workers rolling through the drawing room and a burning kitchen maid are politely ignored whilst a spilt glass causes outrage, and the lovers struggle and fail to unite – are framed

by a borrowed documentary on scorpions and a coda on Sade's *The 120 Days of Sodom*.

The surrealists' passionate interest in the cinema, however, was not matched by a sustained production of surrealist films. Apart from Buñuel, whose later career in Mexico and France produced a stream of masterpieces such as *The Exterminating Angel* (1962) and *That Obscure Object of Desire* (1977), there are only scattered examples of surrealist interventions: Hans Richter's *Dreams that Money Can Buy* (with episodes by Marcel Duchamp, Man Ray and Max Ernst, 1944–7), for instance, or Joseph Cornell's *Rose Hobart* (1936). The latter takes a B-movie, *East of Borneo*, and re-edits the original to a fraction of its former length, with cuts, repeats and inserts of found material, destroying the banal tale of exotic adventure and erotic threat to create a concentrated and obsessional portrait of the actress (Rose Hobart). On the other hand, surrealist ideas filtered broadly into avant-garde cinema in the postwar years, especially among independent film-makers in the United States. Maya Deren's somnambulist films such as *Meshes of the Afternoon* (1943) explore the self through dreams which suspend temporality, and pursue a cinematic self-reflexivity through a metaphoric use of windows and mirrors. Processes of temporal and spatial displacement and the deliberate confusion of apparent and dream realities have also been part of the strength of Latin American cinema, often allied Buñuel-like to political satire.

If a prejudiced view of what surrealism stood for has obscured its influence on film, there is nonetheless an innate congruity between the medium and surrealist ideas, which could allow surrealism to claim kinship in many quarters where film has resisted the unreflexive, theatrical narrative mode. Film, which has every claim to be a true mirror of the outside world is in fact open to any number of subversions of that reality. As part of the broad move to uncover truths hidden beneath surface appearances, of which Freud and Marx are the pre-eminent voices, surrealism's attempt to annex film in its revaluation of the means to express those hidden realities is of fundamental importance to modern culture, even if mainstream film has by and large failed to realise its own unique mechanisms, preferring comfortable escapism and the celebration of national myths purveyed through simple realism.

DA

fig.238
LUIS BUNUEL AND
SALVADOR DALI
Un chien andalou 1929
Film still
Courtesy BFI

fig.239
LUIS BUNUEL
L'Age d'or 1930
Film still
Courtesy BFI

chapter ten
CRITIQUE OF PURE DESIRE, OR
WHEN THE SURREALISTS WERE RIGHT

Neil Cox

n 25 June 1783 the Marquis de Sade wrote one of many long letters to his wife from his prison cell (no.6) in the Château de Vincennes. Having requested a copy of Jean-Jacques Rousseau's *Confessions* to complement his already extensive prison library, Sade was outraged to learn that the book was regarded as inappropriate for someone of his immoral inclinations. In the letter he metes out sarcasm to his captors, those responsible for censoring his literary diet as well as his correspondence, in full knowledge that they would be the first to read his words:

Alas, they do me much honour in reckoning that the writings of a deist can be dangerous reading for me; would that I were still at that stage … Gentlemen … you fancied you were sure to work wonders … by reducing me to an atrocious abstinence in the article of carnal sin. Well, you were wrong: you have produced a ferment in my brain, owing to you phantoms have arisen in me which I shall have to render real. That was beginning to happen, you have done naught but reinforce and accelerate developments …

Had I been given *Monsieur le 6* [i.e. Sade himself] to cure, I'd have proceeded very differently, for instead of locking him up amidst cannibals I would have cloistered him for a while with girls, I'd have supplied him with girls in such good number that damn me if after these seven years there'd be a drop of fuel now left in the lamp! When you have a steed too fiery to bridle you gallop him over rough terrain, you don't shut him up in the stable. Thereby might you have guided *Monsieur le 6* into the good way, into what they call the honourable path. You'd have brought an end to those philosophical subterfuges, to those devious practices nature disavows (as though Nature had anything to do with all this), to those dangerous truancies of a too ardent imagination which ever in hot pursuit of happiness and never able to find it anywhere, finishes by substituting illusions for reality and dishonest detours for lawful pleasure… Yes in the middle of a harem *Monsieur le 6* would have become the friend of woman; he would have discovered and felt that there is nothing so beautiful, nothing so great as her sex, and that outside of her sex there is no salvation. Occupied solely in serving ladies and in satisfying their desires, *Monsieur le 6* would have sacrificed all his own …[1]

The letter concludes with a postscript in which Sade asks his wife to commission a case for maps and plans from a craftsman. In fact, the object in question was almost certainly intended to act as a dildo, an instrument to satisfy the sexual energy that Sade pictured raging within him.[2] In another famous letter of the following year, Sade euphemistically describes the terrible tension he experiences in prison over not being able to attain orgasm, and his absolute need for dildos in helping him to release the tension.[3] Without a person to focus his desires, Sade's imagination must provide the means to excitement, and this causes him greater 'disturbances, convulsions, spasms and aches'. Failure to reach orgasm means that his mind 'goes to the devil'.

fig.241
OSCAR DOMINGUEZ
Electrosexual Sewing Machine
1934
Oil on canvas
100 x 81 cm
Private collection

fig.242
D.A.F. DE SADE
Letter to Mme de Sade 1783
Manuscript
19 x 12.5 cm
Pierre Leroy, Paris

Sade's life, as far as one can now tell, was permanently crossed by these two currents: enlightened argument against strict moralism and the consciousness of an uncontrollable sexual energy.

These letters only entered the public domain long after the surrealists first invoked Sade as a presiding deity over their movement. Yet they would not have been unhappy with their theme: that of desire frustrated by repressive authority. This was the central concept in surrealist discussion of Sade: it was built on the knowledge that Sade spent a total of twenty-seven years in prison, and the belief that he did so either as punishment for perverse sexual acts or for writing pornography or for his radical political views, or for all three. This belief was not well founded: today most biographers concur that Sade's imprisonment was the direct result of the efforts of his mother-in-law to contain scandal, and that Sade's morality and politics, far from being profoundly rational and consistent, were a paradoxical combination of Enlightenment libertarianism, aristocratic privilege and legitimisation of his personal sexual foibles.

Donatien Alphonse François, Marquis de Sade (1740–1814) is best known for his extensive pornographic writings. These include the pendant novels *Justine, or The Misfortunes of Virtue* (1791) and *Juliette, or The Prosperities of Vice* (1798); a bleak storytelling novel, *The 120 Days of Sodom* (first published 1931–5) and the astonishing philosophical dialogue, *Philosophy in the Bedroom* (1795). He also wrote less scabrous books, including *Aline and Valcour, or The Philosophical Novel* (1793) and numerous plays and short stories. Sade was born into a high-ranking Provençal family and claimed to be a descendent of Petrarch's love, Laura. He had a conventional upbringing and became a cavalry officer at the age of seventeen, participating in the Seven Years War until 1763, when he was married into another noble family. It was in the same year that Sade was briefly imprisoned for the first time in the Château de Vincennes, by order of the King,

fig.243
D.A.F. DE SADE
Justine, ou Les Malheurs de la vertu
19.2 x 17.7 cm
Published Paris, Les Libraires associés 1791
Pierre Leroy, Paris

for perverse sexual activities in a brothel. In 1768 Sade's behaviour again brought him trouble: he persuaded a prostitute named Rose Keller to accompany him to his private lodgings, and there ordered her to strip, threatened her with a knife, and flogged her. Afterwards, Keller escaped and reported her experiences to the authorities. Sade found himself imprisoned in Saumur and then Pierre-Encise prison, but was released again before the end of the year, Keller having been bought off by Sade's deeply worried and powerful mother-in-law. His misdemeanours continued, however, and in 1772 he and his valet were found guilty of poisoning and sodomy after a day-long orgy involving Spanish fly pastilles and five women in Marseilles. Sade ended that year in the fortress prison of Miolans, from which he escaped the following April. He managed to seclude himself in his château at La Coste over the winter of 1774–5, during which time he and his wife colluded in sexual exploitation of very young servants recruited especially for the purpose. After the ensuing scandal in the spring Sade went on an Italian tour, but the accusations of relatives haunted him throughout 1776 and into 1777, when he was imprisoned in Vincennes under a *lettre de cachet*. These edicts for the indefinite detention of members of the nobility were issued by the King, usually at the behest of the family of the prisoner, who paid rent to keep him out of sight. Many of the years Sade spent behind bars were as a result not of court sentences or criminal convictions but of a *lettre de cachet*.

Sade managed to escape for a while in 1778, but was incarcerated again in September of that year in cell no.6 at Vincennes, beginning with three months solitary confinement. Sade was moved from Vincennes to the Bastille in 1784, where his cell was in the ironically named Liberty tower, and again from the Bastille to Charenton asylum on 4 July 1789, ten days before the prison was attacked by the revolutionary mob. The constituent assembly, formed under the auspices of the Revolution, passed a law revoking most *lettres de cachet*, and Sade was released in April 1790. Sade used his freedom to launch a career as a dramatist, with only moderate success, but, now somewhat estranged from his wife, he also fell in love with Constance Quesnet, a woman whom he remained close to for the rest of his life. He became an active participant in one of the revolutionary Sections of Paris, doing his best to renounce his noble birth, but confusion over his identity landed him in prison again for most of 1794. After another period of freedom, Sade was imprisoned in April 1801 by the puritanical senior officials of Napoleon's police force, for the first time on suspicion of writing pornography. Sade spent the rest of his days in prison, managing a brief affair with a maid, and died in bed after a period of illness.

The surrealist version of the Marquis de Sade originated, as did so many other aspects of the movements early identity, in the work of the poet Guillaume Apollinaire, who supplemented his income as an art critic with forays into burlesque pornography. Apollinaire's Sade was erected in turn on an inheritance of nineteenth-century writing – for example, by Flaubert and Swinburne – that celebrated Sade's satanic eroticism. In 1909 Apollinaire turned his hand to a serious effort of scholarship on Sade, revealing the existence of a hitherto unknown manuscript, for example, but also offering a grandiloquent defence of Sade as a moral philosopher. Apollinaire considered Sade 'the freest spirit who ever existed', and argued that his prophetic works, consigned to oblivion in the *Enfer* of the Bibliothèque Nationale throughout the nineteenth century, would come to dominate the twentieth.[4] Thus Sade's name appeared among a list of antecedents in the proto-surrealist journal *Littérature* in 1923,[5] and in Breton's first *Manifeste du surréalisme* Sade is described as

fig.244
ANDRE MASSON
Women 1922
Ink and gouache on paper
40 x 31 cm
Private collection, Paris

'surrealist in sadism'. In the December 1926 issue of the surrealist journal *La Révolution surréaliste*, the poet Paul Eluard contributed a homage to 'D.A.F. de Sade, Fantastic and Revolutionary Writer'. This brief article is the first discursive treatment of Sade's reputation within surrealist circles, illustrating awareness of current commentaries and researches concerning Sade's still obscure biography, but also repeating essential tenets of Apollinaire's approach. It emphasised the contrast between moralising criticism of Sade by contemporary historians and the supposedly profound philosophical and ethical stance adopted by Sade during his lifetime. Eluard argued that Sade was locked up for virtually his entire life 'for having wanted to give back to civilised man the force of his primitive instincts, for having wanted to unleash the amorous imagination, and for having struggled desperately for justice and absolute equality'.[6] Whatever the attractions to surrealism of the idea that Sade's writings were too potent for the State to tolerate, it is clear that Sade only *began* writing pornography once in prison. Nevertheless, although surrealist texts like Eluard's often wrongly impute the cause of his confinement to Sade's pornography, it is clear from the 'Monsieur le 6' letter, for example, that Sade did regard his writing as a medium through which his sexual energy was released, and that the frustrations of that imagination caused by imprisonment made the 'dangerous truancies' of his vengeful imaginings all the more brutal.[7]

The year 1926 also saw the publication of one of Sade's hitherto unknown works, the *Dialogue between a Priest and a Dying Man* of 1782. The manuscript of this atheist tract had passed through the hands of various collectors, and was eventually studied by Maurice Heine, a radical communist, poet and historian who played a fundamental role in the reconstruction of

fig.245
HANS BELLMER
Untitled (Dialogue between and Priest and a Dying Man) 1946
Pencil on paper
26 x 22 cm
Private collection

Sade's life as well as in the interpretation of his works.[8] In 1918, shortly before his death, Apollinaire is purported to have met Heine and hatched a plan to publish Sade's entire oeuvre. Heine edited an important Sade anthology and published two further significant Sade novels – *The Misfortunes of Virtue* and *The 120 Days of Sodom* – before his own death in 1940, and became a key figure in surrealist circles, publishing on Sade in *Le Surréalisme au service de la révolution* and *Minotaure*. Heine straddled the interests of both the academic community and the avant-garde: he published both detailed accounts of episodes in Sade's life based on thorough research, and wrote poems and evocative essays concerning Sade's philosophical position. Although Heine worked diligently to expose a historically accurate picture of Sade, he was also committed to the idea that Sade's life and work represented radical liberty. Unlike any of his forerunners in Sade scholarship, however, Heine was alert to the content of Sade's 'philosophical' reflections on desire, developed during those long terms of imprisonment and expressed in the major pornographic novels, especially insofar as they revolved around the notions of pleasure in inflicting pain and the paradoxical need for moral limits to increase the intensity of such pleasures. As the editor of *The 120 Days of Sodom*, Heine drew attention to the solipsism of Sade's universe, and in his 1936 collection of texts on sexual crimes, he confronted both the extraordinary fantasies and the

fig.246
ANDRE MASSON
Drawing for Justine 1928
Collage, ink and watercolour on paper
47 x 36 cm
Private collection, Paris

fig.247
ROBERTO MATTA
The 120 Days of Sodom 1944
Wax crayon and pencil on paper
29.5 x 37 cm
Private collection, Paris,
courtesy Galerie de France, Paris

fig.248
ROBERTO MATTA
I Shame Myself / I Ascend
1948–9
Oil on canvas
195 x 141.9 cm
The Menil Collection, Houston

fig.249
ANDRE MASSON
Erotic Land 1937
Ink and watercolour on paper
50.5 x 65.5 cm
Private collection, Paris

brutality of lived sadism. A full account of the philosophy of Sade's fictional libertines is beyond the scope of this essay, but it is worth reciting a few of their maxims:

On murder as the most satisfying sadistic act:
It is no longer contested, Madame, that libertinage leads logically to murder; and all the world knows that the pleasure-worn individual must regain his strength in this manner of committing what fools are disposed to denominate a crime: we subject some person or other to the maximum agitation, its repercussion upon our nerves is the most potent stimulant imaginable, and to us are restored all the energies we have previously spent in excess. Murder thus qualifies as the most delicious of libertinage's vehicles, and as the surest.[9]

On the need for apathy:
Ah Eugenie, believe me when I tell you that the delights born of apathy are worth much more than those you get of your sensibility; the latter can only touch the heart in one sense, the other titillates and overwhelms all of one's being. In a word, is it possible to compare permissible pleasures with pleasures which, to far more piquant delights, join those inestimable joys that come of bursting socially imposed restraints and of the violation of every law?[10]

On the need for an absolute crime against Nature:
'Very well', said Durcet, 'it is possible to commit crimes such as these our minds yearn after…?
For my part, I must declare that my imagination has always outdistanced my faculties; I lack the means to do what I would do, I have conceived of a thousand times more and better than I have done, and I have ever had complaint against Nature who, while giving me the desire to outrage her, has always deprived me of the means.'

'There are', said Curval, 'but two or three crimes to perform in this world, and they, once done, there's no more to be said; all the rest is inferior, you cease any longer to feel. Ah, how many times, by God, have I not

longed to be able to assail the sun, snatch it out of the universe, make a general darkness, or use that star to burn the world! oh, that would be a crime, oh yes, and not a little misdemeanour such as are all the ones we perform who are limited in a whole year's time to metamorphosing a dozen creatures into lumps of clay.'[11]

On Pity:

What do you call mercy?… That sentiment, chilling to the desires, can it find entry into a stern heart? And when a crime delights me, can I be stopped by mercifulness, the dullest, most stupid, most futile of all the soul's impulsions?… Are plants and animals acquainted with mercy, pity, social obligations, brotherly love? And in Nature do we detect any law other than self-interest, that is, self-preservation? The one great trouble is that human laws are the fruits of nothing but ignorance and prejudice.[12]

On love:

What is love? One can only consider it, so it seems to me, as the effect upon us of a beautiful object's qualities; these effects distract us; they inflame us; were we to possess this object, all would be well with us; if 'tis impossible to have it, we are in despair. But what is the foundation of this sentiment? Desire. What are this sentiment's consequences? Madness. Let us confine ourselves to the cause and guarantee ourselves against the effects. The cause is to possess the object: splendid! Let's strive to succeed, but using our head, not losing our wits; let's enjoy it when we've got it, let's console ourselves if we fail; a thousand other identical and often much more superior objects exist to soothe our regrets and our pride: all men, all women, resemble each other: no love resists the effects of sane reflection. O 'tis a very great cheat and dupery, this intoxication which puts us in a state that we see no more …[13]

This astonishing voice, the voice of Sade's fictional universe, was always fully available to interwar surrealism, but burned like a slow fuse, complicating an initially rather poetic vision of Sade.[14] In 1925, early and heady days for the movement, the surrealists declared themselves 'specialists in revolt', and stressed their preparedness to make use of any means of action in service of their revolution.[15] It was easy to move from this proclamation to the celebration of perverse sexuality as if perversion itself was somehow a medium of revolt. The provocation of the notion of absolute sexual freedom energised the movement in its confrontations with reactionary ideology over specific incidents interpreted by surrealism as sites of resistance to sexual repression. The range of such incidents is interesting: Charlie Chaplin's divorce in 1927, the chastisement of an exhibitionist,[16] a murder motivated by sexual conflict (the Violette Nozières case of 1933; see p.72), and even a brutal double murder with no obvious motivation at all beyond the mysterious and perverse sexual relationship of its perpetrators, the Papin sisters.[17] In the context of surrealism's Sade, it becomes clear that these interventions, a kind of moral guerrilla warfare with bourgeois values, are not *merely* attention-grabbing avant-garde strategy. Surrealist pamphlets, paeans to Sade and to sadistic acts do not escape this interpretation, but they have other aspects besides, enacting rather precise redefinitions of sexuality, and of desire, that are intended to be effective and complex expressions of the nature of 'the surrealist revolution'. But what kind of revolution could be born under the sign of a sexual abuser, pornographer, and aristocrat? Is there anything redeemable in surrealism's factually and perhaps morally dubious celebration of Sade's life and work?

One might answer the question by interrogating the apparent incompatibility between surrealism's Sade and surrealism's concept of 'love'. The absolutely suspect nature of this word in relation to sadistic sexuality often makes surrealist discourse of desire discomfiting, as if 'love' merely functions as a disguise for sadistic fantasies of control over women, the fantasies of the very poets whom these women are supposed to 'inspire'. But arguably the equation of 'Sade' and 'love' also performs a critical function. Gilbert Lely, the poet and Sade biographer who took up Maurice Heine's work after the latter's death in 1940, has been criticised for his claim that 'Sade means love'.[18] His phrase 'tout ce que signe Sade est amour' is difficult to translate but perhaps its critical moment is more evident if it is rendered as 'all that is under Sade's name is love'. In such a phrase, where love is, and what it is, are thrown into question. The surrealist strategy is not to answer this question, but to unravel all certainties attaching to it.

HANDS OFF LOVE

Man, bound by law to live with one woman only, has no alternative but to make her share all his ways, thereby placing himself at her mercy. Therefore, if she delivers him over to the public spite, why is the same law that invests the wife with the most arbitrary rights incapable of being turned against her with all the severity due such breach of faith and a libelous intent obviously motivated by the most sordid interest? And in any case, is it not an absurdity that personal habits should be a matter of legislation? But in restricting ourselves to the very episodic scruples of the virtuous *and* inexperienced *Mrs. Chaplin, it is comic to find that according to her the practice of fellatio is considered 'abnormal, against nature, perverted, degenerate, and indecent.' ('But all married people do this', justly replies Chaplin.) If a free and truthful discussion of sexual habits were possible, it would appear normal, natural, healthy, and decent for a judgement to quash the charges brought by a wife thus shown to have inhumanely* refused *herself to such a general, pure, and defensible practice.*

Transition, September 1927, surrealist tract reprinted in French in
La Révolution surréaliste, October 1927

fig.252
SALVADOR DALI
*Untitled: Composition with
Many Erotic Scenes* 1932
Ink on cardboard
32 x 24 cm
Fundació Gala–Salvador Dalí

fig.253
SALVADOR DALI
Bather (Female Nude) 1928
Oil and pebbles on laminated panel
63.5 x 75 cm
Salvador Dalí Museum,
St Petersburg, Florida

fig.254
SALVADOR DALI
Little Cinders 1927–8
Oil on panel
64 x 48 cm
Museo Nacional Centro de Arte Reina Sofía, Madrid

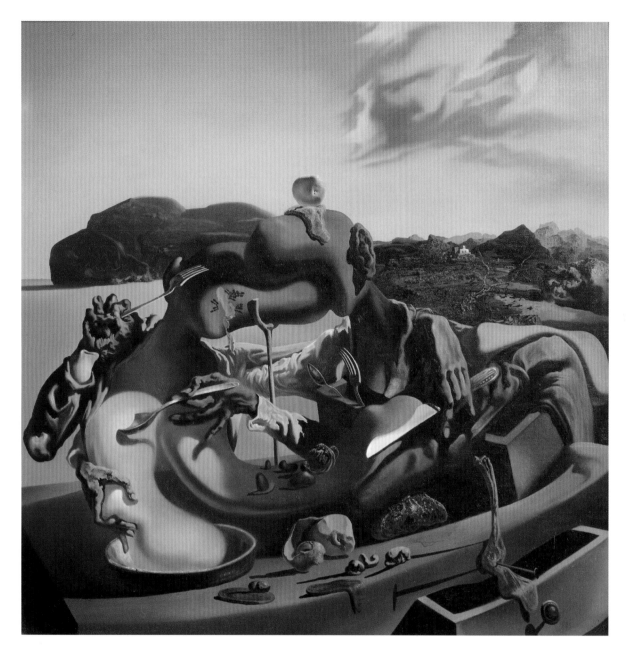

fig.255
SALVADOR DALI
Autumnal Cannibalism 1936
Oil on canvas
65.1 x 65.1 cm
Tate. Purchased 1975

To put the matter another way, surrealism knew the Sade who penned those rationalist sermons against love, against feeling, and yet deliberately made him preside over a movement enamoured of the idea of love as the highest expression of the irrational freedom of the mind in the face of social constraints. The crucial point is that surrealism's speaking of Sade and love in the same breath enacts a critique of the notion of desire, a transvaluation of desire that demands not a surrender or even an expansion of the idea of 'love', but its disorientation or dislocation. To be clear: it is the critical project of surrealist revolution that demands a continuing to speak of 'love' by other means, colouring it with cultural pessimism, rather than an entire abandonment of 'love' altogether. This is apparent on a careful reading of André Breton's poetic invocation of Sade, in *L'Air de l'eau* of 1934:

The Marquis de Sade went back inside the volcano
From which he came
With his beautiful hands still fringed
His eyes like a young lady's
And that reason at panic level that was
His alone
But from the phosphorescent drawing room with viscera lamps
He never ceased shouting mysterious orders
Which open a breach in the moral night
It is through that breach that I see
The great cracking shadows the old undermined crust
Dissolving
To let me love you
As the first man loved the first woman
In full freedom
A freedom
For which fire made itself man
For which the Marquis de Sade defied the centuries with his great abstract trees
Of tragic acrobats
Clinging to the gossamer threads of desire[19]

There is at work among the 'gossamer threads of desire' a voice announcing love's piercing of the moral night with an idea of freedom misshapen by its resistance to oppression. Hence Sade's reason is 'at panic level' and his fantasies are 'great abstract trees of tragic acrobats'. (Clearly what Breton refers to here are the absurd chains of sexual activity that express libertine desire in the novels, illustrated in the pornographic prints that Sade's publishers sometimes commissioned.[20]) These free imaginings are far from arbitrary: they are as the poem makes clear, designed to 'defy the centuries' with their non-reproductive and non-monogamous administration of desire. Breton represented Sade this way more than once: in *L'Amour fou* Sade is a prophet of 'perhaps the most crazy, the most indescribable means of loving'.[21] Again, the phrase has the potent sense of an enigmatic behaviour that is pathological, but which can be authentically lived as the critical

fig.256
JEAN BENOIT
The Eagle, Mademoiselle 1982
Mixed media
34 x 32.5 x 39.5 cm
Galerie Claude Bernard, Paris

Sade wrote to a friend, Mlle de Rousset, 'The eagle,
Mademoiselle, is sometimes obliged to leave the seventh
sphere of the heavens to lower itself onto the summit of
Mount Olympus, the antique pines of the Caucasus, the
cold larches of the Jura, the white ridges of the Taurus
mountains, and sometimes even near the quarries of
Montmartre ... So you see, Mademoiselle, that man
tries in vain to rise above himself. There are always two
fatal instants during the day which bring him back,
despite himself, to the sad condition of beasts, from
which as you know my constitution is not far removed.'

medium of desire under the distorted rule of modernity. But how intelligible is this project?
A detour through Freud's theory of desire may provide a logic for surrealism's 'revolutionary'
equation.

Technically speaking, this surrealist conflation of the pathologies of desire and love runs
counter to Freud's understanding of the two terms. In 'Three Essays on Sexuality' (1905), Freud
offers a complex theory to account for the analytic inaccessibility of desire or 'libido', which he
imagined to be an ever-present and fundamental compulsion for satisfaction akin to hunger. 'We
have defined the concept of libido as a quantitatively variable force which could serve as a measure
of processes and transformations occurring in the field of sexual excitation.' But Freud was clear
that the quantity of this chemical or biological force is also represented in the mind, and this
representation he termed 'ego-libido'. The ebb and flow of this force in the mind was to be the key
to grasping psychosexual phenomena. But gaining access to the changes in the level of libidinal
force or pressure had to be done more indirectly still, since the ego-libido is 'cathected' or concen-
trated by sexual objects (mental images rather than objects in the world), and the resulting aspect
of libido, 'object-libido', can be perceived as it concentrates 'upon objects, becoming fixated to them
or abandoning them, moving from one object to another and, from these situations, directing the
subject's sexual activity, which leads to satisfaction, that is to the partial and temporary extinction
of the libido'.[22] But Freud thought that the ego-libido, which he also called the narcissistic libido,
was the source of all the different manifestations of object-libido, and that every mental represen-
tation of libidinal satisfaction outside of the ego would ultimately be drawn back into it. The

original state of libido is thus narcissistic libido cathected in manifold ways – which could be the condition described elsewhere in the essays as the 'polymorphous perversity' of the infant. Freud had, in other words, loosened the bond between desire and its satisfaction by any particular route or action, and he had asserted the fundamental solipsism of desire, its thoroughly introverted nature.

Freud extended this model in 'Instincts and their Vicissitudes' (1915), reinterpreting libido under the guise of the notion of the sexual instinct. The use of this term represents a stage in Freud's journey towards ever more fundamental problems in his attempts to explain the origins of human sexuality. Freud now imagines the earliest stage of the ego as one cathected by numerous instinctual pressures, representations of their somatic sources. The narcissism of the libido develops thanks to the discovery that some instinctual pressures can be satisfied auto-erotically. This gives rise to a difference between some instinctual pressures and others, and is at the origin of the representation of the external world. Freud suggests that some of the 'external objects' that now confront the ego are introjected as *love* objects (that is, they are incorporated into narcissistic or auto-erotic satisfactions) or rejected as hate objects. Thus, for Freud in 1915, love, like hate, is not an instinct proper, but a relation between the entire ego and an object that can only develop after the contrast between auto-erotic satisfaction of some instincts and the need for objective satisfaction of others is firmly in place.[23]

Yet if Freud's interpretation of libido and love distinguishes between them at the ontological level, one being an instinct proper and the other an 'ego-instinct' or a form of mental organisation, his interpretation of the origins of *sadistic* attitudes comes closer to the conflation of love and desire that we find in Breton's texts, and in the critically perverse surrealist association of Sade with love itself. Freud offered numerous accounts of the origins of sadism, or fundamental aggression. At one level, the sexual aspect of sadism was for him a second order representation of the instinct for self-preservation, depending as the latter does on a sense of the hostility of the external world to the ego, to which the ego develops its own hostile attitudes. A related argument is the connection between aggression and muscular activity, where activity implies modification of the environment. Finally, Freud suggests that mental activity itself, as a particu-

fig.257
MIMI PARENT
Mistress 1996
Hair, leather, wood
47.5 x 24 x 5.5 cm
Mony Vibescu

larly advanced development of the nervous system, allows us to master stimuli (e.g. avoid cold or heat, or endure them), and that in ego terms this experience of mastery is itself pleasurable. This is one reason why Freud links sadism to infantile anal pleasure, one of the earliest forms of sexual pleasure, revolving as it does around the control or mastery of faeces through muscular action. In 'Pre-genital Anal-sadistic Organisation' more broadly conceived, 'the striving for the object appears in the form of an urge for mastery, to which injury or annihilation of the object is a matter of indifference'.[24] This occurs in the context of the early manifestations of love, and according to Freud is almost indistinguishable from hate. So, in a sense, it was precisely the subject of sadism that drew Freud to close the distinction between libido and love, and indeed between sadistic aspects of love (its origins in hatred and aggression) and the only instinct to rival the sexual instinct for priority in the organism, the instinct for self-preservation.

The shifting of the value of love within surrealism, and its equation with sadism and sadistic violence, is nowhere clearer than in the film *L'Age d'or* made by Luis Buñuel with contributions from Salvador Dalí in 1930. The climax of the film made explicit reference to Sade's novel *The 120 Days of Sodom*, showing the leader of four libertines emerging from a castle after their regime of debauchery as none other than Jesus Christ. Christ is shown returning to the castle to finish off a screaming girl, and the film closes with a shot of a windswept crucifix decorated with scalps, to the disturbingly incongruous sound of a *paso doble*.[25] The programme published to accompany the film contains important essays that offer an insight into the meanings of the concept of love for the surrealists, but also show them developing the relationship between love and social conflict. For Eluard, Buñuel had 'formulated a hypothesis on revolution and love that … reaches to the depths of human nature; amid a profusion of salutary acts of cruelty, he fixed this unique instant when, with lips tightly set, one follows the … most entreating voice until it cries LOVE, LOVE, Love, love'.[26]

Echoing Freud's assertion that love and hate meet in the sadism that exists in early ego organisation, the odyssey of the main character in the film represents a mental world in which 'the doors of love and hate are open and open the way to violence'.[27] André Thirion, in his contribution, offered an ultimately ambivalent assessment of the potential for the violence emerging from the frustration of love to generate revolutionary action on the part of the working classes:

> Ultimate pessimism issues from the very heart of the ruling class through the disintegration of its optimism … The passage from state pessimism to action is determined by Love, an evil principle in bourgeois demonology, that demands that one sacrifice everything: situation, family, honour, but into which the failure of the social organisation introduces a feeling of revolt. A similar process can be discerned in the life of the Marquis de Sade, contemporary of the golden age of the *ancien régime*, interrupted as it was by the implacable physical and moral repression of the bour-geoisie. It is no accident then that Buñuel's film is an echo of the blasphemies screamed by the divine Marquis through the bars of his prison cell. The development of this pessimism in the struggle and triumph of the proletariat, which is the decomposition of society as well as of a particular class, remains to be shown.[28]

Thirion has moved the meaning of Sade a long way from the notion of sexual freedom, and squarely

into the terrain of political revolt. Such a connection was being made around the same time by Georges Bataille and the circle of intellectuals and refugees from Breton's surrealist group who gathered around Bataille and the journal *Documents*. Like Thirion, Bataille argued that social organisation was in conflict with another realm of experience, but he defined this as the realm of excessive expenditure or waste. It was in this realm of destructive rather than productive activity that Bataille saw two revolutionary functions for Sade, functions he described in an essay unpublished during his lifetime.[29] Famous for its thinly disguised attack on what he regarded as sentimental celebrations of Sade, probably those very surrealist ones we have been examining so far, in which, he claims, Sade is worshipped whilst also being circumscribed in a discourse of

In order to reach the limits of ecstasy in which we lose ourselves in bliss we must always set an immediate boundary to it: horror. Not only can pain, my own or that of other people, carry me nearer to the moment when horror will seize hold of me and bring me to a state of bordering on delirium, but there is no kind of repugnance whose affinity with desire I do not discern. Horror is sometimes confused with fascination, but if it cannot suppress and destroy the element of fascination it will reinforce it. Danger has a paralysing effect, but if it is a mild danger it can excite desire. We can only reach a state of ecstasy when we are conscious of death or annihilation, even if remotely.

Pierre Angélique [Georges Bataille], *Madame Edwarda*, 3rd ed., 1956

titillating amoralism, the essay attempts to make Sade, by contrast, an immediate presence in all revolutionary action. Bataille's essay sets out many of the themes that would resurface in modified form in his more widely known and more easily grasped postwar writings, such as *Literature and Evil* and *Eroticism*.[30]

Crucially, Bataille argues that all human societies are based on a fundamental distinction between religious and civil orders, between sacred and profane activity. He sees these two orders as developing through contrasting impulses, excretion and appropriation. The former is the impulse that is naturally allied to the sacred order – one that has little to do with the sacred of later organised religions – since the sacred is defined as everything that can be subjectively regarded as an absolutely foreign body, everything heterogeneous. In general, Bataille regards the appearances of the sacred as moments of extreme awe or disgust, fundamentally linked by the presence of what is absolutely other to the subject. The sacred then, includes everything from sperm, menstrual blood, urine and fecal matter, to sexual activity, gods and cadavers. Things that are foreign in this way can nevertheless be taken into the body where an effect of absolute mental alienation is sought. The impulse to appropriation, by contrast, aims at homogeneity and subjective stability. The stabilising/destabilising contrast at the heart of the dichotomy between profane and sacred leads Bataille to map the notion of excretion onto revolution, and to see in the violence of revolution a manifestation of the orgiastic excess that defines the sacred in collective human experience. Bataille claims that this experience is in general absolutely necessary, but that in a revolutionary situation it finds a particular form of expression in mass violence aimed at the destruction and expulsion of the ruling class. Bataille insists on the erotic character of the violent embrace of 'death, cadavers and horrible physical pain' in the sacred.

Sade's sadism, which thus plays a primary role in the definition and representation of revolution, is given a secondary use-value in relation to Bataille's anthropological insistence on a universal need, the erotic bond generated in sacred experience. This theory seems to bring the Freudian notion of a sexual instinct or libido into a direct relationship with experience of the social collective, that is, with experience of other subjectivities. Bataille's conception of a society based on

fig.258
D.A.F. DE SADE
Justine, ou Les Malheurs de la vertu
19 x 12 cm
Book with frontispiece by Hans Bellmer
and preface by Georges Bataille
Paris, Editions Le Soleil Noir 1950
Mony Vibescu

Sade's moral theory may be a reference to the famous political tract embedded in Sade's *Philosophy in the Bedroom*, 'One more effort Frenchman, if you would be republicans'. This text, which both interrupts and anchors the education of a young woman in the ways of libertinage, outlines a libertarian utopia based on 'rational' principles. But it is more likely that Bataille intends to suggest that it is Sade's narratives of libertine excess that provide the real model for post-revolutionary sacred activity. In his much later text *L'Erotisme* (1957), where the political risk of the earlier text is absent, Bataille offers the theory that all erotic actions are determined by a desire to loosen or dissolve the limitations of individual existence, in favour of a merging with a natural continuum. But he is anxious to insist that such a loosening cannot be completed (without death of the subject or reduction to an animal state), and sees the existence of taboos not as the defence of society against the sacred, but as the mechanism whereby the sacred can be given structured recognition and eroticism expressed without the complete collapse of social organisation. For this reason, Bataille argued that 'transgression suspends a taboo without suppressing it'.[31]

It has sometimes been assumed that Bataille's late thought on transgression provides a key to the presence of pornographic

Eroticism and religion are closed books to us if we do not locate them firmly in the realm of inner experience. We put them at the same level as things known from the outside if we yield, albeit unwittingly, to the taboo. Unless the taboo is observed with fear it lacks the counterpoise of desire which gives it its deepest significance.

Georges Bataille, 1957

material within surrealism, and to the importance of Sade in surrealist art and writing.[32] But before accepting this idea, it is important to see that the meaning of Sade remained the same from Bataille's work of 1930 to *Eroticism*, but his evaluation of that meaning changed. In the latter text, Sade appears as a limit case of erotic behaviour, one beyond the pale of a meaningful pattern of taboo and transgression. Although 'the universe of sadism' reveals that 'the urge towards love, pushed to its limit, is an urge towards death', Sade is certainly nowhere considered as a model for a moral system. So whatever Bataille meant by transgression, Sade represented an absolute destruction that could not in any sense be thought to reinforce a system of taboos. On the other hand, in the text of 1930, which predates Bataille's systematic adoption of anthropological notions such as transgression and taboo, Sade's erotics of violence is no limit case – it is identical with both the revolution and the nature of post-revolutionary society.

One way to reflect on Bataille's original claim – to try to make sense of its extremism, is to connect it with contemporary writings by Michel Leiris, Bataille's very close collaborator in *Documents*. For it is in the writings of Leiris that a philosophical interpretation of sadism can be found, one that supports the outrageous assertion that sadism could in some sense bind a post-revolutionary society together. Furthermore, Leiris connects the basic theme of surrealism's Sade, its assertion that the perversity of Sade's desire is the form of authentic desire in the context of repressive modern social life, with the metapsychological theory of sadism elaborated by Freud. He does so without sacrificing the brutality of sadism – indeed he courts it, and conjures with it. One simple phrase, found in an elegant essay on an anatomical treatise, sums up Leiris' strategy: 'sadism, masochism, and in the end all the vices are only ways of feeling more human.'[33] The abruptness of the body brought about in these vices, like the sight of human innards, brings about an intensification of *human* consciousness, he suggests.

Perhaps the most impressive statement of Leiris's position is in an essay written to accompany photographs almost certainly taken by Man Ray.[34] One of Man Ray's acquaintances among the fringe figures of surrealism was William B. Seabrook, an eccentric collector of tribal objects with pretensions as an ethnographer. Seabrook appears in a photograph in a 1929 issue of *Documents*,[35] crouching beside a voodoo altar in Haiti with his

fig.259
HANS BELLMER
To Sade 1961
Drypoint
19.6 x 14.2 cm
Herbert Lust Gallery

fig.260
HANS BELLMER
To Sade 1961
Drypoint
19.6 x 14.2 cm
Herbert Lust Gallery

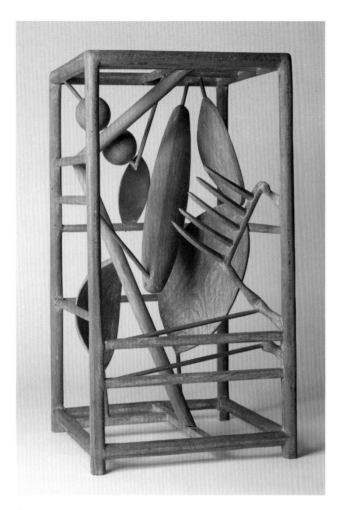

In *The Cage* and *Woman with her Throat Cut* Giacometti combines an exploration of the female form with suggestions of physical violence and pain. His writings in the 1930s showed a concern with the aggressive and threatening aspects of sexuality. 'Hier, sables mouvants' (Yesterday, Quicksand), published in *Le Surréalisme au service de la révolution* in May 1933, for example, culminated in a disturbing rape and murder fantasy.

The Cage, which was executed in wood by a craftsman after Giacometti's original plaster design, shows several simplified forms held in place by a network of thin rods. Flattened oval shapes evoke plant and insect forms, whilst two spheres suggest breasts or bulbous eyes. A row of sharp spikes recalls a ribcage or a menacing hand or claw. The sculpture's overall structure creates a sense of oppressive confinement and physical threat held in an unrelenting tension.

By contrast, *Woman with her Throat Cut* depicts a moment of expansive release, as the figure sprawls awkwardly upon the ground. This work has been seen as an evocation of sexual ecstasy as well as of deathly agony: the woman's back is arched in a moment of extreme pleasure and pain and her sex exposed. Her foot becomes an insect-like carapace, and whilst one hand resembles a hollowed leaf, the other terminates in a strange movable bead of bronze. The woman's cut neck is emphatically represented by an elongated bony windpipe.

This sculpture came out of a series of related drawings, reliefs and a three-dimensional piece on the themes of physical metamorphosis and nocturnal anguish, suggesting a complex combination of associations which have added to its mysterious and troubling nature. Its motif of sexual violence has been related to the explicit interest of the poet Robert Desnos in the sex crimes of Jack the Ripper. The woman in this work, however, is more than just a passive victim: her ambivalent spiky shapes form a trap, and recall the predatory female praying mantises that so fascinated the surrealists. JK

fig.261
ALBERTO GIACOMETTI
The Cage 1930–1
Wood
49 x 26.5 x 26.5 cm
Moderna Museet, Stockholm

fig.262
ALBERTO GIACOMETTI
Three Figures Outdoors 1929
Bronze
51.5 x 38.5 x 9 cm
Art Gallery of Ontario, Toronto. Purchase, 1984

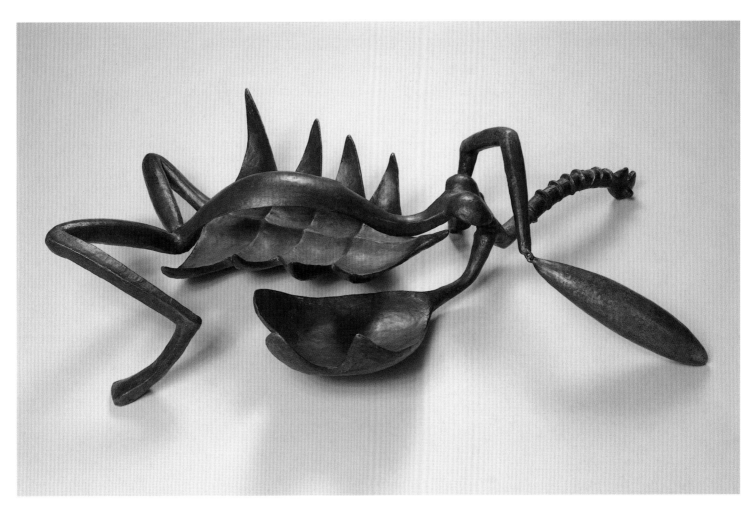

fig.263
ALBERTO GIACOMETTI
Woman with her Throat Cut 1932
Bronze
22 x 87.5 x 53.5 cm
Scottish National Gallery of Modern Art, Edinburgh

fig.264
ALBERTO GIACOMETTI
Disagreeable Object to be Thrown Away 1931
Wood
19.6 x 31 x 29 cm
Scottish National Gallery of Modern Art, Edinburgh

forehead showing a cross symbol supposed to mark his initiation into the religion. Seabrook's photograph accompanies a review by Leiris of the French translation of Seabrook's account of Haiti, *The Magic Island*. Leiris is full of admiration for the book, considering it the work of a westerner who truly understands the culture he describes. Striking a chord that will resonate for some years, Leiris celebrates Seabrook's refusal to distinguish between 'mysticism and eroticism', two currents that reflect 'the intense desire that all men must have to overthrow limitations'.[36] Seabrook was in Paris during the summer of 1930, staying at the Hôtel Place de l'Odéon with his wife Marjorie. He got to know Man Ray and his then partner Lee Miller. We know something of Seabrook's fascination with eroticism as well as mysticism, alluded to in passing by Leiris, thanks to the strange collaboration that he initiated with Man Ray that summer. Seabrook commissioned Man Ray to design a sado-masochistic collar, and it is probably one of the objects that, together with a leather mask made in the United States to Seabrook's design, appears in the photographs for the *Documents* essay.[37] Seabrook wrote numerous notes to Man Ray, some with elaborate plans for photographic sessions involving other sado-masochistic scenarios: 'I've got some additional tentative ideas to go along with the black mask. A black priest's robe and priest's shovel hat … Concealed beneath it a wasp-waist hour-glass corset finished either in some glittering fabric that looks like polished steel, or in black leatherlike material to match the mask. Also boots and slippers with fantastically high heels … Unless I hear from you to the contrary I'll bring the young woman by your studio for a little while around five-thirty this afternoon.'[38] Man Ray and Lee Miller seem to have declined to become full participants in Seabrook's activities, which extended to practising bondage and humiliation rituals on women who were presumably paid for their services.

The central part of the Leiris article deals with a story that Seabrook – who supposedly heard it in Arabia – recounts to Leiris. A gifted young dervish is invited by his master to attain the last level of the mystic way: to see the face of God. Terrified, he eventually succumbs to repeated overtures from the older monk, and goes to the ruined mosque where he must pray and practice rites through the night in order to meet God. The next day the old monk seeks him out and asks him if he did as instructed and if he had seen the face of God. The traumatised dervish replies that he had indeed seen the face of God in the ruined mosque, but that it was his own face. Leiris sees in this story an explanation for the profound pleasure ('at once erotic and mystic like everything completely exalted') to be derived from the simple act of masking, or negating, a face. The masks are disguises rendering the woman anonymous, more schematic, whilst the image of her body becomes more intense. This executioner/victim with annihilated head bears instead the face of God – but the face God is now, by a process of substitution, the face of the sadistic partner. The disintegration or better transference of identity here, where the blankness of the face is a screen for the projection of the self, is another means for reaching a limit of experience that is also a threshold of the divine. The annihilation of the face and the gaze increase the erotic potency of the body, which can now become, Leiris muses, 'a sort of shadowy thing in itself', absolutely ideal and absolutely material all at once. The *caput mortuum* (dead head) of the title was the worthless residue of the alchemist's art, a term referring to the moment when all seems decayed but is in fact to be regenerated – a term which, as Leiris notes, the early nineteenth-century philosopher Hegel borrowed for the philosophical shibboleth of the 'thing in itself'. This shibboleth was a construct in

fig.265
LOUISE BOURGEOIS
Knife Couple 1949
Wood
173.9 x 30.4 x 30.5 cm
Courtesy Cheim and Read, New York

Hegel's view – a pure thing empty of consciousness posited as a logical counterpart to the cogito – a pure consciousness empty of the thing.

Leiris's reference to Hegel is quite precise and deliberate. Hegel alludes to the *caput mortuum* in the *Encylopaedia Logic*, section 44, where he discusses Kantian insistence that the thing-in-itself, as opposed to the object of our mental representations, is completely unknowable. For Hegel, this unknowable thing is *itself* a mental representation of a thing drained of all our subjective determinations of it. Thus he thinks there is nothing easier to know than the thing-in-itself – a pure construct of idealism. The thing that should have been an absolute other, outside of representation, becomes the purest representation of all, a pure product of abstraction. The thing-in-itself is the subject all along.

Why does Leiris connect sadistic photographs with Hegel? Just as the dervish sought the face

of God and only saw himself, so the sadist seeks the face of the other – not in the sense of a particular other, but in the sense of pure otherness – and finds only his own sadism reflected back. In the way that Leiris expresses the idea, this transference is a profoundly creative moment,[39] but it is also an endless one, since the quest for otherness in this scenario is never satisfied. How can this quest be thought of as fundamentally or universally human, when it has the appearance of being abnormal, obscure and pathological?

Freud noted that sadism in its original form, as aggression based on the need for mastery, contains no necessary component of the inflicting of pain.[40] The development of pleasure in the pain of the victim, so Freud thought, was a retrospective addition to sadistic pleasure caused by its partial transformation into masochism. The sadist then has an awareness of the pleasure caused by the pain he inflicts. But why should the sadist enjoy the pain of his victim? Surely this ruins the sadistic satisfaction since it implies that the sadist shows some generosity or kindness to the masochist? Freud suggests that the sadist takes pleasure in causing pain since he *identifies* with the position of the masochist. For Freud, this was just one example of the way in which the paths of the formation of the sexual instinct are dictated by three polarities that dominate mental life: Subject-Object; Pleasure-Unpleasure; Active-Passive.[41] The elaboration of the sadism in the direction of sexual pleasure entails its development in the direction of masochism. This in turn implies a complex identification in fantasy with the other as victim of aggression.

One kind of *ironic* answer to the project of a revolutionary Sade could lie in the relations between sadists and masochists. Towards the end of his text on *L'Age d'or*, André Thirion suggests that the masochism of the ruling class could form the revolutionary complement of the sadism of the proletarian revolt.[42] And Walter Benjamin, in the notes for his *Arcades* project, muses on the meeting of two libidinal utopias – that of the sadist and the masochist in a perfect Fourierist pleasure-pain economy.[43]

In its shifting of the notion of love, and the perverse interpretation of love under the sign of Sade, surrealism colonises alienated desire because, its says, notwithstanding appearances, desire is always alienated in capitalist modernity. Surrealist love is, as many have noted, fetishistic – its objects are so many fragments of the world that structured libidinal energy in the direction of sexuality, but whose final order the ego has rejected.[44] Hence the heroine of *L'Age d'or*, played by Lya Lys, ultimately prefers to suck the toe of a statue than to pass to sexual union with her paramour. The displacement of love from persons to things, implying also that all loved persons are things from the perspective of love, is the correlate of Sade's own vehemence on the subject of the existence of love – in both cases desire finds itself alone with and identical to a mere thing. But as Leiris insists, surrealist thinking always sees in this moment both a triumph of the imagination over circumstance (accepting paltry given things as objects of desire) and its latent atmosphere of disappointment as a sign of desire's restless need to find the other, to finally possess the desire of the other.[45] To put it another way surrealism's Sade could have been a monstrous force of pure desire, but instead he was desire forced through the social press, desire misshapen in its passage to satisfaction, desire become aggression against all the resistance it meets. Desire is no longer pure: it has become irrational love that draws those who embrace it out of stable social life into murder and infamy. But if this picture of desire is alienated, and its alienation is exaggerated by the subversion of the bourgeois concept of love, it is also hopeful, insofar as it preserves not mere narcis-

sistic desire, but desire crossed with the presence of an (abstract) other, a collective, a social world – albeit one where that social world is its one-sidedly masochistic complement. These, then, might be aspects of surrealism's Sade worth keeping: the *corrective* knowledge that desire is neither always pure nor always alienated – and the belief that in its present distorted form it is the empty vessel waiting to be filled by a future collective liberty.

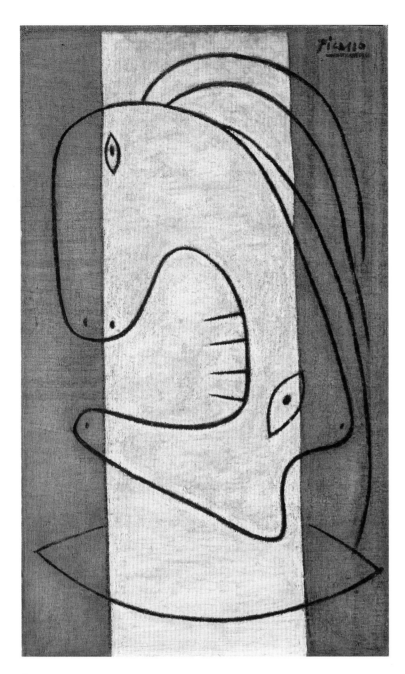

fig.266
PABLO PICASSO
The Scream 1927
Oil on canvas
55.2 x 33.7 cm
The Metropolitan Museum of Art, New York.
Jacques and Natasha Gelman Collection, 1998

Picasso's position vis-à-vis surrealism was never clear-cut. If he was reluctant to align himself explicitly with the movement in the early days, the artist, then in his late forties, would also have seen the benefits of a younger generation championing his art. The 'visionary' Picasso was for Breton a major source of inspiration, and his paintings were widely reproduced in *La Révolution surréaliste*. Significantly, some of the works by Picasso chosen for the journal suggested a darkly sadistic eroticism. The inclusion of the then little seen *Les Demoiselles d'Avignon* (1907), whose sale to Jacques Doucet Breton had recently negotiated, implied the long-held significance for Picasso of themes of sex and violence.

The Scream was reproduced in the October issue of *La Révolution surréaliste* in 1927, along with the surrealists' famous tract 'Hands Off Love', supporting Charlie Chaplin's adultery in his divorce case with his wife (see p.257). Within this broad context of erotic liberation, an illustration of the painting was also placed at the end of a poem by Paul Eluard, which evoked a moment of violent frenzy: 'You can still set your last traps / of suffering, of terror / Downfall at your feet, biting is before you / Claws spread like blood / Around you'. Eluard and Picasso would later become close friends and artistic allies, and they both shared an interest in the Marquis de Sade.

In Picasso's painting, an early example of a predator female figure in his work, a monstrous, deformed face takes on the form of a jaw-bone, while four spiked teeth suggest a *vagina dentata* and the threat of this woman's enveloping embrace. Her head appears framed and constricted by two vertical panels, creating a powerful effect of a voyeuristic snapshot of disturbing events within an enclosed room: the final words of Eluard's poem read 'your shadow is a door lock'.

In *Nude Standing by the Sea*, the figure adopts the classical pose of a standing nude, her arms linked behind her head, but her anatomy is transformed from its natural shape. The sharp, pointed breasts rise abruptly like terrifying teeth from a gouged-out but protective mouth-like niche. Picasso plays on the visual rhymes between body parts, so that the buttocks seem to have stolen the maternal curves of breasts, and the narrow slit is both genitals and mouth. This depersonalising device, the head derisory and faceless, serves to emphasise the figure's monstrous sexuality. *Nude Standing by the Sea* was first reproduced in the magazine *Documents*, in the special issue devoted to Picasso in 1930. Georges Bataille had made *Documents* a centre for disaffected surrealists, and sought to undermine Breton's ideas with a systematic attack on an 'idealistic' surrealism. His insistence on the violent and ignoble nature of human desires provides another standpoint from which to view Picasso's visionary transformations of the human form. JK & DA

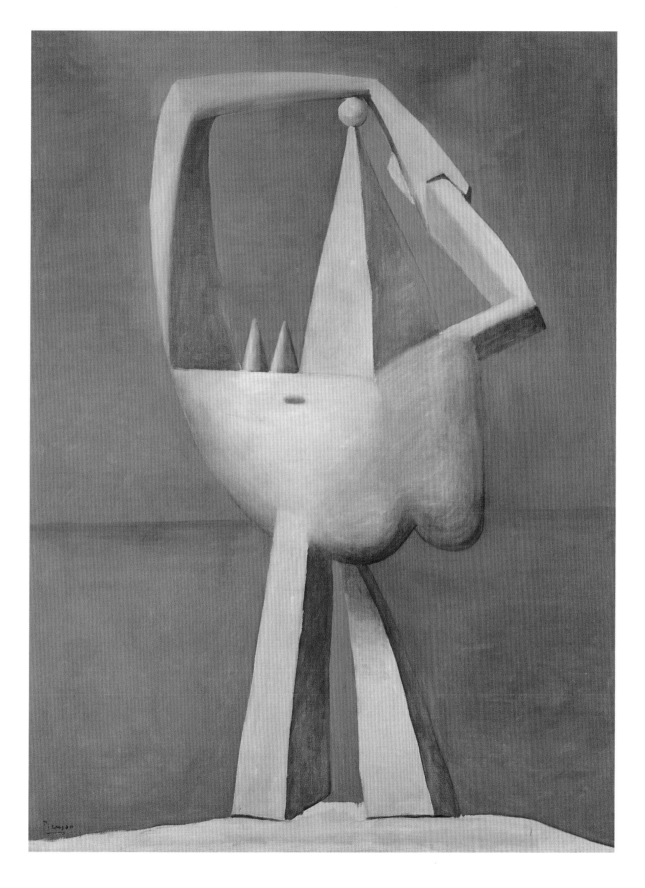

fig.267
PABLO PICASSO
Nude Standing by the Sea 1929
Oil on canvas
129.9 x 96.8 cm
The Metropolitan Museum of Art, New York.
Bequest of Florence M. Schoenborn, 1995

chapter eleven
STAGING DESIRE
Alyce Mahon

esire, myth, poetry, taboo and transgression: these were among the key ingredients of surrealism and of the surrealist exhibition. From the birth of surrealism in 1924 to Jean Schuster's announcement of its demise as a historical movement in 1969, the line between literature, art, architecture and performance became increasingly blurred as the surrealists transformed the notion of the artwork and dramatically revolutionised the concept of the art exhibition.[1] In surrealist exhibitions paintings were often close together and according to the principle of maximum contrast; non-art elements such as beds, braziers and mannequins were introduced; and sound and lighting effects were used to create extraordinary audio-visual experiences that transformed the art gallery into chamber of horrors, avant-garde theatre and installation all in one. People flocked to these exhibitions to see what scandalous surprises would be unleashed. Newspaper reviews either championed the shock of the new or condemned surrealist exhibitions as immoral and even pornographic.[2] Amid all the visual and public excitement the surrealists hoped that desire and eroticism would entice the exhibition visitor to view reality anew, to call his or her own being into question and, ideally, to share in their dream of revolution. As André Breton explained in his preface to the catalogue of the 1959 international exhibition *EROS*, the surrealists hoped an 'organic liaison' would occur between the artist and the viewer: the art on show was to be conceived, he wrote, not so much as objects but as 'suggestions' that would encourage the viewer to discover aspects of his or her true self.[3] The surrealist exhibition was intended to take the viewer beyond the frontiers of reality, by giving free rein to his or her imagination.[4]

The surrealist exhibition, as a stage to be experienced by the individual and as a space in which a new reality could be prefigured, offered the surrealists an opportunity to make manifest the power of art to change life and the power of collective aesthetic experience. The first surrealist exhibition held in 1925, the 1936 exhibition of surrealist objects, and the 1942 *First Papers of Surrealism* exhibition were among a number of shows that signalled the surrealists' radical approach to the exhibition space. In the *First Papers* exhibition, for example, Marcel Duchamp's installation – meshes of twine criss-crossing the room between the temporary partitions on which paintings were hung – contrasted sharply with the elaborate decor of the gallery space, the Whitelaw Reid Victorian Mansion on Fifth Avenue, New York. Exhibits included idols and masks by Native Americans, and during the opening, at the invitation of Duchamp, the children of collector Sidney Janis played ball in the gallery space. The 1965 *Ecart absolu* exhibition at the Galerie L'Oeil in Paris was equally thought-provoking. At the entrance to the gallery was a work titled *Désordinateur* (Does-not-compute), comprising ten compartments each housing an object of contemporary significance. In one of these, for example, was *King of Rats* – seven rats joined by their tails – which parodied the baby-boom of 1950s France; in another was a rugby ball entwined in barbed wire, a subversive symbol of the 'religion' of sport in France. Beyond this work stood *Consommateur* (Consumer), a twelve-foot high installation made up of various objects. It had a siren for a head, a taxi-radio voice, a washing machine stomach, a refrigerator back, and a bridal veil. The exhibition's assault on consumer society won the attention of a younger generation of Parisians, some of

whom would take to the streets in May 1968, calling for revolutionary change and scrawling surrealist-inspired slogans on the walls of the Sorbonne.

In their exhibitions the surrealists aimed to present a surrealist environment where modern life, art, science and literature converged in a theatrical *mise-en-scène*. To some extent their rejection of traditional modes of display in favour of a revolutionary collective approach was shared by other avant-garde art movements in the early part of the twentieth century. Dada, a movement which paved the way for surrealism, for example, was born in the Cabaret Voltaire in Zürich, in 1916 – a noisy, anarchic artistic environment of art, music, poetry and performance. After the war the dadaists' experiments continued in the same vein. Visitors to a 1920 exhibition in Cologne entered the space through a lavatory, were greeted by a girl in a white communion dress reciting obscene poetry, and were invited to destroy some of the objects on display. In an equally radical but diametrically opposed style, the Dutch De Stijl movement, which lasted from 1917 to 1931, strove to unite the arts and instill a new spirit in man through art. The architectonic quality of some of its exhibition designs reflected the movement's belief in the existence of plastic and logical solutions to social and artistic needs. In France, a rationalist and machinist aesthetic was promoted in such exhibitions as the 1925 *Exposition des arts décoratifs*. Later, the vast 1937 *Exposition internationale des Arts et des techniques dans la vie moderne*, exemplified a nationalist approach, with art shown in national pavilions at a time of great political tension. The surrealists had no such truck with such manifestations of patriotism and dogma. They saw the exhibition space as a stage for the liberation of subjective, and, by extension, collective desire; and their approach can be seen as a trenchant critique of the 'white cube' mentality that permeated many avant-garde art exhibitions in the late 1930s.

fig.268
RENE MAGRITTE
A Courtesan's Palace 1928
Oil on canvas
54 x 73 cm
The Menil Collection, Houston

This image was prompted by thinking about the parallels between the features on a woman's face and the parts of the female body. It can be seen in the context of Magritte's investigations into the properties of objects, which had began, Magritte stated, with a painting called *Elective Affinities* (1933). This depicted a huge egg within a cage, and referred to 'secret affinities' between objects. The process of conceiving of these affinities was, he said, difficult, but the solution once found was self-evident, with all the certainty of a fact and the impenetrability of the finest conundrum.

Magritte was not of course the first to find 'affinities' between face and body: and there are numerous such conflations in many cultures (cubist paintings, Sepik River shields, African masks, eighteenth- and nineteenth-century European caricatures, Humpty Dumpty and so on). His title Le *Viol*, through the pun on 'viol' (rape) and 'viole' (the musical instrument the viol), recalls the pictorial metaphor of the body as musical instrument so often used by Pablo Picasso and Georges Braque in cubism. But Magritte's meticulously painted image is disturbing on a number of levels, not least in the erotic invitation that is simultaneously proffered and denied.

In transforming the face into a body, Magritte makes it a fetish. The neck is elongated beyond the demands of erotic sinuosity to become itself an ironic maternal phallus. Gender is also ambiguous: the head of hair becomes pubic in texture, penetrated by rather than crowning the face/body, while the pubic hair itself condenses into a neat goatee beard. Although André Breton did not write about Magritte's work at any length until the 1960s, he recognised this as a key surrealist image, reproducing a drawing of it by Magritte on the cover of the 1934 pamphlet, *What is Surrealism?*. DA

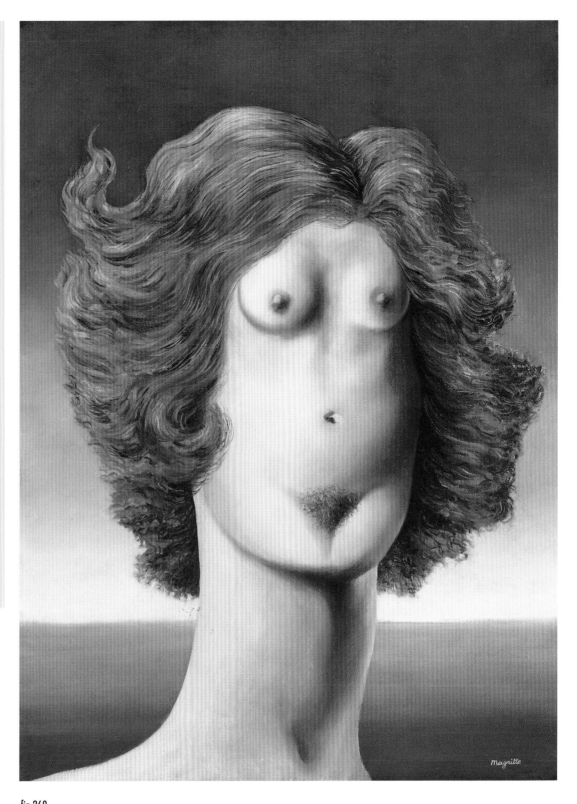

fig.269
RENE MAGRITTE
The Rape 1934
Oil on canvas
77.5 x 58.7 cm
The Menil Collection, Houston

The 1938, 1947 and 1959 international surrealist exhibitions deserve particular attention for their theatrical staging of erotic desire. Although the surrealists despised commercial bourgeois theatre, they recognised the polemical role avant-garde theatre, and the theatrical gesture in itself, could play in changing culture.[5] For theatrical space may be understood as at once fictitious and real; and an emphatically theatrical production of space allowed for eroticisation by means of physiological and psychoanalytical affect. From this standpoint the gallery was not simply a neutral vessel for the display of works of art: through the use of lighting, scenography and sound it could be turned into a dynamic and shocking space, in which the viewer could be persuaded to go beyond the limits of everyday life and to abandon social and moral codes of behaviour. This tactic of induction of the viewer lent the surrealist exhibition an uncanny edge – one augmented by the staging of primal fantasies in emphatically corporeal environments that were often visibly feminine-anatomical in appearance.

The 1938 *Exposition internationale du surréalisme* demonstrated the surrealists' faith in desire and the power of the imagination. It emphasised the creative and erotic potential of the external world, especially of the city. The great central hall of the gallery was described by one of the organisers, Marcel Jean, as 'one of the most remarkable object-pictures – on an architectural scale – that surrealism has ever known'.[6] Provided with a flashlight at the entrance to the gallery, the visitor moved hesitantly through a dimly lit gallery which was effectively an evocation of a surreal Paris. The antechamber to the main exhibition space contained Salvador Dalí's *Rainy Taxi* installation. Continuously drenched with water, the interior of the motor car was overrun by ivy and snail-infested. Among the vegetation sat a male mannequin-driver with the head of a shark, and a glamorous female mannequin. Beside her on the back seat was a sewing machine, a reference to Lautréamont's metaphor so loved by the surrealists, 'As beautiful as the chance encounter of a sewing machine and an umbrella on a dissecting table'.

The visitor then passed through a *Rue surréaliste*, a long corridor with sections marked by evocative street signs, such as 'Street of Lips', 'All Devils Street', 'Weak Street' and 'Blood Transfusion Street'. Here fifteen mannequin ladies-of-the-night traded their wares, each having been dressed by individual surrealist artists. Among the most outrageous of the mannequins were those by Duchamp and André Masson. Duchamp's mannequin was dressed in the artist's clothes (hat, tweed jacket, waistcoat, shirt and tie) but had the name *Rrose Sélavy* ('Eros, c'est la vie' or 'Eros, that's life') scrawled on her naked sex, suggesting a complicated interplay of male and female masquerade. Masson's *Mannequin with Birdcage*, her mouth muted by a black gag and a pansy, and her head trapped in a birdcage, had her genitalia covered by a *cache-sexe* (g-string) adorned with eight glass eyes. Whilst Masson's mannequin appears to signify the supposed inherent misogyny of surrealist discourse, it can also be seen as challenging the male gaze through the suggestion of sexual violence. Masson may have indulged a patriarchal obsession with woman as object of desire but her sexual 'victimisation' on display here served as a means of unsettling reality and transgressing taboo.

Profanity dominated the exhibition. In the half-light of their flashlights viewers peered at sexual tableaux, manoeuvring to see paintings that were hung on swinging doors, and gazing self-consciously at half-dressed female mannequins. The *Rue surréaliste* subverted the role of the street in the city as a space of commerce, communication and social order, and evoked instead *l'amour*

fou and the glamorous decadence and brothels of 1930s Paris. This was the shadowy 'secret Paris', with its half-dressed prostitutes, seedy couples in cafés, tramps and opium dens, as captured in the lens of the photographer Brassaï.[7] The art exhibition, normally a safe environment for the bourgeoisie, here demanded the active participation of the viewer and threatened to become a nightmarish scene of orgiastic desire.

The use of flashlights lent an anxiety to the viewer's experience of the exhibition, that must have reached a peak as he or she entered the immense grotto that lay at the end of the *Rue surréaliste*. Suspended from the ceiling were 1,200 stuffed coal sacks, while the undulating floor was covered with dead leaves. The grotto also contained an artificial pool (symbolic of the synthesis of the inner and outer world), an iron brazier burning coals (symbolic of friendship), and four immense beds (symbolic of love). The room was filled with the sound of hysterical laughter, recorded at an insane asylum and played on a hidden phonograph: according to Man Ray, this was intended to diminish 'any desire on the part of visitors to laugh and joke'.[8] Visitors' olfactory senses were assaulted by smells of Brazilian coffee brewing and coal fires. On the opening night of the exhibition a visual shock augmented this sensory cocktail. Naked under her torn costume, the dancer Hélène Varel performed her erotic 'Unconsummated Act', gyrating, wailing, and wrestling with a live rooster on the beds, before splashing into the pool. As if this were not enough drama for one evening, visitors also anticipated the appearance of the 'authentic descendant of Frankenstein, the automaton Enigmarelle, constructed in 1900 by the American engineer, Ireland' who, it was

fig.270
DENISE BELLON
Salvador Dalí Holding a Mannequin 1938
Vintage photograph
24 x 25 cm
Courtesy Claude Oterelo

promised in the exhibition invitation, would cross the main hall 'in false flesh and false blood'. Some might have been relieved when he did not materialise.[9]

The 1938 exhibition was transgressive and provocative in its use of the gallery space itself as a space of excessive femininity (womb-like with its warm coals and mossy undergrowth, its streets of 'blood', its sexual explicitness, its fantastical female characters). The exhibition flaunted the threat of the 'Other' at a time when all manifestations of 'Otherness' had political connotations. One year earlier, in an atmosphere of increasing instability and anxiety in Europe, official French cultural nationalism was prominently displayed in Paris in the nostalgic exhibition *Chefs-d'oeuvre de l'art français*, at the Palais de Tokio, and at the *Exposition internationale des arts et techniques dans la vie moderne*.[10] In the same year the Nazi Party in Germany held its infamous *Entartete Kunst* exhibition, in which 'degenerate art' (that is, most non-realist, modernist art, including that of the German-born surrealist Max Ernst) was put on show as a lesson to the German people. It is in this highly polarised cultural and artistic context of the late 1930s that the 1938 surrealist exhibition and its aesthetic radicalism must be understood.

If, as Henri Lefebvre suggests in *The Production of Space* (1974), space may be understood both subjectively (space occupied and experienced by the individual) and objectively (space experienced through encounters with other individuals and interaction with the Other), any slippage between subjective and objective space becomes particularly acute when occultism and mysticism are involved.[11] This is the key to understanding the strategy behind the first postwar exhibition of surrealism, at the Galerie Maeght in Paris in 1947, and its staging of desire through recall to myth and the primitive.[12]

Emphatically international in its character (it included artists from the United States, England, Haiti, Japan, Mexico, as well as many other countries in Europe), the 1947 surrealist exhibition turned to early civilisations in response to the horrors of the war and its aftermath that had rendered humans 'powerless to be anything but a victim or a witness'.[13] The exhibition was dedicated to Breton's 'new myth', developed in his writings during the war, of the 'Great Transparent Ones'. These were formless beings which 'mysteriously reveal themselves to us when we are afraid and when we are conscious of the workings of chance'.[14] A sculpture by Jacques Hérold of such an imaginary being stood at the entrance to the Galerie Maeght. Its angular form and wailing face captured the anguish and shattered hopes of society, while the star and crescent at its collar bone intimated the occultist nature of the exhibition space inside. On passing the sculpture, the viewer was thrust into the surreal.

Duchamp and the Austrian-born architect Frederick Kiesler designed and produced an environment in the gallery space that incorporated primitive myth, tales of romance and Oedipal fantasy. The exhibition itself combined taboo and transgression: Duchamp and Enrico Donati's deluxe catalogue had on its cover a false breast ('falsies' imported from the United States) mounted on black velvet with the ironic caption pasted on the back cover 'Prière de toucher' (Please touch).

fig.271
MARCEL DUCHAMP
Prière de toucher
Catalogue for the exhibition *Le Surrealisme en 1947*
Paris, Galerie Maeght 1947
Galerie Maeght, Paris

The surrealists' ambition to spiritually reawaken humankind was suggested in the labyrinthine orchestration of the rooms. As if on a pilgrimage, the viewer progressed from 'Surrealists Despite Themselves' (with works by Hieronymus Bosch, William Blake, Lewis Carroll) to 'Momentary Surrealists' (Giorgio de Chirico, Masson, Dalí), up a flight of twenty-one steps (signifying the Major Arcana of the tarot cards which are numbered from 0 to 21) into a white 'Grotto of Superstition'. The grotto was a collective space housing works which seemed to offer a western experience of the 'primitive' or pre-scientific mind. It included such recent works as *The Anti-Taboo Figure* by Kiesler, *Anguish Man* by David Hare, *The Totem of Religions* by Etienne Martin, and *The Green Ray* by Duchamp. Kiesler specified that the Grotto of Superstition was to be appreciated as a space of continuity where painting, sculpture and architecture metamorphosed into each other and in which men's psychic need for ritual and superstition would be unleashed and satisfied. It was hoped that the viewer would abandon reason and adopt a primitive mentality, before proceeding into a 'Rain Room', devised by Duchamp. Here, as in the 1938 exhibition, nature spilled into 'civilised' space. A billiard table (acting as pedestal for a sculpture by Maria) was juxtaposed with curtains of artificial 'rain' pouring down on artificial grass.

The *pièce de resistance* was the 'Labyrinth of Initiation'. This was a room with twelve octagonal altars, each corresponding to a sign of the zodiac and a mythological being. Placed on the altars were such works as Victor Brauner's *Wolftable* (1947) and Wilfredo Lam's *The Hair of Falmer* (1947).[15] The labyrinth was an architectural metaphor for the labyrinth of the mind.[16] In Greek

fig.272
DENISE BELLON
Installation View of the EROS Exhibition 1959
Vintage photograph
30.5 x 20.5 cm
Courtesy Claude Oterelo

mythology it was associated with the Minotaur, a monstrous figure that was half-man, half-bull, who lived at the heart of the labyrinth, and the story of Ariadne who helped her lover, Theseus, find a way out of the labyrinth. Just as Ariadne helped her lover, so the surrealists looked to the redemptive power of the feminine to guide mankind. In *Arcane 17*, published in 1945 while Breton was in exile in the United States, he had written of Mélusine, the fay of French legend, as a figure who would lead society out of spiritual ruination.[17] Ultimately, the 1947 surrealist exhibition proposed itself, and its feminised mythology, as part of the answer to the personal and collective needs for ritual and myth in the aftermath of the war and in an era of reconstruction.

In the 1959 international surrealist exhibition held at the Galerie Daniel Cordier in Paris, the surrealists celebrated an emphatically Sadean concept of liberty. This concept reflected surrealism's concern with the individual and psycho-sexual revolution and spoke both to the increasingly urgent political conditions of the times and to an emerging counter-culture of social and political engagement. The centrality of Sadean desire to the exhibition was articulated in a performance by the Canadian surrealist Jean Benoît, entitled *The Execution of the Testament of the Marquis de Sade*, which took place on 2 December as part of the build-up to the exhibition's opening.[18] Benoît's performance was a homage to the 'Divine Marquis'. It was intended as a symbolic 'reburial' of Sade who had been buried in a cemetery at Charenton in 1808, despite his wish, expressed in his last will and testament, to be buried in an unmarked grave in a copse on the grounds of his estate at Malmaison and so to disappear from human memory.

Held in the apartment of surrealist poet Joyce Mansour, the performance resembled a shamanistic rite of initiation. Benoît's costume, made ten years earlier, consisted of paper, felt, wood, metal and black dye, and was covered in black arrows, all pointing towards a star on Benoît's chest above his heart. Benoît wore a mask which was reminiscent of tribal headgear, particularly the tribal masks of the Dogon and Kwakiutl. He carried crutches and wooden panels and wore a grotesquely large phallus, which was described as having the phallic proportions of two characters from Sade's novel *The 120 Days of Sodom*, Brise-cul and Bande-au-ciel.[19] The performance began with a

fig.273
JEAN BENOÎT
Costume for 'The Execution of the Testament of the Marquis de Sade': Medallion 1949
Mixed media
39 x 22 x 3 cm
Jean Benoît

fig.274
JEAN BENOÎT
Costume for 'The Execution of the Testament of the Marquis de Sade: 'Cache-vit' 1949
Mixed media
75 x 20 x 30 cm
Jean Benoît

soundtrack, recorded by poet Radovan Ivsic, capturing the turbulent noise of the city and played at such a great volume that it resembled a thunderous volcanic eruption. As the music reached a crescendo, Benoît appeared. Breton read aloud the testament of Sade in which the Marquis called for an unmarked grave. The artist Mimi Parent, Benoît's wife, began removing Benoît's costume piece by piece as Jean-René Major read out Benoît's explanation of the significance of each element. According to Benoît, the best newspapers for making the papier mâché elements of the costume were *L'Humanité* and *Le Figaro*, a left-wing paper of the French Communist Party and right-wing Catholic paper, respectively: in Benoît's estimation, both were better used for making pulp than for reading.[20]

Benoît began his striptease by removing the massive medallion he wore about his neck. This medallion, Major explained to the audience, was dedicated to Breton and to Gilbert Lely and Maurice Heine, the surrealist archivists and biographers of Sade. The medallion bore Lely's statement, written in his 1952 biography of the Marquis de Sade, 'Tout ce que signe Sade est amour' (all that is under Sade's name is love). Benoît then removed the vest that was decorated with painted black arrows, a heart and teardrops. The painted heart had to be purged of its tears: tears that were symbolic of pathos, a pathos induced by dogmas – ideas of nation, family and religion – of which first Sade and later the surrealists vowed to purge society. Benoît's crutches and the wooden panels – said to be symbolic of humankind's state of spiritual slavery – were then cast aside. Benoît finished the performance by raising a hot branding-iron to his chest and burning the word 'Sade' onto his bare flesh, making a sacrifice of himself as a finale to his Sadean testimony. No sooner had Benoît removed the iron from his burnt flesh than the surrealist artist Roberto Matta spontaneously stepped forward, moved by the intensity of the performance, and thrust the hot iron at his chest too.[21] A rhetorical question was posed to the audience as to whether feminist existentialist author Simone de Beauvoir, who had dared ask 'Faut-il brûler Sade?' (Should Sade be burnt?) in 1951, should be burned too. The reply was a joyous 'Oui, sur la fesse' (Yes, on the buttocks). Benoît's performance set the tone for the 1959 exhibition by emphasising the surrealists' belief in the potential of primitivism as a state in which, free from the corruption of logic, man believes in the mystical and sacred powers of the body. The performance also reiterated the political potential of the represented body and the interactive consciousness-raising aspect of the surrealist vision of desire.

The *EROS* exhibition catalogue was called *Boîte Alerte – Missives Lascives* (Box on Alert: Lascivious Missives). As the title playfully suggests, it was presented in the form of a miniature green post-box (or 'boîte à lettres'), into which ideas could be 'posted'.[22] The box contained a catalogue and a series of erotic notes and objects. These included a record with readings of two poems, Benjamin Péret's 'La Brebis galante' and Joyce Mansour's 'L'Ivresse religieuse'; an envelope with the word 'HAUT' printed on it, containing a black nylon stocking ('un bas'); and Duchamp's *Couple*, two rag-doll like objects with genitalia hidden behind tartan flaps, which were made by Mimi Parent.[23] These items parodied erotic genres and censorship, and insisted on a mood of black humour that was to inform the viewer's experience of the

fig.275
JEAN BENOÎT
Costume for 'The Execution of the Testament of the Marquis de Sade': Branding-Iron 1949
Mixed media
50 x 14 x 3 cm
Jean Benoît

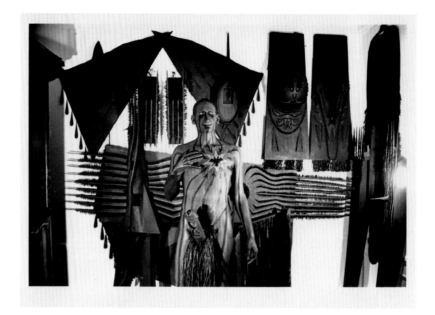

exhibition as a whole. The surrealists wanted eroticism to be appreciated as a 'privileged place, a theatre of provocations and prohibitions in which life's most profound urges confront one another'.[24]

For this show the surrealists created a web of entrances and exits, and a series of games, exploiting and challenging the viewer's inhibitions through allusion and surprise. Seventy-five artists from nineteen countries contributed, including eight Americans (William Copley, Joseph Cornell, Arshile Gorky, Jasper Johns, Man Ray, Louise Nevelson, Robert Rauschenberg, and Dorothea Tanning), thereby suggesting perhaps surrealism's influence on a range of post-war art in the United States. The international character of the exhibition and the free rein given to artists in their exploration of the theme of eros indicated the surrealists' principle of freedom of artistic expression. The inclusion of work by mentally ill artists such as Max Walter Svanberg and the deceased Alöyse also demonstrated surrealism's support of the 'outsider' in society. Even the disfavoured Roberto Matta and Victor Brauner, expelled from the movement in 1948, were welcomed back for this exhibition.

Conceived by Breton and Duchamp and co-ordinated by the graphic designer Pierre Faucheux, the design of the exhibition emphasised the feminine, both in the atmosphere and layout of the gallery space and in the subject matter of the art on display. The visitor entered the exhibition through a 'Love Grotto' – a dark, cavernous tunnel that led into a warm and comforting rose-coloured chamber. Here the ceiling, designed by Duchamp, rhythmically breathed in and out by means of hidden air pumps, and the floor was covered by a layer of sand. This led to another space, with stalagmite- and stalactite-like forms covered in green velvet, in which the sound of orgasmic sighs, recorded by Ivsic, and the fragrance of perfume by Houbigant, aptly called 'Flatterie', filled the air. The viewer next moved deeper into erotic space, into a crypt-like alcove created by Mimi Parent. This area, lined with black velvet, housed a reliquary which contained surrealist objects and also hunting equipment, objects that introduced a more sinister note to the theme of eros. Meret Oppenheim's *Spring Banquet* installation followed: a woman, naked and with

WHEN THE WALLS SIGHED IN PARIS

Radovan Ivsic

Given that I am neither a composer nor a musical expert, I was quite taken aback when, out of the blue, André Breton asked me to produce an acoustic accompaniment to the *Exposition internationale du surréalisme* of 1959–60, which was devoted to the theme of eros. All I had at my disposal was a modest tape recorder which had stood me in good stead, for instance, when I made private recordings of those recitals of nineteenth- and twentieth-century French poetry that Breton occasionally improvised before a circle of friends.

For some time I despaired of finding a proper concept for a soundtrack to accompany this exhibition. It had been conceived as a labyrinthine grotto, with surrealist pictures and objects set out along narrow, ill-lit passageways, amid stalactites and stalagmites coated in green velvet: what is more, the movement of visitors would be encumbered by a thick layer of fine sand covering the floor.

It seemed to me that no music could possibly do justice to all this, whether it be classical, ancient, contemporary, or folk, still less popular cabaret songs. One or two of the younger surrealists made a passionate case for the Modern Jazz Quartet. An avant-garde composer informed me that my solution lay in concrete music, which was in its heyday at the time. Yet none of these seemed to hit the mark.

My problem was further exacerbated because of the avowed suspicion in which certain surrealists held music at large. However, it may be that this disdain for a certain cultural cosiness was exactly what I needed to point me in the right direction. As surrealists, we drew a crucial distinction between mere literature and the lyrical impulse of true poetry: hence I judged it vital to avoid so-called art music at all costs and even to renounce all sounds made by recognisable musical instruments. On the contrary, I saw that what I had to do was to go in search of non-musical sounds. Above all I needed to seek out naked sounds, in all their unprogrammed violence. All the same, exactly what sounds should I go for? Why, the most disturbing ones, of course — those which, at that point in history, were absolutely forbidden in public places. Thus it was that I hit upon the idea of recording the sounds of lovemaking.

With a view to producing my soundtrack, I envisaged a series of a dozen or so short sentences in which soft panting sounds would intermingle with brief moans and intense exhalations produced by a chorus of several voices. These would be interrupted by lengthy silences. The soundtrack would be broadcast at scarcely audible levels through a number of loudspeakers, carefully hidden so as to make it impossible to determine where the sounds were coming from. I finally decided it was essential to transfer my sighs onto a loop, so that they would keep going without interruption.

It was no easy task to bring these ideas to fruition. Given that my technical equipment fell below professional standards — my tape recorder and microphone were of the indifferent quality available on the market at the time — how was I to capture the sounds of breathing or almost inaudible sighing, and how could I eliminate the irritating buzz on the tape? I also had to round up a few performers actually capable of producing the sighs in question. By chance, thanks to contacts I had made through my theatrical writing, I knew a few technicians working for French Radio who told me about the ultrasensitive microphones that had just come out. In those days it was still possible for them to sneak me into a sound studio without anyone knowing. I had enrolled four ravishing young actresses from among my acquaintances, and they grasped what it was I wanted with scarcely any need for explanation; and so the tape was completed on time.

On the day of the opening, the visitors crammed into the grotto's maze, within the shadows of which they were met by a mist of sprayed perfume. The remarkable thing was that everyone kept quiet in order to hear the sighs, which, though scarcely audible, came at them from every direction in an utterly disorientating way. Nothing like this had ever been heard in a public place before. Throughout the run of the exhibition the audience in each gallery remained in absolute silence, even at times of maximum crowding. Just once, at the opening, a dignified old gentleman rapped his cane against the wall and demanded we put a top to these 'puerile obscenities'. In contrast, one of the exhibition attendants congratulated me on what he took to be the evidence of my virility.

A few days later, the headlines on the English-language press ran: 'In Paris, the walls are sighing.'

TRANSLATED BY ROGER CARDINAL

PIERRE MOLINIER

Pierre Molinier (1900–1976) first came to the notice of the surrealists in the early 1950s. Before the Second World War he had worked in a variety of conventional genres, but from 1946 made eroticism his central subject. Having caused a minor scandal with his erotic canvases in his hometown of Bordeaux, he described himself in a letter to Breton in 1952 as a 'pariah and a completely misunderstood man'. His images of female nudes, fetishistically attired in black stockings and entangled in impossible couplings, appealed to Breton. In 1955, on the basis only of seeing photographs of the works, Breton offered Molinier a show at the surrealist gallery L'Etoile scellée, assuring the painter that he had 'only friends in surrealism'. Breton had long confessed that his response to the erotic had been indelibly formed by his teenage response to the seductive but distant *femmes fatales* in the paintings of the late nineteenth-century Symbolist painter Gustave Moreau, and his writings show that he saw in Molinier's work a Moreau-type eroticism that defied 'good taste' and represented female sexuality as enticing and illicit.

Molinier contributed to a number of surrealist magazines in the following years. A haunting photograph of a woman's face (in fact, a doll's face) was reproduced on the cover of the periodical *Le Surréalisme, même* in 1957, with the verse 'Sheltered in my beauty / by the window of my eye / I observe / "the secret" / without respite / without mercy'. Secrecy, for the surrealists, was an essential ingredient of sex appeal, but an element of the 'secret' may have been Molinier's identification with the doll, whose face was moulded and made-up to resemble the features of one of his daughters.

Although rampantly heterosexual, Molinier said that he would have liked to have been born a woman. In his self-portrait photographs of the late 1950s and more especially of the 1960s he strove to present himself as his ideal. He shaved his body hair, applied make-up, wore a corset, black stockings, high heels and sometimes a mask, and photographed himself in alluring poses, generally from the rear, or engaged in sexual acts with female lovers. To create the extraordinary images of multiplied bodies and legs (he was a leg fetishist), Molinier carefully cut up his photographs, creating a store of elements that he would then assemble and rephotograph. The elements might include photographs of the head of the doll, but other body parts were in almost all cases his own. His skill in composing these montages and in developing the prints obscured remaining traces of his masculinity and, as strikingly, his age.

In the late 1960s Molinier wanted to publish these photographs in a volume entitled *The Shaman and his Creatures* but could not find a publisher willing to comply with the high standards he demanded in the reproduction of the photographs. In his projected preface Molinier wrote that in the photographs he had aimed to express himself and to put himself in the place of God or of a shaman using witchcraft. Breton had cited Molinier's work in *L'Art magique* (1957), and it seems that they continued to share a similar vision of the relationship between eroticism, magic and art.

However, Xavière Gauthier, who knew Molinier well, chose to emphasise a different aspect of the artist's work in her critical study of surrealism, *Surréalisme et sexualité* (1971). Quoting the words of the French psychoanalyst Jacques Lacan, Gauthier wrote that the male cross-dresser 'identifies with a woman who has a hidden phallus', and went on to suggest that cross-dressing and other forms of perversion opened the way to an overthrow of the psychological and social barriers that constrained sexuality in symbolically subverting the taboo on incest between mother and son. At the very end of her book she reproduced a Molinier photograph of a many-limbed mêlée and wrote as her conclusion: 'If surrealism has been something, it is very much at the level of the perversions promised by its painters and some of its writers ... The point of impact of surrealism – its truth, some would say – is situated ... between the spread buttocks of a woman whose legs sheathed in black stockings repeat and multiply themselves. Rugby players in a scrum, hindquarters buttressed by the puddle of their discharged jouissance. The gaping anal orifice, between buttocks open onto the shadow, belongs to Pierre Molinier himself: a man then, a man dressed as a woman, a man-woman who exposes and hides the phallus.' JM

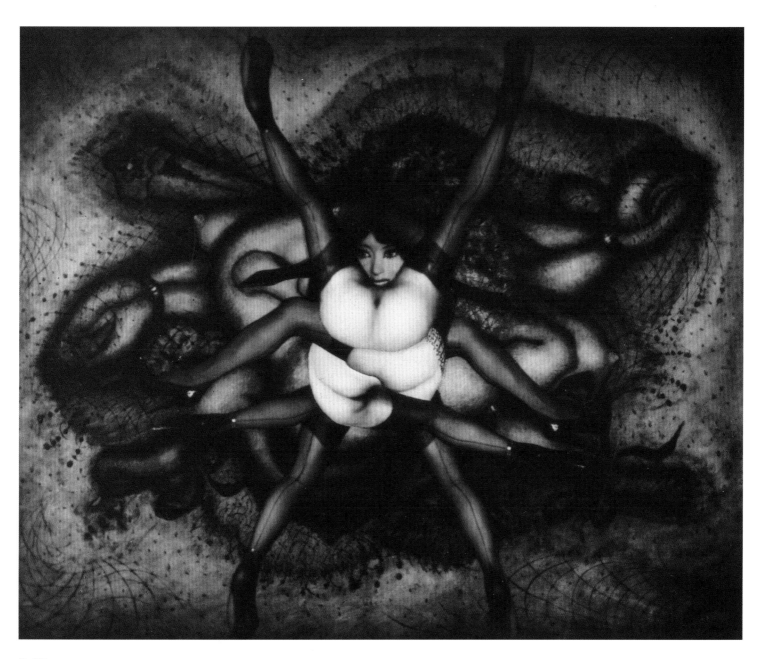

fig.277
PIERRE MOLINIER
Victory c.1970
Gelatin silver print
16.5 x 20.2 cm
Maison Européenne de la Photographie, Paris

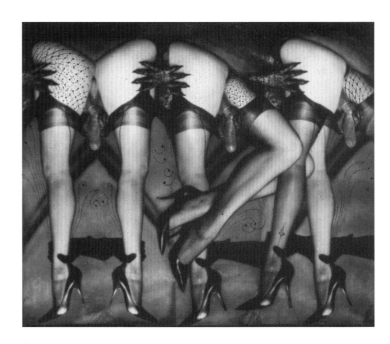

fig.278
PIERRE MOLINIER
The Stylite c.1970
Gelatin silver print with ink
23.8 x 17.7 cm
Maison Européenne de la Photographie, Paris

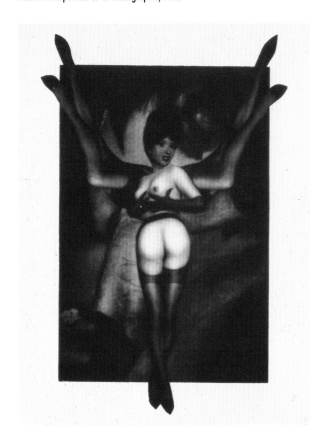

fig.279
PIERRE MOLINIER
Introit c.1970
Gelatin silver print with ink
12.2 x 14.4 cm
Maison Européenne de la Photographie, Paris

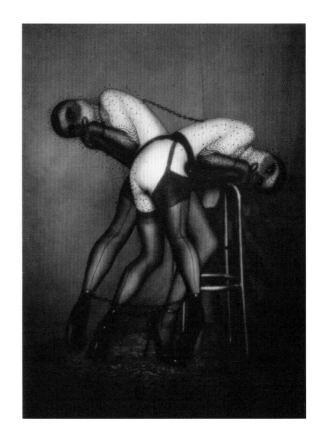

fig.280
PIERRE MOLINIER
Celestial Pantomime II c.1970
Gelatin silver print with ink
18 x 12.5 cm
Maison Européenne de la Photographie, Paris

her face painted gold, lay on a dining table behind a grille. She was surrounded by exotic food and fruits, with sweets between her breasts, champagne-filled glasses by her side, and a lobster between her thighs. This was a banquet for the eyes, for the taste-buds, and for the imagination, although Oppenheim herself was a unhappy with this public restaging of something she had conceived as a private feast for friends.[25] Like Benoît's *Testament*, Oppenheim's banquet evoked the primitive, suggesting both a cannibalistic feast (at the original, private enactment of the banquet people were invited to sit at the table and eat and drink, so 'stripping' the woman, though she too ate the food) and the ritual of death (the model was 'shrouded' in food).

Other works continued this fetishistic play, including Pierre Molinier's paintings *Succubus* (1950) and *The Flower of Paradise* (1955). Breton invited Molinier to exhibit in the *EROS* show, having appreciated his cover of *Le Surréalisme, même* in 1957 (a photomontage of a masked Molinier, disguised as a black-lace-clad temptress). Both of Molinier's paintings in the exhibition were seductive in form and colour yet represented images of grotesque femininity. *Succubus* presented the archetypal beautiful yet demonic female, who preys on unsuspecting men while they sleep. She is depicted with black hair, black stockings and pouting lips, strangling a man caught in her python-like grip. This image was characteristic of the violent enactment of desire in the exhibition as a whole. The *EROS* exhibition presented the visitor with spaces that were enticingly warm and nourishing, yet at the same time threatening and violent. By creating a space in which the public were invited both to indulge in images of the eroticised female body and to confront the fearful aspects of that embodiment, the surrealists wanted visitors to confront their fear of the Other, with a heightened awareness of the social and moral conditioning with which they approached the confrontation.

The surrealists remained consistent in their ground-breaking approach to the exhibition space as a site for radical aesthetic and social change. The surrealist exhibition created an environment of anxiety and desire, a fantasia of surprise and horror. Through the design of their exhibitions, the surrealists strove to create greater opportunity for abstract 'Other' spaces, where neuroses might be heightened and repressed desires unleashed. Indeed, it was hoped, that through desire, the visitor would not only arrive at a new understanding of reality but would also be inspired to challenge the social and political bases of the world in which he or she lived.

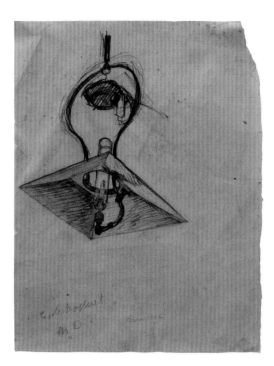

fig.281
MARCEL DUCHAMP
Hanging Gas Lamp 1903–4
Charcoal on paper
22.4 x 17.2 cm
Jacqueline Matisse Monnier

Just after Marcel Duchamp's death in 1968 the existence of an unsuspected major work was revealed. This was *Etant donnés: 1. La Chute d'eau, 2. Le Gaz d'éclairage* (Given: 1. The Waterfall, 2. The Illuminating Gas), on which Duchamp had worked in secret for twenty years, from 1946 to 1966. Having apparently given up art after abandoning *The Bride Stripped Bare by her Bachelors, Even (The Large Glass)* (fig.15) as 'definitively unfinished' in 1923, to devote himself to chess (a choice for which André Breton, bereft, chastised him in the *Second Manifeste du surréalisme* of 1929), Duchamp's involvement in art had seemed to be restricted to the invention of installations for surrealist exhibitions, work on his box-multiple *Boîte-en-valise* (*c.*1936–68), a little art dealing, and the occasional drawing, print, sculpture or object. Such activities gained scant attention during his rediscovery by the new European and American avant-gardes of the 1950s and 1960s, for whom his importance lay in his abnegation of art, rejection of the art industry and espousal of concept rather than creation.

Etant donnés was a shock. Its visible eroticism and paradoxical physicality seemed utterly at odds with the Duchamp of legend. But it was swiftly recognised as closely linked to *The Large Glass* and deriving from the same series of notes about the early work that Duchamp had published in 1934 and regarded as its indispensable text. Moreover, a number of the sporadic sculptures and objects produced since the late 1940s now took on a new dimension as studies for or spin-offs from *Etant donnés*. This work, now installed according to Duchamp's instructions at the Philadelphia Museum of Art, can never be moved nor properly photographed as a whole. Unlike the *The Large Glass*, which though two-dimensional is freestanding and transparent, *Etant donnés* is fully three-dimensional but can only be viewed from one position: through a pair of peepholes in an old wooden door, set in a wall.

The single voyeur is presented with an astonishing scene, which is only partially visible through a black-lined tunnel and jagged hole through a brick wall: a brilliantly illuminated landscape, in which a naked female body is outspread on a bed of twigs, a mane of blond hair just visible before the line of sight is interrupted. Her raised hand holds a gas lamp (a motif first depicted by Duchamp in 1903–4, fig.281) and in the picturesque landscape behind her a waterfall glistens. She is the Bride of *The Large Glass*, and we the spectators are now the oculist witnesses, or peeping toms, of that early work. But her stance and even identity remain controversial. Is she victim, or empowered in a celebration of her own sexuality? The Plexiglas study for her figure is closely based on a leather model, made in 1948–9, of a female torso, reclining on velvet, given to and presumably of Maria Martins, Duchamp's companion in the mid-1940s. Although the Plexiglas study is regarded as a working tool to determine the outline of the female in *Etant donnés*, as is so often the case with Duchamp practical ingenuity generates other associations and ideas. The pierced holes (resembling the pouncing of a fresco) cast shadows like constellations on the wall behind. The body, headless, isolated and truncated, like Gustave Courbet's famous depiction of a woman's genitalia, *Birth of the World* (1866), is almost too anatomical to be erotic, but the posture, though directed to an ultimately reclining form, takes on a strangely lively demeanour. In the closely related collage of photographs the dancing verticality of the figure, interlaced with the cypress-studded landscape, hints at mythological dimensions.

Wedge of Chastity is one of a small group of tiny sculptures in which Duchamp explored his long-standing interest in the erotic properties of moulds and casts, especially in terms of their relation to the human body and its parts. He subverts their literal nature as imprint, to create ambiguous and metaphorical shapes. *Dart Object*, despite its phallic or genital appearance turned out to be part of the armature shaping the breast of the bride in *Etant donnés*; and *Female Fig-leaf* is an equally ambiguous form. Duchamp gave to original example of *Wedge of Chastity* as a wedding present to Teeny Matisse, whom he married in 1954. DA

fig.282
MARCEL DUCHAMP
Study for the Bride in 'Given: 1. The Waterfall,
2. The Illuminating Gas' 1946–66
*c.*1950
Gouache on transparent perforated Plexiglas
91.3 x 55.9 cm
Jacqueline Matisse Monnier

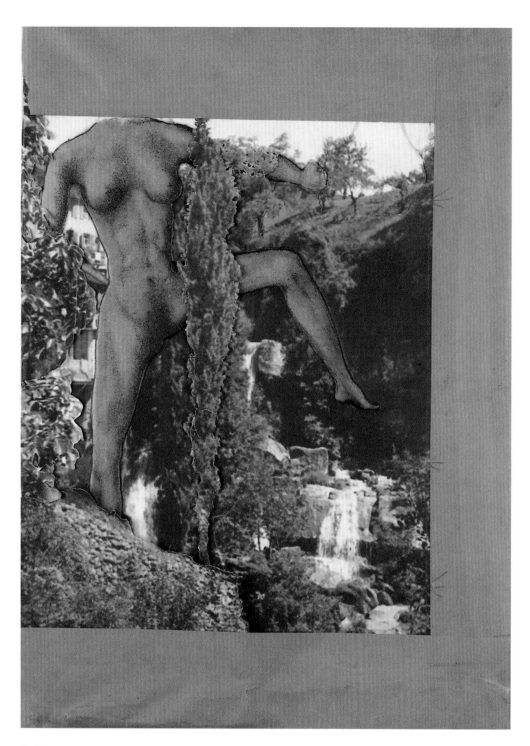

fig.283
MARCEL DUCHAMP
Study for 'Given' 1947
Textured wax and ink on yellow-board paper and
gelatin silver prints, mounted on board
43.2 x 30.5 cm
Private collection

fig.284
MARCEL DUCHAMP
Left to right:

Dart Object 1951,
cast 1962
Bronze
7.8 x 19.7 x 9 cm
Tate. Purchased with assistance
from the National Lottery
through the Heritage Lottery
Fund 1997

Female Fig Leaf 1950,
cast 1961
Bronze
9 x 13.7 x 12.5 cm
Tate. Purchased with assistance
from the National Lottery
through the Heritage Lottery
Fund 1997

Wedge of Chastity 1954,
cast 1963
Bronze and plastic
6.3 x 8.7 x 4.2 cm
Tate. Purchased with assistance
from the National Lottery
through the Heritage Lottery
Fund 1997

fig.285
MARIA
The Impossible III 1946
Bronze
80 x 82.5 x 53.3 cm
The Museum of Modern Art,
New York. Purchase, 1946

The sculptor Maria, known in her private life as Maria Martins, wife of the Brazilian Ambassador to the United States, enjoyed significant success in the 1940s. Her sculptures, which were dominated first by religious themes, expressed in a style related to Paul Gauguin's wood carvings, and then increasingly by subjects inspired by Amazonian myths, were bought by important museums in America and Brazil. *Eighth Veil* began as a naturalistic sculpture (c.1939) of the biblical character Salome, who danced the dance of the seven veils and, at the behest of her mother, asked her father Herod for the head of John the Baptist. In working on the sculpture Maria transformed Salome into a creature that was both woman and animal, its face half-pulled away, suggesting that the eighth veil of the work's title was the veil of identity.

Maria, a vivacious and exuberant woman, mixed with the exiled surrealists in New York. Breton fell under her spell sufficiently to write a catalogue preface for a show of her work in 1947, and she exhibited in the major international surrealist exhibitions of 1947 and 1959. In the early 1940s she became the lover of Duchamp, and it was she who inspired his last major work *Etant donnés*, an installation now housed in Philadelphia Museum of Art: a preliminary drawing for the nude in the installation, dated 1947, bears the inscription 'Etant donnés: Maria, la chute d'eau et le gaz d'eclairage'. Duchamp, who hitherto had retained through his various relationships a somewhat cynical attitude towards love, had fallen in love with Maria; and his letters to her, when she had moved to Paris in 1948 with her husband, suggested that he wanted her to return and live with him.

Theirs was a intense relationship. In 1946 Duchamp gave her one of his 'boîte-en-valise', with an original artwork in the suitcase lid, titled *Faulty Landscape*. Only in 1989 did chemical analysis determine that the abstract-looking form on the celluloid, backed with black satin was ejaculated seminal fluid. In the same year, 1946, Maria worked on a version of *The Impossible*, a work showing a couple seemingly locked in conflict. JM

fig.286
MARIA
Eighth Veil 1949
Polished bronze
104 x 114.3 x 94 cm
Anna Maria Martins Turner

chapter twelve
DESIRE – A SURREALIST 'INVENTION'

Annie Le Brun

To adapt the maxim about the surrealist use of language that André Breton formulated so provocatively over three-quarters of a century ago, 'Desire was given to man that he might make surrealist use of it'. At least, this seems to me a good way of suggesting modernity's debt to surrealism.

The revolution in envisaging desire, both individual and collective, has manifested itself in modern times in fits and starts. It has been explosive and oblique, at times a blinding illumination, at others a detour down offbeat paths. Yet it is this pursuit of desire, a pursuit which the surrealists sustained over four decades and which has its own indistinct but occasionally dazzling impulses, that I hope to sketch here. Bearing in mind all the while that this pursuit did not involve any dimming of the glowing coals of the libertine tradition, initiated two centuries earlier by the earliest atheist philosophers for whom freedom of thought was synonymous with the freedom of the body.

Although it might seem somewhat arbitrary to try to pinpoint the origin of such an adventure, I consider 1923 as the year when desire, seen in the nocturnal depths of subjectivity as much as in the daylight of objectivity, was first recognised as a sovereign value. For it was in 1923 that, independently of one another, André Breton and Robert Desnos – as yet neither of them surrealists, strictly speaking, since it was not until the following year that the *Manifeste du surréalisme* and the first issue of *La Révolution surréaliste* were published – identified desire as the most prominent landmark in the ravaged landscape of the intellect and the emotions. In his text 'La Confession dédaigneuse', Breton grappled with the issue of suicide in terms that highlighted the centrality of desire:

It is ignoble to assume there is any simple cure for moral suffering. To commit suicide seems to me legitimate in only one instance. If I have nothing left but my desire with which to challenge the world, and if death is the greatest challenge, then I might well reach the position of directing my desire towards death. But there is no question of my becoming so feeble-minded; this would mean I had given way to remorse. True, I have tried remorse a couple of times, but it did not suit me one jot. As for desire, that person hit the mark who said that 'assuredly, Breton will forever be concerned with the heart, the very handle of his door.'[1]

These words were written at the same time that Robert Desnos, under commission to the collector and fashion designer Jacques Doucet, was busy preparing his essay 'De l'érotisme considéré dans ses manifestations écrites du point de vue de l'esprit moderne', in which he contrived to validate what amounts to a history of desire, inasmuch as 'once re-appraised from a superior standpoint, these outlawed writings are seen to be of a piece with the modern spirit and the trends of contemporary culture'.[2]

Between Breton's very personal point of view and Desnos's historical vision, there suddenly opened up a vast horizon framed by the notion of desire. For certain people, desire imposed itself with all the impact of a natural phenomenon, like a

rainbow bridging the gap between their emotional and their intellectual life; or it appeared to endorse what the poet Guillaume Apollinaire had proclaimed in his *Calligrams* of 1913, 'Desire is the great force'.

Before they brought about the 'invention' of desire, the surrealists pursued its 'development', not least in the photographic sense of the term, capturing all the flashes and shadows that desire triggers. Admittedly, these effects had already been noticed by some, albeit without a real awareness of the change in perspective that would ensue. I am thinking in particular of Apollinaire. The significance of his efforts in the 1910s, when he was like an explorer blazing a trail through the emotional forest, should never be underestimated. He opened up the darkest corners of the forest to those who would later bring surrealism into being. This is why Breton always cherished the memory of Apollinaire, who used to invite him towards the end of the First World War to his attic apartment at 202 Boulevard Saint-Germain and showed him 'paintings of what was at the time the most revolutionary cast … like so many sails scudding towards the most adventurous horizons of the mind: Picasso, De Chirico, Larionov'. He also introduced him to books impossible to find elsewhere: 'Sometimes he would leave me alone in his apartment for hours on end, having first pressed into my hands some rare work, perhaps something by Sade or a volume of *Monsieur Nicolas*. Soupault and I, and later on Aragon, opted to call on him one after the other.'[3]

Such contacts assume the character of an initiation when one remembers that it was Apollinaire who was the first to defend the writings – reviled if not literally censored – of such authors as Baffo, Nerciat and Sade. He published excerpts of their writings in his collection *Les Maîtres de l'amour* between 1908 and 1913. With perfect justification Louis Aragon, in his anonymous preface to the 1931 reprint of Apollinaire's great erotic novel *Les Onze mille verges*, wrote: 'He deserves every credit for his efforts in defending banned books. It was he who brought Sade, albeit incompletely, within reach of a whole generation.'[4]

This sort of generosity was consistent with that 'curiosity about human behaviour' which Apollinaire unconsciously took to be a component of what he termed the 'new spirit'. He had trouble defining what this spirit was, yet he himself epitomised it more than any of his contemporaries. Not least because he was the first to have enjoyed 'such a lucid awareness of the link between poetry and sexuality, the awareness of an iconoclast and a prophet', as Aragon observed in his preface. 'This is what places Apollinaire at a singular turning-point of history, when those age-old fakers, rhyme and unreason, were brutally demolished.'[5]

This seems to me crucial: the origin of surrealism lies at that 'singular turning-point of history', when, for the very first time, desire was shown by Apollinaire to be nothing less than poetry's beating heart. Even so, it would fall to the surrealists to intuit the devastating potential of this insight, each one of them making it a point of honour to try to seek out for himself the links between desire and poetry. Each would gamble his life upon it, not necessarily even conscious of doing so, yet with the unswerving determination of one who sets forth to lay claim to a new world.

Paradoxically, and astonishingly, Aragon's acute appreciation of Apollinaire's contribution was formulated scarcely a year before his decisive break with André Breton. That break arose after Aragon refused to admit any discussion of erotic freedom when the surrealists clashed with the French Communist Party over the publication in 1932 of a text by Salvador Dalí entitled 'Rêverie érotique' in *Le Surréalisme au service de la révolution*. In a moralising reproach, the commission

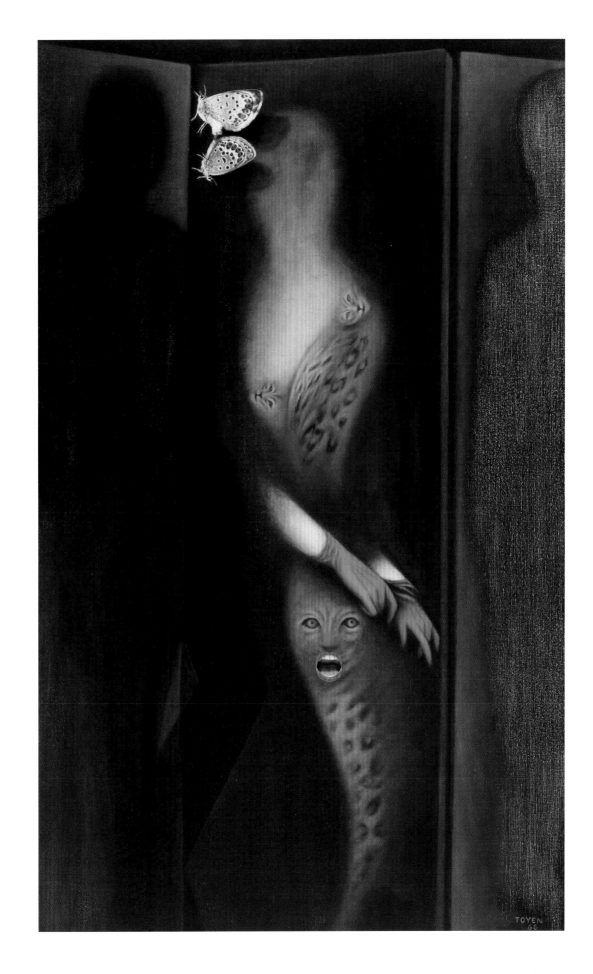

fig.287
TOYEN
Screen 1966
Oil on collage on canvas
116 x 73 cm
Musée d'art moderne de
la Ville de Paris

set up by the Communist Party to investigate the case ruled: 'All you are doing is trying to compli-
cate the relations between man and woman, which are so simple and healthy.'[6] To have let this pass
without protest – as Aragon would have wanted – would have
meant a betrayal of the principle of amorous freedom that the
surrealists increasingly saw as indispensable to the revolution of
their dreams. Indeed, it would have meant a betrayal of every-
thing they had collectively lived for and expressed over the pre-
vious ten years. It would have meant a betrayal of what Aragon had stood for as the author of *Le
Libertinage* (1924) and *Le Paysan de Paris*
(1926). It would have meant a complete
reversal of the values represented in the
collective text 'Hands Off Love' (1927), a
text he himself had drafted and had trans-
lated into English by Nancy Cunard, and which defended Charlie Chaplin against the charges of
sexual impropriety and immorality levelled at him by his wife. Also, and more importantly, it
would have meant a betrayal of all that was at stake in
such works as *La Liberté ou l'amour!* (1927) by Robert
Desnos, *Nadja* (1928) by André Breton, *L'Amour la
poésie* (1929) by Paul Eluard, *La Femme visible* (1930),
L'Amour et la mémoire (1931) by Salvador Dalí, *Artine*
(1930) by René Char and *L'Immaculée Conception* (1930) by Breton and Eluard, one of the most
profound and lyrical reflections upon amorous freedom.

It would have meant a betrayal of all those things Aragon had so ably highlighted in
Apollinaire, particularly in
regard to the latter's *Les Onze
mille verges*. Published anony-
mously in 1907, this book can
be seen as an unexpected companion piece to Picasso's famous painting of a brothel scene, *Les
Demoiselles d'Avignon*, completed in the same year. In both novel and painting the rules of repre-
sentation are swept away in a deluge of violent impulses. Both works, too, were semi-clandestine.
It was only in 1916 that Picasso chose to present his canvas to the public – a delay that may
remind us of that no less strange 'delay in glass' lasting from 1915 to 1923, during which Marcel
Duchamp worked on and refined *The Bride Stripped Bare by her Bachelors, Even*. What with the
coincidences and deliberate delays, fortuitous encounters and unconscious expectancy,
Apollinaire's *Les Onze mille
verges*, Picasso's *Les
Demoiselles d'Avignon* and
Duchamp's *The Bride Stripped
Bare by her Bachelors, Even*
may be said to have joined forces during the early years of the century so as to concentrate their
fullest impact upon a single blind spot. Despite their many differences, these works signal the
emergence of desire as a source of representational power. The genius of the surrealists lay in

*We who have so much space and so little time, we shall trans-
form ourselves into nomads.*

*The fields stretch away as far as the eye can see, beckoning us
to beds made to our measure.*

My love, wonderfully erect, like a table set out in the sunlight.

The nudity of love has scarcely begun.

*The body reaches further than we normally think. It is the matchless hall of lost footsteps where every-
thing is played out in terms of echoes.*

Annie Le Brun, 1972

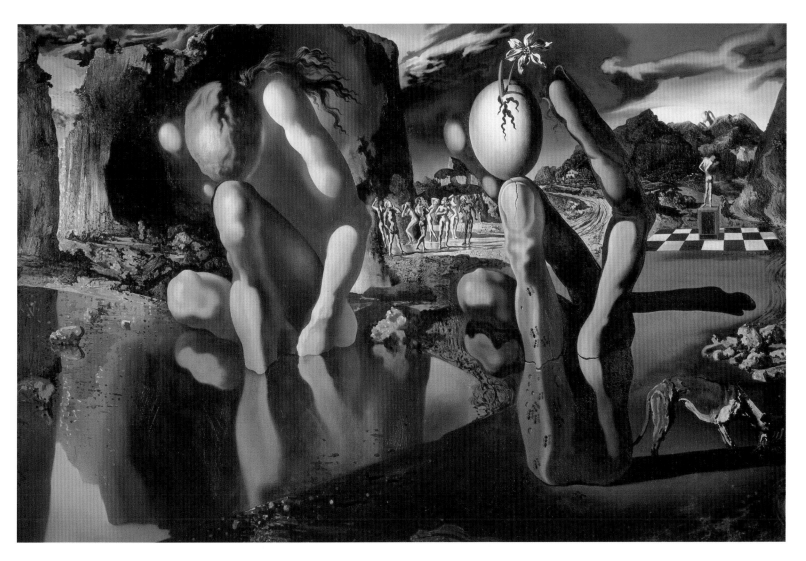

fig.288
SALVADOR DALI
Metamorphosis of Narcissus 1937
Oil on canvas
51.1 x 78.1 cm
Tate. Purchased 1979

their appropriation of a boundless theatre in which each felt able to lay claim to the infinite deep inside the self.

Throughout the 1930s the surrealists devoted themselves to that 'perpetual strolling through the heart of the forbidden zone' called for by Breton in the *Second Manifeste du surréalisme*, instigating a 'systematic illumination of hidden places' along with a 'progressive darkening of all other places'. In retrospect, the diversity of the surrealists' itineraries is striking; and yet one cannot help seeing the journeys as some sort of curious crusade in which individuals enlisted with the sole aim of grappling with whatever it was that haunted them. The fact that a number of them should have risked everything in order to lay bare the singularity of their desire is surely a phenomenon without precedent in history.

As André Breton made clear in *L'Amour fou* (1937), this quest had become progressively part of his everyday existence:

> My most enduring ambition will have been to disengage this unknown character from the most apparently trivial facts of my life to the most meaningful. I think I have succeeded in establishing that both kinds share a common denominator situated in the human mind, and which is none other than desire. What I have wanted to do above all is to show the precautions and ruses which desire, in search of its object, employs as it manoeuvres through preconscious waters, and once this object is discovered, the means (so far stupefying) it uses to reveal it through consciousness.[7]

There was not a single surrealist whose existence was not carried away by the momentum of such an enquiry, strong enough to sweep each one to the furthermost limit of himself while at the same time guiding him back to the secret of his singularity. It was into the depths of a virgin forest that the surrealists advanced, experiencing both terror and wonder as they realised how, beyond all their imagining, 'the flora and fauna of surrealism are not to be avowed'.[8]

What exactly is desire? I don't mean love, but desire. I believe that Sade was the first person to frame this question, and that he addressed it to the world at large with all the aggressiveness of an ontological imperative. We can hardly conceive what an irreparable split such a query was destined to introduce into the horizon of the Enlightenment, given that nowadays the term 'desire' has become the bolt-hole for all the uncertainties and indeterminacies that mark the final years of this century …

Annie Le Brun, 1985

Aspects of love hitherto ignored were for the first time brought out into the open. With the proliferation of images, pictures and objects, as well as of surrealist texts, dream narratives and poems, it was as if, foaming and unconfined, the free tide of desire were dispelling all aesthetic categories and opening up an entirely fresh horizon.

In this context the impact of the writings of the Marquis de Sade, whose life and ideas were being brought into the public domain through the efforts of that passionate scholar Maurice Heine, should not be ignored. The phrase 'Actualité du Marquis de Sade' (The Contemporaneity of the Marquis de Sade) served as the rubric of a regular column in the periodical *Le Surréalisme au service de la révolution*, in which Heine communicated fresh biographical details and reported on his plans for publishing, in discreet editions, a series of important unpublished manuscripts. Everything suggests that, almost unawares, surrealism was being nourished by Sade's philosophy, with its unique defence of desire and the excesses of desire against conformist definitions of humanism, whose invariable purpose is to assign fixed limits to every human aspiration.

As early as 1923 Desnos had written: 'In essence, all our current aspirations were formulated by Sade. He was the first to posit the integrity of one's sexual being as indispensable to the life both of the senses and of the intellect.'[9] Quick to underline that Sade had also been the first to envisage love and all its acts 'within the perspective of infinity', Desnos concluded: 'Let the riff-raff bellow to their hearts' content. Sade will always be a hero to those who can appreciate his exemplary demonstration of intellectual liberty and a moral code. In both his life and his work Sade remained loyal to those principles we hold dear and for which we are resolved to sacrifice everything.'[10]

Foremost among those 'principles we hold dear' was atheism, which cannot be dissociated from that affirmation of desire that the surrealists were the first to experience as a constantly renewed incarnation of the infinite. A consequence of the surrealists' atheism was a more and more vivid perception of the complexity and the contradictoriness of the relations between mankind and the world, a perception that would gradually erase the boundaries between the human and the inhuman, as attested by the 'solarisations' of Man Ray and many of Salvador Dalí's 'paranoia-critical' paintings.

Desire is neither masculine nor feminine, because the primary impulse of desire is to be other: sometimes this goes so far that we are carried away to the very antipodes of what we are. And here lies the reason — the maddening reason — why anything (and not simply anybody) is capable of provoking our desire.
Annie Le Brun, 1994

When Sade framed the question 'What is desire?', rather than 'What is man?', he dispensed with the sovereignty of the human subject and relocated that subject within a system of universal interplay. This was what was so scandalous. Sade not only refused to see man as distinct from the rest of the universe, he also insisted on defining him in terms of an unbridled ambition, namely, the desire to give body to that which lacks body, to give body to thought.
Annie Le Brun, 1985

It is not at all difficult to recognise here those 'short-circuits' which surrealism 'went to every length to multiply', as much in poetry as in painting, with the sole ambition, as stated in the *Second Manifeste du surréalisme*, of 'reproducing artificially that supreme moment when man, exposed to a particular emotion, is suddenly gripped by an irresistible force and propelled, despite his protests, into the dimension of immortality'.[11] This involved nothing less than a revolution in representation. For once desire becomes master of the game, there can be no representation which is not borne away in a vast centrifugal movement that shifts our human horizon towards everything we perceive as alien to ourselves.

Salvador Dalí and Hans Bellmer were among those who set about the progressive disclosure of the mechanisms of desire, dissecting appearances and redesigning the human organism in the most unlikely fashion. In their works can be discerned, if only by inference, the same implacable determination to 'set the amorous imagination free of its own objects' that Eluard attributed to

A RECIPE: HOW TO PRODUCE EROTIC DREAMS

Ingredients: One kilo black radishes; three white hens; one head of garlic; four kilos honey; one mirror; two calf's livers; one brick; two clothes pins; one whalebone corset; two false moustaches; two hats of your choice.

Pluck the hens, carefully setting aside the feathers. Boil in two quarts of unsalted distilled water or rainwater, along with the peeled, crushed garlic. Simmer on a low fire. While simmering, position the bed northwest to southeast and let it rest by an open window. After half an hour, close the window and place the red brick under the left leg at the head of the bed, which must face northwest, and let it rest.

While the bed rests, grate the black radishes directly over the consommé taking special care to allow your hands to absorb the steam. Mix well and simmer. With a spatula, spread the four kilos of honey on the bedsheets and sprinkle the chicken feathers on the honey-smeared sheets. Now, make the bed carefully.

The feathers do not all have to be white — they can be any colour, but be sure you avoid Guinea hen feathers, which sometimes provoke a state of prolonged nymphomania, or dangerous cases of priapism.

Put on corset, tighten well, and sit in front of the mirror. To relax your nerves, smile and try on the moustaches and hats, whichever you prefer (three-cornered Napoleonic, cardinal's hat, lace cap, Basque beret, etc.).

Put the two clothes pins on a saucer and set it near the bed. Warm the calf's livers in a waterbath, but be careful not to boil. Use the warm livers in place of a pillow (in cases of masochism) or on both sides of the bed, within reach (in cases of sadism).

From this moment on, everything must be done very quickly, to keep the livers from getting cold. Run and pour the broth (which should have a certain consistency) into a cup. As quickly as possible, return with it to the mirror, smile, take a sip of broth, try on one of the moustaches, take another sip, try on a hat, drink, try on everything, taking sips in between. Do all this as rapidly you possibly can.

When you have consumed all the broth, run to the bed and jump between the prepared sheets, quickly take the clothes pins and put one on each big toe. These clothespins must be worn all night, firmly pressed to the nails, at an angle from the toes.

This simple recipe guarantees good results, and normal people can proceed pleasantly from a kiss to strangulation, from rape to incest, etc., etc.

Recipes for more complicated cases, such as necrophilia, autophagia, romachia, alpinism, and others, can be found in a special volume in our collection of 'Discreetly Healthy Advice'.

Remedios Varo [published posthumously,1970]

Often known, like many surrealist women painters, simply by her first name, Remedios Varo met the surrealist Benjamin Péret in Madrid in 1936. She went with him to Paris where from 1937 to 1942 they were both members of the surrealist group. In a later interview she recalled, 'Yes, I attended those meetings where they talked a lot and one learned various things. My position was the timid and humble one of a listener; I was not old enough nor did I have the aplomb to face up to them, to a Paul Eluard, a Benjamin Péret, or an André Breton. There I was with my mouth gaping open within this group of brilliant and gifted people.' During the Nazi occupation of France she and Péret escaped to Mexico, where they were active in the surrealist community that included Leonora Carrington and the poet Octavio Paz. They separated and Péret returned to Paris in 1947.

In *Woman Leaving the Psychoanalyst* Varo cloaks the pseudoscience of psychoanalysis in a medieval setting, with the initials of its three fathers inscribed on the portal behind the central figure, 'FJA' standing for Freud, Jung and Adler. Varo uses the various associations of the veil to invoke seduction (Salome) and the idea of stripping to reach psychological or metaphysical truths. The woman is shrouded in a garment, which contains within it a mask, but her face is partly uncovered. Without a trace of hesitation or compunction, she drops a male disembodied head (Varo's father's? or, more likely, Péret's?) down a well, which, Varo wrote, was 'the proper thing to do when leaving the psychoanalyst'. JM

fig.289
REMEDIOS VARO
Woman Leaving the Psychoanalyst 1960
Oil on canvas
70.5 x 40.5 cm
Private collection, Mexico City

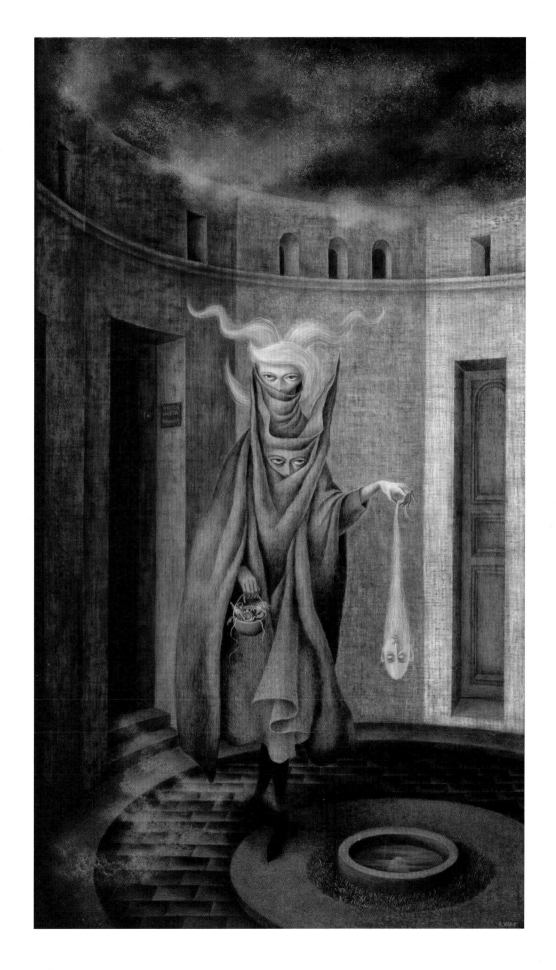

Sade, in so far as the latter compels us to contemplate the singularity of our being as the primary arena of desire. The ferocity of desire that Sade was the first to bring to light should not be ignored, nor the monstrous insatiability of desire that denounces the insufficiencies of reality and lays bare the connection between erotic necessity and the necessity of poetry. Unable to attain satisfaction as desire for the other, desire would seem to assert itself as the desire to become other, confusing, or rather fusing, ethics with aesthetics. From this basis the surrealists embarked upon their dream of a complete overhaul of human understanding.

If there is such a thing as a surrealist revolution, it is inseparable from the affirmation of desire as a physical intuition of the infinite. This physical intuition never loosens its grip upon representation, thanks to the implacable challenge posed by the body to the mind. This is borne out by the investigations and debates that, over a period of four decades, punctuated the history of the surrealist movement. These included lively and unscripted discussions, known as the *Recherches sur la sexualité*, undertaken from 1928 to 1932, and the various questionnaires on love, ranging from the 'Enquiry into Love' of 1929, to the 'Enquiry into Erotic Representations' of 1964. This material allows us to evaluate the quasi-physical commitment implicit in the surrealists' progressive 'invention' of desire, not just as a vital stimulus to thought but also as its most reliable means of verification.

A verification shot through with passion, if ever there was one. What is more, a paradoxical verification, insofar as the surrealists saw desire as the conductor of that energy thanks to which 'eroticism is, within man's consciousness, that which casts his whole being into question'. It was by no means idly that André Breton quoted this remark of Georges Bataille at the very outset of his introduction to the catalogue of *L'Exposition internationale du surréalisme* (*EROS*), which opened in 1959. He did so in order to insist on the shock value of desire and on the darkness of the spaces to which it leads us, once its sovereignty is acknowledged.

Despite their reverence for Freud and the deep interest they showed in his work, the surrealists tended to draw back from the methods of psychoanalysis. While psychoanalysis recognises the irreducible fact of desire, it prefers to see its own practices as unmarked by desire, as if they were entirely governed by rationality. By contrast, the surrealists believed that only an approach that took account of the senses could hope to come to terms with the extraordinary influence, still imperfectly understood, that desire exerts upon our lives. In 1952 Breton declared: 'Surrealism has done its utmost to dispel the taboos which militate against the fullest treatment of the sexual domain, not to say the sexual domain in its entirety, including the perversions.' He confirmed, 'to my knowledge, this domain has – despite the outstanding investigations mounted by Sade and Freud, and as if to thwart our human yearning to penetrate the secrets of the universe – never wavered in preserving its intractable kernel of darkness'.[12]

The surrealists were the first to dare to celebrate this 'intractable kernel of darkness', a disquieting centre of gravity within the landscape at large and, necessarily, of all representation. It was this courageous attitude that led them to consider staging the *EROS* exhibition in 1959. Given the asphyxiating morality, be it bourgeois or socialist, dominant in France and elsewhere at that time, I cannot, even today, remain unmoved by the intellectual and emotional honesty of those who, advancing from positions they had themselves captured, once again took the risk of reappraising the erotic domain in its entirety, analysing their own continuing efforts to push back the horizon.

An expression of this was the inestimable *Lexique succinct de l'érotisme* (1959), drawn up to accompany the exhibition. In its pages some eighteen people offered daring redefinitions of phenomena, beings, sensations and ideas, in an attempt to make visible the inexhaustible aura of non-completion inherent in desire. Unsurprisingly, this dictionary of passion has the character of a storm-warning, appropriate to the feverishness of momentous departures and the imperious appeal of journeys without destination.

As early as 1924 Breton had announced: 'we are intent upon reducing art to its simplest expression, which is love'. Such an intention seems reflected in the spontaneous intertwining of the *Lexicon*'s definitions and illustrations, whose explosive potential still seems at the ready, aimed at the moralistic permissiveness so dominant nowadays, especially in the guise of a paltry neo-feminism. Thanks to the radiance of desire, and thanks to it alone, the *Lexicon* revealed the ultimate singularity of the passions in all their infinite diversity.

I am not tired, I hardly stir, I abjure the parallel roads. My path leads out from the blue vein at your wrist, my own wrist ... I step forth along it, knowing it will lead to that fulcrum of insatiable instability, to that point of convergence of life's infra-luminous rays, whence radiate the occult respiratory canals of water and of wind, in strict harmony with my desire.

Annie Le Brun, 1967

'Sade is surrealist in sadism', insisted Breton in the first *Manifeste du surréalisme*. Far from being a tautology, as some might think, the phrase is in truth the finest homage one could pay to the first person to rethink the world in terms of this singularity of the passions. Sade was the first to voice, out of the depths of his solitude, an affirmation of the supreme power of desire, that same desire that the surrealists were to 'invent' over a century later. 'People rant and rave against the passions without realising that it is from their flames that philosophy is ignited', declared Sade. Similarly, the nineteenth-century thinker Charles Fourier proclaimed, 'no one has any reason to think love misguided, since it is the passion of unreason', writing in 'Le Nouveau Monde amoureux', an unpublished text that the surrealists discovered in the late 1950s.

This reason of which reason knows nothing, this reason which can never be suppressed, given that, when all is said and done, it is always metaphorical, surely this is the same 'ardent reason', to quote Apollinaire, that the surrealists ceaselessly endorsed in their 'invention' of desire. This is what led them to the discovery that our modern age (never as 'absolutely modern' as Rimbaud would have wanted) has constantly sought to repress, namely, that not only is desire the 'great guardian of the key',[13] it is also the paramount, the vital source of all our thinking. Thinking needs only to deviate slightly from desire to become a caricature of itself.

Such a standpoint is destined to be seen as more and more heretical in a world subservient to the iron rule of technology, that operates day by day to undermine the coherence of our feelings. Surely our one hope of resistance lies in this 'reinvention' of desire, whose staggering impact and lesson the surrealists, for over forty years, fought to pass on to us. Take it or leave it: we simply have no other weapon at our disposal if we are to reinstate passion within our lives.

Translated by Roger Cardinal

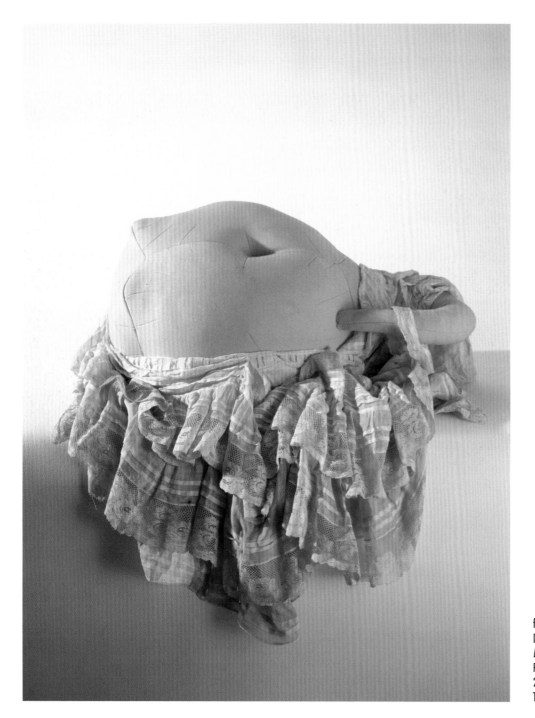

THE STORM SKETCHES A SILVER MARGIN

The storm sketches a silver margin
In the sky
And bursts in a great sticky spasm
On the ground.
The floating foam
Cast up by the receding sea
Comes to cool our tired faces
And our bodies hiding
In the tepid dark of our sleeping desires
Stand up straight.
Our nap the lice have plagued
Ends
And the brief lap of the waves
On the beach where the azure dances
Has fallen quiet, my love,
And it is raining

Joyce Mansour, 1955

fig.290
DOROTHEA TANNING
Emma 1970
Fabric, wool, lace
29.5 x 64.5 x 54.9 cm
The artist, courtesy Cavaliero Fine Arts, New York

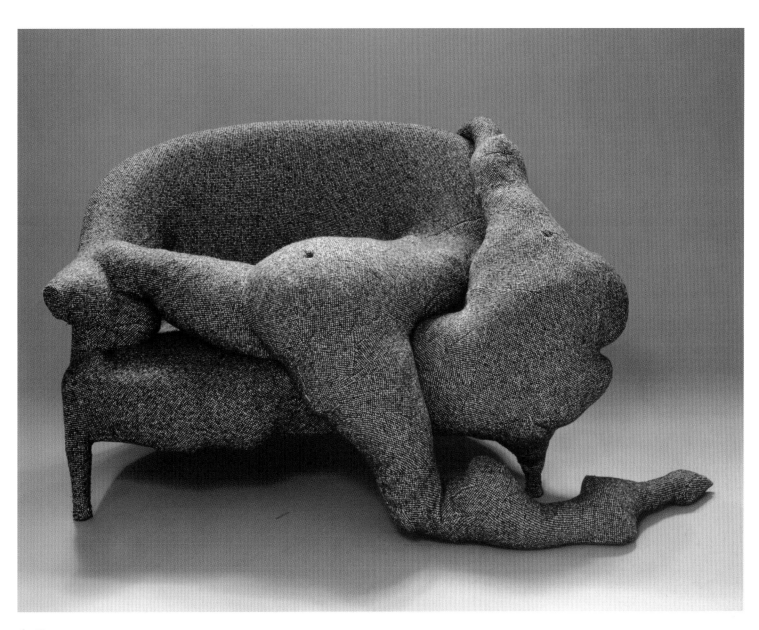

fig.291
DOROTHEA TANNING
Rainy-Day Canapé 1970
Tweed upholstered wood sofa, wool, table-tennis balls, cardboard
81.9 x 174 x 109.9 cm
The artist, courtesy Cavaliero Fine Arts, New York

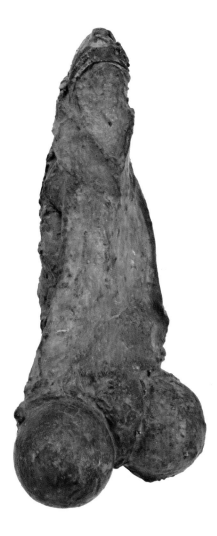

fig.292
LOUISE BOURGEOIS
Fillette 1960
Latex over plaster
59.7 x 28 x 19.1 cm
The Museum of Modern Art, New York.
Gift of the artist in memory of Alfred
H. Barr, Jr., 1992

fig.293
LOUISE BOURGEOIS
Janus Fleuri 1968
Bronze, golden patina
25.7 x 31.8 x 21.3 cm
Courtesy Cheim and Read,
New York

Analogies with body parts are instantly recognisable in Louise Bourgeois's culture, but this allusiveness was out of line with the predominant abstraction in the 1950s and 1960s. She herself never saw a onflict between 'formal perfection' and sexual references, but it was only with shifts in critical perceptions and tastes, a broader appreciation of psychoanalysis and changes in attitudes following feminism, that the complex ways in which she extended and transformed the visual languages of desire and anxiety originally stimulated by surrealism have been acknowledged.

As an art student in Paris before the war Bourgeois studied for a time with Fernand Léger, who recognised the true direction of her talents. 'I don't know why you paint, Louise', she later remembered him saying, 'let me show you something.' So he took a shaving of wood and he hung it under his shelf and said: 'look, the wood turns around like this. This is sculpture...' She encountered surrealism in the galleries near the rue de Seine in Paris, where, by chance, she lived above the surrealists' own gallery Gradiva. The work of Joan Miró especially, at the Galerie Pierre, was a liberation, a 'wonderful aesthetic shock'. However, it was only after she married the American art historian Robert Goldwater in 1938 (the year he published his groundbreaking study *Primitivism in Modern Art*) and moved to New York that she began to move in the milieu of surrealists, most of whom were refugees from the war in Europe. Duchamp responded with particular enthusiasm to her sculptures, and there are interesting affiliations between her later work and his erotic objects of the 1950s (see p.292). But Bourgeois was to react strongly against what she regarded as the dominant 'fathers'. André Breton, Jacques Lacan and Sigmund Freud, she said in 1992, 'promised the truth and just came up with theory. They were like my father: to promise so much and deliver so little.' *Fillette*, which dangles from a hook as in Léger's demonstration, is an ambiguous response to male power and vulnerability.

For Bourgeois, the erotic effect in her work enters unconsciously. She noted in the late 1960s that, 'I do not plan to be erotic and doubt if I am but if when you come into

fig.294
LOUISE BOURGEOIS
Torso, Self-Portrait 1963–4
Bronze, white patina
62.8 x 40.6 x 20 cm
Courtesy Cheim and Read, New York

fig.295
LOUISE BOURGEOIS
Avenza 1968–9
Latex
53.3 x 76.2 x 116.8 cm
Tate. Presented by the artist, 2001

their presence the aesthetic shoe is an erotic one – who am I to tell you it ot so?' Eroticism, Breton wrote in his introduction to the *EROS* exhibition of 1959–60, draws its strength from equivocation and establishes an organic liaison, 'by way of perturbation, between exhibitor and spectator'. The encounter Bourgeois seeks with the spectator is not determined by gender. Asked how men reacted to her work, she replied, 'They find it erotic, even though I am not always aware of it', and gave the same answer with respect to women.

Her sculptures maintain a distance from their anatomical referent, their morphological fluidity enabling multiple allusions to occur, reinforcing or contradicting female or male identifications. Bourgeois could have had *Avenza* in mind, when she wrote in 1974 for a special issue of the magazine New York subtitled, 'Why Women Are Creating Erotic Art': 'sometimes I am totally concerned with female shapes – clusters of breasts like clouds – but often I merge the imagery – phallic breasts, male and female, active and passive.' The bulbous cloudscape of *Avenza* has strongly phallic overtones. The work now known as *Torso, Self-Portrait* includes breast-like forms above and below a symmetrically filleted, tapering torso. It is interesting how the title of this work has changed to reflect alterations in critical tastes: originally *Torso, White Relief*, in tune with the dominant concern with form, material and process, in 1975 it was reproduced in Lucy Lippard's *Artforum* article 'Louise Bourgeois: From the Inside Out' as *Self-Portrait*, conforming to a new stress on personal identity and sexuality.

Bourgeois has suggested that *Janus Fleuri*, suspended, like *Fillette*, and hanging at eye level, is a self-portrait, to be read as a double facial mask. This diverts attention, though, from the most disturbing aspect of the sculpture, the effect as of skin splitting and releasing a formless mass, as though she is testing the limits of Hans Bellmer's inside-out sexual anatomies.

fig.296
JOSEPH CORNELL
Untitled (Blue Nude)
mid-1960s
Collage
28.6 x 21 cm
Robert Lehrman, Washington,
DC

NOTES

LETTERS OF *DESIRE*
Jennifer Mundy

Of those who kindly read and commented on an early draft of this essay I should like to thank in particular Vincent Gille and Sarah Wilson. Unless otherwise attributed, translations are my own.

1 André Breton, *Mad Love*, trans. Mary Ann Caws, Lincoln, Nebr. and London 1987, p.25.

2 Ibid., p.88 (modified translation).

3 André Breton, 'Guillaume Apollinaire', in André Breton, *Oeuvres complètes*, ed. Marguerite Bonnet, I, Paris 1988, p.205.

4 André Breton, 'La Confession dédaigneuse' (1923), in *Oeuvres complètes*, I, 1988, p.194, see note, pp.1222–3.

5 'Lexique succinct de l'érotisme', in *L'Exposition internationale du surréalisme* (*EROS*), exh. cat., Galerie Daniel Cordier, Paris 1959, p.125.

6 Breton, *Oeuvres complètes*, II, 1992, pp.1614–15.

7 Ibid., p.504–5.

8 'An Inquiry into Erotic Representations' (*La Brèche, action surréaliste*, no.8, Nov. 1965) in José Pierre, *Investigating Sex*, trans. Malcolm Imrie, London 1992, p.165.

9 'L'Esprit nouveau', in Breton, *Oeuvres complètes*, I, 1988, pp.257–8.

10 André Breton, *Nadja*, trans. Richard Howard 1960, London 1999, p.11.

11 Ibid., p.64.

12 In 1963 Breton revised the manuscript for a new edition of this work, and took for him the unusual step of excising reference to the night he spent with Nadja from this later edition.

13 'Enquête', in *La Révolution surréaliste*, no.12, 1929. Under Breton's name were printed the responses of Suzanne Muzard, Breton merely adding as a postscript, 'No response other than this could be taken to be mine', p.71.

14 André Breton, *Conversations: The Autobiography of Surrealism*, with André Parinaud and others, trans. Mark Polizotti, New York 1993, p.107.

15 Breton, *Mad Love,* pp.24–5.

16 Ibid., p.87.

17 Quoted in Annie Le Brun, *Sade: A Sudden Abyss*, trans. Camille Nash, San Francisco 1990, p.45.

18 Sigmund Freud, 'Beyond the Pleasure Principle' (1920), reprinted in *On Metapsychology: The Theory of Psychoanalysis*, ed. Angela Richards, trans. James Strachey, London 1991, pp.275–6.

19 Ibid., p.337. For a fuller discussion of these terms, see J. Laplanche and J.-B. Pontalis, *The Language of Psycho-Analysis*, London 1983, especially pp.50–2.

20 Sigmund Freud, *Three Essays on the Theory of Sexuality* (1905), reprinted in *On Sexuality*, ed. Angela Richards, trans. James Strachey, London 1981, p.131.

21 Sigmund Freud, *On the Universal Tendency to Debasement in the Sphere of Love* (1912), in ibid., p.258.

22 Dylan Evans, *An Introductory Dictionary of Lacanian Psychoanalysis*, London 1997, p.37. See note on influence on Lacan and others of the lectures given by Kojève on Hegel in Paris in the 1930s, pp.37–8.

23 See relationship to Hélène Cixous's 'The Laugh of the Medusa' (1975), translated in Elaine Marks and Isabelle de Courtivron (eds.), *New French Feminisms: An Anthology*, Amherst 1980, p.262: 'I don't want a penis to decorate my body with. But I do desire the other for the other, whole and entire, male or female; because living means wanting everything that is, everything that lives, and wanting it alive. Castration? Let others toy with it. What's a desire originating from a lack? A pretty meagre desire.'

24 'Artistic Genesis and Perspective of Surrealism', in André Breton, *Surrealism and Painting*, trans. S. Watson Taylor, New York 1972, p.70.

25 Michel Sanouillet and Elmer Paterson (eds.), *The Essential Writings of Marcel Duchamp*, London 1975, p.74 (modified translation).

26 André Breton, 'Phare de *La Mariée*', *Minotaure*, no.6, winter 1935, pp.45–9.

27 André Breton, *Manifestoes of Surrealism*, trans. Richard Seaver and Helen R. Lane, Ann Arbor 1969, p.21.

28 Ibid., p.37.

29 Ibid., p.123–4.

30 Breton, *Conversations*, p.111.

31 Marie-Claire Dumas (ed.), *Desnos oeuvres*, Paris 1999, p.913.

32 Haim Finkelstein (ed.), *The Collected Writings of Salvador Dalí*, Cambridge 1998, p.165.

33 The full verse has been translated by Margit Rowell as follows: 'A star fondles a black woman's breast / a snail licks a thousand tits / gushing the pope-king's blue piss / so be it.' (*Joan Miró: Selected Writings and Interviews*, London 1987, p.124).

34 'I consider perversion and vice to be the most revolutionary forms of thought and activity, the way that I consider love as the only attitude worthy of man's life' ('L'Amour', 1930, in Finkelstein 1998, p.191).

35 'Since the kernel of desire comes before being, hunger before the self, the self before the other – the experience of Narcissus will feed the image of You'. 'It is certain that the question has not been posed seriously enough until recently to what extent the image of the desired woman might be predetermined by the image of the man who desires, thus, ultimately by a series of projections the phallus', in *Obliques*, special issue, Paris 1975, pp.126, 127.

36 Quoted in Sue Taylor, *Hans Bellmer: The Anatomy of Anxiety*, Boston 2001, p.182. The text was first published in 'L'Anatomie de l'amour', in *Le Surréalisme en 1947*, exh. cat., Galerie Maeght, Paris 1947, p.111.

37 Salvador Dalí, 'The Object as Revealed in Surrealist Experiment' (1932), in Finkelstein 1998, p.239: 'At the limit of the emerging cultivation of desire, we seem to be attracted by a new body, we perceive the existence of a thousand bodies of objects we feel we have forgotten.' Dalí cited Feuerbach's concept of the object as being 'primitively only the concept of second self': 'The concept of the object is usually produced with the help of the "you" which is the "objective self"'. Dalí continued: 'Accordingly, it must be the "you" which acts as "medium of communication" and it may be asked if what at the present moment

haunts surrealism is not the possible body, which can be incarnated in this communication.'

38 Benjamin Péret, 'Wink', from *Je Sublime*, in Mary Ann Caws (ed.), *Surrealist Love Poems*, London 2001.

39 Jindřich Štyrský, *Emilie Comes to Me in a Dream*, exh. cat., Ubu Gallery, New York 1997, p.5.

40 Ibid., p.34.

41 Georges Bataille, 'Le Langage des fleurs', *Documents*, vol.1, no.3, June 1929, pp.160–4.

42 Georges Bataille, *Eroticism: Death and Sensuality*, trans. Mary Dalwood, San Francisco 1986; see pp.11, 15, 20, 21.

43 André Breton, 'Aux Exposants, aux visiteurs', in *EROS* exh. cat., 1959, p.6.

44 Finkelstein 1998, p.136 (modified translation).

45 Max Ernst, 'Danger de pollution', in *Le Surréalisme au service de la révolution*, no.2, Oct. 1930, translated in Marcel Jean (ed.), *The Autobiography of Surrealism*, New York 1980, pp.264–5.

46 Letter dated 30 March 1929, in Paul Eluard, *Lettres à Gala (1924–1948)*, Paris 1984, pp.54–5.

47 Leon Trotsky, *Culture and Socialism and a Manifesto: Art and Revolution*, New York 1975, p.31.

48 André Breton, *Arcane 17*, New York 1945, p.89.

49 Sarane Alexandrian, 'Amour, révolte et poésie', in *Le Surréalisme en 1947*, exh.cat., 1947, p.101.

50 Breton, *Conversations*, p.222.

51 André Breton, *Clair de Terre*, (1923), Paris 1966, pp.72–3.

52 André Breton, *Surrealism and Painting*, trans. Simon Watson Taylor, London 1972, pp.407–8 (modified translation).

53 Simone de Beauvoir, *A History of Sex*, I, London 1961, p.261.

54 André Breton, 'Qu'est-ce que le surréalisme?', in Breton, *Oeuvres complètes*, II, 1992, p.261.

55 Breton, *Arcane 17*, p.86. The legal position of women in France was severely circumscribed. The government rejected proposals for women's suffrage in 1919, 1929, 1932 and 1935. French women were to receive the vote only in April 1944, partly in recompense for their war efforts. Married women became legally responsible in 1938, but nonetheless the signature of their husbands was required for many minor bureaucratic formalities for many years thereafter.

56 André Breton, *Arcanum 17*, trans. Zack Rogow, Toronto 1994, p.64.

57 Alice Paalen, *A même la terre*, Paris 1936, pp.7–8.

58 Breton, *Conversations*, p.176.

59 Ruth Brandon, *Surreal Lives: The Surrealists 1917–1945*, London 1999, p.195.

THE OMNIPOTENCE OF DESIRE: SURREALISM, PSYCHOANALYSIS AND HYSTERIA
David Lomas

1 André Breton, *Qu'est-ce que le surréalisme?*, Brussels 1934, p.25.

2 André Breton, *Nadja* (1928), in *Oeuvres complètes*, ed. Marguerite Bonnet, I, Paris 1988, p.753.

3 Louis Aragon, 'The Challenge to Painting' (1930), in Pontus Hulten (ed.), *The Surrealists Look at Art*, trans. Michael Palmer and Norma Cole, Venice, Calif. 1990, p.50 (modified translation).

4 André Breton, 'Le Message automatique', *Minotaure*, nos.3–4, 12 Dec. 1933, p.57.

5 Sigmund Freud, 'L'Hérédité et l'étiologie des névroses', *Revue neurologique*, vol.4, no.6, 30 March 1896, pp.161–9; 'Heredity and the Aetiology of the Neuroses' (1896), in *The Standard Edition of the Complete Psychological Works of Sigmund Freud*, ed. James Strachey, 24 vols., London 1953–74, III, p.141.

6 Pierre Janet, *L'Etat mental des hystériques*, 2nd ed., Paris 1911, p.185.

7 Pierre Janet, 'Psycho-analyse', *The Journal of Abnormal Psychology*, vol.9, 1914–15, p.176.

8 This brings to mind Freud's remark that: 'A negative judgement is the intellectual substitute for repression; its "no" is the hallmark of repression, a certificate of origin – like, let us say, "Made in Germany".'. Sigmund Freud, 'Negation' (1925), *Pelican Freud Library*, 15 vols., Harmondsworth 1973–87, XI, p.438. For a comprehensive round up of views at the time about psychoanalysis, see 'Freud et la psychanalyse', special issue of *Le Disque vert* (1924) (Paris/Brussels).

9 Sigmund Freud, 'An Autobiographical Study (1925 [1924])', *Standard Edition*, XX, p.13.

10 Sigmund Freud, 'On the History of the Psycho-Analytic Movement' (1914), *Standard Edition*, XIV, p.14.

11 J.-K. Huysmans, *Against Nature*, trans. Robert Baldick, Harmondsworth 1959, p.66.

12 Sigmund Freud, 'Charcot' (1893), *Standard Edition*, III, p.19.

13 Sigmund Freud, *Introductory Lectures on Psychoanalysis* (1916–17), *Pelican Freud Library*, I, pp.497, 498.

14 The source of their information may have been Jules Clarétie's fictionalised reminiscences in *Les Amours d'un interne* (1881). Louis Aragon and André Breton, 'Le Cinquantenaire de l'hystérie, 1878–1928', *La Révolution surréaliste*, no.11, 15 March 1928, pp.20–2.

15 André Breton, *Mad Love*, trans. Mary Ann Caws, Lincoln, Nebr. and London 1987, p.37.

16 That Breton was *au courant* with this mainstream medical opinion is shown by his remark that 'Charcot had not counted on the gift for simulation of his subjects'. Breton, *Oeuvres complètes*, I, 1988, p.243.

17 For a fascinating study of this question, see Mark Micale, 'On the "Disappearance" of Hysteria: A Study in the Clinical Deconstruction of a Diagnosis', *Isis*, no.84, 1993, pp.496–526.

18 Breton, *Oeuvres complètes*, I, 1988, p.243.

19 Sigmund Freud, 'My Views on the Part Played by Sexuality in the Aetiology of the Neuroses', *Pelican Freud Library*, X, pp.71–81.

20 Breton, *Mad Love*, pp.24–5 (modified translation).

21 Sigmund Freud, 'Delusions and Dreams in Jensen's *Gradiva*' (1907 [1906]), *Pelican Freud Library*, XIV, pp.33–118.

22 Sigmund Freud, 'Three Essays on the Theory of Sexuality' (1905), *Pelican Freud Library*, VII, p.75.

23 Salvador Dalí, 'L'Amour' (1930), in *La Femme visible*, Paris 1930.

24 Georges Bataille, 'Dalí hurle avec Sade', in *Oeuvres complètes*, II, Paris 1970, p.113. My claim that for Breton the censorship plays a necessary part in the elaboration of the poetic image is borne out by his remarks concerning Dalí in *Les Vases communicants*. See André Breton, *Communicating Vessels*, trans. Mary Ann Caws and Geoffrey T. Harris, Lincoln, Nebr. 1990, p.55.

25 The crucial issue of censorship flared at the time of Dalí's expulsion from the surrealist group. It was also at issue in Breton's correspondence with Freud (reprinted in Breton, *Communicating Vessels*, pp.149–55), which concerns certain alleged omissions of Freud's in *The Interpretation of Dreams* (1900), *Pelican Freud Library*, IX.

26 Aragon and Breton, 'Le Cinquantenaire de l'hystérie', p.22.

27 See Sigmund Freud, 'On the History of the Psycho-Analytic Movement' (1914), *Standard Edition*, XIV, pp.17–18.

28 Max Ernst, *A Little Girl Dreams of Taking the Veil*, trans. Dorothea

Tanning, New York 1982. See also my book, *The Haunted Self: Surrealism, Psychoanalysis, Subjectivity*, New Haven and London 2000, pp.75–93.

29 Freud, 'Extracts from the Fleiss Papers' (Letter 61), *Standard Edition*, I, p.247.

30 Freud, *The Interpretation of Dreams*, pp.696–7.

31 Max Ernst, 'Danger de pollution', *Le Surréalisme au service de la révolution*, no.3, Dec. 1931, p.22.

32 See Fiona Bradley, 'An Oxymoronic Encounter of Surrealism and Catholicism', unpublished PhD thesis, Courtauld Institute of Art, London, 1995.

33 Pierre Mabille, *Thérèse de Lisieux* (1937), Paris 1975, p.45.

34 Jan Goldstein, 'The Hysteria Diagnosis and the Politics of Anti-clericalism in Late Nineteenth-century France', *Journal of Modern History,* no.54, June 1982, pp.209–39. See also Léon Daudet, *Devant la douleur, souvenirs des milieux littéraires, politiques, artistiques et médicaux de 1880 à 1905*, Paris 1915.

35 Pierre Janet, *De l'angoisse à l'extase*, Paris 1926.

36 The situation is complicated by the fact that Freud's retraction of the seduction theory – his belief in the reality of the abuse – was nowhere near as clear-cut as it is presented in the official history of psychoanalysis. As late as 1917, for example, he writes: 'Phantasies of being seduced are of particular interest, because so often they are not phantasies but real memories.' Freud, *Introductory Lectures on Psychoanalysis*, p.417.

37 André Breton, René Char, Paul Eluard et al., *Violette Nozières*, Brussels 1933. The collage that Ernst contributed to this pamphlet harks back to the bird symbolism and the associated theme of sexual menace in *Two Children Are Threatened by a*

Nightingale of 1924 (fig.50). Elizabeth Legge's subtle analysis of the latter, relating it to the case of Dora, establishes that the threatening nightingale is a father substitute, and that the threat he poses is one of rape. See Elizabeth Legge, *Max Ernst: The Psychoanalytic Sources*, Ann Arbor, Mich. and London 1989, pp.76–84.

38 Louis Aragon and André Breton, 'Le Cinquantenaire de l'hystérie, 1878–1928', *La Révolution surréaliste*, no.11, 15 March 1928, pp.20–2.

39 Bourneville and P. Regnard (eds.), *Iconographie photographique de la Salpêtrière* Paris 1878, II, pp.126–7.

40 Freud, *The Interpretation of Dreams*, pp.198–9.

41 Sigmund Freud, letter to André Breton, 8 Dec. 1937. The letter is reproduced without translation in the literary review *Cahiers G.L.M.*, no.7, March 1938, special issue 'Le Trajectoire du rêve', edited by André Breton.

42 Louis Aragon, 'Max Ernst, peintre des illusions' (1923), in *Écrits sur l'art moderne* Paris 1981, p.12.

43 Werner Spies, 'An Open-ended Oeuvre', preface to William Camfield, *Max Ernst: Dada and the Dawn of Surrealism*, Munich 1993, p.27.

44 Uwe M. Schneede, 'Sightless Vision: Notes on the Iconography of Surrealism', in *Max Ernst*, exh. cat., Tate Gallery, London 1991, p.351.

45 Theodor Adorno, 'Looking Back on Surrealism', in Irving Howe (ed.), *Literary Modernism*, Greenwich, Conn. 1967, pp.220–4.

46 Sigmund Freud, 'The Ego and the Id' (1923), *Pelican Freud Library*, XI, p.353.

47 Dated 26 December 1932. Reprinted in Breton, *Communicating Vessels*, p.152.

48 Jacques Lacan, *The Four Fundamental Concepts of Psycho-*

Analysis, trans. Alan Sheridan, Harmondsworth 1979, p.89.

49 'Le desire, oui, *toujours.*' André Breton, *Entretiens*, Paris 1969, p.252.

PRIÈRE DE FRÔLER: THE TOUCH IN SURREALISM
Julia Kelly

1 André Breton, 'Equation de l'objet trouvé', *Documents 34*, no.1, June 1934, and *L'Amour fou*, Paris 1937.

2 Andre Breton, *Mad Love*, trans. Mary Ann Caws, Lincoln, Nebr. and London 1987, p.26. Further references will be from this translation.

3 Breton, *Mad Love*, p.36. The ambiguity to which Breton refers was thought to be present in Perrault's story itself, but a more recent edition of the tale suggests that Perrault was unlikely to intend a *fur* slipper. See the notes of Gilbert Rouger in Perrault, *Contes*, Paris 1967, pp.153–6.

4 Breton, *Mad Love*, p.25.

5 Breton, *Les Vases communicants*, Paris, 1955, p.129 (my translation).

6 Comte de Lautréamont, *Maldoror and Poems*, Harmondsworth 1978.

7 Ibid., p.67.

8 As in Dora's dream of the 'Schmuckkästchen' (jewellery box) in Freud's 'Fragment of a Analysis of a Case of Hysteria' (1900–1) in the *Standard Edition*, VII, p.91.

9 Paul Scott analyses Delvaux's use of 'erotic' compositional techniques in *Paul Delvaux: Surrealizing the Nude*, London 1992, chap.6, 'Loving Perspectives'.

10 On Cornell's urban wandering as a way of mapping the bodies of the unattainable women he revered, see Jodi Hauptmann, *Joseph Cornell, Stargazing in the Cinema*, New Haven and London 1999, chap.5.

11 André Breton, *Entretiens 1913–1952*, Paris 1952, p.135.

12 Charles Baudelaire, 'The Painter of Modern Life' in *Writings on Art and Artists*, ed. and trans. P.E. Charvet, Cambridge 1972, pp.390–435.

13 Breton, *Nadja* (1928), Paris 1964.

14 Ibid., p.153.

15 Ibid., p.136.

16 Ibid., p.115. The motif of the red hand is taken from Emil Zola's *Nana* (1880), where a glove sign like a bleeding hand prefigures the courtesan's eventual decline.

17 Margaret Cohen reads Breton's evocations of prostitutes as a classic case of repression, *Profane Illumination*, Berkeley, Calif. and London 1993, p.168.

18 Breton, *Les Vases communicants*, p.120.

19 Ibid., pp. 89–90.

20 Ibid., p.95.

21 Ibid., p.123.

22 Louis Aragon, *Le Paysan de Paris* (1926); *Paris Peasant*, trans. Simon Watson Taylor, London 1987.

23 Ibid., p.66.

24 Ibid., p.65.

25 Ibid., pp.52–3, 57–8. The lambda is at the base of the skull at the back of the head.

26 Ibid., p.37.

27 Ibid., p.47.

28 Ibid., p.117.

29 Aragon, *Le Con d'Irène*, in *Oeuvres romansques complètes*, I, Paris 1997, p.446.

30 Recalled in his article 'The Dream, the Sphinx and the Death of T.', *Labyrinthe*, nos.22–3, Dec. 1946, pp.12–13.

31 Evoked in Brassaï's *The Secret Paris of the 30s*, London 1976.

32 On the role of the death drive in Breton's analysis of this work, see Hal Foster, *Compulsive Beauty*, Cambridge, Mass. 1993, pp.36–46.

ANAMORHIC LOVE: THE SURREALIST POETRY OF DESIRE
Katharine Conley

1 In both the first and second *Manifestoes* of surrealism, Breton advocates the ideal of overcoming opposites, the 'old antinomies,' and of resolving them into a desirable synthesis, which, in the 1930s, he would call a 'sublime point'. See *Manifeste de surréalisme* (1924) and *Second Manifeste du surréalisme* (1929) in André Breton, *Oeuvres complètes*, ed. Marguerite Bonnet, I, Paris 1988, p.319, p.781; and *L'Amour fou* (1937) in *Oeuvres complètes*, II, 1992, p.780. See this edition for more on Breton.

2 There also exist anamorphic works, such as as Erhard Schön's *Vexierbild* (1525), that were entirely distorted. Yet these works also combine two in one – both a completely distorted image and a clear one, depending on the viewer's perspective.

3 Jurgis Baltrusaitis, *Anamorphoses*, 1st ed., Paris 1969; Paris 1996, p.147. All translations in this essay are mine.

4 This double perception of the same twofold reality may also be compared with 'reversible images' used in psychology to explain perception. The drawing of an urn that also looks like two facing profiles is one example. Salvador Dalí often used reversible images, which he called 'paranoiac'.

5 Paul Eluard, *Oeuvres complètes*, Paris, I, 1968, p.110. For more on Eluard see Jean-Charles Gâteau, *Paul Eluard*, Paris 1988.

6 See my *Automatic Woman: The Representation of Woman in Surrealism*, Lincoln, Nebr. 1996 for more on the psychic risks in surrealism, particularly with regard to women.

7 Eluard, *Oeuvres complètes*, I, 1968, p.106.

8 Robert Desnos, 'Si tu savais', *Oeuvres*, Paris 1999, p.541. For more on Desnos see Marie-Claire Dumas, *Robert Desnos ou l'exploration des limites*, Paris 1980.

9 See Rosalind Krauss, 'Magnetic Fields: The Structure,' in Rosalind Krauss and Margit Rowell, *Magnetic Fields*, New York 1972, pp.11–38.

10 Ibid., p.12.

11 Later, with the *Constellations*, Miró created a new language using graphic images to create a kind of calligraphy, in what Richard Stamelman calls an 'erotography' whereby 'desire presents itself as writing and writing becomes desire'. See Richard Stamelman, 'La Courbe sans fin du désir: Les *Constellations* de Joan Miró et André Breton', in Michel Murat (ed.), *L'Herne: André Breton*, Paris 1998, pp.313–27.

12 Robert Desnos, *Corps et biens*, Paris 1968, pp.31–46. Duchamp created the alter ego Rrose Sélavy ('éros, c'est la vie' or 'éros, that's life') for himself. Desnos acknowledged his appropriation of Duchamp's alter ego in the short poem 'Rrose Sélavy connaît bien le marchand de sel' (Rrose Sélavy knows well the merchant of salt). The syllables of *Marchand de sel* sounds like Marcel Duchamp as if said circularly, starting with the first syllable and then working backwards from the last.

13 Breton, *Oeuvres complètes*, I, Paris 1988, p.286.

14 See *L'Homme jasmin*, trans. Ruth Henry and Robert Valançay, Paris 1971, p.23–7. Zürn also published a collection of anagrams in 1954, *Hexentexte*.

15 Ibid., pp.89–92.

16 Cited in Peter Webb with Robert Short, *Hans Bellmer*, London 1985, p.38.

17 Arguing that *étoile* is derived from *estela*, Rowell reformulates Miró's poem: 'e(s)toiles en des sexes d'escargot': see Margit Rowell, 'The Magnetic Fields: The Poetics', in Krauss and Rowell 1972, pp.39–69. Juana Sabadell-Nieto clarified for me that *star* is simply *estel* in Miró's native Catalan.

18 Michel Foucault, *Ceci n'est pas une pipe*, Paris 1973, p.21.

19 Foucault makes this argument about Apollinaire's calligrams, ibid., p.27.

20 See my article, 'La Nature Double des yeux (regardés/regardants) de la femme dans le surréalisme,' in Georgiana Colvile and Katharine Conley (eds.), *La Femme s'entête*, Paris 1998, pp.71–89, for more on surrealist women's participation in what I call the surrealist 'conversation'. See also Renée Riese Hubert, *Magnifying Mirrors, Women, Surrealism, and Partnership*, Lincoln, Nebr. 1994.

21 Michael Riffaterre, 'Anamorphose,' in Pierre R. Léon and Henri Mitterand (eds.), *L'Analyse du discours*, Montreal 1976, p.104.

22 Breton, *Oeuvres complètes*, I, 1988, pp.187–8.

23 Lamba formally studied art between 1926 and 1929 and made her first pastels in 1927. See Fabrice Maze, *Jacqueline Lamba*, Paris 1998. See also Salomon Grimberg, Jacqueline Lamba, New York 2001.

24 Riffaterre 1976, p.104.

25 Desnos, *Oeuvres*, Paris 1999, p.539.

26 Eluard, *Oeuvres complètes*, II, 1968, p.9.

27 The myth is described in Plato, *Symposium* (193a) in *The Collected Dialogues*, eds. Edith Hamilton and Huntington Cairns, Printceton, New Jersey, 1961, pp.526–74. Breton makes explicit reference to it in 'On Surrealism in its Living Works', in *Manifestoes of Surrealism*, trans. Richard Seaver and Helen R. Lane, Ann Arbor 1969, p.302.

28 In Baltrusaitis 1996, p.137.

29 Joyce Mansour, 'Cris', *Oeuvres complètes*, Arles 1991, pp.307–27. For more on Mansour's poetry see my 'Femme-amphore de Joyce Mansour,' in Marc Kobert, Irène Fenoglio and Daniel Lançon (eds.), *Entre nil et sable*, Paris 1999, pp.205–13.

LOVE OF BOOKS: LOVE BOOKS
Vincent Gille

1 André Breton, 'Gradiva', presentation text for the Librairie-Galerie Gradiva, 1937, reprinted in *La Clé des champs*, Paris 1967, p.32, and in André Breton, *Oeuvres complètes*, ed. Marguerite Bonnet, III, Paris 1999, p.676.

2 André Breton, 'André Breton n'écrira plus', interview with Roger Vitrac, *Le Journal du Peuple*, 7 April 1923, reprinted in Breton, *Oeuvres complètes*, I, 1988, pp.1214–15. It is also worth mentioning here the flier of 1924 which proclaimed 'Surrealism is the repudiation of writing'; see *Tracts surréalistes et déclarations collectives*, ed. José Pierre, I, Paris 1980, p.32.

3 Breton, Aragon and Eluard were and always would be passionate lovers of poetry and great readers. As Breton recalled about Aragon on the occasion of their first meeting, 'he really has read everything'. One of Eluard's first friends was the printer and bookbinder Aristide Jules Gonon, to whom as early as 1914 he entrusted most of the books in his library, and who printed his first book (see Paul Eluard, *Lettres de jeunesse*, Paris 1952).

4 This was the meaning, redolent with pique as much as mockery, of the enquiry 'Why do you write?' launched by the journal *Littérature* (nos.9–12, Nov. 1919–Feb. 1920). The *Littérature* group also undertook the major job of overhauling a list of desirable and and undesirable classic

books, winnowing severely, and pressing the case of Lautréamont and Rimbaud, some of whose unpublished writings they printed in the review (see 'Liquidation' in *Littérature*, no.8, March 1921). A similar aspiration lay behind the work carried out by Aragon and Breton to enrich Jacques Doucet's library: see François Chapon, *Mystère et splendeur de Jacques Doucet*, Paris 1984, pp.262–80.

5 André Breton, 'Le Surréalisme et la peinture' (1965) in André Breton, *Surrealism and Painting*, trans. S. Watson Taylor, New York 1972, p.4.

6 André Breton, 'Signe ascendant', *Oeuvres complètes*, III, 1999, p.766.

7 André Breton, 'Manifeste du surréalisme' (1924), *Oeuvres complètes*, I, 1988, p.328.

8 André Breton, interview with Roger Vitrac, *Oeuvres complètes*, I, 1988, p.1215.

9 André Breton, 'Les Mots sans rides', first published in *Litterature*, no.7, Dec. 1922, reprinted in *Les Pas perdus* (1924); see *Oeuvres complètes*, I, 1988, p.286.

10 André Breton, 'Poisson soluble' (1924)**,** *Oeuvres complètes*, I, 1988, p.359.

11 André Breton, 'Sur la route de San Romano', in *Poèmes*, Paris 1949, reprinted in *Oeuvres complètes*, III, 1999, p.419. On this subject see also my essay, 'Si vous aimez l'amour' in *Le Surréalisme et l'amour*, exh. cat., Pavillon des Arts, Paris 1997, pp.22–5.

12 Even if the difference was sometimes rather slight: there were texts the manuscripts of which were sold, sometimes before they were written.

13 Thus, Eyre de Lanux is thought to be the 'Dame des Buttes Chaumont' in *Le Paysan de Paris*, Nancy Cunard was the person for whom he wrote the 'Poem to Shout Among the Ruins' and Denise Lévy was the dedicatee of *Le Con d'Irène* (see Pierre Daix, *Aragon*, Paris 1994).

14 André Breton, *Mad Love*, trans. Mary Ann Caws, Lincoln, Nebr. and London 1987, pp.24–5; see *Oeuvres complètes*, II, 1992, p.696 (modified translation).

15 Ibid. See *Oeuvres complètes*, II, 1992, p.744.

16 See for example question IV in the enquiry about love in *La Révolution surréaliste,* no.12, 15 Dec. 1929, p.65: 'Do you believe in the victory of admirable love over sordid life or of sordid life over admirable love?'

17 The beginning of *Le Paysan de Paris* consists of the systematic description, shop by shop, of the Passage de l'Opéra, inscriptions, advertisments and ornamental signwriting included. See, too, Breton's Preface to the second edition of *Nadja*, in which he speaks of a 'document *taken from life*'. Similarly Luis Buñuel's *L'Age d'or* lays claim to being a documentary; on this question see Ado Kyrou, *Le Surréalisme au cinéma*, Paris 1985, p.212.

18 Max Ernst, 'Au-delà de la peinture', *Ecritures*, Paris 1971, p.266.

19 As Eluard emphasised in his preface to *Les Mains libres* (drawings by Man Ray which he lovingly illustrated with poems), 'Man Ray draws in order to be loved'.

20 André Breton and Paul Eluard, 'Note about our collaboration', preface to the Japanese-language edition of *L'Immaculée Conception*, published in *Les Cahiers d'Art*, nos.5–6, 1935; see Breton, *Oeuvres complètes*, II, 1992, p.564.

21 See especially Renée Riese Hubert, *Surrealism and the Book*, Berkeley, Calif. and London, and *Mélusine*, no.4, 'Le Livre surréaliste', Paris 1982.

22 Surrealist games were one of the most striking examples of this, whether it was a matter of the *cadavre exquis*, drawn or written, and its by-products, or the game *l'un dans l'autre* as practised in the 1950s; see *Les Jeux surréalistes*, with introduction and notes by Emmanuel Garrigues, Paris 1995.

23 Paul Eluard, 'Physique de la poésie', *Minotaure*, no.6, Feb. 1933, p.12.

24 André Masson, in Jean-Paul Clébert, *Mythologie d'André Masson*, Geneva 1971, p.97.

25 *1929* comprised song-poems written by Louis Aragon and Benjamin Péret. Péret's poems, taken from *Rouilles encagees*, an erotic novel written, but not published, in 1923 (see above), mimic the form of prayers or religious hymms. The book was illustrated with four photographs of sexual acts by Man Ray, and had been hastily produced in order to help with the costs of a special edition of the journal/ review *Variétés*, issued in June 1929 and devoted to surrealism. Particularly noteworthy for this period, and for a publication of this kind, is the fact that it was published with the real names of the three authors.

26 Publisher's note on the occasion of the publication of *Rouilles encagées* by Satyremont [Benjamin Péret], Paris 1954, quoted in Benjamin Péret, *Oeuvres complètes*, Paris 1987, IV, p.295. Péret's text, written in 1923, should have been published clandestinely in the same year, but the sections which had already been printed were seized at the printer's premises during a police raid. The same thing occurred in 1947 with an edition of *Justine* by the Marquis de Sade illustrated by Bellmer, of which consequently only a few copies remain. (The text and illustrations were eventually published by Le Soleil Noir in 1950).

27 André Breton, *Nadja*, 'Avant-dire' (1962 ed.).

28 This was the case, for example, with the poems in *Nuits partagées* by Paul Eluard. They were first published in *Le Surréalisme au service de la révolution*, no.3, Dec. 1931, then included in the collection *La Vie immédiate* published by Editions Gallimard in 1932, before being reprinted separately, accompanied by a drawing by Dalí, under the G.L.M. imprint in 1935.

29 A print run of 3,000 copies was announced for no.12 of *La Révolution surréaliste*. On the financial management of periodicals, see, for example, Eric Losfeld's testimony in *Endetté comme une mûle*, Paris 1979, and on the economics of publishing, see the evidence of José Corti in *Souvenirs désordonnés (...–1965)*, Paris 1983.

30 A short while before giving the interview in which he announced his intention of never writing again, Breton had signed with Gallimard the contract to publish *Les Pas Perdus*.

31 Jacques Doucet was to terminate his collaboration with Breton and Aragon over the pamphlet entitled 'Un cadavre', written by the surrealists in 1924 after the death of Anatole France, in which they hurled violent abuse at this famous figure in French literature: 'With France', Breton wrote, 'a little human servility departs the scene, and good riddance.'

32 Louis Aragon, 'Le Surréalisme et le devenir révolutionnaire', in *Le Surréalisme au service de la révolution*, no.3, 1931, p.3. Aragon was referring here to the difficulties experienced by Breton over his divorce from his first wife and over his complicated affair with Suzanne Muzard, to the refusal of the Prefecture of Police

in Paris to issue Paul Eluard with a passport to enable him to travel to Spain to see Gala and Dalí, and to the scandals provoked by the release of *L'Age d'or*.

33 Letter from Paul Eluard to E.L.T. Mesens, 17 Jan. 1934, quoted in a later edition of *Violette Nozières*, Paris 1991, p.57.

34 In all, 150 copies of *Le Con d'Irène*, 134 copies of the first edition of *Histoire de l'œil*, forty-five copies of *Madame Edwarda* and 300 copies (of which half were seized) of *Le Grand Ordinaire* were printed.

35 Four hundred copies of *Les 120 Journées de Sodome* were offered on a subscription basis by the Société du Roman Philosophique, a body set up for the purpose of publishing the works of the Marquis de Sade. This was the first time that the work had been edited from the original manuscript, a task carried out by Maurice Heine between 1931 and 1935. However, too few collectors signed up to allow the book to be published.

36 See Jean-Jacques Pauvert, *Anthologie historique des lectures érotiques*, Paris 1995, especially vols.III and IV.

37 On the Editions Surréalistes, see Georges Sebbag, *Les Editions Surréalistes*, Paris 1993.

38 The French term for 'lead copies' is 'tirages "de tête"'. In 1930 the sum of 3,000 francs amounted to approximately 8,000 francs in today's money (*c*.£800 or *c*.$1,100). By way of comparison, in 1934 the average salary of a French civil servant at the bottom of the scale was 12,500 francs per annum, that is approximately 45,000 francs (or *c*.£4,500 or *c*.$6,300) today.

39 Whilst the practice of producing 'lead copies' was relatively widespread at the time, the surrealists considerably extended its use.

40 Gilbert Lély produced in 1942, a clandestine handmade edition – twelve copies in all – of his book *Ma Civilisation.* The pages were typed and the reproductions pasted in. The entire verse collection was censored by the Vichy régime, as it was indeed later under General de Gaulle's administration. In 1927 Aragon himself printed, on the press owned by Nancy Cunard, in an edition of twenty-five copies, his poem 'Voyageur', reprinted in *La Grande Gaîté*. In 1944 Ghérasim Luca put together the 'livre-objet' *Quantitativement aimée*, an illustrated text made up of 944 different kinds of handwriting. Similarly, Jindřich Heisler created three 'livres-objets-poèmes' for Toyen, Péret and Breton in 1950 and 1951. On Breton's 'poèmes-objets', see Jean-Michel Goutier, *Je vois, j'imagine*, Paris 1991.

41 André Breton, letter to Frederick Kiesler, 2 Dec. 1946, quoted in *André Breton: La Beauté convulsive*, exh. cat., Centre Georges Pompidou, Paris 1991, p.395.

42 As the dummy-maker Pierre Faucheux, who created a number of books with Breton, put it, 'the industrial book is pornography compared with the surrealist act' (*Mélusine*, no.4, 1982).

43 Benjamin Péret, 'Livres-objets par Georges Hugnet', *Minotaure*, no.10, Winter 1937, p.40.

SURREALISM, MALE-FEMALE
Dawn Ades

1 Xavière Gauthier, *Surréalisme et sexualité,* Paris 1971, was the first full-scale attack on the movement's sexism. See also Mary Ann Caws, Rudolf Kuenzli and Gwen Raaberg, *Surrealism and Women,* Cambridge, Mass., and London 1991.

2 Toyen, response to questionnaire about the situation of painting, in *Médium,* no.4, Paris 1955, quoted in Penelope Rosemont (ed.), *Surrealist Women,* Austin, Texas 1998, p.81.

3 The seminal study was Whitney Chadwick, *Women Artists and the Surrealist Movement*, London 1985. See also Whitney Chadwick (ed.), *Mirror Images: Women, Surrealism and Self-Representation*, Cambridge, Mass. and London 1998. The disappearance of surrealist women (except as muses and lovers) from the movement's history has much to do with the selective nature of that history as it was written in the movement's latter years. Penelope Rosemont (Rosemont 1998), using journals, catalogues etc., totted up 300 women who had taken part at some point in the surrealist movement. Ninety-seven were included in her anthology.

Many exhibitions about surrealism have overlooked women surrealists in spite of the fact that they were, from the 1930s and increasingly in the postwar years, highly visible in surrealism's own exhibitions, reviews and as signatories of manifestoes. For example, in *Dada and Surrealist Art*, curated by William Rubin at the Museum of Modern Art in New York (1968), only two women (Hannah Höch and Meret Oppenheim) were included, while *L'Exposition Internationale du surréalisme* (*EROS*), of 1959–60, had included sixteen. This was not simply a matter of a time-lag, a tendency to dwell on the 'heroic' period of the 1920s and the achievements of such artists as André Masson, Joan Miró and Max Ernst. Rubin's frank intention was to forge a modernist identity for surrealism, emphasising his conviction that surrealist painting was of fundamental importance for Abstract Expressionism by ending his exhibition with the work of the lyrical painter Arshile Gorky. Forcing a narrow trajectory through the multitudinous products of surrealism and those areas of activity in which women had played a prominent part, such as photography and the surrealist object, the exhibition passed the baton to postwar painting.

The greater prominence of women in surrealism's later phase has also been attributed to the eagerness of the older males 'to welcome young women like Joyce Mansour, Nelly Kaplan, or Annie Le Brun' – they brought new blood at a time when the young male turks of the avant-garde were founding their own alternatives to surrealism such as Situationism and *Tel Quel* (Susan Rubin Suleiman, *Subversive Intent: Gender, Politics and the Avant-Garde*, Cambridge, Mass. 1990, p.32). As attractive disciples of a second or even third wave of surrealism, they were, according to this argument, only tolerated by a movement in decline, but had been allowed no voice in its founding and heroic phase in the 1920s. Susan Rubin Suleiman drew the conclusion that if women want to be part of an avant-garde movement they should found it themselves.

4 Nora Mitrani, 'Des esclaves des suffragettes du fouet', *Le Surréalisme, même*, no.3, Autumn 1957, p.60.

5 Dorothea Tanning, *Birthday*, San Francisco 1986, p.177.

6 Leonora Carrington, in Chadwick 1985, p.105.

7 Marie-Claire Barnet, *La Femme cent sexes ou les genres communicants,* Bern, Berlin, New York, Paris 1998, p.231.

8 André Breton, 'Second Surrealist Manifesto' (1929), in André Breton, *Manifestoes of Surrealism,* trans. Richard Seaver and Helen R. Lane, Ann Arbor 1969, p.180.

9 Vladimir Lenin, *De l'emancipa-tion de la femme,* quoted in Gauthier 1971, p.41.

10 André Breton, 'Legitimate Defence', trans. in Maurice Nadeau, *History of Surrealism,* London 1968, p.251. *Recherches sur la Sexualité,* trans. as *Investigating Sex: Surrealist Discussion 1928-1932,* trans. Malcolm Imrie, London 1992.

11 André Breton, *Les Vases communicants,* Paris 1932, p.83. Luis Buñuel's last film, *That Obscure Object of Desire* (1977) explores these ideas.

12 Among the manifold propositions of the Saint-Simonians about equality and female sexuality, some of the most radical were those of Claire Demar who believed in total sexual freedom. She went far beyond the 'New Women' of *La Tribune des femmes* (Women's Tribune) (1832–4), who struggled for social equality and practical, material improvements. Demar, and those who accepted the idea of free love, wore a red ribbon as symbol of their ardent passions, and 'condemned the hypocrisy of men, who sought to 'restrain women within the bounds of Christian morality' formulated by men, while having neither the desire nor the strength to exercise that morality themselves.' See Susan K. Grogan, *French Socialism and Sexual Difference,* London 1992, p.196, p.121.

13 Simone Debout, 'La Plus Belle des Passions', in *L'Exposition Internationnal du surréalisme* (*EROS*), exh. cat., Galerie Daniel Cordier, Paris 1959–60, p.23.

14 Simone de Beauvoir, *The Second Sex* (1949), London 1953, p.267.

15 André Breton, *Arcane 17,* New York 1945, p.62–3.

16 René Passeron, 'Introduction à une érotique révolutionnaire', in *Le Surréalisme révolutionnaire,* no.1, 1948, p.39. Passeron quotes from Rimbaud's letter to Paul

Demeny (1871): 'When the unending servitude of woman is broken, when she lives by and for herself, when man – hitherto abominable – has given her her freedom, she too will be a poet! Woman will discover part of the unknown! Will her world of ideas be different from ours?' *Rimbaud,* trans. Oliver Bernard, London 1962, p.13.

17 Rudolf Kuenzli, 'Surrealism and Misogyny', in Caws, Kuenzli and Raaberg 1991, p.18.

18 André Breton, *Nadja* (1928), trans. R. Howard 1960, London 1999, p.39.

19 André Breton, *Les vases communicants,* p.89.

20 André Breton, *Entretiens 1913–1952,* Paris 1952, p.136.

21 André Breton, *Surrealism and Painting,* trans. Simon Watson Taylor, New York 1972, p.363.

22 Unica Zürn, *The Man of Jasmine* (1977) trans. Malcolm Green, London 1994, p.25.

23 Ibid., p.27. Zürn also recognised Bellmer as the 'man of jasmine', and cut off her hair to make her face resemble his, but it was Henri Michaux, whose initials matched those of Zürn's beloved Herman Melville, who was her conclusive incarnation of the 'man of jasmine'.

24 See Molly Nesbitt, 'Readymade Originals: The Duchamp Model', *October,* no.37, Summer 1986, and Dawn Ades, Neil Cox and David Hopkins, *Marcel Duchamp,* London 1999, chap.4.

25 Paul Haviland '291', *291,* no.1, March 1915.

26 Eleanor Marx and Edward Aveling, *The Woman Question,* London 1886, p.7.

27 David Hopkins, *Marcel Duchamp and Max Ernst: The Bride Shared,* Oxford 1998, p.83.

28 See Eugene Weber, *France: Fin de Siècle,* Cambridge, Mass. 1986, p.93.

29 Jean Schuster, 'Marcel Duchamp vite', *Le Surréalisme, même,* no.2,

Spring 1957, p.143.

30 Marcel Duchamp, BBC Interview 1966.

31 'In the world's structure dream loosens individuality like a bad tooth': Walter Benjamin, 'Surrealism: The Last Snapshot of the European Intelligentsia', 1929, in *Reflections,* New York 1986, p.179.

32 On Rrose Sélavy see also Hopkins 1999; Dawn Ades, 'Duchamp's Masquerades', in Graham Clarke, (ed.), *The Portrait in Photography,* London 1992; Amelia Jones, *Postmodernism and the Engendering of Marcel Duchamp,* Cambridge 1994. Rrose Sélavy also bears more than a passing resemblance to Charlie Chaplin in *A Woman* (1915), where the comedian dresses as a woman to gain access to the girl he loves: see Francis Naumann, 'Marcel Duchamp: A Reconciliation of Opposites' in R. Kuenzli and F. Naumann (eds.), *Marcel Duchamp: Artist of the Century,* Cambridge, Mass. 1989.

33 Victor Margueritte, *The Bachelor Girl* (1922), trans. Hugh Burnaby, London 1923.

34 For a study of gender and culture at the *fin de siècle* see Elaine Showalter, *Sexual Anarchy: Gender and Culture in the fin de siècle,* London 1991.

35 For the full text and analysis see David Hopkins 'Men before the Mirror: Marcel Duchamp, Man Ray and Masculinity', *Art History,* vol.21, no.3, 1998.

36 Ibid.

37 Steven Harris discusses Cahun's object *La Marseillaise est un chant révolutionnaire* in 'Coup d'oeil', *Oxford Art Journal,* vol.24, no.1, Oxford 2001, pp.89–112. He translates *Aveux non avenus* as 'Abrogated Vows' or, less accurately but more pithily, 'Disavowals'.

38 Objections to the discussion of homosexuality were voiced by Breton, Péret and Unik, who

had all recently joined the Communist Party. Breton's dislike of the 'homosexual milieu' was also probably influenced by his antipathy to Jean Cocteau.

39 Carolyn J. Dean, 'Claude Cahun's Double', *Yale French Studies,* no.90, 1996, p.89.

40 Claude Cahun, *Aveux non avenus,* Paris 1930, p.29.

41 Ibid., p.36.

42 Ibid., p.37.

43 Harris challenges the suggestion that argument that Cahun articulates a specifically lesbian desire (Harris 2001).

44 Ibid., p.94.

45 Dean 1996, p.89.

46 Barnet 1998, p.106.

47 Joyce Mansour, 'Le Grand Jamais' (1981) in *Oeuvres complètes,* Arles 1991, p.570.

VIOLATION AND VEILING IN SURREALIST PHOTOGRAPHY: WOMAN AS FETISH, AS SHATTERED OBJECT, AS PHALLUS
Hal Foster

1 See Sigmund Freud, 'Fetishism' (1927), in *On Sexuality,* ed. Angela Richards, trans. James Strachey, Harmondsworth 1977.

2 As one might expect, the fetish is the dominant model of the surrealist object as well. On this score see, among other texts, my *Compulsive Beauty,* Cambridge, Mass. 1993.

3 In its beginnings surrealism was influenced less by Freud than by the French psychiatrist Pierre Janet, from whom André Breton borrowed the notion of 'psychic automatism' in his first *Manifeste de surréalisme* (1924). See *Manifestoes of Surrealism,* trans. Richard Seaver and Helen Lane, Ann Arbor 1972.

4 Hans Bellmer, *Die Puppe,* Karlsruhe 1934, [n.p.].

5 Sigmund Freud, 'Medusa's Head,' in Philip Rieff (ed.), *Sexuality and the Psychology of Love,* New

York 1963, p.212. A similar logic is at work in the first collage-novel by Max Ernst, *La Femme 100 têtes* (1929), in which 100, *cent*, also reads as *sans*, without. The figure of woman as headless phallus enters surrealism through Ernst (e.g. his overpainting *The Pleiades*, 1920).

6 Rosalind Krauss, in Rosalind Krauss and Jane Livingston (eds.), *L'Amour fou: Photography and Surrealism*, exh. cat., Corcoran Gallery, Washington, D.C. 1985, p.86.

7 Freud describes how Hans, frustrated by nonanswers to his questions about birth, took 'the analysis into his own hands' and, in a 'brilliant symptomatic act,' ripped open a doll (*The Sexual Enlightenment of Children*, ed. Philip Rieff [New York 1963], p.123). Earlier, in 'A Philosophy of Toys' (1853), Charles Baudelaire also commented on this desire of children to 'see the soul of their toys' in terms of a 'first metaphysical tendency', the failure of which is 'the beginning of melancholy and gloom' (*The Painter of Modern Life and Other Essays*, ed. Jonathan Mayne [London 1964], pp.202–3). See, too, the text by Rainer Maria Rilke, 'On the Wax Dolls of Lotte Pritzel' (1913–14), the very dolls that inspired Bellmer.

8 Freud, 'Some Psychical Consequences of the Anatomical Distinction between the Sexes' (1925), in *On Sexuality*, p.336.

9 Bellmer, *Die Puppe*. An illustration in this text shows a disembodied eye peering through this mechanism, 'plundering the charms' of the doll.

10 Bellmer quoted from an interview with Peter Webb in Webb, *Hans Bellmer*, London 1985, p.34.

11 Ibid., p.38.

12 Bellmer quoted in *Le Surréalisme en 1947*, exh. cat., Galerie Maeght, Paris 1947.

13 See Freud, 'The Economic Problem of Masochism' (1924).

14 Bellmer quoted in Webb 1985, p.177.

15 Bellmer, *Die Puppe*.

16 Freud, 'On Transformations of Instinct as Exemplified in Anal Erotism' (1917), in *On Sexuality*, p.296.

17 Janine Chasseguet-Smirgel, *Creativity and Perversion*, New York 1984, p.2.

18 Ibid., p.78.

19 For a relevant discussion of a different breaking up of woman-as-fetish see Laura Mulvey, 'A Phantasmagoria of the Female Body: The Work of Cindy Sherman', *New Left Review*, no.188 (July/Aug. 1991). And on the fetish and the part-object in surrealism and beyond, see Mignon Nixon, 'Posing the Phallus,' *October*, no.92, Spring 2000.

20 Hans Bellmer, *Petite anatomie de l'inconscient physique, ou l'Anatomie d'image*, Paris 1957, [n.p.].

21 Roland Barthes, 'La Métaphore de l'oeil', *Critique*, no.196, Aug.–Sept. 1963; translated as a critical epilogue to Georges Bataille, *Story of the Eye*, London 1982, pp.118–27, p.125.

22 Rosalind Krauss, 'Corpus Delicti,' in Krauss and Livingston 1985, p.74. This spatial *un*forming of the body is only one aspect of these images; another, perhaps more important, is their phallic *in*forming, or so I will suggest below. Perhaps the two are not as opposed as one might think.

23 Jacques Lacan, *Feminine Sexuality*, trans. Jacqueline Rose, New York 1985, p.83.

24 Jacques Lacan, 'Desire and the Interpretation of Desire in *Hamlet*' (1959), in *Yale French Studies*, nos.55/56, 1977, p.28.

25 Lacan, *Feminine Sexuality*, p.84. 'Ideal or typical' here means 'heterosexual'.

26 Ibid.

27 See in particular Kaja Silverman, 'The Lacanian Phallus,' *differences* 4.1, 1992, and Jane Gallop, *Reading Lacan*, Ithaca, New York 1985. There is slippage in Lacan even in his articulation of the difference between phallus and penis. How can men 'protect' the phallus, for example, if they are not assumed to have it in the first place?

28 Lacan, *Feminine Sexuality*, p.84.

29 Bretonian surrealists entertained this collapse primarily through an identification with the hysteric, Bataillean surrealists primarily through an embrace of the *informe*; on this score see *Compulsive Beauty*.

30 On specular idealisation see Silverman 1992: 'There is a good deal of slippage in Lacan, not only between the phallus and the penis, but between the phallus in its symbolic capacity, and the phallus in its imaginary capacity. The erect penis seems to represent both, in the one case as that which no fully constituted subject can any longer "be", and which is consequently "veiled" or lacking, and in the other as that which only the male subject can "have"' (p.97).

31 In his 1914 essay on the subject Freud associates narcissism with the vain introspection of beautiful women, but in this case such narcissism is only a relay for the greater narcissism of men.

32 Krauss, in Krauss and Livingstone 1985, p.35. The examples given by Breton of the veiled-erotic are indeed objects-become-signs, at least for him: a limestone deposit that looks like an egg and a mandrake root that evokes Aeneas carrying Anchises.

33 Lacan, *Feminine Sexuality*, p.82: 'The phallus is the signifier of this *Aufhebung* itself, which it inaugurates (initiates) by its own disappearance.'

34 Breton, *Mad Love*, trans. Mary Ann Caws, Lincoln, Nebr., and London 1987, p.87; cited by Ernst in *Beyond Painting*, New York 1948, p.11.

35 Breton, *Mad Love*, p.15. For a related gloss see *Compulsive Beauty*.

36 Ibid.

HISTORY, PORNOGRAPHY AND THE SOCIAL BODY
Carolyn J. Dean

1 Walter Kendrick, *The Secret Museum: Pornography in Modern Culture*, New York 1987.

2 The term was made famous by Susan Sontag in her essay 'The Pornographic Imagination', in *Styles of Radical Will*, New York 1969, pp.35–73.

3 Quoted in Kendrick 1987, p.121.

4 Havelock Ellis, *The Task of Social Hygiene*, London 1914, p.215.

5 Paul Lapeire, *Essai juridique et historique sur l'outrage aux bonnes moeurs par le livre, l'écrit, et l'imprimé*, Lille 1931, pp.22–3.

6 Paul Englisch, *L'Histoire de l'érotisme en Europe*, French adaptation by Jacques Gorvil, Paris 1933, p.244; Edmond Haracourt, *La Démoralisation par le livre et par l'image*, Paris, 1917, pp.34, 36, 11.

7 Lionel d'Autrec, *L'Outrage aux moeurs*, Paris 1923, pp.288, 92, 287.

8 Havelock Ellis, *More Essays of Love and Virtue*, London 1931, pp.124, 137.

9 Granville Stanley Hall, *Adolescence: Its Psychology and its Relations to Physiology, Anthropology, Sociology, Sex, Crime, Religion, and Education*, New York 1904, I, pp.432–71, and II, pp.95–143.

10 D.H. Lawrence, *Pornography and Obscenity*, London 1929, pp.12–13.

11 Georges Anquetil and Armand Charpentier quoted in Autrec 1923, pp.253, 247.

12 Robert Desnos, *De l'érotisme considérée dans ses manifestations écrites et du point du vue de*

l'esprit moderne (1923), reprinted Paris 1952, p.110.

13 Paul Eluard, *L'Evidence poétique* quoted in Roger Shattuck, *Forbidden Knowledge: From Prometheus to Pornography*, New York 1996, p.238.

14 Adolphe Théry, *Manuel pratique de lutte antipornographique*, Paris 1927, pp.11–12.

15 Much censorship after the First World War targeted the political Left, especially the communist party. The government condemned the authors of pamphlets hostile to the French occupation of the Ruhr, and sought as well to suppress the publication of *L'Humanité*, the party's principal newspaper.

16 The transcripts are reproduced in Gilles Barbedette and Michel Carassou, *Paris gay 1925*, Paris 1981, pp.269–74.

17 Jean-Pierre Jeancolas, 'Cinéma, Censure, Controle, Classement', in Pascal Ory, *La Censure en France*, Paris 1997, pp.213–21.

18 For a fuller account see Daniel Bécourt, *Livres Condamnés, Livres Interdits: Régime juridique du livre*, Paris 1972.

19 Georges Bataille, *Oeuvres complètes*, II, Paris 1970, pp. 51–72, 93–109.

SURREALISM AND FILM
Dawn Ades

1 André Breton, 'As in a Wood' (1951) in Paul Hammond (ed.), *The Shadow and its Shadow: Surrealist Writings on the Cinema*, Edinburgh 1991, p.82.

2 Ibid.

3 Robert Desnos, 'Eroticism' (1923), in Hammond 1991, p.210.

4 *Emak Bakia* (1927); *Etoile de mer* (1928); *Le Mystère du Château de Dés* (1929).

5 Sandy Flitterman-Lewis, 'The Image and the Spark: Dulac and Artuad Reviewed', in Rudolf Kuenzli Willis (ed.), *Dada and Surrealist Film*, New York 1987, p.110.

6 See Salvador Dalí, 'Art Films and Anti-Artistic Films' (1927), in Michael Raeburn (ed.), *Salvador Dalí: The Early Years*, trans. John London, London 1994, p.219; Luis Buñuel, 'Buster Keaton's College' (1927) in Hammond 1991, pp.64–5; Salvador Dalí, 'Sempre, per damunt de la musica, Harry Langdon', *L'Amic de les Arts*, no.31, 1929, p.3; 'Luis Buñuel', interview with Salvador Dalí, ibid., p.16.

7 Luis Buñuel, *My Last Breath*, London 1984, p.104.

8 Luis Buñuel, 'Notes on the Making of *Un chien andalou*' (1947) in Joan Hellen (ed.), *The World of Luis Buñuel*, New York 1978, p.151.

9 Salvador Dalí, *The Secret Life of Salvador Dalí* (1942), London 1968, p.212.

10 Salvador Dalí, 'Art Films and Anti-Artistic Films', p.216.

11 André Breton, 'Max Ernst' (1921) in *Max Ernst: Beyond Painting*, New York 1948, p.177.

12 *L'Age d'or Revue-Programme* 1930, trans. in 'The Film Society Presents Luis Buñuel's Surrealist Film *L'Age d'or*', 19 March 1933, New York.

13 Paul Hammond, *L'Age d'or*, London 1997, p.42.

CRITIQUE OF PURE DESIRE, OR WHEN THE SURREALISTS WERE RIGHT
Neil Cox

I should like to thank Elise Archias, Renu Capelli, Heather Crow, Anthony Grudin, and Laura Levin, who helped me to develop some of the ideas in this paper in my graduate seminar on surrealism's Sade at the University of California, Berkeley. MA students at the University of Essex also helped me to think through the material. Conversations with Dana MacFarlane were, as ever, crucial for allowing me to see my own argument.

1 The complete translation of the letter is in The Marquis de Sade, *The Complete Justine, Philosophy in the Bedroom and Other Writings*, ed. and trans. R. Seaver and A. Wainhouse. New York 1965, pp.133–6. The letter was first published in the anthology *Monsieur le 6: Lettres inédits (1778–1784) publiées et annotées par Georges Daumas. Préface de Gilbert Lély*, Paris 1954.

2 See Maurice Lever, *Donatien Alphonse François, Marquis de Sade*, Paris 1991, pp.357–8.

3 The so-called 'Vanille et manille' letter of late 1784, reproduced in *Oeuvres complètes du Marquis de Sade*, ed. Gilbert Lély, Paris 1966–7, XII, pp.449–51. Excerpts from the letter are translated in Francine du Plessix Gray, *At Home with the Marquis de Sade*, London 1999, pp.239–40.

4 Guillaume Apollinaire, *L'Oeuvre du Marquis de Sade*, Paris 1909, p.17.

5 New Series, nos.11–12, 15 Oct. 1923.

6 Paul Eluard, 'D A F de Sade, écrivain fantastique et révolutionnaire', *La Révolution surréaliste*, no.8, Dec. 1926, pp.8–9, this reference p.9.

7 For a highly critical and thought-provoking study of surrealist and other contemporary interpretations of the relationship between Sade's life and writing, see Carolyn J. Dean, *The Self and its Pleasures: Bataille, Lacan, and the History of the Decentred Subject*, Ithaca and London 1992. My defence of surrealism's Sade is in part a response to Dean's book. For a recent discussion of surrealism's reinvention of Sade through imaginary portraits, see Simon Baker, 'The Unacceptable Face of the French Revolution', *Object*, no.2, [London] 1999, pp.5–27.

8 For more on Maurice Heine, see Dean 1992, and my 'La Mort posthume: Maurice Heine and the Poetics of Decay', *Art History*,

vol.23, no.3, Sept. 2000, pp.417–49. Heine wrote his own pornographic incest novel, *Luce*, recently published for the first time in France by Editions de la différence (1999).

9 From *Juliette*: quoted in Marcel Hénaff, *Sade: The Invention of the Libertine Body*, Minneapolis 1999, p.86.

10 From *Philosophy in the Bedroom*: in The Marquis de Sade, *The Complete Justine*, p.342.

11 From *The 120 Days of Sodom*, ed. and trans. Austryn Wainhouse and Richard Seaver, London 1989, p.364.

12 From *Juliette*: quoted in Hénaff 1999, p.100.

13 From The Marquis de Sade, *Philosophy in the Bedroom*, p.285.

14 Sade's novels could be selectively cited – as for example in *Le Surréalisme au service de la révolutione*, no.2, Oct. 1930 – on the need to oppose religious and bourgeois moral codes, but the eulogies to murder and sadistic torture were not really acknowledged until Maurice Heine published his extraordinary collage text 'Regards sur l'enfer anthropoclassique' in *Minotaure*, no.8, June 1936, pp.41–5.

15 In the tract *Declaration* of 27 January 1925, issued by the Central Office of Surrealist Research.

16 'Last May, on the Cambronne-Glacière line, a man in his thirties, seated opposite a very pretty young girl, gently opened the pages of a magazine he pretended to read in such a way as to expose solely for the benefit of the girl a magnificent and complete erection. Some cretin noticing this exhibitionist act, an act that had plunged the young girl into an enormous and delicious state of confusion, but without the faintest objection, was enough to see the exhibitionist beaten and thrown out by the public. We can only declaim our absolute indignation and our

contempt at the appalling agitation against one of the purest and most disinterested acts the a man is capable of performing in our era of weakness and moral degradation.' Salvador Dalí, *Le Surréalisme au service de la révolutione*, no.2, Oct. 1930, p.9.

17 For on the Papin case see my 'Marat/Sade/Picasso', *Art History*, vol.17, no.3, 1994, pp.383–417, and Francis Dupré, *La 'Solution' du passage à l'acte: le double crime des soeurs Papin*, [Paris?], 1984.

18 See Dean 1992, p.163.

19 André Breton, *Oeuvres complètes*, ed. Marguerite Bonnet, Paris 1992, II, p.399. The poem dates from December 1934.

20 For different readings of Sade's chain of libertines, see Satish Padiyar, 'Sade/David', *Art History*, vol.23, no.3, Sept. 2000, pp.365–95; Hénaff 1999, pp.24–7; and T.W. Adorno and M. Horkheimer, 'Juliette, or Enlightenment and Morality', *Dialectic of Enlightenment*, London 1979, p.88.

21 Dean 1992, p.163.

22 Sigmund Freud, 'Three Essays on the Theory of Sexuality' (1905), in *On Sexuality*, London 1991, pp.138–9.

23 Sigmund Freud, 'Instincts and their Vicissitudes', in *On Metapsychology: The Theory of Psychoanalysis*, London 1984, pp.113–38, this argument pp.129–35.

24 Ibid., p.137.

25 An inspired account of the film is given by Paul Hammond, *L'Age d'or,* London 1998. In a letter published in *Le Surréalisme au service de la révolution*, Maurice Heine objected in Sade's name to Buñuel's failure to attack other great religions, and in supporting evidence he quotes Sade on the subjects of Islam, Judaism, and Buddhism. See *Le Surréalisme au service de la révolutione*, no.3, Dec. 1931, pp.12–13.

26 Marcel Jean, *The Autobiography of Surrealism*, New York 1981, p.257. The discussion of love in the film no doubt builds on the result of the survey on love in *La Révolution surréaliste*, no.12. 15 Dec. 1929, pp.65–76.

27 *Tracts Surréalistes et Déclarations Collectives, 1922–1939*, ed. José Pierre, Paris 1980, p.162.

28 Ibid., p.169.

29 'The Use Value of D A F de Sade', in ibid., pp.91–102.

30 Georges Bataille, 'Literature and Evil', in *Erotism: Death and Sensuality*, San Francisco 1986.

31 Ibid., p.36.

32 Such views probably stem from Michel Foucault's 1963 essay 'A Preface to Transgression', which also explores the link between Bataille and Sade. See Foucault, *Language, Counter-Memory, Practice: Selected Essays and Interviews*, ed. D.F. Bouchard, New York 1977, pp.29–52.

33 Michel Leiris, 'L'Homme et son interieur', *Documents*, vol.2, no.5, 1930, p.265.

34 Michel Leiris, 'Le Caput Mortuum ou la femme de l'alchimiste', *Documents*, no.8, 1930, pp.461–6.

35 Michel Leiris, 'L'Ile magique', *Documents*, no.6, Nov. 1929, p.335.

36 Ibid., p.334.

37 The three photographs that appeared in *Documents* have been variously attributed. They were credited to Seabrook in the original captions, and Leiris goes along with this by suggesting that he received them in the post. But more recent evidence has suggested that they were taken by Man Ray or his assistant Jacques-André Boiffard. Rosalind Krauss, in Rosalind Krauss and Jane Livingston (eds.), *L'Amour fou: Photography and Surrealism*, exh. cat., Corcoran Gallery, Washington D.C., 1985, pp.197–200; Simon Baker, 'The Thinking Man and the Femme sans tête: collective perception and self-representation', forthcoming in the journal *RES*. However, letters exchanged between Bataille and his publisher in the 1950s mention five photographs 'from Seabrook' of a girl in a bondage situation; Georges Bataille, *Tears of Eros*, trans. Peter Connor, San Francisco 1989.

37 Quoted in Neil Baldwin, *Man Ray: American Artist*, New York 1991, p.166.

38 The surrealist idea that extreme and violent perversions are by definition creative is to be found in, for example, Maurice Heine's introduction to his *Recueil des confessions et observations psycho-sexuelles*, Paris 1936, and in Eluard and Péret's text in praise of the Papin sisters, in *Le Surréalisme au service de la révolutione*, no.5, 15 May 1933, pp.27–8.

39 Sigmund Freud, 'Instincts and their Vicissitudes', pp.125–6.

40 Ibid., p.131.

41 *Tracts surréalistes et déclarations collectives, 1922–1939*, p.169.

42 Walter Benjamin, *The Arcades Project*, Harvard, Mass. 1999, p.639.

43 See, for example, T.W. Adorno, 'Looking Back on Surrealism', *Notes to Literature*, I, trans. Shierry Weber Nicholsen, New York 1991, p.89; Hal Foster, *Compulsive Beauty*, Cambridge, Mass. 1993; *Fetishism: Visualising: Power and Desire*, South Bank, exh. cat., London 1995.

44 I make only passing allusion here to Jacques Lacan's challenging essay 'Kant with Sade', *October*, no.51, Winter 1989, pp.55–104, and his dictum 'what I desire is the desire of the other'. A full exploration of the topic of surrealism's Sade as revolutionary device would have to answer Lacan's criticism of the Sade as a reproducer of the law of the father. However, it is worth noting that earlier in Lacan's career, he too drew attention to the hidden 'subjective value' of sadism as a means of apprehending the other. See Jacques Lacan, 'Aggressivity in Psychoanalysis' in *Ecrits: A Selection*, New York 1977, p.25.

STAGING DESIRE
Alyce Mahon

I am grateful to the Arts and Humanities Research Board who provided financial support towards primary research in France for this essay.

1 On 4 October 1969 Jean Schuster officially announced in *Le Monde* that 'historical surrealism' in France was over.

2 Of all the surrealist exhibitions, the 1959 international surrealist exhibition, dedicated to eros, received the greatest condemnation in the press. The surrealists were accused of promoting moral decline in *Libération* (17 Dec. 1959) and pornographic vulgarity in *La Nouvelle Revue française* (1 Feb. 1960).

3 André Breton, preface to the *Exposition intérnationale du surréalisme* (*EROS*) exh. cat., Galerie Daniel Cordier, Paris 1959, pp.6–7.

4 The surrealists were influenced by Alfred-Henri Jarry and his theatrical alter-ego Ubu and the Dadaist notion of 'theatre of chance'.

5 Here the surrealists echoed the views of the influential French philosopher Henri Bergson (1859–1941), who, in *An Introduction to Metaphysics* (1903) and *Creative Evolution* (1907), discussed the importance of understanding reality through intuition rather than logical analysis and emphasised the creative aspects of an individual's experience.

6 Marcel Jean, *The History of Surrealist Painting*, trans. Simon Watson Taylor, New York 1960, p.280.

7 See Brassaï, *Le Paris secret des années 30*, Paris 1976. English edition, *The Secret Paris of the 30s*, trans. Richard Miller, New York 1977.

8 Man Ray, *Self Portrait*, Boston 1988, p.232.

9 Jean, *The History of Surrealist Painting*, p.281.

10 See James D. Herbert's socio-political reading of the 1938 exhibition in *Paris 1937: Worlds on Exhibition*, Ithaca and London 1998.

11 Henri Lefebvre, *La Production de l'espace*, Paris 1974, trans. as *The Production of Space*, by Donald Nicholson-Smith, Oxford 1991, p.183. Lefebvre was at different times both a collaborator and critic of surrealism.

12 Aimé Maeght (1906–1981) opened his gallery in Paris in 1945 and exhibited such artists as Henri Matisse, Pierre Bonnard, Pablo Picasso and Georges Braque. According to Adrien Maeght, his father decided to host a surrealist exhibition out of a certain nostalgia for his own youth and for a prewar sensibility, and because he had a great respect for surrealist literature and its 'anti-doctrinal' liberty (Adrien Maeght, interview with the author, Saint-Paul, 4 Aug. 2000).

13 André Breton, 'Prolegomena to a Third Surrealist Manifesto' (1942), *Manifestoes of Surrealism*, trans. R. Seaver and H.R. Lanes, Ann Arbor 1992, p.293.

14 Ibid.

15 The title refers to an episode in *Les Chants de Maldoror* (1868–9) by Isidore Ducasse, the 'Comte de Lautréamont', a long narrative prose poem that was much admired by the surrealists.

16 In *La Terre et les rêveries de la volonté*, Paris 1948, Gaston Bachelard, a philosopher much admired by Breton, wrote of the spatial forms of the house, grotto and labyrinth and emphasised the ubiquity of the labyrinth in nightmares as a signifier of the private desires and fears of the individual. Georges Bataille was also fascinated with the labyrinth as a 'space where oppositions disintegrate and grow complicated'. (Denis Hollier, *Against Architecture: The Writings of Georges Bataille*, trans. Betsy Wing, Cambridge, Mass. 1989, p.58). Rosalind Krauss has also discussed the labyrinth as a formless space analogous to dream (*The Optical Unconscious*, Cambridge, Mass. 1993).

17 Mélusine was one of the triplet daughters of Presine. She was doomed to be human and to return to the state of ondine – half woman, half water serpent, every Saturday night. She rescued and married a mortal, the Count of Poitiers, but as he could not resist the temptation to see her in her state of metamorphosis, despite his great love for her, she lost her mortality and became a protective spirit for him and his lands forever. As Anna Balakian points out in her introduction to *Arcanum 17* (trans. Z. Rogow, Los Angeles 1994), Mélusine is the symbol of the dispossessed and represented for Breton the power of woman to save civilisation.

18 The *EROS* exhibition officially opened on 15 December 1959 and ran until 29 February 1960.

19 Jean Benoît, 'Notes concernant l'exécution', in *EROS* exh. cat. 1959, p.66.

20 Jean Benoît, interview with the author, Paris, 5 May 1996.

21 Breton praised the performance and, in particular, Matta's impulsive demonstration which, Breton said, 'totally requalified him in [the surrealists'] eyes'. See 'Dernière heure', 4 Dec. 1959, in José Pierre, *Tracts surréalistes et déclarations collectives*, II (1940–69), Paris 1982, pp.182–3.

22 Duchamp is usually cited as the designer of the 'Boîte'. However, Mimi Parent claims it is she who should be credited with the idea of a postbox and that Duchamp only only added the subtitle 'Missives Lascives'. Mimi Parent, interview with the author, Paris, 18 July 2000.

23 Duchamp's *Couple* were based on a pair of late eighteenth-century erotic purses.

24 Breton, preface to *EROS* exh. cat. 1959, p.5.

25 This installation was first staged by Oppenheim as a feast for a few friends in Berne, with everyone, including the nude woman, eating. It was reenacted at Breton's request for the opening of the exhibition. Oppenheim was unhappy with the result, insisting that 'the original intention was misunderstood. Instead of a simple Spring festival, it was yet another woman taken as a source of male pleasure'. Meret Oppenheim, in Robert J. Belton, 'Androgyny: Interview with Meret Oppenheim', in Mary Ann Caws, Rudolf Kuenzli and Gwen Raaberg (eds.), *Surrealism and Women*, Cambridge, Mass. 1993 [1991], p.70.

DESIRE – A SURREALIST 'INVENTION'
Annie Le Brun

1 André Breton, 'La Confession dédaigneuse' in André Breton, *Oeuvres complètes*, ed. Marguerite Bonnet, I, Paris 1988, p.194.

2 Robert Desnos, extract from a letter to Jacques Doucet concerning his text 'De l'érotisme considéré dans ses manifestations écrites du point de vue de l'esprit moderne'; quoted in Robert Desnos, *Nouvelles Hébrides et autres textes 1922–1930*, Paris 1978, p.506.

3 André Breton, *Entretiens 1913–1952*, Paris 1952, pp.40–1.

4 Quoted by Michel Décaudin, in Guillaume Apollinaire, *Oeuvres en prose*, III, Paris 1993, p.1320.

5 Ibid., p.1320.

6 Breton also quotes this remark in his *Misère de la poésie* (1932), through which he sought to engineer a shift of opinion in Aragon's favour at the time when the latter was being attacked by the French establishment for his inflammatory poem 'Front rouge' (Red Front). Breton did so to demonstrate 'what bad faith and what impoverishment of thought' the surrealists had to contend with. However, Aragon, by now more a Stalinist than a surrealist, took violent exception to Breton's intervention. The two broke off relations just as this 'brochure designed to defend him' came out. See André Breton, *Entretiens*, pp.167–8.

7 André Breton, *Mad Love*, trans. Mary Ann Caws, Lincoln, Nebr. and London 1987, pp.24–5.

8 André Breton, *Manifeste du surréalisme*, 1924.

9 Desnos, 'De l'érotisme considéré dans ses manifestations écrites du point de vue de l'esprit moderne' (1923), in Desnos, *Nouvelles Hébrides et autres textes 1922–1930*, p.133.

10 Ibid., p.135.

11 André Breton, *Second Manifeste du surréalisme*, 1930; in Breton, *Oeuvres complètes*, I, 1988, p.809.

12 Breton, *Entretiens*, p.141.

13 Ibid., p.248.

LIST OF EXHIBITED WORKS

Measurements are given in centimetres followed by inches in parentheses, and height before width.

An asterisk (•) indicates that the work will be exhibited at Tate Modern only.

A dagger (†) indicates that the work will be exhibited at The Metropolitan Museum of Art only.

EILEEN AGAR 1899–1991

Angel of Anarchy 1936–40*
Textiles over plaster and mixed media
52 × 31.7 × 33.6 (20¹/₂ × 12¹/₂ × 13¹/₄)
Tate. Presented by the Friends of the Tate Gallery 1983
[fig.73]

Roland Penrose and Lee Miller on the Beach at Juan-les-Pins 1937
Modern photograph 19.1 × 19
(7¹/₂ × 7¹/₂)
Tate Archive Photograph Collection
[fig.150]

ANONYMOUS

Hans Bellmer and Unica Zürn n.d.
Modern photograph 13.9 × 12.2
(5¹/₂ × 4¹³/₁₆)
Tate
[fig.160]

Lady's Glove n.d.*
Gant de femme
Bronze 3 × 22 × 11 (1¹³/₁₆ × 8¹¹/₁₆ × 4⁵/₁₆)
Former collection André Breton
Private collection
[fig.113]

Siren n.d.*
Sirène
Wax, fabric, sequins and human hair
39 × 25 × 10 (15³/₈ × 9¹³/₁₆ × 3¹⁵/₁₆)
Former collection Robert Desnos
Centre d'étude et de documentation Jacovsky-Frère. Commune de Blainville-Crevon
[fig.122]

Spoon-Shoe n.d.*
Cuillère-soulier
Wood 5.5 × 37 × 8.5 (2³/₁₆ × 14⁹/₁₆ × 3³/₈)
Former collection André Breton
Private collection
[fig.14]

Paul Eluard and Gala in Fancy Dress in the Sanatorium at Clavadel 1912–13
Vintage photograph 12 × 8.9 (4³/₄ × 3¹/₂)
Musée d'art et d'histoire, Saint-Denis
[fig.104]

Simone Breton and Denise Lévy c.1925
Modern photograph 13 × 16.5
(5¹/₈ × 6¹/₂)
Private collection
[fig.115]

Eyre de Lanux c.1926
Vintage photograph 24.5 × 19.3
(9⁵/₈ × 7⁵/₈)
Private collection
[fig.114]

Yvonne Georges c.1926
Vintage photograph 11 × 8.5 (4⁵/₁₆ × 3³/₈)
Private collection
[fig.120]

Five Portraits of Nancy Cunard late 1920s
Vintage photographs, framed together by Louis Aragon in the 1970s 14.2 × 8.3, 13.4 × 8.9, 9.1 × 7, 13.8 × 9, 8.1 × 13.4
(5⁹/₁₆ × 3¹/₄, 5¹/₄ × 3¹/₂, 3⁹/₁₆ × 2³/₄, 5⁷/₁₆ × 3⁹/₁₆, 3³/₁₆ × 5¹/₄)
Private collection

Gala Eluard late 1920s
Vintage photograph 11 × 6.5
(4⁵/₁₆ × 2⁹/₁₆)
Musée d'art et d'histoire, Saint-Denis. Purchased with the assistance of FRAM

André Breton and Suzanne Muzard 1929–30
Modern photograph 13.5 × 6.5
(5⁵/₁₆ × 2⁹/₁₆)
Private collection
[fig.132]

Louis Aragon, Elsa Triolet, André Breton, Paul Eluard and Nusch 1930
Vintage photograph 57.6 × 35.4
(22¹¹/₁₆ × 13¹⁵/₁₆)
Private collection
[fig.118]

Jindřich Štyrský, Toyen, Paul and Nusch Eluard 1935
Vintage photograph 6.5 × 6.5
(2⁹/₁₆ × 2⁹/₁₆)
Galerie 1900–2000, Marcel and David Fleiss, Paris
[fig.233]

The Surrealist Group in London 1936
Modern photograph 38 × 50 (15 × 19¹/₂)
Tate Archive
[fig.6]

Elisa Breton mid-1940s
Modern photograph 12.5 × 10
(4¹⁵/₁₆ × 3¹⁵/₁₆)
Private collection
[fig.162]

Members of the Surrealist Group at Pierre Matisse's Home, New York 1945
Photograph 19.7 × 24 (7³/₄ × 9⁷/₁₆)
Marchel Duchamp Archives, Villiers sous Grez
[fig.7]

JEAN ARP
1886–1966

Head: Scottish Lips 1927
Tête: Lèvres écossaises
Painted card with cut-out areas 51 × 39
(20 × 15³/₈)
Géraldine Galateau
[fig.85]

Garland of Buds I 1936
Couronne de bourgeons I
Limestone 49.1 × 37.5 (19³/₈ × 14³/₈):
base height 15.4 (6¹/₁₆)
Peggy Guggenheim Collection, Venice. Solomon R. Guggenheim Foundation, New York
[fig.86]

HANS BELLMER
1902–1975

The Doll 1932–45*
La Poupée
Painted wood, hair, shoes, socks
61 × 170 × 51 (24 × 66⁷/₈ × 20)
Centre Georges Pompidou, Paris. Musée national d'art moderne
[fig.202]

The Doll 1934
La Poupée
Gelatin silver print on original mount
30.3 × 19.3 (11¹³/₁₆ × 7⁵/₈)
Ubu Gallery, New York, and Galerie Berinson, Berlin
[fig.199]

The Doll c.1934
La Poupée
Gelatin silver print 25.3 × 32.7
(9¹⁵/₁₆ × 12⁷/₈)
The Metropolitan Museum of Art, New York. Ford Motor Company Collection, Gift of Ford Motor Company and John C. Waddell, 1987
[fig.200]

The Doll c.1934
La Poupée
Gelatin silver print 29.7 × 19.5
(11¹¹/₁₆ × 7¹¹/₁₆)
The Metropolitan Museum of Art, New York. Ford Motor Company Collection, Gift of Ford Motor Company and John C. Waddell, 1987
[fig.26]

The Doll 1935
La Poupée
Hand-coloured gelatin silver print on original stretcher 66 × 66 (26 × 26)
Ubu Gallery, New York, and Galerie Berinson, Berlin
[fig.204]

The Doll 1935
La Poupée
Gelatin silver print 67.3 × 63.2
(26¹/₂ × 24⁷/₈)
Claude Berri
[fig.208]

The Doll 1935
La Poupée
Gelatin silver print on stretcher 66 × 66
(26 × 26)
Ubu Gallery, New York, and Galerie Berinson, Berlin
[fig.207]

The Doll 1935
La Poupée
Hand-coloured gelatin silver print
66 × 66 (26 × 26)
Claude Berri
[fig.203]

The Doll 1936
La Poupée
Hand-coloured gelatin silver print
73.7 × 50.8 (29 × 20)
Herbert Lust Gallery
[fig.201]

Untitled c.1936
Sans titre
Gouache on paper 24.8 × 32.4
(9³/₄ × 12³/₄)
Ubu Gallery, New York, and Galerie
Berinson, Berlin
[fig.25]

The Doll 1936, cast 1965
La Poupée
Painted aluminium on brass base
63.5 × 30.7 × 30.5 (25 × 12¹/₄ × 12)
Tate. Purchased 1969

The Doll 1938
La Poupée
Gelatin silver print 66.4 × 65.1
(26¹/₈ × 25⁵/₈)
Claude Berri
[fig.205]

The Doll 1938
La Poupée
Hand-coloured gelatin silver print
66 × 66 (26 × 26)
Ubu Gallery, New York, and Galerie
Berinson, Berlin
[fig.206]

The Doll (Maquette for 'Les Jeux de la poupée') c.1938
La Poupée (Maquette pour 'Les Jeux de la poupée')
Hand-coloured gelatin silver contact
print on original mount 5.4 × 5.4
(2¹/₈ × 2¹/₈)
Ubu Gallery, New York, and Galerie
Berinson, Berlin
[fig.210]

The Doll (Maquette for 'Les Jeux de la poupée') c.1938
La Poupée (Maquette pour 'Les Jeux de la poupée')
Hand-coloured gelatin silver contact
print on original mount 5.5 × 5.3
(2³/₁₆ × 2¹/₁₆)
Ubu Gallery, New York, and Galerie
Berinson, Berlin
[fig.211]

The Doll (Maquette for 'Les Jeux de la poupée') c.1938
La Poupée (Maquette pour 'Les Jeux de la poupée')
Hand-coloured gelatin silver contact
print on original mount 5.4 × 5.5
(2¹/₈ × 2³/₁₆)
Ubu Gallery, New York, and Galerie
Berinson, Berlin
[fig.209]

Histoire de l'oeil by Lord Auch [Georges
Bataille], plate no.1 1944
Two-colour etching 20.3 × 12.7 (8 × 5)
Herbert Lust Gallery
[fig.223]

Histoire de l'oeil by Lord Auch [Georges
Bataille], plate no.4 1944
Two-colour etching 12.7 × 20.3 (5 × 8)
Herbert Lust Gallery
[fig.225]

Histoire de l'oeil by Lord Auch [Georges
Bataille], plate no.6 1944
Two-colour etching 20.3 × 12.7 (8 × 5)
Herbert Lust Gallery

The Oral Cross 1946
La Croix gamahuchée
Hand-coloured gelatin silver print
11.8 × 12 (4⁵/₈ × 4³/₄)
Ubu Gallery, New York, and Galerie
Berinson, Berlin
[fig.228]

*Untitled (Dialogue between a Priest
and a Dying Man)* 1946
Sans titre (Le Dialogue d'un prêtre avec
un moribond)
Pencil on paper 26 × 22 (10¹/₄ × 8¹¹/₁₆)
Private collection
[fig.245]

Untitled (**Study for** *Histoire de l'oeil* **by
Lord Auch** [Georges Bataille]) 1946
Gelatin silver print 18.3 × 12 (7³/₁₆ × 4³/₄)
Ubu Gallery, New York, and Galerie
Berinson, Berlin
[fig.229]

Nora Mitrani late 1940s
Gouache on paper 65 × 50
(25⁹/₁₆ × 19¹¹/₁₆)
Private collection
[fig.158]

Max Ernst and Dorothea Tanning
1950s
Watercolour and ink on paper 17 × 8.3
(6¹¹/₁₆ × 3¹/₄)
Private collection

Store in a Cool Place 1958
Tenir au frais
Collaged photographs and gouache
23.4 × 24 (9³/₁₆ × 9⁷/₁₆)
Ubu Gallery, New York, and Galerie
Berinson, Berlin
[fig.159]

To Sade 1961
A Sade
Drypoint 19.6 × 14.2 (7¹¹/₁₆ × 5⁹/₁₆)
Herbert Lust Gallery
[fig.259]

To Sade 1961
A Sade
Drypoint 19.6 × 14.2 (7¹¹/₁₆ × 5⁹/₁₆)
Herbert Lust Gallery
[fig.260]

DENISE BELLON
born 1902

Salvador Dalí Holding a Mannequin
1938
Vintage photograph 25 × 24
(9¹³/₁₆ × 9⁷/₁₆)
Courtesy Claude Oterelo
[fig.270]

**The Surrealist Group at the Galerie
Maeght, Paris** 1947
Vintage photograph 25 × 24
(9¹³/₁₆ × 9⁷/₁₆)
Courtesy Claude Oterelo

The Banquet, EROS Exhibition 1959
Vintage photograph 20.5 × 30.5
(8¹/₁₆ × 12)
Courtesy Claude Oterelo

**Installation View of the EROS
Exhibition** 1959
Vintage photograph 30.5 × 20.5
(12 × 8¹/₁₆)
Courtesy Claude Oterelo
[fig.272]

JEAN BENOIT
born 1922

**Costume for 'The Execution of the
Testament of the Marquis de Sade':
'Cache-vit'** 1949
Costume pour 'L'Exécution du Testament
du Marquis de Sade': Cache-vit
Mixed media 75 × 20 × 30
(29¹/₂ × 7⁷/₈ × 11¹³/₁₆)
Jean Benoît
[fig.274]

**Costume for 'The Execution of the
Testament of the Marquis de Sade':
Branding-Iron** 1949
Costume pour 'L'Exécution du Testament
du Marquis de Sade': Fer
Mixed media 50 × 14 × 3
(19¹¹/₁₆ × 5¹/₂ × 1³/₁₆)
Jean Benoît
[fig.275]

**Costume for 'The Execution of the
Testament of the Marquis de Sade':
Medallion** 1949
Costume pour 'L'Exécution du Testament
du Marquis de Sade': Médaillon
Mixed media 39 × 22 × 3
(15³/₈ × 8¹¹/₁₆ × 1³/₁₆)
Jean Benoît
[fig.273]

The Eagle, Mademoiselle 1982
L'Aigle, Mademoiselle
Mixed media 34 × 32.5 × 39.5
(13³/₈ × 12¹³/₁₆ × 15⁹/₁₆)
Galerie Claude Bernard, Paris
[fig.256]

JACQUES-ANDRE BOIFFARD
1902–1961

Big Toe 1929*
Gros orteil
Gelatin silver print 31 × 23.9
(12³/₁₆ × 9⁷/₁₆)
Centre Georges Pompidou, Paris. Musée
national d'art moderne

Renée Jacobi 1930
Gelatin silver print 23.8 × 18.8
(9³/₈ × 7³/₈)
Centre Georges Pompidou, Paris. Musée
national d'art moderne
[fig.9]

LOUISE BOURGEOIS
born 1911

Knife Couple 1949
Wood 174 × 30.5 × 30.5
(68¹/₂ × 12 × 12)
Courtesy Cheim and Read, New York
[fig.265]

Fillette 1960
Latex over plaster 59.7 × 28 × 19.1
(23.5 × 11 × 7.5)
The Museum of Modern Art, New York.
Gift of the artist in memory of Alfred H.
Barr, Jr., 1992
[fig.292]

Torso, Self-Portrait 1963–4
Bronze, painted white 62.8 × 40.6 × 20
(24³/₄ × 16 × 7⁷/₈)
Courtesy Cheim and Read, New York
[fig.295]

Janus Fleuri 1968
Bronze, golden patina 25.7 × 31.8 × 21.3
(10¹/₈ × 12¹/₂ × 8³/₈)
Courtesy Cheim and Read, New York
[fig.293]

Avenza 1968–9
Latex 53.3 × 76.2 × 116.8
(21 × 30 × 46)
Tate. Presented by the artist, 2001
[fig.294]

BRASSAI
1899–1984

Nude 1931–2
Nu
Gelatin silver print 28.3 × 41.1
(11¹/₈ × 16³/₁₆)
Courtesy Edwynn Houk Gallery
[fig.198]

VICTOR BRAUNER
1903–1966

The Complete Woman [Anatomy of Desire] 1936
La Femme complète [Anatomie du désir]
Ink and watercolour on paper 65 × 50
(25⁹/₁₆ × 19¹¹/₁₆)
Centre Georges Pompidou, Paris. Musée national d'art moderne

Untitled [Anatomy of Desire] 1936
Sans titre [Anatomie du désir]
Ink and watercolour on paper
65.1 × 50.1 (25⁵/₈ × 19³/₄)
Centre Georges Pompidou, Paris. Musée national d'art moderne

ANDRE BRETON
1896–1966

Page-Object 1934
Page-objet
Wooden box, glass eyes, bait
6 × 10 × 6.5 (2³/₈ × 3¹⁵/₁₆ × 2⁹/₁₆)
Galleria Nazionale d'Arte Moderna, Rome
[fig.133]

Poem-Object 1937
Poème-objet
Mixed media 28.3 × 19.8
(11¹/₈ × 7¹³/₁₆)
Timothy Baum, New York
[fig.74]

Song-Object 1937
Chanson-objet
Mixed media 22.5 × 30 × 6
(8⁷/₈ × 11¹³/₁₆ × 2³/₈)
Private collection, Paris
[fig.75]

Heart in the Arrow 1958
Le Coeur dans la flèche
Cork 29.5 × 9.8 (11⁵/₈ × 3⁷/₈)
Private collection
[fig.36]

ANDRE BRETON, JACQUELINE LAMBA, YVES TANGUY
1896–1966, 1910–1993, 1900–1955

Untitled (Exquisite Corpse) 1938
Sans titre (Cadavre exquis)
Collage 25.4 × 15.2 (10 × 6)
The Mayor Gallery, London
[fig.142]

ELISA BRETON
1906–2000

Hold On 1972
Ne quittez pas
Mixed media 30 × 25.5 × 4 (11¹³/₁₆ ×
10¹/₁₆ × 1⁹/₁₆)
Private collection
[fig.164]

V.H. BRUNNER
1886–1928

Untitled Drawing for an Ex Libris late 1920s
Ink on paper 5.6 × 4.6 (2³/₁₆ × 1¹³/₁₆)
Mony Vibescu

LUIS BUNUEL, WITH SCRIPT BY LUIS BUNUEL AND SALVADOR DALI
1900–1983, 1904–1989

L'Age d'or 1930
Film 63 minutes
Centre Pompidou, Paris. Musée national d'art moderne
[fig.239]

LUIS BUNUEL AND SALVADOR DALI
1900–1983, 1904–1989

Un chien andalou 1929
Film 16 minutes
Contemporary Films, London
[fig.238]

CLAUDE CAHUN
1894–1954

Self-Portrait 1927
Autoportrait
Vintage photograph 14 × 9 (5¹/₂ × 3⁹/₁₆)
Private collection
[fig.186]

Self-Portrait c.1927
Autoportrait
Vintage photograph 23.5 × 17.5
(9¹/₄ × 6⁷/₈)
Private collection
[fig.185]

Self-Portrait 1928*
Autoportrait
Gelatin silver print 30 × 23.5
(11³/₄ × 9³/₈)
Musée des Beaux-Arts de Nantes
[fig.182]

Self-Portrait 1928
Autoportrait
Vintage photograph 17.4 × 13
(6⁷/₈ × 5¹/₈)
Private collection
[fig.187]

What Do You Want from Me? 1928
Que me veux-tu?
Gelatin silver print 23 × 18 (9 × 7¹/₈)
Private collection
[fig.183]

Self-Portrait 1929
Autoportrait
Vintage photograph 14 × 9 (5¹/₂ × 3⁹/₁₆)
Private collection
[fig.184]

Untitled (for Aveux non avenus) 1929–30
Vintage photograph 51.9 × 35.1
(20⁷/₁₆ × 13¹³/₁₆)
Private collection
[fig.189]

André Breton and Jacqueline Lamba 1935
Vintage photograph 22.6 × 16
(8⁷/₈ × 6⁵/₁₆)
Courtesy of the Jersey Heritage Trust
[fig.139]

LEONORA CARRINGTON
born 1917

The Pleasures of Dagobert 1945
Les Distractions de Dagobert
Egg tempera on masonite 74.9 × 86.7
(29¹/₂ × 34¹/₈)
Private collection
[fig.195]

Portrait of the Late Mrs Partridge 1947
Oil on board 100 × 68.5 (39³/₈ × 26¹⁵/₁₆)
Trustees of the Edward James Foundation

Cat Woman 1951
Painted wood 201.9 (79¹/₂) high
Private collection
[fig.194]

JACQUES CORDONNIER
[dates unknown]

The Surrealist Group at the Café de la Place Blanche, Paris 1953
Modern photograph 18.6 × 27
(7⁵/₁₆ × 10⁵/₈)
Private collection
[fig.8]

JOSEPH CORNELL
1903–1972

Untitled (Greta Garbo) c.1939
Mixed-media construction
33.7 × 24.1 × 7.6 (13¹/₄ × 9¹/₂ × 3)
Richard L. Feigen
[fig.63]

L'Egypte de Mlle Cléo de Mérode; cours élémentaire d'histoire naturelle 1940
Mixed-media construction
12.1 × 27.3 × 18.4 (4¹¹/₁₆ × 10¹¹/₁₆ × 7¹/₄)
Robert Lehrman, Washington, DC
[fig.57]

Taglioni's Jewel Casket 1940
Wooden box containing glass ice cubes, jewellery, etc. 12 × 30.2 × 21
(4³/₄ × 11⁷/₈ × 8¹/₄)
The Museum of Modern Art, New York. Gift of James Thrall Soby, 1953
[fig.56]

Untitled (Bébé Marie) early 1940s
Papered and painted wooden box with painted corrugated cardboard floor, containing doll in cloth dress and straw hat with cloth flowers, etc. 59.7 × 31.5 ×
13.3 (23¹/₂ × 12³/₈ × 5¹/₄)
Museum of Modern Art, New York. Acquired through the Lillie P. Bliss Bequest, 1980
[fig.64]

Untitled (Mona Lisa) c.1940–2
Lidded and papered cylindrical cardboard box sealed with painted clear glass, containing photographic reproductions, sequins, hairpin, glass beads and black paper fragment
3.2 × 7.6 diameter (1¹/₄ × 3 diameter)
Marguerite and Robert Hoffman
[fig.62]

Untitled (Photomontage for
'"Enchanted Wanderer": Excerpt from
a Journey Album for Hedy Lamarr')
c.1941
Gelatin silver print 22 × 17.7
(8⁵/₈ × 6¹⁵/₁₆)
Joseph Cornell Study Center,
Smithsonian American Art Museum, Gift
of Mr and Mrs John A. Benton
[fig.165]

Untitled (Pinturicchio Boy) 1942–52
Mixed-media construction
35.2 × 28.3 × 9.8 (13¹⁵/₁₆ × 11³/₁₆ × 3⁷/₈)
The Joseph and Robert Cornell
Memorial Foundation, courtesy C&M
Arts, New York
[fig.65]

Untitled (Grand Hôtel) c.1950
Mixed-media construction
48.3 × 32.4 × 10.2 (19 × 12³/₄ × 4)
The Joseph and Robert Cornell
Memorial Foundation, courtesy C&M
Arts, New York
[fig.66]

Observatory Colomba Carrousel
c.1953
Mixed-media construction
46 × 29.2 × 14.6 (18¹/₁₆ × 11⁹/₁₆ × 5¹³/₁₆)
Robert Lehrman, Washington D.C.
[fig.67]

An Image for 2 Emilies c.1954
Mixed-media construction
34.9 × 26.7 × 7 (13¹¹/₁₆ × 10¹/₂ × 2¹¹/₁₆)
Robert Lehrman, Washington, D.C.
[fig.68]

Untitled (Blue Nude) mid-1960s
Collage 28.6 × 21 (11¹/₄ × 8¹/₄)
Robert Lehrman, Washington, D.C.

SALVADOR DALI
1904–1989

Little Cinders 1927–8*
Senicitas
Oil on panel 64 × 48 (25 × 18⁷/₈)
Museo Nacional Centro de Arte Reina
Sofía, Madrid
[fig.254]

Bather (Female Nude) 1928
Beigneuse [sic]
Oil and pebbles on laminated panel
63.5 × 75 (25 × 29¹/₂)
Salvador Dalí Museum, St Petersburg,
Florida
[fig.253]

The Accommodations of Desires 1929
Les Accommodations des désirs
Oil and collage on board 22.2 × 35
(8³/₄ × 13³/₄)
The Metropolitan Museum of Art, New
York. Jacques and Natasha Gelman
Collection, 1998
[fig.2]

Scatological Object Functioning
Symbolically 1930, replica 1973
Objet scatologique à fonctionnement
symbolique
Assemblage 48 × 24 × 14
(18⁷/₈ × 9⁷/₁₆ × 5¹/₂)
Museum Boijmans Van Beuningen,
Rotterdam
[fig.21]

William Tell 1930*
Guillaume Tell
Oil and collage on canvas 113 × 87
(44¹/₂ × 34¹/₄)
Private collection
[fig.48]

Gradiva Rediscovers the
Anthropomorphic Ruins –
Retrospective Fantasy 1931–2
Gradiva retrouve les ruines anthropo-
morphes – Fantaisie rétrospective
Oil on canvas 65 × 54 (25⁹/₁₆ × 21¹/₄)
Museo Thyssen-Bornemisza, Madrid
[fig.45]

Anthropomorphic Bread – Catalonian
Bread 1932
Pain anthropomorphe – Pain catalan
Oil on canvas 24 × 32 (9⁹/₁₆ × 13)
Salvador Dalí Museum, St Petersburg,
Florida
[fig.23]

Fried Eggs on the Plate Without the
Plate 1932
Oeufs sur le plat sans le plat
Oil on canvas 60.3 × 41.9 (23³/₄ × 16¹/₂)
Salvador Dalí Museum, St Petersburg,
Florida
[fig.22]

Untitled (Composition with Many
Erotic Scenes) 1932
Composición con diferentes escenas
eróticas
Ink on cardboard 32 × 24 (12⁵/₈ × 9⁷/₁₆)
Fundació Gala-Salvador Dalí
[fig.252]

Meditation on the Harp 1932–4
Méditation sur la harpe
Oil on canvas 67 × 47 (26³/₈ × 18¹/₂)
Salvador Dalí Museum, St Petersburg,
Florida
[fig.47]

Untitled 1933
Ink and pencil on paper 26.6 × 20.8
(10¹/₂ × 8³/₁₆)
Private collection

Autumnal Cannibalism 1936
Cannibalisme de l'automne
Oil on canvas 65.1 × 65.1 (25⁵/₈ × 25⁵/₈)
Tate. Purchased 1975
[fig.255]

Couple with their Heads Full of Clouds
1936
Couple aux têtes pleines de nuages
Oil on panel
Two panels: 92.5 × 69.6, 82.5 × 62.5
(36⁷/₁₆ × 27³/₈, 32¹/₂ × 24⁵/₈)
Museum Boijmans Van Beuningen,
Rotterdam
[fig.190]

Lobster Telephone 1936
Téléphone – Homard
Plastic, painted plaster and mixed media
17.8 × 33 × 17.8 (7 × 13 × 7)
Tate. Purchased 1981
[fig.3]

Venus with Drawers 1936
Venus aux tiroirs
Plaster, metal and fur 98 × 32.5 × 34
(38⁵/₈ × 12³/₄ × 13³/₈)
Private collection
[fig.72]

Metamorphosis of Narcissus 1937
Métamorphose de Narcisse
Oil on canvas 51.1 × 78.1 (20¹/₈ × 30³/₄)
Tate. Purchased 1979
[fig.288]

GIORGIO DE CHIRICO
1888–1978

Ariadne 1913
Piazza con Arianna
Oil and pencil on canvas 135.6 × 180
(53³/₈ × 71)
The Metropolitan Museum of Art, New
York. Bequest of Florene M. Schoenborn,
1995
[fig.41]

The Uncertainty of the Poet 1913†
L'Incertitude du poète
Oil on canvas 106 × 94 (41³/₄ × 37)
Tate. Purchased with assistance from the
National Art Collections Fund (Eugene
Cremetti Fund), the Carroll Donner
Bequest, the Friends of the Tate Gallery
and members of the public 1985

The Child's Brain 1914*
Le Cerveau de l'enfant
Oil on canvas 80 × 65 (31¹/₂ × 25⁹/₁₆)
Former collection André Breton
Moderna Museet, Stockholm
[fig.37]

The Enigma of a Day 1914
L'Enigme d'un jour
Oil on canvas 185.5 × 139.7 (73¹/₄ × 55)
Former collection André Breton
The Museum of Modern Art, New York.
James Thrall Soby Bequest, 1979
[fig.38]

Spring 1914
Primavera
Oil on canvas 35.1 × 27 (14 × 10⁵/₈)
Private collection
[fig.40]

PAUL DELVAUX
1897–1994

Woman in the Mirror 1936†
Femme au miroir
Oil on canvas 71 × 91.5 (27¹⁵/₁₆ × 36)
Museo Thyssen-Bornemisza, Madrid

Street of Trams 1938–9*
La Rue du tramway
Oil on canvas 90.3 × 130.5 (35⁹/₁₆ × 51³/₈)
Scottish National Gallery of Modern Art,
Edinburgh. Bequeathed by Gabrielle
Keiller 1995
[fig.58]

Dawn over the City 1940
L'Aube sur la ville
Oil on canvas 174 × 200 (68¹/₂ × 78³/₄)
Artesia Bank, Belgium
[fig.59]

MAYA DEREN
1917–1961

Meshes of the Afternoon 1943
Film 12 minutes
Courtesy the British Film Institute,
CineNova and The Estate of Maya Deren

OSCAR DOMINGUEZ
1906–1958

Electrosexual Sewing-Machine 1934
Machine à coudre électrosexuelle
Oil on canvas 100 × 81 (39³/₈ × 31⁷/₈)
Private collection
[fig.241]

ENRICO DONATI

born 1909

La Plume de ma tante 1947
Mixed media 45.7 × 25.4 × 25.4
(18 × 10 × 10)
Enrico Donati, courtesy Zabriskie
Gallery, New York
[fig.1]

MARCEL DUCHAMP

1887–1968

Hanging Gas Lamp 1903–4*
Bec Auer
Charcoal on paper 22.4 × 17.2 (18¹³/₁₆ ×
6³/₄)
Jacqueline Matisse Monnier
[fig.281]

Coffee Mill 1911
Moulin à café
Oil on cardboard 33 × 12.7 (13 × 5)
Tate. Purchased 1981

Sad Young Man on a Train 1911–12
Jeune homme triste dans un train
Oil on cardboard 100 × 73 (39³/₈ × 28³/₄)
Peggy Guggenheim Collection, Venice.
Solomon R. Guggenheim Foundation,
New York
[fig.171]

Bride 1912
La Mariée
Oil on canvas 90.2 × 53.3 (35¹/₄ × 21¹/₄)
Philadelphia Museum of Art, Louise and
Walter Arensberg Collection
[fig.172]

*'The Bride Stripped Bare by Her
Bachelors, Even / To Give the Painting
the Appearance / Of Continuity …'*
c.1912*
'La mariée mise à nu par ses célibataires
même/pour donner au tableau
l'aspect/de la continuité ...'
Ink on paper 11 × 16.2 (4⁵/₁₆ × 6³/₈)
Centre Georges Pompidou, Paris. Musée
national d'art moderne

Free Will 1913*
'=libre arbitre=âne de Buridan ...'
Ink and pencil on torn paper
15.3 × 20.2 (6 × 7¹⁵/₁₆)
Centre Georges Pompidou, Paris. Musée
national d'art moderne
[fig.16]

*Sketch for the Mobile Weight and the
Chocolate Grinder* 1913*
Croquis pour le Poids mobile et la
Broyeuse de chocolat
Ink on paper 18.8 × 14.1 (7³/₈ × 5⁹/₁₆)
Centre Georges Pompidou, Paris. Musée
national d'art moderne

Churn 1914*
Baratte
Ink and pencil on paper 7.6 × 19.1
(3 × 7¹/₂)
Centre Georges Pompidou, Paris. Musée
national d'art moderne

Sketch for the Sieves 1914*
Croquis pour les Tamis
Ink on paper 11.9 × 11
(4¹¹/₁₆ × 4⁵/₁₆)
Centre Georges Pompidou, Paris. Musée
national d'art moderne

Intention, Fear and Desire 1915*
'1 l'intention / 2 la crainte / 3 désir'
Crayon on paper 20 × 15.8 (7⁷/₈ × 6¹/₄)
Centre Georges Pompidou, Paris. Musée
national d'art moderne
[fig.17]

L.H.O.O.Q. 1919*
Pencil on photographic reproduction
19.6 × 12.3 (7³/₄ × 4⁷/₈)
Private collection
[fig.18]

Beautiful Breath, Veil Water 1921
Belle Haleine, Eau de voilette
Perfume bottle with label created by
Duchamp and Man Ray in a cardboard
box 16.3 × 11.2 (6³/₈ × 4³/₈)
Yves Saint Laurent - Pierre Bergé
[fig.181]

Study for 'Given' 1947*
Etude pour 'Etant donnés'
Textured wax and ink on yellow-board
paper and gelatin silver prints, mounted
on board 43.2 × 30.5 (17 × 12)
Private collection
[fig.283]

Female Fig Leaf 1950, cast 1961
Feuille de vigne femelle
Bronze 9 × 13.7 × 12.5
(3⁹/₁₆ × 5³/₈ × 4¹⁵/₁₆)
Tate. Purchased with assistance from the
National Lottery through the Heritage
Lottery Fund 1997
[fig.284]

*Study for the Bride in 'Given: 1. The
Waterfall, 2. The Illuminating Gas'*
1946–66, c.1950*
Etude pour la mariée en 'Etant donnés: 1.
La Chute d'eau, 2. Le Gaz d'éclairage'
Gouache on transparent perforated
Plexiglas 91.3 × 55.9 (35¹⁵/₁₆ × 22)
Jacqueline Matisse Monnier
[fig.282]

Dart Object 1951, cast 1962
Objet-Dard
Bronze 7.8 × 19.7 × 9 (3¹/₁₆ × 7³/₄ × 3⁹/₁₆)
Tate. Purchased with assistance from the
National Lottery through the Heritage
Lottery Fund 1997
[fig.284]

Wedge of Chastity 1954, cast 1963
Coin de chasteté
Bronze and plastic 6.3 × 8.7 × 4.2
(2¹/₂ × 3⁷/₁₆ × 1⁵/₈)
Tate. Purchased with assistance from the
National Lottery through the Heritage
Lottery Fund 1997
[fig.284]

**MARCEL DUCHAMP AND RICHARD
HAMILTON**

1887–1968, born 1922

*The Bride Stripped Bare by her
Bachelors, Even (The Large Glass)*
1915–23 replica 1965–6*
La Mariée mise à nu par ses célibataires,
même
Mixed-media on glass 277.5 × 175.9
(109 × 69¹/₄)
Tate. Presented by William N. Copley
through the American Federation of Arts
1975
[fig.15]

NUSCH ELUARD

1906–1946

Untitled c.1936
Collage on postcard 13.7 × 8.7
(5³/₈ × 3⁷/₁₆)
Karen Amiel Baum, New York

Wood of the Islands c.1936
Bois des Iles
Collage on postcard 13.7 × 8.6 (5³/₈ × 3³/₈)
Timothy Baum, New York
[fig.91]

GILLES EHRMANN

born 1928

Joyce Mansour c.1958
Photograph 18 × 13 (7¹/₁₆ × 5¹/₈)
Private collection, Paris
[fig.90]

*Jean Benoît in front of the Costume for
'The Execution of the Testament of the
Marquis de Sade'* 1959
Photograph 30 × 24 (11¹³/₁₆ × 9⁷/₁₆)
Private collection, Paris
[fig.276]

?LOUISE ERNST

[dates unknown]

Max Ernst, Gala Eluard and Paul Eluard
in the Tyrol 1922
Modern photograph 13.6 × 22.5
(5³/₈ × 8⁷/₈)
Musée d'art et d'histoire, Saint-Denis
[fig.105]

MAX ERNST

1891–1976

Aquis Submersus 1919
Oil on canvas 54 × 43.8 (21¹/₄ × 17¹/₄)
Städtische Galerie im Städelschen
Kunstinstitut, Frankfurt am Main
[fig.43]

Men Shall Know Nothing of This 1923
Les Hommes n'en sauront rien
Oil on canvas 80.3 × 63.8
(31³/₄ × 25¹/₄)
Former collection André Breton
Tate. Purchased 1960
[fig.42]

Pietà or Revolution by Night 1923
Pietà ou La Révolution la nuit
Oil on canvas 116.2 × 88.9 (45⁵/₈ × 35)
Former collection Paul Eluard
Tate. Purchased 1981
[fig.52]

Gala Eluard c.1924
India ink on paper 20.6 × 17.6
(8¹/₈ × 6¹⁵/₁₆)
Former collection Paul Eluard
Musée d'art et d'histoire, Saint-Denis.
Purchased with the assistance of FRAM
[fig.107]

Five Portraits of Gala c.1924
China ink on paper 20.6 × 17.6
(8¹/₈ × 6¹⁵/₁₆)
Former collection Paul Eluard
Musée d'art et d'histoire, Saint-Denis.
Purchased with the assistance of FRAM

*Two Children Are Threatened by a
Nightingale* 1924*
Deux enfants sont menacés par un
rossignol
Oil on wood with wood construction
69.8 × 57.1 × 11.4 (27¹/₂ × 22¹/₂ × 4¹/₂)
The Museum of Modern Art, New York.
Purchase 1937
[fig.50]

*Mobile Object Recommended to
Families* 1936
Objet mobile recommandé aux familles
Wood and hemp 98.5 × 57.5 × 46
(38³/₄ × 22⁵/₈ × 18¹/₈)
Stiftung Wilhelm Lehmbruck Museum,
Duisburg
[fig.44]

The Robing of the Bride 1940
L'Habillement de la mariée
Oil on canvas 129.6 × 96.3 (51 × 38)
Peggy Guggenheim Collection, Venice.
Solomon R. Guggenheim Foundation,
New York
[fig.53]

Alice in 1941 1941
Alice en 1941
Oil on paper mounted on canvas
40 × 32.3 (15³/₄ × 12³/₄)
The Museum of Modern Art, New York .
James Thrall Soby Bequest
[fig.32]

LEONOR FINI
1908–1996

The Ends of the Earth 1949
Le Bout du monde
Oil on canvas 35 × 28 (13³/₄ × 11)
Private collection
[fig.35]

WILHELM FREDDIE
1909–1995

Sex-paralysappeal 1936*
Painted plaster, glass, rope, wood, suede
64.5 cm high (25³/₈)
Nordjyllands Kunstmuseum, Aalborg
[fig.226]

The Definite Rejection of a Request for a Kiss 1940
Det definitive Afslag på Anmodningen
om et Kys
Oil on wood 21 × 33.5 (8¹/₄ × 13³/₁₆)
Birger Raben-Skov, Copenhagen
[fig.227]

ALBERTO GIACOMETTI
1901–1966

Standing Woman 1928*
Femme debout
Bronze 39.5 × 16.5 × 8 (15¹/₂ × 6⁵/₈ × 3)
Alberto Giacometti-Stiftung,
Dauerleihgabe Kunsthaus Zürich
[fig.89]

Reclining Woman who Dreams 1929,
cast 1959 or 1960
Femme couchée qui rêve
Painted bronze 23.5 × 42.8 × 14.6
(9¹/₄ × 16⁷/₈ × 5³/₄)
Hirshhorn Museum and Sculpture
Garden, Smithsonian Institution. Gift of
Joseph H. Hirshhorn, 1966
[fig.87]

Three Figures Outdoors 1929
Trois figures au dehors
Bronze 51.5 × 38.5 × 9
(20¹/₄ × 15¹/₈ × 3¹/₂)
Art Gallery of Ontario, Toronto.
Purchase, 1984
[fig.262]

Woman 1929*
Femme
Bronze 48 × 39 × 8.5 (18⁷/₈ × 15³/₈ × 3³/₈)
Alberto Giacometti-Stiftung,
Dauerleihgabe Kunsthaus Zürich
[fig.88]

The Cage 1930–1*
La Cage
Wood 49 × 26.5 × 26.5
(19¹/₄ × 10³/₈ × 10³/₈)
Moderna Museet, Stockholm
[fig.261]

Disagreeable Object to be Thrown Away 1931*
Objet désagréable, à jeter
Wood 19.6 × 31 × 29
(7¹¹/₁₆ × 12³/₁₆ × 11⁷/₁₆)
Scottish National Gallery of Modern Art,
Edinburgh
[fig.264]

Woman with her Throat Cut 1932*
Femme égorgée
Bronze 22 × 87.5 × 53.5
(8⁵/₈ × 29¹/₂ × 22⁷/₈)
Scottish National Gallery of Modern Art,
Edinburgh
[fig.263]

Woman with her Throat Cut 1932†
Femme égorgée
Bronze 22 × 75 × 58
(8⁵/₈ × 29¹/₂ × 22⁷/₈)
The Museum of Modern Art, New York.
Purchased, 1949

The Invisible Object (Hands Holding the Void) 1934, cast 1935*
L'Objet invisible (Mains tenant le vide)
Bronze 153 × 32.6 × 29.8
(60¹/₄ × 12⁷/₈ × 11³/₄)
National Gallery of Art, Washington,
D.C., Ailsa Mellon Bruce Fund
[fig.54]

The Invisible Object (Hands Holding the Void) 1934, cast *c.*1954–5†
L'Objet invisible (Mains tenant le vide)
Bronze 153 × 32.6 × 29.8
(60¹/₄ × 12⁷/₈ × 11³/₄)
The Museum of Modern Art, New York.
Louise Reinhardt Smith Bequest, 1995

ARSHILE GORKY
1904–1948

Diary of a Seducer 1945†
Oil on canvas 127 × 157 (50 × 61¹³/₁₆)
The Museum of Modern Art, New York.
Gift of Mr and Mrs William A. M.
Burden, 1985

Charred Beloved II 1946
Oil on canvas 137 × 101.6 (53¹⁵/₁₆ × 40)
National Gallery of Canada, Ottawa.
Purchased 1971
[fig.93]

GEORGES HUGNET
1906–1974

Untitled 1961
Collage 23.8 × 19 (9³/₈ × 7¹/₂)
D. Grandsart – Galerie Obsis, Paris
[fig.196]

VALENTINE HUGO
1887–1968

Paul Eluard and André Breton on the Ile de Sein 1930
Vintage photograph 14.2 × 8.6
(5⁹/₁₆ × 3³/₈)
Musée d'art et d'histoire, Saint-Denis

Paul and Gala Eluard in the Plaine de la Crau 1931
Vintage photograph 28.6 × 17.6
(11¹/₄ × 6¹⁵/₁₆)
Musée d'art et d'histoire, Saint-Denis

Spirit of the Sunflower 1934
L'Esprit du tournesol
Oil on wood 36 × 25.5 (14³/₁₆ × 10)
Dominique Rabourdin
[fig.140]

VALENTINE HUGO, PAUL ELUARD, ANDRE BRETON AND NUSCH ELUARD
1887–1968, 1895–1952, 1896–1966, 1906–1946

Exquisite Corpse 1934
Cadavre exquis
Crayon on paper 31 × 24 (12³/₁₆ × 9⁷/₁₆)
Musée d'art et d'histoire, Saint-Denis
[fig.12]

VALENTINE HUGO, GRETA KNUTSON, TRISTAN TZARA
1887–1968, 1899–?, 1896–1963

Exquisite Corpse 1929
Cadavre exquis
Crayon on paper 32.5 × 25 (12¹³/₁₆ × 9¹³/₁₆)
Centre Georges Pompidou, Paris. Musée
national d'art moderne

RADOVAN IVSIC
born 1921

Soundtrack from the *EROS* Exhibition
1959
Sound recording 4 minutes, 5 seconds
Radovan Ivsic

FRIDA KAHLO
1907–1954

Self-Portrait with Cropped Hair 1940
Autorretrato con pelo cortado
Oil on canvas 40 × 27.9 (15³/₄ × 11)
The Museum of Modern Art, New York.
Gift of Edgar Kaufmann, Jr., 1943
[fig.192]

Self-Portrait with Monkey 1940
Autorretrato con mono
Oil on masonite 55 × 43.5 (21 × 16³/₄)
Madonna
[fig.193]

WILFREDO LAM
1902–1982

The Casting of the Spell (Personnage) 1947
Oil on burlap 109.5 × 91.5 (43¹/₈ × 36)
Santa Barbara Museum of Art, Gift of
Wright S. Ludington
[fig.94]

ALBERT VAN LOOK
[dates unknown]

The Belgian Surrealist Group 1953
Vintage photograph 10.9 × 10.6
(4⁵/₁₆ × 4³/₁₆)
Galerie 1900-2000, Marcel and David
Fleiss, Paris

DORA MAAR
1907–1997

Untitled 1933–4*
Gelatin silver print glued on cardboard
photomontage 37.5 × 27 (14³/₄ × 10⁵/₈)on
card 40.1 × 28.9 (15¹³/₁₆ × 11³/₈)
Centre Georges Pompidou, Paris. Musée
national d'art moderne
[fig.69]

Legs I, Legs II 1935
Jambes I, Jambes II
Two silver gelatin prints framed together
28.5 × 22.5 (11¹/₄ × 8⁷/₈)
Roger Thérond Collection
[fig.216]

RENE MAGRITTE
1898–1967

A Courtesan's Palace 1928
Le Palais d'une courtisane
Oil on canvas 54 × 73 (21¼ × 28¾)
The Menil Collection, Houston
[fig.268]

The Elusive Woman 1928
La Femme introuvable
Oil on canvas 81 × 116 (31⅞ × 45⅝)
Private collection
[fig.60]

The Lovers 1928
Les Aimants
Oil on canvas 54 × 73.4 (21⅜ × 28⅞)
The Museum of Modern Art, New York.
Fractional and promised gift of Richard
S. Zeisler, 1998
[fig.61]

The Rape 1934
Le Viol
Oil on canvas 77.5 × 58.7 (28⅞ × 21½)
The Menil Collection, Houston
[fig.269]

MAN RAY
1890–1976

Self-Portrait 1916
Autoportrait
Gelatin silver print 28 × 20.5 (11 × 8¹/₁₆)
Private collection
[fig.178]

Man 1918
L'Homme
Gelatin silver print 48.3 × 36.8
(19 × 14½)
Jedermann Collection, N.A.
[fig.168]

The Enigma of Isidore Ducasse 1920,
replica 1970*
L'Enigme d'Isidore Ducasse
Sewing machine, wood, fabric, card
38 × 53 × 23 (14¹⁵/₁₆ × 20⅞ × 9¹/₁₆)
Lucien Treillard
[fig.70]

Man 1920
L'Homme
Gelatin silver print 39 × 29
(14¹⁵/₁₆ × 11⁷/₁₆)
Marguerite Arp Foundation, Locarno
[fig.167]

Barbette Dressing 1920s
Gelatin silver print 10.5 × 7.5
(4⅛ × 2⅞)
The Metropolitan Museum of Art, New
York. Ford Motor Company Collection,
Gift of Ford Motor Company and John C.
Waddell, 1987
[fig.180]

Rrose Sélavy 1921*
Gelatin silver print 17.5 × 12.5
(6⅞ × 4¹⁵/₁₆)
Jacqueline Matisse Monnier
[fig.173]

Rrose Sélavy 1921*
Sepia-toned print 14.9 × 11 (5⅞ × 4⁵/₁₆)
Private collection
[fig.174]

Rrose Sélavy c.1924*
Gelatin silver print 21.7 × 17.9
(8⁹/₁₆ × 7¹/₁₆)
Private collection
[fig.175]

Rrose Sélavy c.1924*
Gelatin silver print 13.5 × 10.7
(5½ × 4¼)
Private collection
[fig.176]

Indestructible Object 1923, remade
1965
Objet indestructible
Wooden metronome and photograph
Height 22.2 (8¾)
Tate. Purchased 2000

Gala Eluard c.1924
Vintage photograph 21.5 × 16.1
(8⁷/₁₆ × 6⁵/₁₆)
Musée d'art et d'histoire, Saint-Denis.
Purchased with the assistance of FRAM

*Inside the Central Office of Surrealist
Research* 1924
La Centrale surréaliste
Modern photograph 17 × 23
(6¹¹/₁₆ × 9¹/₁₆)
Private collection
[fig.4]

*André Breton, Max Morise, Roland
Tual; Simone Breton, Louis Aragon,
Colette Tual* 1925
Modern photograph 8.5 × 8.5
(3⅜ × 3⅜)
Private collection

Kiki de Montparnasse as Odalisque
c.1925*
Vintage photograph 12 × 17.5
(4¾ × 6⅞)
Lucien Treillard
[fig.143]

Untitled 1926
Sans titre
Gelatin silver print 28.2 × 18.1
(11⅛ × 7⅛)
Roger Thérond Collection
[fig.217]

Nancy Cunard c.1928
Vintage photograph 27.7 × 22
(10⅞ × 8¹¹/₁₆)
Private collection
[fig.116]

Suzanne Muzard c.1928
Modern photograph 22.7 × 17.5
(8¹⁵/₁₆ × 6⅞)
Private collection

Anatomies 1929
Gelatin silver print 22.6 × 17.2
(8⅞ × 6¾)
Museum of Modern Art, New York. Gift
of James Thrall Soby
[fig.212]

Primacy of Matter over Thought 1929
Primat de la matière sur la pensée
Gelatin silver print 20.8 × 29.1
(8³/₁₆ × 11⁷/₁₆)
Manfred Heiting, Amsterdam
[fig.10]

Youki Desnos Foujita 1929
Gelatin silver print 12 × 9.2 (4¾ × 3⅝)
Centre Georges Pompidou, Paris. Musée
national d'art moderne
[fig.121]

Lee's Eye c.1929–30
Vintage photograph
7.9 × 10.5 (3⅛ × 4⅛)
A. & R. Penrose
[fig.147]

*Georges and Yvette Malkine, André
de la Rivière, Robert Desnos and the
sculptor Lasserre* 1930*
Modern photograph 9.1 × 8.4
(3⁹/₁₆ × 3⁵/₁₆)
Lucien Treillard
[fig.119]

Lee Miller (Torso) c.1930
Gelatin silver print 29.6 × 22.5
(11⅝ × 8⅞)
A. & R. Penrose
[fig.215]

Lee Miller (Neck) c.1930
Gelatin silver print 22.5 × 18 (8⅞ × 7¹/₁₆)
A. & R. Penrose
[fig.213]

Louis Aragon c.1930
Vintage photogaph 22.4 × 16.4
(8¹³/₁₆ × 6⁷/₁₆)
Fonds Elsa Triolet/Aragon – C.N.R.S.

*Marie-Berthe Aurenche, Max Ernst,
Lee Miller, Man Ray* c.1930*
Vintage photograph 13.5 × 5 (5⁵/₁₆ × 4½)
Lucien Treillard
[fig.155]

*Surrealists in front of Tristan Tzara's
Studio, Paris* 1930
Vintage photograph 10 × 13.5
(3¹⁵/₁₆ × 5⁵/₁₆)
Musée d'art et d'histoire, Saint-Denis
[fig.5]

Valentine Hugo c.1930
Modern photograph 22.8 × 17.2
(9 × 6¾)
Private collection

Elizabeth Lee 1932
Drawing on paper 27 × 21 (8¹³/₁₆ × 6⁷/₁₆)
A. & R. Penrose
[fig.145]

Valentine Penrose c.1932
Vintage photograph 23.7 × 17.9
(9⁵/₁₆ × 7¹/₁₆)
A. & R. Penrose
[fig.148]

The Lovers (My Dream) 1933, remade
1973*
Les Amoureux (Mon rêve)
Lead, rope, paint 72.5 × 26
(28⁹/₁₆ × 10¼)
Lucien Treillard
[fig.144]

*Untitled (from the 'Veiled Erotic'
series)* 1933*
Sans titre (de la série 'Erotique voilée')
Vintage photograph 11.5 × 8.5
(4½ × 3⅜)
Lucien Treillard
[fig.218]

Veiled Erotic 1933*
Erotique voilée
Vintage photograph 11.5 × 8.5
(4½ × 3⅜)
Lucien Treillard
[fig.219]

Nusch Eluard c.1933–5*
Vintage photograph 11.5 × 6 (4½ × 2⅜)
Lucien Treillard

Gisèle Prassinos Reading her Poems
1934
Modern photograph 17 × 23
(6¹¹/₁₆ × 9¹/₁₆)
Private collection

Minotaur 1934
Minotaure
Gelatin silver print 15 × 23.3 (5⅞ × 9³/₁₆)
Michael Senft, New York
[fig.214]

Hands of Gala and Dalí 1936*
Vintage photograph 13.7 × 9 (5⅜ × 3½)
Lucien Treillard
[fig.126]

Nusch Eluard and Ady Fidelin c.1937
Gelatin silver print 11 × 8.3 (4⁵/₁₆ × 3¹/₂)
Centre Georges Pompidou, Paris. Musée
national d'art moderne
[fig.137]

Optical Hopes and Illusions 1944
Wood, string, glass 53.3 × 17.7 × 11.5
(21 × 6¹⁵/₁₆ × 4¹/₂)
Private collection
[fig.71]

Juliet c.1945*
Vintage photograph 19.1 × 15.2
(7¹/₂ × 6)
Lucien Treillard

MARIA
1900–1973

The Impossible III 1946
Bronze 80 × 82.5 × 53.3
(31¹/₂ × 32¹/₂ × 21)
The Museum of Modern Art, New York.
Purchase, 1946
[fig.285]

Eighth Veil 1949
Le Huitième Voile
Polished bronze 104 × 114.3 × 94
(41 × 45 × 37)
Anna Maria Martins Turner
[fig.286]

ANDRE MASSON
1896–1987

Women 1922
Femmes
Ink and gouache on paper 40 × 31
(15³/₄ × 12³/₁₆)
Private collection, Paris
[fig.244]

The Armour 1925
L'Armure
Oil on canvas 80.6 × 54 (31⁷/₈ × 21¹/₄)
Former collection Georges Bataille
Peggy Guggenheim Collection, Venice.
Solomon R. Guggenheim Foundation,
New York
[fig.77]

Birth of Birds 1925
La Naissance des oiseaux
Pen and ink on paper 41.9 × 31.4
(16¹/₂ × 12³/₈)
The Museum of Modern Art, New York.
Purchase
[fig.80]

Vegetable Delirium 1925
Délire végétal
Ink on paper 42.5 × 30.5 (16³/₄ × 12)
Private collection, Paris
[fig.79]

Children of the Islands 1926–7
Enfants des Iles
Oil on canvas 92 × 60 (36¹/₄ × 23⁵/₈)
Former collection Jacques Lacan
Private collection, Paris
[fig.78]

Drawing for Histoire de l'oeil 1928
Pencil on tracing paper 25 × 20
(9¹³/₁₆ × 7⁷/₈)
Mony Vibescu
[fig.224]

Drawing for Histoire de l'oeil 1928
Pencil on tracing paper 25 × 20
(9¹³/₁₆ × 7⁷/₈)
Mony Vibescu
[fig.222]

Drawing for Justine 1928
Collage, ink and watercolour on paper
47 × 36 (18¹/₂ × 14³/₁₆)
Private collection, Paris
[fig.246]

Erotic Land 1937
Terre érotique
Ink and watercolour on paper
50.5 × 65.5 (19⁷/₈ × 25¹³/₁₆)
Private collection, Paris
[fig.249]

Ariadne's Thread 1938
Le Fil d'Arianne
Oil and sand on board 22 × 27
(8⁵/₈ × 10⁵/₈)
Private collection, Paris
[fig.81]

Gradiva 1939
Oil on canvas 97 × 130 (38¹/₈ × 51¹/₈)
Private collection
[fig.46]

ROBERTO MATTA
born 1911

The 120 Days of Sodom 1944
Les 120 Jours de Sodome
Wax crayon and pencil on paper
29.5 × 37 (11⁵/₈ × 14⁹/₁₆)
Private collection, Paris, courtesy Galerie
de France, Paris
[fig.247]

I Shame Myself / I Ascend 1948–9
Je m'honte
Oil on canvas 195 × 141,9 (76³/₄ × 55⁷/₈)
The Menil Collection, Houston
[fig.248]

LEE MILLER
1907–1977

Nude Bent Forward c.1931
Gelatin silver print 20 × 17.5 (7⁷/₈ × 6⁷/₈)
The Art Institute of Chicago, Julian Levy
Collection, Gift of Jean Levy and the
Estate of Julien Levy
[fig.197]

Leonora Carrington 1939
Modern photograph 25.5 × 25.5
(10¹/₁₆ × 10¹/₁₆)
Lee Miller Archives
[fig.156]

*Max Ernst and Dorothea Tanning at
Sedona* 1946
Modern photograph 25.5 × 25.5
(10¹/₁₆ × 10¹/₁₆)
Lee Miller Archives
[fig.157]

JOAN MIRO
1893–1983

*Lady Strolling on the Rambla in
Barcelona* 1925
Dame se promenant sur la Rambla de
Barcelone
Oil on canvas 132 × 97 (51¹/₄ × 38³/₈)
New Orleans Museum of Art. Bequest of
Victor K. Kiam
[fig.83]

Love 1925
Amour
Oil on canvas 74.3 × 92 (29¹/₄ × 35¹/₄)
Mr and Mrs Ahmet Ertegun
[fig.20]

The Red Spot 1925*
La Tache rouge
Oil on canvas 116 × 114 (45³/₁₆ × 44¹/₂)
Museo Nacional Centro de Arte Reina
Sofía, Madrid
[fig.84]

Stars in the Sexes of Snails 1925*
Etoiles en des sexes d'escargot
Oil on canvas 129.5 × 97 (51 × 38¹/₈)
Kunstsammlung Nordrhein-Westfalen,
Düsseldorf
[fig.82]

*A Star Caresses the Breast of a Negress
(Painting-Poem)* 1938
Une Etoile caresse le sein d'une négresse
(peinture-poème)
Oil on canvas 129.5 × 194.3 (51 × 76¹/₂)
Tate. Purchased 1983
[fig.19]

*The Beautiful Bird Revealing the
Unknown to a Pair of Lovers* 1941
Le Bel Oiseau déchiffrant l'inconnu au
couple d'amoureux
Gouache and oil wash on paper
45.7 × 38 (18 × 15)
The Museum of Modern Art, New York.
Acquired through the Lillie P. Bliss
Bequest
[fig.92]

*Women at the Border of a Lake
Irradiated by the Passage of a Swan*
1941
Femmes au bord du lac à la surface
irisée par le passage d'un cygne
Gouache and oil wash on paper
46 × 38.1 (18¹/₈ × 15)
Private collection
[fig.76]

PIERRE MOLINIER
1900–1976

Celestial Pantomime II c.1970
Pantomime céleste II
Gelatin silver print with ink 18 × 12.5
(7¹/₁₆ × 4¹⁵/₁₆)
Maison Européenne de Photographie,
Paris
[fig.280]

Introit c.1970
Gelatin silver print with ink 12.2 × 14.4
(4¹⁵/₁₆ × 5¹¹/₁₆)
Maison Européenne de la Photographie,
Paris
[fig.279]

The Stylite c.1970
Le Stylite
Gelatin silver print with ink 23.8 × 17.7
(9³/₈ × 6¹⁵/₁₆)
Maison Européenne de la Photographie,
Paris
[fig.278]

Victory c.1970
La Victoire
Gelatin silver print 16.5 × 20.2
(6^1/$_2$ × 7^{15}/$_{16}$)
Maison Européenne de la Photographie,
Paris
[fig.277]

HENRY MOORE
1898–1986

Figure 1933–4
Corsehill stone 74 × 40 × 43
(29^1/$_8$ × 15^3/$_4$ × 16^{15}/$_{16}$)
Private collection, courtesy Pieter Coray
[fig.39]

NADJA
1902–1941

The Lovers' Flower 1926
Le Fleur des amants
Pencil on paper 29 × 21.5 (11^7/$_{16}$ × 8^7/$_{16}$)
Pierre Leroy, Paris
[fig.112]

Portrait of a Woman [Self-Portrait?]
c.1926–7
Portrait de femme [Autoportrait?]
Pencil on paper 29 × 43 (11^7/$_{16}$ × 16^{15}/$_{16}$)
Pierre Leroy, Paris

MERET OPPENHEIM
1913–1985

*Ma Gouvernante – My Nurse – Mein
Kindermädchen* 1936*
Metal, shoes, string and paper
14 × 21 × 33 (5^1/$_2$ × 8^1/$_4$ × 13)
Moderna Museet, Stockholm
[fig.30]

Object (Le Déjeuner en fourrure) 1936*
Objet (Le Déjeuner en fourrure)
Fur-covered cup, saucer and spoon
7.3 high (2^7/$_8$ high)
The Museum of Modern Art, New York.
Purchase 1946
[fig.55]

MIMI PARENT
born 1924

Mistress 1996
Maîtresse
Hair, leather, wood 47.5 × 24 × 5.5
(18^{11}/$_{16}$ × 9^7/$_{16}$ × 2^3/$_{16}$)
Mony Vibescu
[fig.257]

ROLAND PENROSE
1900–1984

*Paul and Nusch Eluard at Downshire
Hill, London* 1936
Modern photograph 26.5 × 32.5
(10^7/$_{16}$ × 12^{13}/$_{16}$)
Lee Miller Archives
[fig.136]

*Leonora Carrington, Nusch Eluard,
Ady Fidelin, Lee Miller in Cornwall*
1937
Modern photograph 40.6 × 30.5
(16 × 12)
Lee Miller Archives
[fig.18]

Picasso and Dora Maar at Mougins
1937
Modern photograph 40.6 × 30.5
(16 × 12)
Lee Miller Archives

Picnic at Mougins 1937
Modern photograph 30.5 × 40.6
(12 × 16)
Lee Miller Archives
[fig.151]

Winged Domino: Portrait of Valentine
1938
Oil on canvas 60 × 46 (23^5/$_8$ × 18^1/$_8$)
Private collection
[fig.149]

FRANCIS PICABIA
1879–1953

Paroxysm of Suffering 1915*
Paroxysme de la douleur
Oil and metallic paint on cardboard
80 × 80 (31^3/$_1$ × 31^3/$_{16}$)
National Gallery of Canada, Ottawa.
Purchased 1982
[fig.169]

The Fiancé c.1915–17
Le Fiancé
Gouache and metallic paint on canvas
26.5 × 33.5 (10^7/$_{16}$ × 13^3/$_{16}$)
Musée d'Art Moderne, Saint-Etienne
[fig.170]

PABLO PICASSO
1882–1973

The Scream 1927
Le Cri
Oil on canvas 55.2 × 33.7 (21^3/$_4$ × 13^1/$_4$)
The Metropolitan Museum of Art, New
York. Jacques and Natasha Gelman
Collection, 1998
[fig.266]

Head: Study for Monument 1929
Tête: Etude pour monument
Oil on canvas 71.8 × 59.7 (28^3/$_4$ × 23^1/$_2$)
Baltimore Museum of Art: The Dexter
M. Ferry, Jr. Trustee Corporation Fund
(BMA 1966.41)
[fig.24]

Nude Standing by the Sea 1929
Nu debout au bord de la mer
Oil on canvas 129.9 × 96.8 (51^1/$_8$ × 38^1/$_8$)
The Metropolitan Museum of Art, New
York. Bequest of Florene M. Schoenborn,
1995
[fig.267]

JINDŘICH ŠTYRSKÝ
1899–1942

Sexual Nocturne 1931
Sexuálnï nocturno
Collage and ink on paper 20.1 × 15.5
(7^{15}/$_{16}$ × 6^1/$_8$)
Mony Vibescu

Sexual Nocturne 1931
Sexuálnï nocturno
Collage and ink on paper 18.5 × 14
(7^5/$_{16}$ × 5^1/$_2$)
Mony Vibescu
[fig.237]

Sexual Nocturne 1931
Sexuálnï nocturno
Collage and ink on paper 23.3 × 17.7
(9^3/$_{16}$ × 6^{15}/$_{16}$)
Mony Vibescu
[fig.238]

*Untitled (Emilie Comes to Me in a
Dream, No.1)* 1933
Collage 24.3 × 18.5 (9^9/$_{16}$ × 7^5/$_{16}$)
Ubu Gallery, New York
[fig.234]

*Untitled (Emilie Comes to Me in a
Dream, No.5)* 1933
Collage 20.9 × 17.7 (8^1/$_4$ × 6^{15}/$_{16}$)
Ordóñez Falcón Collection of
Photography
[fig.236]

*Untitled (Emilie Comes to Me in a
Dream, No.6)* 1933
Collage 30 × 22.8 (11^{13}/$_{16}$ × 9)
Thomas Walther
[fig.235]

French Cardinal 1941
Le Cardinal français
Collage 23.5 × 15 (9^1/$_4$ × 5^7/$_8$)
Private collection, Paris
[fig.29]

YVES TANGUY
1900–1955

Erotic Drawing 1928
Dessin érotique
Indian ink on paper 45.5 × 29.5
(17^{15}/$_{16}$ × 11^5/$_8$)
Mony Vibescu
[fig.251]

Erotic Drawing 1928
Dessin érotique
Indian ink on paper 20 × 13 (7^7/$_8$ × 5^1/$_8$)
Mony Vibescu
[fig.250]

DOROTHEA TANNING
born 1910

Birthday 1942
Oil on canvas 102.2 × 64.8
(40^1/$_4$ × 25^1/$_2$)
Philadelphia Museum of Art. Purchased
with funds contributed by Charles K.
Williams II, 1999
[fig.191]

Eine Kleine Nachtmusik 1943
Oil on canvas 40.7 × 61 (16 × 24)
Tate. Purchased with assistance from the
National Art Collections Fund and the
American Fund for the Tate Gallery 1997
[fig.33]

The Mirror 1950
Oil on canvas 30.5 × 46.4 (12 × 18^1/$_4$)
Arno Schefler
[fig.34]

Rainy-Day Canapé 1970
Canapé en temps de pluie
Tweed upholstered wood sofa, wool,
table-tennis balls, cardboard
81.9 × 174 × 109.9 (32^1/$_4$ × 68^1/$_2$ × 43^1/$_4$)
The artist, courtesy Cavaliero Fine Arts,
New York
[fig.291]

Emma 1970
Fabric, wool, lace
29.5 × 64.5 × 54.9 (11^{11}/$_{16}$ × 25^3/$_8$ × 21^5/$_8$)
The artist, courtesy Cavaliero Fine Arts,
New York
[fig.290]

KAREL TEIGE
1900–1951

Untitled 1938
Collage 38.8 × 51 (15^1/$_4$ × 20^1/$_8$)
Museum of Czech Literature, Prague
[fig.221]

Untitled 1947
Collage
49.8 × 36 (19⁵/₈ × 14³/₁₆)
Museum of Czech Literature, Prague
[fig.220]

TOYEN
1902–1980

Young Girl Who Dreams 1930
Jeune fille qui rêve
Ink and watercolour on paper 20 × 17
(7⁷/₈ × 6¹¹/₁₆)
Mony Vibescu
[fig.232]

Hermaphrodite with Shell 1930–1
Hermaphrodite au coquillage
Ink on paper 27 × 21 (10⁵/₈ × 8¹/₄)
Mony Vibescu
[fig.230]

Screen 1966
Paravent
Oil on collage on canvas 116 × 73
(45¹¹/₁₆ × 28³/₄)
Musée d'art moderne de la Ville de Paris
[fig.287]

RAOUL UBAC
1910–1985

Untitled 1938
Gelatin silver print 22.5 × 16.5
(8⁷/₈ × 6¹/₂)
Former collection Jacques Hérold
Private collection
[fig.28]

Group 1 1939
Groupe 1
Gelatin silver print 38.7 × 29.3
(15¹/₈ × 11³/₈)
Claude Berri
[fig.27]

REMEDIOS VARO
1908–1963

Woman Leaving the Psychoanalyst
1960
Mujer saliendo del psicoanalista
Oil on canvas 70.5 × 40.5 (27³/₄ × 15¹⁵/₁₆)
Private collection, Mexico City
[fig.289]

MANUSCRIPTS

LOUIS ARAGON
1896–1966

L'Extra (extract from *Le Libertinage*)
*c.*1920
Manuscript with a drawing by Louis
Aragon and diverse documents, bound
by Paul Eluard 22 × 17.5 (8¹¹/₁₆ × 6⁷/₈)
Pierre Leroy, Paris

Idylle *c.*1920
Poem by Louis Aragon copied out by
André Breton 25.3 × 20 (9¹⁵/₁₆ × 7⁷/₈)
Fonds Elsa Triolet/Aragon - C.N.R.S.

Le Paysan de Paris 1926
Manuscript on paper
Two pages, each 26.8 × 21 (10⁹/₁₆ × 8¹/₄)
Fonds Elsa Triolet/Aragon - C.N.R.S.

*Poème écrit dans les toilettes avec un
couteau sur le mur* 1930
Manuscript on paper 29.7 × 21
(11¹¹/₁₆ × 8¹/₄)
Private collection
[fig.117]

ANDRE BRETON
1896–1966

Tournesol 1923
Manuscript on paper 24.5 × 20.1
(9⁵/₈ × 7¹⁵/₁₆)
Fonds Elsa Triolet/Aragon – C.N.R.S.

Nadja 1927
Bound manuscript on paper with letters,
postcards and drawings by Nadja, and
various photographic documents
32 × 23 (12⁵/₈ × 9¹/₁₆)
Yves Saint Laurent – Pierre Bergé
[figs.22, 108, 111]

Letter to Claude Cahun, dated 28 April
1936
Manuscript on paper 26.9 × 21.1
(10⁹/₁₆ × 8⁵/₁₆)
Private collection

Arcane 17 1944
Manuscript on paper, bound specially
for Elisa Breton, with various additional
elements 24 × 20 (9⁷/₁₆ × 7⁷/₈)
Lucienne Talheimer binding
Private collection
[figs.96, 97]

ANDRE BRETON AND PAUL ELUARD
Pages from chapter on 'Love' in
'L'Immaculée Conception' 1930
Manuscript on paper
Each page 32.8 × 25.5 (12¹⁵/₁₆ × 10¹/₁₆)
Musée national Picasso, Paris
[fig.129]

CLAUDE CAHUN
1894–1954

Les Jeux uraniens *c.*1916–19
Typescript on paper with hand additions
27.3 × 21.3 (10³/₄ × 8³/₈)
Courtesy of the Jersey Heritage Trust

RENE CHAR
1907–1988

Artine 1930
Manuscript on paper with photographic
portrait of Char by Man Ray
30.2 × 25.5 (11⁷/₈ × 10¹/₁₆)
Dedication to Yvonne Zervos
Pierre Leroy, Paris

MAN RAY
1890–1976

'My darling Lee', letter dated 'Saturday
Morning' *c.*1930
Typed and signed letter, 2 pages
Each 26.5 × 21 (10⁷/₁₆ × 8¹/₄)
A. & R. Penrose

Miss You *c.*1950*
Postcard 13.9 × 10.4 (5¹/₂ × 4¹/₈)
Lucien Treillard
[fig.146]

NORA MITRANI
1921–1961

Toi l'amour incorrigible 1948
Typescript with manuscript additions
[dated 28 March 1948]
27 × 21 (10⁵/₈ × 8¹/₄)
Private collection, Paris

NADJA
1902–1941

Poems 1926
Manuscript on paper [dated December
1926] 22.2 × 16.9 (8³/₄ × 6 /58)
Pierre Leroy, Paris
[fig.110]

Letter to André Breton 1927
Manuscript on paper [dated 20 January
1927] 22.2 × 16.9 (8³/₄ × 6⁵/₈)
Pierre Leroy, Paris

Letter to André Breton 1927
Manuscript on paper [dated 25 February
1927] 22.2 × 16.9 (8³/₄ × 6⁵/₈)
Pierre Leroy, Paris

ROLAND PENROSE
1900–1984

The Road Is Wider than Long 1938
Manuscript book 20.7 × 17.2
(8¹/₈ × 6³/₄)
A. & R. Penrose
[fig.153]

PABLO PICASSO
1881–1973

Automatic Text, dated 28 April 1936
(State II, State IV†)
Ink on paper
30 × 20 (11¹³/₁₆ × 7⁷/₈)
Musée national Picasso, Paris

D.A.F. DE SADE
1740–1814

Letter to Mme de Sade 1783
Manuscript on paper [Donjon de
Vincennes]
19 × 12.5 (7¹/₂ × 4¹⁵/₁₆)
Pierre Leroy, Paris
[fig.242]

Testament of D.A.F. de Sade 1806
Manuscript on paper [Charenton Saint-
Maurice, 1 February 1806] 32 × 24
(12⁵/₈ × 9⁷/₁₆)
Pierre Leroy, Paris

VARIOUS

*Transcript: 'Research on Sexuality'
(first session, 27 January)* 1928
'Recherches sur la
sexualité' (première séance)
Manuscript on paper
Each page 31 × 20 (12³/₁₆ × 7⁷/₈)
Private collection
[fig.31]

Postcards addressed to Man Ray late
1930s*
Postcards
4 elements, each *c.*10 × 15 (3¹⁵/₁₆ × 5⁷/₈)
Lucien Treillard
[fig.152]

BOOKS

When a pseudonym is used, square brackets indicate the real name of author.

LOUIS ARAGON
1897–1982

Le Paysan de Paris
Book 19 × 12 (7$^{1}/_{2}$ × 4$^{3}/_{4}$)
Paris, Editions de la N.R.F. 1926
Copy on best quality wove cotton paper
no.642/900
Benoît Lardières

ANONYMOUS [Louis Aragon]
Voyageur
Book 25 × 16.4 (9$^{13}/_{16}$ × 6$^{7}/_{16}$)
The Hours Press [1927]
Copy no.3/25
Private collection

ALBERT DE ROUTISIE [Louis Aragon]
Le Con d'Irène
Book with illustrations by André Masson
24.5 × 19.7 (9$^{5}/_{8}$ × 7$^{3}/_{4}$)
Without place [Paris] or publisher's
name [René Bonnel] 1928
Copy on Arches laid paper no.106/125
Binding by Leroux 1989
Claude Oterelo

La Grande Gaîté
Book with illustrations by Yves Tanguy
23.8 × 18.5 (9$^{3}/_{8}$ × 7$^{5}/_{16}$)
Paris, Editions Gallimard 1929
Copy on Arches wove paper no.36/50
Private collection

Hourra l'Oural
Book 19 × 14.5 (7$^{1}/_{2}$ × 5$^{11}/_{16}$)
Paris, Editions Denoël 1934
Dedication by Aragon to Elsa Triolet
Private collection

LOUIS ARAGON, BENJAMIN PERET AND MAN RAY

1929
Book with photographs by Man Ray
31 × 21 (12$^{3}/_{16}$ × 8$^{1}/_{4}$)
Without place [Brussels] or publisher's
name [Paul-Gustave Van Hecke] 1929
Unnumbered copy; only known copy on
light green paper
D. Grandsart – Galerie Obsis, Paris

PIETRO ARETINO
1492–1556

Život Kajícnic
The Life of Penitents
Book with illustrations by Toyen
13.4 × 11 (5$^{1}/_{4}$ × 4$^{5}/_{16}$)
Prague, Editions 69, no.4 1933
Copy no.98
Mony Vibescu

GEORGES BATAILLE
1897–1962

LORD AUCH [Georges Bataille]
Histoire de l'oeil
Book with illustrations by André
Masson, and, additionally, a manuscript
by Georges Bataille, 'A Trickle of Blood',
1928 25 × 19.5 (9$^{13}/_{16}$ × 7$^{11}/_{16}$)
Paris, without publisher's name [Pascal
Pia] 1928
One of eight copies on Japon de
Shidzoka paper, printed for Pascal Pia,
and dedicated to Robert Chatté
Pierre Leroy, Paris

PIERRE ANGELIQUE [Georges Bataille]
Mme Edwarda
Book 15.8 × 10.7 (6$^{1}/_{4}$ × 4$^{3}/_{16}$)
Without place, Editions du Solitaire
[Robert Chatté] 1937 [1941]
One of ten copies on tinted Auvergne
mill paper no.13
Dedicated by Georges Bataille to Paul
Eluard (1941), by Paul Eluard to René
Char (1944), and by Georges Bataille to
René Char (1945)
Pierre Leroy, Paris

Mme Edwarda
Book with engravings by Hans Bellmer
[dating from 1955] 40 × 26
(15$^{3}/_{4}$ × 10$^{1}/_{4}$)
Paris, Georges Visat 1965
Copy on Rives wove paper no.54/150
Private collection

HANS BELLMER
1902–1975

La Poupée
Book with gelatin silver prints
16.3 × 12.4 (6$^{7}/_{16}$ × 5)
Paris, G.L.M. 1936
One of twenty copies in Normandy
vellum no.8/100
The Museum of Modern Art, New York.
Purchase

Les Jeux de la poupée
Book with photographs by Bellmer, illus-
trated with texts by Paul Eluard
25.7 × 19.5 (10$^{1}/_{8}$ × 7$^{11}/_{16}$)
Paris, Editions Premières 1949
Musée d'art et d'histoire, Saint-Denis

ANDRE BRETON
1896–1966

Nadja
Book 18.5 × 12.5 (7$^{5}/_{16}$ × 4$^{5}/_{16}$)
Paris, Editions de la N.R.F. 1928
One of thirty 'exemplaires d'auteur',
no.754
Dedicated by Breton to Benjamin Péret
Dominique Rabourdin

Nadja
Book 18.5 × 12.5 (7$^{5}/_{16}$ × 4$^{5}/_{16}$)
Paris, Editions de la N.R.F. 1928
With messages from Breton and Paul
Eluard to Jacqueline Lamba, dated 21
December 1935 [the day after the birth
of Aube Breton], and special slip cover
with three cut-outs with dedication by
Breton
Dominique Rabourdin

Nadja
Book 18.5 × 17 (7$^{5}/_{16}$ × 6$^{7}/_{16}$)
Paris, Editions de la N.R.F. 1928
Reimposed copy no.LXXXIV/109
Photographic binding by Miguet
Private collection

ANONYMOUS [André Breton]
L'Union libre
Book 16.1 × 22.5 (6$^{5}/_{16}$ × 8$^{7}/_{8}$)
Without the author's or publisher's name
1931
Copy on matt grey calendered paper
no.65/65
Private collection

Le Revolver à cheveux blancs
Book with frontispiece etching by
Salvador Dalí, and, additionally, manu-
script poems and two states of the
etching by Dalí 19.5 × 14.5 (7$^{11}/_{16}$ × 5$^{11}/_{16}$)
Paris, Editions des Cahiers Libres 1932
Copy on glossy Japan paper no.3/10
Former collection Valentine Hugo, with
dedication by André Breton to her
Pierre Leroy, Paris

Les Vases communicants
Book with cover design by Max Ernst
18.5 × 13.5 (7$^{5}/_{16}$ × 5$^{5}/_{16}$)
Paris, Editions des Cahiers Libres 1932
Copy on Omnia wove paper
no.1381/2025
Benoît Lardières

Qu'est-ce que le surréalisme?
Book with cover illustration by René
Magritte 25.2 × 16 (9$^{15}/_{16}$ × 6$^{5}/_{16}$)
Brussels, Editions René Henriquez 1933
Dedicated by Breton to Lise Deharme
Private collection

L'Air de l'eau
Book with engravings by Alberto
Giacometti 30.2 × 19.7 (11$^{7}/_{8}$ × 7$^{3}/_{4}$)
Paris, Editions des Cahiers d'Art 1934
Copy on Montval paper no.24/40
Dedicated by Breton to Lise Deharme
Dominique Rabourdin

L'Amour fou
Book 19.5 × 14.3 (7$^{11}/_{16}$ × 5$^{5}/_{8}$)
Paris, Editions Gallimard 1937
Private collection

Arcane 17
Book with frontispiece etching and
plates by Roberto Matta 23 × 16
(9$^{1}/_{16}$ × 6$^{5}/_{16}$)
New York, Brentano's 1944
Copy 'M' on Umbria paper, signed by the
author
Mony Vibescu
[fig.161]

Arcane 17
Book with plates by Matta 23.5 × 16.5
(9$^{1}/_{4}$ × 6$^{1}/_{2}$)
New York, Brentano's 1944
Copy on Oxbow paper no.237/300
Signed by Breton
Miguet binding 1970
Private collection

Ode à Charles Fourier
Book 28.5 × 17.5 (11$^{1}/_{4}$ × 6$^{7}/_{8}$)
Paris, Editions de la Revue Fontaine
1947
Typography and design by Frederick
Kiesler
Copy on Alfa paper no.79/175
Private collection

L'Amour fou
Book 21.7 × 18.4 (8$^{9}/_{16}$ × 7$^{1}/_{4}$)
Paris, Club français du livre 1937, re-edi-
tion 1965
Dedicated by Breton to Jacqueline
Lamba, dated 23 April 1965, with an
original photograph [by Elisa Breton?]
Dominique Rabourdin
[fig.163]

ANDRE BRETON AND PAUL ELUARD
1896–1966, 1895–1952

Prière d'insérer for *Artine* 1930
Insert 21.5 × 16.5 (8$^{7}/_{16}$ × 6$^{1}/_{2}$)
Claude Oterelo
[fig.128]

Prière d'insérer for *La Femme visible*
1930
Insert 21 × 15.1 (8$^{1}/_{4}$ × 5 /516)
Musée d'art et d'histoire, Saint-Denis
[fig.125]

L'Immaculée Conception
Book 23.7 × 18 (9⁵/₁₆ × 7¹/₁₆)
Paris, Editions Surréalistes chez José Corti 1930
Copy on 'imponderable' no.1010/2000
Benoît Lardières

L'Immaculée Conception
Book with frontispiece engraving by Salvador Dalí and, additionally, drawings by Dalí, manuscripts by Breton, Eluard and Jean Cassou, two collages by Breton based on portraits of himself and of Eluard, a photographic portrait of Eluard by Man Ray, and other photographs 25.5 × 19.5 (10⁵/₁₆ × 7¹/₁₆)
Paris, Editions Surréalistes chez José Corti 1930
Copy on glossy white Japan paper no.6/13
Former collection Paul Eluard; with dedication by André Breton
Paul Bonet binding 1941–2
Pierre Leroy, Paris
[figs.95, 130, 131]

CLAUDE CAHUN
1889–1954

Aveux non avenus
Book with photogravures of photomontages by the artist 22 × 17 (8¹¹/₁₆ × 6¹¹/₁₆)
Paris, Editions du Carrefour 1930
Copy on Lafuma best quality wove cotton paper no.134/370
Private collection

LEONORA CARRINGTON
born 1917

La Dame ovale
Book with reproductions of collages by Max Ernst 19 × 14.1 (7¹/₂ × 5⁹/₁₆)
Paris, G.L.M. 1939
Copy on white wove paper no.179/535
Private collection

RENE CHAR
1907–1988

Artine
Book with frontispiece engraving by Salvador Dalí, and, additionally, a drawing attributed to Char, one page of the manuscript, a *prière d'insérer*, and a photographic portrait of Char by Man Ray 24 × 19 (9⁷/₁₆ × 7¹/₂)
Paris, Editions Surréalistes, chez José Corti 1930
Copy on glossy Japan paper no.5/5

Former collection Paul Eluard, with dedication by Char
Paul Bonet binding 1959
Pierre Leroy, Paris
[fig.127]

Artine
Book with frontispiece engraving by Salvador Dalí 24 × 19 (9⁷/₁₆ × 7¹/₂)
Paris, Editions Surréalistes, chez José Corti 1930
Copy on glossy Japan paper no.HC 2/2
Former collection Salvador Dalí; with dedication by Char
Pierre Leroy, Paris

RENE CREVEL
1900–1935

Mr Knife, Miss Fork
Book: part of René Crevel's *Babylon*, translated by Kay Boyle, with photographic reproductions of frottages by Max Ernst 18.5 × 12.2 (7⁵/₁₆ × 4¹³/₁₆)
Paris, The Black Sun Press 1931
Copy on Hollande paper no.47/50
Signed by René Crevel
Private collection

SALVADOR DALI
1904–1989

La Femme visible
Book with, additionally, several photographs and an original drawing by Dalí 28.7 × 23 (11⁵/₁₆ × 9¹/₁₆)
Paris, Editions Surréalistes 1930
Copy hors commerce, on glossy Japan paper no.1/4, printed for René Char
Leroux binding 1989
Dedication by Dalí to Char
Pierre Leroy, Paris
[fig.124]

L'Amour et la mémoire
Book 19.3 × 14.2 (7⁵/₈ × 5⁹/₁₆)
Paris, Editions Surréalistes 1931
Copy on white wove paper no.110/300
Mony Vibescu
[fig.123]

ROBERT DESNOS
1900–1945

Deuil pour deuil
Book 16 × 12 (6⁵/₁₆ × 4³/₄)
Paris, Editions Simon Kra 1924
Dedication by Desnos to Philippe Soupault
Private collection

La Liberté ou l'amour!
Book, in case, with examples of the additional censored pages, left blank in the standard edition 16.5 × 12 (6¹/₂ × 4³/₄)
Paris, Aux Editions du Sagittaire 1927
Copy on Rives wove paper no.817/965
Dedication by Desnos to Raymond Roussel
Pierre Leroy, Paris

La Liberté ou l'amour!
Book 16.5 × 12 (6¹/₂ × 4³/₄)
Paris, Aux Editions du Sagittaire 1927
Copy on Rives wove paper no.655/965
Claude Oterelo
[fig.101]

Corps et bien
Book 21.7 × 17 (8⁹/₁₆ × 6¹¹/₁₆)
Paris, Editions de la N.R.F. 1930
Copy reimposed on Lafuma-Navarre paper no.G/9
Private collection

De l'erotisme considéré dans ses manifestations écrites et du point de vue de l'esprit moderne
Book 19.3 × 12.2 (7⁵/₈ × 4¹³/₁₆)
Paris, Editions 'Cercle des Arts' 1953 [text written 1923]
Copy on Alfama paper no.1267
Benoît Lardières

PAUL ELUARD
1895–1952

L'Amour la poésie
Book with, additionally, manuscript of a poem from 'Seconde nature' 21.7 × 17 (8⁹/₁₆ × 6¹¹/₁₆)
Paris, Editions de la N.R.F. 1929
Copy reimposed on Lafuma-Navarre paper no.XXXVIII/109
Leroux binding
Musée d'art et d'histoire, Saint-Denis

Comme deux gouttes d'eau
Book 18.7 × 13.8 (7³/₈ × 5⁷/₁₆)
Paris, Editions Surréalistes 1933
Benoît Lardières

Nuits partagées
Book with illustrations by Salvador Dalí, and, additionally, a drawing by Dalí, some photographs, three manuscript poems by Paul Eluard and a photograph of Gala by Man Ray 25 × 19.5 (9¹³/₁₆ × 7¹¹/₁₆)
Paris, G.L.M. 1935
Copy on tinted Normandy wove paper no.43/70
Cover and box by Claudie de Seguier
Dedication by Eluard to René Char
Former collection René Char
Pierre Leroy, Paris

PAUL ELUARD AND MAX ERNST
1895–1952, 1891–1976

ANONYMOUS [Paul Eluard, Max Ernst]
Au Défaut du silence
Book with, additionally, manuscripts by Eluard, Gala and René Crevel, and original drawings by Max Ernst and de Chirico 28.5 × 23 (11¹/₄ × 9¹/₁₆)
Paris 1925
Copy on Hollande paper no.28/50
Former collection Paul Eluard
Pierre Leroy, Paris
[figs.103, 106]

PAUL ELUARD AND MAN RAY
1895–1952, 1890–1976

Facile
Book 24.5 × 18.5 (9⁵/₈ × 7⁵/₁₆)
Paris, G.L.M. 1935
Copy on wove paper
Dedication by Paul Eluard to André and Katia Thirion
Dominique Rabourdin

Facile
Book with, additionally, a letter by Nusch Eluard to Man Ray, and three Man Ray photographs made in 1966 from original negatives 24.1 × 18 (9¹/₂ × 7¹/₁₆)
Paris, G.L.M. 1935
Copy hors commerce on wove paper no.LVI/200
Former collection René Char, with dedication by Eluard
Pierre Leroy, Paris
[figs.99, 135]

MAX ERNST
1891–1976

La Femme 100 têtes
Book 25.2 × 19.5 (9¹⁵/₁₆ × 7¹¹/₁₆)
Paris, Editions du Carrefour 1929
Copy on tinted wove paper no.172/900
Claude Oterelo

A Little Girl Dreams of Taking the Veil
Book (translated by Dorothea Tanning) 25.7 × 19.5 (10¹/₈ × 7¹¹/₁₆)
New York 1982
Tate Library

FRANTIŠEK HALAS
1901–1949

Thyrsos
Book with illustrations by Jindřich Štyrský 26.5 × 20 (10⁷/₁₆ × 7⁷/₈)
Prague, Editions 69, no.3 1932
Copy no.122
Mony Vibescu

JINDŘICH HEISLER
1914–1953

L'Amour fou 1950
Book-object 41 × 66 (16⅛ × 26)
Dedicated by Heisler to André Breton
Private collection

GEORGES HUGNET
1906–1974

Onan
Book with frontispiece engraving by
Salvador Dalí, and, additionally, a
separate engraving by Dalí 29.5 × 24
(11⅝ × 9⁷/₁₆)
Paris, Editions Surréalistes 1934
Copy on Turner Geranium paper HC
VII/XXV
Dedication by Hugnet to Jeanne Bucher
P.N. Antonio binding 1998
Private collection

Oeillades ciselées en branche
Book with illustrations by Hans Bellmer,
reproduced as heliogravures 13.8 × 10
(5⁷/₁₆ × 3¹⁵/₁₆)
Paris, Editions Jeanne Bucher 1939
Copy on wove paper no.59/130
Mony Vibescu
[fig.102]

Anonymous [Georges Hugnet]
Le Feu au cul
Book illustrated by Oscar Dominguez,
with, additionally, two engravings and an
original drawing by Dominguez
10.3 × 15.3 (16⅛ × 26)
Without place [Paris] or publisher's
name [R.J. Godet], undated [1943]
Copy on best quality cotton paper from
the Marais paper mill no.33/40
Mony Vibescu

GILBERT LELY
1904–1985

Ma Civilisation
Book 22.5 × 18 (8⁷/₈ × 7¹/₁₆)
Number six of edition of twelve copies
typed by the author 1942
Former collection Michel Nulcéa, with
dedication to him by Lely
Private collection

GHERASIM LUCA
1913–1994

Quantitativement aimée 1944
Book-object with 944 nibs
30.5 × 28.5 (12 × 11¼)
Private collection, Paris

MAN RAY
1890–1976

Les Mains libres
Book with drawings by Man Ray, illus-
trated by poems by Paul Eluard
28.5 × 25 (11¼ × 9¹³/₁₆)
Paris, Editions Jeanne Bucher 1937
Copy on laid Chester paper no.369/650
Leroux binding 1992
Dedicated by Man Ray and Eluard to
Max Ernst
Claude Oterelo

JOYCE MANSOUR
1928–1986

*Jules César**
Book with five engravings by Hans
Bellmer 20.5 × 11 (8 1/10 × 4⅝)
Paris, Editions Pierre Seghers 1956
One of seven copies not for sale, on Rives
wove paper
Dedication by Mansour to Gerald Neveu
J.-P. Dutel

VITEZSLAV NEZVAL
1900–1958

Sexuálnï Nocturno
Book with collages by Jindřich Štyrský
20 × 13 (7⅞ × 5⅛)
Prague, Editions 69, no.1, 1931
Copy no.87/138
Mony Vibescu

ALICE PAALEN
1904–1979

A même la terre
Book 14.6 × 10 (5¾ × 3¹⁵/₁₆)
Paris, Editions Surréalistes 1936
Private collection

*Sablier couché**
Book with etching by Joan Miró and,
additionally, collage frontispiece by Miró
21.8 × 17 (8⅝ × 6¹¹/₁₆)
Paris, Editions Sagesse 1938
Dedication by Paalen to Georges Hugnet
Copy no.72/75
Scottish National Gallery of Modern Art,
Edinburgh. Bequeathed by Gabrielle
Keiller 1995

VALENTINE PENROSE
1898–1978

Herbe à la lune
Book with preface by Paul Eluard
19.5 × 15 (7¹¹/₁₆ × 5⅞)
Paris, G.L.M. 1935
Copy on tinted Normandy vellum

no.20/300
Georges Hugnet binding
A. & R. Penrose

Sorts de la lueur
Book with illustration by Wolfgang
Paalen 25 × 19.5 (9¹³/₁₆ × 7¹¹/₁₆)
Paris, Editions G.L.M. 1937
Copy on tinted Normandy vellum, num-
bered HC
Signed by Guy Levis Mano
D. Grandsart - Galerie Obsis, Paris

Dons des féminines
Book with, additionally, an engraving by
Pablo Picasso 34 × 26 (13⅜ × 10¼)
Paris, Les Pas perdus 1951
Copy on Alfa paper no.48
A. & R. Penrose

BENJAMIN PERET
1899–1959

Je sublime
Book with frottage illustrations by Max
Ernst 14.5 × 10 (5¹¹/₁₆ × 3¹⁵/₁₆)
Paris, Editions Surréalistes 1936
Copy hors commerce on tinted
Normandy 'Le Roy Louis' paper from
Vitry no.17/25
Private collection

Satyremont [Benjamin Péret]
Les Rouilles encagées
Book with illustrations by Yves Tanguy
19 × 14 (7½ × 5½)
Paris, Eric Losfeld 1954
Mony Vibescu

GISELE PRASSINOS
born 1920

Quand le bruit travaille
Book with frontispiece drawing by Hans
Bellmer, and, additionally, a letter from
Bellmer to Prassinos 16.8 × 12.7
(6⅝ × 5)
Paris, G.L.M. 1936
Copy on wove paper no.175/200
Binding by P.N. Antonio 1998
Dedication by Prassinos
Claude Oterelo

D.A.F. DE SADE
1740–1814

Justine, ou Les Malheurs de la vertu
Book 19.2 × 17.7 (7⁹/₁₆ × 6¹⁵/₁₆)
Holland, chez les Libraires associés
[Paris] 1791
Nineteenth-century binding
Pierre Leroy, Paris
[fig.243]

Justina, čili prokletí cnosti
Justine, or The Misfortunes of Virtue
Book with illustrations by Toyen
19.3 × 13 (7⅝ × 5⅛)
Prague, Editions 69, no.2 1932
Copy no.157/200
Mony Vibescu

Justine, ou Les Malheurs de la vertu
Book with frontispiece by Hans Bellmer
and preface by Georges Bataille
19 × 12 (7½ × 4¾)
Paris, Editions Le Soleil Noir 1950
Copy on Plumex wove paper no.461/910
Mony Vibescu
[fig.258]

La Vanille et la manille
Book, publishing letter to Mme de Sade,
edited by Gilbert Lély, with engravings
by Jacques Hérold, and, additionally,
annotations by Lély 30 × 20.5
(11¹³/₁₆ × 8¹/₁₆)
Paris, Collection Drosera 1 1950
Copy on Arches wove paper no.44/100
Pierre Leroy, Paris

JINDŘICH ŠTYRSKÝ
1899–1942

Emile přicházi ke mně ve snu
Emilie Comes to Me in a Dream
Book illustrated with collages by the
author, postface by Bohuslav Brouk
21 × 13.7 (8¼ × 5⅜)
Prague, Editions 69, no.6, 1933
Ubu Gallery, New York

ANDRE THIRION
1907–2000

Le Grand Ordinaire
Book with illustrations by Oscar
Dominguez, and, additionally, an etching
by the same artist 19.5 × 14.7
(7¹¹/₁₆ × 5¹³/₁₆)
Without place [Paris] or publisher's
name [R.J. Godet] 1934 [1943]
Copy on Lafuma paper no.4
Mony Vibescu

VARIOUS

Violette Nozières 1933
Book with original collage by Breton
dated 1 January 1934 19.7 × 14.7
(7¾ × 5¹³/₁₆)
Brussels, Editions Nicolas Flamel, 1934
Dedicated to Marcelle Ferry
Dominique Rabourdin

Violette Nozières 1933
Book 19.8 × 14.5 (7^{13}/$_{16}$ × 5^{11}/$_{16}$)
Brussels, Editions Nicolas Flamel, 1933
Musée d'art et d'histoire, Saint-Denis

UNICA ZÜRN

1916–1970

Hexentexte 1954
Book with illustrations by Zürn, and,
additionally, a pencil drawing by Hans
Bellmer 19.5 × 19.4 (7^{11}/$_{16}$ × 7^5/$_8$)
Victor & Gretha Arwas

Sombre Printemps
Book with frontispiece illustration by
Hans Bellmer 22 × 11.2 (8^3/$_4$ × 4^3/$_4$)
Paris, Editions Pierre Belfond 1971
Benoît Lardières

PERIODICALS, COLLECTIVE TRACTS & PRINTED MATTER

*If You Love Love, You'll Love
Surrealism* 1924
Si vous aimez l'amour, vous aimerez le
surréalisme
Printed paper 6.8 × 10.8 (2^{11}/$_{16}$ × 4 1/$_4$)
Galerie 1900–2000, Marcel and David
Fleiss, Paris
[fig.11]

*Parents, Tell your Children your
Dreams* 1924
Parents, racontez vos rêves à vos enfants
Printed paper, three colours
Each 7 × 10.6 (2^3/$_4$ × 4^3/$_{16}$)
Galerie 1900–2000, Marcel and David
Fleiss, Paris

Surrealism Is Literature Denied 1924
Le surréalisme, c'est l'écriture niée
Printed paper, two colours
Each 6.8 × 10.4 (2^{11}/$_{16}$ × 4^1/$_4$)
Galerie 1900–2000, Marcel and David
Fleiss, Paris

*Open your Mouth like an Oven and
Nuts Will Come Out* 1924
Ouvrez la bouche comme un four, il en
sortira des noisettes
Printed paper, two colours, each
6.5 × 10.5 (2^9/$_{16}$ × 4^1/$_8$)
Galerie 1900–2000, Marcel and David
Fleiss, Paris

La Révolution surréaliste, no.1, 1924
Periodical 29.5 × 20.3 (11^5/$_8$ × 8)
Galerie 1900–2000, Marcel and David
Fleiss, Paris

Transition 1927 [Hands Off Love]
Pamphlet 19.5 × 14.3 (7^{11}/$_{16}$ × 5^5/$_8$)
Dominique Rabourdin

La Révolution surréaliste, no.11,
15 March 1928
Periodical 29.5 × 20.3 (11^5/$_8$ × 8)
Galerie 1900–2000, Marcel and David
Fleiss, Paris

Variétés, special number, June 1929
[Surrealism in 1929]
Periodical 24.8 × 17.7 (9^3/$_4$ × 6^{15}/$_{16}$)
Galerie 1900–2000, Marcel and David
Fleiss, Paris

La Révolution surréaliste, no.12,
15 December 1929
Periodical 29.5 × 20.3 (11^5/$_8$ × 8)
Galerie 1900–2000, Marcel and David
Fleiss, Paris
[fig.166]

Erotická revue, vol.1, 1930
Periodical 20.8 × 15.3 (8^3/$_{16}$ × 6)
Copy on Van Gelder paper no.15/30
Parchment binding with two original
drawings by Jindřich Štyrský
Mony Vibescu

Erotická revue, vol.2, 1932
Periodical 20.8 × 13.5 (8^3/$_{16}$ × 5^5/$_{16}$)
Copy on imitation Japan paper
no.201/250, with Ex Libris by V.H.
Brunner
Mony Vibescu
[fig.231]

Pula 1932
Periodical, sole issue
Bucharest
Private collection

Minotaure, no.3–4, 12 December 1933*
Periodical 31.6 × 24.6 (12 1/$_2$ × 9^1/$_4$)
Tate Library

Minotaure, no.7, June 1935
Periodical 31.6 × 24.6 (12 1/$_2$ × 9^1/$_4$)
Serge Benhamou, Paris

The London Bulletin, no.18–19–20,
June 1940
Periodical 25 × 18.7 (9^{13}/$_{16}$ × 7^3/$_8$)
Conroy Maddox

VVV, no.1, 1940
Periodical
28 × 21.9 (11 × 8^3/$_4$)
Private collection, London

View, series 2, no.1, April 1942
Periodical 26.5 × 19 (10^7/$_{16}$ × 7 1/$_2$)
Conroy Maddox

Le Surréalisme, même, no.4, 1958
Periodical 19.2 × 19.4 (7^9/$_{16}$ × 7^5/$_8$)
Benoît Lardières

*Invitation for 'The Execution of the
Testament of the Marquis de Sade'*
1959
Card 21.5 × 15.5 (8^7/$_{16}$ × 6^1/$_8$)
D. Grandsart – Galerie Obsis, Paris

La Brèche, no.8 1965
Periodical 22.5 × 15.5 (8^7/$_8$ × 6^1/$_8$)
Benoît Lardières

MARCEL DUCHAMP

1887–1968

Prière de toucher
Catalogue for the exhibition *Le
Surréalisme en 1947*
Paris, Galerie Maeght 1947
Galerie Maeght, Paris
[fig.271]

Boîte alerte (Missives lascives) 1959
Mixed media 28.5 × 18 × 6.5
(11^1/$_4$ × 7^1/$_{16}$ × 2^9/$_{16}$)
Tate. Purchased 2000

LENDERS

PUBLIC COLLECTIONS

Aalborg, Nordjyllands Kunstmuseum

Baltimore, Baltimore Museum of Art

Blainville-Crevon, Centre d'étude et de documentation JACOVSKY-FRERE, Commune de Blainville-Crevon

Chichester, The Edward James Foundation

Chicago, The Art Institute of Chicago

Duisburg, Stiftung Wilhelm Lehmbruck Museum

Düsseldorf, Kunstsammlung Nordrhein-Westfalen

Edinburgh, Scottish National Gallery of Modern Art

Figueres, Fundació Gala-Salvador Dalí

Frankfurt am Main, Städtische Galerie im Städelschen Kunstinstitut

Houston, The Menil Collection

Locarno, Marguerite Arp Foundation

London, Tate

London, The British Film Institute

Madrid, Museo Nacional Centro de Arte Reina Sofía

Madrid, Museo Thyssen-Bornemisza

Nantes, Musée des Beaux-Arts de Nantes

New Orleans, New Orleans Museum of Art

New York, The Joseph and Robert Cornell Memorial Foundation, courtesy C&M Arts

New York, The Metropolitan Museum of Art

New York, The Museum of Modern Art

Ottawa, National Gallery of Canada

Paris, Fonds Elsa Triolet / Aragon – C.N.R.S.

Paris, Maison Européenne de la Photographie

Paris, Musée d'art moderne de la Ville de Paris

Paris, Musée national Picasso

Philadelphia, Philadelphia Museum of Art

Prague, Museum of Czech Literature

Rome, Galleria Nazionale d'Arte Moderna

Rotterdam, Museum Boijmans Van Beuningen

Saint-Denis, Musée d'art et d'histoire

Saint-Etienne, Musée d'art moderne

Saint Helier, The Jersey Heritage Trust

St Petersburg, Salvador Dalí Museum

Santa Barbara, Santa Barbara Museum of Art

Toronto, Art Gallery of Ontario

Venice, Peggy Guggenheim Collection

Washington D.C., Hirshhorn Museum and Sculpture Garden, Smithsonian Institution

Washington D.C., Joseph Cornell Study Center, Smithsonian American Art Museum

Washington, DC, National Gallery of Art

Zürich, Kunsthaus Zürich

PRIVATE COLLECTIONS

Dawn Ades

Artesia Bank, Belgium

Victor & Gretha Arwas

Karen Amiel Baum, New York

Timothy Baum, New York

Serge Benhamou, Paris

Jean Benoît

Claude Berri

Cheim and Read, New York

CineNova, London

Contemporary Films, London

The Estate of Maya Deren

Enrico Donati, courtesy Zabriskie Gallery, New York

J.-P. Dutel

Edwynn Houk Gallery

Mr and Mrs Ahmet Ertegun

Richard L. Feigen

Géraldine Galateau

Galerie 1900–2000, Marcel and David Fleiss, Paris

Galerie Claude Bernard, Paris

Galerie Maeght, Paris

D. Grandsart – Galerie Obsis, Paris

Manfred Heiting, Amsterdam

Herbert Lust Gallery

Marguerite and Robert Hoffman

Radovan Ivsic

Benoît Lardières

Lee Miller Archives

Robert Lehrman, Washington, DC

Pierre Leroy, Paris

Conroy Maddox

Madonna

Marcel Duchamp Archives, Villiers sous Grez

Anna Maria Martins Turner

Jacqueline Matisse Monnier

The Mayor Gallery, London

Jennifer Mundy

Ordóñez Falcón Collection of Photography

Claude Oterelo

A. & R. Penrose

Birger Raben-Skov, Copenhagen

Dominique Rabourdin

Yves Saint Laurent – Pierre Bergé

Arno Schefler

Michael Senft, New York

Dorothea Tanning, courtesy Cavaliero Fine Arts, New York

Roger Thérond Collection

Lucien Treillard

Ubu Gallery, New York

Ubu Gallery, New York, and Galerie Berinson, Berlin

Mony Vibescu

Thomas Walther

Richard S. Zeisler

PHOTOGRAPHIC CREDITS

Irène Andréani
Fondazione Marguerite Arp, Locarno
Arthotek, Peissenberg
The Baltimore Museum of Art
Galerie Berinson, Berlin
Gilles Berquet
BFI Stills, Posters and Designs, London
Museum Boijmans Van Beuningen,
　Rotterdam
Yves Bresson
Will Brown
Christopher Burke
National Gallery of Canada, Ottawa
Carlo Cantenazzi
The Art Institute of Chicago
CNAC / MNAM Dist. RMN / Georges
　Meguerditchian, Paris
CNAC / MNAM Dist. RMN / Philippe Migeat,
　Paris
CNAC / MNAM Dist. RMN, Phototèque des
　Musées de la ville de Paris
Cornell Foundation, New York
Dalí Museum, Florida
Farvelaborateit, Denmark
Allan Finkelman
Jacques Faujour, Paris
Archives Galerie de France, Paris
Fondacio Gala-Salvador Dali, Figueres
Giacometti Foundation Kunsthaus Zürich
Emmanuel Grancher, Zürich
Paul Hester, Houston
Hickey-Robertson, Houston
Jersey Heritage Trust, Saint Helier
Bernd Kirtz, Fotograph BFF, Duisburg
Walter Klein, Düsseldorf
Francisco Kochen

Michael Korol
Hugo Maertens, Bruges
Archives Comité André Masson, Paris
Lee Miller Archives, Chiddingly, East Sussex
Patrice Maurin-Berthier
Courtesy of the Mayor Gallery, London
The Metropolitan Museum of Art, New York
The Metropolitan Museum of Art, New York /
　Malcolm Varon
MIT List Visual Arts Center, Massachusetts
Musée des Beaux-Arts de la ville de
　Nantes / photo: A.G.
New Orleans Museum of Art
Thomas Pedersen & Poul Pedersen
Philadelphia Museum of Art
Centre Pompidou, Paris / Adam Rzepka
Museo Nacional Centro de Arte Reina
　Sofia Photographic Archive, Madrid
National Gallery of Modern Art, Rome
RMN / Frank Raux, Paris
Lynn Rosenthal
Santa Barbara Museum of Art
John Sargent
National Galleries of Scotland, Edinburgh
Lee Stalsworth
Modern Museet, Stockholm / P.-A. Allsten
Smithsonian American Art Museum,
　Washington, DC
The Solomon R. Guggenheim Foundation,
　Venice / David Heald
Tate Photography, London / Andrew Dunkley
　/ Marcus Leith
Museo Thyssen-Bornemisza, Madrid
Ubu Gallery, New York
Galerie Zabriskie, New York
Dorothy Zeidman

COPYRIGHT CREDITS

Every effort has been made to contact the copyright holders of the works reproduced. The publishers apologise for any omissions that may inadvertently have been made.

Eileen Agar © Artist's Estate
Louis Aragon: 'Poeme écrit dans les toilettes avec un couteau sur le mur' © Jean Ristat
Jean Arp © DACS 2001
Denise Bellon © Les Films de l'equinoxe – Fonds photographique Denise Bellon
Hans Bellmer © ADAGP, Paris and DACS, London
Jean Benoît © Jean Benoît
Jacques-André Boiffard © Madame Boiffard
Louise Bourgeois © Louise Bourgeois / VAGA, New York / DACS, London 2001
Brassaï © Estate Brassaï
Victor Brauner © ADAGP, Paris and DACS, London
André Breton:
 works of art © ADAGP, Paris and DACS, London 2001
 manuscript of *Arcane 17* © Aube Elléouet Breton
 Arcane 17 © 1944, 1965, Société Nouvelle des Editions Pauvert
 Arcanum 17 © Sun & Moon Press
 'Free Union', from *Le Revolver à cheveux blancs* © Editions Gallimard 1948, trans. © M.A. Caws 2001
 Nadja © Editions Gallimard
 'They Tell me That Over There', from *L'Air de l'eau* © Editions Gallimard 1948, trans. © M.A. Caws 2001
 'Sunflower' from *L'Amour fou* © Editions Gallimard 1937, trans © Katharine Conley 2001
André Breton and Paul Eluard, *L'immaculée conception* © Editions Seghers
Leonora Carrington © ARS, NY and DACS, London 2001
René Char, *Artine*, in *Le Marteau sans maître* © Librairie José Corti

Joseph Cornell © The Joseph and Robert Cornell Memorial Foundation / VAGA, New York / DACS, London
Salvador Dalí © Kingdom of Spain, Gala Salvador Dalí Foundation, DACS, London 2001
Robert Desnos:
 'I Have Dreamed So Much of You' © Editions Gallimard 1930
 La Liberté ou l'amour! © Editions Gallimard
Giorgio de Chirico © DACS 2001
Paul Delvaux © Foundation P. Delvaux-St Idesbald, Belgium / DACS London 2001
Oscar Dominguez © ADAGP, Paris and DACS, London 2001
Enrico Donati © Enrico Donati
Marcel Duchamp © Succession Marcel Duchamp, ADAGP, Paris and DACS, London 2001
Nusch Eluard © courtesy of Cecile Eluard
Paul Eluard:
 Collages and drawings © courtesy of Cecile Eluard
 Au défaut du silence © Editions Gallimard
 Facile © Editions Gallimard
 'I've Told You', from *L'Amour La Poesie* © Editions Gallimard 1929, trans. © M.A. Caws 2001
 'My Love Because You Understand my Desires' from *L'Amour La Poesie* © Editions Gallimard 1929, trans. © Jennifer Mundy 2001
Gilles Ehrmann © Gilles Ehrmann
Max Ernst © ADAGP, Paris and DACS, London 2001
Leonor Fini © Estate of Leonor Fini and Rafael Martinez
Wilhelm Freddie © DACS 2001
Alberto Giacometti © ADAGP, Paris and DACS, London 2001
Arshile Gorky © ADAGP, Paris and DACS, London 2001
George Hugnet © ADAGP, Paris and DACS, London 2001
Valentine Hugo © ADAGP, Paris and DACS, London 2001
Frida Kahlo © Banco de Mexico, Diego Rivera and Frida Kahlo Museums

Wilfredo Lam ©ADAGP, Paris and DACS, London 2001
Jacqueline Lamba ©ADAGP, Paris and DACS, London 2001
Dora Maar © ADAGP, Paris and DACS, London 2001
René Magritte © ADAGP, Paris, and DACS, London 2001
Joyce Mansour, *Cris* © Editions Seghers. Paris 1953
André Masson © ADAGP, Paris and DACS London 2001
Roberto Sebastian Enchaurren Matta © ADAGP, Paris and DACS London 2001
Joan Miró © ADAGP, Paris and DACS, London 2001
Pierre Molinier © ADAGP, Paris and DACS, London 2001
Henry Moore © The Henry Moore Fondation
Meret Oppenheim © DACS 2001
Mimi Parent © Mimi Parent
Roland Penrose © Roland Penrose estate, care of the Lee Miller Archives
Valentine Penrose © Artist's estate
Benjamin Péret: 'Wink', from *Je Sublime* © Editions Surréalistes chez José Corti 1936, trans. © M.A. Caws 2001
Francis Picabia © ADAGP, Paris and DACS, London 2001
Pablo Picasso © Succession Picasso / DACS 2001
Man Ray © Man Ray Trust / ADAGP, Paris and DACS, London 2001
Yves Tanguy © ARS, NY and DACS, London 2001
Dorothea Tanning © DACS 2001
Karel Teige © The Artist's estate
Marie Toyen © Estate Marie Toyen
Raoul Ubac © ADAGP, Paris and DACS, London 2001
Remedios Varo
 Works of art © DACS 2001
 'A Recipe: How to Produce Erotic Dreams', trans. Walter Gruen in Penelope Rosemont (ed.), *Surrealist Women: An International Anthology*, Austin, Texas 1998

Film stills from *Un chien andalou* and *L'Age d'or* © Contemporary Films Ltd

SURREALISM

desire unbound

Edited by Jennifer Mundy
Consultant Editor, Dawn Ades
Special Adviser, Vincent Gille

Published to accompany a major exhibition of international surrealism at
Tate Modern and The Metropolitan Museum of Art in 2002, this lavishly
illustrated catalogue explores desire in surrealist art in both words and
images. Key works by such artists as Duchamp, Magritte, Ernst, Dalí,
de Chirico, Giacometti, Bellmer, Oppenheim, and Cahun are illustrated and
discussed, as are surrealist films and photographs by Man Ray, Brassaï,
and others. The volume also features some of the rare and beautiful books
produced by the surrealists in their celebration of love, as well as a selection
of fascinating manuscripts, letters, and documentary photographs that
reveal the personal contexts of the group's exploration of desire. Essays by
leading scholars show how the theme of desire was implicated in almost all
aspects of surrealist activity.

"The lavishly illustrated catalogue ... provides additional lenses through
which to view the often hypnotic artworks and the affiliated groups of artists
that produced them."
—Robert Askins, *ArtNews*

"[A] gripping album of surrealist works in all media, from the movement's
origins in interwar Europe to its legacy in contemporary art, with special
attention to erotic content. Thematic essays offer as much historical sweep
and critical penetration as any single book on the subject."
—Kenneth Baker, *San Francisco Chronicle*

"Since the notion of desire is central to surrealism, this volume is overdue
and most welcome.... A variety of presentations and explanations of events,
artists, works, and particular manifestations of surrealism provide useful
background and detail, thus usefully complementing the annotated essays."
—*Choice*

Jennifer Mundy is Head of Research and International Modern Art
at Tate; **Dawn Ades** is Professor of Art History and Theory at Essex
University and Director of the Centre of the Study of Surrealism and its
Legacies; **Vincent Gille** works at the Pavillon des Arts, Paris.

300 color plates
Published by Tate Publishing, London, in association with Princeton University Press
pup.princeton.edu
Cover image: Man Ray, *Untitled* (from *Facile*) 1935

Printed in Great Britain
Bound in the United States

ISBN 0-691-12336-5

90000

9 780691 123363